Adobe Photoshop CS for Photographers

A professional image editor's guide to the creative use of Photoshop for the Macintosh and PC

Martin Evening

ELSEVIER

AMSTERDAM • BOSTON • HEIDELBERG • LONDON • NEW YORK • OXFORD
PARIS • SAN DIEGO • SAN FRANCISCO • SINGAPORE • SYDNEY • TOKYO

Focal Press is an imprint of Elsevier

Focal Press

Focal Press
An imprint of Elsevier
Linacre House, Jordan Hill, Oxford OX2 8DP
200 Wheeler Road, Burlington MA 01803

First published 2004

British Library Cataloguing in Publication Data
A catalogue record for this book is available from the British Library

Library of Congress Cataloguing in Publication Data
A catalogue record for this book is available from the Library of Congress

ISBN: 0 240 51942 6

For information on all Focal Press publications visit our website at
www.focalpress.com

Printed and bound in Italy

Adobe Photoshop CS
for Photographers

In memory of my mother Marjorie Evening

Contents

Foreword .. xix
Preface ... xxi
Acknowledgments .. xxii

Chapter 1: What's New in Adobe Photoshop CS

Editing metadata ... 2
Quick folder access ... 2
Improved Mac OS X performance .. 2
Custom Keyboard Shortcuts ... 2
File Browser and Camera Raw ... 2
Backward compatibility options ... 3
Extended 16 Bit support .. 4
Live Histogram palette ... 4
Interface changes .. 4
Image Adjustments ... 5
Image interpolation ... 7
Filters ... 7
Hard Mix blending mode ... 7
Scrubby sliders .. 7
Extracting textures .. 8
Layer management .. 9
Automation .. 9
On-line Services .. 10
Brushes .. 11
Creating new documents ... 11
How do you do that? .. 11
Type features ... 12
Overall impressions ... 12

Chapter 2: The Work Space 13

Macintosh and PC keys .. 14
 Image window ... 14
 Document Sizes ... 15
 Document Profile ... 15
 Document Dimensions .. 15
 Scratch Sizes .. 15
 Efficiency ... 15
 Timing .. 15
 Tool Selection .. 15
Keyboard shortcuts ... 15
Preview box options ... 16
Title bar proxy icons (Macintosh) .. 16
Managing document windows ... 16
Rulers, Guides & Grid .. 17
'Snap to' behavior ... 18
The Photoshop palettes ... 18
Palette docking .. 19
Workspace settings ... 19

Contents

File Browser ... 20
Navigator .. 22
Info .. 22
Histogram palette .. 23
Tool Options bar ... 24
Tool Presets .. 25
Character .. 26
Paragraph .. 26
Brushes .. 26
Brushes palette ... 27
Pressure sensitive control ... 28
Styles .. 29
Swatches .. 30
Color ... 30
Preset Manager ... 30
Actions ... 30
History .. 32
Layers ... 32
Layer Comps ... 33
Channels .. 33
Paths .. 34
Tools palette ... 35
Selection tools .. 36
Modifier keys ... 37
Magic wand tolerance setting .. 37
Easter eggs .. 39
Spacebar tip ... 40
Lasso: freehand/polygon/magnetic ... 40
Move tool ... 44
Crop tool .. 45
Switching unit dimensions .. 45
Crop presets .. 46
Crop tool cursor icons ... 46
Slicing tools ... 47
The paint tools .. 48
Healing brush/Patch tool ... 48
Color replacement tool .. 48
Brush .. 49
Pencil .. 49
Clone stamp/Pattern stamp .. 49
History brush ... 50
History brush and Snapshot .. 51
History and memory usage ... 52
Nonlinear history .. 53
Art history brush ... 55
Eraser/background eraser/magic eraser .. 55
The Wacom eraser .. 55
Contiguous selection modes .. 55
The Extract command ... 57
Gradients .. 58
Noise gradients ... 60

Paint bucket .. 60
Focus: blur/sharpen/smudge .. 61
Toning: dodge/burn/sponge .. 62
Pen and path drawing .. 63
Type tool .. 63
Get out of filled layer mode .. 63
For more about type .. 64
Shape tools .. 64
Annotation tools .. 65
Eyedropper/color sampler .. 65
Sample size .. 66
Measure .. 66
Navigation tools – hand and zoom .. 67
Foreground/background colors .. 67
Scroll All/Zoom All Windows .. 67
Selection mode/Quick mask .. 68
Screen display .. 68
Jump to button .. 69
Changing the color of the canvas .. 69

Chapter 3: Configuring Photoshop 70

Buying a system .. 71
Start out small .. 71
Macintosh G5 optimization .. 71
Operating environment .. 72
Choosing a display .. 73
Where to buy .. 73
Running a second display .. 74
Display calibration and profiling .. 75
Video cards .. 75
Calibrating hardware .. 77
Visual display calibration for Mac OS X and PC 80
Contrast and brightness .. 80
Neutralizing the color .. 81
Target Gamma .. 81
White point .. 82
Color management settings .. 83
Graphics tablets .. 84
Extras .. 84
Photoshop preferences .. 85
Chip speed .. 85
Chip acceleration .. 86
File Handling .. 87
File editing history .. 87
Resetting dialogs .. 87
Economical web saves .. 87
Backward compatibility issues .. 88
Enabling Workgroups .. 89
Recent File List .. 89
Cursor display options .. 90
Display & Cursors .. 90

Transparency & Gamut ... 91
Units & Rulers .. 91
Guides, Grid & Slices .. 92
Plug-ins & Scratch Disks ... 92
How much RAM does Photoshop need? ... 94
RAM memory and scratch disks ... 94
Virtual memory tricks .. 95
RAID array hard drives .. 96
Memory & Image Cache .. 97
Configuring the RAM memory settings ... 97
Clearing the Photoshop memory .. 98
File Browser ... 98
Photoshop and Mac OS X 10.2 ... 99
Mac OS X and Photoshop 7.0 ... 100
Installing Mac OS X 10.2 and Photoshop .. 100
Windows XP .. 101
SCSI compatibility in Mac OS X .. 101
Windows XP System reverts .. 101
Norton disk doctor tip ... 102
System software maintenance .. 102

Chapter 4: Basic Image Adjustments 103

Interpreting an image .. 104
The Histogram .. 104
The Histogram palette ... 105
Camera histograms ... 105
Levels adjustments ... 107
Setting the highlights .. 107
Resetting Image adjustments ... 107
Specular highlights ... 110
Cutouts against a white background ... 111
Brightness and contrast .. 111
Brightness/Contrast .. 113
Levels after conversion ... 115
Fine-tuning the endpoints .. 115
Automatic Levels compensation ... 115
Assigning shadow and highlight points ... 116
Curves adjustments ... 117
Correcting shadow and highlight detail ... 120
 Radius ... 122
 Amount .. 123
 Tonal Width .. 123
 Color Correction ... 123
 Midtone Contrast .. 123
Adjustment layers ... 123
Screen redraw times ... 124
Repeated adjustments warning .. 124
Cumulative adjustments .. 124
Multiple adjustment layers ... 124
Blending mode adjustments ... 124
16 bits per channel support ... 125

Where did the extra levels go? ... 127
Background layers and Big Data ... 128
Cropping .. 128
Orientation and canvas .. 128
Perspective cropping ... 128
Unsharp masking .. 131
Precise image rotation ... 132
Origins of unsharp masking ... 132
Sharpening for repro .. 133
 Amount ... 133
 Radius ... 133
 Evaluating sharpening on the display .. 133
 Threshold .. 135
Selective sharpening .. 135
Sharpening selected channels ... 137
Luminance sharpening ... 138
Progressive sharpening .. 138
Edge sharpening ... 138
Third-party sharpening plug-ins .. 140
Beyond the basics .. 141

Chapter 5: Color Correction 142

Variations ... 143
Finding neutral RGB ... 144
Color balancing with Levels ... 144
Auto adjustments .. 144
Color Balance ... 146
Precise color correction with Curves .. 146
Arbitrary Map mode ... 149
Color Temperature ... 150
Photo Filter ... 150
Match Color .. 152
Hue/Saturation ... 154
Color Replacement brush ... 156
Replace Color ... 159
Color Range .. 159
Selective Color .. 159
Alternative Replace Color technique ... 159

Chapter 6: Repairing an Image 162

Clone stamp brush settings ... 163
Use all layers .. 163
Basic cloning methods ... 163
Alternative history brush spotting technique ... 166
Working with the healing brush ... 166
Healing brush settings .. 168
Heal using 'All Layers' .. 168
Source and Destination modes .. 171
Patch tool .. 171
Healing brush strategies ... 174

Healing brush modes .. 174
Cloning selections .. 178
Restoring a faded image ... 180
Removing camera noise and moiré ... 182
Luminosity blending ... 183
 Blurring along a path ... 184
 Disguise your retouching ... 184
Tool applications and characteristics .. 184
Brush blending modes .. 184
Beauty retouching ... 185
Removing wrinkles ... 189
Dodge and burn ... 189

Chapter 7: Montage Techniques 190

Selections and channels ... 191
Quickmasks .. 191
Reloading selections .. 192
 Selections ... 192
 Quick mask mode ... 192
 Alpha channels ... 192
 Work paths ... 192
Modifying selections .. 194
Smoothing and enlarging a selection .. 194
Anti-aliasing and feathering ... 194
Selection modifier keys .. 194
Expanding and shrinking .. 194
Grow and Similar ... 196
Layers .. 196
Smoother edges ... 197
Layer Blending Modes .. 198
Masking layers ... 203
Adding a selection-based image layer mask ... 203
Applying and removing image layer masks ... 203
Adding an empty image layer mask .. 203
Viewing in Mask or Rubylith mode ... 203
Hiding/showing layer/vector masks .. 203
Vector masks ... 205
Vector mask display ... 205
Working with multiple layers .. 207
Layer set management ... 207
Nested layer sets ... 207
Layer sets .. 208
Advanced blending options .. 209
Layer locking ... 209
Transform commands ... 211
Numeric Transforms ... 213
Repeat Transform ... 214
Recalling the last used selection .. 214
Transforming selections and paths ... 214
Drawing paths with the pen tool .. 214
Guidelines for drawing pen paths ... 215

Montages .. 217
Editing path segments .. 217
Realistic retouching .. 218
Masking hair .. 223
Keeping the edges soft .. 224
Clipping groups .. 228
Removing a matte color .. 230
Extract command .. 231
Exporting clipping paths .. 234

Chapter 8: Darkroom Effects 235

Color filters for monochrome work 236
Getting the mix right .. 236
Black and white from color .. 236
Full color toning .. 239
Split toning .. 241
Solarization .. 242
Duotone mode .. 245
Printing duotones .. 245
Deficiencies of grayscale printing 245
Preserving the image luminosity 248
Infrared film simulation .. 248
Adding a photographic border .. 250
Cross-processing .. 251
History of cross-processing .. 251
Channel Mixer adjustments .. 254
Color overlays .. 255
Color blending modes .. 257
Gradient Map coloring .. 259
Softening the focus .. 260

Chapter 9: Layer Effects 261

Layer effects and Styles .. 262
Drop Shadow .. 262
Inner Shadow .. 263
Outer Glow and Inner Glow .. 263
Bevel and Emboss .. 264
Satin .. 265
Gradient Overlay .. 265
Pattern Overlay .. 266
Color Overlay .. 266
Stroke .. 267
Creating Styles .. 267
Applying layer styles to image layers 268
Layer effect contours .. 270
Transforms and alignment .. 272
Ring flash shadow effect .. 274
Text on a path .. 276
Shared linguistic libraries .. 276

Spot color channels .. 276
Adding type ... 276
Vector output .. 278

Chapter 10: Photoshop Filters 280

Filter Essentials .. 281
Fade command .. 281
RGB only filters .. 281
Blur filters .. 281
 Gaussian Blur .. 281
 Radial blur .. 281
 Motion blur ... 282
 Smart blur .. 283
 Lens Blur .. 283
Distortions and displacements ... 287
Pattern Maker ... 288
Filters for alpha channel effects .. 289
Rapid filter access .. 290
Filter Gallery .. 290
Liquify .. 291
The Liquify tools explained .. 292
Missing 3D Transform ... 296
Fibers filter .. 296
Lighting and rendering .. 296
Clouds and Difference Clouds ... 296
Lens Flare .. 296
Practical applications .. 299

Chapter 11: Digital Capture 300

Digitizing from analog ... 301
Structure of a digital image .. 302
Scanners .. 302
CCD scanners ... 303
Illusions of high resolution .. 304
Resolution .. 304
Dynamic range .. 305
What to look for in a scanner .. 305
Scanner Bit depth ... 306
Bit depth .. 306
Software ... 309
Scanning speed .. 309
Visual assessment .. 310
Purchasing bureau scans .. 310
Kodak Photo CD and Picture CD ... 311
Picture CD .. 311
Photo CD profiles ... 312
Photo CD website ... 312
Early digital camera systems .. 312
Opening a Photo CD image ... 312

Digital cameras .. 312
Comparing chips ... 313
Which digital camera is right for you? .. 313
Counting the megapixels .. 314
The sensor size .. 315
Megapixel limits ... 318
Making every pixel count .. 318
Chip performance ... 319
Comparing film with digital ... 319
Multishot exposures ... 321
Quality on a budget .. 322
Memory cards .. 322
Choosing a memory card .. 323
Looking after the chip .. 324
Dust removal .. 324
Camera response times .. 324
Comparing sharpness ... 324
A digital lightbox .. 325
Hot mirror filters .. 325
Anti-aliasing filters ... 326
The need for a Camera Raw plug-in .. 326
Camera Raw in Photoshop CS .. 326
 Camera Raw in use .. 327
 General controls ... 327
 Camera Raw incompatibility .. 327
 White Balance controls ... 329
 Color temperature response .. 329
 Image tonal adjustments ... 330
 Digital exposure ... 330
 Detail settings .. 331
 Lens settings .. 332
 Camera Raw calibration .. 334
 Batch processing .. 335
Metamerism and color shifts .. 335
Sidecar .xmp files .. 336
Scanning backs .. 337
Modifying the default settings .. 337
Cataloging digital images ... 339
Pros and cons of going digital .. 339
Storage .. 339

Chapter 12: Resolution 341

The Pixel resolution .. 342
Photoshop as a vector program .. 344
Pixels versus vectors .. 344
Terminology .. 344
Confusing terminology .. 346
Repro considerations .. 346
Determining output image size ... 347
Ideal pixel resolution for printing .. 347

New Document presets .. 348
 Inkjet output resolution .. 348
Creating a new document ... 348
Altering the image size ... 349
When to interpolate? .. 350
Planning ahead ... 352
Resolution and viewing distance .. 354

Chapter 13: Color Management 355

The need for color management ... 356
The way things were ... 357
Why not all RGB spaces are the same ... 357
CMYK color management ... 358
RGB devices .. 358
ICC profiled color management .. 359
Not all RGB color devices are the same .. 359
Switching on Photoshop color management .. 363
Profiling the display .. 363
Color vision trickery .. 364
The value of a calibrated display .. 365
The Photoshop color engine ... 367
The profiled approach ... 367
Working in isolation .. 368
The versatility of RGB ... 368
Choosing an RGB work space .. 369
Apple RGB .. 369
Beyond CMYK .. 369
sRGB IEC-61966-2.1 .. 370
ColorMatch RGB .. 370
ProPhoto RGB .. 370
Adobe RGB (1998) ... 370
Photoshop color management interface ... 371
The Color Settings .. 371
The ideal RGB working space ... 371
The new Photoshop CS presets ... 372
Color management policies ... 372
Managing the Color Settings .. 375
Adjusting from Photoshop 5.0 ... 375
Saving the settings .. 376
Profile conversions ... 376
When to use Assign Profile ... 378
Converting to the work space ... 378
Reducing the opportunities for error .. 379
Include a 'Read Me' file .. 379
Handling legacy files ... 380
Working with Grayscale .. 381
Grayscale for screen display ... 382
Advanced color settings ... 383
Blend RGB colors using gamma ... 384
Customizing the RGB and work space gamma .. 385
Desaturate monitor colors .. 385

Establishing a CMYK work space .. 386
RGB to CMYK ... 386
CMYK setup ... 386
Rendering intents ... 386
 Perceptual .. 387
 Saturation (Graphics) ... 387
 Relative Colorimetric ... 387
 Absolute Colorimetric ... 388
Photoshop CMYK myths ... 387
Conversion options ... 388
Which rendering intent is best? .. 388
Creating a custom CMYK setting ... 388
Advanced CMYK settings ... 390
Use Dither (8-bit per channel images) ... 390
Separation options .. 390
Gray Component Replacement (GCR) ... 390
Undercolor Removal (UCR) ... 391
Black Point Compensation .. 391
Dot gain ... 392
Undercolor Addition (UCA) ... 393
Opening CMYK and Lab files .. 393
Ink Colors .. 393
Black generation ... 394
Information palette .. 394
The ICC color managed workflow .. 397

Chapter 14: Output for Print 398

RGB output to transparency and print .. 399
Pictrography .. 399
RGB photographic prints ... 399
Substituting photographic prints .. 400
Inkjet printers .. 400
Inkjet origins ... 401
Branded Consumables .. 402
The ideal inkjet ... 402
Photographic print quality .. 402
Image permanence ... 402
Inks and media ... 403
Third party delays ... 403
Inkjet economies ... 404
Making an inkjet print ... 405
Building a custom printer profile .. 411
Inkjet papers ... 416
Perfect results from your printer profiles ... 416
Soft proofing via the display ... 417
Proof Setup ... 417
Simulate Paper White and Ink Black .. 418
Color proofing for press output .. 418
Realistic proofs ... 419
Truer whites .. 420
PostScript printing .. 421

PostScript printers ... 421
Printing via a RIP ... 422
Repro considerations .. 423
Quantity printing .. 423
File Formats ... 425
Maximum compatibility .. 425
TIFF compression options .. 426
 TIFF (Tagged Image File Format) .. 426
 PSB format ... 427
Extended pixel limit .. 428
EPS pros and cons .. 428
 EPS .. 428
 DCS ... 430
 PICT ... 430
 IVUE .. 430

Chapter 15: Output for the Web 432

Email Attachments ... 433
Sending multiple images by email .. 433
FTP software ... 434
Uploading to a server .. 434
Recompressing JPEGs .. 436
File formats for the Web .. 436
 JPEG .. 436
Choosing the right compression type ... 437
Keeping it small .. 440
JPEG extras ... 440
 JPEG 2000 .. 440
 GIF ... 441
Working with GIF in Photoshop ... 441
PDF versatility .. 442
 Photoshop PDF .. 442
 PDF security ... 442
Importing multi-page PDF files .. 444
 PNG (Portable Network Graphics) .. 444
Save for Web ... 444
Web snap colors .. 450
ZoomView Export ... 452
Web Photo Gallery .. 453
 General .. 457
 Banner ... 457
 Large Images ... 457
 Thumbnails .. 458
 Custom Colors ... 458
 Security ... 458
 Client feedback .. 460
 Information and feedback ... 460
Adobe ImageReady™ CS ... 461
 The ImageReady interface .. 462
 ImageReady layers ... 462

Jump to .. 462
Image slicing ... 462
Slice content ... 463
Optimizing images and image slices .. 464
Animation .. 465
Compression options ... 465
Linked slices ... 465

Chapter 16: Image Management 468

The File Browser .. 469
Keeping track of your data ... 469
Rotation and flagging .. 471
Searching images .. 471
File Browser history ... 471
Saving Workspaces .. 471
Arranging the File Browser contents .. 473
Deleting contents .. 473
File Browser Preferences ... 475
Sidecar and non-image files .. 475
Folders palette .. 476
Keywords palette ... 477
Image metadata .. 479
File Info metadata .. 479
Metadata everywhere .. 479
Metadata in use .. 480
Interpreting the metadata .. 480
Metadata palette ... 481
Future uses of metadata .. 481
Increasing the font size ... 482
Edit history log .. 483
File Browser management .. 483
Flagging and Ranking .. 484
File Browser automation .. 484
Editing the Batch renaming fields .. 485
Applying Camera Raw settings .. 486
On-line Services .. 487
Managing your images .. 488
The digital lightbox experience .. 489
Storage Media ... 493
DVD as an alternative to CD .. 493
Bureau checklist .. 494
Image protection ... 494
Investing in protection ... 495

Chapter 17: Automating Photoshop 496

Modifier key tip ... 498
Keyboard shortcuts tip .. 498
Custom Keyboard shortcuts ... 498
Window display options ... 507

Contextual menus .. 508
Moving and cloning selections .. 508
Selections .. 508
Info and Navigator ... 508
Working with Actions ... 509
Playing an Action ... 509
Sourcing ready made actions ... 509
Limitations when recording Actions ... 510
Recording Actions .. 510
Actions only record changed settings ... 512
Troubleshooting Actions .. 512
Action recording tips .. 513
Inserting menu items .. 513
Stop and pause ... 513
Complete Photoshop scripting .. 514
Batch processing Actions ... 514
Creating a Droplet ... 515
Cross Platform Droplets .. 516
Picture Package ... 516
Fit Image ... 518
Multi page PDF to PSD ... 518
Contact Sheet II .. 518
Automation plug-ins ... 519
Crop and Straighten Photos ... 520
PDF Presentation .. 520
Photomerge ... 520
Using Photomerge to align images .. 525
How To help files .. 525
Export Transparent Image and Resize Image .. 526
Compact saves .. 528
Layers and channels ... 528
Layer Sets .. 531
Let Photoshop take the strain .. 536

Appendix **537**

Davis Cairns .. 537
Laurie Evans .. 538
Thomas Fahey .. 538
Jon Gibson-Skinner .. 538
Peter Hince .. 539
Thomas Holm ... 539
Eric Richmond .. 539
Paul Webster .. 539
SOLUTIONS Photographic .. 540
Rod Wynne-Powell ... 540
Special Offers Page ... 541
 PIXL profiling service for readers .. 541
 Pixel Genius PhotoKit plug-in discounts ... 541
World Wide Web contacts ... 542

Index .. 544

Foreword

Despite its name, Photoshop has not always been a welcome companion amongst the photography set. Much as assembly line automation was seen as the death knell for craftsmen and craftsmanship, at various times, Photoshop was seen as a threat against the skilled photographer. However, a change has recently taken place. Fueled primarily by the advent of digital SLRs with professional features offered at non-professional prices, the confluence of Photoshop and photography, particularly digital photography, has become a certainty. Photoshop is now accepted as a powerful tool in the photographer's arsenal.

But what are veteran shooters and those digital photographers newly minted to make of this brave new world? How can your wealth of darkroom experience be brought to bear on a computer screen and a mouse? Will the sterile environment of technology replace the comforting mess and sickly-sweet chemical smells of fixer and developer? Most importantly, how will you and your photography benefit from the new opportunities offered by Photoshop in its latest incarnation, Photoshop CS?

Whether you are a long-time traditional film photographer, a newcomer to the 'tradigital' world, or a weekend snapshotter, this book has something to offer. From the broad coverage of the 'Photoshop ways' of performing traditional film and darkroom techniques to new techniques only possible using Photoshop, Martin takes you there and teaches everything step by step. This isn't another 'recipe' book that ignores your skilled eye and assumes all you want to do is paste your head on a supermodel's body. (Of course, Photoshop can do that, but if that is your goal, this is not the book for you.)

Martin understands the photographer's craft isn't always about the creative and artistic side of life. Rest assured, Martin covers the full spectrum of photographic tasks. Important aspects of the workflow of the film photographer moving to digital – scanning and image capture – usually ignored in most other books are covered in-depth. Martin also

tackles the usually mundane issue of image management within Photoshop CS, showing how the Photoshop CS File Browser can move you well beyond just a 'digital shoebox'.

Viewing Photoshop through the eyes of an experienced photographer takes specialized talent and skills. In this book, Martin effectively shares his experience and expertise both on photography and Photoshop in a thorough and balanced presentation. While this book is also an excellent general Photoshop reference, the focus here is always on photography.

Photoshop can be daunting, photography even more so. To have someone expertly versed in both, presenting his knowledge here in a clean and clear manner, is a real treat.

Marc Pawliger
Director of Engineering, Digital Imaging
Adobe Systems

Preface

We have all heard the expression 'a picture is worth a thousand words'. And this is as true now today as it has ever been. The information-rich world we live in is awash with photographs that are use in all sorts of ways: to communicate, educate, sell things, to remember special events by, or simply 'to create'. Ever since I first took an interest in photography I have always wanted to discover and understand as much as I could about the photographic process so that I could perfect my craft and become a more creative photographer. For me, learning how to use Photoshop represents an important continuation of that learning process. Making the transition from shooting film to shooting digitally has been an interesting experience. As someone who got involved with digital imaging in the early days, I have endured many frustrations with equipment and software. But Photoshop has proved to be an essential tool, without which, the digital imaging industry we know today just wouldn't be the same.

Let me make a confession – I don't actually know a whole lot about computers! I am a busy, professional studio photographer and running the photography business takes up most of my day. So I study Photoshop and write these books mostly in my part-time. And maybe that is one of the reasons why this series of Photoshop books have become so successful, because like you, I too had to learn all this stuff from scratch. I make no grandiose claims to have written the best book ever on the subject. I simply write from personal experience and aim to offer, you the reader, a detailed and comprehensive manual on the subject of digital photography and Photoshop, written by somebody who has had firsthand photographic experience.

This edition has been thoroughly revised to ensure that you are provided with an updated account of everything that is new in Photoshop CS as well as containing all the latest information on digital capture and print output. The book's format has also been completely redesigned. The chapters are ordered to provide an introduction to all of Photoshop's features plus how to configure your system and then goes straight into looking at basic image adjustments and color corrections.

Acknowledgments

I must first thank Andrea Bruno of Adobe Europe for her suggestion that I write a book about Photoshop aimed at photographers and thank you to all at Focal Press: Marie Hooper, Jennifer Ridout, Christina Donaldson, Beth Howard, Margaret Denley, Debbie Clark and Jane Read. None of this would have got started without the founding work of Adam Woolfitt and Mike Laye who helped form the Digital Imaging Group (DIG) forum for UK digital photographers. The production of this book was done with the help of Gwilym Johnston, who compiled and authored the CD-ROM and Rod Wynne-Powell, who reviewed the final manuscript and provided an enormous amount of help with technical advice and assistance and Jason Simmons, who came up with the new book layout template and who designed the cover. I also received a lot of help from my assistants: Lisa Tebbutt and Matt Wreford. I must give a special mention to fellow Photoshop alpha tester Jeff Schewe for all his guidance and help over the years, not to mention the other members of the 'pixel mafia': Katrin Eismann, Bruce Fraser, Seth Resnick, Andrew Rodney and Mike Skurski.

Many thanks too to the following clients, companies and individuals: Adobe Systems Inc, Anita Cox, Neil Barstow, Bookings, Steve Broback, Russell Brown, Steve Caplin, Clipso, Jeremy Cope, Chris Cox, Laurie Evans, Tom Fahey, FM models, Karen Gauthier, Jon Gibson-Skinner, Greg Gorman, Gretag Macbeth, Nick Haddon, Mark Hamburg, Leon Herbert, Peter Hince, Thomas Holm, Isis, Ed Horwich, John Knack, Imacon, Thomas Knoll, Ricky Liversidge, Thomas McMillan, MacUser UK, M&P Models, Bob Marchant, Ian McKinnell, Models One, MOT models, Nevs, Marc Pawliger, Pixl, Profile, Herb Paynter, Red or Dead Ltd, Eric Richmond, Schwarzkopf Ltd, Michael Smiley, The Smithsonian Institution, Susanne Sturton, Martin Soan, Storm, Tresemme, Russell Williams, Mark Williford, What Digital Camera and YU salon. And lastly, thanks to friends and family. My late mother for all her love and encouragement and who was always so supportive and proud of my success.

Martin Evening, November 2003

Photoshop for Photographers website

There is a website set up to promote this book where you can find active links mentioned in the book and late-breaking news on Photoshop CS:
<www.photoshopforphotographers.com>

About the CD ROM

The CD that comes with this book contains movie versions of many of the step-by-step techniques shown in this book. It is designed to run on Macintosh and PC systems and only requires you to install QuickTime on your computer in order to view them. If you should experience any problems running the disk, please always refer to the FAQ section on the disk or on the website above for guidance on how to configure your computer for optimum viewing.

In the past a lot of readers have requested access to the images that are featured in this book. Many of the pictures are indeed now available on the CD for you to experiment with and can also be downloaded from the website. But please realize that some of the photographs in this book do not have the necessary clearance to be made generally available. For example, some belong to other photographers. So although there are quite a few pictures you can play with, you won't be able to access every photograph you see in this book.

Chapter 1

What's New in Adobe Photoshop CS

Photoshop CS offers a wealth of features that will truly be of benefit to photographers everywhere. In this first chapter I am going to give a you a quick run through all the new major features that will be of interest to photographers. If you are a Macintosh user Photoshop CS will only run using Mac OS X 10.2.4 or later (10.2.6 or 10.3 is recommended), and only a G3, G4 or G5 computer. If you are using a PC, you will need to use Windows 2000 (with Service pack 2) or Windows XP operating systems running on an Intel Pentium class III or 4 processor.

Figure 1.1 The Keyboard Shortcuts dialog.

Editing metadata

Certain metadata information is editable within the File Browser, so you can edit the File Info text entries, add keywords and conduct metadata or keyword searches, all from within the browser interface. An edit history log can be kept as you edit an image. This can be saved within the metadata or as a separate log file.

Quick folder access

You can get the File Browser to target on a folder by dragging the folder from the Mac OS X Finder or from the Windows Explorer to the File Browser Preview pane.

Improved Mac OS X performance

When Apple released the Mac OS X 10.2 update (code name: Jaguar), a number of Mac OS X users experienced terrible crashing problems when using the File Browser. Initially the problem was fixed with a free plug-in patch for Photoshop 7.0, but now Photoshop CS runs more smoothly and faster in Mac OS X 10.2.

Custom Keyboard Shortcuts

For some time now, just about every keyboard combination shortcut in Photoshop has been exhausted. Furthermore, the keyboards in some countries differ quite significantly from the standard US English keyboard design, sometimes missing keys such as the tilde (~) on the computer keyboard. In the past, because of these restrictions, not all language users are able to make the full use of the program. And not everyone has the same priorities and objectives when using Photoshop. With the Keyboard Shortcuts editing dialog, you can now decide which keyboard shortcuts you want to use to call specific Photoshop actions and save these as custom shortcut sets.

File Browser and Camera Raw

The first thing you will notice about the File Browser is that it is no longer a dockable palette. The File Browser is opened and closed by clicking a button on the Tool Options bar. The File Browser operating speed is noticeably faster in Macintosh OS X 10.2 and the Camera Raw plug-in is fully integrated, including updates for the latest raw camera file formats. Many existing customers will have already purchased the Camera Raw plug-in for Photoshop 7.0. And to my mind, this is one of the most useful productivity plug-ins for Photoshop that has ever been built. Using Camera Raw is like injecting rocket fuel into your digital capture work flow, because it enables you to shoot raw captures with your digital camera and process the data in Photoshop at a much faster speed compared to the software supplied with most of today's digital cameras. The knock-on effect of the Camera Raw plug-in has made a huge difference to the way photographers are able to process their capture files and make full use of the high quality of a raw file compared to shooting in JPEG mode.

The image file management in the File Browser has been improved. Images can be flagged and this provides a nice simple way in which to designate the pictures you like best. Using the Thumbnail View options, you can then hide all unflagged images, making it easier to conduct the image

Figure 1.2 The layout of the new improved File Browser can easily be customized to suit the way you work. The panes on the left hand side can be rearranged any way you like and the preview pane can be scaled to display larger, rendered previews. A custom size can be set for the Thumbnails which makes it possible to compare images side-by-side more easily.

Figure 1.3 The Camera Raw plug-in enables you to process raw camera file images and open them directly in Photoshop. The revised interface also contains extra controls for advanced users, providing greater control over the image color and the ability to suppress noise and other camera file artifacts.

Backward compatibility options

You can save files with the 'Maximize Backward Compatibility' option set to Never in the General Photoshop preferences and not keep being bugged by a warning dialog every time you come to save a layered image.

selection process. Folder navigation is made easier too. The folder menu allows you to quickly access recently visited folders and assign favorite folders. The File Browser has its own menu which among other things, allows you to run automation routines within the Browser interface directly.

3

Figure 1.4 Photoshop CS provides extended features for images in 16-bit per channel mode. The bit depth is always indicated in the document window status/title bar.

Extended 16 Bit support

The Camera Raw plug-in takes full advantage of the fact that most digital cameras are capable of capturing a greater tonal depth than 8-bits per channel. And many photographers prefer to scan their originals using 16-bits per channel mode. Over the years, the number of Photoshop features that will work in 16-bit mode have increased. Now for the first time, you can use tools such as the brush tool and history brush in 16-bit. Even more importantly, you can add image and adjustment layers as well. The image bit depth is always indicated in the title bar just after the color mode. For example, the document status title bar may show: CMYK/8 or RGB/16.

Figure 1.5 The Histogram palette.

Live Histogram palette

The new Histogram palette provides a live histogram of the image or the active selection contents. This is especially useful if you wish to view graphical feedback of the Levels histogram when making any type of image adjustment (not just Levels), such as when making a Curves adjustment. The Histogram palette can display the composite channel information along with an expanded view of the individual color channels, or a luminosity histogram (as used to be displayed in the Image menu Histogram). This latter mode is preferable for accurate image assessment. And lastly, a color histogram bar mode, like the one you see in the Camera Raw dialog.

Interface changes

The first thing you will see when launching Photoshop CS is the Welcome screen. Use this to access the latest information about what is new in the program, learn about hot new tips and access the latest Photoshop tutorials which are available on-line.

The canvas area has been extended. If you are using one of the full screen viewing modes, you can scroll the image beyond the limits of the document bounds. This is particularly useful if you are viewing a large image at an Actual Pixels display view but the Photoshop palettes are

Figure 1.6 The Photoshop CS Welcome splash screen.

obscuring part of the picture and you want to draw a pen path that extends outside of the image area.

As before, you can use the Window ➪ Arrange menu to force all open image documents to display in a cascade or tiled view. In Photoshop CS you can now hold down the Shift key to apply zooming and scrolling simultaneously to all open documents. And if you thought the previous 30,000 pixel limit was too limiting, this has been raised to 300,000. However, there is still a 4 GB cap on the size of file that can be saved using TIFF and 2 GB for the native Photoshop file format. If you need to save a larger image, you can do so by enabling the new PSB file format in the general preferences.

Figure 1.7 The extended canvas area allows you to work up close without having palettes get in the way.

Image Adjustments

Photoshop CS offers some useful new image adjustment tools. The Shadow/Highlight Correction can be simply described as an image adjustment that can be used to selectively bring out detail that was otherwise hidden, such as in images that have heavy shadow areas or where the highlights appear to be almost completely blown out. This adjustment tool can apply a shadow or highlight correction but without affecting the contrast in the midtone areas. The Match Color adjustment enables you to match the color and tonal range between two images. This works exceptionally well if you have a series of almost identical looking pictures, but where the white balance of the lighting has maybe shifted a little and you want the appearance to match, such as a portrait series shot under changing lighting conditions.

The Photo Filter adjustments simulate the Kodak Wratten™ series of photographic filters. Applying one of these image adjustments is just like adding a Kodak™ color correcting filter over the lens at the post-production stage. You can warm or cool the colors in your photos or color correct pictures that were photographed using the wrong white balance setting, the same way as using the white balance controls in the Camera Raw dialog.

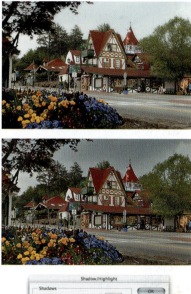

Figure 1.8 The Shadow/Highlight Correction adjustment can be used as shown here, to lighten the shadows and darken the highlights, to produce an improved full tone image. The advanced options provide even more subtle control.

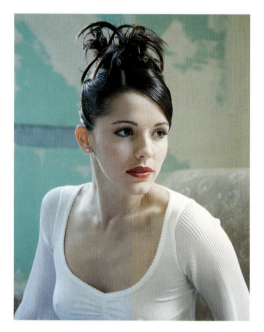

Figure 1.9 The Photo Filter image adjustment can replicate in Photoshop the effect of adding a colored camera filter over the lens. The naming scheme used matches the Kodak Wratten color correction camera filters. So if the image you are editing looks too cool, you can use the 85 filter setting in Photoshop to 'warm up' the picture.

Figure 1.10 If you have a series of photographs where you wish to make the colors all match, then the Match Color image adjustment can be used to select a sample image, sample the colors and apply as an image adjustment to another photograph. This adjustment tool can also work using selections from a sample image, or a separate layer in the same picture. In this example the photograph on the right shows a split view of before and after where this image was made to match the color of the one on the left.

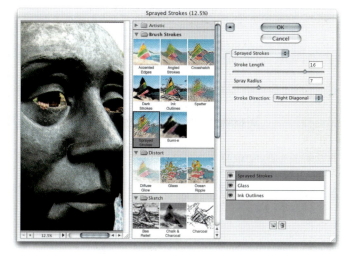

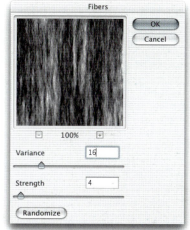

Figure 1.11 The Filter Gallery dialog makes it easier to navigate the Photoshop special effects filters and compare the outcome of the various filters more quickly using the filter history section.

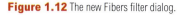

Figure 1.12 The new Fibers filter dialog.

Image interpolation

Photoshop CS provides two new interpolation options that will produce better results when you increase or decrease the number of pixels in an image. Bicubic Smoother will produce smoother results when enlarging an image and Bicubic Sharper will preserve more detail when you reduce an image in size. These interpolation methods will produce results as good as if not better than using what was known as the 'step interpolation' method, and more quickly too.

Filters

The Photoshop Effects filters namely the Artistic, Brush Strokes, Distort, Sketch, Stylize and Texturize series, can all be accessed via a single dialog in the Filter menu called the Filter Gallery, which is shown in Figure 1.12. Instead of trying out one filter after another, you can use the Filter Gallery to quickly compare the outcome of using different filter effects. And as you try out different filters, the individual effect settings are stored in the dialog's history.

The Fibers filter is new. It is located in the Filter ▷ Render menu and can be used to generate natural fiber texture effects. The Lens Blur filter is also new and can be

Hard Mix blending mode

The new Hard Mix blending mode produces a posterized image consisting of up to eight colors: red, green, blue, cyan, magenta, yellow, black and white. The blend color is a product of the base color and the luminosity of the blend layer.

Scrubby sliders

You can change the unit values for a numeric field by ⌘ *ctrl* clicking and dragging the 'scrubby slider' cursor to the left or right. If the field label has a name, you can simply mouse-down over the label name and drag. Holding down the *Shift* key at the same time will make the units change ten times faster and holding down the ⌥ *alt* key will change them ten times more slowly.

used to simulate camera lens blur and is capable of making a background look realistically out of focus. This is achieved by accentuating flare from the brightest highlights and producing iris-shaped highlights. And you can use the transparency of a layer that is being filtered to create a graduated focus effect.

Figure 1.13 The Lens Blur filter has a range of controls that enable you to simulate the blur produced when something is photographed out of focus. The results this filter produces are more convincing than the simple gaussian blur. You can also use a variable density layer mask to govern the focal blur amount.

Figure 1.14 The Liquify dialog interface has been updated to provide improved brush setting controls, masking and backdrop viewing options.

Extracting textures

The Extract command features a textured image mode which utilizes the image texture as well as the color to calculate an image extraction. This can come in handy when there is a contrast between the texture of the subject and that of the background you want to cut out from.

Layer management

The Layer Comps palette can help you organize your layers by saving the layer visibility configurations. This feature can have many applications, but will be particularly useful to web page designers who very often work with lots of layers and who need to quickly switch between different layer visibility settings. With layer sets you can now create new sets by dragging linked layers to the layer set button in the Layers palette. And layer sets can also now be nested within Layer Sets, up to five levels deep.

Automation

Several new changes have been made to the Automate plug-ins (located under the File ➪ Automate menu). Most of the Automate plug-ins can also be accessed via the File Browser Automate menu and applied directly to selected images in the File Browser.

 The Crop and Straighten Automate plug-in will neatly auto-extract single or multiple images from a scanned image, like the example shown in Figure 1.16, applying rotation as necessary and automatically cropping to the edges of the picture.

 There are many applications that can be used to create slide shows (such as iPhoto). The new PDF Presentation feature will enable you to produce simple self-contained PDF format slide shows of selected images which can incorporate a variety of image dissolve effects. PDF Presentation files will work best with Acrobat 6 and the latest Acrobat Reader programs. They will be able to activate special features such as 'Picture Tasks', that allow operations to be done on each image individually, such as ordering prints and uploading images to other picture services, etc. As a professional tool it is unfortunately somewhat limited, but nonetheless it has interesting potential for the future.

 Photomerge was first introduced in Adobe Photoshop Elements and has now been included with Photoshop CS. This new version of Photomerge has none of the file size restrictions that were associated with Photoshop Elements.

Figure 1.15 The Layer Comps palette and New Layer Comps dialog.

Figure 1.16 You can use the Crop and Straighten Photos automate plug-in to automatically prepare scanned images that need to be cropped and rotated. In this example, two photographs were scanned at the same time. The Crop and Straighten Photos command will extract both images, rotating and trimming them and preparing them ready for you to edit.

Figure 1.17 The Photomerge plug-in first appeared in Photoshop Elements 1.0. Now for the first time, it is included in Photoshop CS and robust enough to allow you to make quite large composite files compared to the limitations of the Elements version of this plug-in. You also have the facility to save a Photomerge document with the layers preserved. This makes the plug-in even more versatile to use.

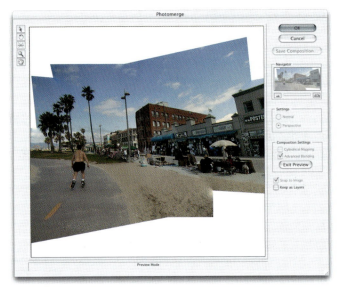

On-line Services

The Automate menu hosts on-line services, which will enable you to access external services such as a remote printing service, like 'Shutterfly', directly without leaving Photoshop.

It features a 'Make Layered Image Only' option, which means you can use Photomerge to align multiple exposures of the same image. For example, if you want to align and merge two or more almost identical exposures, Photomerge will automatically take care of the alignment and produce a layered document for you.

The image spacing in Contact Sheet II is more efficiently designed. It can be set manually to tighten up the gaps in your contact sheets quite considerably. The spacing is improved even when the Auto spacing option is selected. Picture Package features a new layout editing

Figure 1.18 The Horizontal Feedback template is one of several new templates that are used with the Web Photo Gallery. The page shown here includes a feedback form that will enable visitors to the gallery site email picture selections and any comments back to you.

dialog with an easy-to-use interface. Designing your own custom Picture Package layouts has never been simpler. The Web Photo Gallery has a completely new set of web gallery templates. Figure 1.18 shows an example of a website created using the Horizontal Feedback template. Examples of the other new templates can be seen in Chapter 15.

A small selection of JavaScripts can be accessed via the File ⇨ Scripts menu. More scripts can be added to the Adobe Photoshop CS\Presets\Scripts\ folder. Ready made Scripts can be found on the Adobe Studio Exchange website at: <http://share.studio.adobe.com>.

Figure 1.19 The color replacement brush is ideal as a fast and effective tool for fixing red eye in snap shots such as this.

Brushes

The healing brush will now work on a separate, empty layer. This means that you can do all your healing work on a new layer and be able to easily remove or selectively erase any healing brush or patch tool repairs that are carried out. When the patch tool is used in Source mode, a preview of the patch blend is displayed in the Source selection area.

The color replacement brush is a new brush tool, grouped with the patch tool and healing brush. It is an effective tool for certain basic retouching tasks such as reducing red eye from flash photographs.

Creating new documents

The New Document dialog contains new preset options that are designed with video designers in mind. You can select a preset size that matches the screen resolution of all popular video formats and some of these also open with preset guides. The View menu includes a Pixel Aspect Ratio Correction option. This can be used to render a scaled preview on the screen that more closely represents the proportions of a video pixel display, that uses non square pixels.

How do you do that?

Photoshop CS has many useful tips built-in to the program. The Help menu is a good starting point, from where you can load the Welcome Splash screen, or launch the Photoshop Help web document or you can use the new 'How To' menus and sub-menus to get instant help and advice on a range of Photoshop issues. The How Tos you see here are integrated within Photoshop Help, but the How To format is available for anyone to write their own series of top tips for use in Photoshop CS.

Figure 1.20 Type can be added to an active pen path by clicking anywhere near to the path with any of the type tools. Type can also be made to fill the interior of a shape vector path.

Illustration: Rod Wynne-Powell.

Type features

The type engine has undergone another overhaul. Improvements have been made to improve compatibility. One consequence of this is that when a text layered document created in Photoshop 6.0 or 7.0 is opened in Photoshop CS you will always see a warning requiring you to update the text layers. In common with other Adobe applications like InDesign, GoLive and Illustrator, Photoshop CS uses a shared linguistic library for the spelling library database. So if you update a word in the spell checker in a recent version of one of the above mentioned Adobe programs, the spelling update will be shared with all other Adobe programs sharing the same capability.

Type can be added to a pen path or vector shape so that any type entered will follow along the path outline. Simply move the type cursor close to the edge of the path to begin adding the type. You can then edit the shape of the path to change the shape of the type.

Overall impressions

Photoshop CS is bound to receive a mixed reception, which is always the case with every new release of Photoshop. There has certainly been an ongoing expectation that each new version of the program should include a 'killer feature'. At first Photoshop CS may appear to lack exciting new features such as the healing brush which was introduced in version 7.0. But nonetheless this is another important step forward in the evolution of Photoshop. As a working photographer, the refinements made to the File Browser, with its full integration of the Camera Raw plug-in and the new Web Photo gallery feedback templates have all significantly aided my production work flow. The Shadow/Highlight image adjustment is another powerful tool, which I can't live without now.

This introductory chapter has provided a brief overview of what's new in Photoshop CS. Now we need to put these features all in context and begin by looking at the Photoshop interface and what all the different tools and palettes do.

Chapter 2

The Work Space

Before moving on to the practical Photoshop techniques, let's first look at the Photoshop interface. If you switch between using current versions of Photoshop, Illustrator and InDesign, the Adobe interface and keyboard command conventions will remain fairly consistent. For example, the zoom tool shortcut in all these programs is ⌘ ctrl +Spacebar. Apart from a few necessary deviations, the transition between all Adobe graphics programs is fairly seamless. The following pages give an account of the basic Photoshop working area and introduce you to the new tools. Use this chapter as a reference as you work through the remainder of the book.

Figure 2.1 This is the Photoshop CS interface showing the default layout for all the palettes. The Options bar is normally positioned at the top of the screen just below the menu bar, but you can also position it at the bottom or even on a second monitor.

Macintosh and PC keys

Throughout this book I will be referring to the keyboard modifier keys used on the Macintosh and PC computers. Where the keys used are the same, such as the ⟨Shift⟩ key, these will be printed in black. Where the keys used are different on each system, I use the Macintosh key first in magenta and the PC equivalent after in blue. So, if the shortcut used is Command (Mac) and Control (PC) this appears abbreviated in the text as: ⌘ ⟨ctrl⟩. Other keys will be explained as you progress through this and subsequent chapters.

Image window

The document window displays extra information about the image in the two boxes located in the bottom left corner of the image window (Mac) or at the bottom of the screen (PC). The left-most displays the zoom scaling percentage, showing the current zoom factor. You can type in a new percentage of any value you like from 0.2% to 1600% up to two decimal places and hit ⟨Enter⟩ or ⟨Return⟩ to set this as the new viewing resolution. In the middle is the Work Group Server button, which you can use to check in or check out a document that is being shared over a WebDAV server. Next to this is the Preview box. Mousing down on the Preview box will display an outline box of how the image will be scaled relative to the current Page Setup paper size. The preview reflects the image dimensions at the current pixel resolution. The resolution can be checked by holding

down 🔲 *alt* while you mouse down. This will display both the dimensions and image resolution. 🔲 *ctrl*+mouse down shows the image tiling information. The Preview box also displays updated information about the file. The display information can be changed by mousing down on the arrow next to the box to select one of the following:

Document Sizes
Displays the current document size. The first figure is the file size of a flattened version of the image. The second, the size if saved including all the layers.

Document Profile
This displays the current profile assigned to an open document.

Document Dimensions
This displays the physical image dimensions, as would currently be shown in the Image Size dialog box.

Scratch Sizes
The first figure displays the amount of RAM memory used. The second shows the total RAM memory available to Photoshop after taking into account the system and application overhead. The latter figure remains constant and only changes if you quit Photoshop and re-configure the memory partition. RAM memory consumption can be minimized if you avoid making too many global changes.

Efficiency
This summarizes how efficiently Photoshop is working. Basically it provides a simplified report on the amount of Scratch Disk usage.

Timing
This will time Photoshop operations. It records the time taken to filter an image or the accumulated timing of a series of brush strokes. Every time you change tools or execute a new operation, the timer resets itself.

Tool Selection
This displays the name of the tool you currently have selected. This is a useful aide-memoire for users who like to work with most of the palettes hidden.

Keyboard shortcuts
You can temporarily access the move tool by holding down the 🔲 *ctrl* key (except when the pen or hand tool is selected). The keyboard arrow keys can be used to nudge a layer or selection in 1 pixel (10 pixels with the *Shift* key also held down) increments. A series of nudges count as a single Photoshop step in History and undone with a single undo or step back in History.

Hold down the Spacebar to temporarily access the hand tool. Hold down 🔲 *ctrl*+Spacebar to zoom in. To zoom out, hold down the 🔲 *alt*+Spacebar keys. If the hand tool is already selected, then holding down either the 🔲 *ctrl* or 🔲 *alt* keys will have the same effect. Double-clicking the zoom tool will set the view to actual pixel size (100%) as does the keyboard combination of 🔲 🔲 *0* *ctrl* *alt* *0*. Double-clicking the hand tool will set the view to the fullest screen size within the constraints of the visible palettes. The alternative keyboard shortcut is 🔲 *0* *ctrl* *0*. Pressing the *Tab* key (also shown as ↱) will toggle hiding and displaying the Tools palette and all palettes (except when a palette settings box is selected). The *Shift* *Tab* keys will keep the Tools palette in view and toggle hiding/displaying the palettes only.

Preview box options

⌘ click to display the Title bar proxy icons (Mac only)

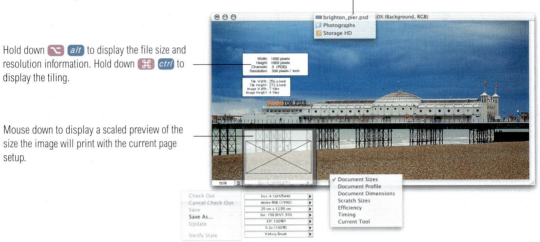

Hold down ⌥ *alt* to display the file size and resolution information. Hold down ⌘ *ctrl* to display the tiling.

Mouse down to display a scaled preview of the size the image will print with the current page setup.

Figure 2.2 The window layout of a Photoshop document as it appears on the Macintosh. If you mouse down on the arrow icon next to the status information box, you can select the type of information you wish to see displayed there.

Title bar proxy icons (Macintosh)

Macintosh users may see a proxy image icon in the title bar. This is dimmed when the document is in an unsaved state and is reliant on there being a preview icon; many JPEGs will not have these until saved as something else. *ctrl* drag the proxy icon to copy and relocate the saved file to another location. ⌘ click to view the file's folder hierarchy and jump to a specific folder location.

Managing document windows

You can create a second window view of the image you are working on by choosing View ⇨ New View. The image is duplicated in a second window. For example, you can have one window with the image at a Fit to Screen view and the other zoomed in close-up on a detailed area. Any changes you make can then be viewed simultaneously in both windows. If you refer back to the chapter on color management you will remember you can use multiple window views to soft proof the image in different color spaces. You can arrange the way all the document windows are displayed on the screen. Choose Window ⇨ Arrange ⇨ Cascade to have all cascading down from the upper left corner of the screen. Choose Window ⇨ Arrange ⇨ Tile to have all the currently opened image windows tiled edge to edge. Note that in Photoshop CS, when two or more document windows are open, you can synchronize the scrolling and magnification to affect all document windows by depressing the *Shift* key as you scroll or zoom in and out on any window view.

Figure 2.3 To open a second window view of a Photoshop document, choose Window ➪ Arrange ➪ New Window. Changes applied to the close-up view are automatically updated in the full frame view. New view document windows can usefully be used to display the same image with different color proof setups applied, so you can preview an RGB image in a different CMYK color space in each new view window.

Photo: Eric Richmond.

Rulers, Guides & Grid

The Grid provides you with a means for aligning image elements to the horizontal and vertical axis (go to the View menu and choose Show Grid). To alter the grid spacing, go to the General preferences and select Guides & Grid.

Guides can flexibly be positioned anywhere in the image area and be used for the precise positioning and alignment of image elements. Guides can be added at any time, providing the Rulers are displayed (View ➪ Show Rulers). To add a new guide, mouse down and drag out a new guide from the ruler bar. Release the mouse to drop the guideline in place. If you are not happy with the positioning, select the move tool and drag the guide into the exact required position. But once positioned, it is often a good idea to lock the guides to avoid accidentally moving them again.

Figure 2.4 These windows show an image displaying the Grid (top) and Guides (below). To display the Grid, chose View ➪ Show ➪ Grid. To position a Guide, choose View ➪ Show Rulers and drag from either the horizontal or vertical ruler. Hold down the `Shift` key as you drag to make the guide snap to a ruler tick mark (providing View ➪ Snap is checked). `⌘` `H` `ctrl` `H` will toggle hiding/showing Extras like the Grid & Guides. Hold down the `⌥` `alt` key to switch dragging a horizontal guide to dragging it as a vertical (and vice versa).

'Snap to' behavior

The Snap option in the View menu allows you to toggle the snap to behavior for the Guides, Grid, Slices, Document bounds and Layer bounds. The shortcut for toggling snap to behavior is `⌘` `;` `ctrl` `;`. When the Snap to is active and you reposition an image, type or shape layer, or use a crop or marquee selection tool, these will snap to one or more of the above. It is also the case that when snap is active, and new guides are added with the `Shift` key held down, the guide will snap to the nearest indentation on the ruler. Objects on layers will snap to position when placed within close proximity of a guide edge. The reverse is also true: when dragging a guide, it will snap to the edge of an object on a layer at the point where the opacity is greater than 50%. Furthermore you can Lock Guides and Clear Guides. If the ruler units need changing, double-click anywhere on a ruler to call up the Ruler Units preferences dialog box. If the rulers are visible but the guides are hidden, dragging out a new guide will make the others reappear. You can even position a guide using New Guide... Enter the exact measurement coordinate for the horizontal or vertical axis in the dialog box.

The Photoshop palettes

The Photoshop palettes can be positioned anywhere you like on the screen by mousing down on the palette title bar and dragging to a new location. You can change the height of a palette by dragging the size box at the bottom. To return a palette to its default size, click the plus button ⊛ ◦ ● (Mac) or click the minimize/maximize box ▬ ❑✕ (PC). One click will resize, a second click collapses the palette. Double-clicking the palette tab will also collapse the palette. If an uncollapsed palette is positioned on the bottom of the screen display, the palette collapses downwards when you double-click on the palette tab and open upwards again when you double-click.

Palettes can be grouped together. To do this mouse down on the palette tab and drag it across to another palette. When palettes are grouped this way they are like folders in a filing

cabinet. Click on a tab to bring a palette to the front of the group. To separate a palette from a group, mouse down on the palette tab and drag it outside of the palette group.

Palette docking

The Photoshop palettes can be arranged in individual groups (as in the default work space layout setting) or they can be docked together as shown in Figure 2.5. If you have a limited sized screen this is a convenient way of arranging the palettes and it also makes it easier to expand and shrink the height of individual palettes so as to allow more room to expand to one or more of the other palettes.

To set up palette docking, first separate all your palettes and position one palette (like Color) immediately below another (the Navigator/Info/Character & Paragraph set) and drag the tab of the lower palette up to meet the bottom edge of the one above. As the palettes dock, you will see the bottom edge of the upper palette change to a double bar. Release and the two palettes are joined. Drag the Swatches and Style palette across to rejoin the Color palette. Repeat by separating the History and Actions palette and doing the same with the History palette, dragging the tab up to the base of the Color palette set. When the cursor is positioned over the palette divider, you will see the icon change to a double arrow, indicating that you can adjust the relative height between two sets of palettes (where allowable). If you drag on the lower height adjustment/grow tab in any palette, you can adjust the overall height of the docked palette grouping.

Workspace settings

If you are searching for a particular palette and can't find it, the palette may just be hidden. Go to the Window menu and select the palette name from the menu. The Tab key (also indicated as) shortcut will toggle hiding and showing all the palettes. Tab $Shift$ will toggle hiding/showing all the currently visible palettes except the Tools palette and Options bar. This is useful to remember if all your palettes seem to have disappeared. Try pressing Tab to get to view them again.

Figure 2.5 The Photoshop palettes shown with vertical docking.

Figure 2.6 The Save Workspace menu in Photoshop can be used to save custom palette workspace setups. These can be recalled by revisiting the menu and highlighting the workspace name. To remove a workspace, choose Delete Workspace... from the menu.

If at any time you wish to restore the palette positions, go to the Window ⇨ Workspace menu and select Reset Palette Locations. You can save the current palette arrangement as a custom Workspace. Go to the Window menu and choose Workspace ⇨ Save Workspace... A dialog box will pop up that will ask you to name the workspace and save it. The next time you visit the Window ⇨ Workspace menu you will see the saved workspace appear in the menu listing. This is a real handy feature that enables you to switch quickly between different custom palette arrangements. If you want to be extra clever, you can record the loading of a saved Workspace setting as an action and assign a hot key to play the action back. This will allow you to switch workspace settings using a single keystroke. If you want to remove a workspace setting, use the Delete Workspace... command. If you have a second monitor display, you can arrange for all the palettes to be displayed nestled on the second screen, leaving the main monitor clear to display the whole image.

File Browser

The File Browser is one of the star attractions of Photoshop CS. It is the gateway that enables you to access images within Photoshop and it allows you to preview, select, manage, search and open up images, all within the File Browser environment. The File Browser can be accessed by choosing the File ⇨ Browse or by clicking on the View File Browser button which is always present in the Tool Options bar (see the circled button in Figure 2.7). It makes sense to resize the Browser window to fill the screen and the next time you open the File Browser up, the browser setting will be remembered. If you have a dual monitor setup you can always have the File Browser permanently displayed on the second screen, although there are some limitations with Windows systems, which are discussed in the following chapter. Image folders can be selected using the folder view palette and the folder contents are then viewed in the thumbnail view area. An enlarged view of individually selected images can be seen

Folder view palette

Image preview palette

Keywords palette

Metadata palette

Thumbnail view area

Figure 2.7 The new Photoshop CS File Browser.

in the image preview palette. Images can be opened by double-clicking on the thumbnail or image preview. The File Browser will remain open after you open an image. If you hold down ⌥ *alt* as you double-click, the Browser will close after opening the image.

The File Browser palette can be customized. The palettes can be grouped together and the palette dividers dragged so that if you wish, the preview palette can fill the browser more. There are a great many features to explore in the revamped browser and ways you can use it as an essential Photoshop tool, which is why I have devoted most of Chapter 16 at the back of this book to the discussion of image management and how to get the most out of the File Browser.

Figure 2.8 The Navigator palette.

Figure 2.9 The Info palette and Info Options dialog. Now that there is more extensive support for 16-bit editing in Photoshop CS, you can check the Show 16 bit values box to see the color RGB readouts expressed using 16-bit values. Well, 15-bit values actually (the reasons for this will be explained later in Chapter Four). The higher precision readouts will mainly be of interest to specialist Photoshop users only.

Navigator

The Navigator is usually grouped with the Info, Character and Paragraph palettes. The Navigator offers an easy and direct method of scrolling and zooming in and out of the image window. The palette window contains a small preview of the whole image and enables you to scroll very fast, with a minimum of mouse movement by dragging the colored rectangle. This colored rectangle indicates the current view as seen in relation to the whole image (other rectangle colors can be selected via the palette fly-out menu options). To operate the zoom, hold down the ⌘ ctrl key and drag the mouse to define an area to zoom to. Alternatively, with the slider control at the bottom, you can quickly zoom in and out or click on the 'little mountain' or 'big mountain' icons to adjust the magnification in increments. You can also type in a specific zoom percentage in the bottom left corner up to two decimal places and hit Return or Enter to set the new zoom percentage. It is also possible to resize the palette as shown in the illustration here, by dragging the bottom of the palette window out – this will provide you with a bigger preview.

Info

This palette reports information relating to the position of the cursor in the image window, namely: pixel color values and coordinate positions. When you drag with a tool, the coordinates update and in the case of crop, marquee, line and zoom tools, report back the size of a dragging movement. The sub-menu leads to Palette Options... Here you can change the preferences for the ruler units and color readouts. The default color display shows pixel values for the current selected color mode plus the CMYK equivalents. When working in RGB, illegal colors which fall outside the current CMYK workspace gamut are expressed with an exclamation mark against the CMYK value.

Histogram palette

The Histogram palette is new to Photoshop CS. It compliments the histogram display found in the Levels and Camera Raw dialogs, except this is a persistent display which can be used to help you observe visually, the levels in an image when you use other image adjustment tools and are applying these to the whole image or a selected area. The Histogram palette can be expanded to provide a larger palette size and expanded again to simultaneously show all the color channels. The main histogram view can be set to display the merged channel RGB/CMYK composite view you normally see in the Levels histogram, individual color channel views, a colored histogram view (as shown in Figure 2.10) or a Luminosity view. There used to be an Image menu item called Histogram which displayed a luminosity histogram view of the merged channels. This is considered a more accurate representation of the merged channel image data and useful for making shadow and highlight assessments (more on this in Chapter 4). Although the histogram palette will provide a continual update on the image levels, it is unable to provide a consistently accurate and true representation. The histogram display will reflect levels changes based on the pixels stored in what is known as the image cache. If the image you are editing is zoomed out to fit the screen, the histogram display information will be based on the current image cache – the stored image view used to display the image at that magnification only. The histogram palette does not attempt to read in the pixels for the whole image each time you perform an operation, it uses the image cache only. Because of this, the histogram may display an unrepresentative, broken histogram with gaps in it. You know when the cache is being used, the Cache Level will indicate a number higher than '1' and a warning triangle appears in the top right corner of the histogram display area. To update the histogram display based on the full image size data: double-click anywhere inside the histogram palette, click on this warning triangle or click the Refresh histogram button just above the warning triangle.

Refresh button

Histogram view Warning triangle

Expanded channels

Figure 2.10 The Histogram palette.

Figure 2.11 The Tool Options bar.

Tool Options bar

When you first install Photoshop, the Options bar will appear at the top of the screen, snapped to the main menu. This is a convenient location for the tool options, and you will soon appreciate the ease with which you can make changes to the options with minimal mouse navigation movement. The Options bar can be unhooked, by dragging the gripper bar (on the left edge) away from the top of the screen. The Options bar contains a 'palette well' docking area to the right, which will be visible whenever the Options bar is docked at the top or bottom of the screen and your monitor pixel display is at least 1024 × 768 pixels (although ideally you will want a larger pixel display to see this properly). Palettes can be docked here by dragging a palette tab into the Options bar palette well. Palettes that are docked this way are made visible by clicking on the palette tab. One advantage of this arrangement is that you can use the *Shift* *Tab* shortcut to toggle hiding the palette stack only, keeping just the Tools palette and Options bar visible. The individual Options bar settings for each tool

Figure 2.12 The Tool Options bar and palette well showing the contextual menu.

are shown throughout the rest of this chapter. To reset a tool or all tools, mouse down on the tool icon on the left. The 'tick' and 'cross' icons are there to make it simpler for users to know how to exit a tool which is in a modal state.

You can change the palette tab order by *ctrl* Right mouse-clicking on a palette tab in the well. A contextual menu will pop up and you can select to move the palette tab left or right or to the beginning or end of the palette well (see Figure 2.12).

Tool Presets

The Tool Presets palette can be used to store custom tool presets. All of the Photoshop tools have a range of tool options and the Tool Presets palette allows you to configure a specific tool setting and save it. This will allow you to quickly access a number of tool options very quickly and saves you the bother of having to re-configure the Options bar settings each time you use a particular tool. For example, you might find it useful to save crop tool settings for different image dimensions and pixel resolutions. The example in Figure 2.13 shows a display of presets for all available tools. If you click on the Current Tool Only button at the bottom of the palette, you can restrict the preset options to the current tool.

The Tool Presets palette is particularly useful for storing pre-configured brush preset settings. In fact one of the first things you should do is go to the Tool Presets palette sub-menu and choose Load Presets... Choose: Presets ⇨ Tools ⇨ Brushes.tpl. Another thing that may not be immediately apparent is the fact that you can also use the Tool Presets to save Type tool settings. This again is very useful, as you can save the font, font size, type attributes and font color settings all within the single tool preset. This feature will be very useful, for example, if you are working on a web page design project.

Figure 2.13 The Tool Presets palette.

Figure 2.14 The Character palette.

Figure 2.15 The Paragraph palette.

Character

Using the Character palette you can exercise full control over the font character attributes such as: point size, leading, tracking, baseline shift and text color. The Character palette provides a level of character control that is comparable to InDesign's text handling (when the type tool is selected, click on the 'palettes' button to open this and the Paragraph palette). Multilingual spell checking is available and the small type buttons at the bottom enable you to quickly modify the capitalization of text, plus select anti-aliasing options.

Paragraph

Photoshop will let you place multiple lines of text. The Paragraph palette lets you exercise control over the paragraph text alignment and justification. The indentation controls enable you to indent the whole paragraph left and right, or just indent the first line of text.

Brushes

The standard brush presets in Photoshop range from a single pixel, hard-edged brush, to a 300 pixel-wide soft-edged brush, plus various elliptical and other creative textured brush shapes in the default list. To find and select a new brush preset, mouse down on the downward pointing arrow, next to the brush shape icon in the Options bar (you can do this when any other painting type tool is selected in the Tools palette). *ctrl* right mouse-clicking in the document window area will open the contextual menu and open the Brush Preset list on screen next to the cursor. Click on the brush you wish to select. Once you start painting, the menu will then close. If you double-click a selected brush the menu will close automatically. *ctrl* *Shift* click right mouse *Shift* click will allow you to select a new paint blending mode or choose Edit Brush... which will open the Brush Preset list again. You can use the square bracket keys *[* *]* on the keyboard, to make the brush larger or smaller (the upper brush size limit is now 2500 pixels). Use *Shift* *[* *Shift* *]* to adjust the edge hardness

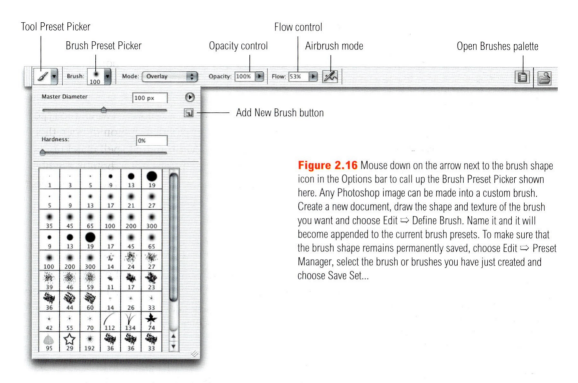

Tool Preset Picker
Brush Preset Picker
Opacity control
Flow control
Airbrush mode
Open Brushes palette

Add New Brush button

Figure 2.16 Mouse down on the arrow next to the brush shape icon in the Options bar to call up the Brush Preset Picker shown here. Any Photoshop image can be made into a custom brush. Create a new document, draw the shape and texture of the brush you want and choose Edit ⇨ Define Brush. Name it and it will become appended to the current brush presets. To make sure that the brush shape remains permanently saved, choose Edit ⇨ Preset Manager, select the brush or brushes you have just created and choose Save Set...

of the brush up or down on-the-fly. You can add a new brush by choosing the New Brush... option in either the Options bar brush sub-menu, or by clicking on the New brush icon in the Options bar brush menu, or the Brushes palette sub-menu. The New Brush dialog will appear and allow you to name the new brush shape, then click OK to append it to the current list. You will notice that Photoshop does not have a separate Airbrush tool. Instead, the Brush tool features an Airbrush mode button in the Options bar.

Brushes palette
The brush presets determine the brush shape only. You can make the brush relatively larger or smaller either by adjusting the slider control, selecting a different brush preset or using the square bracket keys to modify the brush preset size on-the-fly. The Brush Tool Presets (to the left of the brush presets in the Options bar) are a combination of two things: the brush preset and brush attributes, which are

Pressure sensitive control

The Wacom Intuos range includes some pens that have a thumbwheel control and in Photoshop you can exploit all of these responsive built-in Wacom features to the full via the brush dynamics settings. You will notice that as you alter the brush dynamics settings, the brush stroke preview below will change to reflect what the expected outcome would be if you had drawn a squiggly line that faded from zero to full pen pressure (likewise with the tilt and thumbwheel). This visual feedback is extremely useful as it allows you to experiment with the brush dynamics settings in the Brushes palette and learn how these will affect the brush dynamic behavior.

defined in the separate Brushes palette – this includes settings for things like the 'brush dynamics'. If you are using a pressure sensitive pen stylus and you click on the Other Dynamics checkbox (see Figure 2.17), you can determine how the paint opacity and flow will be controlled by the pen pressure or the angle of tilt of the pen. The following paragraph explains these settings in a little more detail.

The 'jitter' settings introduce randomness into the brush dynamic behavior. Increasing the opacity jitter means that the opacity will still respond according to how much pen pressure is applied, but there will be a built-in random fluctuation to the opacity that will vary even more as the jitter value is increased. The flow setting governs the speed at which the paint is applied. To understand how the brush flow dynamics work, try selecting a brush and quickly paint a series of brush strokes at a low and then a high flow

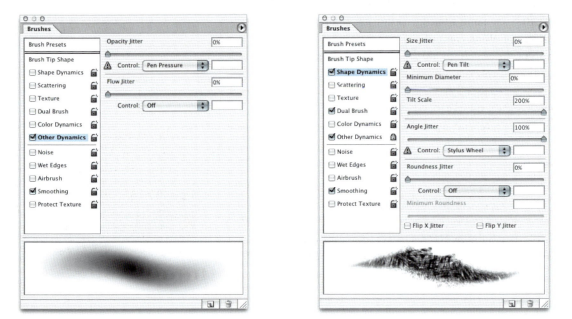

Figure 2.17 Highlight a brush dynamic option in the Brushes palette to display the dynamics settings on the right. Click in the checkbox if you want to activate the settings and modify them. As you can see above, Photoshop CS allows you to lock specific brush panel settings, such as the Shape dynamics shown here. This means that the Shape dynamic settings will now always remain fixed whenever you select other, different brush presets.

rate. When the flow rate is low, less paint will be applied, but more if you increase the flow setting or apply more pressure (or you paint slower). Other tools like the dodge and burn toning tools, use the terms Exposure and Strength. Essentially these have the same meaning as the opacity controls.

The Shape dynamics can be adjusted as well to introduce jitter into the size angle and roundness of the brush. The scattering controls can enable you to produce broad, sweeping brush strokes with a random scatter. The Color dynamics let you introduce random color variation to the paint color. The foreground/background color control can be useful as this will let you vary the paint color between the foreground and background color, according to how much pressure is applied. The Dual brush and Texture dynamics introduce texture and more interactive complexity to the brush texture. It is worth experimenting with the Scale control in the Dual Brush options. The Texture dynamics utilize a choice of blending modes for different effects and of course you can add a custom texture of your own design, direct from the Pattern presets. When you have finished tweaking with the Brushes palette dynamics and other settings, go to the Tool Presets palette and click on the New preset button at the bottom, to add your new settings as a preset.

Styles

Styles are layer effect presets. New custom layer effect combinations can be saved as Styles, where they are represented in the palette by a square button icon, which will visually indicate the outcome of applying the style. Styles can incorporate the new Pattern and Gradient fill layer effects.

Figure 2.18 In this example, I selected the Aurora brush preset and experimented with the pen tilt settings for things such as the size and angle in the Shape Dynamics settings. I then set Turquoise as the foreground color and purple for the background. I used a pen pressure setting to vary the paint color from foreground to background. I created the doodle in this image by twisting the pen angles as I applied the brush strokes.

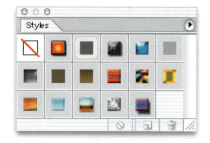

Figure 2.19 The Styles palette.

Figure 2.20 The Swatches palette.

Figure 2.21 The Color palette.

Swatches

You can choose a foreground color by Clicking on a swatch in the Swatches palette. To add a new color, click in the empty area at the bottom (and name the new color being added). ⎇ *alt* click to erase an existing swatch. New sets of color swatches can be appended or replaced via the palette sub-menu. You can edit the position of swatches (and other presets) by dragging with the cursor within the Preset Manager.

Color

Use this palette to set the foreground and background colors by dragging the color sliders, clicking inside the color slider or in the color field below. Several color modes for the sliders are available from the sub-menu including HTML and hexadecimal web colors. Out-of-gamut CMYK colors are flagged by a warning symbol in the palette box. Black and white swatches appear at the far right of the color field.

Preset Manager

The Preset Manager manages all your presets from within the one dialog. It keeps track of: brushes, swatches, gradients, styles, patterns, layer effect contours and custom Shapes. Figure 2.22 shows how you can use the Preset Manager to edit a current set of Custom shapes. You can append or replace an existing set (if the current set is saved, then you can easily reload it again). The Preset Manager will directly locate the relevant preset files from the Presets folder. The Preset Manager can be customized, which is particularly helpful if you wish to display the thumbnails of the gradients (see Figure 2.23). If you double-click any Photoshop setting that is outside the Photoshop folder, it will automatically load the program and append the relevant preset group.

Actions

Actions are recordable Photoshop scripts. The palette shown opposite has the default actions set loaded. As you can see from the descriptions, these will perform

Figure 2.22 You can use the Photoshop Preset Manager to load custom settings or replace them with one of the pre-supplied defaults. Presets include: Brushes, Swatches, Gradients, Styles, Patterns, Contours and Custom Shapes.

Figure 2.23 Apart from being able to load and replace presets, you are able to choose how the presets are displayed. In the case of Gradients, it is immensely useful to be able to see a thumbnail preview alongside the name of the gradient.

automated tasks such as adding a vignette or creating a wood frame edge effect. If you go to the palette fly-out menu and select Load Actions... you will be taken to the Photoshop CS/Presets/Photoshop Actions folder. Here you will find many more sets of actions to add to your Actions palette. To run an Action, you will mostly need to have a document already open in Photoshop and then you simply press the Play button to commence replay. You can record your own custom actions as well. Chapter 17 explains these in more detail and lists many other useful Photoshop shortcuts.

Figure 2.24 The Actions palette.

Figure 2.25 The History palette.

History

Photoshop can temporarily store multiple undo states and snapshots during a Photoshop session. These history states are recorded in the History palette. The number of recorded states can be anywhere between 1 and 1000, although the more histories you record the more memory Photoshop will need to save all of these. You can click on an earlier history state to revert to that particular stage of the edit, or you can paint in from history, using the history brush. For more information, see the later section on History, page 50.

Layers

Photoshop layers are akin to layers of acetate overlaying the background layer. Each layer can contain an image element, be that a duplicate of the background image, a copied selection from another layer, another Photoshop document which has been dragged across using the move tool or Photoshop text. Adjustment layers are image adjustment instructions in a layer form. Layers can be grouped together in sets (note you can now go beyond the 99 layers limit in a single document). You can apply masking to layer contents with either a pixel layer mask or a vector mask. Layers can blend with those underneath in 22 different blending modes. Layer effects/styles can be used to add effects such as drop shadows, gradient/pattern

Figure 2.26 The Layers palette.

fills or glows to a text or image layer. Custom styles can be loaded from and saved to the Styles palette. You will find some of the sub-menu options for layers are duplicated in the Layer main menu. See Chapter 11 for more information about layers and montage techniques.

Layer Comps

Layers are commonly used all the time as a means to edit an image and preserve the edited sections on discrete layers. Graphic designers and Web designers can sometimes use layers to construct very complex images, where a single, layered image can be designed so that by showing and hiding the various layers, contained within it, several different layout variations can be produced from using the one document. In these circumstances, showing and hiding layers can be a tricky and error-prone exercise. The Layer Comps palette enables you to save specific layer visibility and layer positionings as a layer comp that can be quickly accessed using this palette. To synchronize a layer comp configuration as you work, click on the layer comp in the palette.

Figure 2.27 The Layer Comps palette.

Channels

A Photoshop grayscale mode image is comprised of a single 8-bit channel of image information, with 256 levels (except when in 16-bit per channel mode). RGB images are comprised of three channels: Channel 1-Red, Channel 2-Green and Channel 3-Blue (RGB); CMYK images, four

Load selection Save selection

New channel Delete channel

Composite channel —
Red channel —
Green channel —
Blue channel —
Layer mask channel —
Alpha/mask channel —

Figure 2.28 The Channels palette.

channels: Channel 1-Cyan, Channel 2-Magenta, Channel 3-Yellow and Channel 4-blacK. The Photoshop channels palette displays the color channels in this order, with a composite channel (Channel ~) listed at the top. Use ⌘ ctrl+the channel number (or tilde key in the case of the composite channel) as a keyboard shortcut for viewing channels individually. When saving a selection (Select ⇨ Save Selection), this action either generates a new alpha channel or overwrites an existing one. New channels can also be added by clicking the Add channel button at the bottom of the Channels palette (up to 56 channels including the color channels are allowed). For specialist types of printing, alpha channels can be used to store print color information like varnish overlays or fifth/sixth color printing of special inks. Photoshop has a spot channel feature enabling spot color channels to have a color specified and be previewed on screen in color (see Chapter 9). You can use the Channels palette sub-menu or the buttons at the bottom of the Channels palette to delete, duplicate or create a new channel.

Paths

A vector path is a mathematically described outline which, unlike a pixel-based mask channel, is resolution-independent and infinitely editable. Paths can be imported from a vector drawing program such as Adobe Illustrator™, or they can be created within Photoshop using the pen path or shape tools. A freshly drawn path is displayed as a Work Path in the palette window. Work Paths should be saved (double-click the Work Path or drag it down to the New Path button) if you don't wish the current work path to be

Figure 2.29 The Paths palette.

overwritten. A path can be used in several ways: to convert
to a selection; apply as a layer clipping path or save as a
clipping path in an Encapsulated PostScript (EPS) or TIFF
file. To rename a path, just double-click it.

Tools palette

The Tools palette contains 56 separate tools and their icons
give a clue as to each tool's function. The individual tool
options are located in the Options bar (Window ⇨ Show
Options) and double-clicking any tool will automatically
display the Options bar if this happens to be hidden for
some reason. Figure 2.30 shows the Tools palette layout.
Within the basic Tools palette are extra tools (designated by

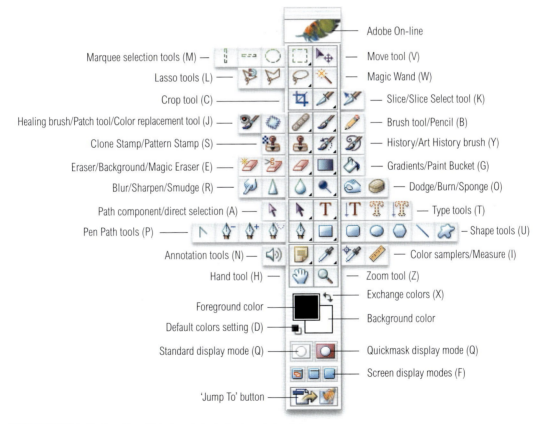

Figure 2.30 The Tools palette with keyboard shortcuts shown in brackets.

the small triangle at the bottom of the icon). These become visible when you mouse down on the Tools palette icon. You will notice that each tool or set of tools has a keyboard shortcut associated with it (this is displayed when you mouse down to reveal the nested tools or hover with the cursor to reveal the tool tip info). For example, pressing C on the keyboard will activate the crop tool. Where more than one tool shares the same keyboard shortcut, you can cycle through these other tools by holding down the Shift key as you press the letter key. If you prefer to restore the old behavior whereby repeated pressing of the key would cycle the tool selection, go to the Photoshop menu, select Preferences ⇨ General and deselect the Use Shift Key for Tool Switch option. Personally, I prefer to use the shift modifier. You can also ⌥ alt click the tool icon in the Tools palette to cycle through the grouped tools.

Clicking in the image document window will call up a dialog explaining the exact reason why you cannot access or use a particular feature. If you click at the very top of the Tools palette, this will now open the Adobe On-line... dialog (also available in the File menu). Any late-breaking information plus access to on-line help and professional tips are all easily accessible within Photoshop.

Selection tools

The usual editing conventions apply in Photoshop: pixels can be cut, copied and pasted just as you would do with text in a word processing document. Mistakes can be undone with the Edit ⇨ Undo command or by selecting a previous history state in the History palette. Selection tools are used to define a specific area of the image that you wish to modify separately, float as a layer or copy and paste. The use of the selection tools in Photoshop is therefore like highlighting text in a word processor program.

The marquee options include rectangular, elliptical or single row/single column selection tools. The lasso tool is

used to draw freehand selection outlines and has two other modes – the polygon lasso tool, which can draw both straight line *and* freehand selections and the magnetic lasso tool. The magic wand tool selects pixels on the basis of their luminosity values within the individual channels. If you have a picture of a red London bus (there are still a few left in London) click on the bus with the magic wand tool and 'hey presto' the red color is selected! That's what most people expect the magic wand tool to do; in reality it does not perform that reliable a job. I find it works all right on low resolution images (such as those prepared for screen-sized viewing). You can use the smoothing options in the Select menu to tidy up a magic wand selection. If you are going to create complex selections this way then really you are often better off choosing the Select ⇨ Color Range option, that does base the selection on color values. This selection command provides all the power of the magic wand tool, but has much more control. I rarely ever use the magic wand when defining critical outlines, but do find it quite useful when I want to make a rough selection area based on color. In short, don't dismiss the wand completely but don't place too much faith either in its capabilities for professional mask making. There are better ways of going about doing this, as shall be explained later in the book.

Modifier keys

Macintosh and Windows keyboards have slightly different key arrangements, hence the double sets of instructions throughout the book reminding you that the ⌘ key on the Macintosh is equivalent to the *ctrl* key on a Windows keyboard (because Windows PC computers don't have a Command key) and the Macintosh ⌥ key is equivalent to the *alt* key in Windows. In fact, on most Macintosh keyboards the Option key is labeled as Alt. Macintoshes do have a *ctrl* key too. On the Mac its function is to access contextual menus (more of which later). Windows users will find their equivalent is to click with the right mouse button. Finally, the *Shift* key operates the same on both Mac and PC.

Magic wand tolerance setting

You can adjust the magic wand tolerance setting so that it will select fewer or more pixels, based on how similar they are in color to the pixels you click on. The tolerance setting governs the sensitivity of the magic wand selection. When you click on an area in the image, Photoshop selects all the adjacent pixels whose numeric color values are within the specified tolerance either side of the pixel value. If the pixels clicked on have a mean value of 120 and the tolerance setting is set at the default of 32, Photoshop will select pixels with a color value between 88 and 152.

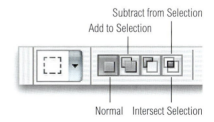

Figure 2.31 The Options bar has four modes of operation for each of the selection tools: Normal; Add to Selection; Subtract from Selection; and Intersect Selection. You can also achieve these same operating modes by using the modifier keys.

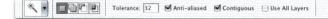

1 The magic wand tool can be used to create a selection of pixels which are similar in color to the point where you clicked. So, clicking in the blue sky area will select all the blue pixels surrounding the click point. Because the Contiguous option is switched on, the selection is limited to neighboring pixels only.

2 If you were to deselect the Contiguous option in the Options bar, the magic wand tool will then select blue pixels of similar tonal value from everywhere in the image. This has now selected the blue sky areas on the other side of the cloud.

3 If you have most of the desired pixels selected, the Select ⇨ Grow command will expand the wand selection according to the tolerance value configured in the magic wand Options bar.

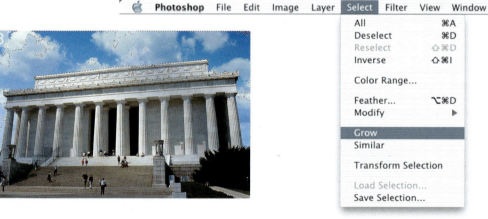

These keys are 'modifier' keys, because they modify tool behavior. Modifier keys do other things too – hold down the ⌥ *alt* key and click on the marquee tool in the Tools palette. Notice that the tool displayed cycles through the options available. For the most part, modifier keys are used in conjunction with the selection tools and as you get more proficient you should be able to reach to the appropriate key instinctively without your eyes having to leave the display.

The *Shift* and ⌥ *alt* keys also affect the shape and drawing behavior of the marquee tools: holding down *Shift* when drawing a marquee selection constrains the selection to a square or circle; holding down ⌥ *alt* when drawing a marquee selection centers the selection around the point where you clicked on the image.

Holding down *Shift* ⌥ *Shift* *alt* when drawing a marquee selection constrains the selection to a square or circle and centers the selection around the point where you first clicked.

After the first stage of drawing a selection, whether by marquee, lasso, magic wand or a selection has been loaded from a saved alpha channel with subsequent selection tool adjustments, the modifying keys now behave differently.

Holding down the *Shift* key as you drag with the marquee or lasso tool adds to the selection. Holding down the *Shift* key and clicking with the magic wand tool also adds to the existing selection.

Easter eggs

Drag down from the system or Apple menu to select About Photoshop... The splash screen reopens and after about 5 seconds the text starts to scroll telling you lots of stuff about the Adobe team who wrote the program etc. Hold down ⌥ *alt* and the text scrolls faster. Hold down ⌘ *ctrl* and choose About Photoshop... you will see the Dark Matter beta test version of the splash screen. If you want to see another Easter egg, go to the Layers palette, hold down ⌥ *alt* and choose Palette Options from the palette sub-menu.

Figure 2.32 The Dark Matter splash screen.

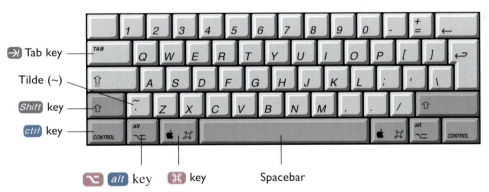

Figure 2.33 The modifier keys on a Macintosh keyboard and their Windows PC equivalents.

Spacebar tip

After drawing the selection, do not release the mouse button yet – hold down the Spacebar. This allows you to reposition the placement of the selection. Release the Spacebar and you can continue to modify the shape as before.

Holding down the `⌥` `alt` key as you drag with the marquee or lasso tool subtracts from the selection. Holding down the `⌥` `alt` key and clicking with the magic wand tool also subtracts from the existing selection.

A combination of holding down the `Shift` `⌥` `Shift` `alt` keys together whilst dragging with a selection tool (or clicking with the magic wand) creates an intersection of the two selections.

To summarize: The `Shift` key adds to a selection. The `⌥` `alt` key subtracts from a selection and the `Shift` `⌥` `Shift` `alt` keys intersect a selection. To find out more about practical techniques requiring you to modify selection contents, refer to Chapter Seven on montage techniques.

Lasso: freehand/polygon/magnetic

The lasso tool behavior is more or less identical to that of the marquee selection tools – the same modifier key rules apply. To use the standard lasso tool, just drag around the area to be selected holding down the mouse as you draw. When you release the mouse, the selection joins up from the last point drawn with the starting point.

In polygon mode, you can click to start the selection, release the mouse and position the cursor to draw a straight line, click to draw another line and so on. To revert temporarily to freehand operation, hold down the `⌥` `alt` key and drag with the mouse. Release the `⌥` `alt` key and the tool reverts to polygon mode. To complete the polygon lasso tool selection position the cursor directly above the starting point (a small circle icon appears next to the cursor) and click.

The magnetic lasso and the magnetic pen tool both use the same code and they are therefore basically the same in operation, except one draws a selection and the other a pen path. The magnetic lasso has a sensing area (set in the

Options bar). When you brush along an image edge, where an outline is detectable, the magnetic lasso intelligently prepares to create a selection edge. You continue to brush along the edges until the outline is complete and then you close the selection.

This innovation is bound to appeal to beginners and anyone who has problems learning to draw paths with the pen tool. I reckon on this being quite a powerful Photoshop feature and should not be dismissed lightly as an 'idiot's pen tool'. Used in conjunction with a graphics tablet, you can broaden or narrow the area of focus by varying the stylus pressure. Without such a tablet, you have basic mouse plus keyboard control, using the square bracket keys [and] to determine the size of the tool focus area. The only way to truly evaluate the performance of the magnetic tools is to take them for a spin and learn how to use them in combination with the relevant keyboard keys. In operation, the magnetic lasso and magnetic pen tool operate alike: the magnetic lasso draws a pseudo path, laying down fastening points along the way – the distance apart of the points can be set in the Options bar as a frequency value, whilst the edge contrast specifies the minimum contrast of an edge before the tool is attracted. As you brush along an edge, an outline follows the edge of greatest contrast within the brush width area and sticks to it like a magnet.

To reverse a magnetic outline, drag back over the outline so far drawn. Where you meet a fastening point, you can either proceed from that position or hit the delete key to reverse your tracks even further to the fastening point before that and so on... You can manually add fastening points by clicking with the mouse.

When defining an outline, a combination of mousing down with the ⌥ alt key changes the tool back to the regular lasso to manually draw round an edge. Holding down ⌥ alt with the mouse up changes the tool to the polygon lasso (or freeform pen tool if using the magnetic pen). Other selection modifier key behavior comes into play before you start to drag with the tool – hold down the

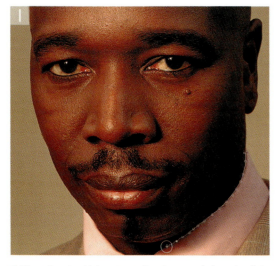

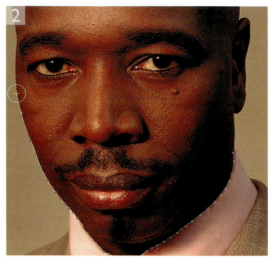

1 Where there is a high contrast edge, the magnetic lasso has little problem following the suggested path roughly drawn by dragging along the shirt collar. Fastening points are automatically added along the path. The center cross-hair hotspot will help guide you when locating the edge.

2 The size of the magic lasso selection area can be enlarged by lessening the pressure if using a graphic tablet input device. This makes drawing an outline much quicker. For precise edge definition, add more pressure to narrow down the tool's field of view.

3 As you draw with the tool, it does not add another point until it senses a continuation of the edge. You can watch the magnetic lasso laying down a path like a magnet sticking to an edge. To scroll the screen as you work, hold down the Spacebar – this temporarily accesses the hand tool without disturbing the operational flow of the selection tool.

4&5 If you veer too far off course, reverse the path of the tool and hit the `Delete` key to erase the previous point (there are no limits to this type of undo). To complete the selection, hit the Enter key or double-click. The end points will join up and if there is a gap, attempt to follow and continue the image outline.

1 The magnetic tools in Photoshop operate by analyzing the composite image to determine where the edges of an object lie. The difficulty is that the edges are not always as clear to Photoshop as they seem to be to us.

2 One answer is to sometimes add a temporary, contrast increasing adjustment layer to the image. So, add a new curves adjustment layer and make the curve an 'S' shape. Now the outline appears much clearer and the magnetic tools have no trouble seeing the edges. When the magnetic selection or path is complete, discard the adjustment layer.

Photograph: Peter Hince.

Shift key then drag to add to an existing selection. You don't have to keep the mouse pressed down as is necessary with the lasso. When using the magnetic lasso, you can just click, drag and only click again when you wish to lay down a fastening point.

To complete a selection, click on the start point. Double-click or hit *Enter* to close with a line determined by the magnetic tool. Photoshop will intelligently follow the line you are currently on and close the loop wherever there is good edge contrast for the tool to follow. *⌥ alt* +double-click closes the path with a straight line segment.

You can use the move tool to:

- Drag and drop layers and selections from one image window to another.
- Move selections or whole images from Photoshop to another application.
- Move selection contents or layer contents within a layer.
- Copy and move a selection (hold down ⌥ *alt*).
- Apply a Transform to a layer.
- Align and/or distribute layers.

Move tool

The move tool can now be more accurately described as a move/transform/alignment tool. The transform mode is apparent whenever the Show Bounding Box is checked (initially a dotted bounding box appears around the object). When you mouse down on the bounding box handles, the Options bar display will change to reveal the numeric transform controls (no longer a menu item). This transform feature is only active when the move tool itself is selected and not when you use the ⌘ *ctrl* shortcut.

When several layers are linked together, you can click on the align and distribute buttons in the Options bar as an alternative to navigating via the Layer ⇨ Align Linked and Distribute Linked menus (see Chapter 9 for more about the align and distribute commands). The move tool is also activated whenever you hold down ⌘ *ctrl*. The exceptions to this are when the slice or slice select tools are selected (⌘ *ctrl* toggles between the two), or when the hand, pen tool or path selection tools are active. ⌥ *alt* modifies move tool behavior. Holding down ⌥ *alt* plus ⌘ *ctrl* (the move tool shortcut) as you drag a selection makes a copy of the selection.

When the move tool is selected, dragging will move the layer or selection contents (the cursor does not have to be centered on the object or selection, it can be anywhere in the image window). When the Auto Select Layer is switched on, the move tool will auto-select the uppermost layer containing the most opaque image data below the cursor. This is a useful mode for the move tool with certain layered images. If you have the move tool selected in the Tools palette and the Auto Select Layer option is unchecked, holding down ⌘ *ctrl* temporarily inverts the state of the move tool to Auto Select Layer mode. Where many layers overlap, you can use the move tool plus *ctrl*

right mouse-click to access the contextual layer menu. This
is a more precise method of selecting any layer with greater
than 50% opacity from within the document window.

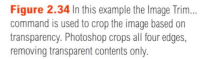

Crop tool

The crop tool uses color shading to mask the outer crop
area. This provides a useful visual clue when making a crop.
Figure 2.35 shows the Options bar in 'crop active' mode,
where the default shade color is black at 75% opacity. This
color can easily be changed by clicking on the color swatch
in the Options bar and choosing a new color from the
picker. The standard color and opacity will enable you to
preview the crop with most images quite adequately. Only
if the images you are working on have very dark
background will you benefit from changing the color to
something like a 'ruby lith' red or another lighter color.
You can also hide/show the crop outline using the View
menu ⇨ Hide Extras command. The delete button in the
Options bar will delete layered image data outside of the
crop boundary. The Hide button will crop the image, but
only hide the layer data that is outside the crop boundary
(also referred to as big data). The hidden layer data will be
preserved, but only on non-background layers. When one or
more layer's contents extend beyond the canvas boundary,
the Image ⇨ Reveal All command can be used to enlarge the
canvas size to show the hidden 'big data'.

You can use the <kbd>Enter</kbd> key to OK the crop and the <kbd>esc</kbd>
key to cancel and exit from a crop. On Macintosh and PC
keyboards, these keys should be diagonally positioned,
with <kbd>esc</kbd> at the top left and <kbd>Enter</kbd> at bottom right. Drag the
crop tool across the image to marquee the area to be
cropped. Refine the position of the crop by directly
dragging any of the eight crop handles. If View ⇨ Snap to
⇨ Document Bounds is checked, the crop tool will snap to
the edge of the document. To avoid this, go to the View
menu and uncheck the Document Bounds or general Snap
To behavior. If the Perspective box is checked in the crop

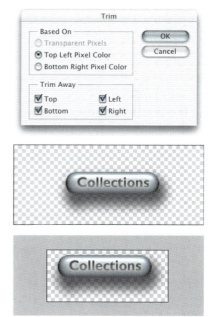

Figure 2.34 In this example the Image Trim...
command is used to crop the image based on
transparency. Photoshop crops all four edges,
removing transparent contents only.

Switching unit dimensions

You will notice the switch arrows icon in
the Crop Options bar (and also in other
tool options). If you click on this it allows
you to toggle between landscape and
portrait mode cropping

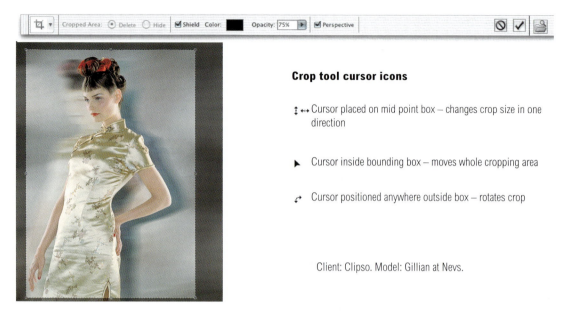

Crop tool cursor icons

↕ ↔ Cursor placed on mid point box – changes crop size in one direction

▶ Cursor inside bounding box – moves whole cropping area

↻ Cursor positioned anywhere outside box – rotates crop

Client: Clipso. Model: Gillian at Nevs.

Figure 2.35 The crop tool bounding box. The cursor positioned on the corner box changes the crop dimensions both horizontally and diagonally. The center point can be repositioned to set the central axis of rotation.

Crop presets

I find that it is very useful to save the crop sizes that you use regularly as Tool Presets. If the Tool Preset contains a resolution setting, then the crop will resize the image to fit the resolution (the number of pixels per inch) and the dimensions (for more on resolution, see Chapter 12). If the resolution field is left blank, the crop will be made to fit the image dimensions and the number of pixels per inch will adjust accordingly. Note that in Photoshop CS, you only need to save one preset for landscape and portrait crops. Just click on the double arrow between the width and height fields to switch them.

tool options bar, this will take you into the perspective cropping mode. For more about perspective cropping, see Chapter 4.

To constrain the proportions of the crop, hold down the *Shift* key as you drag. You can reposition the crop without altering the crop size by dragging within the crop area. To rotate the angle of the crop, move the cursor anywhere just slightly outside the crop window. The crop bounding box has a movable center point. When you click and drag the center point elsewhere, the central axis of rotation is repositioned accordingly, even to a point outside the crop rectangle. The Image ⇨ Trim... command can be used to crop an image based on pixel color values. Figure 2.34 shows an example of how trimming can crop an image based on transparency.

Slicing tools

Slices are a web designer's tool that is used to divide an image into rectangular sections. These are then used in Photoshop or ImageReady, for example, to specify how each individual slice will be optimized, what file format a slice area will be saved in and what compression shall be utilized. You use the slice tool to manually define a user-slice. As you create user-slices, Photoshop automatically generates auto-slices to divide up the other areas (as can be see in Figure 2.36). You can use the slice select tool (toggle with the ⌘ *ctrl* key) to go back and edit the size of each slice afterwards. If you are looking for the Show Slice Numbers checkbox, this is now contained in the Guides, Grid and Slices preferences. In Photoshop you can auto-create slices from the Photoshop guides, by clicking on the Slices From Guides button in the Options bar.

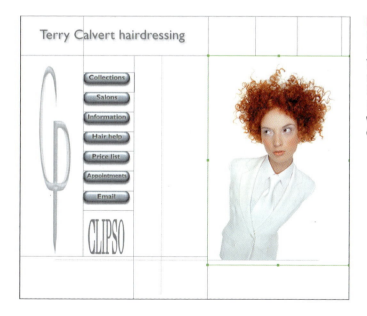

Figure 2.36 Images can be sliced up in Photoshop using the slice tool. You can optimize individual slices inside the Photoshop Save for Web Dialog (ImageReady slices will also be recognized in Photoshop). Choose Layer ⇨ 'New Layer Based Slice' to create slices based on Photoshop layers. This will update the slices when layer effects like Drop Shadows are added or adjusted.

The paint tools

The painting tools are all grouped below the selection and move tools. There are some common options available for these tools – they all make use of blending modes and have variable opacity settings. If you have a graphic tablet as your input device (which I highly recommend) the stylus pressure sensitivity options will become active in Photoshop. These offer fine control over tool behavior (see the earlier section on the Brushes palette). The Fade options found in the Brushes palette brush dynamics are not stylus-dependent. The number of fade steps entered will allow you to 'fade out' a brush stroke. Here now is a rundown of the main Photoshop paint tools.

Healing brush/Patch tool

The healing tools will enable you to perform complex retouching tasks with an incredible level of finesse and in a fraction of the time that it took previously. For examples of the healing brush and the patch tool in action, check out some of the repairing and retouching tutorials shown in Chapter 6.

Color replacement tool

The color replacement brush is new in Photoshop CS and is grouped with the healing brush and patch tool in the tools palette. It is most commonly used as a tool for removing red eye from photographs taken with a direct flash source. You typically use this tool in Color mode only, and the best red eye removal setting is obtained with the Sampling set to Once, the Limits set to contiguous and the tolerance raised to around 40–50%.

Brush

The brush tool can be used with a range of brush sizes from a single hard edged pixel up to the largest soft edged brush (2500 pixels). The airbrush mode makes the brush tool mimic the effect of an airbrush, producing a spray of paint. As you click with the mouse or press down with the stylus, just as in real life, if you stop moving the cursor, the airbrush paint will continue to spread out until the opacity level you set is reached. The Flow control determines how 'fast' the brush tool applies paint to the image. You can open the Brushes palette by clicking on the palette icon at the far right. The Wet Edge painting mode (now in the Brushes palette options) builds extra density around the edges of the brush stroke. This imitates a natural water color effect.

Pencil

The pencil produces hard edged, anti-aliased, pencil-like drawing lines. The pencil tool is a fast response sketching tool. It maybe had some uses in the early days of Photoshop when computers ran more slowly and the painting speed was restricted. These days, you can do all your painting using the brush tool.

Clone stamp/Pattern stamp

An essential tool for retouching work such as spotting (discussed later in Chapter 6) and general image repairing. The clone stamp tool is used to sample pixels from one part of the image to paint in another. Keep the Aligned box checked, hold down ⌥ *alt* and click where you want to sample from. Release the key and click in the area you

want to clone to. This action defines a relationship between sample and painting positions. Once set, any subsequent clicking or dragging will allow you to apply the clone stamp, always using the same coordinates relationship until a new source and destination are defined. The sample point can also be from a separate image. This is useful for combining elements or textures from other pictures. The clone stamp normally samples from a single layer only. The Use All Layers option permits the clone sample to be taken from merged layer pixel information. The pattern stamp tool allows you to select a pattern in the Options bar and paint using the chosen pattern as your image source. The Impressionist mode option adds some jitter to the pattern source and can be used to produce a more diffuse pattern texture.

Figure 2.37 The History Options can ne accessed via the History palette fly-out menu. These will allow you to decide the Snapshot settings. I usually prefer to check the Allow Non-Linear History option, because this enables me to use the History feature to its full potential (see page 53).

History brush

Before History made its first appearance in Photoshop 5.0, there were few ways you could restore a previous image state. The History amalgamates some of the old work-arounds into a single Photoshop feature. It augments the use of the Snapshot and very cleverly makes use of the image tiling to limit any unnecessary drain on memory usage. One can look at the History as a multiple undo feature in which you can reverse through up to 1000 image states, but in actual fact History is a far more sophisticated and powerful tool than just that. Painting from History saves you from tedious work-arounds like having to duplicate a portion of the image to another layer, retouching this layer and merging back down to the underlying layer again.

The History palette displays the sequence of Photoshop states as you progress through a Photoshop session (as shown in Figure 2.39). To reverse to a previous state, you can either click on it or drag the arrow slider back up the list. The number of histories allowed can be set in the Photoshop preferences. When the maximum number of

history states has been reached, the earliest history state at the top of the list is discarded. If you reduce the number of history states allowed, any subsequent action will also cause the earlier history states to be discarded.

History brush and Snapshot

To create a snapshot, click on the Snapshot button at the bottom of the palette. Snapshots are stored above the divider – this records the image in its current state and prevents this version of the image from being overwritten for as long as the document is open and being edited. The default operating mode stores a snapshot of the opening image state. You can choose not to store an opening image this way if you prefer or take more snapshots at any time to add to the list. This feature is useful if you have an image state that you wish to temporarily store and not lose as you make further image changes. There is no real constraint on the number of Snapshots stored. In the History palette options you can check to automatically generate a new snapshot each time you save (which will also be time-stamped). This can be useful, but be aware that it may cause Photoshop's memory usage to increase significantly. Alternatively, you can click the duplicate image button to create a duplicate image state and then save this as a file.

To use the history brush, go to the History palette and click on the space just to the left of the history state you wish to paint from – you will see a history brush icon appear against it. You can then paint information in from a previous history state (or from one of the snapshots) to the active state. The history brush lets you selectively restore the previously held image information as desired. That is a simple way of looking at the history brush, but it has the potential to be very versatile. The alternative spotting technique in Chapter 6 shows how the history feature can be used to avoid the need for duplicating layers. The history feature does not really take on the role of a repeat Edit ⇨ Undo command and nor should it. There are several actions which will remain only undoable with the undo command, like intermediate changes when setting shadow

Figure 2.38 Click on the New Snapshot button (circled) at the bottom of the History palette – this will record a snapshot of the history at this stage. If you ⌥ *alt* click the button, there are now three options: Full Document, which stores all layers intact; Merged Layers, which stores a composite; and Current Layer, which stores just the currently active layer. The adjacent New Document button will duplicate the active image in its current history state.

History stages	Scratch disk
Open file	61.2
Levels adjustment layer	138.9
Curves adjustment layer	139.9
Rubber stamp	158.3
Rubber stamp	159.1
Rubber stamp	160.1
Rectangular marquee	139.7
Feather 100 pixels	149.9
Inverse selection	162.6
Levels adjustment layer	175.3
Flatten image	233.5
Unsharp mask filter	291.7
Close	

Figure 2.39 The accompanying table shows how the scratch disk memory will fluctuate during a typical Photoshop session. The opened image was 38.7 MB in size and 250 MB of memory was allocated to Photoshop. Notice how minor local changes to the image do not increase the amount of memory used compared with the global changes. The history states are recorded in the History palette. The active history state is indicated by the pointer icon. In this case the last one in the list.

and highlights in the levels dialog. Furthermore there are things which can be undone with Edit ⇨ Undo that have nothing to do with the history. If you delete an action or delete a history, these are only recoverable using Edit ⇨ Undo. So although the history feature is described as a multiple undo, it is important not to confuse history with the role of the undo command. The undo command is toggled and this is because the majority of Photoshop users like to switch quickly back and forth to see a before and after version of the image. The current combination of undo commands and history has been carefully planned to provide the most flexible and logical approach – history is not just as an 'oh I messed up. Let's go back a few stages' feature, the way some other programs work, it is a tool designed to ease the workflow and allow you more creative options in Photoshop.

History and memory usage

Conventional wisdom suggested that any multiple undo feature would require vast amounts of memory to be tied up storing all the previous image states. Testing Photoshop history will tell you this is not necessarily so. It is true that a combination of global Photoshop actions will cause the memory usage to soar, but localized changes will not. You can observe this for yourself – set the image window bottom left corner status display to show Scratch Disk usage and monitor the readout over a number of stages. The right hand value is the total amount of scratch disk memory currently available – this will remain constant, watch the left hand figure only. Every Photoshop image is made up of tiled sections. When a large image is in the process of redrawing you see these tiles rendering across the screen. With history, Photoshop memorizes changes to the image at the tile level. If a brush stroke takes place across two image tiles, only the changes taking place in those tiles are updated and therefore the larger the image the more economical the memory usage will be. When a global change takes place such as a filter effect, the whole of the image area is updated and memory usage will rise

accordingly. A savvy Photoshop user will want to customize the history feature to record a reasonable number of histories, while at the same time being aware of the need to change this setting if the history usage is likely to place too heavy a burden on the scratch disk memory. The example in Figure 2.39 demonstrates that successive histories need not consume an escalating amount of memory. After the first adjustment layer, successive adjustment layers have little impact on the memory usage (only the screen preview is being changed). Clone stamp tool cloning and brush work affect changes in small tiled sections. Only the flatten image and unsharp mask filter which are applied at the end add a noticeable amount to the scratch disk usage. The Purge History command in the Edit ⇨ Purge menu provides a useful method of keeping the amount of scratch disk memory used under control. If the picture you are working with is exceptionally large, then having more than one undo can be both wasteful and unnecessary, so you should perhaps consider restricting the number of recordable history states. On the other hand, if multiple history undos are well within your physical system limits, then make the most of it. Clearly it is a matter of judging each case on its merits. After all, History is not just there as a mistake correcting tool, it has great potential for mixing composites from previous image states.

Figure 2.40 This picture shows the underlying tiled structure of a Photoshop image when it is being edited. In this example we have a width of four tiles and a height of three tiles. This is the clue to how history works as economically as possible. The history only stores in Photoshop memory the minimum amount of data necessary at each step. So if only one or two tile areas are altered by a Photoshop action, only the data change for those tiles is recorded.

Nonlinear history

Nonlinear history enables you to branch off in different directions and recombine effects without the need for duplicating separate layers. Nonlinear history is not an easy concept to grasp. The best way to think about nonlinear history is to imagine each history state having more than one 'linear' progression, allowing the user to branch off in different directions instead of as a single chain of events in Photoshop. You can take an image down several different routes, whilst working on the same file in a single Photoshop session. Snapshots of history branches can be taken and painted in with other history branches without

the need to save duplicate files. Nonlinear history requires a little more thinking on your part in order to monitor and recall image states, but ultimately makes for more efficient use of the available memory. To see some practical examples of how to use this and other history features in a Photoshop retouching session, refer to Chapter 6.

1 To explore the potential of the art history brush, I took the backlit flower image and applied a Brush Stroke ⇨ Ink Outlines filter. I then clicked to the left of the unfiltered history state, to set this as the history source. The art history brush is located next to the history brush in the Tools palette. With it you can paint from history with impressionistic type brush strokes.

2 The most significant factor will be the brush stroke type – in this particular example I mostly used 'Dab' and set the blending mode to Lighten only. The brush shape will have an impact too, so I varied the choice of brushes, using several of the bristle type brushes (see Photoshop brushes, earlier in this chapter).

Art history brush

The art history brush was introduced in version 5.5. I have to say that this is not the most essential Photoshop tool that was ever invented and am at a loss to know how a photographer like myself might wish to use it. Nevertheless, with art history you use the art history brush to sample from a history state, but the brush strokes have some unusual and abstract characteristics which smudge the pixels with sampling from the selected history state. The brush characteristics are defined in the Art History Options bar. Fidelity determines how close in color the paint strokes are to the original color. The larger the Area setting, the larger the area covered by and more numerous the paint strokes.

Eraser/background eraser/magic eraser

The eraser removes pixels from an image, replacing them with the current background color. There are three brush modes: brush, pencil and block. If you check the Erase to History box, the eraser behaves like the history brush. Holding down ⌥ *alt* as you paint also erases to the currently selected History. The brush flow option is only available when erasing in brush mode.

The background eraser erases pixels on a layer to transparent based on the pixel color sampled, while the magic eraser works like the paint bucket tool in reverse – erasing neighboring or 'similar' pixels, based on the pixel color value where you click. The magic wand and paint bucket tools also have the 'Contiguous' mode of selection, available as a switchable option in the Options bar. Switching this on or off allows you to make a selection based either on neighboring pixels only falling within the specified tolerance or all pixels in the image of a similar value.

The Wacom eraser

Note that some graphic tablet devices like the Wacom™ series operate in eraser mode when you flip the stylus upside down. This is recognized in Photoshop without having to select the eraser tool.

Contiguous selection modes

The magic wand and paint bucket tools also have a Contiguous' selection mode. Switching this on or off in the Options bar allows you to make a selection based either on just those neighboring pixels which fall within the specified tolerance or all pixels in the image which have a similar color value.

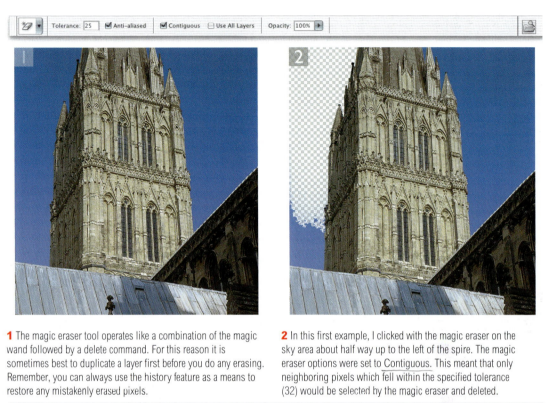

1 The magic eraser tool operates like a combination of the magic wand followed by a delete command. For this reason it is sometimes best to duplicate a layer first before you do any erasing. Remember, you can always use the history feature as a means to restore any mistakenly erased pixels.

2 In this first example, I clicked with the magic eraser on the sky area about half way up to the left of the spire. The magic eraser options were set to Contiguous. This meant that only neighboring pixels which fell within the specified tolerance (32) would be selected by the magic eraser and deleted.

3 When the Contiguous option is deselected, all pixels with a color value within the specified tolerance will be deleted. In this example, I clicked with the magic eraser in the same position as example 2. Nearly all of the blue pixels are erased at a stroke, like all the sky pixels on the right of the spire, but also some of the blue pixels contained in the shadow of the roof. This does not matter too much because I can always use the history brush later to restore any detail which becomes lost this way.

4 The background eraser tool provides more precise control. Here the tool is set to erase sampling 'Once' and in Find Edges mode. This means that when I click and drag, all pixels within a specified tolerance (or pressure applied by the stylus) of the pixel value where I first clicked will be erased by the tool. The background eraser will also erase the background sample color from the edge pixels – this will help remove the color contamination as you erase. The Find Edges mode preserves the edge sharpness better.

The Extract command

1 The Photoshop Extract command is a sophisticated, automated masking tool and can be compared directly to competing plug-in products. The Extract command is an integral part of the program and works well in combination with the background eraser which can remove any portions of the image that the Extract command fails to erase. You first define the edge of an object, roughly painting along the edge with the highlighter tool (Smart Highlighting makes this task easier now) and mistakes can be undone using ⌘ Z ctrl Z. Where the object to be extracted has a solid, well-defined interior, you can fill the inside areas using the fill tool.

2 When you click on the Preview button, Photoshop calculates and previews the resulting mask in the dialog window. Inside the dialog window interface, you can edit the mask edges with the highlighter, eraser and fill tools or adjust the smoothness to remove any pixel artifacts. You can also tidy up the extraction in the preview using the new clean-up tools. Test with the Preview as many times as you wish before proceeding to apply the chosen settings and erase the areas outside the object to transparency. For more on how to use the new eraser tools and the Extract command, see Chapter 11 on montage techniques.

Client: YU salon. Model: Kate Broe at M&P.

Gradients

The gradient tool can be used to draw linear, radial, angular reflected or diamond gradients. Go to the Options bar and click on the gradient ramp (top left) to select a gradient option such as Foreground to Background color, or click on the small arrow to the right to open the gradient list. When you drag with the gradient tool inside the image window, a gradient fill is created between those two points. Hold down the *Shift* key to constrain the gradient angle to a horizontal/vertical or 45 degree angle. Check the Reverse box to reverse the gradient fill colors before you drag. The Dither checkbox should be kept on – this will add a subtle noise, ensuring there is less risk of any banding appearing in the gradient fill. When the Transparency box is checked, the transparency masks in gradients are recognized. A number of preset gradients are readily available when you first open the gradient list from the Options bar. You can also easily edit and create your own gradient pattern and any alterations you make to an existing preset gradient will not overwrite that preset. See the accompanying tutorial showing how to create and customize a gradient.

Gradients can also be applied as a fill layer in Photoshop. Go to the Layers palette, click on the adjustment layer button and select Gradient Layer. This action will add a gradient that fills the whole layer and add a layer mask. This feature is like any other type of adjustment layer in that it allows you to edit the gradient fill. You can alter the precise angle or gradient type etc. at any time.

1 To create a custom gradient, click on the gradient ramp in the Gradient Options bar and choose Edit... This will open the accompanying Edit dialog box. (Clicking on the side arrow will call up the gradient list – shown here in Small Text view mode.)

2 Click on the lower left-most stop to select it and then double-click it or click once on the color box – this will open the Color Picker. Choose a new color for the start of the gradient. In this example, I picked a bright blue.

3 If I click above the bar, I can add a new transparency stop. Notice how the lower part of the dialog changes. I can alter the opacity of the gradient at this 'stop' point to, say, 50%. I can position this transparency stop anywhere along the gradient scale and adjust the diamond-shaped midpoints accordingly.

4 I can then add another transparency stop, but this time restore the opacity to 100% and prevent the transparency fading to the right of this point. I added another color stop below and made the color purple. When the gradient editing is complete all I have to do is rename the gradient in the space above and click on the New button. The new gradient will be saved and added to the current gradient set.

Noise gradients

1 It is important to note that the Noise Gradient Editor is separate to the Solid Gradient Editor and any settings made in the Solid Gradient Editor will have no bearing on the appearance of the noise gradient. When you select Gradient Type: Noise, the smooth gradient ramp will be replaced by a random noise ramp. Clicking on the Randomize button will present you with many interesting new random gradient options to choose from.

2 Increase the amount Roughness to make the noise gradient more spiky. The color sliders below edit the color content. In RGB mode, the red right-hand slider controls the amount of red content, while the left-hand slider controls the complimentary, cyan content and so on... Check the Saturate Colors box to boost color richness.

3 The Noise Gradient Editor is a very versatile tool, and it is well worth experimenting with the roughness slider – lower percentage settings can produce some very subtle effects. More about gradients is covered in the Preset Manager section of this chapter, page 30 and Chapter 8 on darkroom effects and the use of gradient fill and gradient map fill layers.

Paint bucket

In some ways this tool is in effect nothing more than 'make a magic wand selection based on the sampled color and Tolerance setting in the Options bar and fill the selection with the current foreground color or predefined pattern'. In this mode of operation, there is none of the flexibility associated with making a magic wand or Color Range

selection and modifying it before filling. You can use the paint bucket to quickly fill the inside areas of a mask or quickmask outline. The Contiguous option is also available for the paint bucket (see the magic wand description) and the All Layers option neatly allows you to fill using a pixel color sample based on all layers. The paint bucket can also be used for filling with a pattern as well as with a solid color. Choose the Pattern mode from the Options bar and select the pattern type.

Focus: blur/sharpen/smudge

Using the blur tool is just like painting with the gaussian blur filter. I often use the blur tool to soften portions of an image or to locally modify an alpha channel mask. The Use All Layers option is useful if you want to paint in a blur on a new layer but create a blur that blends better with the pixels on all the other layers. When you use the blur, sharpen or smudge tool, it will read all the visible image data when adding blurred, sharpened or smudged pixels to the currently active layer. Use the sharpen tool sparingly, as excessive sharpening can create nasty image artifacts. It is much better to make a feather edged selection of the area to be sharpened and apply the unsharp mask filter instead. When the blur or sharpen tool is selected, you can temporarily switch between one tool and the other, by holding down the ⌥ *alt* modifier key.

The smudge tool selects the color of the pixels where you first click and smears the pixels in whichever direction you drag the brush. For best results I recommend using a pressure sensitive graphics tablet. The Finger Painting option uses the current foreground color for the start of the smudge. It is best to think of this as an artist's tool like a palette knife used in oil painting.

Toning: dodge/burn/sponge

Dodging and burning should be familiar photographic concepts (for those who can remember darkrooms that is). Photoshop provides a certain element of control over the tool effect: you can choose to apply the toning effect selectively to either the Highlights, Midtones or Shadows. Thus if you want to darken or burn the shadow portion of an image without affecting the adjacent highlights, choosing the burn tool in Shadows mode will enable you to do this. As an alternative to the clone stamp tool, the dodge tool is excellent for removing wrinkles and facial lines without altering the underlying texture if applied in very

Tone tool options		
Mac	**PC**	**Function**
⌥ Shift W	alt Shift W	Set Dodge to Shadows
⌥ Shift V	alt Shift V	Set Dodge to Midtones
⌥ Shift Z	alt Shift Z	Set Dodge to Highlights
⌥	alt	Toggle to Burn tool
Burn tool		**Function**
⌥ Shift W	alt Shift W	Set Burn to Shadows
⌥ Shift X	alt Shift X	Set Burn to Midtones
⌥ Shift Z	alt Shift Z	Set Burn to Highlights
⌥	alt	Toggle to Dodge tool
Sponge tool		**Function**
⌥ Shift J	alt Shift J	Set Sponge to Desaturate
⌥ Shift A	alt Shift A	Set Sponge to Saturate

Figure 2.41 The toning tool shortcut options.

low percentages. The third option is the sponge tool, which has two modes: Saturate increases the color saturation, Desaturate lowers the color saturation. The handy shortcuts listed in Figure 2.41 permit quick access to the tonal range application settings. As with the blur and sharpen tool, holding down the ⌥ *alt* modifier key will temporarily switch between the dodge and burn tools.

Pen and path drawing

Photoshop provides a suite of vector path drawing tools that work in the same way as the pen path tools found in drawing programs like Illustrator and Freehand. For detailed instructions on drawing paths and working with the pen tool, refer to Chapter 7 on montage techniques. The magnetic pen tool behavior is more or less identical to the magnetic lasso tool described earlier.

Get out of filled layer mode

There is an annoying default in Photoshop where whenever you select the pen tool the first, it will default to drawing a filled shape layer. If you simply want to draw a pen path, make sure the paths button 🔲 is selected in the Options bar.

Type tool

The type tool allows direct on-image text editing. There are two ways you can use the type tool: either click in the image window and begin typing – this will add a single line of text – or you can click and drag to define a type box to which you can add lines of wraparound text (where the text wraps within the text box). Click on the Palettes button (on the far right in the Options bar) to bring the Character and Paragraph palettes to the front of the palette set. These provide fairly comprehensive typographical control (although importantly it does not provide Tab spacing).

For more about type

This is a book about Photoshop and photography. A rich variety of text effects can be achieved in Photoshop and designers who work in print and multimedia often mainly use the program for this purpose. Since there are plenty of other Photoshop books dedicated to the needs of graphic designers, I am going to concentrate here on the needs of image makers. But you will find more information on using the type tools in Chapter 9.

Because the type is in vector art form, it remains fully editable. To edit, highlight the type using the type tool. (Tip: choose View ⇨ Hide Extras to hide highlighting.) You can change the fonts, apply different colors to all the text or just single characters, or enter new text. Layer effects/styles can be applied to both type layers and image layers. Layer effects automate the process of adding grouped layers to provide effects such as drop shadows. Although you can create advanced text effects with plug-ins like Vector Effects from Metacreations, there are so many more text effects which can only be achieved in Photoshop. Layer effects now offer a phenomenal variety of text effects and you can also distort text using the warp controls that are available from the Options bar Warp Text menu.

Shape tools

Photoshop can let you create shapes that can be in the form of a filled layer with a vector mask (formerly referred to as a layer clipping path), a solid fill, or a path outline. You can define polygon shapes and also import custom shapes from EPS graphics, such as a regularly used company logo, and store these as Shape presets using the Preset Manager. The shape tools are a recently added crossover feature from ImageReady. Single pixel or wider lines can be drawn with the line shape tool. To constrain the drawing angle by 45 degree increments, hold down *Shift* (this applies to all the painting tools as well). Arrowheads can be added to the line at the start or finish (or both ends) of the line. Click the Shape... button in line tool Options to customize the appearance of the arrowhead proportions.

Annotation tools

You can add text or sound notes to a file in Photoshop. Documents that are annotated in this way can be saved in the Photoshop, PDF or TIFF formats. To annotate an open document, select the text note tool and click inside the image window. A note icon is placed together with an open text window. Enter text inside the window – for example, this can be a short description of the retouching which needs to be carried out on this part of the picture. After completing the text entry, close the text window. The text note will remain as a small icon floating above the actual image. Although viewable in Photoshop, these notes will not be visible when you actually come to print the image. If you save a copy of an image as a PDF and send this to a client, they will be able to open it in Acrobat, add notes in Acrobat and export a Notes file for you to import back into the original Photoshop image. To delete a note or delete all notes, *ctrl* right mouse-click on a note icon. The contextual menu will offer you the choice of deleting that note or all notes in the current document. If you want to append a sound note to a file, check in your System Control Panels that the computer's built-in microphone is selected as the incoming sound source. When you click in the window with the sound note tool a small sound recording dialog appears. Press the record button and record your spoken instructions. When finished, press Stop. The sound message will be stored in the document when saved in the above file formats.

Figure 2.42 The text annotation tool is a handy way for you and your clients to communicate with each other. Notes that are added to an image will not appear when the image is printed.

Eyedropper/color sampler

The eyedropper samples pixel color values from any open image window and makes that the foreground color. If you hold down *⌥ alt*, the sample becomes the background color (but when working with any of the following tools – brush, pencil, type, line, gradient or bucket – holding down

Sample size

The sample area can be set to Point, 3 × 3 Average, 5 × 5 Average. The Point option will sample a single pixel color value only and this may not be truly representative of the color you are trying to sample. You might quite easily be clicking on a 'noisy' pixel or some other pixel artifact. A 3 × 3 average, 5 × 5 average sample area will usually provide a better indication of the color value of the pixels in the area you are clicking.

the [⌥] *alt* key will create a new foreground color). The color sampler tool provides persistent pixel value readouts in the Info palette from up to four points in the image. The sample point readouts will remain visible all the time in the Info palette. The sample points themselves are only visible whenever the color sampler tool is selected. The great value of the color sampler tool is having the ability to monitor pixel color values at fixed points in an image. To see what I mean, take a look at the tutorial in Chapter 5, which demonstrates how the combination of placing color samplers and precise curves point positioning means that you now have even more fine color control with valuable numeric feedback in Photoshop. Sample points can be deleted by dragging them outside the image window or [⌥] *alt* clicking on them.

Measure

The measure tool provides an easy means of measuring distances and angles. To draw a measuring line, open the Info palette and click and drag with the measure tool in the image window. The measure tool also has a protractor mode – after drawing a measuring line, [⌥] *alt* click on one of the end points and drag out a second measuring line. As you drag this out, the angle measurements are updated in the Info palette. The measure tool line will only remain visible when the tool is selected, or you can hide it with the View ⇨ Hide Extras command. The measure tool line can be updated at any time by clicking and dragging any of the end points. As with other tools the measure tool can be made to snap to the grid or guides.

Navigation tools – hand and zoom

To navigate around an image, select the hand tool and drag to scroll. To zoom in on an image, either click with the zoom tool to magnify, or drag with the zoom tool, marqueeing the area to magnify. This combines a zoom and scrolling function. In normal mode, a plus icon appears inside the magnifying glass icon. To zoom out, hold down `alt` and click (the plus sign is replaced with a minus sign). A useful shortcut well worth memorizing is that at any time, holding down the Spacebar accesses the hand tool. Holding down the Spacebar+`ctrl` key calls up the zoom tool (except when editing text). Holding down the Spacebar+`alt` calls up the zoom tool in and zoom out tools. An image can be viewed anywhere between 0.2% and 1600%. Another zoom shortcut is `ctrl` `+` (Command-click the '=' key) to zoom in and `ctrl` `—` (next to '=') to zoom out. The hand and zoom tools also have another navigational function. Double-click the hand tool to make the image fit to screen. Double-click the zoom tool to magnify the image to 100%. There are buttons on the Options bar which perform similar zoom commands: Fit On Screen; Actual Pixels; Print Size. Navigation can also be controlled from the Navigator palette, the View menu and the lower left box of the image window. Checking the Resize Windows to Fit box will cause the Photoshop document windows to always resize to accommodate resizing, but within the constraints of the free screen area space. The Ignore Palettes checkbox will tell Photoshop to ignore this constraint and resize the windows behind the palettes.

Foreground/background colors

As mentioned earlier when discussing use of the eyedropper tool, the default setting has black as the foreground color and white as the background color. To

Scroll All/Zoom All Windows

When two or more documents are open, if you check the Scroll All Windows box in the hand tool Options Bar, Photoshop will synchronize the scrolling for all open windows. If Scroll All Windows is selected, when you click in a document window all other document windows will snap to match the same zoom location. Another way to set Photoshop up to do this is to choose Window ⇨ Arrange ⇨ Match Location. And if you hold down the `Shift` key and click in an area of an image or drag with the hand tool, the other image windows will match the location and scroll accordingly.

If you check the Zoom All Windows box for the zoom tool, Photoshop will synchronize the zooming across all windows. You can also set Photoshop up to do this by choosing Window ⇨ Arrange ⇨ Match Zoom. If you hold down the `Shift` key and click in an area of an image with the zoom tool, the other image windows will all zoom in by a corresponding amount. And if you use `alt` `Shift` the windows will simultaneously zoom out.

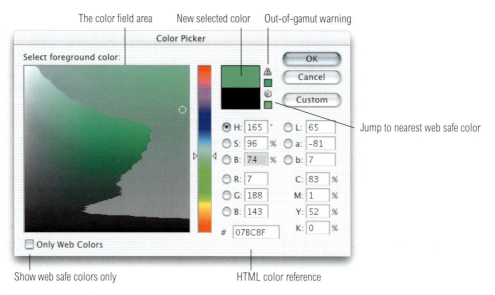

The color field area New selected color Out-of-gamut warning

Jump to nearest web safe color

Show web safe colors only HTML color reference

Figure 2.43 The Photoshop Color Picker, which is shown with a 'grayed out' color field because Gamut Warning is currently checked in the View menu. The alert icon beside the newly selected foreground color tells you it is out of gamut. If you check on the cube icon below, this will make the selected color jump to the nearest HTML web safe color. If you check the Only Web Colors box the Color Picker will display the restricted web safe color palette.

reset the default colors, either click on the black/white foreground/background mini icon or simply click *D*. Next to the main icon is a switch symbol. Clicking on this exchanges the colors, so the foreground becomes the background. The keyboard shortcut for this is *X*.

Selection mode/Quick mask
The left icon is the standard for Selection mode display. The right icon converts a selection to display as a semitransparent colored 'Quick mask'. Double-click either icon to change the default overlay mask color. Hit *Q* to toggle between the two modes.

Screen display
The standard mode displays images in the familiar separate windows. More than one document can be opened at a time and it is easy to select individual images by clicking on their windows. The middle display option changes the background display to an even medium gray color and

centers the image in the window with none of the distracting system window border. All remaining open documents are hidden from view (but can be accessed via the Window menu). Full Screen mode displays the image against a black background and hides the menu bar. The Tools palette and other palettes can be hidden too by pressing the *Tab* key (also marked as ⇥ on the keyboard). To show all the palettes, press *Tab* again. To toggle between these three viewing modes, press the *F* key. You can also use *Tab* *ctrl* *Tab* right mouse-click to cycle through each open image window, however the associated screen display is set.

Jump to button

ImageReady™ CS is a stand-alone application, that is installed with Photoshop CS. Clicking on the 'Jump to' icon will switch you from Photoshop to ImageReady™ and vice versa, without having to exit from the current program. The file will always continue to remain open in the previous program and you can select different programs to jump to from the File ⇨ Jump to menu. Upon installation, applicable application aliases are installed in the Photoshop CS ⇨ Helpers ⇨ Jump to Graphics Editor folder, i.e. Adobe Illustrator™ from Photoshop or HTML editing programs like Adobe GoLive™ from ImageReady™. If the other program is not currently open, the Jump to button will launch it.

Summary

The tools and palettes mentioned here will be cropping up again over the following chapters. Hopefully the later tutorials will help reinforce the message. In order to help familiarize yourself with the Photoshop tools and Palette functions, help dialog boxes will pop up after a few seconds whenever you leave a cursor hovering over any one of the Photoshop buttons or tool icons (see: Show Tool Tips in the General Preferences). A brief description is included in the box and tools have their keyboard shortcuts written in brackets.

Changing the color of the canvas

If you are fond of working in Full Screen mode with a totally black border, but miss not having access to the menu bar, in the two full screen modes you can toggle the display of the menu bar with the *Shift* *F* keyboard command. When you are in the middle full-screen viewing mode you can replace the gray colored Canvas by selecting a new color in the Color Picker and *Shift* clicking with the paint bucket tool in the canvas area. Be warned that this action cannot be undone using *⌘* *Z* *ctrl* *Z*! If you do need to restore the original gray canvas color, go to the color picker and enter 192 in the red, green and blue fields to make a new gray foreground color and *Shift* click in the canvas area.

Chapter 3
Configuring Photoshop

I n order to get the best performance out of
Photoshop, you need to ensure that your computer
system has been optimized for image editing work.
When I first began writing the *Photoshop for
Photographers* series of books, it was always necessary to
guide readers on how to buy the most suitable computer for
Photoshop work and what hardware specifications to look
for. These days I would suggest that almost any computer
you can buy is capable of running Photoshop and can be
upgraded later to run the program faster. As always, I try to
avoid making distinctions between the superiority of the
Macintosh or PC systems. If you are an experienced
computer user, you know what works best for you and I see
no reason to evangelize my preference for using a Mac.
Throughout my computer career, it's what I have grown up

with and it feels like home. The same arguments apply if you're a Windows PC user and apart from anything else, once you have bought a bunch of programs, you are locked into that particular system. If you switch, it means facing the prospect of buying your favorite software packages all over again.

Buying a system

Today's entry level computer will contain everything you need. For example, take the Apple G4 700 MHz eMac. At the time of writing, this entry level Apple eMac features a fast G4 processor, a 17" CRT display, has 128 MB of on-board RAM which can be upgraded to a maximum of 1 GB. It's got a 40 GB hard drive, CD drive and the video performance is provided by a GeForce2 MX Graphics processor unit. Photoshop CS requires a minimum of 128 MB of RAM so you would probably want to add another 256 MB of RAM at the time of purchase, but otherwise it's got quite enough to get you started. If you purchased the basic 1.6 GHz PowerMac G5 Macintosh, then this too has excellent specifications for Photoshop work and its processor can be upgraded. Again, I would suggest adding another 256 MB of RAM to take the memory up to 512 MB total. On the PC side there are many more choices and I would say that without being able to pinpoint any particular model, nearly all the basic PC bundles will be able to satisfy your basic Photoshop requirements. I shall be dealing with the specifics shortly but I would assume that at the very least your entry level computer should have the following: a Pentium class III or 4 processor, 20 GB hard drive and ideally a minimum of 256 MB with room for further RAM expansion. If you are able to get all of this and more, then you have yourself the beginnings of a powerful image editing system. If you have acquired an old computer system you will almost certainly encounter compatibility problems since Photoshop CS will run on a Macintosh G3, G4 or G5 with OS X 10.2.4 (or later) or OS X 10.3. On the Windows platform: a PC Pentium III or 4 running Windows 2000 with service Pack 2, or Windows XP.

Start out small

If you are new to Photoshop, My main buying advice is don't splash out on a top of the range system just yet. If you later decide image editing is not for you, then at least you can make use of your computer for general purpose office use, or shooting down rogue asteroids. In a year or two you can either upgrade your current system or purchase a machine that will probably be at least twice as fast as the most powerful computers around today. And besides, even a basic system can include a pretty good-sized monitor and plenty of opportunities for expansion.

Macintosh G5 optimization

The new G5 Macintosh is the first computer to use 64-bit processing and at the time of writing, it promises the fastest Photoshop processing speeds ever (until the next fastest computer comes along). Photoshop CS has been optimized for the Macintosh G5 to take full use of the 64-bit processing. Adobe have also released a free plug-in that will enable Photoshop 7.0 users to get optimized G5 performance as well.

Operating environment

Your computer working area matters. Even if space is limited there is much you can do to make your work space as comfortable as possible to work in. Choose a comfortable operator's chair, ideally one with arm rests and adjust the seating position so that your wrists are comfortably resting on the table top. The monitor should be level with your line of view or slightly lower. Figure 3.1 shows a general view of the office area from where I run my business and do all my Photoshop work and as you can see, it allows two operators to work simultaneously. The desk unit was custom-built to provide a large continuous work top area with good cable management in order to minimize the number of stray leads hanging all over the place. The walls are painted neutral gray. I was able to get the paint from a local hardware store, and when measured

Figure 3.1 This is the office area where I carry out all my Photoshop work. It has been custom built so that the desk area remains as clear as possible. The walls are painted neutral gray to absorb light and reduce the risk of color casts affecting what you see on the monitor screens. The lighting comes from daylight balanced tubes which backlights the monitor screens. I usually have the light level turned down quite low, in order to maximize the monitor viewing contrast. It really did used to look this tidy once!

with a spectrophotometer it is almost a perfect gray. The under the shelf lighting uses cool fluorescent strips that bounce off behind the displays to avoid any light directly hitting the screens. The window is north facing, so I never have any problems with direct sunlight entering the room and the amount of daylight entering the office can be controlled with the venetian blind. If I could just find a way to block annoying incoming phone calls while I am in the middle of a complex retouching session, it would be the perfect setup!

Once you start building an imaging workstation, you will soon end up with lots of electrical devices. While these in themselves may not consume a huge amount of power, do take precautions against too many power leads trailing off from a single power point. Cathode ray tube monitors are vulnerable to damage from the magnets in an unshielded speaker or the electrical motor in an inkjet printer. Just try not to position any item other than the computer too close to a CRT monitor screen. Interference from other electrical items can cause problems too. To prevent damage or loss of data from a sudden power cut, place an uninterruptible power supply unit between your computer and the mains source. These devices will also smooth out any voltage spikes or surges in the electricity supply.

Choosing a display

The display is one of the most important components in your entire kit. It is what you will spend all your time looking at as you work in Photoshop. You really do not want to economize by buying a cheap display that is unsuited for graphics use. There are two types of display that you can buy. Cathode Ray Tube (CRT) monitors and Liquid Crystal Displays (LCDs). A cathode ray tube fires electrons from its red, green and blue guns to produce a color image as the electrons strike the colored phosphor screen. CRTs have been around a long time and they remain popular with high-end graphics users. This is because most CRT displays make it possible to manually

Where to buy

Mail order companies are hard to beat on price, and the customer service is generally satisfactory, but you do occasionally come across bad shopping experiences, particularly when a piece of kit goes wrong. Try to find out if anyone else has had bad service with a particular dealer before parting with your money. Under UK consumer law, any claim on your warranty will require you to pursue the matter via the company who sold the equipment. Legally your consumer rights are protected. For extra protection, use your credit card for mail order purchases. In practice, these suppliers are working in a very competitive market and make small margins on all equipment sold. Consequently, you can expect little in the way of technical support and the procedures for handling complaints can be very slow. If you do have a problem, and wish to ensure your complaint is dealt with swiftly, be patient, be polite, but above all be methodical in pursuing your grievance. Note down dates and times of any calls you make. Computer trade shows are a good place to find special offers, but again check who you are dealing with. Remember prices are always dropping – the system you buy today could be selling for half that price next year (assuming it is still manufactured). Your capital investment is not going to hold its value. Businesses that rely on their equipment to be working every day of the week will choose to buy from a specialist dealer – someone who will provide professional advice and equipment tailored to their exact needs and, most important of all, instant backup in case things go disastrously wrong.

Running a second display

If you are able to run two displays from your computer, then you might want to invest in a second, smaller screen and have this located beside the main display and use it to show the Photoshop palette windows and keep the main screen area clear of palette clutter. To run a second display you will need to buy an additional PCI card that can provide a second video port. Since both displays will share a single monitor profile, the profile will be correct for the main display only. The Macintosh OS system is flexible when it comes to running dual displays. It can still be done on a PC, but there are some limitations. You will need to drag the lower right corner of the Photoshop application window across to the second screen which unfortunately will obscure the desktop on both monitors.

adjust the calibration of the display (see page 75) so that you can achieve a nice, neutral-looking output and there is less further adjustment required with the monitor profile. So ideally, the monitor profile will simply fine tune the calibrated CRT display. Because CRT displays are analog devices, they are prone to fluctuate in performance and output. This is why you must regularly calibrate a CRT display, like once a week. The hardware controls of a CRT typically allow you to adjust the contrast, brightness and color balance of the display output. The more expensive CRT monitors such as the Barco Calibrator have built-in self-calibrating tools. These continually monitor and regulate the output from the moment you switch the device on. A 22" CRT display is a big and bulky piece of equipment. The light, slim-line design of a Flat panel LCD screen will occupy less desk space than an equivalent sized CRT display and these have become the most popular type of display you can buy now. LCDs range in size from the screens used on a laptop computer to 23" graphics displays. An LCD uses a translucent film of fixed-size liquid crystal elements to individually filter the color of a backlit, florescent light source. Therefore the only hardware adjustment you can make is to adjust the brightness of the backlit screen. You can calibrate the brightness of the LCD hardware but that is about all you can do. The contrast is fixed, but it is usually as high as, if not higher even than a typical CRT monitor. This is not a bad thing when doing print work using Photoshop. Because LCDs are digital devices they tend to produce a more consistent color output. They still need to be calibrated and profiled, but the display's performance (unlike a CRT monitor) will remain fairly consistent. On the other hand, there will be some variance in the viewed image appearance depending on the angle from which you view the screen. The brightness and color output of an LCD will only appear to be correct when the screen is viewed front on. And this very much depends on the design of the LCD display. The worst example of this can be seen on ultrathin laptop display screens. But the evenness of the output from a 22" Apple Cinema display and other large LCDs is certainly a lot more consistent.

Display calibration and profiling

We now need to focus on what is the most important aspect of any Photoshop system: getting the monitor to correctly display your images in Photoshop at the right brightness and neutralized to remove color casts. This basic setup advice should be self-evident, because we all want our images in Photoshop to be consistent from session to session and match in appearance when viewed on another user's system. There are several ways that you can go about this. At a bare minimum you will want to calibrate the monitor display so that the contrast is turned up to maximum, the brightness is consistent with what everyone else would be using and that a neutral gray really does display gray. As I mentioned earlier, CRT displays will fluctuate in performance all the time. So before you calibrate a CRT monitor, it should be left switched on for at least half an hour to give it a chance to warm up properly and stabilize. A decent CRT monitor will have hardware controls that allow you to adjust the brightness and the color output from the individual color guns so that you can easily correct for color shifts and reset the gray balance of the output. However, the life-span of a CRT is about three years and as these devices get older they will lose their brightness and contrast to the point where they can no longer be successfully calibrated or be reliable enough for Photoshop image editing.

The initial calibration process should get your display close to an idealized state. From there, you can build a monitor profile which at a minimum describes the black point, white point and chosen gamma. The black point describes the darkest black that can be displayed so that the next lightest tone of dark gray is just visible. The white point information tells the video card how to display a pure white on the screen that matches the specified color temperature (I suggest you always use D65/6500 K and not D50). And lastly the gamma. This tells the video card how much to adjust the midtone levels compensation. Note that the gamma you choose when creating a monitor profile does not impact on how light or dark an image will be

Video cards

The graphics card in your computer is what drives the display. It processes all the pixel information and converts it to draw a color image on the screen. An accelerated graphics card will enable your screen to do several things. It will allow you to run your screen display at higher screen resolutions, it will allow you to view everything in millions of colors, it will also hold more image screen view data in memory and it will use the monitor profile information to finely adjust the color appearance. When more of the off-screen image data remains in memory the image scrolling is enhanced and this provides generally faster screen refreshes. In the old days, computers were sold with a limited amount of video memory. If you were lucky you could just about manage to run a small screen in millions of colors. If you buy a computer today the chances are that it will already be equipped with a good, high performance graphics card, easily capable of doing all of the above. These cards will contain 32 MB (or more) of dedicated memory and there is probably not much advantage to be gained by fitting anything other than this. This is because the top of the range graphics cards are optimized to provide faster 3D games performance rather than providing a better 2-D display.

Figure 3.2 This is a screen shot showing the hardware monitor controls for the LaCie Electron blue III CRT display. The hardware controls enable me to adjust the output of the individual guns that control the red, green and blue color of the display. I adjust these settings as part of the display calibration process to make the screen neutral before building the monitor profile.

displayed in Photoshop. The monitor profile gamma only affects how the midtone levels are distributed. Whether you use a Mac or PC computer, in most instances you should choose a gamma of 2.2 when building a monitor profile. If you use a measuring instrument (see Figure 3.3) to accurately calibrate and profile the display, you can build a monitor profile that contains a lot more detailed information about how the screen is able to display a broad range of colors.

The calibration resets your hardware to a standardized output. Finally you build a monitor profile that describes how well the display actually performs after it has been calibrated. A good CRT monitor will let you manually adjust the color output of the individual guns (the Barco Calibrator is a 'smart' monitor and it does this automatically). If the screen is more or less neutral after calibration there is less further adjustment required to get a perfectly profiled display. The monitor profile sends instructions to the video card to fine-tune the display. If these adjustments are relatively minor, you are making full use of the video card to describe a full range of colors on the screen. If you rely on video card adjustments to calibrate the display as well, then the video card is having to make bigger adjustments and the color output may suffer as a result. For example, when you use the Adobe Gamma or the Apple Display Calibrator Assistant method described on the following pages, as you adjust the color gamma sliders you are color compensating via the video card to neutralize the color on the display. It is much better to do this using the hardware controls, if your monitor has them. Not all CRT monitors do and LCD displays certainly don't. The only adjustment you can make on an LCD monitor is to adjust the brightness. This is not to say that all LCD screens are unsuitable devices for graphics work. The better LCD screens feature relatively good viewing angle consistency, are not too far off from a neutral color and D65 white balance and will not fluctuate much in performance. If you are not going to invest in a calibration/measuring device, your best option with an LCD is to load

a canned profile for your monitor and keep your fingers crossed. It will sort of work and is better than doing nothing.

Calibrating hardware

Let's now look at the practical steps for calibrating and profiling the display. First get rid of any distracting background colors or patterns on the computer desktop. And consider choosing a neutral color theme for your operating system. The Mac OS X system has a Graphite appearance setting especially there for Photoshop users! If you are using a PC, try going to Control Panels ⇨ Appearance ⇨ Themes, choose Display and click the Appearance tab. Click on the active and inactive window samples and choose a gray color for both. If you are using Windows XP, simply choose the Silver color scheme. This is all very subjective of course, but personally I think this improves the system appearance.

The only reliable way to calibrate and profile your display is by using a hardware calibration system. The LaCie Electron BlueEye, Mitsubishi SpectraView and Barco Calibrator are examples of monitors that come bundled with their own calibrating systems. Alternatively you can buy a stand-alone calibration instrument to do the job. The Monitor Spyder from ColorVisions is very affordable, and is sold either with PhotoCal or the more advanced OptiCal software. The Monitor Spyder is a colorimeter device and can only be used to measure the output from a monitor display. It is available as a 'CRT only' device that uses rubber suckers to attach to the screen, or as a CRT/LCD device that includes a weighted strap to balance the instrument so it just rests against the LCD screen. Whatever you do, don't try attaching anything with rubber suckers to an LCD screen – you will completely ruin the display! My personal preference is the Gretag Macbeth Eye-One system, which is available in several different packages. The Eye-One measuring device is an emissive spectrophotometer that can measure all types of displays and build printer profiles as well when used in

Figure 3.3 The Gretag Macbeth Eye-One is a popular spectrophotometer that can be used to accurately measure the output from the monitor display to both calibrate the output and using the accompanying Eye-One software, measure color patches, and build an ICC profile for your display.

1 An uncalibrated and unprofiled monitor cannot be relied on to provide an accurate indication of how colors should look.

2 The calibration process simply aims to optimize the display for gray balance, contrast and brightness.

3 The profiling process records at a minimum the black point, white point, and gamma. With the right software, the profiling process will also measure how a broad range of colors are displayed. Recording this extra color information is the only way you can truly produce an accurate profile.

4 To create a profile of this kind you need a colorimeter device like the ColorVisions Monitor Spyder with PhotoCal or OptiCal software. A spectrophotometer such as the Gretag Macbeth Eye-One with Eye-One Match or Profile Maker Professional software will produce the most accurate results.

conjunction with the Eye-One software. The new Eye-One Display device is a budget-priced device and is designed for measuring both CRT and LCD displays.

If you would like the display to provide an accurate representation of what you might expect to see in print, then do think about including a calibration device such as one of the above when you buy your display. I know that a lot of Photoshop users out there will still feel that they cannot afford this, so I do need to also cover the eyeball methods of display calibration. These are not particularly accurate methods, but again, it is a better than doing nothing at all. When you are finished, a basic profile of your monitor will be automatically created and placed in the appropriate system folder. I have provided a step-by-step guide for Mac and PC here. If you are using a Macintosh you will need to launch the Apple Display Calibrator Assistant. Open the System Preferences, choose Displays, click on the Color tab and click the Calibrate... button. If you are using a PC, the Adobe Gamma control panel should be located in the Program files/Common files/ Adobe/Calibration folder which may also be accessed on a PC by going to My Computer and opening the Control Panel folder. Adobe Gamma will now work with most PC computers, providing the video card will allow Adobe Gamma to interact with the monitor tube. Do not use the older Gamma control panel which shipped with Photoshop 4.0 or earlier. This older control panel must be discarded. When you launch Adobe Gamma select the Assistant radio button and click Next. If you already have a monitor profile, such as a canned profile supplied by the manufacturer, click the Load... button, locate this profile and use that as your starting point. Any existing monitor profiles should be found in the ICM Color Profiles folder. If not, any will do as a starting point here. When this is complete you will be ready to configure the color management settings.

Visual display calibration for Mac OS X and PC

The Display Calibration Assistant opening screen introduces the calibration utility and steps to create a monitor profile. Check the Expert Mode button at the bottom of the screen. If you already have a monitor profile, such as a canned profile supplied by the manufacturer, click the Load... button in Adobe Gamma, locate this profile and use that as your starting point. Any existing monitor profiles should be found in the ICM Color Profiles folder.

Contrast and brightness

You will then be asked to set the contrast to maximum and adjust the monitor brightness control so that the gray circle (or box) inside the larger box just becomes visible and the two darker halves of the square appear to be a solid black. This step optimizes the monitor to display at its full dynamic range and establishes the optimum brightness for the shadow tones.

Neutralizing the color

To define the Phosphors In Adobe Gamma keep the setting indicated by the profile you loaded at stage one. If starting from scratch, check with the monitor vendor. The next dialog will have a striped gray box with a square inside it. Deselect the 'View Single Gamma' check box so that you see the red, green and blue squares (the Apple dialog automatically shows three color squares). Squint your eyes as you adjust the individual color gamma sliders, so that the stripes appear to blend with the solid box or Apple logo in the middle. When making this judgement it helps to have the screen behind filled with a neutral gray. Use the gray as well to judge whether the color is indeed neutral.

Target Gamma

If you have an LCD display or you have already installed a third-party monitor calibration utility, the Calibration Assistant will recognize this and bypass the previous dialog, to display the target gamma screen. Whether you are using a PC or a Macintosh you are advised to select a 2.2 Gamma both here and in the Adobe Gamma dialog as this is the best monitor gamma setting for most Mac and Windows graphics cards.

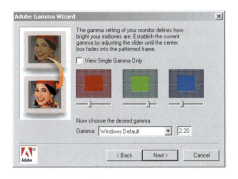

White point

I would advise choosing a white point of 6500 K. You might be guided to choose a white point of 5000 K, because this is the color temperature of a calibrated, proofing lightbox, but the screen will look rather dull and have a slightly yellow cast, so stick to using a 6500 K white point. The next Adobe Gamma screen asks if you want to work with a different white point other than that entered previously. Unless you have a particular need to alter the white point, leave this set to Same as Hardware.

Conclusion

Name the new monitor profile and click on the Create button. You will have created an ICC profile that describes the basic characteristics of the monitor and which Photoshop will automatically recognize.

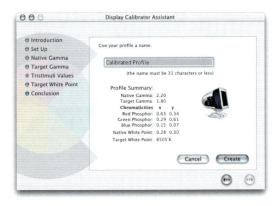

Color management settings

When you first install Photoshop a dialog box appears
asking if you would like to configure the color
management settings. The default Photoshop color settings
are configured for web graphics design use, and with color
management switched off. If you are using Photoshop for
design work or photography, you will want to follow the
prompt that Photoshop is giving you here. Go to the
Photoshop menu (Mac OS X) or the Edit menu (PC) and
select Color Settings. This will open the dialog shown in
Figure 3.4. Go to the Settings menu and change it from the
installed, 'General' default to one of the prepress settings.
These individual preset settings only differ in the default
RGB to CMYK conversions that they use. Which you
should choose will depend on the geographical area you
are working in. So if you live and work in the US, choose
US Prepress Defaults and you will be fine with that setting.
Please note that adjusting the RGB working space from
sRGB to Adobe RGB is a good thing to do if you intend
editing RGB photographs in Photoshop. But it is not
enough just to change the RGB work space setting on its
own. The prepress settings will also adjust the policy
settings as well to minimize any errors or frustrations when

Figure 3.4 The Photoshop Color Settings. All
the Photoshop color settings can be managed
from within this single dialog.

Figure 3.5 Wacom pad and pen.

Graphics tablets

I highly recommend getting a digitizing graphics tablet. It can be used alongside the mouse as an input device, is pressure responsive and is easier to draw with. Bigger is not necessarily better. Some people use the A4-sized tablets, others find it easier to work with an A5 or A6 tablet from the Wacom Intuos™ range, which also feature a cordless mouse and switchable pens. You don't have to move the pen around so much with smaller pads and are therefore easier to use for painting and drawing. Once you have experienced working with a pen, using the mouse will seem like trying to draw while wearing boxing gloves. Wacom recently introduced the Cintiq, which is a combination of LCD monitor and digitizing pen pad. This radical new design will potentially introduce a whole new concept to the way we interact with the on-screen image. I don't know if it is going to be generally seen as the ideal way of working with photographs, but early reports suggest that it makes painting and drawing a more fluid experience.

working with image files that are in different color spaces. You are on much safer ground if you follow Adobe's lead and choose a prepress setting here. By now your display should be neutralized and the brightness is at the correct luminosity. Photoshop is aware of the monitor profile you just created and your color settings are configured to correctly read the colors of any incoming, profiled files and you are all set to get to work with confidence. You don't need to worry too much more about the ins and outs of Photoshop color management just yet, but as your Photoshop knowledge increases you will definitely want to read in more detail about the color management system in Chapter 13 as well as how to make perfect prints in Chapter 14.

Extras

An internal 24× or faster CD-ROM drive is standard issue these days. Other things to buy could include a second hard drive to use as a scratch disk plus a removable media storage device such as the Iomega Zip drive or a CD writer, although a lot of computers are sold with a CD drive that functions as a CD writer and DVD writer too. You need these to back up your main hard disk and store all your image documents. It is tempting to accumulate lots of image files on the computer hard drive, but you have to ask yourself what would happen if your computer got stolen or that hard drive failed. Removable disks are ideal for transferring documents off-site. Print bureaux should be able to satisfactorily read Mac and PC format files whether supplied on ZIP, CD or DVD. If you are going to continue using any SCSI devices, check to see if you need to install a SCSI card interface. USB and FireWire™ (IEEE 1394) are the latest connection standards for peripheral devices. You can have up to 127 USB devices linked to a single computer and you can plug and unplug USB devices while the machine is switched on. USB data transfer rates are rather slow though and USB is best for connecting control devices such as the mouse, Wacom tablet and printer. FireWire™ has the potential to provide fast data transfer

rates of 100 MB+ per second, or faster with FireWire™ 800. So use FireWire™ wherever possible to connect devices that rely on fast data transfer such as hard drives, CD writers, digital cameras and scanners.

Photoshop preferences

The Photoshop preferences are located in the Edit menu in Windows and the Photoshop menu in OS X. You can use the preference dialogs to customize the various Photoshop functions and update the *preference file* which is stored along with other program settings in the system level Preferences folder (Mac) or Registry folder (PC): (C:\Documents and Settings*Current User*\Application Data\Adobe\Photoshop\8.0\Adobe Photoshop CS Settings). A new preference file is generated each time you exit Photoshop. Deleting or removing this file will force Photoshop to reset all its preferences.

When you open the Preferences you will first be shown the general preferences. I would suggest you leave the Color Picker set to Adobe – this is the picker referred to throughout this book (unless you have a strong attachment to the system Color Picker). Leave the interpolation option set to Bicubic. If you need to override this setting then you can do so in the Image ⇨ Image Size dialog. The Redo and Print Keys options have vanished because you are now able to customize the keyboard shortcuts separately in Photoshop CS via the Edit menu. Unchecking the Export Clipboard box saves time when exiting Photoshop to launch another program. If you really need the ability to paste clipboard contents to another program, then leave it on, otherwise switch it off. When the Show Tool Tips option is checked you will see tool tips displayed a few seconds after you roll over almost any item in the Photoshop interface. Tool tips are an excellent learning tool, but they can become irritating after a while as you learn more about what everything does. Check the Keyboard Zoom Resizes Windows, if you want the image window to shrink to fit whenever you use a keyboard zoom shortcut like ⌘ – ctrl – or ⌘ + ctrl +. If you are

Chip speed

Microchip processing speed is expressed in megahertz, but performance speed also depends on the chip type. A 2 GHz Pentium III is not as fast as a 2 GHz Pentium class 4 chip. Speed comparisons in terms of the number of megahertz are only valid between chips of the same series. Many of the latest Pentium computers are enabled with twin processing. And Apple have also introduced multiprocessor computers in the latest G4 and G5 range. The Macintosh Motorola G4/G5 processor includes AltiVec, that is also described as a 'velocity engine'. This helps in providing several instructions per clock cycle to enabled programs such as Photoshop, and is claimed can boost performance speeds of certain operations by at least a third. Windows machines use a similar speed enhancer which is known as MMX. Another crucial factor is the bus speed. This refers to the speed of data transfer from RAM memory to the CPU (the central processing unit, i.e. the chip). CPU performance can be restricted by slow system bus speeds so faster is better, especially for Photoshop work where large chunks of data are always being processed. At the time of writing, some PC computers have overtaken the G4 Macintosh because they have a faster bus speed. But it looks like the G5 may restake its claim soon to be the fastest processor in town.

Chip acceleration

Upgrading the processor chip is the most dramatic way you can boost a computer's performance. But not all computers will allow you to do this. If you have either a daughter card slot or some other processor upgrade slot then you will be able to upgrade your old computer and give it a new lease of life. The upgrade card will probably also include an increase of backside cache memory to further enhance performance. The cache memory stores frequently used system commands and thereby takes the strain away from the processor chip allowing faster performance on application tasks.

going to be jumping between Photoshop and ImageReady, then you may want to check the Auto-update open documents option. Otherwise, Photoshop will remind you anyway when you jump applications. The Mac OS X system broke some of the once hallowed rules about not implementing keyboard shortcuts that might conflict with shortcuts in an application designed to run on the Mac system. Photoshop 7.0 used to include a preference to disable this behavior. But OS X keyboard shortcuts are now disabled completely (including the ⌘ *ctrl* tilde key bug in OS X 10.2), since this would only further conflict with the new custom keyboard shortcuts in Photoshop CS. The Show Asian Text option enables the Chinese, Japanese and Korean text options in the Character palette. You can check the Beep When Done box, if you want Photoshop to signal a sound alert when tasks are complete. The Dynamic Color Sliders option ensures that the colors change in the Color palette as you drag the sliders – keep this selected. If you would like Photoshop to always remember the last used palette layout, check the Save Palette Locations box (the Reset Palette Locations to Default option is located under the Window menu, as are the new saved Workspace

Figure 3.6 The General preferences dialog.

settings). The Show Font Names in English option is of more significance for non-English language users, who will see instead an option for displaying font names in the native language of their localized version of Photoshop. The Use Shift Key for Tool Switch answers the needs of users who wish to disable the Shift key modifier for switching tools in the Tools palette with repeated keyboard strokes.

File Handling

You will normally want to include image previews when you save a file. It is very useful to have image thumbnail previews in the Open dialog boxes although the File Browser is capable of generating large thumbnails regardless of whether a preview is present or not. If you are working on a Mac, you can choose to save a Windows and Macintosh thumbnail with your file, to allow for cross-platform access. Appending a file with a file extension is handy for keeping tabs on which format a document was saved in. It is also very necessary when saving JPEG and GIF web graphics that need to be recognized in an HTML page. If you are exporting for the web, you may want to check the Use Lower Case box for appending files. But instances of servers tripping up on upper case naming are few these days.

Photoshop PSD files created in Photoshop CS are never going to be 100% compatible if read by someone using an earlier version of the program. This has always been the case with each upgrade of Photoshop. Setting the Maximize PSD File Compatibility to 'Always' will allow you to always include a flattened version of the image in a saved Photoshop file and the safe option is to keep this checked. For example, if you add the new Photo Filter image adjustment as an adjustment layer in Photoshop CS, it will not be interpreted correctly when read by Photoshop 7.0 or earlier without being made backwards compatible. In these circumstances, if Photoshop is unable to interpret an image, it will present an alert dialog. This will warn that certain elements cannot be read and offer the option to

File editing history

The File editing log is new to Photoshop and includes options to save a text record of any image editing you carry out either within the file metadata (see Chapter 16) or as a log text file, or both. The edit log items can be recorded in three modes. Sessions will record which files are opened and closed and when. The Concise mode will record an abbreviated list of which tools or commands were applied, again with times. Both these modes can provide basic feedback that could be useful in a studio environment to monitor time spent on a particular project and calculate billing. The Verbose mode records everything in detail, such as the coordinates used to make crop. This mode would be useful for example in forensic work.

Resetting dialogs

The Reset All Warning Dialogs will reset things like the profile mismatch warning messages. These dialogs contain a Don't Warn Me Again checkbox – if you had pressed any of these at any time, and wished to restore them, click here. The Reset All Tools in the Options bar will reset the tool behavior.

Economical web saves

There are times though when you don't need previews. Web graphic files should be uploaded as small as possible without a thumbnail or platform specific header information (Save for Web defaults to removing previews). I usually upload files to my server in a raw binary format, which strips out the previews and other file resource information anyway.

Backward compatibility issues

Once I update to a new version of Photoshop, I never need to go back to using a previous version and I am not in the habit of allowing anyone else access to my layered, version-specific Photoshop files. I have no need to maximize backward compatibility, so I prefer to switch this option off and keep the file size down and the save times shorter. But by doing so, I am losing out when I use the File Browser, because the Browser likes to utilize the flattened composite layer as it builds the thumbnails and previews. Without the composite layers it may take longer to cache the PSD files, but once the cache is written, it is stored in the individual volume's File Browser cache folder and will be instantly available the next time I visit that folder, unless I have edited the image in between.

discard these and continue or to read the composite image data. Discarding the unreadable data will allow another user to open your image, but when opened, it will be missing the elements you added and look unexpectedly different. If they click the Read composite data button, and a composite was saved, the image they open will open as a flattened composite layer that does look the same as the image you saved. If no composite was created, they will just see a white picture and a multi-language message saying that no composite data was available. So there are good reasons for maintaining backward compatibility, but checking this option will lead to slower saves and bigger Photoshop files.

A TIFF format file saved in Photoshop 6.0 or later is able to contain all types of Photoshop layer information and a flattened composite is always saved in a TIFF. If you place a layered TIFF image in a page layout, only the flattened composite will be read by the program when the page is finally converted to print. Some people argue that there are specific instances where a layered TIFF might trip

Figure 3.7 The file handling Preferences.

up a print production workflow, so it might be safer to never save layers in a TIFF if you don't know how your files will be printed. Adobe InDesign allows you to do the same thing with a Photoshop format (PSD) image file. But the Maximize Backwards Compatibility option must be checked in the General preferences, which as I just explained, will generate a flattened composite when you save as a PSD. If you use layered TIFF or PSD format files in your page layout workflow, you can modify the layers in Photoshop and the page design image will immediately be updated. This way you don't run the risk of losing synchronization between the master image that is used for Photoshop edits and a TIFF or EPS version of the same image that is used solely for placing in the layout. If you want to 'round trip' your images this way, TIFF is the more universally recognized file format. The downside of this is that you can end up with bloated files and these can significantly increase the file transmission times. For example, I typically begin my Photoshop editing with a single layer, 8-bit per channel, RGB image. As a PSD document it occupies about 75 MB on my hard disk. After adding a few layers it may easily double to 150 MB in size. If I were to save as a PSD with maximize compatibility switched on, the size will increase to 215 MB and if I save as a layered TIFF it may increase to 275 MB. These figures will vary depending on factors such as how many layers are present. If you are archiving layered Photoshop images, the most efficient option is to save using the native PSD format and have Maximize PSD File Compatibility set to 'Never', which happens to be the one I use. When the Ask Before Saving Layered TIFF Files option is checked, Photoshop will present you an option to either flatten or preserve the layers whenever you save a layered image as a TIFF. If this is unchecked, then the layer information will always be saved with a composite and there will be no warning dialog.

Enabling Workgroups

The Enable Workgroup Functionality options relate to the use of Web Distributed Authoring and Versioning (WebDAV) server technology. This is supported in Photoshop and will allow you to connect to a WebDAV server so that you can have your files shared with other Photoshop users. When a user 'checks out' a file, only he or she can edit it. The other users who are sharing your files will only be able to make edit changes after the file has been checked back in again. This precautionary behavior ensures that other users cannot overwrite your work while it is being edited.

Recent File List

The Recent file list refers to the number of image document locations remembered in the Photoshop 7.0 File ⇨ Open Recent sub-menu. The default number is 4, which I find to be too low – you might want to consider increasing this number.

Cursor display options

The Painting cursor displays an outline of the brush shape at its actual size in relation to the image magnification. This is the default setting, or alternatively, you can display the cursor with a precise cross-hair or a standard tool icon (which is the default setting for Other Cursors). For precision work I suggest changing the Other Cursors setting to Precise. Depending on how you configure the Display & Cursor options, the Caps lock key will toggle the cursor display. When the standard paint cursor is selected, the caps lock will toggle between standard and precise. When the precise or brush size paint cursor option is selected, the Caps lock will toggle between precise and brush size. When standard cursor mode is selected for all other cursors, the Caps lock key will toggle between the standard and precise cursor.

Display & Cursors

The display Color Channels in Color option is a somewhat redundant feature as this does not really help you to visualize the channels any better. If anything it is a distraction and is best left unchecked. The Use Diffusion Dither option is a legacy from the days when people were trying to run Photoshop on an underpowered system with an 8-bit color monitor displaying only 256 colors. The Use Diffusion Dither option uses a dithered pattern to approximate the in-between colors to produce a smoother looking if not completely accurate color display. I cannot imagine anyone needing to use this option with a modern computer system The Use Pixel Doubling option will temporarily convert the image preview to display a quarter as many pixels when you are making an image adjustment with, say, Levels or Curves or moving a pixel selection or layer on screen. Pixel Doubling will greatly improve screen refresh times, but again, this is not really necessary with today's Mac and PC computers.

Figure 3.8 The Display & Cursors Preferences.

Transparency & Gamut

The transparency settings determine how image transparency is represented on the screen. For example, if a layer contains transparency and is viewed on its own with the background layer visibility switched off, the transparent areas are normally shown using a checkerboard pattern. The display preferences let you decide how the checkerboard grid size and colors are displayed. If you are working in RGB or Lab color mode and choose View ➪ Gamut Warning, you will be alerted as to which colors are out of gamut. Photoshop represents these with a color overlay, which can be a solid or specified percentage color.

Figure 3.9 The transparency display settings are editable. You have a choice of transparency display settings: none, small, medium or large grid pattern as well as a choice of different grid colors.

Units & Rulers

Use this preference to set the Ruler measurement (inches or centimeters etc.) and type units used. The measurement units can also be changed via the Info palette sub-menu or by Control/right mouse-clicking a ruler to open the contextual menu. Double-click the ruler bar as a shortcut for opening this preference window. The New Document

Preset Resolution options allow you to decide what pixel resolution should be the default for screen display or print output work when you select a Preset size from the File ⇨ New Document dialog.

Figure 3.10 Ruler units can be set in pixels, inches, cm, mm, points, picas or as a percentage. The percentage setting is ideal for recording Actions that you wish to apply proportionally at any image size.

Guides, Grid & Slices

There are a choice of colors and two line styles to choose from and you can customize the grid appearance, such as the number of Grid subdivisions, to suit whatever project you are working on. The Slice options include Line color style and whether the Slice numbers are displayed or not.

Plug-ins & Scratch Disks

The Plug-ins folder will automatically be recognized by Photoshop so long as it resides in the same application folder. You can also choose an additional plug-ins folder that may be located in another application folder (such as Adobe Photoshop Elements) so these can in effect be shared with Photoshop. Click the Browse... button to locate the additional folder. If you install any third-party plug-ins

Figure 3.11 The preference settings governing the appearance of the Guides, Grid & Slices.

Figure 3.12 Up to four scratch disks are supported by Photoshop. And you can specify if any additional Plug-in folders are to be used (these may be shared with another application).

How much RAM does Photoshop need?

The general rule used to be that Photoshop requires available RAM memory of 3–5 times the image file size to work in real time. That will still hold true except under certain circumstances where the History options are set to allow a great many multiple undos and you are performing global changes, with each operation affecting the entire image, like applying a series of filters to the whole image. If you do that the memory requirements will soon escalate to many times the document file size. If, for example, you are editing a 30 MB RGB image in Photoshop, you will need around 90 MB to 150 MB of RAM memory beyond the amount of RAM used by the system and Photoshop itself, to edit the picture in real time. And that is assuming you have no layers added to the image, in which case the RAM memory requirements will be even greater. To get round this memory devouring problem, Photoshop utilizes free hard disk space as an extension of RAM memory. It uses all the available free hard disk as 'virtual memory'. In Photoshop terms, this is known as a 'scratch disk'. If you are making extensive use of scratch disk space in place of real RAM, you will see a real slowdown in performance. So this is why you are recommended to install as much RAM memory as you can. But be aware that Photoshop has a 2 GB RAM limit. There is no point in allocating any more than that to Photoshop.

that predate Photoshop CS, these may possibly incorporate a hidden installation process that looks for a valid Photoshop serial number in the older style, consisting of letters and numbers. If you experience this type of problem, just remember that you can enter your old Photoshop serial number in the Legacy Serial Number box.

In the section below you can specify the primary and spill-over scratch disks. The scratch disk choice will only take effect after you restart Photoshop and the primary scratch disk should ideally be one that is separate to the disk running the operating system and Photoshop. Partitioning the main disk volume and designating an empty partition as the scratch disk serves no useful purpose, as the disk drive head will simply be switching back and forth between different sectors of the same disk as it tries to do the job of running the computer system and providing scratch disk space. If you hold down the ⌘ ⌥ `ctrl` `alt` at the beginning of the start-up cycle, you can choose the location of the additional Plug-ins folder first then hold down the same key combination again and then choose the scratch disks. Up to four scratch disks can be specified. Holding down ⌘ ⌥ `Shift` `ctrl` `alt` `Shift` during start-up will delete the current Photoshop preferences.

RAM memory and scratch disks

The amount of RAM memory you have installed is a key factor that will determine how fast you can edit your images in Photoshop. Adobe recommend you allocate a minimum of 128 MB application memory to Photoshop CS, which means that if you allow 128 MB of RAM for the operating system, you need at least 256 MB of RAM in total. Most PCs and Macs use DIMMs (Dual In-line Memory Modules). The specific RAM memory chips may vary for each type of computer, so check carefully with the vendor that you are buying the right type for your machine. RAM memory used to cost a small fortune, but these days the price of RAM is almost inconsequential. If you have four RAM slots on your machine, you should easily be able to install 4×512 MB RAM chips, which will give you 2

gigabytes of installed RAM (which is the maximum Photoshop can make use of). The speed boost gained from having extra RAM installed in your machine will be significant.

Allocate as much RAM memory as possible and run Photoshop on its own. Check the scratch disk size by having the status box at the bottom of the document/ application window set to show Scratch Disk memory usage. Once the left-hand value starts to exceed the right, you know that Photoshop is running short of RAM memory and employing the scratch disk as virtual memory. To copy selections and layers between documents, use drag and drop actions with the move tool. This will save on memory usage and preserve any clipboard image at the same time.

The free hard disk space must be at least equivalent to the amount of RAM allocated for Photoshop. To use an extreme example, if you have 200 MB of free RAM allocated to Photoshop but only 100 MB of free disk space on the drive allocated as the primary scratch disk, Photoshop will use only 100 MB of the real RAM. For optimal image editing, at least 2 GB of free hard disk space is recommended. Under these conditions, Photoshop will use all the available free RAM for real-time calculations (mirroring the actual RAM on the scratch disk) and when

Virtual memory tricks

The Apple Macintosh and Windows operating systems are able to make efficient use of memory using their own virtual memory management systems. The Windows VM file should be set to at least 1.5 times your physical memory size. There are some software utilities that claim to double your RAM, but these will conflict with Photoshop's virtual memory and should not be used.

Figure 3.13 The chart to the left shows a comparison of hard disk sustained data transfer rates measured using the ATTO Performance Utility. The test results show data transfer speed on the vertical axis against increasing data block sizes on the horizontal axis. The slowest test result was for a Magneto Optical media disk. The ZIP proved slightly faster. The internal AV hard disk demonstrates a faster sustained speed, while the RAID performance figures dwarf everything else.

Green: MO disk; Red: ZIP disk; Blue: External AV HD; Black: Internal AV HD; Cyan: RAID SCSI 3 drive

RAID array hard drives

Until we see fast data transfer rates provided with FireWire™ drives (and this is just beginning to happen now), you may need to look at using a wide array RAID disk connected via an internal SCSI accelerating PCI card like a SCSI 3 standard (note that internal SCSI is compatible with OS X). Specifications vary according to the drives and the PCI card, but Figure 3.13 quite clearly shows that the sustained performance of a 25 MB per second RAID system is a huge improvement over a standard internal drive. But whichever type of drive you allocate as a scratch disk, you should ensure that it is a separate, discrete hard drive and is not shared with the disk which is running either Photoshop or the operating system. There is provision in Photoshop for as many as four scratch disks. Each individual scratch file created by Photoshop can be a maximum of 2 gigabytes and Photoshop can keep writing scratch files to a scratch disk volume until it becomes full. When the primary scratch disk runs out of room to accommodate all the scratch files during a Photoshop session, it will then start writing scratch files to the secondary scratch disk and so on. This makes for more efficient and faster disk usage.

Photoshop runs out of real memory, it uses the extra space on the scratch disk as a source of virtual memory. Photoshop is designed always to make the most efficient use of real RAM memory and essentially the program tries to keep as much RAM as possible free for memory intensive calculations. Low level data like the 'last saved' version of the image are stored in the scratch disk memory giving priority to the current version and last undo versions being held in RAM. Photoshop continually looks for ways to economize the use of RAM memory, writing to the hard disk in the background, whenever there are periods of inactivity. Scratch disk data is also compressed when not in use, unless the optional plug-in extension that prevents this has been loaded at Start-up.

With all this scratch disk activity going on, the hard disk performance of your scratch disk plays an important role in enhancing Photoshop speed. Most modern Macs and PCs have IDE, ATA or ATA 160 drives as standard. A fast internal hard disk is adequate for getting started. But for better performance results, you should really install a second hard drive, and have this dedicated as the primary scratch disk (assign it as the primary scratch disk in the Photoshop preferences). Most likely your computer will have the choice of a USB or FireWire™ connector for linking external devices. USB is about as fast as an old SCSI 1 connection. USB 2 is faster, although at the time of writing I will have to wait to see how much faster it runs on a Macintosh computer running OS X 10.3. FireWire™ (IEEE 1394) is the latest connection standard and has many advantages over the older SCSI interface. First of all FireWire™ is a lot faster and second, it will allow you to hot swap a drive between one computer and another. This is particularly useful when you wish to shuttle very large files around quickly. Although the promised FireWire™ data transfer speeds of 100+ MB sounds impressive, most external FireWire™ drives are not actually any faster than the SCSI drives they replaced. But with the advent of FireWire™ 800 we are now seeing an appreciable improvement in speed. FireWire™ drives are still IDE

drives with a bridge to the FireWire™ standard, and the Oxford Chipset came out to enhance the throughput closer to the theoretical limit. Internal SCSI connections are often SCSI 2, which provides a quicker data transfer standard (data transfer not data access time is the measure of disk speed to look out for).

Memory & Image Cache

The image cache settings affect the speed of screen redraws. Whenever you are working with a large image, Photoshop uses a pyramid type structure of lower resolution, cached versions of the full resolution picture. Each cached image is a quarter scale version of the previous cache level and is temporarily stored in memory to provide speedier screen previews. Basically, if you are viewing a large image on screen in 'fit to screen' display mode, Photoshop will use a cache level that is closest to the fit to screen resolution to provide a screen refresh view of any edit changes you make at this viewing scale. The cached screen previews can provide you with faster screen

Configuring the RAM memory settings

When you first install Adobe Photoshop CS, 50% of all available system RAM is automatically allocated for Photoshop use. You can improve upon this memory allowance by increasing the partition. For example, if you are running Mac OS X and have a gigabyte or more of RAM memory, you can increase the memory allocation in the Memory and Image Cache preferences to 90% or higher. But on a Windows system, do not go higher than 75–85%, as this percentage does not take into account the percentage used by the operating system. If you want to run other programs simultaneously with Photoshop, then lower the percentage of RAM that is allocated to Photoshop. In either case, you have to quit and relaunch Photoshop for these changes to take effect.

Figure 3.14 If you are editing large images, increase the image cache setting to 5 or more. This will speed up the screen redraws. Deselect the Use cache for histograms as this will give you more accurate histograms at screen magnifications other than Actual Pixels.

Clearing the Photoshop memory

Photoshop wants all the memory it can get, so allocate most of the RAM available to Photoshop and ideally run the application on its own. Whenever you perform a Photoshop task that uses up a lot of program memory, you can check the system performance in the document status box `Scr: 109M/204.1M` in the lower left window display or in the Status bar of a PC. The right-hand figure shows the amount of memory available and the left, the amount used so far. Photoshop stores data such as recent history states and clipboard data in its memory on the scratch disk. Copying a large selection to the clipboard also occupies a lot of memory. Should you experience a temporary slow down in performance you might want to purge Photoshop of any excess temporarily held data in the memory. To do this, choose Edit ⇨ Purge ⇨ Undo, Clipboard, Histories or All.

redraws and larger images will therefore benefit from using a higher cache level. A higher setting will provide a faster screen redraw, but at the expense of sacrificing the quality of the preview. This is because a lower resolution cache preview is not as accurate as viewing the image at Actual Pixels. You may sometimes notice how the layered Photoshop image on screen is not completely accurate at anything other than the 100% magnification – this is the image cache at work, it is speeding up the display preview at the expense of accuracy. Note also that the number of cache levels chosen here will affect the structure of a 'Save Image Pyramid' TIFF file.

File Browser

The final preference pane allows you to optimize the File Browser performance. Large image files, unless they contain a composite image layer, can take a long time to generate a preview image. If you limit the file size for rendering previews using 'Do not process file larger than: x MB' this will help speed up the time it takes to build a cache of previews. The revised File Browser always maintains a list of most recently visited folders to allow fast and easy access. The default number is ten, but you can make this any number you want. And there is also a new custom thumbnail size setting that now allows you to display larger thumbnails. This is useful if you wish to see big previews of images side by side in the File Browser.

I prefer to check the Allow Background Processing option, because this instructs Photoshop to always build image previews of image folders in the background. This is a good thing if you shoot a lot of digital files, transfer them to your computer and want Photoshop to do the work of building previews for all your shots while you are getting on with other work. When you come back some time later to inspect the folder contents, the file browsing experience should be very smooth. It should be a simple matter of clicking the down arrow key to view each image in turn. Render Vector Files will create a preview in the file browser of non-pixel image artwork files and screengrab

PDFs created by Mac OS X. Select Parse XMP Metadata from non-image files if you want to view the metadata in the file browser. Some digital camera capture file formats produce what are known as 'sidecar' files. For example, the Minolta DiMage produces sidecar files with a THM extension alongside the raw TIFF capture files. If you have not configured the File Browser View menu to display unreadable files, you may not even be aware these exist. If Keep sidecar files is checked then these will automatically be kept with the master file if you move it to another folder.

Photoshop and Mac OS X 10.2

Photoshop CS will only run on a Macintosh computer using the Mac OS X 10.2.4 operating system upwards. The Macintosh OS 9 system is not supported. Because OS X is based on the UNIX operating system, the Adobe engineers had to rewrite a lot of the existing program code. This was an enormous challenge, and it was decided that OS 9 support would be discontinued for all future versions of

Mac OS X and Photoshop 7.0

If you are new to Mac OS X, you should notice that the OS X system loads much faster than before and is very stable. Mac OS X features memory protection, which will prevent any application-level memory leaks from affecting another open application, resulting in fewer system-level crashes. Now if you previously upgraded to OS X 10.2 and were running Photoshop 7.0 your experience may be different. But Adobe had managed to solve all the problems which were linked to a conflict with heavy file browser usage and the OS X 10.2 operating system (which only affected certain high-end Macs). If you are still using Photoshop 7.0, go to the Adobe web site and download the File Browser update plug-in. Suffice to say these conflicts have all been resolved in Photoshop CS.

Photoshop, starting with Photoshop CS. This decision will frustrate some, but in some ways it makes the situation regarding third party plug-ins and drivers clearer. If you are forced to run Photoshop exclusively in OS X, then you will only be able to use plug-ins and drivers that are compatible with OS X. When Photoshop 7.0 was launched, the Mac OS X system was relatively new. But now you can easily obtain drivers for most devices and download these via the Internet.

While OS X may be a more stable operating system, Photoshop's speed performance is compromised somewhat by the demands made by the OS X system itself which will at times devour a sizeable chunk of the processor's resources. For example, the anti-aliasing engine that produces the rounded corners on the windows and the transparency support will place extra demands on the processor chip. The OS X throbbing buttons alone can consume up to 10% of the processor's resources. But if you are running a more recent twin processor G4, these high overhead demands on the processor are much less noticeable. Remember also that OS X will require at least 128 MB of RAM memory to run the operating system and consequently there will be less memory available to run Photoshop. And the symmetric multiprocessing under OS X means that Photoshop will receive less of a speed boost on the new multiprocessor Macintoshes than might be expected. In my opinion OS X is a very smart looking operating system that in some ways is ahead of its time. But still, much of OS X is very recent and there are a number of neat OS 9 features like the ability to grab the document window sidebars and drag the window, that are sadly missing in Mac OS X.

Installing Mac OS X 10.2 and Photoshop

The standard Aqua blue interface is rather too colorful for my taste, but you can easily switch to using the Graphite look instead via the system preferences. Any non-OS X compliant program can be run from native OS X, but it will do so by launching the Classic OS 9 operating system from

within OS X (you basically end up with a classic window appearing within the OS X operating system). The Mac OS X software package contains clear guidance on how to install the OS X and the Classic OS. I have an older G4 Macintosh with the main hard drive divided into two partitioned drives. The first partition is 8 Gigabytes (the recommended maximum) and I installed Mac OS X onto this partition first. I then installed OS 9.2 on the secondary partition. Photoshop users typically rely on the use of third-party plug-ins such as filters and import/export plug-ins to add functionality to the program. If any of your plug-ins are not OS X compliant, they will not function within OS X and you will have to check the availability of any OS X updates.

Windows XP

While Apple were bringing out OS X, Microsoft were busy developing the Windows XP operating system. Like OS X, Windows XP has radically abandoned the previous Windows interface design. The standard Windows XP interface design is known as Luna. The dark blue color featured in Luna is rather distracting for Photoshop work and so I would advise you to choose the 'Silver' theme instead. Both OS X and XP feature advanced operating systems, and are more reliable and not prone to regular crashing, like their predecessors. Or if a program does crash, at least it does not disrupt the system and freeze the whole computer. Photoshop users will be interested to know that Windows XP does have a neat way of displaying image folder information, which in a way complements the Photoshop 7.0 file browser. The XP file navigation system can enable you to browse the images contained in a folder as a slide show, which is very cool.

SCSI compatibility in Mac OS X

Many professional Photoshop users like myself still rely on certain digital devices like drum scanners or high end printers that are SCSI-based. If you are using a PC, then there should be no problem to connect with a SCSI device using any of the compatible OS systems with Photoshop CS. On a Mac you have to be more crafty to keep these devices compatible with OS X. For example, I use a Pictrograph printer that only has a SCSI connection. I can get this printer to be recognized in Photoshop by downloading the latest Pictrography driver for OS X 10.2 from the <www.fujifilm.com> website. But I also had to make sure that the device was connected to the computer by an Adaptec 2930 SCSI adapter PCI card.

Windows XP System reverts

Adapting to a new system can be a slow learning process. Fortunately, Windows XP features the ability to revert to a previous system configuration. This is particularly useful if you were to install a driver that proved troublesome. You simply revert to earlier system setup. Windows XP is a much refined version of the Windows NT operating system, so it has a good solid legacy.

Norton disk doctor tip

Rod Wynne-Powell has this extra advice to offer Norton users: I have never read it in print or in Norton's literature, but an essential procedure for running Norton is that you run it more than once, if you find that it reports any error at the end. On the second or subsequent runs you may ignore the search for bad blocks, as if they occur you have more than a simple glitch, but in this way you find out whether any 'fixed' item has caused any other anomalies. If you are unlucky enough to have 'bad blocks' do not assume that their reallocation has solved the problem; it may well have reassigned the faulty block, but it could be that the data present in that area is now invalid, and could be a vital system component, which will now start to corrupt more of your disk. The advice is simple, and not welcome; the hard disk must be reformatted, and the system and applications all reloaded. If bad blocks recur the drive needs replacing. And another thing to note is this. Of late Apple has gone against its own advice and introduced files that are preceded by a period (files such as .FS). It should be noted that these must *not* be changed, yet Norton throws these up as damaged. The consequence of this is that currently you will always receive a 'Minor problems' warning at the end of your session. Be wary of Norton in relation to Mac OS X. I have had to stop using Nortons Utilities since upgrading.

System software maintenance

A computer that is in daily use will after a month noticeably slow down unless you do some housekeeping. PC users should search for temporary files while no applications are running, using the Find command and entering '*.tmp', to search for any files that have the .tmp (temporary) file extension. These should then be deleted. With Mac OS X you can also purge the cache, which has a similar effect to rebuilding the desktop in OS 9. Norton Utilities is a suite of programs that add functionality. Image files continually read and write data to the hard disk, which leads to disk fragmentation. Norton's Speed disk (which has to be run from a separate start-up disk), will defragment files on the main hard disk or any other drive. Windows users should also look out for a program like Windows Disk Defragmenter. This is essential on the drives you allocate as the scratch disks in Photoshop. If you're experiencing bugs or operating glitches and want to diagnose the problem, run Norton's Disk Doctor. This will hunt out disk problems and fix them on the spot.

Keep the imaging workstation free of unnecessary clutter. When more applications are loaded, the machine will soon slow down. It is best to have a separate computer to run the office software Internet/modem connections and games etc.

Housekeeping on Mac OS X can be effected by opening the computer in Single User Mode (holding ⌘ S at startup) the computer starts in verbose mode filling the screen with white text information against a black background. When this is complete you type in "/sbin/fsck -y" and hit Return Do this until the message "This volume seems OK" appears, then type in "reboot". Another measure is to always Repair Disk Permissions after the installation of any new program and at signs of any untoward system behavior.

Chapter 4

Basic Image Adjustments

I t is reasonable to assume that a lot of readers who bought this book mainly wanted to learn how to simply open an image, improve its appearance and make a print that matches what they saw on the display. It is important that you follow the instructions in the last chapter on how to calibrate the display and configure the color settings. Do this and you will now be ready to start editing your photographs with confidence. The aim of this chapter is to introduce you to Photoshop's image correction tools and everything you need to know about making basic image corrections. And since this is what you are going to be doing to every picture you edit in Photoshop, it is worth spending some time understanding the underlying principles of what the image correction tools do and how they should be used.

Interpreting an image

A digital image is nothing more than a lot of numbers and it is how those numbers are interpreted in Photoshop that creates the image you see on the display. We can use our eyes to make subjective judgements about how the picture looks, but we can also use the number information to provide useful and useable feedback. The Info palette is your friend. If you understand the numbers, it can help you see the fine detail that your eyes are not sharp enough to discern. And we now have the Histogram palette in Photoshop CS, which is a godsend to geeks who just love all that statistical analysis stuff, but it is also an excellent teaching tool. The Histogram palette will make everything that follows much easier to understand.

The Histogram

The histogram is a bar chart that graphically represents the tone levels that make up a digital photograph and is a graphical representation of an image's tonal range. Let's begin with a basic 8-bit per channel grayscale image, which has a single channel and uses 256 shades of gray to describe all the shades of tone from black to white. Black has a levels value of 0 (zero) and a white has a levels value of 255. All the numbers in between represent the shades of gray going from black to white. The histogram is like a graph with 256 increments, each representing how often a particular levels number (a specific gray color) will be found in an image. If a picture contains a lot of grays with a value of 20 and 50 levels, more so than any other grays in the picture, you will expect to see a peak in the histogram around this point of the graph. Figure 4.1 shows a typical histogram and how the appearance of the graph relates to the tonal structure of a photographic image.

Now you know what a histogram represents let's look at what that information can tell us about the image. A histogram represents the distribution of tones in an image. A high-key photograph will have lots of peaks towards the right of the graph and a low-key photograph will have lots of peaks on the left. OK, so you don't need a histogram to tell you what is blindingly obvious. But what a histogram can tell you is where the shadow and highlight points are exactly. When you apply a tonal correction using Levels or Curves, the histogram provides a visual clue that helps you

Figure 4.1 An image histogram representing the distribution of tones from black to white.

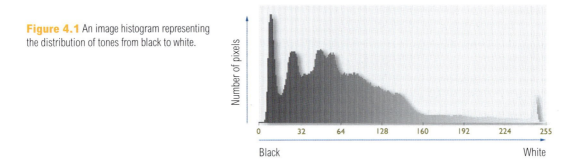

judge where the highlights and shadows should be. And the histogram also tells you something about the condition of the image you are editing. If the bars are bunched up at either end of the histogram, this suggests that the highlights or shadows are most likely clipped and that when the original photograph was scanned or captured it was effectively under or overexposed. If the levels are clipped at either end of the scale you can't restore the detail that has been lost. If there are gaps in the histogram, this will indicate a poor quality scan or that the image had previously been heavily manipulated.

The histogram can therefore be used to check the quality of an image at the beginning of an edit session. If it looks particularly dreadful then maybe you should try re-scanning the picture. But must one be so absolutely pixel-correct about always obtaining a smooth histogram? Any image editing you do will degrade the image, and after a picture has been manipulated the histogram will always look rougher than it was at the beginning. If you are preparing a photograph to go to a printing press, you would be lucky to be able to detect more than 50 levels of tonal separation from any single ink plate. So the loss of a few levels at the completed edit stage does not necessarily imply that you have too little digital tonal information from which to reproduce a full-tonal range image in print. But appreciate that if you begin with a bad-looking histogram, the image is only going to be in a worse state after it has been retouched, so start with the best image scan or capture. And in particular watch out for any signs of clipping.

We are now going to look at a few different ways to make a tonal correction in Photoshop. We will begin with some black and white images. I deliberately chose to start with monochrome images in RGB mode, because it would simplify interpretation of the histogram. And because the images are in RGB mode, this allows me to demonstrate the use of the Threshold mode display feature.

The Histogram palette

There has always been a histogram in the Levels dialog and there is now also a Histogram palette, which gives you even more feedback when working in Photoshop. With the histogram palette, you can continuously observe the impact your image editing has on the image's levels. You can also check the histogram while making curves or any other type of image adjustment. The histogram palette only provides an approximate representation of the image levels. To ensure that the Histogram palette is giving an accurate representation of the image levels, it is advisable to force Photoshop to update the histogram view, by clicking on the Refresh button at the top of the palette.

Camera histograms

Some digital cameras provide a histogram display that enables you to check the quality of what you have just shot. This too can be used as an early-warning device to ensure that whatever you have captured has a decent tonal scale for you to work with in Photoshop.

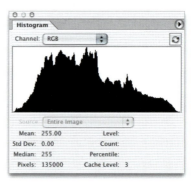

Figure 4.2 If the levels are bunched up towards the left, this is a sign of shadow clipping. But in this example we probably want the shadows to be clipped in order to produce a rich black sky.

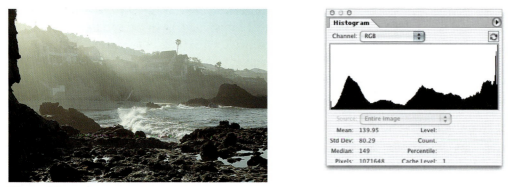

Figure 4.3 If the levels are bunched up towards the right, the highlights may be clipped. But in this image I wanted the brightest areas of the sky to burn out to white.

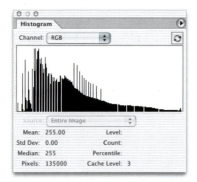

Figure 4.4 A histogram with a comblike appearance indicates that either the image has already been heavily manipulated or an insufficient number of levels were captured in the original scan.

Figure 4.5 This histogram shows that the image contains a full range of tones, without any shadow or highlight clipping evident and no gaps between the levels.

Levels adjustments

When you open an image in Photoshop your main objective is probably going to be to make an inkjet print, or convert the image to CMYK to be printed on a page, or add the picture to a website. And the first thing you will want to do is adjust the tonal range so that the photograph has a nice, full contrast. If it is destined for the web, your only concern will be how light or dark you want to make it, so that it appears OK on an average computer display (whatever that is). If it is going to print then you may be aware of the fact that the shadow point should be adjusted to compensate for the printing process. But you shouldn't let any of this concern you too much, because the shadow point is always adjusted automatically in Photoshop when you choose a print profile in the print driver (as described in Chapter 14) or whenever you convert from RGB to CMYK. If you are optimizing an RGB image for output, all you need to worry about is making sure that the blacks go to black and the whites go to white. This is true for most types of output, but you should be aware that some repro companies operate what is known as a closed-loop system where they edit files in CMYK and do not use a profiled workflow. This is something that will affect high-end repro users of Photoshop and if this is the case, then you will need to target the shadows manually according to the conditions of the printing press. The same is also true if you are editing a grayscale file in Photoshop that is going to press. These specific prepress examples are covered later in this chapter.

Setting the highlights

As you aim to expand the tonal range, you want to make the lightest point go to white so the whites do not look too dull. But at the same time you don't want the highlights to look burnt out either. Setting the highlight point is very often a subjective decision and where you set the white point is really dependent on the nature of the image. In most cases you can use the basic Levels adjustment threshold mode technique to locate the highlight point and set the endpoint accordingly and not worry about losing any highlight detail. But if the picture you are editing contains a lot of delicate highlight information then you will want to be careful to set the highlight point to somewhere slightly less than pure white on the levels scale. This is because a pixel value that is close to maximum white, when converted to a printing process, may blow out to white as well. But what if the image contains bright specular highlights, such as highlight reflections off of metal? Specular highlights do not contain any detail, so you therefore want these to print to paper white. If you don't, then the image will print a lot duller than is necessary.

Resetting Image adjustments

If you want to reset the settings in any of the Image adjustment dialog boxes, hold down the ⌥ *alt* key – the Cancel button changes to Reset. The Auto button will set the clipping points automatically (the Auto settings are covered in Chapter 5).

1 The monochromatic photograph shown here was in fact in RGB mode (because this allowed me to demonstrate the full range of Levels adjustment options). And the histogram palette displays a histogram of the composite RGB channel. The contrast could be improved by expanding the levels so that the histogram displays a fuller range of tones going from black to white.

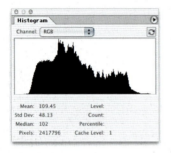

2 To improve the tonal range, I chose Image ⇨ Adjustments ⇨ Levels. As I dragged the highlight and shadow Input sliders in the Levels dialog, I could decide where the new shadow and highlight endpoints should be. One way of doing this is to simply look at the histogram in the Levels dialog and drag the Input sliders inwards until they meet either end of the histogram. But you can get a better idea of where to set the endpoints by switching to threshold display mode. I held down the ⌥ *alt* key as I dragged the shadow slider inwards and the image in the document window then appeared posterized. This threshold view enables you to discern more easily where the darkest shadows are in the picture, so that you have a better idea of how much you need to drag the slider inwards. Drag in too much and you will clip all the shadow detail. The view shown opposite was too extreme, so I would want to back off from here, otherwise the shadow detail would become clipped.

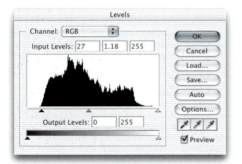

3 I now wanted to adjust the highlights. The same technique can be applied here as well. I held down the ⌥ *alt* key as I dragged the highlight slider to the left. The threshold mode display started off completely black and the lightest highlights appeared first as I dragged inwards. As before, the view shown here was too extreme so I would want to back off a bit and search for the lightest highlight point without the risk of clipping too much of the highlight detail.

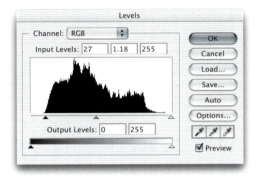

4 All that remained now was to compensate the lightness of the picture, which was achieved by dragging the gamma slider (which is the middle Input slider). Dragging to the right made the image relatively darker, and dragging to the left made it relatively lighter. The final image shown here has a full contrast range and the correct brightness.

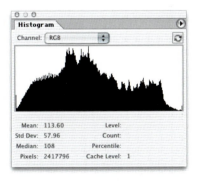

Specular highlights

1 The guidelines for setting the shadow and highlight points will help you choose the optimum settings for retaining the shadow and highlight detail and work within the constraints of the printing press. At the same time it can also lead to a dull print output if you do not make full use of the tonal range. There are times when you will want to make use of rich blacks and bright paper whites to reproduce a full contrast image. The subject shown here contains highlights which have no detail. If I assign these 'specular' highlights a white point of 243, and the shadow point 12, the printed result will look needlessly dull.

2 The brightest portions of the image are the shiny skin reflections and I can safely let these areas burn out to white, because they do not contain any significant image detail. I assigned the brightest area in the highlights (where there is detail) as the white point and let the specular highlights print to paper white. The adjusted version shown here benefits from a wider tonal scale making full use of the press and at the same time retains important highlight detail where it matters.

Cutouts against a white background

Subjects photographed or cutout against a white background are another special case deserving special treatment. Ideally you want the white background to print as pure white on the paper, but not at the expense of losing image detail in important highlight areas elsewhere in the photograph. When preparing such a cutout, the levels should first be adjusted with consideration for the subject only. The background should be adjusted separately without compromising the tonal range of the subject. The accompanying example suggests one strategy to achieve this. I made a feathered selection of the background, filled with white and then used the history brush to paint the edge detail back in. Graphic designers may use a clipping path to create the cutout. A clipping path is a designated pen path saved in an EPS or TIFF file format that is used to mask an image when placed in a page layout program. If I was preparing a clipping path of the model in the following step-by-step, I would do everything the same, but make the clipping path a few pixels wider of the model's outline, so that the tonal transition to pure white is preserved.

Brightness and contrast

So far we have discussed how to maximize the tonal range and lighten or darken an image. Since Photoshop has an image adjustment tool called Brightness/Contrast, you might assume this does the same thing as Levels. But I think it should more accurately be described as the 'how to ruin your brightness and contrast' image adjustment, and here is why. In Levels you set the shadow and highlight input points individually and the gamma slider is used to adjust the 'relative' brightness without clipping the endpoints. The mid point is reassigned to make the image relatively lighter or darker. Brightness/Contrast is a very crude image adjustment tool. The Brightness slider simply shifts all the pixels to make everything lighter or darker. And the Contrast slider evenly brings the Input sliders inwards to increase contrast or the output sliders inwards to decrease the contrast.

1 The above image required special attention to ensure the background went to pure white. Yet I did not want to blow out the highlights on the white shirt or on the model's blonde hair.

2 A Levels adjustment was applied to make the highlights go as light as possible on the shirt, but without losing any detail. But the background still needed to go whiter. I made a 'contiguous' magic wand selection of the background area, feathered the selection by 2-4 pixels and filled this with white.

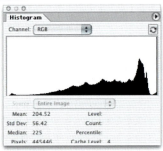

3 There should be a gentle tonal transition between the white cutout and the edges of the subject. If not, the edge detail will become lost in print. I deselect the selection, set the history source to the original history state and carefully painted around the subject edges, especially around the fine strands of hair, to restore detail.

4 If we check the final histogram you can see a slight gap between where the highlight tones of the subject tail off and the white background cuts in.

Client: Jordan Burr. Model: Vivi at M&P.

Brightness/Contrast

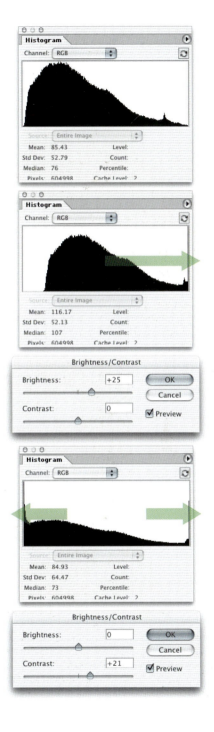

Figure 4.6 The Histogram palette makes it easier to see why the Brightness/Contrast image adjustment is such a poor tool to use for photographic tonal correction. Yet so many Photoshop users are drawn to use it because of its simple interface. The uppermost histogram shows a full range of tones for the image above. If you use the Brightness slider to increase the brightness, what you are doing is shifting all the tones lighter and the highlight detail will immediately become clipped. If you try to increase the contrast, then the tones are stretched in both directions so that both the shadows and highlights become clipped.

Don't use Brightness/Contrast, use Levels instead. The middle (gamma) input slider in Levels is used to lighten or darken without clipping the image. The Curves image adjustment will also enable you to lighten or darken an image and control the contrast.

Once again, the Histogram palette is a useful teaching tool with which to demonstrate the weakness of the Brightness/Contrast adjustment and why you should avoid using it and always work with Levels and Curves instead.

113

Original histogram – Adobe RGB

sRGB

Epson Heavyweight Matte paper

US SWOP Uncoated CMYK

CMYK setting used for this book

Figure 4.7 The appearance of the histogram will change when you make a mode or profile conversion. If you want to prepare an image for the Web and convert to sRGB mode, the histogram will only change slightly, but maintain the full range of tones. When you use the Print dialog to convert to an inkjet printing space the shadow tones are automatically made a little lighter so as to render the best shadow detail on the paper. The same thing happens when you do a CMYK conversion, but the black point will probably shift in even more. If you see a box called Black Point Compensation, leave it checked. Photoshop will automatically compensate the black point to suit your CMYK conversion. Do not worry about deliberately making the shadows lighter beforehand when you are editing the image in RGB.

Levels after conversion

So far you have learned that the histogram can be used to help you visualize the tonal range of an image from the shadows to the highlights. And as has just been discussed, special consideration needs to be given to setting the highlights. And this will be dependent on the type of image that you are editing. The shadow point may need to be adjusted to compensate for various types of output and in the majority of instances this will happen automatically whenever you make an image mode change or a profile conversion.

Fine-tuning the endpoints

You can also use the eyedropper tools in the Levels or Curves adjustment dialogs to assign specific pixel values independently to the shadows and the highlights. Before making such a tonal adjustment, go to the Eyedropper options and set the Sample Size to 3 × 3 Average. You can use the eyedroppers with their default settings to assign a highlight point of 100% and a shadow point of 0%, before converting for output. Target values can be assigned, so you can map specific parts of the image to new pixel values. This method allows you to decide exactly where the highlight and shadow points should be.

Normally you can rely on the image mode conversion to adjust the shadow points. But there are situations where it is desirable to fine-tune the endpoints yourself manually. Targeting and assigning the endpoints in this way is important if you are working on grayscale images that are destined for print in a book, magazine or newspaper. And it may also be necessary if the image is already in CMYK mode but without an embedded profile, and yet you know what the press output should be. Instead of relying on profiles to do the conversion, you can assign a shadow point that is higher than 0% and assign a highlight point that is slightly darker than 100%, where you wish to ensure that the highlight detail will be adequately preserved. It can also be useful as a means of color correcting an image and removing a color cast from the shadows or highlights. The

Automatic Levels compensation

Figure 4.7 illustrates this by showing you what the image histogram of an RGB image looks like after optimizing the levels. This is followed by views of the histogram after converting to different types of output. If you are preparing a photograph to appear on the web, sRGB would be the best RGB space to convert the file to. The histogram looks different in sRGB, but note that the shadows and highlights stay put, which is what is meant to happen, because you want to keep the contrast in the image. If you are converting the image to CMYK or some other print output space, the shadow point must be adjusted, but how much it needs to be adjusted depends on the printing process. To describe this more simply, when you convert to CMYK mode or you convert to the profile of a specific print output, or you select the profile of a printing paper in a printer dialog, Photoshop will automatically calculate the shadow point compensation for you (Advanced users who use the Convert to Profile command in the Image ⇨ Mode menu, should remember to check Black Point Compensation check box).

Assigning shadow and highlight points

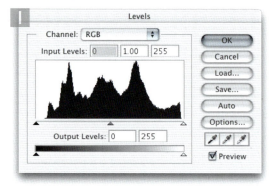

1 I double-clicked the highlight eyedropper icon in the Levels dialog box and set the highlight target value to match that of the press. A brightness setting of 96% as shown here is OK for most printing situations.

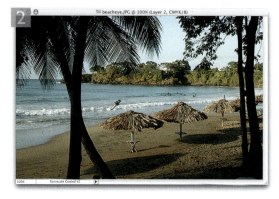

2 I studied the image and looked for the shadow and highlight points. The previously described Threshold mode technique is a good way of finding out where these are. I zoomed in on the image and clicked on the area I wanted to assign as the highlight target point. This should be a subject highlight, not a specular highlight such as a reflection or glare.

3 Next I set the shadow point. I double-clicked the shadow eyedropper icon and set a brightness setting of 4% (or higher, depending on the press) in the text box as the target brightness. After that, with the shadow eyedropper still selected, I zoomed in on the image to identify and click on the darkest shadow point. The gamma slider could be adjusted the same way as in the last example to adjust the relative image brightness.

Levels and Curves Grayscale eyedropper in the middle can be used to assign a target gray color to the midtones. This and other color correction techniques will be dealt with more thoroughly in the next chapter.

Curves adjustments

Any adjustment that can be done in Levels can also be done using Curves. At first, the Curves interface may appear less easy to use, but it is much more powerful because you can not only set the shadows and highlights, but also have accurate control of the overall contrast as well as in the individual color channels. And you can use it in conjunction with the new Histogram palette.

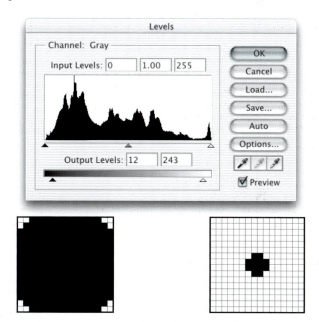

Figure 4.8 Dot gain is a phenomenon that occurs at the printing stage after the halftone plates have been made. A Photoshop level of 24 is equivalent to a 9% ink dot. An imagesetter would plot this on the film that goes to make the plate as shown top. When the printing press reproduces a halftone ink dot on the page from the plate, the dot will swell in size and hence appears slightly darker (as shown bottom). Dot gain will therefore make the 95% shadow halftone dot plotted in Figure 4.9 appear as solid black.

Figure 4.9 The Levels dialog. This shows the histogram for a grayscale image, with the shadows on the left and the highlights on the right. The shadow point Output level is set to 12. This is equivalent to a 95% dot on the press and typically any higher value percentage will clog up to solid black (see Figure 4.8). Setting the shadow point below 12 may cause the shadows to be clipped. The highlight point is set to level 243. This is equivalent to a 5% dot at which point the halftone dot produced by the imagesetter will on the press just be capable of applying ink to the page. Any higher level value will produce a smaller dot but the smaller dot will not register any ink on the page – it will appear as pure white.

Figure 4.10 The Curves dialog can be looked upon as an alternative represents the input and output levels plotting them as a graph. In this example, the two ends of the curve have been dragged in as you would in Levels, in order to set the optimum shadow and highlight points. You can control both the lightness and the contrast of the image by adjusting the shape of the curve. To enlarge the curves dialog, click on the bottom right box.

Figure 4.11 If you click on the horizontal output ramp (circled in blue), the input/output ranges will become reversed with the shadow point in the top right corner and the highlight point in the bottom left, and the units will be displayed using percentage values. If you [alt] click anywhere inside the grid area the grid units will switch from 25% to 10% increments.

Figure 4.10 shows the Curves dialog. You can toggle enlarging the dialog view by clicking the zoom button in the bottom right corner. You can also toggle the grid by [alt] clicking in the graph area; the finer grid allows for more accurate tweaking. The linear curve line represents the tonal range from 0 in the bottom left corner to 255 levels top right. The vertical axis represents the output values and the horizontal axis, the input values. So, if you move the shadow or highlight points only, this is equivalent to adjusting the input and output sliders in Levels. In Figure 4.10, the highlight input point has been moved inwards several levels. With Curves, you can target a specific range of tones and remap the pixel values to make them lighter or darker or increase the contrast in that tonal area only. Various examples of how to use curves are featured throughout this book. For example, in Chapter 8 you will discover how coloring effects can be achieved through individual channel curves adjustments. The default RGB units are measured in brightness levels from 0 to 255. CMYK curves are by default displayed differently (click on the horizontal output ramp to toggle between displaying with levels or ink percentage readouts). This alternate mode (see Figure 4.11) is designed for repro users who primarily prefer to see the output values expressed as ink percentages.

Figure 4.12 This is a normal landscape view with no Curves adjustment.

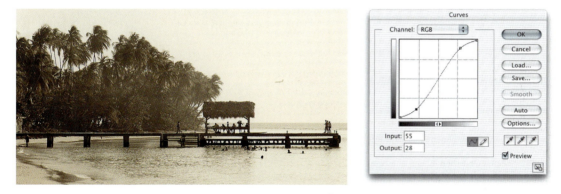

Figure 4.13 You can increase the contrast in this image by adding two or more curves points and creating an 'S' shaped curve as shown in the accompanying Curves dialog.

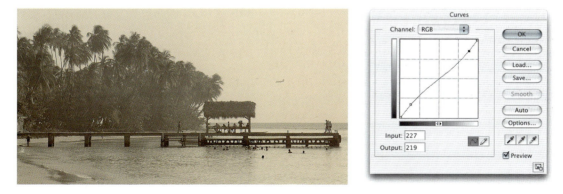

Figure 4.14 You can also decrease the contrast in the same image by adding two or more curve points and creating an 'S' shaped curve in the opposite direction as shown in the accompanying Curves dialog.

Correcting shadow and highlight detail

The Shadow/Highlight image adjustment is a new Photoshop CS tool that can be used to perform wonders on most images, not just those that desperately require corrections to recover detail in the shadows and highlights.

1 To make a shadow/highlight correction to this photo, I chose Image ⇨ Adjustments ⇨ Shadow/Highlight. The dialog opened in Basic mode, but if you click on the Advanced button you will see the expanded dialog below (shown in section). I increased the Shadow amount to 60% and reduced the Tonal Width setting to narrow the adjustment to correct just the deepest shadows in the model's dark hair.

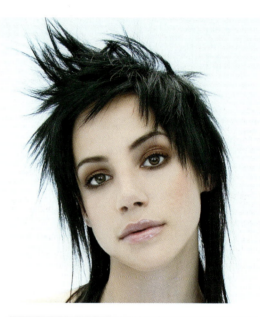

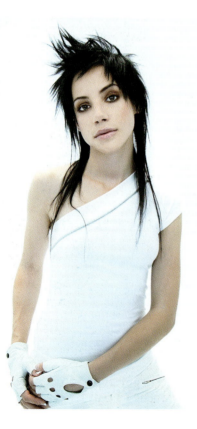

2 Next, I wanted to focus on correcting the highlights. I took the Amount to 26% and increased the Tonal Width slightly. As you can see from this detail view, this was enough to reveal more of the subtle highlight detail without affecting the midtone areas.

3 But inevitably, the midtones and the color will be affected as a result of the corrections made to the shadows and highlights. The two controls at the bottom of the dialog allowed me to reduce the color boost a little. Because the photograph was beginning to look a little flat at this stage, I increased the midtone contrast to compensate.

Client: Reflections. Model: Anaya @ Oxygen.

The Shadow/Highlight image adjustment tool makes adaptive adjustments to an image, and it works much in the same way as our eyes do when they automatically compensate and adjust to the amount of light illuminating a subject. The Shadow/Highlight adjustment works in a similar fashion, by looking at the neighboring pixels in an image and making a compensating adjustment based on the average pixel values within a given radius.

In Advanced mode, the Shadow/Highlight dialog has various controls which allow you to make the following fine tuning adjustments.

Figure 4.15 If the Shadow/Highlight radius setting set to zero pixels, this will result in a general flattening of the image contrast.

Radius

Figures 4.15 and 4.16 help explain the principles behind the selection of an optimum radius setting, which basically governs the pixel width of the area that is analyzed when making an adaptive correction. If the Shadow Radius is set to zero, the result will be a very flat-looking image. You can dial in the 'Amount' to lighten the shadows and restrict the 'Tonal Width', but if the Radius is low or is set to zero, Photoshop will have very little 'neighbor pixel' information to work with when trying to calculate the average luminance of the neighboring pixels. So if the sample radius is too small, the midtones will become lightened as well. If the Radius setting is set too high, this will have the effect of averaging all of the pixels in the image and likewise, the lightening effect will be distributed such that all the pixels will get the lightening treatment, not just the dark pixels. The optimum setting to use is dependent on the image content and the area size of the dark pixels. In Figure 4.16, the bird is about 100 pixels wide. The optimum pixel Radius width will be half that amount or less. You don't have to measure the pixel width of the light and dark in every image to work this out. Just be aware that after you have established the Amount and Tonal Width settings, you should adjust the Radius setting according to how large the dark or light areas are – there will be a 'sweet spot' where the Shadow/Highlight correction is just right and the midtone contrast is hardly affected.

Figure 4.16 If you carefully target the radius setting to be half the pixel width or less for the areas of interest, the adjustment will be more focussed on the subject and contrast maintained.

Amount

This is an easy one to get to get to grips with. The default Amount setting is 50%. Increase or decrease this to achieve the desired amount of highlight or shadow correction.

Tonal Width

The Tonal Width determines the tonal range of pixel values that will be affected by the Amount set. A low Tonal Width setting will narrow the adjustment to the darkest or lightest pixels only. As the Tonal Width is increased the adjustment will begin to spread to affect more of the midtone pixels as well. If you refer back to the step 1 example on page 120, the Tonal Width setting was deliberately kept very low in order to focus the 60% Amount adjustment on the very darkest portions of the hair.

Color Correction

As you adjust the highlights or the shadows in the image the color saturation may unexpectedly change as a consequence of the adjustment made. If you refer back again to step 3 on page 121, you will notice that I needed to reduce the color saturation to -20, as part of the correction in order to restore the gentle blue cast that was present in the original image.

Midtone Contrast

Even though you may have paid careful attention to getting all the above settings optimized just right so that you target only the shadows or highlights (or both), the midtone areas may still get affected and lose some contrast. This slider control lets you restore or add more contrast to the midtone areas.

Adjustment layers

Adjustment layers and the Image ⇨ Adjustments commands are identical in purpose. Adjustment layers offer the facility to apply multiple image adjustments and/or fills to an image and have these changes remain 'dynamic'. In other words, an adjustment layer is an image adjustment

Screen redraw times

One potential drawback is that having a lot of adjustment layers in an image may slow down the monitor preview. This slowness is not a RAM memory issue, but to do with the extra calculations that are required to redraw the pixels on the screen.

Repeated adjustments warning

It is important to stress here that the color data in an image can easily become lost through repeated image adjustments. It is a bit like trying to carry a round of drinks from the bar – the less steady your hand, the more drink that gets spilt. The glasses will never get fuller, only emptier. Pixel color information will progressively become lost through successive adjustments as the pixel values are rounded off. This is one reason why it is better to use adjustment layers, because you can keep editing the adjustments without damaging the image.

Cumulative adjustments

When you add multiple adjustment layers to an image, it is wrong to assume that the cumulative adjustments will somehow merge to become a single image adjustment when you flatten all the layers. When you merge down a series of adjustment layers, Photoshop will apply then sequentially as if you had made a series of normal image adjustments. The chief advantages of adjustment layers are therefore: the ability to defer image adjustment processing and the ability to selectively edit the layers and make selective image adjustments.

that can be revised at any time – adjustment layers enable the image adjustment processing to be deferred until the time when the image is flattened. Adjustment layers always have an active layer mask, which means that whenever an adjustment layer is active, you can paint or fill using black to selectively hide the adjustment effect, and paint or fill with white to reveal. Adjustment layers are savable in the Photoshop native, TIFF and PDF formats, they add very little to the overall file size and best of all, provide limitless opportunities to edit and revise the image adjustments that are made to an image.

Multiple adjustment layers

You can have more than one adjustment layer saved in a document, with each producing a separate image adjustment. In this respect, they are very useful because combinations of adjustments can be previewed to see how they will affect a single layer or the whole image before you apply them. You can have several adjustment layers in a file and choose to readjust the settings as many times as you want. It is possible to keep changing your mind and make multiple changes to an adjustment layer without compromising the image quality. The ability to edit adjustment layers and mask them to selectively apply an adjustment provides the most obvious benefit over making a series of normal image adjustments.

Blending mode adjustments

You can lighten or darken an image by adding an adjustment layer above the Background layer (or at the top of the layer stack) and simply change the blend mode Screen or Multiply. You don't have to even make any image adjustments, just add an adjustment layer (any will do) and change the layer blending mode. You could achieve the same type of result by duplicating a background layer and changing the blend mode, but it is pointless to do so and as you can see, the technique described on page 126, is more economical (and more flexible).

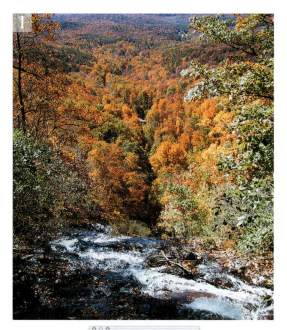

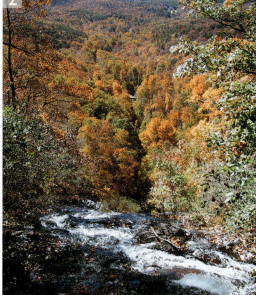

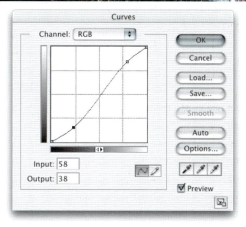

1 When you increase the contrast in an image using curves, you will also be increasing the color saturation.

2 In this example I applied a Curves adjustment as an adjustment layer and changed the blending mode to Luminosity. This effectively increased the contrast in the original scene, but without increasing the saturation.

16 bits per channel support

Most of the techniques described in this book have been carried out on files that originated from a 48-bit RGB color original file (an image made up of three 16-bit color channels). Most scanners and professional digital cameras are able to capture more than 8 bits per channel. And if an imported image contains more than 8 bits per channel data, it will be opened in Photoshop in 16 bits per channel mode.

1 You can use the layer blending modes as an alternative method to lighten or darken an image. In this example I had a dark image that needed to be made brighter. I went to the Layers palette and added a new adjustment layer. It does not particularly matter which. In this example I happened to chose Levels.

2 I changed the adjustment layer blending mode to Screen. The result of this would be the same as if I had made a copy of the Background layer and set it to Screen blend mode. Screening will make the image lighter and Multiply will make the image darker. I then added a gradient to the adjustment layer using the default foreground/background colors. This partially hid the adjustment layer and retained some of the original darker tones at the top of the picture.

A 24-bit color image will have only 256 data points in each of its 8-bit per color channels, whereas a 16-bit per channel image in Photoshop can have up to 32,000 data points per color channel (because in truth, Photoshop's 16-bit depth is 15-bit +1). This gives you quite a lot more levels of tone to play around with, especially when using levels or curves adjustments where you are stretching these levels to expand the tonal range and are modifying the contrast or altering the color balance.

I have read arguments which suggest that 16-bit image editing is a futile exercise because no one can tell the difference by looking at an image that has been edited in

16-bit compared to one that has been edited in 8-bit. Well, maybe... but I personally believe this to be a foolish argument. For a start, if you can capture a picture in 16-bit why not make use of all that extra tonal information, even if it is only to make you primary levels and curves edits and then you switch to do everything else in 8-bit per channel mode? If you look at Figure 4.17, this shows two histogram displays which compare the result of making levels and curves edits to an image in both 8-bit per channel and 16-bit per channel modes. You may save a second or two by making these corrections in 8-bit mode, but is that saving worth it when you see how much data that gets lost? The second point is you never know what the future has in store. A few pages back we looked at Shadow/Highlight adjustments. This is a new Photoshop CS feature exploits the fact that a deep-bit image can contain lots of hidden levels data which can be exploited to reveal more image detail than was possible before. It will work with 8-bit images too, but you will get better results if you scan or capture in 16-bit per channel mode.

Photoshop CS offers more extensive support for 16-bit mode editing. You can crop, rotate, make all the usual image adjustments and now use all the Photoshop tools and work with layers in 16-bit mode, in grayscale, RGB, CMYK and Lab color modes. But only the following filters are available: Gaussian Blur; Add Noise; Dust & Scratches; Median; Unsharp Mask; Solarize; and High Pass. Wherever possible, I always aim to begin my editing with a file that has been scanned or captured using high-bit data and brought into Photoshop in 16-bit per channel mode. I will crop the picture and apply a Levels and Curves adjustment to get the picture looking good on the screen and then and only then, will I consider converting the image to 8 bits per channel mode. But since Photoshop CS also allows you to work using layered images in 16-bit, I will keep the image in this mode for as long as I can. You may not feel the need to use 16 bits per channel all the time for every job, but I would say that for critical jobs where you don't want to lose an ounce of detail, it is essential to make all your preliminary edits in this mode.

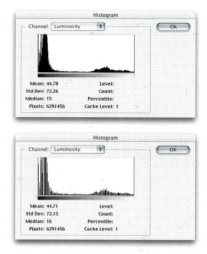

Figure 4.17 The histogram at the top is from an image in 8 bits per channel mode that started out in 16 bit per channel mode but where the levels were expanded using a Levels and a curves adjustment. The histogram below is of the same image after the same adjustments had been applied as before, but the image was in 8 bits per channel mode throughout. As you can see, if you keep a picture in 16 bits per channel mode while you apply levels and curves adjustments, more of the levels data will be preserved.

Where did the extra levels go?

If you have a keen knowledge of math, you will notice that Photoshop uses only 32,768 levels out of a possible 65,536 levels when describing a 16-bit mode image. This is because having a tonal range that goes from 0..32,767 is more than adequate to describe the data coming off of any digital device. And also because from an engineering point of view, this a more useful structure for image calculation math.

Figure 4.18 The Photoshop, PDF and TIFF formats all support 'big data'. This means that if any of the layered image data extends beyond the confines of the canvas boundary, it will still be saved as part of the image when you save it, even though it is no longer visibly part of the image. If you have layers in your image that extend outside the bounds of the canvas, you can expand the canvas to reveal all of the 'big data' by choosing Image ⇨ Reveal All. But remember, you will only be able to reveal the big data again providing you have saved the image using the PSD, PDF or TIFF format. When you crop a picture using the crop tool, you can either Delete or Hide the layered big data by selecting either of these radio buttons in the Options bar.

Background layers and Big Data

If your image contains a background layer, you must first double-click the background layer to promote it to a normal layer if you want the information on this layer to be hidden as well. If you don't Photoshop will always delete the background layer data that you crop.

Cropping

The image you are editing will most likely require some type of crop, either to remove unwanted edges or to focus more attention on the subject. Select the crop tool from the Tools palette and drag to define the area to be cropped. To zoom in on the image as you make the crop, you will find it useful to use the zoom tool shortcut: ⌘ *ctrl*+Spacebar and marquee drag area to magnify. To zoom out, here is a handy tip: use ⌘ *0* *ctrl 0*, which is the shortcut for View ⇨ Fit To Window. Then zoom back in again to magnify another corner of the image to adjust the crop handles.

Orientation and canvas

Use the Image ⇨ Rotate controls to orientate your image the correct way up. For example, you can rotate the image 90 degrees clockwise or anti-clockwise, or by an arbitrary amount, for precise image rotation.

The Image ⇨ Canvas size lets you enlarge the image canvas area, extending in any direction, as set in the Canvas size dialog box. This is useful if you want to extend the image dimensions in order to place new elements. If you check the Relative box you can simply enter the unit dimensions you want added to the current image size. The pixels that are added will be filled using the current background color. It is also possible to add to the canvas area without having to use the Canvas Size command. After the initial crop placing, just resize the crop boundaries beyond the document bounds and into the canvas area.

Perspective cropping

With Photoshop's crop tool you can crop and correct any converging verticals or horizontal lines in a picture, with a single crop action. In the Figure 4.19 example. We might wish to remove the converging verticals or 'keystone' effect in the photograph of the buildings. If you check the Perspective box, you can accurately reposition the corner handles on the image to match the perspective of the buildings and then apply the crop to straighten the lines

1 I selected the crop tool and dragged across the image to roughly define the cropping area. As was explained in Chapter 6, after you do this, the cursor can be placed above any of the eight handles in the bounding rectangle to reposition the crop. Dragging the cursor inside the crop area will allow you to move the crop.

2 You can also make a crop using the rectangular marquee tool. I made a marquee selection and chose Image ⇨ Crop. The constraining options available in the marquee options include Constrain Aspect Ratio and Fixed Size. Note that irregular-shaped selections are also recognized, but the crop will be made to the outer limits of the selection and the selection will be retained.

3 You can enter the target image dimensions and resolution in the Options bar as shown above. You can enter numeric values and measurement units. To match the dimensions and resolution of an existing picture, make the target image active and click Front Image (this automatically sets the fixed target size to match the image size). Activate the other image and apply the crop tool. The image will be cropped to match the resolution and size of the former image.

4 You can mouse down outside the crop area and drag to rotate the crop around the center point (which can be positioned outside the crop area). You normally do this to realign an image that has been scanned slightly at an angle. Should there not be enough canvas size available, Photoshop will add the current Background color as extra canvas (or transparency if not a Background layer) after cropping. The crop bounding box center point (see step 1) can be repositioned to change the central axis of rotation.

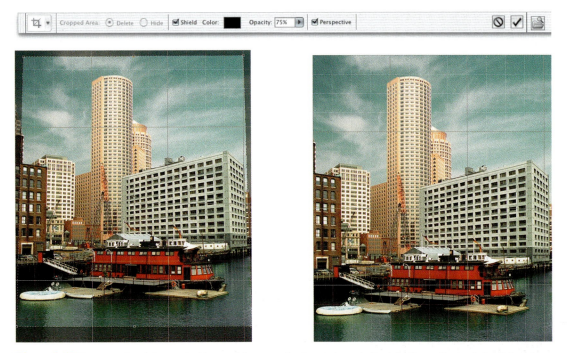

Figure 4.19 You can easily use the crop tool to correct the perspective in a photograph. Check the Perspective box in the Options bar and move the corner handles independently. Using this method, you will find it much easier to zoom in and gauge the alignment of the crop edges against the converging verticals in the photograph. And it helps as well to switch on the Grid display. Go to the Window menu and choose Show ⇨ Grid.

that should be vertical. This tweaking adjustment can be made even more precisely if you hold down the *Shift* key as you drag a corner handle. This will restrict the movement to one plane only. I find the perspective crop tool is very useful when preparing photographs of flat copy artwork as it enables me to always get the copied artwork perfectly square. Edge snapping can be very distracting when you are working with the crop tool. But this can easily be disabled in the View ⇨ Snap To sub-menu (or by using the ⌘ *Shift* ; *ctrl Shift* ; shortcut).

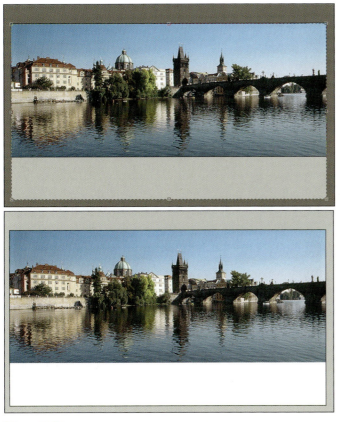

Figure 4.21 To add extra pixels beyond the current document bounds, use the Canvas Size from the Image menu. In the example shown here, the image is anchored so that pixels will be added equally left and right and to the bottom of the image only. The relative box is checked and this allows you to enter the number of units of measurement you wish to add 'relative' to the current image size.

Figure 4.20 The crop tool as canvas size tool – drag any one of the bounding box handles outside of the image and into the pasteboard area. Double-click inside the bounding box area or hit Enter to add to the canvas size, filling with the background color.

Unsharp masking

The only sharpening filter you ever need is the Unsharp Mask (Filter ⇨ Sharpen ⇨ Unsharp Mask). Sharpen and Sharpen More are preset filters which sharpen edges but feature none of the flexibility associated with USM.

Wherever possible, use an unsharpened original as your master and apply any sharpening as necessary in Photoshop at the end of the editing session. Much depends on the capture device, scanner or scanner settings, because a lot of manufacturers like to sneak in some unsharp masking in

Precise image rotation

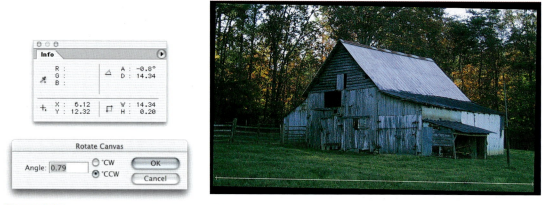

Figure 4.22 When an image is opened up in Photoshop, you may discover that a scanned original is not perfectly aligned. Although the crop tool will allow you to both crop and rotate at the same time, there is another, more accurate way of correcting the alignment. Select the measure tool from the Tools palette and drag along what should be a straight edge in the photo. After doing this, go to the Image menu and select Rotate Canvas ⇨ Arbitrary... You will find that the angle you have just measured is already entered in the Angle box. Choose to rotate either clockwise or counterclockwise and the picture will then be accurately rotated so that it appears to be perfectly level. Although Photoshop usually auto-selects the correct direction to rotate in.

Origins of unsharp masking

Unsharp masking sounds like a contradiction in terms, because how can unsharpening make a picture sharper? The term in fact relates to the reprographic film process whereby a light, soft unsharp negative version of the image was sandwiched next to the original positive during exposure. This technique was used to increase the edge sharpness on the resulting plate. The Photoshop Unsharp Mask (USM) filter reproduces the effect digitally and you have a lot of control over the amount of sharpening and the manner in which it is to be applied.

the default settings. If you find this is happening, turn off the sharpening in the scanner software. Most scans will still benefit from a little USM and Photo CD images in particular will always require sharpening. The Kodak Photo CD system relies on the softness of the scanned image to enable the Image PAC files to compress more easily on to the CD disc and produce equally good quality results at any of the chosen resolutions. So although it may not *always* be required, it can sometimes be necessary to apply some level of unsharp masking to get an image looking sharp on the display and do this in Photoshop. While unsharp masking may make a picture look sharper, this apparent sharpening is achieved at the expense of introducing artifacts into the image that will permanently degrade the picture and possibly emphasize any noise present. Furthermore, if you over-sharpen the image before carrying out color adjustments and any retouching, the sharpening artifacts can become even more noticeable afterwards.

Sharpening for repro

What you see on the screen will not exactly match the printed result. The process of converting a digital image to a halftone plate and from there to ink on the page inevitably incurs a loss of sharpness along the way. For this reason it is always necessary to 'sharpen for repro'. This means that if you are preparing a picture to appear in print, you have to apply an extra amount of unsharp masking, beyond what would make the image look sharp enough on screen. Such unsharp masking should be done at the end of a Photoshop session. It therefore makes sense to keep a master version which you can reseparate from as requested and always apply the final unsharp masking on a copy version. Unsharp masking artifacts will create darker and lighter pixels. This can affect the tonal range, so it is best not to set the final levels till after applying USM. Figure 4.15 reproduces three versions: a raw Photo CD scan; sharpened for display on the screen; and sharpened for repro output.

Amount

The amount setting controls the intensity of the sharpening applied. The higher the percentage (up to 500%) the greater the sharpening effect will be. The correct amount to apply will vary depending on the state of the image and the type of press output. Generally speaking, I would typically apply an amount between 120% and 200%. Experience will help you make the right judgment on screen as to what the correct amount to use should be. Try setting the amount value really high to begin with. Try to find out which Radius and Threshold settings work best at this high Amount setting and then reduce the percentage to an appropriate level.

Radius

The Amount setting controls the level or intensity of unsharp masking, but the Radius and Threshold settings affect the distribution of the sharpening effect. The Radius setting controls the width of the sharpening effect and the

Evaluating sharpening on the display

I usually find that to evaluate how much sharpening to apply to an image, it helps to view the picture on the display at 50% magnification (or sometimes even 25%). At this viewing scale, you can get a better idea of how sharp the picture will appear in print after applying unsharp masking sharpening.

Figure 4.23 The Unsharp Mask filter dialog.

Figure 4.24 The left-most version shows a raw Photo CD scan converted to CMYK and reproduced without using any USM. The middle version has been partially sharpened only to appear sharp on the monitor. The version on the right has been converted to CMYK and additional USM applied to appear correct when printed in this book.

Photograph: Peter Hince.

Figure 4.25 When presented with an image or portion of an image that needs 'bringing into focus', a higher Radius setting will help create the illusion of better definition. The above pictures have been treated as follows: On the left: No sharpening. Middle: Amount 150% Radius 1, Threshold 1. Right: Amount 150% Radius 2, Threshold 1.

setting you should choose will depend very much on the subject matter and the size of your output. The recommended setting is usually between 1 and 2. As the Radius setting is increased you will notice how the edges are emphasized more when using a wider radius. Figure 4.16 demonstrates the impact increasing the Radius can have on the edge sharpness, while all the other settings remain constant.

Threshold

The Threshold setting controls which pixels will be sharpened based on how much the pixels to be sharpened deviate in brightness from their neighbors. Higher Threshold settings apply the filter only to neighboring pixels which are markedly different in tonal brightness, i.e. edge outlines. At lower settings more or all pixels are sharpened including areas of smooth continuous tone. If the Threshold setting is 4, and two neighboring pixels have values of 100 and 115, then they will be sharpened, because their tonal difference is greater than 4. If one pixel has a value of 100 and the other 103, they will be left unsharpened because the pixel difference is less than 4. Raising the Threshold setting will enable you to sharpen edge contrast, but without sharpening any scanner noise or film grain which is visible. Scans made from 35 mm film originals usually benefit from being sharpened with a higher Threshold setting than would need to be applied to a 120 film scan.

Selective sharpening

Anti-aliased text and other graphic artwork is fine left as it is and will not benefit from being sharpened. Photoshop vector objects are on separate layers anyway and will be processed separately by a PostScript RIP when rendered in print. If you do render any of the shape or type layers, try to keep them on their separate layers. Only sharpen the bitmapped image data.

The unsharp masking controls will enable you to globally correct most pictures and prepare them ready for

Figure 4.26 This photograph taken of musicians underwater was shot through a very scratched plastic porthole. As a result of these environmental conditions, the picture was already quite soft in appearance and therefore needed a lot of extra sharpening. But the problem with doing that is that at a low threshold setting, the high Amount and Radius also emphasized the film grain. Increasing the Threshold to 10 solved the problem. The photograph was made to appear sharper but without sharpening too much of the film grain.

Photograph by Eric Richmond.

print output. But you may find it preferable to selectively apply the sharpening in a way that will reduce the problems of unwanted artifacts becoming too noticeable. You may not want to globally sharpen every image and this is where the history brush can come in use to selectively apply the unsharp masking (refer to the history section in Chapter 2 for advice on how to use the History palette and history brush). Basically, you can create a sharpened image state in Photoshop, undo the sharpening in the History palette, but select the sharpened image state as the history source. You can then use the history brush to selectively paint in any unsharp masking.

Another strategy is to add a new layer to the top of the layer stack and fill this with a merged snapshot of the current image. Apply your sharpening to this merged layer and then add a layer mask, filled with black, that hides the layer contents. Now if you activate the sharpened image layer mask and paint with white, you can paint in the sharpened version of the image.

Sharpening selected channels

The blue channel in an RGB image usually contains the most noise and so it can sometimes be a good idea to sharpen the red and green channels only. Activate the Channels palette, click on the Red channel and then shift-click on the Green channel to select this as well. The image will now appear yellow, but if you click on the eyeball icon next to the composite color channel, you can preview the photograph as a full-color image. If you now apply the unsharp mask filter, the preview box in the filter dialog will still show a yellow preview, but you can judge how much to sharpen using the normal full-color preview in the image document window. When you are happy with the sharpening, click OK and remember to then click on the composite channel in the channels palette. If you don't do this, you will continue editing the red and green channels only.

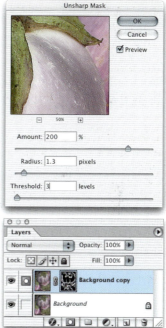

Figure 4.27 This illustrates one way of applying unsharp masking to a picture. I copied the background layer and applied a hefty amount of unsharp masking to the layer. I then added ⟨⟩ *alt* clicked on the Add Layer Mask button at the bottom of the Layers palette to add a layer mask that 'hides all'. With the layer mask active, one can paint in the sharpness using a brush with white as the foreground color.

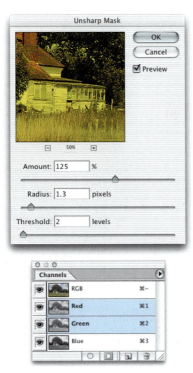

Figure 4.28 As discussed in the text, the blue channel is often the most noisy. If you wish to avoid sharpening the blue channel, go to the Channels palette, click on the Red channel to make it active and then *Shift* click on the Green channel to make it active as well. Click on the eyeball icon for the RGB composite channel in order to see a full color preview in the document window. When you apply the unsharp mask filter, the dialog preview will appear yellow, but the document image will preview the sharpening in normal color.

Luminance sharpening

The artifacts caused by unsharp masking can sometimes be avoided by filtering the luminance information in the image only. Some people will suggest that you convert the image to Lab color mode, select the luminance channel only, apply the unsharp mask filter and then convert back to RGB mode again. But this mode conversion process is unnecessary. Instead what you can do is apply the unsharp mask filter, and follow this immediately with Fade Filter from the Edit menu and change the blending mode from Normal to Luminance. This will accomplish the same type of result, but you will want to make the initial unsharp masking amount just slightly stronger than is required and use the fade amount slider to adjust the sharpening effect to achieve the desired result.

Progressive sharpening

Smoother sharpening can also be achieved by applying the unsharp mask filter in steps. Let's say that you want to do some strong sharpening to a photograph. Instead of applying the unsharp mask filter at an amount of 300% in a single pass, you could try applying the filter using an amount of 100% in three successive passes, but keeping the Radius and Threshold values the same.

Edge sharpening

This is a technique designed to selectively sharpen the edges only, which is useful if you want to minimize the amount of unsharp masking that is applied to area of flat tone. For example, if you wish to sharpen a portrait photograph, the main thing you want to see looking sharp are things like the eyes, lips and the hair, and you don't really want to apply too much unsharp masking to the areas of flatter detail such as the skin, because this will most likely only exaggerate any grain or noise in the image. The basic formula for edge sharpening goes something like this. You want to first make a new alpha channel and then modify it to produce an edge mask where the white areas

of the mask trace the contours of the edge detail. The mask is then loaded as a selection. When you apply the unsharp mask filter the sharpening is focussed on the edges only.

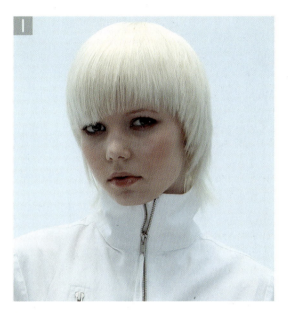

1 I first created an alpha channel mask based on the image luminance information. One way to do this is to drag the RGB composite channel to the Make Selection button in the Channels palette and follow this by clicking on the Make New Channel button just to the right of it and choose Select ▷ Deselect to get rid of the selection.

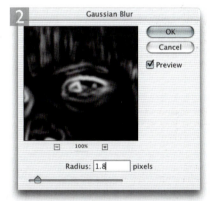

2 I made sure that this new alpha channel was now active. I went to the Filter menu and chose Stylize ▷ Find Edges. There is no dialog for this filter – it will simply produce a high contrast edge image like an ink pen drawing of the photograph. I Chose Image ▷ Adjustments ▷ Invert. This created a negative. I then applied a Gaussian Blur filter to the alpha channel. I chose Filter ▷ Blur ▷ Gaussian Blur and used something in the region of a 1–2 pixel radius. This softened the edges of the mask.

3 With the alpha channel active, I went to the Image menu and chose Adjustments ▷ Auto Levels. This helped expand the contrast of the alpha channel automatically.

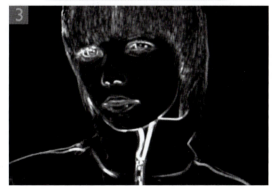

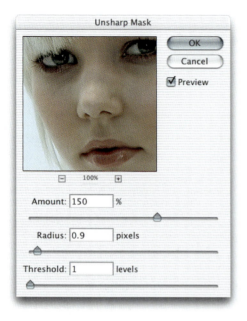

4 I then loaded the modified alpha channel as a selection (in this example, you could use the shortcut: ⌘ ⌥ 4 *ctrl alt* 4) and chose the Unsharp Mask filter. The unsharp mask filtering will be applied to the selected areas only. This technique basically allows you to apply sharpening to the image edges where the sharpening matters most, while leaving the softer areas of continuous tone, mostly unaffected.

Figure 4.29 Unsharp masking can produce chromatic artifacts around some areas of the image. If this happens, apply an Edit ➩ Fade command and change the blending mode to Luminosity. This has the same effect as converting an image to Lab mode and sharpening the luminosity channel only (but quicker).

Third-party sharpening plug-ins

As you can see, there is a lot more to sharpening than meets the eye. The unsharp mask filter in Photoshop is perfectly capable of giving good results and these can be further enhanced using some of the selective sharpening tips I have described here. But there are also some third-party plug-in solutions available that offer an alternative to the unsharp mask filter. For example, there is a product called PhotoKit Sharpener from Pixel Genius, a company I am personally involved with. But all credit goes to fellow Pixel Genius member and author, Bruce Fraser, who devised this special set of Photoshop sharpening effects

Client: Reflections. Model: Elle S @ FM.

that are designed to apply just the right amount of image sharpening for all different types of film and digital file formats. Bruce's sharpening routines incorporate all the techniques discussed here in this chapter, and then some. They include import sharpening for a multitude of film types and digital captures, output sharpening for inkjet printers or repro and creative sharpening layers for selective image sharpening. A demo version of PhotoKit Sharpener can be downloaded from the Pixel Genius website www.pixelgenius.com.

Beyond the basics

That concludes this first section on basic image correction. Most of the time you may be simply concerned with getting an image from your camera or scanner into Photoshop and having it look good. The following chapters explore techniques that are used for color correction and how to repair an image.

Figure 4.30 The Pixel Genius PhotoKit Sharpener automated plug-in that is able to apply sharpening routines in stages for capture selective (painting in on a layer) and output sharpening. The sharpening routines are each customized to provide the optimum amount of sharpening for these different tasks.

Chapter 5
Color Correction

The image adjustment controls discussed in the preceding chapter looked at basic image enhancements. Now we shall get to grips with the fine tuning aspects of the Photoshop image adjustment controls, and more specifically, methods for correcting and enhancing color. Color correction is just like tonal correction, but when corrections are applied to individual color channels, these will allow you to affect the color balance in an image. But before all that it helps to understand the relationship colors have to each other. The color wheel shown in Figure 5.1 is a visual representation of this relationship. You will find it useful to refer to when applying a color correction. For example, if you want to make a picture less blue, by looking at the diagram you know you will need to add more yellow etc.

Variations

The Variations adjustment features an impressive and easy to use dialog box. It is not a tool I use that often myself, but the Variations interface is a good starting point for looking at the way color correction works in practice and how this relates to the color wheel diagram shown in Figure 5.1. You can choose to add color in either the shadows, midtones or highlights, making the image more green, more red etc. by clicking on the image color previews in the dialog. You can then select from the darker, lighter and more/less saturated options. You can adjust the increments of adjustment so they can be fine or coarse. If the Show Clipping is checked, you will see a gamut warning alert (usually as a gray overlay color) displayed in the previews. This will indicate when you have reached the point beyond which the image detail will become clipped. Variations is not bad as a starting tool for beginners, because it combines a range of basic image adjustment tools in a single interface. Use it to help familiarize yourself with the basic principles of color correction.

Figure 5.1 The Variations dialog displays color balance variations based on the color wheel model (shown right). Here you see the additive primaries, red, green, and blue, and the subtractive primaries, cyan, magenta, and yellow, placed in their complementary positions on the color wheel. Red is the opposite of cyan; green is the opposite of magenta, and blue, the opposite of yellow. Use these basic rules to gain an understanding of how to correct color.

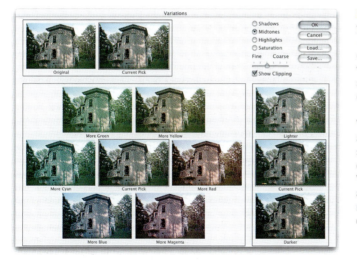

Figure 5.2 The Variations interface will enable you to modify the color of the shadows, highlights or midtones separately. For example, clicking on the red preview will cause the red variant to shift to the center and readjust the surround previews accordingly. Clicking on the cyan preview will restore the central preview to its original color balance. In this respect, Variations is just like the Color Balance adjustment, but you also have built in the saturation adjustment and a lighter or darker option. And you can save or load a previous Variations adjustment setting. Variations may be a crude color correcting tool, but it is nonetheless a useful means by which to learn color theory.

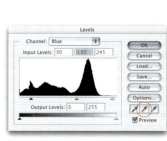

Figure 5.3 The Info palette can be used to read color information which helps determine whether the colors are neutral or not regardless of any monitor inaccuracies. Equal values of R, G, and B give a neutral gray tone.

Finding neutral RGB

Repro professionals will often rely more on the numeric readouts to judge the color in a digital image. The step-by-step tutorial, featuring the white boot, is a good example of where the Info palette readout can be used to determine the neutrality of the image tones and is the ultimate guarantee of perfect color correction. If you match up the RGB values so that red = green = blue, the resulting color is always a neutral gray. Remember, this is not the case with CMYK color (see Chapter 13 on color management).

Color balancing with Levels

You can correct color casts by adjusting the input and output sliders in the individual color channels in the Levels dialog. Where you see the pop-up menu next to the channel at the top, mouse down and choose an individual color channel to edit. Increasing the gamma in the *Green* channel will make an image appear more green (RGB mode). In CMYK mode, increasing the gamma setting in the *Magenta* channel will make the image go more green. To neutralize midtones, in the Levels or Curves dialog box, select the gray eyedropper and click on an area in the image that should be a neutral gray (circled in Figure 5.4). The levels will automatically adjust the gamma setting in each color channel to remove the cast. Levels may be adequate enough to carry out basic image corrections, but does not provide you with much control beyond reassigning the highlights, shadows and midpoint color values. The best tool to use for color correction is Curves. This is because you can change the color balance and contrast with a degree of precision that is not available with all the other image adjustments.

Auto adjustments

The Image ⇨ Adjustments menu contains three auto adjustment commands: Auto Levels, Auto Contrast and Auto Color. The difference between each is explained in Figure 5.5. Of these, Auto Color is the most effective auto adjustment. But if you choose Levels or Curves, you will

Figure 5.4 Basic color adjustments can be made by adjusting the Input and Output sliders in the Levels dialog. In this example the right half of the image was color corrected by adjusting the levels in the color channels. In Levels or Curves there is an easy way to neutralize a cast like this. Select the gray eyedropper (circled), and click on an area you wish to make gray.

Before

Auto Levels (Enhance Per Channel Contrast)

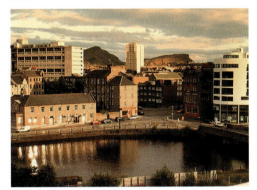

Auto Contrast (Enhance Monochromatic Contrast)

Auto Color (Find Dark & Light Colors)

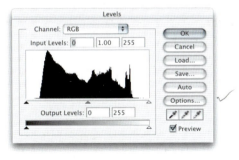

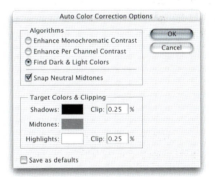

Figure 5.5 These photographs show the three auto adjustment methods (with equivalent descriptions as displayed in the Levels and Curves dialogs). Auto Levels expands the shadow and highlight points in all three color channels – this will generally improve the image contrast and color balance. Auto Contrast will apply an identical adjustment across all three channels. This will increase the contrast, but without correcting any color cast. The Auto Color option will map the darkest and lightest colors to the colors shown in the Options dialog. If Snap Neutral Midtones is selected, Auto Color will also neutralize these (as in the Auto Color example shown here). You can customize the Clipping values to set how much the highlights and shadow tones are clipped by the image adjustment.

notice an Options button. This will open an Auto dialog in which you can specify an auto correction method, plus neutralize the midtones and set the clipping values for the highlights and shadows.

Figure 5.6 The Color Balance dialog allows you to separately adjust the color in the shadows, midtones and highlights. The color correction principles here are identical to those in the Variations dialog. If you use Color Balance for making fine-tuned adjustments, keep Preserve Luminosity checked. However, if you are making extreme color adjustments you will get less posterized-looking results by deselecting this check box.

Color Balance

The Color Balance is a sort of blind curves adjustment command. The interface controls may look intuitive enough, but it is not really the most useful tool for balancing and correcting color. If you are able to follow the later tutorials which show how to use curves adjustments to correct color accurately, then you might as well disregard Color Balance. Although I do sometimes use Color Balance to tone black and white photographs.

Precise color correction with Curves

There is also a more precise way of correcting the color balance. If you exploit the fine tuning capabilities built into the Curves dialog and combine this with the use of the color sampler tool, you can correct with absolute precision.

To add a new color value as a control point on the curve, ⌘ ctrl click inside the document window and you will see a control point appear on the corresponding portion of the curve. If you use ⌘ Shift ctrl Shift to click in the document window, Control points will be automatically added to all three color channels at once. So when adding control points to color correct the white boot image example that follows, I would ⌘ Shift ctrl Shift click on top of each of the color sampler points to add these as control points in all three color channels in the Curves dialog. When you are editing the points in the Curves dialog, use Shift click to select multiple points. As you adjust one control point the others will move in unison. To deselect all the points, use ⌘ D ctrl D. When a single point is selected you can select the next point using Tab ctrl Tab right mouse and the previous point by using Tab Shift ctrl Tab Shift right mouse.

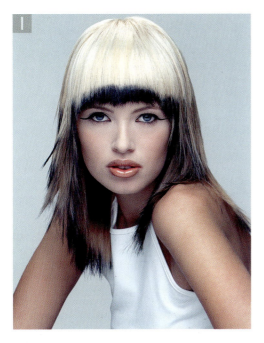

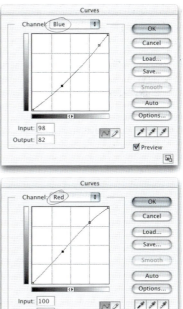

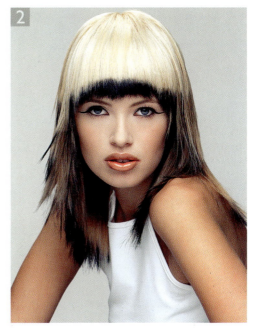

1 The above photograph has a cold color cast. This is particularly noticeable in the backdrop, which should be a neutral gray. If I want to correct the color in this picture, the best method is to apply a curves image adjustment. Go to the Image ⇨ Adjustments menu and choose Curves...

2 This shows you the curves corrected version. The main Curves dialog allows you to make tonal corrections to the composite color channel (in this case, the RGB composite channel). I dragged down from the RGB channel to select first the red color channel and added a couple of control points to the curve to adjust the color balance for the midtones and highlights. If you are not happy about the position of a curve point, it is very easy to move it around and change the shape. When a control point is selected, to select the next point, use Tab ctrl Tab right mouse. To select the previous control point, use Tab Shift ctrl Tab Shift right mouse. To get rid of a point altogether, drag it to the outer edge of the graph or ⌘ ctrl click on the point in the grid. I then went to the Blue channel and added a couple of points. This time to correct the color for the shadows and highlights in the Blue channel.

Client: Anita Cox Salon.

1 When you have a white object photographed against a white background, any color cast will always be very noticeable. First of all select the color sampler tool and click on the image in up to four places to locate the persistent color readouts at different places on the boot.

Info				
R :	255	C :	0%	
G :	255	M :	0%	
B :	255	Y :	0%	
		K :	0%	
X :	4.11	W :		
Y :	3.87	H :		
#1 R :	165	#2 R :	220	
G :	182	G :	236	
B :	184	B :	237	
#3 R :	168			
G :	184			
B :	185			

Levels

Channel: Red

Input Levels: 0 1.23 255

OK
Cancel
Load...
Save...
Auto
Options...

Output Levels: 0 248

☑ Preview

2 Follow the Levels adjustment procedure as outlined in the previous chapter (Assigning shadow and highlight points, page 116). Expand the tonal range and neutralize the shadows and highlights as much as possible. This improves the picture already and removes most of the cyan cast.

Info				
R :		C :		
G :		M :		
B :		Y :		
		K :		
X :		W :		
Y :		H :		
#1 R :		#2 R :	224	
G :		G :	238	
B :		B :	240	
#3 R :	165			
G :	179			
B :	184			

3 The color sample points can be repositioned as necessary by dragging on them with the color sampler (you can access the tool while in an image adjustment dialog, by holding down the Shift key). Apply a Curves adjustment and adjust each color channel curve as necessary. The first RGB readout figure in the Info palette tells you exactly where to position the point on the curve (see the Input numeric box). Either manually drag the point or use the keyboard arrows (*Shift*+arrow key moves the control points in multiples of 10) to balance the output value to match those of the other two channels. What you adjust at one point on the curve will affect the shape and consequently the color in another part. This is why it is advisable to monitor the color values across the range of tones from light to dark. Remember that you can shift select image sampled colors to add points to the curve.

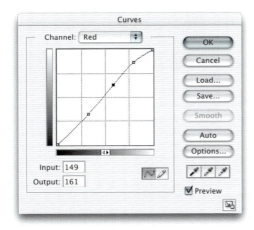

Photograph: Davis Cairns. Client: Red or Dead Ltd.

Arbitrary Map mode

If you click on the Arbitrary Map mode button in the Curves dialog, you can sketch in the grid area with the pencil cursor to create a freehand curve map shape. The results are likely to be quite repulsive, but if you click on the smooth button a few times you will see the curve become less jagged and the tonal transitions will then become more gentle. Another example of an Arbitrary Map mode curves adjustment can be found in Chapter 8 on darkroom effects.

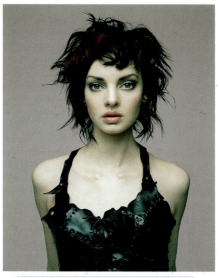
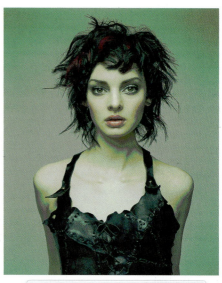

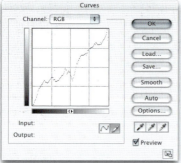
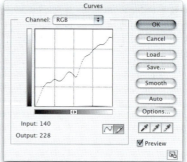

Figure 5.7 If you click on the Arbitrary Map button in the Curves dialog, you can draw a freehand curve shape like the one shown here. Click on the Smooth button to produce a gentler effect.

Client: Anita Cox Salon. Model: Sorcha, Bookings.

Color Temperature

Color Temperature is a scientific term referring to the measured color of a black body as it is heated up. Think of a piece of metal being heated in a furnace. At first it will glow red but as it gets hotter, it emits a yellow and then a white glow. Indoor tungsten lighting has a low color temperature and is warmer than sunlight which emits a cooler, bluer light.

Photo Filter

One of the advantages of shooting digitally is that most digital cameras will record a white balance reading at the time of capture and this information can be used to automatically process an image either in-camera or using Camera Raw in Photoshop to produce an improved color balance. But if you are shooting with color film, then the only way to compensate for fluctuations in the color temperature of the lighting, is to use the right film (daylight or tungsten balanced) and to also use color compensating

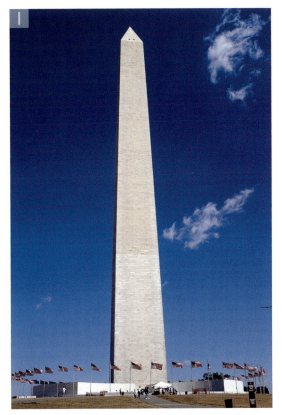

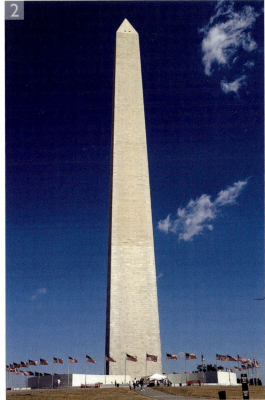

1 This photograph was shot using 35 mm transparency daylight film, balanced for a color temperature of 5500 K. The color temperature was clearly higher when the photograph was taken, hence the blue cast.

2 To improve the photograph, I chose Image ⇨ Adjustments ⇨ Photo Filter. By mousing down in the Filter pop-up menu, I could select a preset filter color to apply to the image. In this case, I chose the Yellow filter at its default density setting of 25%.

filters. The Photo Filter can be found in the Image ⇨ Adjustments menu and is new to Photoshop CS. In the example shown here, a Photo Filter correction can be applied after the picture has been shot and scanned. The Photo Filter adjustment offers a set range of filter colors, but if you click on the color button, you can select any color you like after clicking on the color swatch.

Figure 5.8 The Match Color image adjustment is also a useful image correction tool in its own right. In this extreme example, I used the Match Color adjustment with the Neutralize button checked, to help reduce the color cast in this underwater photograph.

Match Color

The Match Color image adjustment is an interesting, new image adjustment tool in Photoshop CS. The concept is quite simple: Match Color can be used to adjust the color balance in a photograph match the color in a reference image. To achieve this, the Match Color adjustment converts the image data to a separate, high-precision perceptual color space made up of Luminance and two color components. Match Color aims to transfer the image statistics from a source image to the active, target image so that the active image will 'match' the source. Match Color works very effectively if, as in the accompanying step-by-step example, the image content is very similar. It is therefore a useful tool to use when trying to match the lighting color conditions in a series of photographs taken of a similar subject content. It is less good at matching dissimilar photographs, because the reference source needs to have something in common with the target. In the accompanying step-by-step example, you will note that the source and target images are quite similar and because of this, Match Color is able to make a successful color match adjustment.

However, even under near-match circumstances, it may be desirable to fade the adjustment slightly as I did in the accompanying example. In general use, the Luminance and Color Intensity sliders will prove useful in allowing you to compensate the image adjustment correction to get an ideal color match between two images. If you are unable to obtain a successful match, then you may find it helps to make a selection of the areas of interest in the source or target image, discarding distracting elements in the picture. Select use Selection in Source/Target to Calculate Colors in the Match Color dialog.

Finally, the Match Color image adjustment serves as an image adjustment tool in its own right. As you can see in Figure 5.8, it is an effective tool for neutralizing color casts in tricky images.

1 Here we have a photograph with ideal color in the skin tones.

2 This is another photograph from the same series where the skin tones do not match those in the other picture.

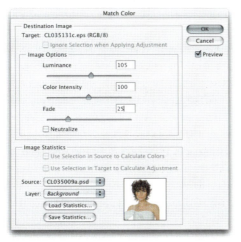

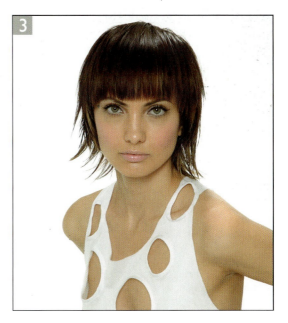

3 I chose Image ⇨ Adjustments ⇨ Match Color and selected the 'good color' image as the Source at the bottom of the dialog. This adjusted the colors of the selected image to match more closely that of the source. I faded the result slightly, to bring back some of the original color and clicked OK.

Client: Clipso. Models: Catherine Bell @ Bookings (left) Kate Bandura @ IMG (right).

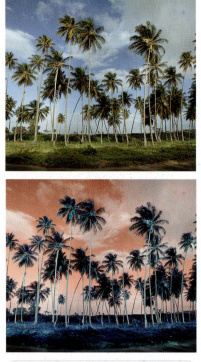

Hue/Saturation

The Hue/Saturation dialog controls are based around the HSB (Hue, Saturation, Brightness) color model, which is basically an intuitive form of the Lab color model. When you select the Hue/Saturation image adjustment you can alter these components of the image globally, or selectively apply an adjustment to a narrow range of colors. The two color spectrum ramps at the bottom of the Hue/Saturation dialog box provide a visual clue as to how the colors are being mapped from one color to another. The hue values are based on a 360 degree spectrum. Red is positioned in the middle at 0 degrees. All other colors are assigned numeric values in relation to this, so cyan (the complementary color of red) can be found at either -180 or +180 degrees. Adjusting the hue slider only will alter the way color in the image will be mapped to a new color value. Figure 5.9 shows extreme examples of how the colors in a normal color image will be mapped by a Hue adjustment only. As the hue slider is moved you will notice the color mapping outcome is represented by the position of the color spectrum on the lower color ramp. Saturation adjustments are easy enough to understand. A plus value will boost saturation, a negative value will reduce the saturation. Outside the Master edit mode, you can choose from one of six preset color ranges with which to narrow the focus of the Hue/Saturation adjustment. Once in any of these specific color ranges, a new color value can be sampled from the image window, around which to center a Hue/Saturation adjustment. *Shift* click in the image area to add to the color selection and *alt* click to subtract colors (see page 155).

When the Colorize option is switched on, the hue component of the image is replaced with red (hue value 0 degrees), lightness remains the same at 0% and saturation is 25%. Some people recommend this as a method of obtaining a colored monochrome image, but there are better ways of achieving this, which are outlined later in Chapter 8 on darkroom effects.

Figure 5.9 This is an extreme example of how a Hue/Saturation adjustment can be used to radically alter the appearance of a photograph. As you move the hue slider left or right the colors in the image will be mapped to new values. You get an indication of this transformation by looking at the two color ramps at the bottom of the dialog. The top one represents the original 'input' color spectrum and the lower ramp represents how those colors will be translated as output colors.

1 The Edit menu in the Hue/Saturation dialog box defaults to Master, and any adjustments will affect all colors in the image. If you mouse down on 'Master' you can narrow the Hue/Saturation adjustment to specific colors. If I select Greens, I can enhance or subdue the saturation of the green color component of the image. And I can shift the green colors so that they become more yellow and less cyan.

2 As you can see, if I move the Hue slider to the left, I can make the green leaves turn more yellow and rapidly change the seasonal appearance of the photograph. You can also be very specific as to which colors are selected. In this example I clicked on the standard eyedropper in the Hue/Saturation dialog and clicked on a leaf in the picture to set this as the target green color to change (the two vertical markers creating the gap in the middle of the sliders represent the chosen color range to modify and the spaces defined by the outer triangular markers represent the threshold drop-off either side of the color selection). I then added to the color selection by selecting the Add to Sample eyedropper (circled) and clicked to add more color sample points to the Hue/Saturation adjustment color range.

Color Replacement brush

The color replacement brush was briefly introduced in Chapter 1, where I showed how it could be used to remove unwanted redeye from a photograph. But as you can see it is also suitable for making general color changes. The steps shown here were done using the Color mode. This modifies the pixels, replacing the color and saturation with that of the foreground color. The Hue and Saturation modes are also useful if you want to modify these color components individually.

In Sample Once mode, the color replacement will be based on where you first click and only the pixels within

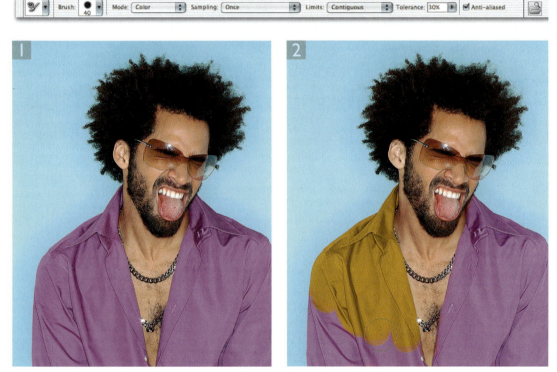

1 There are various ways one can change the color of an object. In Photoshop CS now, the color replacement brush offers a simple easy-to-use solution. I began by selecting it from the tools palette (it is grouped with the healing brush and the patch tool).

2 I wanted to change the color of the purple shirt. I double-clicked the Foreground color in the tools palette. This opened the color picker dialog and selected a dark yellow as the new foreground color. The color replacement brush was set to work in Color mode with the sampling set to Once, which meant that the brush would start replacing the color based on the color of the pixels I clicked on first.

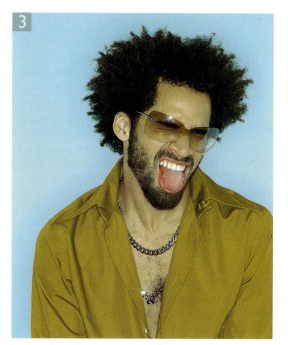

Client: Anita Cox.

3 The color replacement brush limits in the Tool options bar were set to Contiguous. This meant that I was able to use the brush to click and paint over the left hand side of the shirt in one action. Because the shirt was undone, there were no contiguous pixels to allow me to carry on painting the other side of the shirt. So I clicked again and painted with the brush to complete the color transformation.

As was explained on the previous page, you can also use the Hue/Saturation image adjustment to make selective color corrections. In this example, I added a new Hue/Saturation image adjustment layer, selected Reds from the Edit pop-up menu and adjusted the red component of the underlying image such that the skin tones were made more yellow and less red and less saturated.

the specified tolerance will be modified. As with the magic wand, the tolerance setting determines the tonal range of pixels that will be modified. In Continuous mode, the sample source is updated as you drag through the image. In some instances this mode can produce smoother results, but as you drag, take care that the cursor cross hair doesn't stray outside the area you are modifying.

Limits can be set for the color replacement too. In this example the Contiguous mode limits the tool's application to the pixels that are within the tolerance range and are also adjacent to each other. In Discontiguous mode you can paint beyond isolated groups of pixels. If you refer back to the forest images on page 155, you would need to use the color replacement brush in Discontiguous mode in order to bring about a similar color transformation of all the leaves.

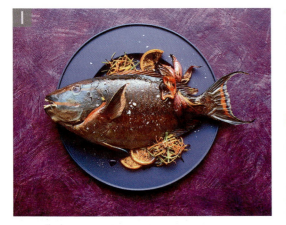

1 This is the before image. Using the Replace Color adjustment command I can quickly take the image information in the purple backdrop and alter the Hue, Saturation and Lightness values. This image adjustment command is not available as an adjustment layer, because the single command is a combined two-stage process which involves making a pixel selection.

2 I chose Image ⇨ Adjustments ⇨ Replace Color. To make the selection, I first clicked with the eyedropper either on the image or in the dialog box mask preview window. I clicked again with the 'add eyedropper' icon to add to the selection. I clicked with the 'minus eyedropper' to remove colors. You can use the Fuzziness control slider to determine how much tolerance you want to apply to the selection area (see magic wand tool). I then changed the Hue/Saturation values. As you can see here, the biggest change took place with the Hue, making the background go green instead of purple. Small saturation and lightness adjustments were also necessary.

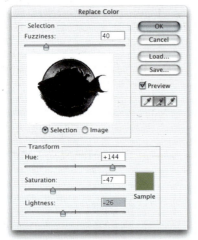

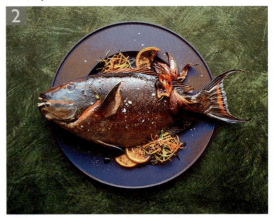

3 After performing the Replace Color operation, there was a little spill-over on to the blue plate. All I had to do was to erase the offending areas. I made a circular selection of the inside of the plate, using the elliptical marquee tool. I feathered the selection by choosing Select ⇨ Feather and entering a value of 2 pixels. I then selected the Open image state as the History source and using the history brush and painted to restore the original unaltered image.

To modify the marquee actions, hold down the ⌥ *alt* key to draw out from the center. The elliptical marquee can be constrained to a circle when you hold down the *Shift* key at the same time. If at any time you also hold down the Spacebar, you can drag to reposition the selection. If you release the Spacebar (but have still held down the ⌥ *Shift* *alt* *Shift* keys), you can carry on expanding or contracting the selection.

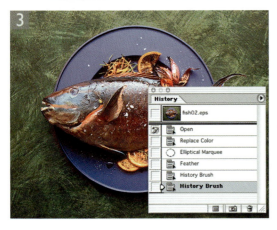

Replace Color

Hue/Saturation crops up again in the Replace Color command, which is really like a combination of the Select ⇨ Color Range and Hue/Saturation command combined in one. With Replace Color, you can select a color or range of colors, adjust the fuzziness of your selection and apply the Hue/Saturation adjustments to those selected pixels only. Alas, the selection made this way is not savable.

Color Range

Where the magic wand creates selections solely based on luminosity, the Select ⇨ Color Range option creates selections that are based on color values which are similar to the sample pixel color. Among other things, you can use the Color Range command to make a selection based on out-of-gamut colors. This means you can use Color Range to make a selection of all those 'illegal' RGB colors outside the CMYK gamut and apply corrections to these pixels only. This task is made easier if you feather the selection slightly and hide the selection edges (View ⇨ Hide Extras). Then choose View ⇨ Gamut Warning. Adjustments can be made using the Selective Color or Hue/Saturation commands as before. Local areas may also be corrected with the sponge tool set to Desaturate.

Selective Color

The Selective Color command is the ultimate, precision color control tool. It allows you to selectively fine tune the color balance in the additive and subtractive primaries, blacks, neutrals and whites. In that respect the controls are fairly similar to the Hue/Saturation command, except here you can adjust the cyan, magenta, yellow and black component of the chosen color range. The Selective Color command is therefore a tool for correcting CMYK color, but you can also use it to prepare an RGB file before converting it to CMYK. The color control available with Selective Color is a bit like adjusting the sound on a music system with a sophisticated graphics equalizer. Subtle or

Alternative Replace Color technique

For critical situations you will want to make a Color Range type selection first and while the selection is active, choose New Adjustment Layer... ⇨ Hue/ Saturation from the Layers palette. This two-step process is probably the more flexible approach.

Figure 5.10 When you are retouching a portrait, you can use the Info palette CMYK readout numbers to help judge if the skin tones are the right color. Set the palette options to display RGB and CMYK readouts. Using the eyedropper, Caucasian skin tones should have roughly a third or a quarter as much cyan as magenta and slightly more yellow than magenta. Black skin tones should be denser, have the same proportion of cyan to magenta, but usually a higher amount of yellow than magenta and also some black.

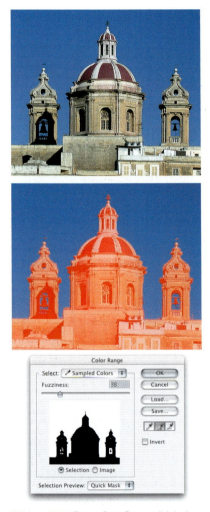

quite strong changes can be made with ease to the desired band of color tones. The Selective Color command is therefore another alternative to the Hue/Saturation adjustment for getting RGB colors to fit the CMYK color space. In the accompanying example, the gamut warning can help you pinpoint the illegal out-of-gamut colors in RGB. You may want to consider carrying out such adjustments using two window views: one with the normal RGB version and the other with gamut warning and the Working CMYK proofing switched on in the View menu.

As a final note on the above technique – there is bound to be a noticeable color shift and more than just the blue colors will benefit from adjustment. Since the initial blue did not exist in CMYK it had to be converted to something else. What that something else is, well, that is the art of preparing images for four-color printing. The trick is to convert the existing colors in a way that the color values obviously change but the final perception looks right to the eye. Blue skies are a good example – bright deep blues do not convert well to CMYK, and will fall outside the CMYK gamut. But you can use Selective Color to adjust the values of the magenta, cyan and black color plates so that these will produce another type of blue using a different combination of inks. Where the color matching is critical, Selective Color may help to correct an imbalance and improve the output color, provided the output color to be targeted is within the CMYK gamut. When this is not so, special printing techniques must be adopted, like adding an extra printing plate to substitute a custom color.

You may like to explore other refinements to the technique shown here. For example, the CMYK Preview window could also have the Gamut Warning switched on as well. As corrections are made using Selective Color, you can see whether the colors are changing to your satisfaction and still falling inside the CMYK gamut.

1 This is not an easy one to show because we are starting with an 'RGB' image that is printed in CMYK. But imagine you have an RGB scan that looks fine on screen, but not all the colors fall within the CMYK gamut. A relative colorimetric CMYK conversion will automatically translate the out-of-gamut RGB colors to their nearest CMYK equivalent. If there are only a few out-of-gamut RGB colors to start with, there will be little change to the image appearance after converting.

3 In the previous picture the 'illegal' RGB colors have been adjusted so that when the conversion takes place all the RGB colors now have a direct CMYK equivalent. You can also just as easily use the Hue/Saturation command to do this job. I used Selective Color because it is a fine-tuning color adjustment tool and one based around the destination CMYK color model. A Relative percentage change will proportionally add or subtract from the current value. So if the cyan value is currently 40% adding a Relative 10% will equal 44%. Adding an Absolute 10% will make the new value 50%.

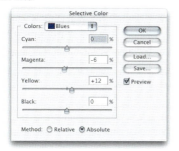

2 To check if this is the case, you can select View ⇨ Proof Setup ⇨ Working CMYK and then choose View ⇨ Gamut Warning. The latter will display out-of-gamut RGB colors with a predefined solid color (refer to the Preferences section in Chapter 3). If the gamut warning shows any out-of-gamut pixels you can bring them within the CMYK gamut using the Image ⇨ Adjustments ⇨ Selective Color command to selectively shift the magenta and yellow percentages that affect the blue component color.

Chapter 6
Repairing an Image

Most photographers are interested in the potential of using Photoshop as a tool for retouching pictures. So we shall start with simple techniques like cloning and then go on to explore some other advanced methods that can be used to clean up and repair damaged photographs. The clone stamp is a popular retouching tool even if it is a little difficult to master. But everyone has been very excited by the healing brush and patch tool, both of which are new to Photoshop 7.0, which can make Photoshop retouching so much easier to accomplish. The healing brush in particular can always be guaranteed to impress!

Basic cloning methods

The clone stamp tool can be used to repeat parts of an image elsewhere and requires some basic keyboard/mouse coordination. Select the clone stamp from the Tools palette. To establish the area where you wish to sample from, hold down the ⌥ *alt* key and click. Then release the ⌥ *alt* key and click or mouse down to paint over the area you want to clone to. When the Aligned box is checked, the sample area retains the same angle and distance in relation to where you paint with the clone stamp tool. When the Aligned option is unchecked, the sample point remains fixed for each discreet brush stroke. This latter mode is ideally used when the sample area is very small, as you can keep a tight control over the area you are sampling from. But the Aligned mode is the most appropriate option to select for everyday spotting. Select the Use All Layers option to sample from all merged layers. As with all the other painting tools, you can change brush size, shape and opacity to suit your needs. While you may find it useful working with different combinations of these settings with the painting tools, the same does not apply to the clone stamp tool. Typically you want to stick to using the fine to medium-sized brushes (just as you would always choose a fine paintbrush for spotting bromide prints). Lines and wrinkles can also be removed effectively with the dodge tool or with the brush tool set to Lighten mode. When cloning over an area where there is a gentle change in tonal gradation, it will be almost impossible to disguise your retouching work, unless the point you sample from and the destination point match exactly in hue and lightness. In these situations you will be better off using the healing brush, which is described later in this chapter.

Spotting used to be such a laborious and tricky process. I am reminded of an old story about a commercial photographer who rather than use a scalpel knife to remove a black speck in the sky, would paint in a couple of wings and turn it into a seagull. Thankfully with Photoshop anyone can learn to quickly spot a picture now.

Clone stamp brush settings

I mostly always leave the opacity set to 100%. Cloning at less than full opacity usually leads to telltale evidence of cloning. Where the film grain in the photograph is visible, this can lead to a faint overlapping grain structure, making the retouched area look slightly blurred or mis-registered. When smoothing out skin tone shadows or blemishes, I will occasionally switch to an opacity of 50% or less. Retouching light soft detailed areas means I can get away with this. Otherwise stick to 100%. And for similar reasons, you don't want the clone stamp to have too soft an edge; ideally make the clone stamp brush shape have a slightly harder edge.

Use all layers

The 'Use All Layers' option is useful if you want to make sure that your retouching is always stored on a separate layer. First create a new empty layer above the Background layer, select the clone stamp tool and check the Use All Layers button in the options bar. Make sure the empty new layer is kept active and as you carry out all your spotting. This technique will allow you to spot an image without altering the underlying image layer in any way. It could even be a useful way of proving to a client the amount of retouching work you had to do!

1 The Options bar displays the clone stamp options. The 'Aligned' box is normally checked by default. The Nonaligned mode allows you to set the source sample point so that repeat cloning always starts from the same source point for each new stroke you paint. The tool opacity should be left at 100%. Sometimes painting at a lower opacity will work, but the best way to disguise your cloning is to use the clone stamp at 100%.

2 This first example shows the source image area identified by a surrounding yellow rectangle. All the other clones (which are marked with cyan rectangles) were repeated from the same source starting point using the clone stamp in Nonaligned mode.

3 However, once you have created an alignment between the sampled source and the destination in the (default) Aligned mode, Photoshop will retain this relationship for all subsequent brush strokes until a new source and destination are created or until a change in tool occurs.

Normally, the clone stamp tool will only reference the layer that is active and ignore all others. But when the Use All Layers box is checked, Photoshop will sample data from all the layers that are currently visible, as if they were a single flattened layer and clone to the active layer. So you can source from one layer (even when this is another image) and clone to another active layer.

Figure 6.1 You can sample the sky from one image window and copy it using the clone stamp to another separate image. [⌥] [alt] click with the clone stamp in the source image, select the other image window and click to establish a cloning relationship between the source and destination images.

Figure 6.2 Gradient banding is a common problem in Photoshop. Banding can occur whenever you apply a heavy blur filtration. It can also sometimes appear on gradient fills. The gradient options include a dither mode and this will help somewhat. However, the best way to hide banding is to apply a small amount of noise, using the Noise ⇒ Add Noise filter. The Gaussian option will produce a more irregular distribution of noise. The example here shows a noticeably banded gradient with and without the noise being added. The noise filter is well worth remembering any time you wish to hide banding or make Photoshop painting work appear to merge better with the grain of the scanned original.

Alternative history brush spotting technique

This method of spotting a photograph has evolved from a technique that was first described by Russell Brown, Senior Creative Director of the Adobe Photoshop team. It revolves around using the Remove Dust & Scratches filter, which is found in the Filter ⇨ Noise sub-menu. If this filter is applied globally to the whole image, you will end up with a very soft-looking result. You are actually only meant to apply this filter selectively to the damaged portions of a picture in Photoshop. The technique shown here has the advantage of applying the filtered information precisely to fill in the dirty areas without the risk of destroying the tonal values in the rest of the picture.

As you can see, this method works well when you have a picture that is very badly damaged and where using the clone stamp would be a very tedious process. What is really clever is the way that the history brush is used in Lighten or Darken mode so that Photoshop can be made to target replacing specific pixels. However, you may encounter a problem if the photographic original contains noticeable film grain. To counteract this It may help to apply a small amount of noise after you have applied the Dust & Scratches filter. Add enough noise to match the grain of the original (usually around 2–3%). This will enable you to better disguise the history brush retouching.

Working with the healing brush

The healing brush is a dream tool to use for all types of retouching work. The healing brush and patch tool utilize some extremely clever math to perform complex blends to produce smooth seamless retouching results. I did once try asking Marc Pawliger, who is the principal engineer on the Photoshop team, to explain how the healing brush worked, but all I can remember is that it has something to do with complex algebra which went completely over my head. But it will help if you understand a little about how the healing brush and patch tool work, so here is my simplified interpretation of what these tools do.

1 This photograph serves as a good example with which to demonstrate the history brush spotting technique, as there are a lot of hair and scratch marks that are clearly visible in this picture.

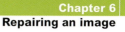

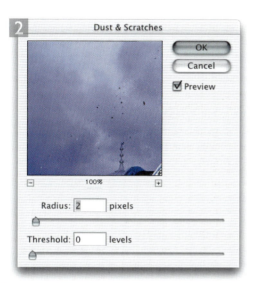

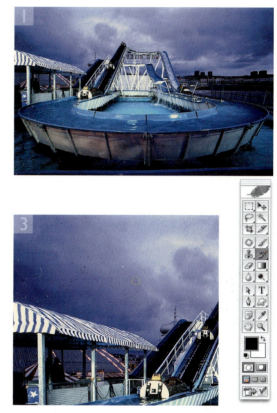

2 I went to the Filter menu and chose Noise ⇨ Remove Dust & Scratches to the image. I checked the filter dialog preview and adjusted the Amount and Threshold settings so that most of the marks appeared to have become dissolved away by the filter and clicked OK to apply this filtration to the image.

3 I then went to the History palette and clicked on the previous unfiltered image history state, but set the history brush source to paint from the filtered version. I selected the history brush and changed the history brush blending mode in the tool options bar to Lighten. As I painted over the dark spots, the history brush would lighten only those pixels that were lighter than the sampled history state. All other pixels remained unchanged.

4 I continued using the history brush in this way. To remove light spots, changing the tool blending mode to Darken to remove the dark marks

Healing brush settings

The default mode for the healing brush has the Aligned box unchecked. This makes sense, because when you are using the healing brush to specifically retouch just the skin tones (as shown in the accompanying example) you ideally want the sample point to always be made from the same area of skin tone texture. If you want to switch to retouching the backdrop (as in the second example) you can then set a fresh sample point that matches the texture of the background pixels.

Heal using 'All Layers'

In Photoshop CS the healing brush can now work on a new empty layer, just like you can with the clone stamp tool when you check the Use All Layers box in the Options bar (see page 163). So to carry out all your healing without permanently affecting the image, add a new layer above the background layer, select Use All Layers from the healing brush or patch tool options bar and carry out your healing and patch work on this separate layer. But be warned, if you work on large images in 16-bit mode, this may cause a potential slowdown in Photoshop's performance. You will need a fast computer in order to take full advantage of this flexibility.

The healing brush is used in the same way as the Clone Stamp tool, although it is important to stress that the healing brush is more than just a magic clone stamp and has its own unique characteristics and methods of working with it. You can establish a pixel sample point by ⎇ *alt* clicking an area of an image to sample from. You then release the ⎇ *alt* key and mouse and click in a new part of the image and paint with the healing brush to carry out your retouching.

After you set the sample point and paint with the healing brush, it will analyze the texture from the sample area and apply a blend to the painting area that merges the texture sampled from the sample point and smoothly blend this with the color and luminosity of the painting area. Around the outer edge of where you paint with the healing brush, a soft edge with a feathered radius of up to 10% is used to calculate a smooth transition of color and luminosity with the pixels outside the painting area. For this reason there is no need to use a soft edged brush and in fact you will find that you get more controlled results using a hard edged brush.

In practice, the healing brush is able to perfectly blend sampled pixels with the destination point. When you paint with the healing brush it can seem a little strange that you don't need to match the sample area with the color and lightness of the destination point. To get the best results you have only to look at matching the textures.

Although the healing brush can appear to be a miracle retouching tool once you get the hang of how it works, you still have to be careful about retouching any blemishes that are close to a sharp change in tonal contrast. The second example of how to use the healing brush (on page 170) illustrates the problem quite clearly. Even though a hard edged brush is being used, the healing brush stroke will tend to pick up the darker colored pixels adjoining the edge of the brush painting area (because it always analyzes the pixels immediately outside the brush painting radius).

1 The healing brush retouching can be carried out on the Background layer, on a copied background layer or an empty new layer. I selected the healing brush from the Tools palette and edited the brush style to make a hard edged brush. The brush blending mode should be Normal, the Source radio button checked and ideally the Aligned box left unchecked.

2 To use the healing brush, ⌥ *alt* click to define the source point. This should be a clean area of skin texture. You are now ready to retouch with the healing brush. In this example, I clicked on the areas of skin tone with the healing brush where I wished to remove a blemish. If you are using a pressure-sensitive tablet as an input device, then the default brush dynamics will be size-sensitive. I applied light pressure to paint with a small brush, and applied heavier pressure to get a full-sized brush.

3 I continued using the healing brush to complete the skin tone retouching. In this example I sampled one pixel source point for the chest and neck areas and another to retouch the face.

Client: Thomas McMillan.
Model: Sophie Boeson – Models One.

1 The healing brush is the perfect retouching tool to use when you are faced with the challenge of having to retouch blemishes against a backdrop such as the one shown here, especially where the backdrop contains gentle transitions of tone. It used to be extremely difficult to retouch backdrops in shots like this when all you had was the clone stamp tool.

2 A potential problem arises when you wish to retouch a blemish that is adjacent to a sudden shift in lightness or color.

3 In this picture you can see that even if you use the healing brush with a small hard edged brush, the brush may pick up the darker tones of the model's dress and you will get to see the ugly looking shading shown here.

4 The answer to the problem is to make a pre-selection first of the area you wish to heal (with maybe some minimal feathering) and thereby restrict the extent to which the healing brush tool analyzes the surrounding pixels.

Client: Anita Cox. Model: Steph at IMG.

Patch tool

The patch tool uses the same complex algebra as the healing brush to carry out its blend calculations, but the patch tool uses selection-defined areas instead of a brush. When the patch tool is selected, it initially operates in a lasso selection mode that can be used to define the area to patch from or patch to. For example, you can hold down the ⟍ *alt* key to temporarily convert the tool to become a polygonal lasso tool with which to draw straight line selection edges. You don't actually need the patch tool to define the selection, any selection tool or selection method can be used to prepare a patch selection. Once you have a selection made, select the patch tool to proceed to the next stage. As before, the patch tool has to work with either the Background layer or a copied pixel layer. One of the nice touches in Photoshop CS is the way that the Selection area in Source and Destination mode will preview the image as you drag to define the patch selection.

Source and Destination modes

In Destination mode you can drag the selection area with the patch tool to a new destination point and Photoshop will perform a healing blend calculation to merge the sampled patch area with the underlying pixels in the new area of the image. In Source mode you can drag the selection area with the patch tool to a new destination point to select the pixels that will replace those in the original source selection area. The Use Pattern button in the Options bar for the patch tool will let you fill a selected area with a preset pattern using a healing type blend.

1 The patch tool works in a way that is similar to the healing brush. Using the picture opposite, I can show you how the patch tool can be used in Source mode to cover up the metal staples that are holding the large pot together. When you select the patch tool you can use it just like the lasso tool to loosely define a selection area. For example, you can use the ⟍ *alt* modifier key to temporarily switch from free form lasso to polygonal lasso selection drawing mode. Or you can use any other preferred selection method (it really doesn't matter at this stage) as you prepare the image for patching.

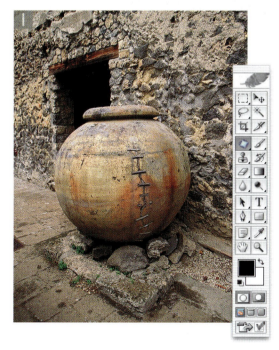

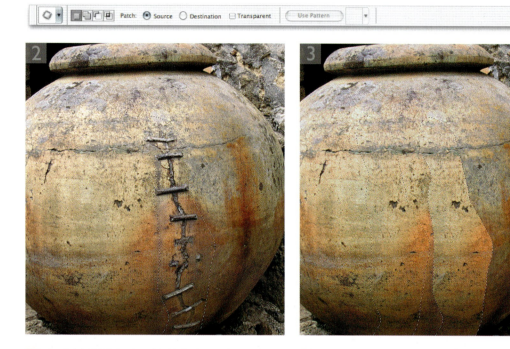

2 Having finished defining the selection for the area I wanted to patch, I made sure that the patch tool was selected in the Tools palette and dragged inside the selection to relocate it on an area of texture on the urn that I wished to sample from.

3 As I released the mouse, Photoshop commenced calculating a healing blend, analyzing the pixels from the source area I had just defined and using these to merge seamlessly with the pixels in the original selection area.

4 If the patch/healing process was successful, you should see an almost completely smooth join. The pixels that you select to be sampled from in the patch process will adjust their luminosity and color to blend with the pixels in the original defined area, to match the lighting and shade etc. However, you won't always get a 100% perfectly convincing result. In the example used here, I made a couple of attempts at patching the staples before finding a patch selection that worked well. Furthermore, as when using the Clone Stamp tool, you have to beware of any repeating patterns giving away the fact that the image has been cloned. I finished retouching this photograph by applying a few healing brush strokes to remove those telltale signs.

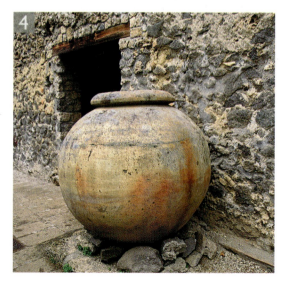

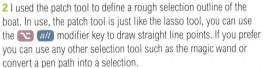

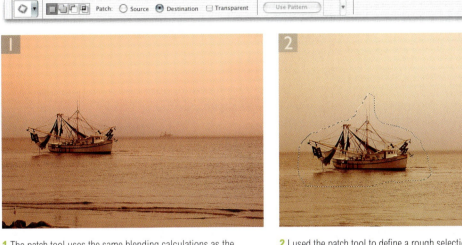

1 The patch tool uses the same blending calculations as the healing brush to perform its blend calculations. In this image I wanted to demonstrate how you can use the patch tool in Destination mode to make a duplicate of this fishing boat.

2 I used the patch tool to define a rough selection outline of the boat. In use, the patch tool is just like the lasso tool, you can use the ⌥ alt modifier key to draw straight line points. If you prefer you can use any other selection tool such as the magic wand or convert a pen path into a selection.

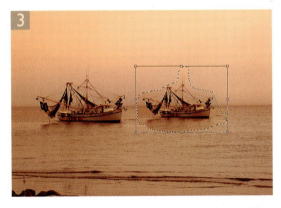

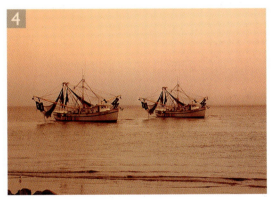

3 I made sure that Destination was selected in the Options bar. When the selection was complete, I used ⌘ ⌥ T ctrl alt T, which copied the pixel selection and added the free transform bounding box to the selected pixels. I dragged the transform to a new location. In this example I dragged the transform across to the right, aligned the center point to the horizon and held down the Shift ⌥ Shift alt keys, to scale the transform down in size to make the second boat smaller and appear to be further away in the distance.

4 I then hit Enter just to OK the transformation. After that I moused down with the patch tool inside the selection area and moved the selection very slightly. If you follow these steps precisely and release the copied selection, the patch tool will calculate how to merge the dropped selection with the underlying pixels. This will produce a smooth looking blend with the surrounding sky and sea area. The patch tool works well with a subject such as this, because the sea and sky provide a fairly smooth backdrop for blending the pixels smoothly.

Photograph: Thomas Fahey.

Healing brush modes

The healing brush has a choice of blending modes. The Replace mode is identical to the clone stamp tool, except it allows you to merge film grain more reliably and smoothly around the edges of your brush strokes. Or choose from a cutdown list of brush blending modes. The healing brush is already utilizing a special form of image blending to perform its work. The other healing brush blending modes can produce different results, but in my opinion they won't actually improve upon the ability of the healing brush in Normal mode.

Healing brush strategies

You can also use a pattern preset as the source for the healing brush or patch tool. You can either choose a pre-loaded preset or create your own. The Filter ⇨ Pattern Maker is ideal for this purpose as you can sample from just a small area of useful texture in an image and use the Pattern Maker to create a randomly generated pattern source that can be used to apply a smoothly blended texture over a larger area of the picture using the healing brush.

The following example illustrates how you can use the healing brush and patch tool to solve a rather more complex retouching problem. Although the healing brush and patch tool are natural candidates to use here, I needed to plan carefully how they would be used, as I also needed to rely on the clone stamp tool to do some of the preparation work, in particular where the edges of the selection to be healed extend to the edge of the document bounds.

1 Let us consider how we would go about covering up all the exposed bricks in the picture opposite, so as to match the remaining plaster work. Some of these areas are too large to use the patch tool in one operation. Notice how I prepared three paths to define some of the areas to be repaired, which closely follow the outline of the cactus leaves. These will be used in the following steps. To begin with, I converted Path 2 into a selection by dragging the Path 2 palette icon down to the Make Selection button in the Paths palette.

2 I then used this selection to copy the pixels to make a new layer. Choose: Layer ⇨ New ⇨ Layer via Copy (⌘ J ctrl J). I clicked on the Lock Transparency box in the Layers palette and selected the clone stamp, and was then able to clone some of the pixels in the image to provide a wall textured border edge on the left and the right. I did this in order to provide the healing brush or patch tool some edge pixels to work with. If I don't do this, Photoshop will try to create a patch blend that merges with the cactus leaf colors.

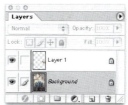

3 I could try selecting the healing brush and attempt to sample some of the plaster texture to fill in the remaining gap. In this and the other sections to be repaired, the area to be covered up was so large that I decided to create a new pattern based on a small selection of the image. I made the Background layer active and chose Pattern Maker from the Filter menu. I then marquee selected a small area as shown here.

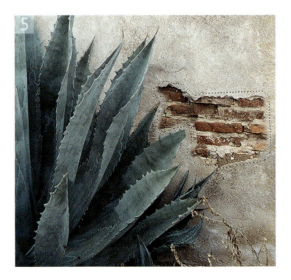

4 I made the tile area fairly large – 600 pixels square in this example, and I set the Smoothness setting to 3. If I click on the Generate button at the top of the dialog, the Pattern Maker will generate a randomized pattern that is a wraparound texture. The result of which is previewed in the dialog. I didn't need to click OK as this will apply the texture as a fill to the current image. Instead I clicked on the Save Preset Pattern button at the bottom of the dialog. Once I had named the new pattern, it was appended to the other Pattern presets.

5 I then activated Layer 1 again, selected the patch tool and drew a rough selection of the plaster wall area I had just prepared as shown in this close-up image.

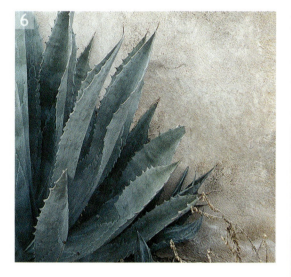

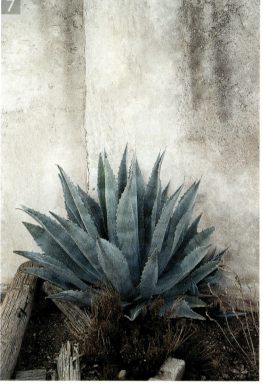

6&7 I selected this new custom pattern in the patch tool Options bar, then clicked the Use Pattern button. As you can see, Photoshop was able to calculate a perfectly smooth blend, and this was achieved using a texture pattern that had been synthesized in Photoshop. I repeated using this method on the other parts of the photograph and ended up with the finished result seen here.

Cloning selections

Cloning with the clone stamp tool is an acquired skill and to hide your cloning effectively, you need to keep changing the source point you are sampling from. If you don't, you may find parallel herringbone patterns betray signs of your retouching. The clone stamp tool always clones from the previous image state and does not resample the 'clone added' pixels. The previous techniques are suitable for many repair jobs, but it is not always practical to reconstruct everything using the clone stamp, healing brush or patch tool. This can matter where it is important to match the geometry of the photograph. The next example shows how to replace an area to be repaired with a cloned selection from another part of the same image.

1 In the following steps I wanted to demonstrate how to clone the windows in the building on the right. If I were to use the clone stamp tool to sample and copy the windows, then the perspective of the cloned windows would not match correctly. So instead, I made a selection of some of the windows in order to copy them as a new layer and then position this copied layer to match the correct perspective.

[🖋️ ▾ | ⬛⬛⬛⬛ | Feather: 3 px | ☑ Anti–aliased] 📷

2 I first make a rough selection of the area I was going to copy from. I selected the polygonal lasso tool and set the Feather to 3 pixels. I clicked with the polygonal lasso tool around the outside of the upper windows to make the selection as shown.

3 Now that I had a feathered selection of the windows, I went to the Layer menu and chose New ⇨ Via Copy (or you can use the keyboard shortcut ⌘ J ctrl J). The copied selection then appeared as a separate layer in the Layers palette. I selected the move tool and dragged the new layer down to where I wished to add the new windows.

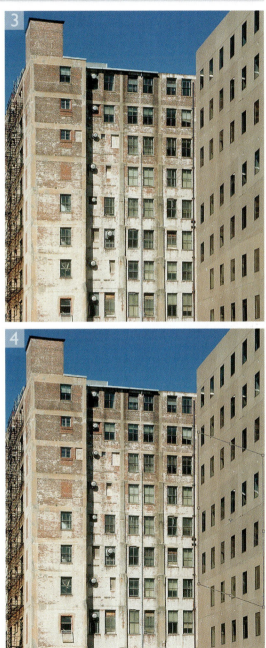

4 As was predicted, after they have been copied and repositioned, the cloned windows did not match the perspective of the rest of the building. I selected the Edit ⇨ Free Transform command. A bounding box appeared around the layer 1 contents. I held down the ⌘ Shift ctrl Shift and dragged the middle left handle upwards. I repeated with the middle right handle. (This modifier key combination will constrain the transform to a shear type transformation). I then dragged either the top or bottom middle handle to compensate for any vertical stretching. The photograph here shows how the layer 1 preview looked after the perspective correcting transformation had been applied. I then hit Enter to apply the transform.

Restoring a faded image

If you need to restore a photograph that suffers from uneven fading, the solution is to make an image adjustment to darken the photograph and then selectively remove this image adjustment to restore the areas which were not faded. The technique shown here uses adjustment layers, which provides a quick and easy way of allowing you to selectively apply an image adjustment.

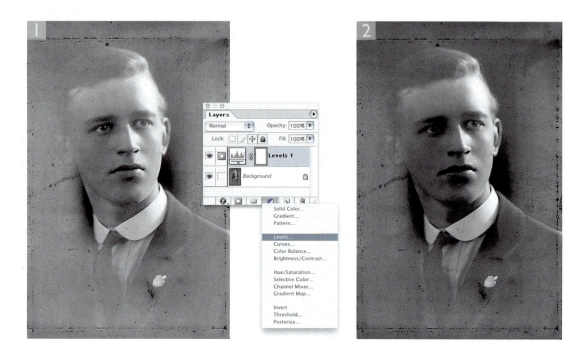

1 In this example, I wanted to restore the fading in an old photograph by using an adjustment layer. I first went to the Layers palette and clicked on the Create New Adjustment Layer button at the bottom of the palette and selected Levels from the pop-up menu.

2 The Levels dialog box will open. I wanted to darken the image with this levels adjustment layer, so I dragged the gamma input slider to the right. At this stage, the amount of darkening is not critical. Remember that adjustment layers do not permanently affect the image until after you flatten the image or merge down the adjustment layer.

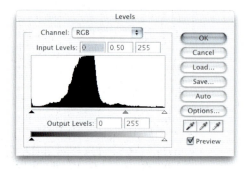

3 When the adjustment layer is selected, painting anywhere in the image area is just like painting on a layer mask linked to an image layer. To restore the lightness at the center of the photograph, I selected the gradient tool and selected the radial gradient mode in the Tool options bar. I then dragged with the radial gradient from the center outwards, using the default foreground/background colors, and the gradient options set to use the foreground to background gradient option. The Layer mask should look like the one in the layers palette below. If not, try pressing X to exchange the foreground and background colors.

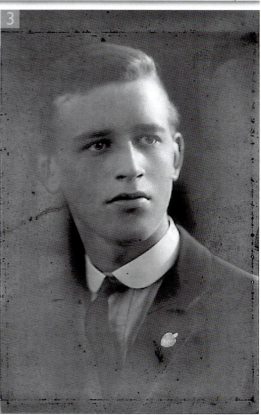

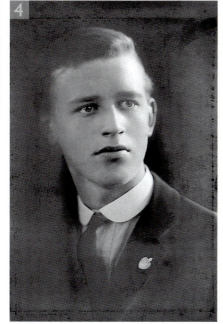

4 I double-clicked the levels adjustment layer in order to open the Levels dialog again and readjusted the levels to get the exposure balance of the masked image adjustment just right. I also modified the adjustment layer mask by making the adjustment layer active and selectively painted away, using a low opacity brush. In this final version, I also changed the layer blending mode from Normal to Multiply and reduced the blend opacity slightly. This darkened the outer edges while keeping the same lightness in the center.

Removing camera noise and moiré

The following technique was shown to me by Thomas Holm of Pixl in Denmark. Camera noise and moiré problems can often arise when you shoot digitally. Typical examples of this can be seen in the accompanying step-by-step examples. Digital noise can occur whenever you shoot at high ISO settings and especially in dark areas of the picture. If you are shooting in raw mode, one way to overcome this is to use the color noise filter in the Camera Raw dialog (see page 332). Failing that camera noise can be removed by duplicating the background layer, changing the

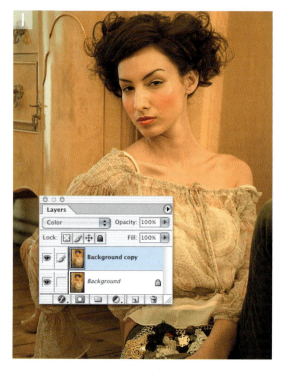

1 This photograph was shot digitally using a high ISO setting on the camera in low light conditions. Inevitably, the quality of the image capture was compromised by the presence of noise in the image. As in the previous example, I duplicated the background layer and changed the blend mode to Color.

Client: Impressions. Model: Jana at Isis.

2 I then went to the Filter menu and chose Blur ⇨ Gaussian Blur and applied a 5 pixel radius blur to the Background copy layer. This was enough blur to remove the color noise. Because the layer is blending in Color mode, the luminosity in the underlying Background layer is preserved. The left half of this image shows a comparison of the image with the noise removed.

1 In this digitally captured photograph, there is a moiré pattern visible on the fabric of the dress.

2 To remove the moiré pattern, I again copied the background layer, changed the blend mode to Color and applied the Gaussian blur filter to this layer. In this instance, more blur was required to eradicate the moiré.

blend mode to Color and applying the Gaussian Blur filter to the copied layer. When you use a color blending mode, the color information only is blurred and the luminosity (the detail information) remains unblurred.

A moiré pattern can also be dealt with in a similar way. Follow the same steps as for removing camera noise, but you may have to apply rather more Gaussian Blur to effectively remove all of the distracting pattern.

In a still-life setup, one solution would be to change the digital capture resolution (this applies to scanning backs mainly) or adjust the shooting distance slightly. And I would also advise applying a layer mask to the blurred layer and selectively painting in the blurred layer.

Luminosity blending

An alternative strategy is to duplicate the background layer, change the copied layer blending mode to Luminosity and blur the original, underlying layer. This method will produce the same result as converting an RGB image to Lab color mode, and individually blurring the 'a' and 'b' channels and converting back to RGB again. Except the layer blending mode is a lot quicker to use. I find that the methods described on these pages do a better job of retaining the color saturation.

Disguise your retouching

I have included in this chapter a mixture of Photoshop retouching techniques that would be useful for photographers and have selected a few specific Photoshop retouching tasks that demand a special approach, like how to retouch areas where there is not enough information to clone from. In one of the following examples, I show how to retouch using the paint brush and where it is important to carefully disguise your retouching. Unless you are careful, your brush strokes may not look as if they are part of the original photograph (excessive cloning, especially at low opacities, creates the same type of mushy result). The reason such brushwork tends to stand out is because the underlying film grain texture is missing. This can easily be remedied by introducing the Add Noise filter selectively to thc 'painted' pixels.

Blurring along a path

If you have a selection saved, this can be converted to a path (load the selection, go to the Paths palette and choose Make Work Path). You can use paths as a guideline for stroking with Photoshop tools. For example, the blur tool can be used to selectively soften an edge. So, if you want to soften the outline of an image element and have a matching selection saved, convert this to a path, select the blur tool and choose Stroke (Sub) Path from the Paths palette. And, of course, in the History palette you can always selectively paint back in the non-blurred image state data using the history brush.

Tool applications and characteristics

Some Photoshop tools are more suitable for retouching work than others. The blur tool is very useful for localized blurring – use it to soften edges that appear unnaturally sharp. Exercise caution when using the sharpen tool, as it has a tendency to produce unpleasant artifacts. If you wish to apply localized sharpening, follow the instructions described at the end of Chapter 5.

The smudge tool is a paint smearing tool. It is important to recognize the difference between this and the blur tool (which is best suited for merging pixels). The smudge tool is more of a painting tool, either used for blending in a foreground color or 'finger painting', smearing pixels across an image. Smudge strokes look odd on a photographic image unless you are trying to recreate the effect of Instant Polaroid™ smearing. A better smudge tool is the super putty plug-in which is part of the Pen Tools suite freely distributed by Wacom™. Some retouchers like to use the smudge tool to refine mask channels, working in Quickmask mode, and the smudge tool set to Finger Painting to drag out mask pixels to follow the outline of hair strands. I tend to stick with the brush tool and use this in conjunction with a pressure-sensitive graphic tablet device. Under the Other Dynamics options you can set to use a low stylus pressure to produce faint brush strokes. And under the Size Dynamics you can set the Size control to also be linked to the stylus pressure.

Brush blending modes

The painting and editing tools can be applied using a variety of blending modes which are identical to those you come across in layers and channel operations. You could try experimenting with all the different tool blending mode combinations but I wouldn't advise you do so, as it is unlikely you will ever want to use them all. I reckon that the following modes are probably the most useful: Screen, Multiply, Lighten, Darken and Color when combined with the paint brush, blur and gradient tools.

Beauty retouching

I photograph and retouch a lot of hair and beauty type photographs and sometimes get requested to tidy up the hair color where perhaps the roots are showing. I will first marquee the area and float it to a new layer so that if I don't like the result I can ditch the new layer. I sample a color from the area with the right hair color, then set the brush to Color mode and paint over the roots. When painting in Color mode, the lightness values which define the hair texture and shape are unaffected – only the color values are replaced. The saturation values remain unaffected, so it may be necessary to run over the area to be colored beforehand, desaturating the area and then coloring it in. Painting in Color mode has many uses. Artists who use Photoshop to colorize scanned line art drawings will regularly use the Color and other blending modes as they work. Painting using the Color blending mode is also ideal for hand coloring a black and white photograph.

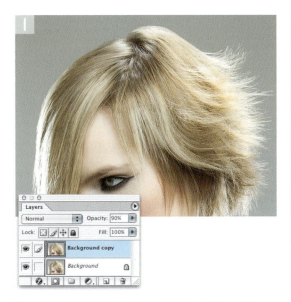

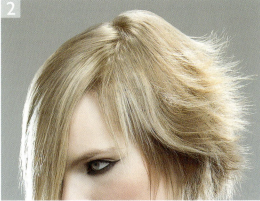

1 To disguise the hair roots that were showing, I duplicated the background layer, selected the brush tool and changed the brush blending mode to Color.

2 I held down the ⌥ *alt* key to sample a color from some of the lighter hair area and gently painted over the dark hair areas where the roots were showing most. This colorizes the hair. I then changed the brush blend mode to Soft Light and painted some more, gently adding more lightness to the hair. It sometimes helps to add a layer mask to the Background Copy layer and paint thin brush strokes to restore some of the hair shadows and achieve a smoother blend with the rest of the hair.

1 The first thing to retouch here are the eyes, which I nearly always want to lighten to some extent. I used the lasso tool to draw around the outline of the whites of the eyes. This selection does not have to be perfect – a reasonably steady hand is all you need! After that I went to the Select menu and chose Feather... and entered a feather radius of 1 or 2 pixels. After making the selection and feathering it, I moused down on the Adjustment Layer button at the bottom of the Layers palette and selected Curves. This will automatically add a Curves adjustment layer with a layer mask based on the selection just made. I normally draw a curve that will lighten the whites of the eyes and also increase the contrast between the whites and the iris. I also added a Hue/Saturation adjustment layer to gently reduce the saturation of the red veins in the eyes. I then 🔲 alt clicked between this and the Curves adjustment layer in the Layers palette to create a clipping group with the eye lightening adjustment layer.

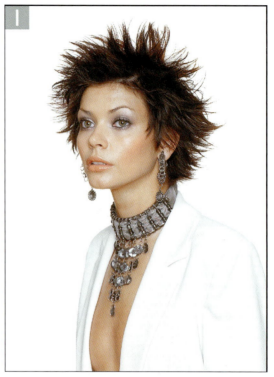

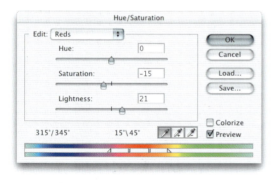

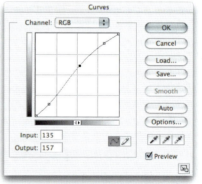

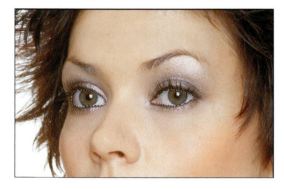

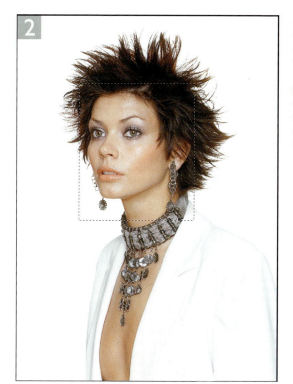

2 When you create a clipping group in the Layers palette, the clipped layer will be displayed indented with a downward pointing arrow, as shown in the Layers palette screen shot below. I next wanted to concentrate on retouching the face. This was done by marqueeing the head and making a new layer via copy (⌘ J ctrl J). This enabled me to modify the pixels on a separate layer, without permanently altering the background layer. Mistakes are easily made and this way I can always revert to the before version and compare the retouched layer with the original version of the image.

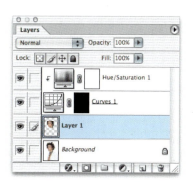

3 I do much of my beauty retouching using the brush tool on this copied layer. I prefer to use a pressure sensitive stylus and pad such as the Wacom Intuos™, because this allows me a much finer degree of control than I can get with a normal mouse. Whenever you select a painting type tool you can select from a number of options from the Brushes palette that will enable you to determine what aspects of the brush behavior (brush dynamics) will be governed by the way you use the pressure sensitive stylus. Photoshop will not just be aware of the amount of pressure you apply with the stylus. If you are using the Wacom Intuos™, Photoshop is now able to respond to input information such as the angle of tilt or the movement of the thumbwheel (if you have one). In the example shown here I have checked the Other Dynamics checkbox and selected Pen Pressure from the Control menu. In Photoshop CS, you can lock these brush attribute settings so that they stay fixed when you change brush presets.

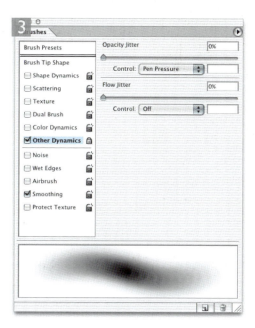

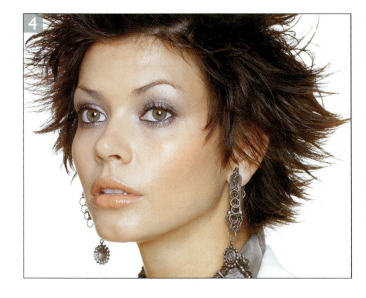

4 I began by painting with the brush tool in Lighten mode. When the brush tool is selected, you can sample a flesh tone color by ⌐ *alt* clicking in the image window. I then brushed lightly over the darker areas of the face such as underneath the eyes, to lighten the darker areas. When using Lighten mode only the pixels that are darker than the sampled color will be replaced. It is also a good idea to always keep resampling new colors as you paint.

5 I continued painting like this in Lighten mode to smooth other areas of the face. Where there were some shiny highlights, I switched to using the brush tool in Darken mode. I sampled a new color that was a touch darker than the highlights and painted over these areas to remove the shine. When using Darken mode only the pixels that are lighter than the sampled color will be replaced. I like to retouch at 'full volume' so to speak. Some fashion photographers quite like the super-retouched effect. Others will argue that too much retouching will make the model's skin look more like a plastic doll rather than that of a real woman. It is up to you, but I usually prefer to fade the opacity of the retouched layer. Try reducing the layer opacity down to somewhere between 55 to 85%. Doing so will restore more of the original skin texture. The final result will be retouched but look more convincing.

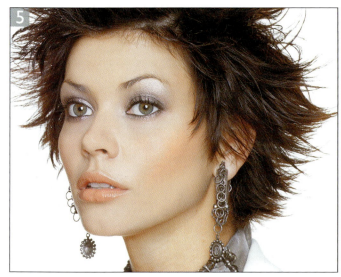

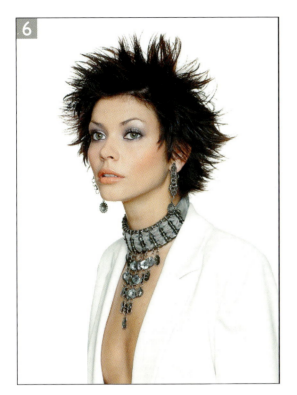

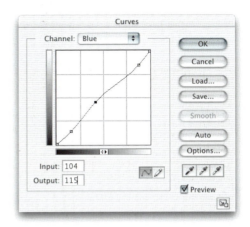

6 Finally, I introduced a curves adjustment to increase the contrast in the red and green color channels and decreased the contrast in the blue color channel, to produce a subtle cross processing type of look to the photograph.

Client: Andrew Price Salon.
Model: Lisa Moulson at MOT models.

Dodge and burn

The dodge and burn tools are certainly very handy, but they are not really suitable for use as the Photoshop equivalent of the darkroom printing methods. The tutorial featured earlier in this chapter showed you how to restore a faded photograph by using a combination of adjustment layers and a soft radial mask. So, to dodge or burn a large area of a picture, you are better off making a heavily feathered selection and applying a Levels or Curves image adjustment – the results will be a lot smoother. The dodge and burn tools are better suited for modifying small areas of a picture only and mostly using light opacity brush strokes.

Removing wrinkles

Cloning out facial wrinkles and such like can also be done with the dodge tool set to Midtones and applied with a smallish soft edged brush at low opacity (1–2%). After gently brushing with the dodge tool, you will notice how the lines start to disappear.

Montage Techniques

For a lot of people the real fun starts when you can use Photoshop to swap parts of one photograph with another and make composite photographs using different image elements. This chapter explains the different tools that can be used in montage work. I suggest some strategies for shooting pictures with a view to making a composite image as well as introducing image layers and showing you some of the other tools and methods that can be used to isolate picture elements from more general images. But to begin with we shall focus on some of the basic principles of how to make a selection and the interrelationship between alpha channels, masks, Quick mask mode, paths and selections.

Selections and channels

When you read somewhere about masks, mask channels, image layer mask channels, alpha channels, Quick masks and saved selections, they are basically all the same thing: either an active, semipermanent or permanently saved selection. We will begin with defining a selection. There are several tools you can use to do this – the marquee, lasso, magic wand and Select ⇨ Color Range. The marquee comes in four flavors: rectangular, oval, single pixel horizontal row and vertical column. The lasso has three modes – one for freehand, another for polygon (point by point) drawing and a magnetic lasso tool. When you use a selection tool to define an area within an image (see Figure 11.1), you will notice that a selection is defined by a border of marching ants. Selections are only temporary. If you make a selection and accidentally click outside the selected area with the selection tool, it will disappear – although you can restore the selection with Edit ⇨ Undo (⌘ Z ctrl Z).

During a typical Photoshop session, I will draw basic selections to define areas of the image where I want to carry out image adjustments and afterwards deselect them. If you end up spending any length of time preparing a selection then you will usually want to save the selection as an alpha channel (also referred to as a mask channel). To do this, choose Save Selection from the Select menu. The dialog box will ask if you want to save as a new selection. Doing so creates a brand new alpha channel. If you check the Channels palette, you will notice the selection appears there labeled as an alpha channel (#4 in RGB mode, #5 if in CMYK mode). To reactivate this saved selection, choose 'Load Selection' from the Select menu and select the appropriate channel number from the sub-menu, or ⌘ ctrl click the alpha channel in the Channels palette.

You can also create a new alpha channel by clicking on the Make New Channel button at the bottom of the Channels palette and fill the empty new channel with a gradient or paint in the alpha channel with a painting tool using the default white or black colors. This new channel can then be converted into a selection.

Figure 7.1 The right half of the image shows a feathered selection (feathering is discussed later in this chapter) and the left half the Quick mask mode equivalent display.

Quickmasks

To see how a selection looks as a mask, switch to Quick mask mode (click on the right-hand icon third up from the bottom in the Tools palette). Now you see the selection areas as a transparent colored overlay mask. If the mask color is too similar to the subject image, double-click the Quick mask icon, click on the Color box in the opened dialog and choose a different color with the Color Picker. In Quick mask mode (or when working directly on the alpha channel) you can use any combination of Photoshop paint tools, Image adjustments to modify the alpha channel content. To revert from a Quick mask to a selection, click the selection icon in the Tools palette (a quick tip is to press Q to toggle between the two modes).

Reloading selections

To reload a selection from the saved mask channel, go to Select ⇨ Load Selection. ⌘ ctrl clicking a channel is the other shortcut for loading selection and by extension, combining ⌘ ⌥ channel # ctrl alt channel # (where # equals the channel number) does the same thing. Alternatively you can also drag the channel icon down to the Make Selection button in the Channels palette.

Selections

In marching ants mode, a selection is active and available for use. All image modifications made will be effective within the selected area only. Selections are temporary and can be deselected by clicking outside the selection area with a selection tool or choose Select ⇨ Deselect (⌘ D ctrl D).

Quick mask mode

A semipermanent selection, whereby you can view a selection as a transparent colored mask overlay. To switch to Quick mask mode from a selection, click on the Quick mask icon in the Tools palette or use the keyboard shortcut 'Q' to toggle between selection and Quick mask mode. Quick mask modifications can be carried out using any of the fill or paint tools.

Alpha channels

A selection can be stored as a saved selection, converting it to become a new alpha channel (Select ⇨ Save Selection). A selection can be reactivated by loading a selection from the saved channel (Select ⇨ Load Selection). Alpha channels contain 256 shades of gray, 8-bit information. An anti-aliased selection, or one that has been modified in Quick mask mode with the fill and paint tools, will contain graduated tonal information. An active alpha channel (click on the channel in the Channels palette to make it active) can be manipulated any way you want in Photoshop. A saved channel can be viewed as a colored transparent mask, overlaying the composite channel image, similar in appearance to a Quick mask. To view an alpha channel this way, click on the eye icon next to the alpha channel.

Work paths

A work path can be created in Photoshop using the pen tool in work path mode. A path is (among other things) an alternative method for defining an image outline. A work path (closed or not) can be converted to a foreground fill, stroke or a selection. For example, in the Paths palette,

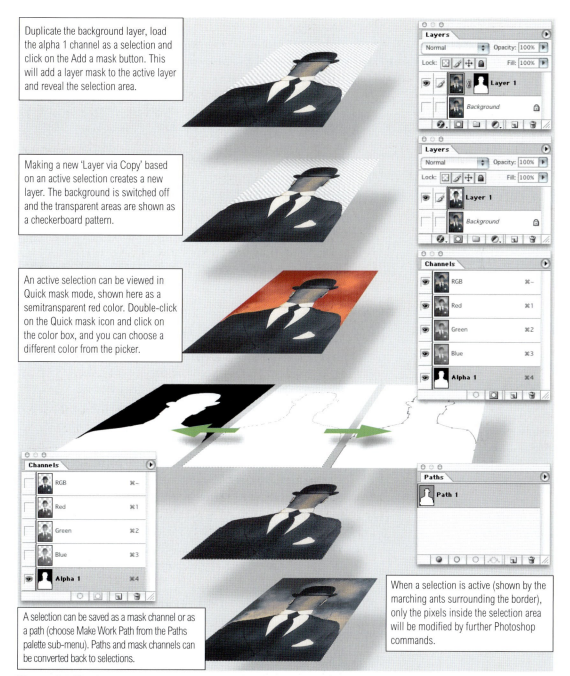

Duplicate the background layer, load the alpha 1 channel as a selection and click on the Add a mask button. This will add a layer mask to the active layer and reveal the selection area.

Making a new 'Layer via Copy' based on an active selection creates a new layer. The background is switched off and the transparent areas are shown as a checkerboard pattern.

An active selection can be viewed in Quick mask mode, shown here as a semitransparent red color. Double-click on the Quick mask icon and click on the color box, and you can choose a different color from the picker.

A selection can be saved as a mask channel or as a path (choose Make Work Path from the Paths palette sub-menu). Paths and mask channels can be converted back to selections.

When a selection is active (shown by the marching ants surrounding the border), only the pixels inside the selection area will be modified by further Photoshop commands.

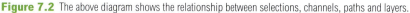

Figure 7.2 The above diagram shows the relationship between selections, channels, paths and layers.

Selection modifier keys

To add to a selection with a selection tool, hold down the Shift key as you drag. To subtract from a selection with a selection tool, hold down the alt key as you drag. To intersect a selection with a selection tool, hold down the Shift alt Shift keys as you drag.

Expanding and shrinking

To expand or shrink a selection, choose Select ⇨ Modify ⇨ Expand/Contract. Selections can be modified up to a maximum of 100 pixels (but produces angled corners when expanding a rectangular marquee selection). Other options include Border and Smooth. To see how these work, make a selection and choose Select ⇨ Modify options. Enter various pixel amounts and inspect the results by switching from selection to Quick mask mode. The border modification feature is rather crude and can be improved by applying feathering or saving the selection as a channel and filtering with Gaussian blur. An example of a border modification is featured in the Extract tutorial on page 232.

There is an inherent flaw in Photoshop that creates angled corners when you use Expand Selection. The most accurate way to expand an active selection is to choose: Select ⇨ Transform Selection, and use the bounding box handles to scale a selection more accurately.

drag the path icon down to one of the buttons such as the Make Selection button. An active selection can be saved as a path – choose Make Path from the Paths palette sub-menu. Saving a selection as a path occupies just a few kilobytes of file space. This is only more economical than saving as an alpha channel if you are saving in the TIFF, PSD or PDF format. Paths cannot save graduated tone selections though. A saved path can only generate a non-anti-aliased, anti-aliased or feathered selection, but we'll come to that later on in the chapter. A path can be used to define a vector mask (which will mask a layer's contents) or it can be used in Create Shape Layer mode to add a filled layer which is auto masked as you define a path outline.

Modifying selections

As was mentioned in Chapter 6, to modify the content of a selection you need to learn how to coordinate the use of the modifier keys with the dragging of the mouse as you define a selection. While the lasso or marquee is still selected, placing the cursor inside the selection and dragging moves the selection boundary position, but not the selection contents. The magic wand is a selection tool too – click with the wand, holding down the appropriate key(s) to add or subtract from a selection

Smoothing and enlarging a selection

Selections that are made using the magic wand or Color Range method, under close inspection are rarely complete. The Smooth option in the Select ⇨ Modify sub-menu addresses this by enabling you to smooth out the pixels selected or not selected to the level of tolerance you set in the dialog box.

Anti-aliasing and feathering

All selections and converted selections are by default anti-aliased. A bitmapped image consists of a grid of square pixels. Without anti-aliasing, a diagonal line would be represented by a sawtooth of jagged pixels. Photoshop gets round this problem by anti-aliasing the edges – filling the

gaps with in-between tonal values. All non-vertical/
horizontal sharp edges are rendered smoother by this
process. Therefore anti-aliasing is chosen by default. There
are only a few occasions when you may wish to turn it off.
Sometimes you have an 8-bit image which resembles a 1-bit
data file (say an alpha channel after you have applied the
Threshold command) which needs to be anti-aliased. If it is
just a small portion that requires correction, use the blur
tool to lightly soften the edge, otherwise follow the
technique on the following page.

To soften a selection edge, go to the Select menu,
choose Feather and enter the pixel radius value to feather
by. A value between 1.0 or 2.0 is enough to dampen the

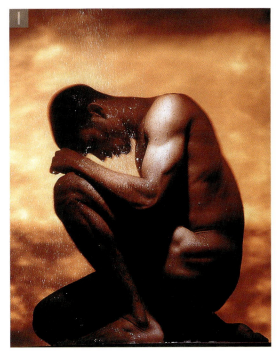

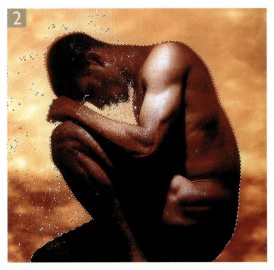

2 The magic wand tool may not select all the desired backdrop
pixels. I chose Select ⇨ Modify ⇨ Smooth, and entered a Radius
value of between 1 and 16. The selection is now a lot smoother.
Smooth works like this: if the Radius chosen was 5, Photoshop will
examine all pixels with an 11 × 11 pixel block around each pixel. If
more than half are selected, any stray pixels will be selected as well.
If less than half are selected, any stray pixels will be deselected.

1 The objective here was to make a simple soft edged selection
based on tonal values and change the color of the background
slightly. I used the magic wand tool to make a selection of the
backdrop. A tolerance setting of 25 was used. I enlarged the
selection locally by choosing Select ⇨ Grow. Note that the amount
of growth is governed by the tolerance values linked to the magic
wand tool options.

3 With the selection satisfactorily complete, I hid the selection edges (View ⇨ Hide Extras) and opened the Hue/Saturation dialog box. Adjust the Hue and Saturation sliders to color the selected area.

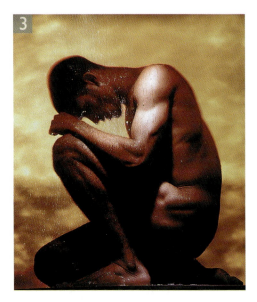

Photograph by Eric Richmond.

Grow and Similar

The Grow and Similar options enlarge the selection using the same criteria as with the magic wand tool, regardless of whether the original selection was created with the wand or not. To determine the range of color levels to expand the selection by, enter a tolerance value in the Options palette. A higher tolerance value means that a wider range of color levels will be included in the enlarged selection.

The Select Ô Grow option expands the selection, adding contiguous pixels, i.e. those immediately surrounding the original selection of the same color values within the specified tolerance. The Select ⇨ Similar option selects more pixels from anywhere in the image of the same color values within the specified tolerance.

sharpness of a selection outline, but you can select a much higher radius. For example, if you want to create a custom vignette effect, use the lasso tool to define the outline, feather the selection heavily (50–100 pixels or more depending on file size), invert the selection and apply a Levels or Curves adjustment. This will enable you to lighten or darken the outside edges with a smooth vignette.

Layers

Layers are like images on pin-registered actetates overlaying a print, the background image. Figure 7.2 shows an example of a layered image. You can now add as many new layers as you like to a document up to a new limit of 8000. Every time you drag and drop the contents from one document window into another using the move tool, it becomes a new layer in the destination document. New empty layers can be created by clicking the New Layer button in the Layers palette. A new layer can also be made based on a selection. Choose Layer ⇨ New via copy (⌘ J / ctrl J). This will 'float' the selection contents, duplicating them to become a new layer in register with the image below. Layers are individually controllable image

elements. In any multilayered document, you can selectively choose which layers are to be viewed (by selecting and deselecting the eye icons), link layers together in groups, arrange groups of layers into layer sets, merge linked layers or merge just those that are visible. To rename a layer in Photoshop, simply double-click the layer name. The same is also now true for the Paths and Channels palettes. Layers are easily discarded – just drag the layer icon to the Layers palette delete button. There is also a Delete Hidden Layers command in both the Layers palette sub-menu and the Layer ⇨ Delete sub-menu. To duplicate a layer, drag the layer icon to the New Layer button.

Smoother edges

Anti-aliasing sorts out the problem of jagged edges. Selections usually need to be softened more than this. It is obvious when a photograph has been retouched or montaged, when the edges of a picture element are too sharply defined – the result looks unnatural. The secret of good compositing lies in keeping the edges of your picture elements looking soft and not too hard.

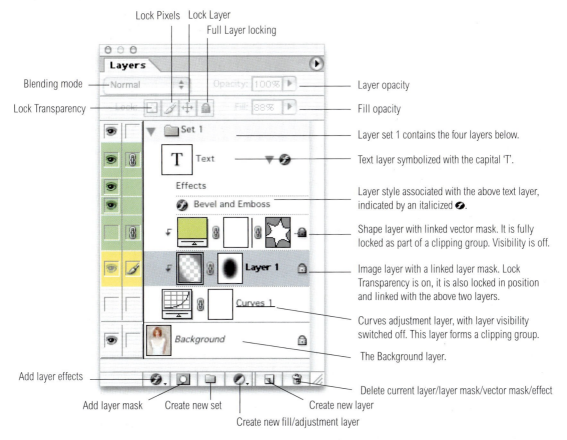

Lock Pixels Lock Layer

Full Layer locking

Blending mode — Normal

Lock Transparency —— Lock

Layer opacity

Fill opacity

Set 1 — Layer set 1 contains the four layers below.

T Text — Text layer symbolized with the capital 'T'.

Effects

Bevel and Emboss — Layer style associated with the above text layer, indicated by an italicized ●.

Shape layer with linked vector mask. It is fully locked as part of a clipping group. Visibility is off.

Layer 1 — Image layer with a linked layer mask. Lock Transparency is on, it is also locked in position and linked with the above two layers.

Curves 1 — Curves adjustment layer, with layer visibility switched off. This layer forms a clipping group.

Background — The Background layer.

Add layer effects

Delete current layer/layer mask/vector mask/effect

Add layer mask Create new set Create new layer

Create new fill/adjustment layer

Figure 7.3 This is an overview of the Photoshop Layers palette. Note how the layers that belong to a set are colored a light gray in the layer stack and also indented. Photoshop allows you to label layers with different colors as well as rename them.

Layer Blending Modes

Figure 7.4 The following pages illustrate all the different blending modes in Photoshop. In these examples, the photograph of the model was added as a new layer above the gray textured background layer and the layer settings recorded in the accompanying palette screen shot.

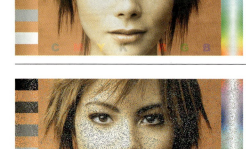

Normal

This is the default mode. Changing opacity simply fades the intensity of overlaying pixels by averaging the color pixels of the blend layer with the values of the composite pixels below (Opacity set to 80%).

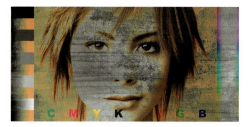

Dissolve

Combines the blend layer with the base using a randomized pattern of pixels. No change occurs when using Dissolve at 100% opacity. As the opacity is reduced, the diffusion becomes more apparent (Opacity set to 80%).

Darken

Looks at the base and blending colors and color is only applied if the blend color is darker than the base color.

Multiply

Multiplies the base by the blend pixel values, always producing a darker color, except where the blend color is white. The effect is similar to viewing two transparency slides sandwiched together on a lightbox.

Color Burn

Darkens the image using the blend color. The darker the color, the more pronounced the effect. Blending with white has no effect.

Linear Burn

The Linear Burn mode produces an even more pronounced darkening effect than Multiply or Color Burn. Note that the Linear Burn blending mode will clip the darker pixel values. Blending with white has no effect.

Lighten

Looks at the base and blending colors and color is only applied if the blend color is lighter than the base color.

Screen

Multiplies the inverse of the blend and base pixel values together, always making a lighter color, except where the blend color is black. The effect is similar to printing with two negatives sandwiched together in the enlarger.

Color Dodge

Brightens the image using the blend color. The brighter the color, the more pronounced the effect. Blending with black has no effect (Opacity set to 80%).

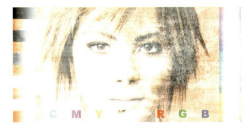

Linear Dodge

This blending mode does the opposite of the Linear Burn tool. It produces a stronger lightening effect than Screen or Lighten, but will clip the lighter pixel values. Blending with black has no effect.

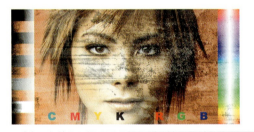

Overlay

The Overlay blending mode superimposes the blend image on the base (multiplying or screening the colors depending on the base color) whilst preserving the highlights and shadows of the base color. Blending with 50% gray has no effect.

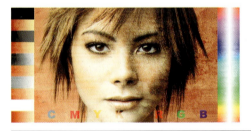

Soft Light

Darkens or lightens the colors depending on the base color. Soft Light produces a more gentle effect than the Overlay mode. Blending with 50% gray has no effect.

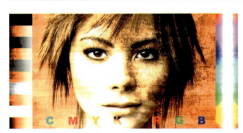

Hard Light

Multiplies or screens the colors depending on the base color. Hard Light produces a more pronounced effect than the Overlay mode. Blending with 50% gray has no effect.

Vivid Light

Applies a Color Dodge or Color Burn blending mode, depending on the base color. Vivid Light produces a stronger effect than Hard Light mode. Blending with 50% gray has no effect.

Linear Light

Applies a Linear Dodge or Linear Burn blending mode, depending on the base color. Linear Light produces a slightly stronger effect than the Vivid Light mode. Blending with 50% gray has no effect.

Pin Light

Applies a Lighten blend mode to the lighter colors and a Darken blend mode to the darker colors. Pin Light produces a stronger effect than Soft Light mode. Blending with 50% gray has no effect.

Hard Mix

Produces a posterized image consisting of up to eight colors: red, green, blue, cyan, magenta, yellow, black and white. The blend color is a product of the base color and the luminosity of the blend layer.

Difference

Subtracts either the base color from the blending color or the blending color from the base, depending on whichever has the highest brightness value. In visual terms, a 100% white blend value will invert (i.e. turn negative) the base layer completely, a black value will have no effect and values in between will partially invert the base layer. Duplicating a background layer and applying Difference at 100% will produce a black image. Dramatic changes can be gained by experimenting with different opacities. An analytical application of Difference is to do a pin register sandwich of two near identical images to detect any image changes – such as a comparison of two images in different RGB color spaces, for example.

Exclusion

A slightly muted variant of the Difference blending mode. Blending with pure white will invert the base image.

Hue

Preserves the luminance and saturation of the base image, replacing with the hue of the blending pixels.

Saturation

Preserves the luminance and hue of the base image, replacing with the saturation of the blending pixels.

Color

Preserves the luminance values of the base image, replacing the hue and saturation values of the blending pixels. Color mode is particularly suited for hand coloring photographs.

Luminosity

Preserves the hue and saturation of the base image while applying the luminance of the blending pixels.

Client: Taylor Phillipps. Model: Tina at FM.

Masking layers

There are two ways to mask a layer in Photoshop. Portions of the layer image can be removed by adding either a layer mask or a vector mask to the individual layer, which will hide the layer contents. Layer masks are defined using a pixel-based mask while vector masks are defined using path outlines. Either method (or both) can be used to mask unwanted areas in a layer, and do so without permanently erasing the layer contents. By using a layer mask to hide rather than erase unwanted image areas, you can go back and change the mask at a later date. Or if you make a mistake when editing the layer mask, it is easy to correct mistakes – you are not limited to a single level of undo.

Adding a selection-based image layer mask

To add a layer mask based on a selection, highlight a layer, make the selection active and click on the Add Layer Mask button at the bottom of the Layer menu. Or, choose Layer ⇨ Add Layer Mask ⇨ Reveal Selection. To add a layer mask to a layer with the area within the selection hidden, choose Layer ⇨ Add Layer Mask ⇨ Hide Selection. Or *alt* click the Layer Mask button in the Layers palette. Choosing 'Add Layer Mask ⇨ Reveal Selection' was how I created the top layer in Figure 7.2. A layer mask is active when a thin black border appears around the layer mask icon and the Brush icon in the Layers palette changes to a circle surrounded by gray (⊡).

Applying and removing image layer masks

There are several ways to remove a layer mask. From the Layer menu, choose Layer ⇨ Remove Layer Mask. A dialog box asks do you want to Discard, Cancel the operation or Apply the layer mask? Select either option and click OK. With the mask icon for the layer selected in the Layers palette, click on the palette delete button or drag the active layer mask icon to the delete button. The same dialog box appears asking do you want to Discard, Cancel the operation, or Apply the layer mask? To temporarily disable a layer mask, choose Layer ⇨ Disable Layer Mask.

Adding an empty image layer mask

If you create an empty layer mask (one that is filled with white) on a layer, you can hide pixels in a layer using the fill and paint tools. To add a layer mask to a layer with all the layer remaining visible, click the Layer Mask button in the Layers palette. Alternatively, choose Layer ⇨ Add Layer Mask ⇨ Reveal All. To add a layer mask to a layer that hides all the pixels, *alt* click the Add Layer Mask button in the Layers palette. Alternatively, choose Layer ⇨ Add Layer Mask ⇨ Hide All. This will add a layer mask filled with black.

Viewing in Mask or Rubylith mode

The small Layer Mask icon shows you roughly how the mask looks. You can if you wish view the mask on its own as a full screen image: *alt* click the Layer Mask icon to view the layer mask as a full mask. *Shift* *alt Shift* click to display the layer mask as a transparent overlay (rubylith). Both these actions can be toggled.

Hiding/showing layer/vector masks

You can temporarily hide/show a layer mask by *Shift* clicking on the layer mask icon. Also, clicking a vector mask's icon in the Layers palette hides the path itself. Once hidden, hover over it with the cursor and it will temporarily become visible. Click it to restore visibility.

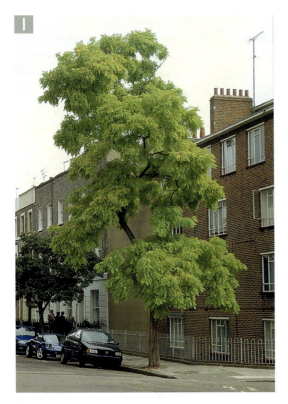

1 An alpha channel can contain up to 256 levels of gray. Alpha channels are typically used to create black and white masks like the one shown in step 2.

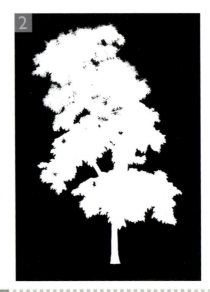

2 This shows the alpha channel mask in isolation. This is an alpha channel I had created which was designed to define the outline of the tree so that I could use it to extract the tree from its surroundings. How you would go about making such a mask is discussed later in this chapter.

3 In this example. I duplicated the Background layer and converted the alpha channel mask to a selection. I then clicked on the Add layer mask button in the Layers palette, which automatically added the layer mask shown in the Layers palette below. To display the masked layer on its own, I clicked the Background layer eyeball icon.

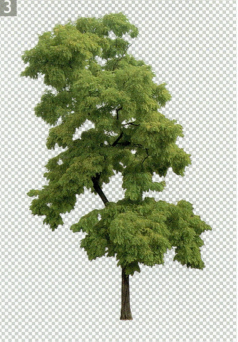

To reverse this, choose Layer ⇨ Enable Layer Mask. Another shortcut is to *Shift* click the Layer Mask icon to disable, click again to enable. When a layer mask is disabled the icon is overlaid with a red cross. *ctrl* right mouse-click the mask icon to open the full list of contextual menu options to apply, discard or disable a layer mask.

Vector masks

A vector mask is just like an image layer mask, except the masking is described using a vector path. A vector mask can be edited using the pen path tools or the shape geometry tools. Because a vector mask is vector based, it is resolution-independent and can be transformed or scaled to any size without a loss in image quality. To add a vector mask from an existing work path, go to the Paths palette, make a work path there active and choose Layer ⇨ Add Vector Mask ⇨ Current Path.

Vector mask display

You will notice that a vector mask icon is represented by a path outline. The gray fill represents the hidden areas. This visual clue will become important when you wish to make a hole in the layer and need to draw an additional path in subtract mode, which is placed inside the first and subtracts from it. An example of this scenario is shown later in the Spirit of St Louis tutorial.

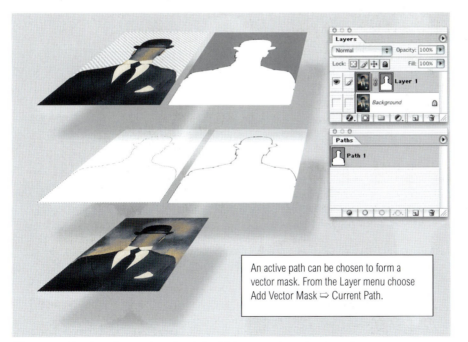

An active path can be chosen to form a vector mask. From the Layer menu choose Add Vector Mask ⇨ Current Path.

Figure 7.5 The above diagram shows the relationship between paths and vector masks.

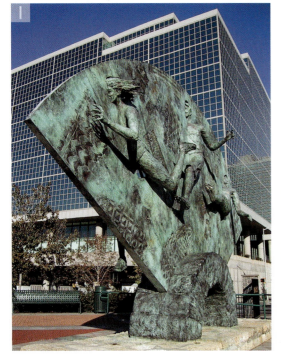

1 I used the pen tool to define the outline of this park sculpture. Note that the pen tool has to be in path mode (circled in blue in the Options bar). And because I wanted to create a path that selected everything outside the enclosed path, I checked the Subtract from path area button (circled in red) before I began drawing the path.

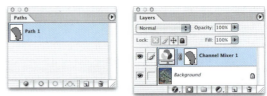

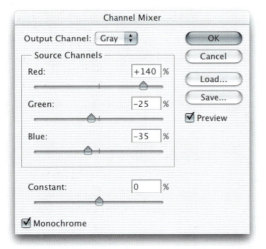

2 With the work path active, I clicked on the New adjustment layer button in the Layers palette and selected Channel Mixer. This added an adjustment layer with a linked vector mask. I used Channel Mixer to make a black and white conversion of the areas selected by the vector mask. You can use Layer ➡ Change Layer Content to switch between different types of adjustment/fill layers. To edit a vector mask, use the direct path selection tool to manipulate the path outline.

Channel Mixer

Output Channel: Gray

OK
Cancel
Load...
Save...
☑ Preview

Source Channels

Red: +140 %

Green: -25 %

Blue: -35 %

Constant: 0 %

☑ Monochrome

Working with multiple layers

Layers have become such an essential Photoshop feature for doing complex montage work. When working with more than one layer you can choose to link layers together by creating links in the Layers palette. To do this, click in the column space between the eye icon and the layer name – you will see a link icon appear. When two or more layers are linked, movement or transform operations will be applied to the linked layers as if they were one, but they still remain as separate layers, retaining their individual opacity and blending modes. To unlink a layer, click on the link icon to switch it off.

Layer masks and vector masks are by default linked to the layer content. If you move a masked layer, the mask moves with it, as long as no selection is active – then any movement or transformation of the layer content will be carried out independently of the associated mask. Switch off the link between layer mask/vector mask and the layer, then the two become unlinked. Any further movements or changes can now be applied to the layer or the layer/vector mask separately. You can tell if the layer or the layer/vector mask are selected – a thin black border surrounds the layer or layer mask icon and the icon the right of the eye icon changes from a paint brush to a selection icon.

Layer set management

Layers can now be organized more efficiently in sets. This brings several advantages: because multilayered documents can be grouped together inside the Layers palette in layer folders or 'sets', the Layers palette stack can be made less cluttered and groups of layers in a complex document can therefore be organized more logically. Layers grouped in a set can be made visible/invisible by clicking on the Layer set eye icon. It is possible to adjust the opacity and blending mode of a set as if it were a single layer, while the layers inside the set itself can contain subsets of layers with individually set opacities and blend modes or adjustment layers. You can also add a layer mask or vector mask to a layer set and use this to edit the layer set visibility as you

Figure 7.6 The layers palette contains two layers. The selected layer is the one highlighted in blue. The border line around the image layer icon, indicates that the image layer is active and any editing operations will be carried out on the image layer only. There is no link icon between the image layer and the layer mask. This means that the image layer can be moved independent of the layer mask.

Figure 7.7 In this next palette screen shot, the border surrounding the layer mask indicates that the layer mask is active and that any editing operations will be carried out on the layer mask only and not the image layer. The third icon is a vector mask. The link icons indicate that the image layer, layer mask and vector mask are all linked together.

Nested layer sets

New to Photoshop CS are nested layer sets. You can now have a layer set (or sets) within a layer set up to three nested sets deep.

Layer sets

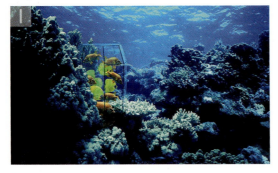
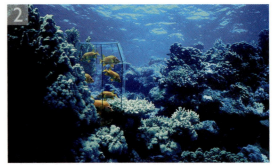

1 A total of forty-six layers were used in the construction of this image. When a Photoshop document ends up with this many layers, the layer stack can become extremely unwieldy. It is possible to organize layers within layer sets. All the layers which relate to the yellow butterfly fish are grouped together in a single layer set folder. I was able to group them by *Shift* clicking on the fish in the document window using the move tool in Auto Select mode. This linked each layer I clicked on. I then chose New Set From Linked... from the Layers palette menu.

2 The visibility of all layers in a set can be switched on or off and the opacity of the layer set group can be adjusted as if all the layers were a merged layer. Double-clicking a layer set will call up the Layer Set Properties dialog. Here you can select a label color and rename the set.

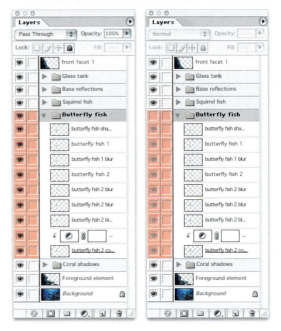

Photograph: Peter Hince. Client: Araldite. Agency: Warman & Bannister.

would with an individual layer. To reposition a layer, click on the layer and drag it up or down the layer stack. To move a layer into a set, drag it to the set icon or into the open set list. Dragging a layer down and to the left of the icon of the last layer in a set and releasing will move the layer out of the set. To drag the last layer in a set out of that set, drag it across to the left and release. Clicking on the Create a new set button will add a layer set above the

current target layer. ⌘ *ctrl* clicking on the Create a new
set button will add a layer set below the target layer.
⌥ *alt* clicking opens the New Layer Set dialog. You can
also lock all layers inside a set via the Layers palette sub-
menu.

Advanced blending options

Layer sets allow you to group a number of layers together
such that the layers contained within a set are in effect like
a single layer. In Pass Through blending mode the layer
blending passes through the set and the interaction is no
different than if the individual layers were in a normal
layer stack. However, when you select any other blending
mode, this is equivalent to what would happen if you chose
to merge all the layers in the current set and made them
become a single layer.

Among the Advance Blending modes, the Knockout
blending options enable you to force a layer to punch
through some or all of the layers underneath it. A Shallow
knockout will punch through to the bottom of the layer set.
A Deep knockout will punch through to just above the
Background layer. Layer styles are normally applied
independent of the layer blending mode. When you check
the Blend Interior Effects as Group box, such effects will
take on the blending characteristics of the selected layer.
Try opening the image shown on page 210 from the CD
disk and observe the Blend Interior Effects options using
Layer C which is using the Difference blending mode. The
result is the same as if you had 'fixed' the interior layer
effect in normal mode and then changed the blend mode to
Difference. Other aspects of the Layer Style blending
options dialog box are covered in Chapter 9.

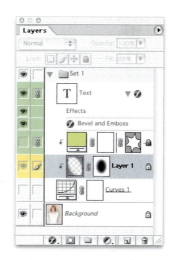

Figure 7.8 Layers can be color coded.
Choose Layer Properties from the Layers palette
fly-out menu and pick a color to identify each of
the layers with.

Layer locking

Layers and their contents can be locked in a number of
ways. The Lock Transparency option is identical to the old
Preserve Transparency checkbox. When Lock
Transparency is switched on, any painting you do to that

1 The four letter layers shown here are grouped together in a set. Layer A is using the Multiply blending mode; B is using Overlay; C is using Difference; and D is using the Screen blending mode. The blending mode of the set these layers are contained in is 'Pass Through'. This means that the layers in the set blend with the layers below the same as they would if they were in a normal layer stack.

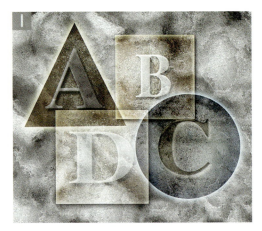

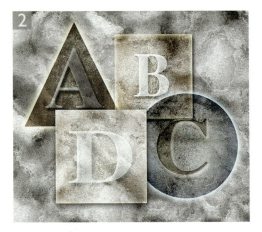

2 If I select Layer D and ⌥ *alt* +double-click the layer to open the Layer Style dialog, I can alter the advanced blending options. The Knockout option allows you to 'punch through' the layers. A 'Deep' knockout will make Layer D punch through the three layers below it, straight down to the background layer. Layer D now appears as it would if resting directly above the background layer. A 'Shallow' Knockout will punch through to just above the layer or layer set immediately below.

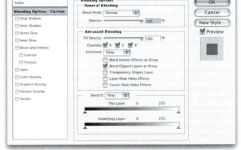

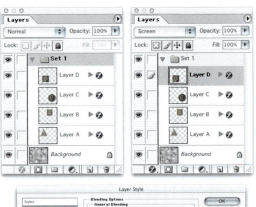

3 The default layer set blend mode is Pass Through. If you change the layer set blending mode to anything else, then the layers within the set will continue to blend with each other as before, but will not interact with the layers underneath as they did in Pass Through mode. When the layer set blend mode is Normal, the set's layers appear as they would if you switched off the visibility of the background layer.

layer will only affect the opaque portion of the layer and where the image is semitransparent, will retain that level of transparency. The Lock Image Pixels option will lock both pixels and the transparent areas. If you attempt to paint on a layer locked this way, you will see a prohibit warning sign.

Lock Image will lock the Layer position only. This means that while you can continue to edit a layer's pixel contents, you are not able to accidentally 'knock' the layer position with the move tool or apply a transform command. You can select combinations of Lock Transparency; Lock Image Pixels; and Lock Image, but you can also check the Lock All box for those situations where you wish to lock everything absolutely.

Transform commands

You have a choice of options in the Image menu to rotate or flip an image. You use these commands to reorient a document where, for example, the photograph was perhaps scanned upside down. The Edit ⇨ Transform commands are applied to a layer or grouped layers only, whereas the Image menu commands rotate or flip the whole canvas. Select a layer or make a selection and choose either Edit ⇨ Transform or Edit ⇨ Free Transform (or check Show Bounding Box in the move tool Options bar). Rotating, flipping, scaling, skew and perspective controls can be applied either singly or combined in one process. All these commands are to be found under the Edit ⇨ Transform menu and also under the contextual menus (*ctrl* right mouse-click). The Free Transform options permit you to apply any number of tweaking adjustments before applying the actual transform. A low resolution preview quickly shows you the changed image shape. At any time you can use the Undo command (⌘ Z *ctrl* Z) to revert to the last defined transform preview setting.

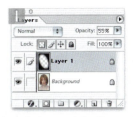

1 This shows the Layers palette with a new image layer (Layer 1) above the Background layer. Lock Transparent Pixels will prevent you from painting in the layer's transparent areas accidentally.

2 Lock Image Pixels will preserve transparency and prevent you from accidentally painting on any part of the image layer, yet allow movement of the layer.

3 Lock Layer Position will prevent the layer from being moved, while you can continue to edit the layer pixels.

4 The Lock All box will lock absolutely. The layer position will be locked, the contents cannot be edited. The opacity or blend modes cannot be altered, but the layer can be moved up or down the layer stack.

1 You can rotate, skew or distort an image in one go using the Edit ⇨ Free Transform command. The following steps show you some of the modifier key commands to use to constrain a free transform adjustment.

2 Place the cursor outside the bounding border and drag in any direction to rotate the image. Holding down the *Shift* key as you drag constrains the rotation in 15 degree increments.

3 Hold down the ⌘ *ctrl* key as you click any of the handles of the bounding border to perform a free distortion.

4 If you want to constrain the distortion symmetrically around the center of the image, hold down the ⌥ *alt* key as you drag a handle.

5 To skew an image, hold down the ⌘ *Shift* *ctrl* *Shift* keys and drag one of the side handles.

Photograph by Davis Cairns. Client: Red or Dead.

6 To carry out a perspective distortion, hold down the ⌘ ⌥ *Shift* *ctrl* *alt* *Shift* keys together and drag a corner handle. When you are happy with the new shape, press Enter to carry out the transform. Press *esc* to cancel. The transform uses the default interpolation method selected in Preferences to calculate the new image shape.

Numeric Transforms

When you select any of the transform commands from the Edit menu or check Show Bounding Box in the move tool options, the Options bar will display the numeric transform commands shown below. The numeric transform options enable you to accurately define any transformation as well as choose where to position the centering reference point position. For example, a common use of the Numeric Transform is to change the percentage scale of a selection or layer. Enter the scale percentages in the Width and Height boxes. If the Constrain Proportions link icon is switched off, you can set the width and height independently. You can also change the central axis for the transformation by repositioning the black dot (circled).

Repeat Transform

After applying a transform to the image data, you can instruct Photoshop to repeat that transform again. The shortcut is ⌘ *Shift* *T* *ctrl* *Shift* *T*. The image transform will take place again on whatever layer is selected and regardless of other steps occurring in between. Therefore you can apply the transform to the same layer again or transform another existing layer.

Recalling the last used selection

The last used selection will be memorized in Photoshop. Choose Select ⇨ Reselect to bring back the last used selection.

Transforming selections and paths

You can also apply transforms to Photoshop selections and paths. Make a selection and choose Transform Selection from the Select menu (if you choose Edit ⇨ Transform, you will transform the selection contents). Transform Selection is just like the Edit ⇨ Free Transform command – you can use the same modifier key combinations to scale, rotate and distort the selection outline. Or you can use *ctrl* right mouse-click to call up the contextual menu of transform options. With Transform Selection, you can modify a selection shape effortlessly.

Whenever you have an active pen path the Edit menu will switch to Transform Path mode. You can use the Transform Path command to manipulate a completed path or a group of selected path points (the path does not have to be closed). You will not be able to execute a transform on an image layer until you select a tool other than the pen tool or direct select tool.

Drawing paths with the pen tool

Unless you have had previous experience working with a vector-based drawing program like Freehand or Adobe Illustrator, the concept of drawing with paths will be unfamiliar. It is difficult at first to get the hang of it, but I promise you it is well worth mastering the art of drawing with the pen tool. Hard as it may seem at first, it is like

Figure 7.9 Our eyes have no trouble seeing the edge of this blouse. But a selection tool such as the magic wand will only see closely related pixel luminosity values, and any attempt to define the edge using the magic wand will always prove disappointing. This is a classic example of where the pen tool in Photoshop wins over the use of masking tools that require the presence of a high contrast edge in order to make a reasonably accurate selection.

riding a bike, and once learned, never forgotten. Paths are useful in several ways: either applying a stroke with one of the paint tools, for saving as a clipping path, or defining a complex selection shape, which can be converted to a selection or applied as a vector mask to mask a layer.

Because it is difficult to master the art of drawing with the pen tool, many people are inclined to give up on paths and persevere with other mask methods. Figure 7.9 shows an example of a photograph where it would be hard to define a smooth edge boundary other than by drawing a path outline. The pen tool is the professional's selection tool, so if you are planning to work on large sized files, you will mostly find it quicker to draw a path and convert this to a selection rather than relying on the selection and paint tools alone. The magic wand may do a fine job on tutorial sized images, but is not a method that translates well to working on bigger files. The magnetic tools fall half way between. They are cleverly designed to automate the selection process, but there is usually no alternative available but to manually define the outline with a path.

Figure 7.10 The path tutorial file which can be found on the CD-ROM.

Guidelines for drawing pen paths

We shall start with the task of following the simple contours illustrated in Figure 7.10. You will find a copy of this image in a layered Photoshop format on the CD-ROM. This Photoshop file contains saved path outlines of each of the shapes. The background layer contains the basic image and above it there is another layer of the same image but with the pen path outlines and all the points and handles showing. Make this layer visible and fade the opacity if necessary so that you can follow the handle positions when trying to match drawing the path yourself. Start at kindergarten level with the letter 'd'. If you mastered drawing with the polygon lasso tool, you will have no problem doing this. Click on the corner points one after another until you reach the point where you started to draw the path. As you approach this point with the cursor you will notice a small circle appear next to the cursor which

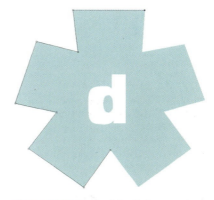

Figure 7.11 Simply click with the pen tool to create straight line segments.

Figure 7.12 To draw a curved segment, instead of clicking, mouse-down and drag as you add each point. The direction and the length of the handles define the shape of the curve between each path point.

Figure 7.13 When you create a curved segment the next handle will continue to predict a curve, continuing on from the last curved segment. To make a break, you need to modify the curve point, converting it into a corner point. To do this, hold down the ⌥ *alt* key, click on the path point or click and drag to create a new predictor handle going off in a new direction.

indicates you are now able to click (or drag) to close the path. Actually this is better than drawing with the polygon lasso, because you can now zoom in if required and precisely reposition each and every point. As before, hold down the ⌘ *ctrl* key to switch to the pointer and drag any point to realign it precisely. After closing the path, hit ⌘ *Enter* *ctrl* *Enter* to convert the path to a selection. Click *Enter* on its own to deselect a path.

If you now try to follow the 'h', this will allow you to concentrate on the art of drawing curved segments. Observe that the beginning of any curved segment starts by dragging the handle outward in the direction of the intended curve. To understand the reasoning behind this, imagine you are trying to define a circle by following the imagined edges of a square box that contains the circle. To continue a curved segment, click and hold the mouse down while you drag to complete the shape of the end of the last curve segment and predict the initial curve angle of the next segment. This assumes the next curve will be a smooth continuation of the last. Whenever there is a sharp change in direction you need to make a corner point. Convert the curved segment by holding down the ⌥ *alt* key and clicking. Click to place another point. This will create another straight segment as before in the 'd' example.

Hold down the ⌘ *ctrl* key to temporarily access the direct selection tool which can be used to reposition points. When you click a point or segment with this tool, the handles are displayed. Adjust these to refine the curve shape. The 'v' shape will help you further practice making curved segments and corner points. A corner point should be placed whenever you intend the next segment to break with the angle of the previous segment. In the niches of the 'v' symbol, hold down the ⌥ *alt* key and drag to define the predictor handle for the next curve shape.

So, to edit a pen path, you use the ⌘ *ctrl* key to temporarily convert the pen tool to the direct selection tool, which you use to click on or marquee anchor points and reposition them. And you use the ⌥ *alt* key to convert a

Figure 7.14 The easiest way to get accustomed with the ways of the pen tool is to go to the Pen Options in the Options bar, mouse down on the palette options and check the Rubber Band box. The pen tool will now work in rubber band mode, which means that you will see the segments you are drawing take shape as you move the mouse cursor, and not just when you mouse down again to define the next path point.

curve anchor point to a corner anchor point and vice versa. If you want to convert a corner point to a curve, ⌥ *alt* +mouse down and drag. To change the direction of one handle only, ⌥ *alt* drag on a handle. To add a new anchor point to an active path, simply click on a segment with the pen tool. To remove an anchor point, just click on it again.

Montages

Now to put the previous discussion on drawing a path with the pen tool in context. The first montage technique demonstrated here shows you how to make a simple, layered composite that adds a new sky to a picture.

Editing path segments

You can edit a straight line or curved segment by selecting the direct selection tool, clicking on the segment and dragging. With a straight segment the anchor points either end will move in unison. With a curved segment, the anchor points remain fixed and you can manipulate the shape of the curve as you drag with the direct selection tool.

1 Here is a relatively straight forward montage task, where I wanted to add a new sky to the picture and have it extend above the building. Because the photograph was cropped quite tightly, I added extra white canvas to the top of the frame and began by making a selection of the sky area. A simple way of doing this is to select the magic wand tool, set the tolerance to around 12 and click in the sky area. You can see here an example of the selection saved as a new alpha channel mask. My preferred method was to draw a pen path of the building and save as a new path in the paths palette.

2 I then looked for an image with an interesting sky, opened it, selected the move tool and dragged the beach image across to the museum image, to add it as a new layer. This new layer needed to be scaled up slightly, so I chose Edit ⇨ Free Transform and dragged the corner handles so as to make the sky fit the width of the picture.

3 Once I had scaled the sky to match the dimensions of the master image, it was time to cut out the sky, which I did by loading the mask I had created earlier. I activated the pen path and hit ⌘ *Enter* *ctrl* *Enter* to convert the path to a selection. Alternatively, I could have ⌘ *ctrl* clicked the alpha channel I had pre-saved to reload the magic wand selection. I then clicked on the Add New Layer mask button at the bottom of the Layer palette to convert the selection to a layer mask, hiding all but the sky of Layer 1.

Realistic retouching

Providing that the perspective of the individual elements is the same and the lighting conditions are near enough right, half the battle will already be won. If you don't have these attributes there to begin with in the elements to be assembled, it will be virtually impossible to produce a convincing composite.

This next example shows how I prepared a silhouette mask based entirely on an outline made with the pen tool. A pen path is the most sensible solution to use here because the object to be cut out has a smooth 'geometric' outline and the background behind the aircraft is very 'busy' and it would be almost impossible to separate the aircraft from the scenery behind using any other method. This technique also shows a use of vector masks in Photoshop.

The Spirit of St Louis, flown by Charles Lindbergh, made the world's first solo transatlantic flight from the US to Paris in 1927 and I photographed this historic aircraft inside the Washington DC National Air and Space Museum, Smithsonian Institution. The daylight coming in from the skylight above enabled me to composite the aircraft against an outdoor backdrop.

1 Here are the two images: the sky background and the museum interior shot of the Spirit of St Louis. I selected the move tool from the Tools palette and dragged the St Louis image across to the sky image window, where it became a new layer (if the *Shift* key is held down, the layer will be centered). The aircraft layer was then scaled in size using the Transform ⇨ Free Transform command.

2 I needed to isolate the aircraft from its surroundings. Because the subject had such a detailed background, there was no automatic way of doing this in Photoshop, so in this instance, the only solution was to draw a path. I magnified the image to view on screen at 200% and drew a path with the pen tool around the edges of the aircraft.

When the pen tool is selected, you can access all the other family of pen path modifying tools using just the ⌘ *ctrl* and ⌥ *alt* keys. Holding down the ⌘ *ctrl* key temporarily changes the pen tool to the direct selection tool. Holding down the ⌥ *alt* key temporarily changes it to the convert point tool. Clicking on a path adds a new point and clicking on an existing point deletes it. To make a hole in a work path, inside the outer edge, click on the Subtract from path area mode button in the pen tool Options bar (circled in red).

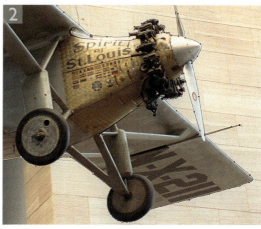

Spirit of St Louis: Pioneers of Flight Gallery.

Reproduced courtesy of: National Air and Space Museum, Smithsonian Institution.

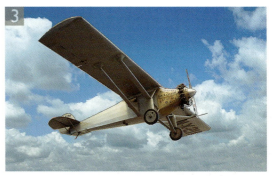

3 When the path was complete, I made sure that the aircraft layer and path were both active. I went to the Layer menu and chose: Add Vector Mask ⇨ Current Path. This added a vector mask to the aircraft layer based on the active work path. The vector mask appeared linked alongside the aircraft layer.

4 At this stage it was possible to reposition the aircraft again if I wished, because the vector mask was linked to the layer image contents. Under close inspection, the aircraft appeared to have been reasonably well isolated by the path. However, where this is not the case, you can edit the vector mask outline using the usual pen path editing tools. If I group selected several of the path points around the wheel and move them, you can see how the background is still visible and will now show through.

5 Once I was happy with the way the vector mask was hugging the outline, I chose Layer ⇨ Rasterize ⇨ Vector Mask. This converted the vector mask into an image layer mask.

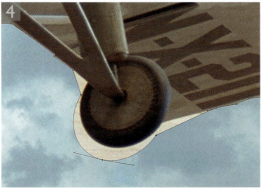

6 I activated the image layer mask. I then went to the Filter menu and selected Other ⇨ Minimum and chose a 1 pixel radius. This step effectively 'choked' the mask, making it shrink to fit around the edge of the masked object. Sometimes it helps to fade the last filter slightly using the Edit ⇨ Fade... command. Next, I applied a 1 pixel radius gaussian blur and followed this with an Edit ⇨ Fade... of 50% or higher. I then applied a levels adjustment to the mask. I chose Image ⇨ Adjustments ⇨ Levels, but kept the shadow point set where it was and adjusted the gamma and highlight sliders only. The gamma adjustment needed to be quite extreme. In effect what I did over these past few steps was to shrink the mask slightly, soften the edge and used the Levels adjustment to fine tune the choke on the mask.

7 The mask was mostly OK and only a couple of areas needed further improvement. I went to the History palette and reverted back to the history state which was the one before where I began adjusting the mask (it usually helps to have Allow Nonlinear History switched on in the History palette options). I then clicked on the history brush icon to the left of the fully modified mask history state and selected the history brush from the Tools palette. The image had now reverted to the unmodified layer mask state, but wherever I painted with the history brush, I could paint in the modified mask and vary the opacity of the history painting as I did so.

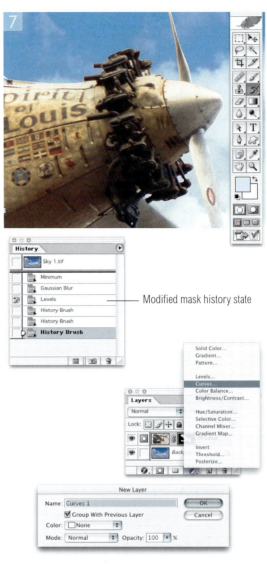

Modified mask history state

8 By this stage, the Spirit of St Louis appeared successfully cut out from its original museum surroundings. Because an image layer mask had been used to isolate the aircraft, no pixels had actually been erased and the mask could be edited at any time.

9 I selected the aircraft layer again and [] alt +mouse down on the adjustment layer button in the Layers palette. I chose Curves and in the New Layer dialog box, checked Group With Previous Layer. This ensured that the following color adjustment would affect this layer only. The curves adjustment made the aircraft slightly more blue and helped it blend more realistically with the color balance of the sky.

10 I duplicated the aircraft layer and applied a motion blur to this copied layer. This was placed as shown in the Layers palette and the opacity reduced to 80%. I then prepared a spinning propeller image. I dragged this in as a separate layer and transformed it to match the scale of the aircraft. This final tweaking helped create the illusion of the Spirit of St Louis flying through the air. Except, did they have high speed color film to record Charles Lindbergh's transatlantic flight in 1927?

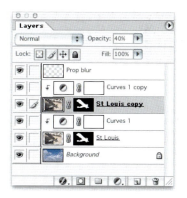

Masking hair

Once you get the hang of using the pen tool and combining its use with vector masks, you will soon discover that this is an effective way of isolating a subject such as in the previous composite where the object you wish to cut out contains smooth, geometric contours.

When you are presented with a subject that contains a complex outline, such as the model's hair in the next photograph, the main question is: how do you go about separating the hair from the background? More to the point, how can you do this convincingly without it looking like an obvious retouch job? The trick here is to make use of the existing color channel contents and to copy the information which is already there in the image and modify it to produce a new mask channel. So instead of attempting

Keeping the edges soft

Retouched photographs will not look right if they feature 'pixel-sharp' edges. Softer masks usually make for a more natural-looking finish. A mask derived from a path conversion will be too crisp, even if it is anti-aliased. So, either feather your selections and if you have a layer mask, try applying a little Gaussian blur. You might find it helpful to use the blur tool to locally soften mask edges. Or you could apply a global gaussian blur filtration to the mask.

to trace every single strand of hair with the pen or paintbrush tool, you can save yourself a lot of time by recycling the information already contained in the color channels and use this to define the finely detailed edges. You will find that the pen tool can then be used to finish off tracing the curves of the model's body.

Whenever I shoot a subject where I intend later to make a cutout, I always ensure that I am shooting against a plain colored background. I find white backgrounds usually provide the best channel contrast and allow me to composite easily using the following technique.

1 The following steps describe how I would go about photographing a model with a view to adding a new backdrop later. I normally plan my shoots to always photograph against a white background as this is the best way to mask the fine hair detail, although the photograph here happens to have some light shading in the background.

2 I began looking at the individual color channels and duplicated the one that contained the most contrast, in this case the green channel. I duplicated the channel by dragging it to the New channel button in the Channels palette.

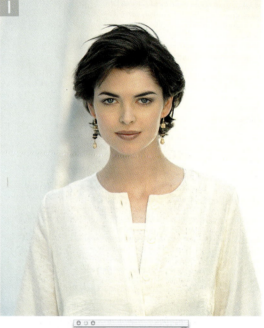

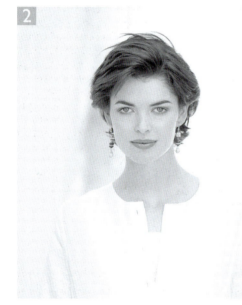

3

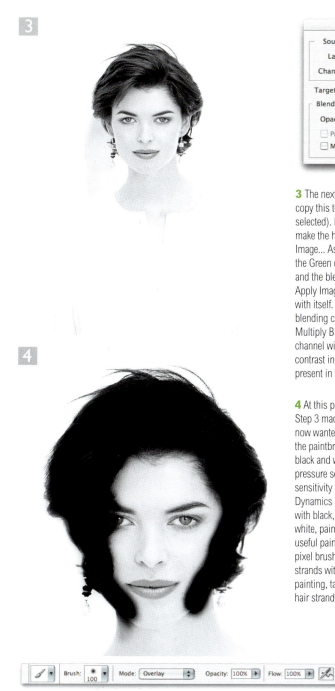

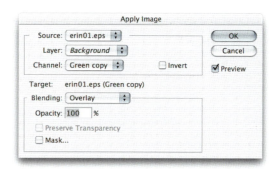

3 The next few steps all took place on the Green copy channel (if you copy this technique, make sure that the Green copy channel is selected). I wanted to increase the contrast in the alpha channel and make the hair darker. I went to the Image menu and chose Apply Image... As you can see in the above dialog, the Target channel was the Green copy channel, the Source channel was also Green copy and the blending mode had been set to Overlay. So I was using the Apply Image to apply an Overlay blend mode on the alpha channel with itself. With Apply Image you can choose all sorts of channel blending combinations. Most of the time I use Apply Image in the Multiply Blending mode and will experiment blending one color channel with another. The objective at this stage is to increase the contrast in the hair making use of the pixel information already present in the photograph.

4 At this point I am only interested in making a mask for the hair. Step 3 made quite a difference to the appearance of the channel and I now wanted to edit to increase the contrast more. I can do this using the paintbrush tool set to Overlay mode and switch between using black and white as the foreground color. And I prefer to paint using a pressure sensitive Wacom pen and tablet, with the pen pressure sensitivity for the Opacity switched on in the Brushes palette Other Dynamics options. When using the Overlay blend mode, as you paint with black, paint is only applied to dark pixels. As you paint with white, paint is only applied to the lighter pixels. Overlay is therefore a useful paint mode because you can paint quite freely using a large pixel brush to gradually build up the density around the dark hair strands without risk of painting over the light areas. I continued painting, taking care not to build up too much density on the outer hair strands.

225

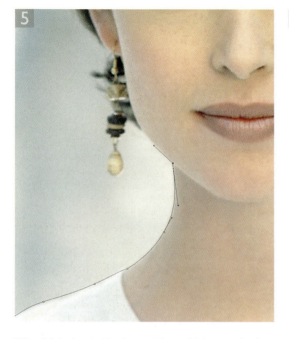

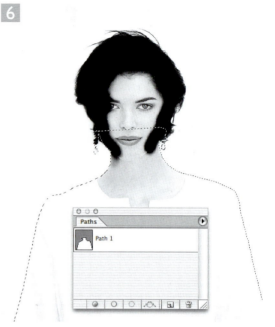

5 Now let's look at masking the rest of the model. As was pointed out in Figure 7.9, the model's clothing is almost the same color as the backdrop. Therefore, the best way to isolate the rest of her body is to draw a pen path.

6 I used the pen tool to draw a path that followed the top half of the model, following the outline of her jaws and the finer outline detail of her earrings. I then converted the pen path to a selection by dragging Path 1 down to the Make Selection button in the Paths palette. I filled the selection with black and used the paintbrush tool in Normal mode to paint over the rest of her face.

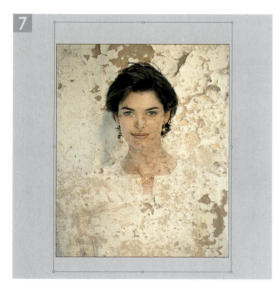

7 With the mask complete, it was time to add a new backdrop. I opened up a photograph of a textured wall in Photoshop, selected the move tool and dragged the backdrop image across to the model image window. This added the backdrop as a new layer. I went to the layers palette and changed the blending mode to Multiply. The Multiply blend mode effectively 'projects' the new layer on top of the background layer. I kept the Layer 1 active and chose Edit ⇨ Free Transform and dragged the handles to scale the backdrop layer.

8 | ⌘ *ctrl* clicked the Green Copy channel to load it as a selection and then clicked on the Add Layer Mask button in the Layers palette to convert the selection to a layer mask.

The layer mask worked reasonably well, but benefited from some fine-tuning. I first went to the History palette and made sure that Allow Non-Linear History was selected. The layer mask was selected and I applied: Filter ⇨ Other ⇨ Maximum, followed by Filter ⇨ Blur ⇨ Gaussian Blur, followed by a Levels adjustment using the settings shown on this page. The Maximum+Blur+Levels adjustment shrunk the mask around the hair.

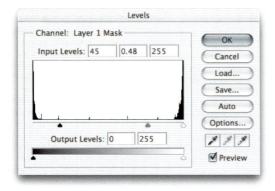

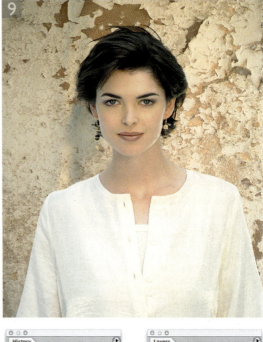

9 The reason for setting the History palette to allow nonlinear history may now become clear. In the last step, I modified the mask using a Levels adjustment to improve the hair masking. But doing so made the edges around the shoulder and neck too crisp.

I went to the History palette and clicked on the Gaussian Blur history state (note that the Levels history state does not go dim). I then applied an alternative levels adjustment, one that modified the layer mask so that the edges around the body were kept soft. I went to the History palette and clicked on the icon to the left of the previous levels adjustment. This set the history source to use the previous levels history state. I then selected the history brush from the tools palette and painted around the edges of the hair to restore the optimized hair mask state.

And that completes the steps required to add a new backdrop to a studio-shot photograph. This is a complex technique, so I have included this as a tutorial movie on the CD. You will also find the two images used are also available on the CD for you to experiment with.

Client: Schwarzkopf Ltd. Model: Erin Connelly.

Clipping groups

You can create clipping groups within layers. The lowest layer in a clipping group acts as a layer mask for all the grouped layers above it. To create a clipping group, you can either link layers together and choose Layer ⇨ Group Linked, ⌥ *alt* click the border line between the two layers, or use ⌘ G *ctrl* G to make the selected layer group with the one below. When a layer is grouped, the upper layer(s) becomes indented. All layers in a clipping group assume the opacity and blending mode of the bottom layer. To ungroup the layers, ⌥ *alt* click between the layers, the layers ungroup and the dotted line becomes solid again.

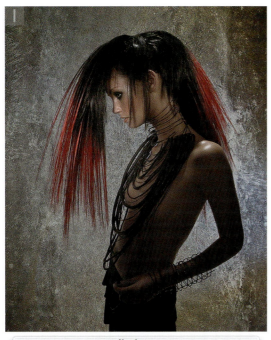

1 If you check out the layers palette below, you will notice that this is another example where a photograph was shot against white in the studio and a mask was made to mask a backdrop that was added on a separate layer. This was done using the same steps described in the preceding tutorial.

2 I wanted to add a gradient glow to make it look as if I had shone a light on the backdrop. I set white as the foreground color, selected the Backdrop layer and ⌥ *alt* moused down on the Add Adjustment Layer button at the bottom of the Layers palette, and selected Gradient from the pop-up menu. In the New Layer dialog, I checked: Use Previous Layer to Create Clipping Mask. I clicked OK and the Gradient Fill dialog appeared. I selected the foreground to transparency gradient, using a Radial gradient style. If you check the Layers palette again, you will notice that the Gradient layer appears indented, which signifies that it is in a clipping group with the layer below. I can remove the grouping by ⌥ *alt* clicking in the space between the two layers.

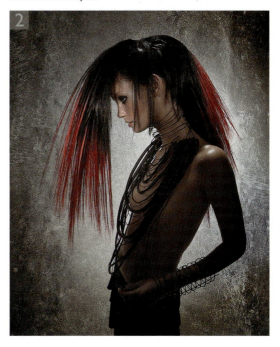

Client: JFK Hair. Model: Indriarty at Isis.

Removing a matte color

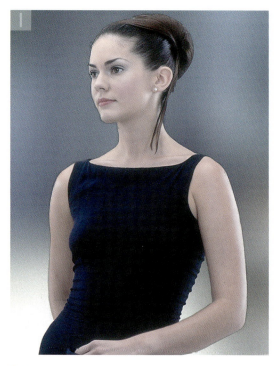 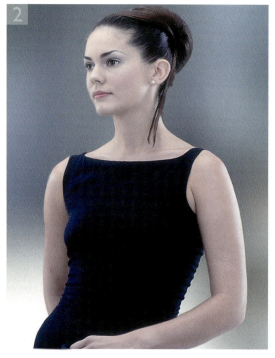

1 If you add a layered image with an anti-aliased edge, some of the edge pixels will still contain some of the original background color. If the original picture has a black background, when the cutout appears pasted as a layer against the new backdrop, some of the black matte pixels will appear as a dark gray around the outline edge.

2 Use the Layer ⇨ Matting ⇨ Remove Black Matte command to remove all the stray black pixels. Likewise, the Remove White Matte command will remove the white pixels from a cutout which was once against a white background. Where you have colored fringing, the Layer ⇨ Matting ⇨ Defringe command will replace edge pixels with color from neighboring pixels from just inside the edge.

Extract command

The Image ⇨ Extract command is able to intelligently isolate an object from its background. While automatic masking can sometimes make light of tedious manual masking, it can rarely ever be 100% successful. However, the enhancements added since version 6.0 certainly do make the Extract command a very workable tool now, including the means to separate an object based on texture content as well as color. Before using the command, you may find it helpful first to duplicate the layer which is to be extracted. The active layer will be displayed in the Extract dialog window. You then define the outline of the object using the edge highlighter tool. This task is made easier using the Smart Highlighting option, which is like a magnetic lasso tool for the Extract command. Smart highlighting will work well on clearly defined edges and can be temporarily disabled by holding down the ⌘ ctrl key as you drag. You have to highlight the complete edge of the object first (excluding where the object may meet the edge boundaries) and then fill the interior with the Extract fill tool (clicking again with the fill tool will undo the fill). The Extract command eraser tool can be used to erase highlight edges and when using the edge highlighter tool, you can toggle between highlighting and erasing by holding down the ⌥ alt key. When the edges and interior fill are completed, click on the Preview button to see a preview of the extraction, or click OK to make an immediate extraction. The edge touchup tool can be used inside the preview window to add definition to weak edges – adding opacity where it sees transparency inside the edge and removing opacity outside of this edge. The cleanup tool will merely erase transparency from the extraction or restore erased transparency when you ⌥ alt drag.

As you define the highlight edge, wherever possible, you want to select a small size brush and aim to draw a narrow edge. Where there is overlap between the object you want to extract and the background, you need to draw a wider edge.

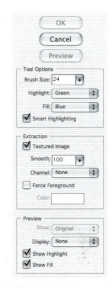

Figure 7.15 The Extract command options:

Tool Options Enter a value for the highlight or eraser brush size and choose a color for the Highlight and Fill displays. Smart Highlighting helps auto-detect the edges as you define a highlight edge.

Extraction The smoothness can be set anywhere between 0 and 100. If the preview shows an incomplete pixel selection, increasing the smoothness value will help reign in the remaining pixels. Force Foreground is useful where the object interior edge is particularly hard to define and the interior pixels are of a similar color value. Select the eyedropper tool to sample the interior color and check Force Foreground. Textured Image will take into account differences in texture as well as color.

Preview The view choices can be switched between the original image and the current extracted versions. The Show option allows you to choose the type of matte background to preview the extraction against. This can be the standard, transparent, Photoshop background pattern, gray, white, black or any other custom color.

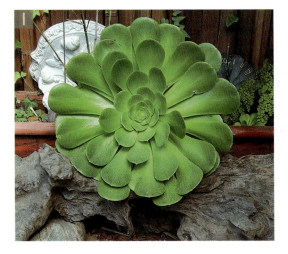

1 Here is an example of an ordinary photograph where I wanted to make a cutout of the large plant and remove it from the distracting elements in the background. I began by dragging the background layer to the Make New Layer button in the Layers palette. (This duplicated the background layer).

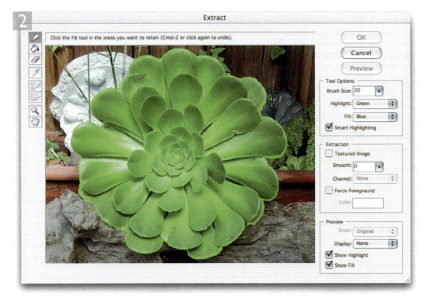

2 I then chose Filter ⇨ Extract. I selected the edge highlighter tool and started to draw around the edges of the leaves. You want the highlight edge to overlap the foreground and background areas. But the highlight edge must form a complete enclosure (you can ignore where the object meets the image boundaries). Notice that I had checked the Smart Highlighting box. This can make the edge drawing a little easier. The smart highlighting mode works in a similar way to the magic lasso and magic pen tool, it forces the edge highlighter tool to 'hug' the sharp edges as you draw. If you use a pressure sensitive pen, as you apply more pressure, you will produce a thicker edge.

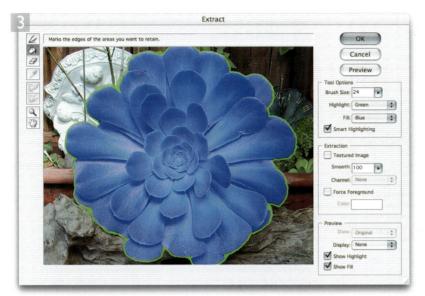

3 When I had finished drawing the outline around all of the leaves, I checked the result carefully and used the eraser tool to delete any parts where the edge was untidy and I then selected the fill tool to click inside and fill the interior. You can use the edge cleanup tool to follow edges, adding opacity where the tool sees transparency inside the edge and removing opacity outside the edge.

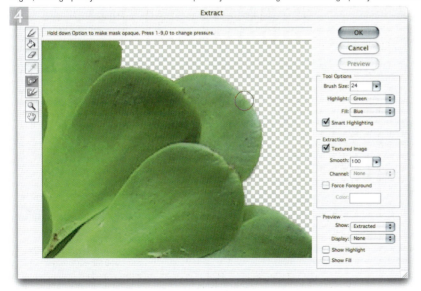

4 To test the potential success of the extraction, I clicked on the Preview button. This applied the extraction to the image in the preview window only. I first checked the Textured Image button though and set the Smooth setting to 100. While in preview mode, you can edit the edges using tools within the Extract dialog. Here, I selected the cleanup tool and used it to erase unwanted pixels and held down the Option to restore pixels so far erased by the extraction.

5 I clicked OK to permanently apply the extraction to the Background copy layer. If for some reason I needed to go back to the original version, it was still available in the layer below. But more usefully, one can use the History palette to restore any detail that shouldn't have been erased during the extraction. Go to the History palette, set the history state one before the Extraction, as the history source and use the history brush to paint those pixels back in. If you want to erase more pixels, I recommend selecting the background eraser tool, described on page 57. Set the background eraser tool to Find Edges mode, click on a sample area to define the pixel colors you want to erase and paint around the outside edge.

Figure 7.16 In this example, I drew a pen path around the edge of the Cello case. I then went to the Paths palette fly-out menu and chose Clipping Path.... and entered a Flatness of 1 pixel. The image was saved as a TIFF and placed on this page. You can see the page guides show through the transparent areas of the cutout.

Exporting clipping paths

Clipping paths are vector paths that can be used to mask the outline of an image when it is exported to be used in a DTP layout program such as Adobe PageMaker™, Adobe InDesign™ or QuarkXPress™. If an image you are working on contains a closed path, you can make that path become a Clipping Path within Photoshop. When the image is saved as an EPS or TIFF format file, the clipping path will define the transparency in an image. So when an image like the one in Figure 7.16 is imported into a DTP layout it will appear as a cutout. If you are using QuarkXPress, any path present in an imported image can be promoted to a clipping path.

Imagine a catalog brochure shoot with lots of products shot against white ready for cutting out. Still-life photographers normally mask off the areas surrounding the object with black card to prevent unnecessary light flare from softening the image contrast. Whoever is preparing the digital files for export to DTP will produce an outline mask and convert this to a path in Photoshop or simply draw a path from scratch. This is saved with the EPS or TIFF file and used by the DTP designer to mask the object.

Client: Dan Tyrrell Photograph: Eric Richmond

Chapter 8
Darkroom Effects

Duplicating black and white darkroom techniques in Photoshop will be of particular interest to photographers. This chapter shows you how to use Photoshop as your digital darkroom and how to replicate in Photoshop some traditional photographic effects such as solarization, split tone printing, cross processing and diffusion printing. We will also look at the different ways that you can convert a color image to monochrome. The distinction between shooting black and white or color is lost on many of the clients I have worked with. How you light and color compose a shot is determined by whether it is intended for color or monochrome. In the digital age, everything is captured in RGB color and if you want a black and white image, your best bet is to do the monochrome conversion in Photoshop and not 'in camera'.

Color filters for monochrome work

Color filters can be used in monochrome photography to filter the colors in a scene and thereby alter the color contrast. A strong red filter will filter out the blue/cyan colors and make white clouds stand out with more contrast against a dark sky. A yellow or orange filter will produce a softer effect. A green filter can be used to make foliage appear lighter relative to everything else in the scene and so on... These principles can also be applied to the formulas used in the channel mixer to simulate the same type of filtration. A 50% Red channel and 50% Green channel mix in Monochrome mode, will simulate the effect of using a yellow filter.

Getting the mix right

When you use the Channel Mixer in Monochrome mode to make a mono conversion, the channel percentages should all add up near enough to 100%. As demonstrated in the accompanying step-by-step, the Red channel was combined at 80% with the Green channel at 20%. To create even stronger effects, you can take one or more channels above 100% and compensate by entering a negative percentage amount in the other channels.

Black and white from color

When you change a color image from RGB to Grayscale mode in Photoshop, the tonal values of the three RGB channels are averaged out, usually producing a smooth continuous tone grayscale. The formula for this conversion roughly consists of blending 60% of the green channel with 30% of the red and 10% of the blue. The rigidity of this color to mono conversion formula limits the scope for obtaining the best grayscale conversion from a scanned color original. This is what a panchromatic black and white film does or should be doing rather, because there are slight variations in the evenness of emulsion sensitivity to the visual and nonvisual color spectrum. And it is these variations in spectral sensitivity that give black and white films their own unique character. But the point is, that like a grayscale conversion in Photoshop, a black and white film interprets color using a standard formula. You may also be familiar with the concept of attaching strong colored filters over the lens to bring out improved tonal contrast in a monochrome image. The same principles can apply to converting from color to black and white in Photoshop, and of course, this allows the freedom to make this decision after the photograph has been shot. Using the Channel Mixer, you can create a custom RGB to grayscale conversion. This gives you the latitude in Photoshop of being able to make creative decisions at the editing stage that will allow you to simulate the effect of shooting using black and white film with a color filter placed over the lens at the time of shooting.

I have included an alternative technique on page 238 for producing a monochrome image from a color original, which simultaneously uses the Hue/Saturation image adjustment to modify the hue color of the underlying image and at the same time, a second Hue/Saturation layer neutralizes the color to create a neutral, monochrome image.

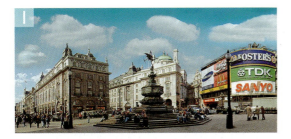

1 If you shoot using black and white film, the emulsion is more or less evenly sensitive to all colors of the visual spectrum. If you add a strong colored filter over the camera lens at the time of shooting, that color sensitivity is altered as certain wavelengths of color are blocked out by the filter. The following steps mimic the effect of a red lens filter being used to strengthen the cloud contrast in the sky.

2 To start with I went to the Image menu and chose Adjustments ⇨ Desaturate. This produced a flat-looking result based on a standard grayscale conversion formula where the monochrome RGB image is calculated using a mix of 30% red, 60% green and 10% blue.

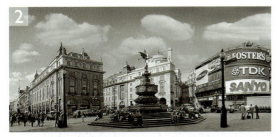

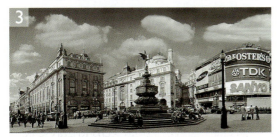

3 I chose Edit ⇨ Undo to revert to the original color version of the image and added a Channel Mixer adjustment layer using the settings shown in the dialog above. Note that when the Monochrome box is checked the Channel Mixer will produce a monochrome result based on a color channel mix of your choosing. For the very best results, try to get the percentages in each slider box to add up to 100%. This is not a hard and fast rule – variations other that 100% will just be lighter or darker. Use whichever looks best. The predominant use of the red channel created a stronger tonal contrast with the clouds in the sky.

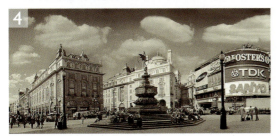

4 Lastly, I added a Color Balance adjustment layer to create a split tone coloring effect. I changed the blending mode of this layer to Color. Doing this preserved the full luminosity information of the layers below.

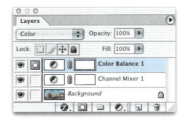

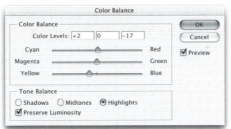

237

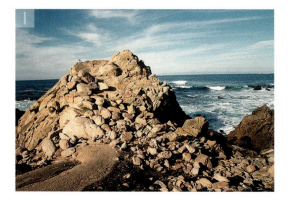

1 Russell Brown, the Senior Creative Director of the Adobe Photoshop team, was one of the first people to demonstrate the following alternative technique for creating a color to monochrome conversion in Photoshop.

2 I opened an RGB image, and went to the Layers palette and added a Hue/Saturation adjustment layer. I took the saturation all the way down to zero so that the photograph was desaturated and became a monochrome version of the color original. The result was more or less what you would expect to get if I had simply converted the image to Grayscale.

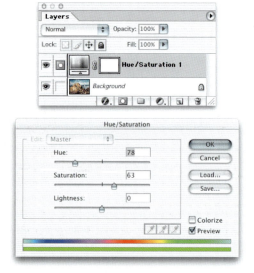

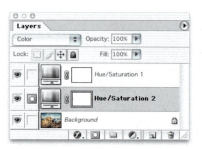

3 I activated the background layer and added a second Hue/Saturation adjustment layer. This will be between the Background layer and the earlier Hue/Saturation layer. I made no adjustments and clicked OK and set the layer blending mode to Color. When you reopen the dialog you can now adjust the Hue slider and achieve a similar result to adjusting the channel mix in the Channel Mixer as shown in the previous tutorial. When you try this out for yourself, you can also adjust the Saturation and Lightness to further tweak the monochrome conversion.

Full color toning

The simplest way of toning an image is to use the Color Balance adjustment. I am normally inclined to disregard the Color Balance as a serious color correction tool. But in situations such as this, the simple Color Balance controls are perfectly adequate for the job of coloring a monochrome image that is in RGB mode. The Color Balance controls are intuitive: if you want to colorize the shadows, click on the Shadows radio button and adjust the color settings. Then go to the Highlights and make them a different color and so on. If you apply the color adjustment as an adjustment layer, you can afford to make quite a dramatic color adjustment and then fade the adjustment layer opacity afterwards.

1 I started with a grayscale image and converted it to RGB color mode. Alternatively, you could take an RGB image and convert it to black and white using one of the methods I just described. I then added a Color Balance adjustment layer to colorize the RGB/monochrome image. To do this, I chose New Adjustment Layer... from the Layers palette fly-out menu and selected Color Balance. I clicked on the Shadows button and moved the sliders to change the shadow tone color balance.

Photograph: Eric Richmond.

2 I repeated doing the same thing with the Midtones and Highlights. I then returned to the Shadows and readjusted the settings as necessary. When you use an adjustment layer you can return and alter these Color Balance settings at any time. The Color Balance image adjustment method is ideal for toning monochrome images. To further modify the Color Balance toning, try varying the adjustment layer opacity in the Layers palette.

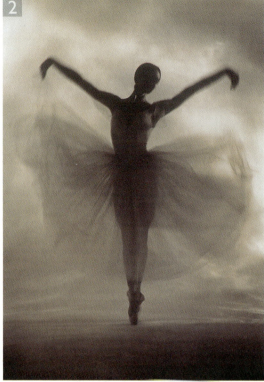

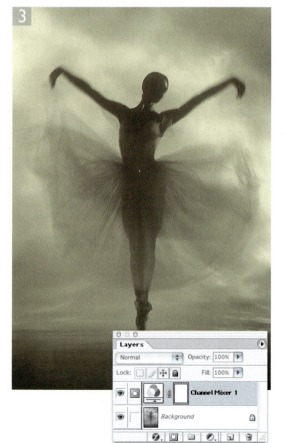

3 Providing the original monochrome image is in RGB or CMYK color mode, the Channel Mixer is another interesting tool that can be used for coloring an image and imitating color toning effects. For more instructions on Channel Mixer use, see the simulating sunset light technique described on page 254.

Split toning

For those who are not familiar with this printing method, a split tone is a black and white image that has only been partly toned or where a mix of toning effects has been applied. For example, a silver print is placed in a bleach bath to remove all the silver image, then it is thoroughly washed and placed in a bath of toner solution, that replaces the bleached silver with the sepia or other dye image. If the print is only partially bleached, you get an interesting split tone effect in the transition between the base and toned colors. The following steps demonstrate how to use the Layer blending options in conjunction with adjustment layers.

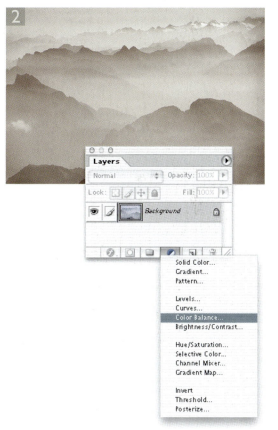

1 The color original photograph was converted to monochrome while remaining in RGB. This can be done by using Image ⇨ Adjust ⇨ Desaturate or applying the Channel Mixer in Monochrome mode.

2 I toned the monochrome image using a Color Balance adjustment layer (as described in the previous example). I clicked on the Midtone and Shadow buttons and moved the sliders to adjust the shadow and midtone colors and kept the Preserve Luminosity option checked, as this helped maintain a consistent lightness in the image.

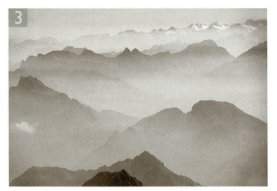

3 I added a second adjustment layer and chose Color Balance again. I then clicked on the Midtone and Highlight buttons to set the highlight color tones.

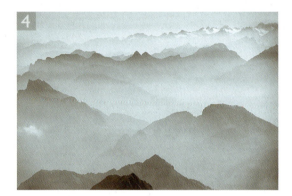

4 I went to the Layers palette sub-menu and selected Blending Options. I held down the ⎇ *alt* key and dragged one half of the shadow triangle slider as shown here to separate the sliders. The wide spacing between the slider halves produced the gentle color shade transition shown here.

Solarization

The original photographic technique is associated with the artist Man Ray and is achieved by briefly fogging the print paper towards the end of its development. Working in the darkroom, you can get nice effects by selectively solarizing the print image: place the partially developed print under a white light source, dodging the print during second exposure. Needless to say, this is a very hit and miss business. The digital method provides more control, because you can precisely select the level of solarization and the areas of the image to be affected.

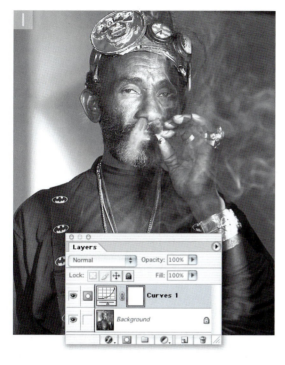

1 I began with an image in Grayscale mode. I went to the Layers palette and added a new Curves adjustment layer (I wanted to apply the solarization using this layer and later remove parts of it to reveal the unaffected background layer).

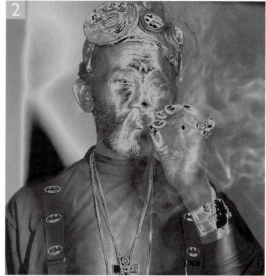

2 I selected the arbitrary map tool (circled in red) and drew an inverted V. The easiest way to do this is to draw by *Shift* clicking which will create straight lines, or use the point curve tool to draw a series of wavy curves.

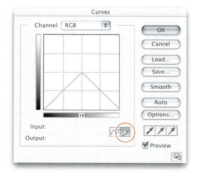

3 I added a mask to the adjustment layer and used the lasso tool to define the areas of the adjustment layer I wished to hide. I applied a heavy feathering to the selection by choosing: Select ➪ Feather and entered a feathering amount (I used 80 pixels, but you could apply a greater or lesser amount, depending on the file size).

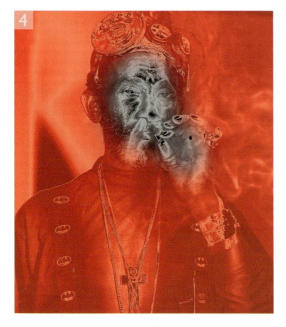

4 You can check the success of a feathered selection by switching to Quick mask mode. I didn't worry about the mask being absolutely perfect, as I could refine the mask at the next stage.

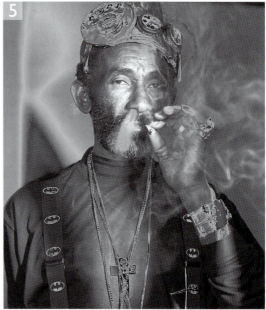

5 I switched back to Selection mode and filled the adjustment layer mask with black. In Layer Mask mode, the default foreground/ background colors are black and white: I chose Edit ⇨ Fill ⇨ Foreground Color. I deselected the selection, chose a large brush, set to a low opacity and by toggling between the foreground and background colors I could hide or reveal the unsolarized Background layer.

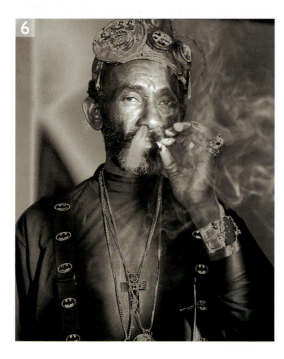

6 Finally, I merged the layers, converted the image to RGB color mode and colorized the picture using the previously described split tone technique.

Duotone mode

When you select a duotone preset you get to see a preview of the color on the screen and this opens up many possibilities for the creative use of working in duotone mode to simulate all types of print toning effects.

A duotone is made using two printing plates, a tritone has three and a quadtone four. You need to start with an image in grayscale mode first before you convert to a duotone by choosing: Image ⇨ Mode ⇨ Duotone. The Ink Color boxes display a Photoshop preview of the ink color with the name of the color (i.e. process color name) appearing in the box to the right. The graph icon to the left is the transfer function box. In here you specify the proportions of ink used to print at the different brightness levels of the grayscale image. The transfer function box opens when you double-click the graph icon. You can change the shape of the curve to represent the proportion of ink used to print in the highlights/midtones/shadows. Normally the inks are ordered with the darkest at the top and the lightest inks at the bottom of the list. There are a number of duotone Presets (plus tritones and quadtones) to be found in the Photoshop Goodies folder. Experiment with these by clicking the Load... button in the duotone dialog box and locating the different preset settings.

Printing duotones

The only file formats (other than Photoshop) to support duotones are EPS and DCS. So save using these when preparing an image for placing in either an InDesign™ or QuarkXPress™ document. Remember though that if any custom ink colors are used to make the duotone, these need to be specified to the printer and this will add to the cost of making the separations if CMYK inks are already being used in the publication. Duotones that are converted to Multichannel mode are converted as spot color channels. Alternatively you can take a duotone image and convert it to CMYK mode in Photoshop. This may well produce a compromise in the color output as you will be limited to using the CMYK gamut of colors.

Deficiencies of grayscale printing

A black and white image can be reproduced a number of ways in print. If you are working from a basic 8-bit grayscale image, this will have a maximum of 256 brightness levels. A practical consequence of using basic 8-bit grayscale files for print is that as many as a third of the tonal shades will get lost during the reproduction process and this is why images reproduced from a grayscale file can look extremely flat when printed, especially when compared alongside a CMYK printed example. Adding two or more printing plates will dramatically increase the range of tones that can be reproduced from a monochrome image. The fine quality black and white printing you see in certain magazines and books is often achieved using a duotone or conventional CMYK printing process.

Duotone: 159 dk orange 614 (Pantone)

Duotone: 327 aqua (50%) bl1

Duotone: 506 burgundy (75%) bl 3

Tritone: BMC blue 2 (Process)

Normal – Grayscale Mode

Tritone: bl 313 aqua 127 gold (Pantone)

Quadtone: bl 541 513 5773 (Pantone)

Quadtone: Custom (Process)

Quadtone: Extra Warm (Process)

Figure 8.1 Examples of preset duotones (see Goodies folder) applied to a grayscale image. Process color duotones are formed using the standard CMYK process inks. Pantone (or any custom process color ink) duotones can be made from specified color inks other than these process colors.

1 The grayscale display in Photoshop is foremost based on the assumption that you want to see a representation on screen of how the grayscale file will print. Go to the Color Settings and select the anticipated dot gain for the print output. This will be the Photoshop grayscale work space that all new documents will be created in or be converted to. If you are working on a grayscale image intended for screen-based publishing then go to Window ⇨ Proof setup and select the Windows RGB preview.

2 When the Preview is checked in Duotone Options, any changes you make to the duotone settings will immediately be reflected in the appearance of the on-screen image. In the example shown here, a custom color tritone was selected and the component ink colors are displayed with the darkest color at the top. If I double-click the orange graph icon, this will open the transform curve dialog. The transform curve is similar to the image adjustment curves, except a little more restrictive in setting the points. The color ramp in the duotone dialog reflects the tonal transformation across an evenly stepped grayscale ramp and you can specify the ink percentage variance at set points along the horizontal axis.

Preserving the image luminosity

Some of the techniques described in this chapter involve applying extreme image adjustments. Therefore there is always the potential risk that if you are not careful, you will lose important highlight and shadow detail. A solution to this is to make a copy of the original background layer and place it at the top of the layer stack, set the layer blending mode to Luminosity and fade the opacity. This will allow you to restore varying percentages of the original image's luminance detail.

Figure 8.2 You can restore all or some of the original image luminance information by copying the background layer, dragging it to the top of the layer stack and setting the layer blend mode to Luminosity. Adjust the layer percentage to taste.

So, I hear you say, 'in that case why not use the CMYK mode instead of duotone, what difference will an extra plate make between a tritone and CMYK?' Well, a designer's job is to make the best use of their skills within an allocated budget. It is common for a color print job to include extra plates beyond the four employed in CMYK. Yes, you can construct many flat colors using a mix of these four inks, but designers have to be wary of misregistration problems. It is all right to specify large headline text in a process color, but not smaller body text. For this reason, designers specify one or more process colors for the accurate printing of colors other than black or a pure cyan, magenta or yellow. A typical custom brochure print job with full color images might require a total of six color plates, whereas a brochure featuring black plus one or two process colors requires fewer printing plates to make sumptuous duotones or tritones. You find designers working within the limitations of black plus two custom inks are still able to pull off some remarkable illusions of full color printing.

Infrared film simulation

The spectral sensitivity of a photographic film emulsion will extend slightly beyond that of the human visual spectrum. This can sometimes cause problems in color photography when an object radiates light we cannot see, but the film does. This phenomenon, known as metamerism, can affect the way the colors of specific garments can appear the wrong color on the final film. There is also a special infrared sensitive film emulsion you can buy, which is acutely sensitive to infrared radiation. The black and white emulsion is quite grainy. Vegetation reflects a lot of infrared light which we human observers are not aware of. Hence, green foliage will appear very bright and almost iridescent when captured on infrared film.

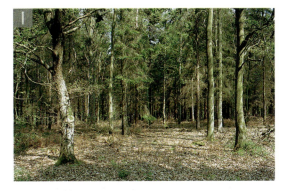

1 This spring woodland scene is a prime candidate with which to demonstrate the following infrared technique. As you can see, there are a lot of fresh green leaves in the picture. What follows is an extension of the color to monochrome technique using the Channel Mixer.

2 Essentially, what I am attempting to do here is to take this Channel Mixer technique to extremes. Now if we want the green channel to appear the lightest, because that's where all the green foliage information is, then we have got to somehow boost the green channel mix. The maximum setting allowed is 200% which produces a burnt-out 'screened' result. Bearing in mind the 'keep everything adding up close to 100%' rule, I reduced the other two channel percentages, to give them minus values. There was a little cyan coloring in the green, so I reduced the red channel by only 30% and the blue channel was therefore set to minus 70%.

3 So far so good. Now I want to add some glow to the foliage. It is important that the underlying image has remained in RGB (because it is the adjustment layer which is making the monochrome conversion). I went to the Channels palette and highlighted the green channel and applied a Gaussian blur filtration to that channel only. The result of the full blur is shown below. This isn't the desired result, so I followed that with an Edit > Fade Filter command, reducing the blur to a 26% opacity and Screen blend mode.

4 This is the final result after applying the Channel Mixer adjustment and green channel blur on the Background layer. To further simulate the infrared emulsion, try adding a hefty amount of Gaussian noise filtration to either all three color channels or the green channel only.

Adding a photographic border

If I want to mimic the effect of a photographic type border, like that associated with a Polaroid™ negative emulsion, I will go about this by opening a prepared scan of such a rebate, add this as an image layer and set the blend mode to Multiply. The border image must have clear 100% white areas. That way, only the dark areas will show through using the Multiply blending mode.

1 The starting point is an RGB image that I converted to monochrome using one of the techniques described at the beginning of the chapter.

2 This image is of a scan made from a print of Polaroid™ processed border. I selected the move tool and dragged this image across to the master image document window in order to add it as a new layer.

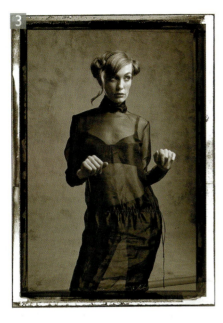

3 I then changed the layer blending mode to Multiply which made the border layer merge with the underlying layer. Lastly I added a Curves adjustment layer to colorize the image and create a sepia tone effect.

Client: Tresemme. Model: Stevie at Nevs.

Cross-processing

Cross-processing has been a very popular technique with fashion and portrait photographers who were fond of bleaching out skin tones anyway. The digital cross-processing method of manipulating images can be destructive too. It is all too easy to distort the color in such a way that image data slips off the end of the histogram scale and is irrevocably lost. But with the digital method you can be working on a copy file and so the original data is never completely thrown away. Secondly, you are in precise control of which data is to be discarded, taking the hit or miss element out of the equation. I have looked at several methods of imitating the cross-processed look in Photoshop and concluded that Curves adjustments are probably the best method with which to demonstrate these particular techniques. Figure 8.3 replicates the C-41 film processed in E-6 effect. Notice the adjustment of the highlight points in the red and blue channels – this creates the creamy white highlight and the curve shape of the lower portions of the red and blue channels produces the cross-curved color cast in the shadows.

History of cross-processing

There are two types of cross-processing: E-6 transparency film processed in C-41 color negative chemicals and C-41 film processed in E-6. To produce the latter, you used to use Kodak VHC film, overexposed by 2 stops and over-processed by 1 stop. The highlights became compressed in the yellow and magenta layers, so pure whites appeared pinky orange and shadow tones contained a strong cyan/blue cast. Kodak originally designed this emulsion specifically for wedding photographers. As the sales of VHC rocketed Kodak must have assumed the new demand was coming from their traditional wedding market base, so set about improving the VHC emulsion after which VHC did not cross-process so effectively!

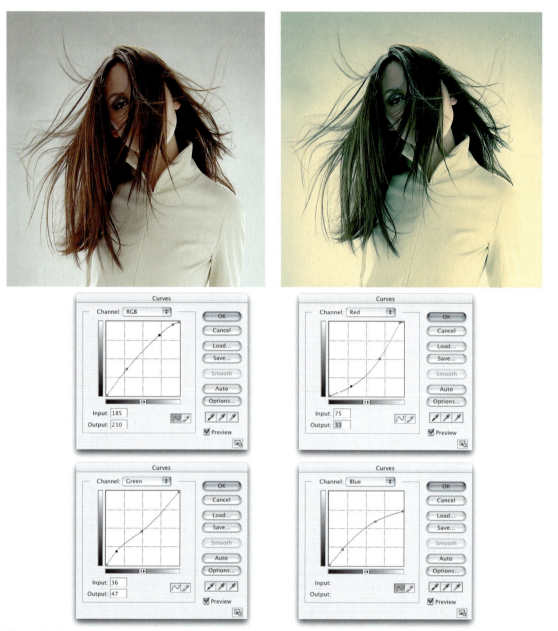

Figure 8.3 The C-41 film processed in E-6 chemicals cross-processing color effect. Note how the red highlight point is shifted to go more red and the blue highlight point shifted to go more yellow. The shadows and midtones are made more blue and the shadows in the reds are made more cyan – this creates a cross-curved color cast.

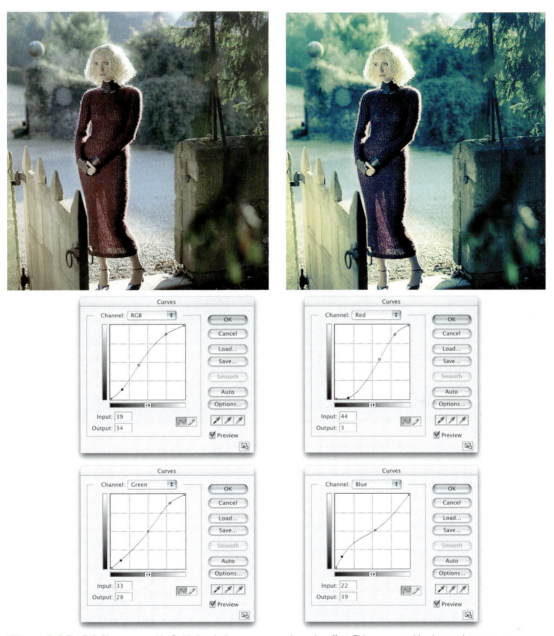

Figure 8.4 The E-6 film processed in C-41 chemicals cross-processing color effect. This curve combination produces a more contrasty outcome than the effect shown in Figure 8.3. Contrast is increased in all the composite, red and green channels and the contrast reduced in the blue channel.

Model: Ane Linge. Photograph by Thomas Fahey.

Channel Mixer adjustments

As the Photoshop program develops, so you adapt your way of working. The Channel Mixer can achieve the sort of coloring effects that once could only be done with the Apply Image command. The Channel Mixer is an interesting image adjustment tool, which alters the image by swapping color channel information, sometimes producing quite unique and subtle color adjustments which cannot necessarily be achieved with the other color adjustment tools. Controlling the Channel Mixer is no easy task. The example here shows you how to make a photograph appear to have been taken at sunset and make the scene appear to have richer, golden colors.

1 This image is correctly color balanced, but it lacks the drama of a golden warm sunlit image. One answer would be to adjust the overall color balance by applying a curves correction. The Channel Mixer, however, offers a radically different approach, it allows you to mix the color channel contents and does so on-the-fly.

2 Examine the Channel Mixer settings shown below. The main color enhancement occurs in the red channel. I boosted the red channel to 125%, mixed in a little of the green channel and subtracted 34% with the blue channel. Very slight adjustments were made to the green and blue channels, but you will notice how the green and blue channel percentages remained anchored close to 100%.

Color overlays

My favorite method for colorizing an image is to add a solid color fill layer from the adjustment layer menu in the Layers palette and alter the layer blending mode to either Color or Overlay mode. The Overlay blend mode generally produces the most satisfying results. Try adding a solid color fill layer, set the blend mode to Overlay (or Color for a slightly more washed-out look) and reduce the opacity to 20–30%. The Color blending mode is grouped with Luminosity, Hue and Saturation. Each of these blending modes operates along a similar principle: an HSB component of the pixel values of the blend layer replaces those of the underlying pixels. HSB refers to Hue, Saturation and Brightness (luminosity). The following technique illustrates how you can combine a color gradient fill in an Overlay blend mode to simulate the effect of filtering the light that is used to light the subject in a photograph.

1 This is a fairly simple technique to reproduce, which uses a Gradient Fill layer to simulate the effect of lighting a subject with strong colored gels. To reproduce the technique shown here, the subject has to be shot against a white background. Go to the Layers palette and click on the Adjustment layer button and choose Gradient Fill. It doesn't matter which gradient loads to start with. Close the gradient dialog and change the blend mode for the Gradient Fill layer to Overlay and maybe reduce the Opacity percentage down to 66%. Now double-click the Gradient Fill layer (I also selected the radial gradient option) and choose a suitable color gradient. In this example I chose Blue, Red, Yellow and I checked the Dither checkbox.

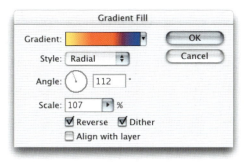

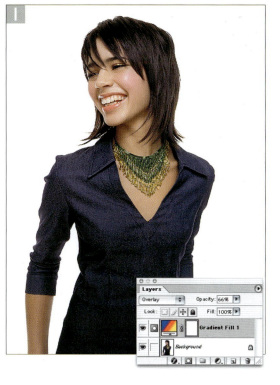

Client: Clipso.

2 If the gradient was seen in Normal blend mode it would look like this. But because it is set to Overlay blend mode we get a nice colorized effect as shown in the next diagram.

3 When the Align with layer checkbox is left unchecked and you move the cursor over to the document window, it will change to become a move tool and enable you to position the gradient anywhere you please in the image. To change gradient settings, click on the gradient bar in the Gradient Fill dialog. You can use the Scale setting to scale the proportions of the gradient.

Color blending modes

Let's look at more ways these and other overlay blending modes can be applied when retouching a photograph. Suppose you have a landscape picture and are looking for a simple method to remove the clouds from the sky. Cloning with the clone stamp tool or cutting and pasting feathered selections could possibly work, but you would have to be very careful to prevent your repairs from showing. For example, how will you manage to clone in the sky around the branches and leaves?

The sky is graduated from dark blue at the top to a lighter blue on the horizon. The easiest way to approach this task is to fill the sky using a gradient set to the Darken blending mode. The foreground and background colors used in the gradient are sampled from the sky image. Darken mode checks the pixel densities in each color channel. If the pixel value is lighter than the blend color it gets replaced with the blend color. In the accompanying example, the clouds (which are lighter than the fill colors) are removed by a linear gradient fill. The trees, which are darker than the fill colors, are left almost completely unaltered. To apply a gradient fill, I clicked the fill layer button at the bottom of the Layers palette and chose Gradient. The Gradient type was Foreground to Background, and I changed the fill layer blending mode to Darken. Before I did this, I loaded the blue channel as a selection. The Blue channel contains the most contrast between the sky and the trees. When a selection is active and you add a new fill or adjustment layer, or you click on the Add layer mask button, a layer mask is automatically added which reveals the selected areas only. As with adjustment layers, fill layers can be adjusted on-the-fly while retaining the layer masking.

Blending mode summaries:

Color mode: The hue and saturation values of the blend layer are combined with the luminosity of the underlying layers. The effect is to colorize the layers below.

Hue mode: Only the hue values of the blend layer are combined with the underlying saturation and luminosity values. The layers beneath are colorized, but the saturation of the base image is retained.

Saturation mode: The saturation values of the blend layer replace those of the underlying layer. A pastel colored overlay layer will cause the underlying layers to become desaturated, but not alter the hue or luminosity values.

Luminosity mode: The brightness values of the blend layer replace those of the underlying, but do not effect the hue and saturation.

1 The before picture contained a cloudy sky. I sampled colors from the top of the sky and from the horizon to set the foreground and background colors.

2 I Loaded the blue channel as a selection and clicked on the Create New Adjustment layer button at the bottom of the Layers palette and chose Gradient from the list. This opened the Gradient Fill dialog (shown below). I clicked OK to add the new gradient layer using the Foreground to Background gradient at the angle shown. I then set the fill layer to Darken blending mode. Note that the pre-loaded selection will have added a layer mask to hide everything in the picture but the sky area.

Gradient Map coloring

Normal blending mode at 45%.

Overlay blending mode at 40%.

Figure 8.5 The above examples show how various types of gradient layers can be applied to a color image as a Gradient Map and how the original photograph can be radically colored in many different ways. The Noise gradients can look very interesting as well. In most cases, I have discovered that it pays to fine tune the smoothness and shape of the gradient using the gradient edit options and also to experiment with the layer blending modes. Client: Crescendo Ventures. Agency: Moline Willett.

Softening the focus

If you wish to soften the focus, the best way to go about this is to apply a Gaussian blur filtration and follow this with a Fade command (the Fade command will also fade an image adjustment or a paint stroke) in order to restore some of the sharpness contained in the unfiltered image state. As shown below, you can change the fade blend mode to achieve interesting variations with which you can simulate favorite camera and darkroom printing techniques. If you prefer, duplicate the background layer, apply a Gaussian blur and selectively remove the blurred layer using a layer mask.

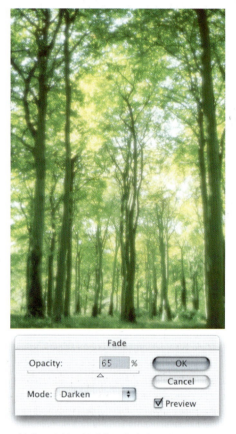

Figure 8.6 In the javelin thrower example, I applied a Gaussian blur filter and followed this with Edit ⇨ Fade Gaussian Blur and changed the mode to Darken. This action will simulate diffusion darkroom printing. With the forest scene I applied a similar amount of blur and faded using Lighten mode. This produced a soft focus lens effect.

Chapter 9
Layer Effects

This chapter shows you some of the special things you can now do in Layers and how these features will be of use to image makers as well as designers working in graphics or web design. Layer effects enable multiple (and reversible) Photoshop layering actions. This is a wonderful tool with which to automate the application of various Photoshop effects like embossing or adding a drop shadow. Layer effects can be used in various ways: applying effects to an image element on a layer; text effects with a type layer; and creating special painting effects where an empty layer can have layer effects active and anything painted in that layer will have the effect applied as you add image data to it.

Layer effects and Styles

In Photoshop you can add various layer effects to any of the following: a type layer; an image layer; or a filled layer masked by either a vector mask or a layer mask. The individual layer effects can be accessed via the Layer menu or by clicking on the Add a layer style button at the bottom of the Layers palette. Layer effects can be applied individually or as a combination of effects and these can be saved to become a 'layer Style' and added to the Styles palette presets. Layer effects are fully editable and will follow any edits you make to the type or the contents of a layer. When you add a new effect, the Layer Style dialog will open and allow you to adjust the effect settings. After creating a new layer effect, an italicized symbol appears in the layer caption area with a layer called 'Effects' and an itemized list of all the effects below. Double-clicking the layer/layer effect name or symbol reopens the Layer Style dialog. Drag and drop the 'Effects' layer to copy the effects to another layer.

Drop Shadow

As you can see, there are quite a range of options associated with each layer effect. The Drop Shadow uses the Multiply blending mode to make the shadow with the default color set to black. Now obviously you can change these parameters, so the effect can become something like a drop glow instead, applied using any color you want and with varying opacities. Below this is the angle setting, where you can either enter a numeric value or use the rotary control to manually set the shadow angle. The Use Global Angle comes into play when you want to link the angle set here with those used in the Inner Shadow and the Bevel and Emboss layer effects and that of any other Layer Styles layers. Deselect this option if you want to set the angles independently. While the window is open you can adjust the drop shadow angle and position by simply dragging with the cursor in the document window area. Below this are the shadow distance and blur controls.

Inner Shadow

The Inner Shadow controls are more or less identical to the Drop Shadow effect. The only difference being that this applies a shadow within the layered type or object area. The result may appear to be either that of a recessed shadow or will give a convex 3D appearance to the layer object. It all depends on the angle you choose and the size and distance of the shadow. The shadow and glow effects feature a Noise slider. At one level this will reduce the risk of banding, but the noise can also be used to add a grainy texture to your layer style.

Outer Glow and Inner Glow

These both have similar controls. The Outer Glow is very much like the Drop Shadow, but is defaulted to the Screen blending mode, spreading evenly outwards from the center; you could say that the Inner Glow corresponds with the Inner Shadow effect. The glow layer effects can apply either a solid or a gradient-based glow. The Inner Glow contains options for edge and center glows. Used in conjunction with the Inner Shadow, you can achieve a very smooth 3D 'contoured' appearance with the centered Inner Glow setting. Note the Spread and Choke controls that are available with the shadow and glow effects.

Bevel and Emboss

This adds a highlight and a shadow edge 180 degrees apart from each other. When you adjust the height or angle settings of the light, the two move in sync, creating an illusion of depth. There are many options here – the bevel style can be applied to create an outer bevel, an inner bevel, or pillow emboss. The embossing technique can be 'chisel hard' or 'soft'. There are some interesting Gloss Contour options in the shading section which can produce metallic-looking effects and you can also add a contour separately to the bevel edge and add an 'embossed' pattern texture to the surface.

Satin

This can add a satin type finish to the surface of the layer or type. You will want to adjust the distance and size to suit the pixel area of the layer you are applying the effect to.

Gradient Overlay

This will add a gradient fill. Separate opacity and blend modes can be applied to create subtle combinations of coloring. Use Align with layer to center align the gradient to the middle of the layer. The scale option will enlarge or shrink the spread of the gradient. As with other effects, the settings can be adjusted by dragging in the window area.

Pattern Overlay

Select a saved pattern from the presets. The opacity and scale sliders will modify the appearance of the overlay pattern. Use 'Link with Layer' to lock the pattern relative to the layer object.

Color Overlay

This Layer effect will add a color fill overlay to the layer contents. You are able to vary the opacity and change the blending mode.

Stroke

The Stroke effect applies a stroke to the outline of the layer or text with either a color, a gradient or a pattern. The options in this dialog are similar to those in the Edit > Stroke command, except as with all layer effects, the stroke is scalable and will adapt to follow any edits or modifications made to the associated layer.

Creating Styles

Figure 9.1 When you add a new layer effect, the effect will appear in a list below the layer in the Layers palette in the same descending order that the layer effects appear in the Layer Styles dialog. Each effect has its own 'f' effect icon and the effect can be made visible or invisible by toggling the eye icon next to it in the Layers palette. Or you can hide all of the effects at once by clicking on the eye icon next to 'Effects'. When you have found an effect setting or a combination of settings which you would like to keep, you can save these as a style via the Layer Style dialog. Click on the New Style button and give the style a name and it will be appended in the Styles palette. There are several preset styles that you can load in Photoshop. The Styles palette shown opposite contains the 'Textures' Styles presets using the Large Thumbnail view setting.

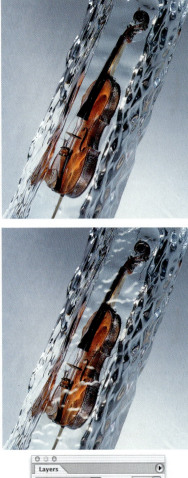

Client: The South Bank.
Photograph: Eric Richmond.

Applying layer styles to image layers

The illustrations opposite show how you can add layer effects and styles to image layers. Layer effects operate in the same way as adjustment layers do – they create a live preview of the final effect and only when you flatten down the layer are the pixels modified and does the effect become fixed. Layer effects are not scalable in the same way as the image data is. If you resize the image the Layer effect settings will not adapt, they will remain constant. If you go to the Layer menu and choose Layer Style ⇨ Scale Effects, you will have the ability to scale the effects up or down in size. The layer effect parameters in Photoshop are now large enough to suit high-resolution images. In the Layer Styles dialog you can select or deselect the global angle to be used by all the other layer effects. Although normally the effects work best when the same global angle is used throughout (the global light setting can be established in the Layer ⇨ Layer Styles menu). The Create Layers option is also in the Layer Styles menu options. This will deconstruct a layer style into its separate components. You can use this to edit individual layer elements if so desired. Layer effects and styles can be shared with other files or other layers. Select a layer that already has a style applied to it. Go to the Layer Styles sub-menu and choose Copy Layer Style, then select a different layer and choose Paste Layer Style from the same sub-menu

Figure 9.2 Using Layer Effects, you can create and save layer styles that can be used in Photoshop to paint texture. This illustration at the top shows a violin trapped in a block of ice and in the version below, I added an empty new layer and applied a layer style I had created called: *waterdroplet* (you can load the *waterdroplet* layer style from the CD). For the water droplet style to work effectively, I had to take he layer Fill opacity down to 0%. As I painted on the empty new layer with the brush tool, I was effectively able to paint using the layer style effect and create the translucent melted ice effect you see here. The Style is one that I created myself but which was based on the steps outlined by Greg Vander Houwen in a tutorial on the Tips and tricks PDF. You can access this PDF which includes Greg's great Rain Drop tutorial via the Photoshop CS Welcome screen.

1 Layer effects can be used to add glows and shadows to a type layer but Layer effects can work equally well on pixel image layers too. An EPS logo is first imported into Photoshop using the File ⇨ Place command. After resizing, hitting the Return or Enter key will rasterize the vector art as an image layer. A series of Layer effects were applied to the layer to create a new layer style.

2 In more detail, Bevel and Emboss, Inner Glow and Inner Shadow Layer styles were applied to the image layer. The global angle settings were deselected so that the Inner Glow angle was separate to the Bevel and Emboss angle. Note that the angle controls in the Bevel and Emboss dialog contain adjustments for both the lighting angle and the attitude of the light source.

3 If a layer mask is added to the layer you can then mask out portions of the layer contents. The combined layer effects in the layer style will adapt to follow the new contours and update as the layer contents change. When painting in the layer mask, the layer style adapts to follow the mask outline.

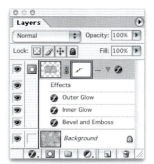

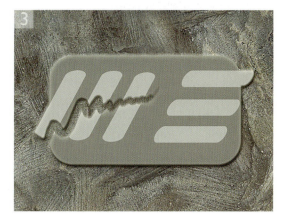

Figure 9.3 A Layer style was applied to a filled shape layer. The silky texture can be attributed to the use of an inverted cone contour being combined with the Satin layer effect.

Layer effect contours

The layer effect contours in Photoshop will affect the shape of the shadows and glows for the Drop Shadow, Inner Shadow, Outer Glow and Inner Glow layer effects. The examples on this and the next page show the results of applying different contours and how this will affect the outcomes of these various layer effects. The Bevel and Emboss and the Satin layer effects are handled slightly differently. In these cases, the contour will affect the surface texture appearance of the layer effect. The Bevel and Emboss dialog refers to this type of contour being a 'Gloss Contour' and you can generate some interesting metallic textures by selecting different contour shapes. The Bevel and Emboss edge itself can be modified with a separate contour (see Bevel and Emboss dialog at the beginning of this chapter).

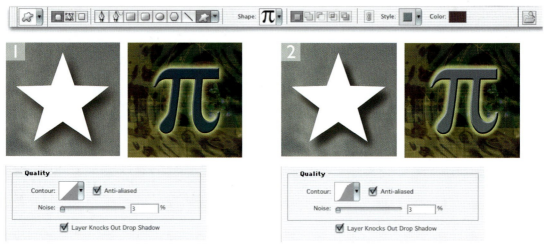

1 The linear contour is the default. In all these examples a Drop Shadow effect was added to the Star shape. Bevel and Emboss and Outer Glow effects were applied to the Pi shape layer.

2 The Gaussian curve contour accentuates the contrast of the layer effect edges by making the shadows and glows fall off more steeply.

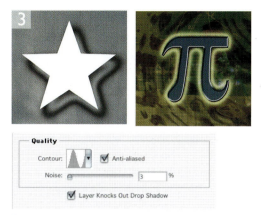

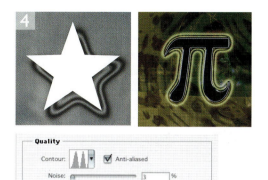

3 When applied with a slight displacement, the single ring contour can produce a subtle bevel type shadow. The Outer Glow was made with Range set to 100%.

4 & 5 The double and triple ring shapes produce a more graphic type of layer effect. As can be seen here, the shadows look like contoured neon lights and the Bevel and Emboss resembles a chrome type effect. The Outer Glow Range in both cases was set to 70%.

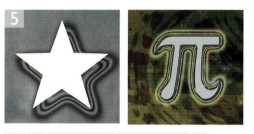

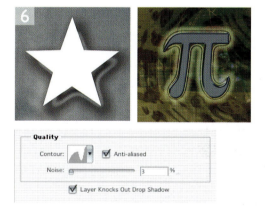

6 Click on the contour shape icon to open the Contour Editor dialog (shown opposite). Use this to load, edit and save a custom contour shape. You can create your own customized contour and save as a new contour to add to your current set. You can preview the effect the new custom contour has on the current Layer Effect. Check the Corner box to make a point an angled corner.

Transforms and alignment

Any transform you carry out can be repeated using the Edit ⇨ Transform ⇨ Again command (⌘ Shift T ctrl Shift T). The transform coordinate change is memorized in Photoshop, so even if other image edits are carried out in between, the Transform ⇨ Again command will remember the last used transform. When more than one layer is present, the layer order can be changed via the Layer ⇨ Arrange menu, to bring a layer forward or back in the layer stack. The full Layer menu and Layers palette shortcuts are listed in Chapter 12. In addition, two or more linked layers can be aligned in various ways via the Layer ⇨ Align Linked menu. The latter is a desirable feature for design-based work when you want to precisely align image or text layer objects in a design, although as can be seen the combination of repeat transforms and align layers provides interesting possibilities for making image patterns.

The alignment commands allow you to both distribute and align linked layers according to a number of different rules in the sub-menu list. To use this feature, first make sure the layers are all linked. The distribute command evenly distributes the linked layers based on either the top, vertical central, bottom, left, horizontal central or right axis. So if you have several linked layer elements and you want them to be evenly spread apart horizontally and you want the distance between the midpoints of each layer element to be equidistant, then choose Layer ⇨ Distribute Linked ⇨ Horizontal Center. If you next want the layer elements to align, then go to the Layer ⇨ Align Linked menu. How the align command centers or aligns the layers will be based on whichever of the linked layers is selected. The other layer elements will always reposition themselves around the active layer.

Figure 9.4 These linked, layered images were arranged using the layer alignment feature. I chose Layer ⇨ Distribute Linked ⇨ Vertical Centers to evenly balance out the spacing and followed this with the Layer ⇨ Align Linked ⇨ Horizontal Centers. These alignments brought all the individual images horizontally centered around their common axis as shown in the example above.

Photograph: Laurie Evans.

1 I wanted to add more motion blur to the saxophone in this photograph. I began by making a mask of the saxophone instrument (which you can see in the channels palette). I loaded this mask as a selection and used ⌘ J ctrl J to make a new copy layer from the background. I then selected Free Transform from the Edit menu, positioned the central axis point on the mouthpiece and dragged outside the bounding box to rotate the layer.

2 I dragged the rotated layer to the New Layer button in the Layers palette to make a duplicate layer and chose Edit ⇨ Transform ⇨ Again command (⌘ Shift T ctrl Shift T). This applied a repeat transformation. I then changed the blend mode of the two layers to Screen mode at 38%.

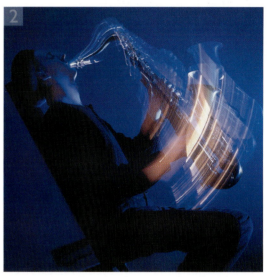

3 To complete the effect, I chose Filter ⇨ Blur ⇨ Radial Blur and applied a Spin blur to the first layer. Note that the blur center was offset roughly to where the mouthpiece was. I then applied the filter again (⌘ F ctrl F) to the second layer.

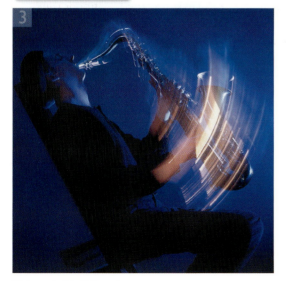

Photograph: Eric Richmond.

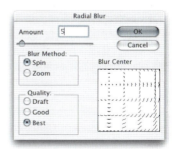

273

Ring flash shadow effect

This example shows how to create a lighting effect shadow. The amount of blurring applied to the first copy mask determines the extent of the glow. If experimenting with your own pictures, try different blur settings to judge which is the right one to use. The opposite effect of adding an outer glow can also be achieved by making a Levels lighten adjustment and maybe use the Screen blend mode as well. The original mask used for the technique must be very precise.

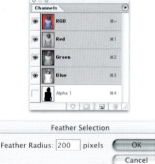

1 This photograph was taken against a red background, which was some distance behind the model. Colored gels were used to provide the blue lighting on the model, although some further Hue/Saturation adjustments were made to tweak the final colors.

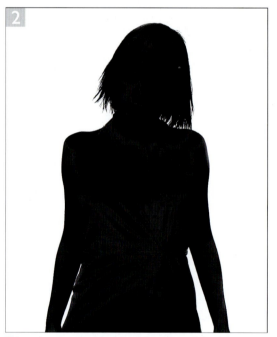

2 A mask was prepared based on information existing in one or more of the color channels (see Chapter 7 on montage techniques). The modified color channel alpha mask is shown here. I then loaded this alpha channel as a selection and applied a Select ⇨ Feather of 200 pixels.

Client: Alta Moda. Model: Melody at Storm.

3 I then saved the feathered selection as a new alpha channel. I followed this by adding the original alpha channel to the duplicate. There are several ways of doing this: you could, for example, try going Image ⇨ Apply Image, select channel-4 as the source and set the blending mode to Multiply at 100%.

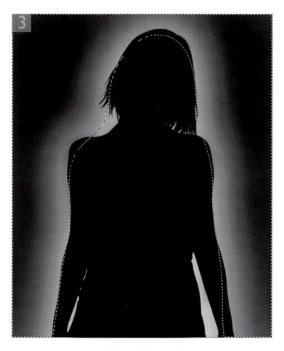

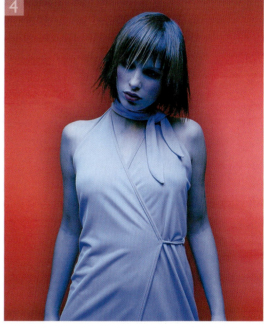

4 The new alpha channel might have benefited from adding some Gaussian noise to remove any banding which might have been introduced at the feathering stage. I loaded the duplicate channel as a selection by dragging the channel down to the Make Selection button and then clicked on the Add a new layer mask button at the bottom of the Layers palette and selected Levels. This operation added a new adjustment layer and masked it at the same time. In the Levels dialog, I adjusted the settings to darken the background areas and this achieved the result shown opposite.

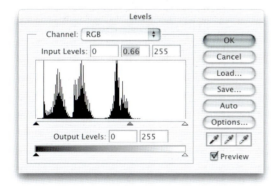

Text on a path

Type can be added to a pen path or vector shape so that any type entered will follow along the path outline. Simply move the type cursor close to the edge of the path to begin adding the type. You can then edit the shape of the path to change the shape of the type. Similarly, type can also be constrained by a shape outline.

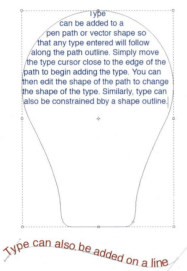

Figure 9.5 Examples of type being added inside a shape or following a pen path.

Shared linguistic libraries

Photoshop CS can share its linguistic library with Adobe applications, spelling additions can be shared between programs. Photoshop CS also shares its text engine with Illustrator™ CS, so it is now possible to export type as layered type or as type on a path or in a shape.

Spot color channels

Photoshop is able to simulate the effect of how a spot color will reproduce in print and how a special color overlay will interplay with the underlying image. Spot colors include a wide range of industry standard colors. You use the manufacturer's printed book color guides as a reference for how a color will print and not judge this from the screen. The colors available can include those found in the CMYK gamut, but also a whole lot more that are not, including metallic 'specials'. Spot colors are used where it is important that the printed color conforms to a known standard and for the printing of small point size type and graphics in color. A four-color process mix can be used when printing larger non-serif point sizes, but not for fine type and lines as the slightest misregistration will make the edges appear fuzzy. Spot colors can be added to images as part of the graphic design or as a means of accomplishing a color not available in the CMYK gamut.

A colleague of mine once won the dubious honor of 'most out-of-gamut color of the month' award from his repro company, after presenting them with a vivid green backdrop in his RGB transparency. The image was being printed as an advert to promote his work, so they made a masked color plate, adding a spot color to the background, simulating the green in the original.

Adding type

Photoshop type is fully editable and is added to a document using vector type layers. A type layer can be rasterized or converted to a work path or shape layer. You can still place type as a selection and import EPS artwork as before (see page 269). Or you can copy and paste path outlines of logos and save these as custom shapes (see Figure 9.8). OpenType fonts and their associated features are supported by Photoshop. The text paragraph formatting, justification and hyphenation options available in the Paragraph palette work similar to the text engine found in Adobe InDesign™. Paragraph text is created by clicking and dragging to create a paragraph box. Single line text is entered by clicking

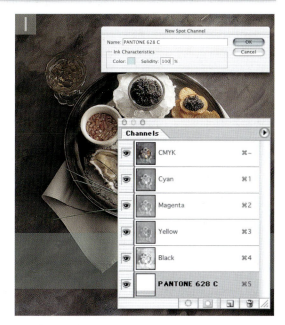

1 I chose New Spot Channel... from the Channels palette fly-out menu. This showed the dialog shown opposite. When you click on the Color box, this calls up the custom color dialog and you can choose from any of the installed custom colors including the Pantone™ color selected here. You normally choose a solidity percentage that matches the solidity of the custom color specified. When you change the solidity of the custom color, the effect is simulated in the image preview, matching the ink characteristics. Most custom colors are opaque (100%), whilst varnish colors are translucent (0%). To produce a faint tint, lower the opacity in the spot channel. The block shown here was created by filling a marquee selection with a light gray.

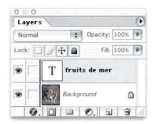

2 If the spot color channel remains active and the type tool is selected, any type entered will go directly into the spot color channel. As I input the text 'Oyster Bar', it first appeared cut out against the Quick mask color and after I clicked Enter, the type was rasterized as a floating selection, which can be repositioned using the move tool. Once deselected, the type became fixed in the spot color channel.

More type was added, this time using a type layer with white text. I selected the composite channel (the spot color channel was by then deselected) and chose a white foreground color from the color picker dialog. A new font could be chosen, or combination of fonts applied in the body of text. And as type was entered, a live preview appeared in the image.

A type layer is using vectors to describe the shape of the type, which will not become fixed as rasterized pixels. A file saved using the PSD or PDF formats, for example, will preserve all the vector information through to the final print stage.

Photograph: Laurie Evans.

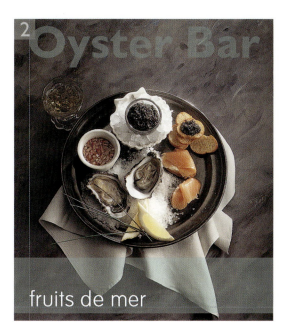

Vector output

The vector layer information contained in the Figure 9.8 page design can be read by a PostScript device and output the same way as vectors and type in a page layout program are normally handled. If you save a Photoshop document as a PDF, you can use the pixel compression options to reduce the file size, while the vector layer content will be preserved and will print perfectly at any resolution.

Figure 9.6 The PDF Save options can enable saving embedded fonts in the file.

directly in the document window and can be edited at a per-character level, i.e. you can change individual character colors and font size etc. The fractional widths option in the Character palette options is normally left on – this will automatically calculate how to render the anti-aliased text using fractional widths of pixels. However, when setting small point sized type in Photoshop to be displayed on the screen, it is better to turn this option off. Photoshop will then round up the gap between individual characters to the nearest pixel distance. Small text rendered this way will be easier to read. The anti-aliasing settings provide four levels: Sharp, Crisp, Strong and Smooth. With no anti-aliasing (None), font edges are likely to appear jagged. The Strong setting is suited to most graphics work. The Crisp setting is the least smooth and will probably prove useful when creating small point sized bitmapped text in Photoshop that is designed to appear on a web page. Photoshop notably features multilingual spell checking, which can be accessed from both the Edit menu and the Character palette. The Tool presets palette is extremely useful if you wish to save your custom type and type attribute settings as a custom preset.

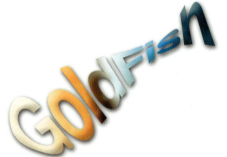

Figure 9.7 The Warp Text options are accessible from the Options bar and the Layer ⇨ Type menu. Select a type layer and open the Warp text dialog. Set the warping to apply on vertical or horizontal text and select a warp option from the pop-up menu and adjust the Bend and distortion sliders below.

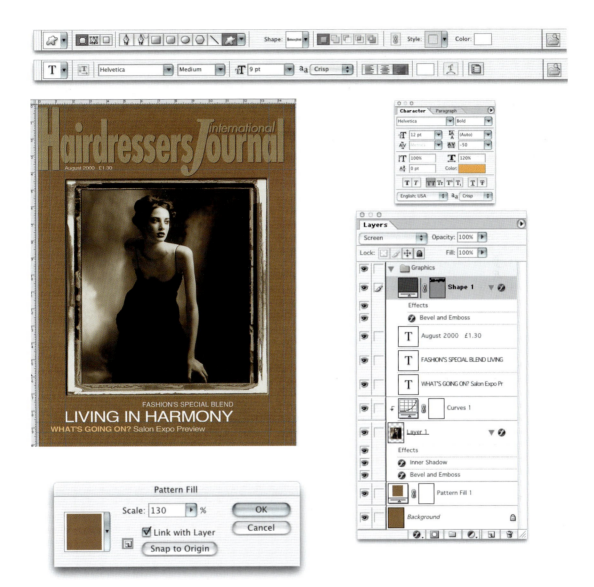

Figure 9.8 A magazine cover like this could be designed entirely within Photoshop. The masthead was a path I copied from Illustrator and pasted into Photoshop. I then chose Edit ⇨ Define Custom Shape, to add it to the Shape presets. When saved as a Shape, I can select it at any time and add as a new shape layer and apply a Style from the Styles palette. I added a Pattern fill layer above the background, using a custom pattern, which was scaled up slightly. I then applied a couple of layer effects to the main image, to make it appear as if recessed in a card frame. I added the text on separate layers, and was able to set different point sizes and change the color of the type on a single line of text.

Chapter 10

Photoshop Filters

O
ne of the key factors attributed to Photoshop's success has been the program's support for plug-in filters. A huge industry of third-party companies has grown in response to the needs of users wanting extra features within Photoshop. John Knoll, who together with his brother Thomas Knoll originally wrote the Photoshop program, was responsible for creating many of the plug-ins that shipped with the earlier versions of Photoshop (plug-ins that still survive today). The open door development policy has enabled many independent software companies to add creative tools and functionality to Photoshop. In turn this ongoing development can largely be attributed to the success of Photoshop as a professional image manipulation program.

Filter Essentials

Most of the Photoshop filters provide a preview dialog and variable settings. Some of the more sophisticated plug-ins (such as Liquify) are like applications operating within Photoshop. These have a modal dialog interface, which means that whenever the filter dialog is open, Photoshop is pushed into the background. This can usefully free up keyboard shortcuts. With so many effects filters to choose from in Photoshop, there is plenty enough to experiment with. The danger is that you can all too easily get lost endlessly searching through all the different filter settings. There is not enough room for me to describe every filter present, but in this chapter, we shall look at a few of the ways filters can enhance an image, highlighting the more useful creative filters plus a few personal favorites.

Blur filters

There are several ways you can blur a photograph in Photoshop. What follows is a brief description of each.

Gaussian Blur

The Gaussian blur filter is very versatile. I make many references to its use throughout the book. It can serve many purposes from blurring areas of an image to softening mask edges. It has been possible to produce optical blurs that make a background element appear out-of-focus, but the new Lens Blur filter is worth looking at as an alternative and better way to produce convincing photographic blurs.

Radial blur

Radial blur does a very good job of creating blurred spinning motion effects. It has many uses, like adding movement to car wheels shot stationary in the studio. Similarly when switched to the Zoom blur setting, it does a neat impression of a zooming camera lens. There are a choice of render quality settings. This may appear quite a sluggish plug-in, but it is after all carrying out a major distortion of the image. So either be very patient or opt for a lesser quality setting.

Fade command

Filter effects can be further refined by fading them after you have applied a filter. The Fade command is referred to at various places in the book (you can also fade image adjustments and brush strokes etc.). Choose Edit ⇨ Fade Filter and experiment with different blending modes. The Fade command is almost like an adjustment layer feature, but without the versatility and ability to undo later. It makes use of the fact that the previous undo version of the image is stored in the undo buffer and allows you to calculate many different blends but without the time-consuming expense of having to duplicate the layer first. Having said all that, history offers an alternative approach whereby you can do just that. If you filter an image, or make several filtrations, you can return to the original state and then paint in the future (filtered) state using the history brush or make a fill using the filtered history state (providing nonlinear history has been enabled).

RGB only filters

You will notice that most of the effects filters work in RGB mode only. This is because they can have such a dramatic effect on the pixel values, and they would easily send colors way out of the CMYK gamut. So to unleash the full creative power of Photoshop plug-ins, this is a good argument for having to work in RGB mode and convert to CMYK later.

Figure 10.1 The Radial Blur dialog shown in Spin mode. The above image shows the before on the left and the filtered version on the right.

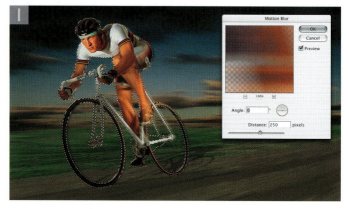

Figure 10.2 The Smart Blur filter.

Motion blur

The Motion blur filter can create effective impressions of blurred movement. Both the blurring angle and length of blur (defined in pixels) can be adjusted. The blurring spreads evenly in both directions along the axis of the angle set, but that need not be a problem. If the blur is applied to a duplicate of a layer element, the blur can be shifted with the move tool either side as desired.

1 I drew a path around the outline of the cyclist, converted this to a selection and chose Layer ⇨ New ⇨ Layer via Copy (⌘ J ctrl J). I then chose Filter ⇨ Blur ⇨ Motion Blur and applied a 250 pixel blur to the copied cyclist layer.

2 I loaded the selection again, but this time inverted it and clicked on the Add Layer Mask button (this hid the blurred layer where it overlapped the cyclist). I unlinked the layer mask from the layer, ensured the blurred image layer was selected and with the move tool was able to drag the blur behind the cyclist and reduced the opacity to 50%.

Smart blur

This filter blurs the image while at the same time identifying the sharp edges and preserving them. When the settings are pushed to the extremes, the effect becomes very graphic and can look rather ugly. In some ways its function mimics the Median Noise filter and is another useful tool for cleaning up noisy color channels or artificially softening skin tones to create an airbrushed look. When retouching with this tool you could apply the smart blur to a copied layer and then lower the opacity.

Lens Blur

The Gaussian Blur is a popular choice of filter for most blur tasks. But if you want to make a photograph appear realistically out of focus, it is not a simple matter of making the detail softer. This is where the Photoshop CS Lens Blur filter comes in useful, as it has the potential to mimic the way a camera lens forms an optical image. Consider for a moment the way a lens works. The camera lens will focus an object to form an image made up of circular points on the film/sensor surface. When the radius of these points is very small, the image is considered sharp. When the radiuses are large, the image will be out of focus. It is particularly noticeable the way bright highlights blow out when this happens and how you can see the shape of the camera lens iris in the blurred highlight points. The Lens Blur filter is able to mimic this effect. The best way to understand how it works is to look at the shape of the bright lights in the nighttime scene in Figure 10.5, after I had applied the Lens Blur filter. You will also find this image on the CD.

You can also create a mask to define the areas you wish to selectively apply the Lens Blur to. This will allow you to create shallow depth of field effects. Using the Lens Blur dialog you can then load this mask under the Depth Map section in order to define the plane of focus. There is an example showing you how to do this on page 286 that shows how to throw the foreground and background out of focus and keep the main object of interest sharp.

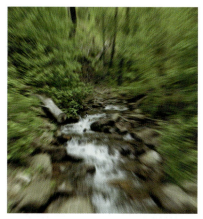

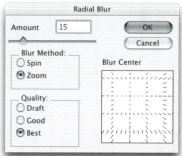

Figure 10.3 When using the Radial Blur filter in zoom mode, you can drag the center point to match the center of interest of the image you are about to filter.

Figure 10.4 The Average blur simply averages the colors in an image or a selection. Useful if you want to analyze the color of some fabric to create a color swatch for a catalog.

1 I wanted to blend this photograph of the model with the New York street scene above. Now the model has been lit in such a way that the lighting matches the outdoor daylight. But if I merge the two images together, the background detail would probably be too distracting.

2 To make the background appear out of focus, I selected the New York street scene and chose Filter ⇨ Blur ⇨ Lens Blur. I first adjusted the Specular Highlights Threshold setting, bringing it down just enough until the highlights started to bloom. I then adjusted the Specular Highlights Brightness setting to create the desired amount of lens flare. The Iris Radius controls the width of the blur and the effect of this adjustment will be particularly noticeable in the specular highlights. Further adjustments can then be made to the iris shape, the blade curvature of the iris and the rotation. These minor tweaks will allow precise control over the iris shape.

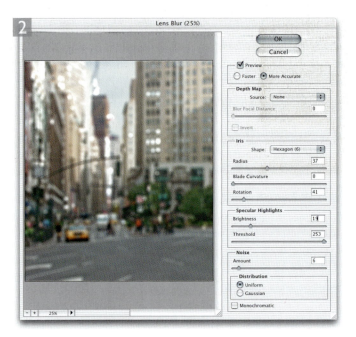

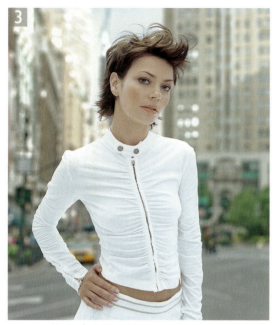

3 I combined the two images together using the montage technique described in Chapter Seven. As you can see in the layers palette dialog, the street scene image is hidden by a mask I had prepared earlier and is blended with the Background layer using the Multiply blend mode. I also added a curves adjustment layer which was grouped with the street image layer beneath it. The curves adjustment was added in order to lighten the blurred layer and match the lightness of the model in the picture.

Client: Reflections. Model: Lisa Moulson at MOT.

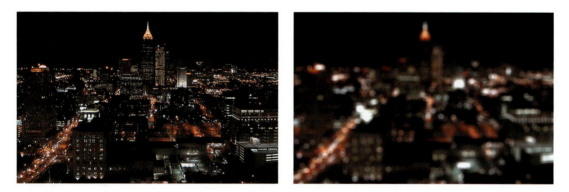

Figure 10.5 The best way to learn how to use the Lens Blur filter is to experiment with an image like the one shown here, which is available on the CD ROM. It is an ideal test image because this is a nighttime scene with lots of small points of light. In this example, you can get a clear idea of how the Specular Highlights and Iris controls work and how they will affect the appearance of the blur in the photograph.

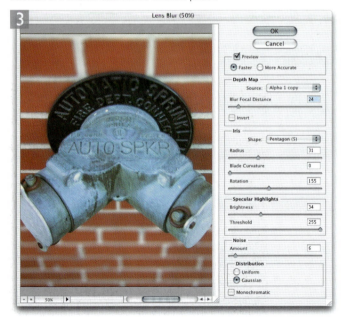

1 The Depth Map controls in the Lens Blur dialog are designed to allow you to simulate a shallow depth of field focus effect. The image shown here is a good choice to demonstrate this with because the wall is photographed at an oblique angle and starts off with everything in sharp focus, which is one of the pluses (and minuses) of using a compact digital camera! I first drew a pen path to define the outline of the hydrant, I hit ⌘ Enter ctrl Enter to convert the path to a selection, and then clicked on the Save Selection as a Channel button in the Channels palette.

2 I then needed to modify the mask to define a depth of field map. I selected the gradient tool, in reflected gradient mode (circled in blue) and set the tool blend mode to Multiply mode and dragged vertically from the center. To get the fade at the top, I kept the gradient tool in reflected mode and changed the blend to Screen mode (circled in red). I made a rectangular marquee selection of the top half of the picture, selected the gradient tool again and dragged vertically from the middle again (as shown above).

3 I chose Filter ⇨ Blur ⇨ Lens Blur. I went to the Depth Map section and moused down on the channel source menu and selected the channel I had just created, which in this case was named: *Alpha 1 copy*. If you try this out for yourself, try adjusting the Blur Focal Distance slider to adjust the amount of blur that is applied to the areas that are selected and partially selected by the depth mask channel.

Distortions and displacements

The displacement filter is capable of producing strong image distortions like the classic parabola shape described in the Adobe manual. Intuitive it is not. The effect works well with text effects and where the displacement map has been softened beforehand. Displacement maps are useful for generating texture patterns. You will find a large number of displacement maps contained on the Adobe Photoshop CD and these can be loaded to generate all types of surface texture patterns.

1 I borrowed this sparkling sea shot as it was likely to show the displacement effect quite clearly. To displace an image, one needs to have a separate 'map' source image which can be any type of image (except Index color).

2 I created the basis for the displacement map as a new channel in the destination water image – it would be used later to enhance the effect. I placed an Illustrator file (File ⇨ Place...) and duplicated the channel.

3 Gaussian blur was applied to the copy channel, which was inverted, then copied and saved as a new separate 'map' image (Select ⇨ All; Edit ⇨ Copy; File ⇨ New; Edit ⇨ Paste; Layer ⇨ Flatten Image).

4 Back at the original image, I selected Filter ⇨ Distort ⇨ Displace. The options were set to Stretch to fit and Repeat edge pixels. After clicking OK, a dialog box asks you to find and select the map to be used. The lightest parts of the map produce no pixel movement, whilst the darker areas shift according to the parameters set.

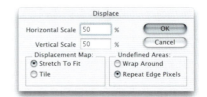

5 Some extra finishing work was done to add emphasis to the displacement. The border was cut away and a couple of layers added based on the original logo placed and stored in the new channel. The blending modes were set to Screen at low opacity and Hard Light at 49% above.

Pattern Maker

The Pattern Maker, is a creative tool that you can use to generate random, abstract patterns that are based on a sampled image, either a whole image or a selected area. It is useful for creating interesting textures that can be saved as custom patterns, but more specifically, it can be used to generate texture patterns that can be used to convincingly fill parts of an image. The Pattern Maker is shown being put to use in Chapter 6, to create a stone wall texture pattern that can be used in conjunction with the healing brush to cover up an area with a texture matching the surroundings.

Figure 10.6 The Pattern Maker dialog controls. You can generate a pattern based on either the actual image size or a tile area of specified pixel size. If you wish, the generated tiles can be offset either horizontally or vertically by a set percentage amount. Increasing the smoothness will produce better results, but take longer to process. Increasing the sample detail will preserve more recognizable detail. A lesser amount will produce more abstract results. Check the Saves Preset Pattern button at the bottom of the palette if you want to save a generated pattern to the Pattern Presets. For as long as the dialog is open, you can keep generating new presets, review their histories using the navigator buttons and delete or retain them as necessary.

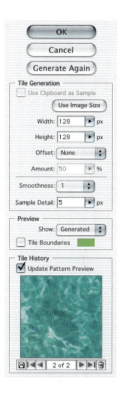

Filters for alpha channel effects

The Other Filter sub-menu contains a collection of filters, some of which are very handy for editing alpha mask channels. The High Pass filter is useful as a tool for detecting and emphasizing image areas of high contrast in preparation for converting a duplicated color channel to a mask. I use the Maximum and Minimum filters to either choke or expand an alpha channel mask and if you refer back to Chapter 7 you will see two of the step-by-step examples show examples of the Maximum and Minimum filter in use.

Figure 10.7 This shows a quick before (top half) and after (lower half) where I have choked a mask. The technique is described in full detail in Chapter 7. Basically the Maximum and Minimum filters can be used to shrink or expand a mask. Which you use depends on whether the mask is white against black or black against white. As shown here, I usually want to choke the masks I make and have devised an effective way of working out which one to use. I apply Maximum first and if it's wrong, I know to use Minimum instead.

Rapid filter access

There are around 100 filters in the Filter menu. That's a lot of plug-ins to choose from of which many are used to produce artistic effects. The Filter Gallery makes 47 of these filters accessible from the one dialog. The following filter categories are available: Artistic; Brush Strokes; Distort; Sketch; Stylize; Texture (note that not all the filters in the above categories are included in the Filter Gallery).

Filter Gallery

To use the Filter Gallery, select an image, choose Filter Gallery from the Filter menu and click on various filter effect icons, revealed in the expanded filter folders. The filter icons provide a visual clue as to the outcome of the filter. As you click on it the filter effect can be previewed in the preview pane area. This in itself is a huge improvement as you can preview a much bigger area now. On the right, you can also combine filters and preview how they will look when applied in sequence. To add a new filter, click on the New effect layer button at the bottom. As you click on the effect layers you can edit the individual filter settings above. To remove a filter effect layer, click on the Delete button.

Filter Gallery preview Filter effect folder Collapse/expand filter effects Filter effect settings

Preview magnification controls Filter effect visibility on/off Delete button

Filter effect layer New effect layer button

Figure 10.8 The Filter Gallery. Client: Altered Image. Model: Lidia @ M&P

Liquify

While the outcome of the Displacement filter is determined by a prepared alpha mask, Liquify is in effect an interactive version of the Displacement filter. Liquify enables you to magnify, melt, smear and generally make all manner of distortions to an image and preview the outcome of the distortion in the preview window as you apply the various distorting tools. The distortion is then post-rendered at full resolution. The Liquify tool controls have been improved in Photoshop CS. You can also save and load the liquify mesh. It is possible to zoom in on the image within the modal Liquify dialog and you can also preview the liquify effect against selected views of the undistorted image in various ways.

The underlying mesh can be made visible in the Liquify Tool Options. The grid will give you an indication of how the warp is being applied or reconstructed and readily help you pinpoint the areas where a distortion has been applied. Liquify is a perfect tool for many types of subtle retouching such as the occasions when you might wish to gently alter the shape of someone's facial features. The View options allow you to preview the distorted version with a variable overlay of the undistorted image – this can be an overlay of all merged layers or a specific target layer.

Having the ability to zoom in on the image area within the Liquify dialog is very useful. However, the Liquify command is a very processor intensive plug-in. If you are working on a large image then it may take a long time to carry out a liquify distortion. This is where the save and load mesh options can help. If you carry out your liquify distortions on a scaled-down version of the master image, you can save the mesh as a separate file. Open up the master file later, load the mesh you saved and apply.

Figure 10.9 If you want to correct lens barrel distortion, you can try doing so by using the Pinch filter. As a first step you should go to the Image menu and choose Add Canvas to add a border around the photograph, because adding a border beforehand will produce a more even pinch effect. Now go to the Filter menu and choose Distort ⇨ Pinch and apply a lowish value. In this example, I added 15%. Once the filter has been applied, crop the photograph to trim the edges.

The Liquify tools explained

The Warp tool (W) provides a basic warp distortion with which you can stretch the pixels in any direction you wish. The new ≋ Turbulence tool (A) produces random turbulent distortions. The ↻ Twirl Clockwise tool (R), as the name suggests, will twist the pixels in a clockwise direction, while the ↺ Twirl Counter Clockwise tool (L) twists the pixels in the opposite direction. A larger brush works best with these tools. The ▓ Pucker tool (P) shrinks pixels and produces an effect which is similar to the 'Pinch' filter. Warp and Reflection distortions can sometimes benefit from 'taming'. The pucker tool is therefore ideal for correcting over-distorted areas. The ◈ Bloat tool (B) magnifies pixels and is similar to the 'Bloat' filter. The ▓ Shift Pixels tool (S) shifts the pixels at 90 degrees to the left of the direction in which you are dragging. When you ⌥ *alt* drag, the tool will shift pixels 90 degrees to the right. When you understand how the shift tool works, you can introduce some nice rippled distortions. The ▨ Reflection tool (M) is perhaps the most unwieldy of all, copying pixels from 90 degrees to the direction you are dragging and therefore acting as an inverting lens (which if you are not careful will easily rip an image apart). Fortunately, the ✔ Reconstruct tool (E) will enable you to restore the undistorted image. If you want, you can protect areas of the image using the ▨ Freeze tool (F). Frozen portions of the image are indicated by a Quick mask type overlay. These areas will be protected from any further liquify distortion tool actions. The Freeze mask can be selectively or wholly erased using the ▨ Thaw tool (T). Use the 🔍 Zoom tool (Z) to magnify or zoom out and the 🖐 Hand tool (H) to scroll the preview image.

Warp tool

Twirl Clockwise tool

Twirl Counter Clockwise tool

Pucker tool

Bloat tool

Shift Pixels tool

Reflection tool

Reconstruct tool

Freeze tool

Thaw tool

Figure 10.10 Set the brush size and pressure settings in the Tool Options section. In View options you can display the underlying mesh grid (shown in the above illustrations). When freezing an area, you can load an alpha channel as a mask with which to protect the exact areas of the picture you don't want to distort. The reconstruction options provide different modes for reversing any distortions made. The Rigid mode provides one-click reconstruction. Stiff, Smooth and Loose provide varying speeds of continual reconstruction – the image mesh continues to unravel as you mouse down. Click on the Reconstruction button to observe the distortions undoing progressively. Use *esc* or ⌘ . *ctrl* . To halt the reconstruction at an intermediate stage. Avoid applying a second click, as this will exit the modal dialog and you will lose all your work!

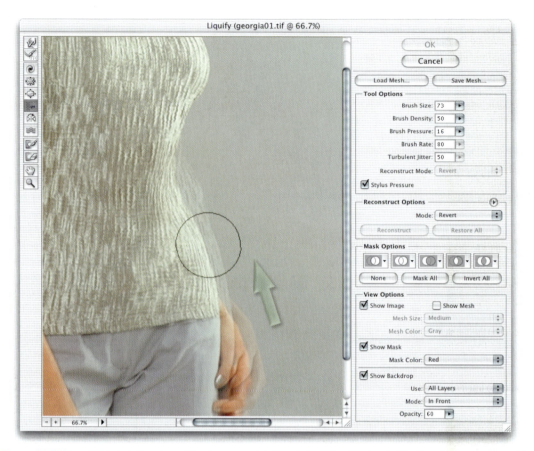

Figure 10.11 The shift pixels tool can be used to slim down waists. The pixels will be shifted to the left of the direction you drag with the tool. In this example the pixels were shifted inwards to the left as I dragged in an upward direction. If I drag downwards they would be shifted to the right. Because the Backdrop option is selected in the Preview options, you can see an overlaying preview of the undistorted version. If you have more than one layer selected, you can select a specific layer to preview your distortion against.

Figure 10.12 Liquify distortions can be applied in stages and masks used to protect the work that you have done. In the screen shot shown here, I used the warp tool to add more of a smile to the lips and then used the freeze tool to mask the result of this distortion and decided to choose a nice shade of yellow for the mask! When you freeze an area, it is protected from subsequent distortions. The frozen areas can be erased using the thaw tool.

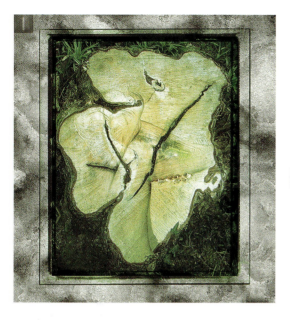

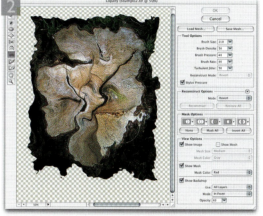

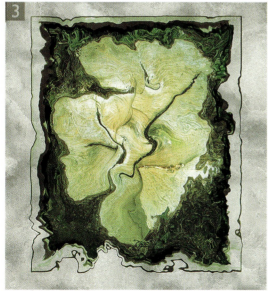

1 In the earlier editions of this book, I used to feature a technique showing how to imitate a Polaroid film emulsion transfer. It is now easier to accomplish with the Liquify filter. The image shown here has a background layer, a tree stump image layer (with an associated adjustment layer), and above this, an independent Polaroid emulsion border layer set to Multiply blend mode.

2 I activated the tree stump image layer and chose Liquify from the Filter menu. I mainly used the Turbulence tool plus the clockwise and counterclockwise twirl tools to create the distortions that you see here. I then clicked on the Save Mesh button to save this distortion so that it could be reused.

3 I then selected Layer 2 (which was the border image in Multiply mode) and opened Liquify again. This time I clicked on the Load Mesh button and loaded the recently saved mesh, applying an identical distortion, to produce the result shown here.

Missing 3D Transform

The 3D Transform filter is no longer installed as standard in Photoshop. It hasn't been completely dumped, it is there on the Photoshop application CD ROM and you can install it by simply copying it across to the Photoshop plug-ins folder.

Figure 10.13 Examples of the Render ⇨ Clouds filter (top) and the Render ⇨ Difference Clouds (bottom).

Fibers filter

The Fibers filter is a new Photoshop CS plug-in which can be found in the Filter ⇨ Render menu. In some ways it is similar to the Render Clouds filters. It can generate abstract fiber patterns which could be useful if you wanted to artificially create a natural-looking fibrous texture. There is an example of the Fibers filter dialog in Chapter 1 on page 7.

Lighting and rendering

Rendering processes are normally associated with 3D design programs, yet Photoshop has hidden powers itself when it comes to rendering 3D shapes and textures. One of the most interesting of which is Lighting Effects, but let's look at some of the other rendering filters first.

Clouds and Difference Clouds

This filter generates a cloud pattern which fills the whole image or selected area based on the foreground and background colors. The cloud pattern alters each time the filter is applied, so repeated filtering (⌘ *F* *ctrl* *F*), for example, will produce a fresh cloudscape every time. If you hold down the ⌥ *alt* key whilst applying the Cloud filter, the effect is magnified. The Difference Cloud filter has a cumulative effect on the image. Applying it once creates a cloud pattern based on the inverse color values. Repeating the filter produces clouds based on the original colors and so on... although after each filtration the clouds become more pronounced and contrasty.

Lens Flare

This is another one of the render filters and a little overused perhaps, but nevertheless quite realistic when it comes to adding the effect of light shining into the lens along with the ghosting type of patterns normally associated with camera lens flare. For the purposes of illustration or adding realism to computer rendered landscapes, it is ideal. Instead of applying the lens flare directly to the background layer, I added a new layer filled with neutral gray set to Overlay mode and applied the Lens Flare filter to this layer only. This allows the option of repositioning the flare after filtering. Another approach is to apply the filter to a black fill layer in Screen blending mode.

Whilst Photoshop is no replacement for professional 3D design packages, there is more to the Lighting Effects filter than first meets the eye. I thought I would begin by introducing an over-the-top use of the filter that does not

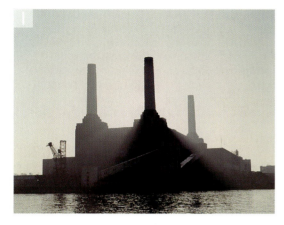

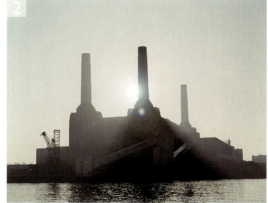

1 To add a new layer filled with a neutral blending gray, I ⌥ alt clicked on the New Layer button in the Layers palette, selected the Overlay blend mode and then checked the Fill with Overlay Neutral color checkbox.

2 I next applied the Lens Flare filter. The position of the lens flare center point can be adjusted in the dialog preview. If you ⌥ alt click in the preview box, this will call up the Precise Flare Center dialog, where you can set precise mouse coordinates for where to center the lens flare effect.

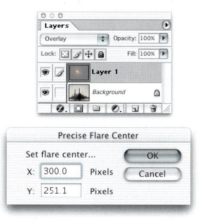

use photography at all, just to demonstrate its potential before showing a more typical, photographic use. The following example shows how lighting can be added to an existing studio photograph – either to add emphasis or to introduce a spotlight effect in the background. I should mention that Lighting Effects is a memory hungry plug-in. You will not always be able to use it on large files unless your computer is well equipped with RAM memory.

1 This is a photograph taken for a Tresemme advertorial promotion. The Lighting Effects filter works well as a means of adding lighting afterwards to a photographic scene. But with a little careful control you can achieve a more realistic effect. Here, I wanted to use the Lighting Effects filter to add some spotlights to the background only. So to begin with I drew a path around the outline of the model and inside the outer border. This was converted to a selection and feathered slightly by about 2 pixels.

2 The Lighting Effects filter is found under the Filter ⇨ Render section. The dialog box displays the selected area in the Preview window. I selected one of the effects presets: Crossing Down. Each light can be adjusted by dragging any of the four ellipse handles or the center point. A new light can be added by clicking on the light bulb icon at the bottom.

3 In this example, the two light sources are of the spotlight type. This produces an effect that is like having two fresnel spots hitting the back cloth from above. The combined controls of the Intensity and the Focus slider are like the flood/spot wheel on a tungsten spotlight. Below that are the Properties sliders. This is where you can set the desired surface texture, to simulate a plastic matte or a shiny metallic type surface to reflect the added lighting. The Exposure slider governs the brightness of the individual lights, while the Ambience slider can be used to add a fill light to the overall scene.

Client: Tresemme/*Hairdressers Journal*.
Model: Karen at Models One.

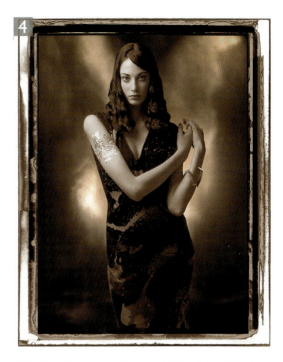

4 The Omni light source is like a round diffuse light, which when positioned centered behind the model adds an extra glow to the backdrop, although this time with a softer edge. One can also color the lights in Lighting Effects. If you double-click the swatch to the right of the lighting controls, you can choose a color from the picker, which will in effect 'gel' the light.

Practical applications

When used properly, the Lighting Effects filter is an exceptionally useful Photoshop tool for generating textures, 3D objects or lighting fills. I once saw a good example of a flood-lit hotel exterior where the client couldn't get it together to organize replacement bulbs and the photographer had to shoot the scene as it was. There was enough shadow detail recorded in the shadows so that the retoucher was able to apply the Lighting Effects filter to replicate the missing lights. He used one of the image color channels as a texture map to make the floodlighting appear more realistic and made the light source color match that of the other exterior lights

Digital Capture

A photographer I worked for once told me 'learn the tricks of the trade first, and art will find its course'. Photoshop is certainly a complex program to learn, but as you begin to understand it in depth, this acquired knowledge will give you the freedom to solve all sorts of technical challenges and the talent to express yourself photographically. This chapter is all about the process of capturing a digital image before it is brought into Photoshop and an updated account of the latest camera and scanning equipment. It is very relevant to everything else you do in Photoshop, because everything begins with the creation of an image and how you capture that image matters greatly, especially from a technical standpoint. Because the better the image is to begin with, the easier it will be to manipulate it.

Digital imaging has successfully been employed by the printing industry for over fifteen years now and if you are photographing anything that is destined to be printed, Your images will at some stage be digitized. At what point in the production process that digitization takes place is up for grabs. Before, it was the sole responsibility of the scanner operator working at the printers or high-end bureau. The worldwide sales success of Photoshop is evidence that prepress scanning and image editing now takes place more commonly at the desktop level. It is self-evident that the quality of your final output can only be as good as the quality of the original. Taking the digitization process out of the hands of the repro house and closer to the point of origination is quite a major task. Before, your responsibility ended with the supply of film to the client. Issues such as image resolution and CMYK conversions were not your problem, whereas now they can be.

It is worth bearing in mind the end product we are discussing here: digital files that have been optimized for reproduction on the printed page. The media by which the images are processed are irrelevant to the person viewing the final product. Those beautiful transparencies are only ever appreciated by a small audience – you, the art director and the client. Pretty as they might be, transparencies are just a means to an end and it is odd if a client should still insist on digital files being 'proofed' as transparency outputs when a calibrated digital proof would give a better impression of how the job will look in print. I am not knocking film – a roll of film has the potential to record and store many gigabytes of data at high quality quickly, and for a very reasonable cost. The majority of my work involves shooting live action. Throughout the last year I have been shooting nearly every job digitally using a Canon EOS 1Ds camera. But I have also been shooting film as well with a Fuji GX68 II film camera system. Some clients have embraced digital completely, while others still prefer to edit from the pictures that are supplied as transparencies (chromes). The reason why I prefer using the Canon EOS 1Ds is because the main priority for me is

Digitizing from analog

Scans can be made from all types of photographic images: transparencies, black and white negatives, color negatives or prints. Each of these media is primarily optimized for the photographic process and not for digital scanning. For example, the density range of a negative is very narrow compared to that of a transparency. This is because a negative's density range is optimized to match the sensitometric curve of printing papers. A negative emulsion is also able to capture a wider subject brightness range. That is to say, a negative emulsion can record more subject detail in both the shadows and the highlights compared to a transparency emulsion. Therefore the task of creating a standardized digital result from all these different types of sources is dependent on the quality of the scanning hardware and software used and their ability to translate different photographic media to a standard digital form. If one were to design an ideal film with CMYK print reproduction in mind, it would be a transparency emulsion which had a slightly reduced density range and an ability to record natural color without oversaturating the blues and greens (what looks good on a light box is not necessarily the best image to use for print reproduction).

Structure of a digital image

A digital image is a long string of binary code (like the digital code recorded and translated into an audio signal on your music CDs). It contains information which when read by the computer's software displays or outputs as a full tone image. A digital image original is capable of being replicated exactly, any number of times. Each picture element or 'pixel' is part of a mosaic of many thousands or millions of pixels and each individual pixel's brightness is defined numerically.

the speed of capture and with the Canon camera I can shoot up to about 25 frames without having to stop and wait for the camera to catch up. After that, I do have to stop, and that is when I switch over to the film camera. And swapping between the two allows me to work seamlessly without interruption or delay. Ideally, I would like to have at least twice the buffer capture rate, and it is probably only a matter of time before this happens.

Scanners

A scanner reads information from an original, which can be a print, negative, transparency or artwork, and converts this to digital information at the preferred output size and in the preferred color space, ready for image editing. High-end drum scanners are the choice of professional bureaux as these produce the best quality. The optical recording sensors and mechanics are superior, as is the software, and of course you are paying a skilled operator who will be able to adjust the settings to get the finest digital results from your original. Desktop drum scanners are available at a slightly more affordable price, but hot on the heels of these are the top of the range flatbeds, in particular the Agfa, Umax, Fuji Lanovia and Linotype-Hell models. The reason for this improved performance is largely due to the quality of the professional scanning software now bundled (i.e. Linotype and Binuscan). In fact it has been rumored that these flatbed scanners have for quite a while been capable of improved output. They were hindered from achieving their full potential by software limitations which maintained a division in the market between these and the more pricey desktop drum scanners.

Flatbed scanners work a bit like a photocopying machine. The better models record all the color densities in a single pass and have a transparency hood for transparency scanning. One or two high-end flatbeds use a method of three pass scanning, which provides better color accuracy. Flatbeds fall mostly into the cheap and cheerful class of equipment, but there are professional ranges of flatbed that are gaining popularity in bureaux due to the

true repro quality output which can be obtained and the ease of placing images flat on the platen, compared to the messiness of oil mounting on a drum. Heidelberg have a good reputation – they manufacture a broad range of nicely designed flatbed scanners. Even the cheapest scanner in their Linoscan range has an integrated transparency hood. A lot of designers use budget scanners such as these to create what are known as 'positional' scans for placing in the layout. Although not necessarily designed for repro work, a great many photographers are finding they can nevertheless squeeze out quite acceptable scans within the limiting confines of a cheap flatbed.

With a drum scanner, the image is placed around the surface of a transparent drum. To avoid Newton rings, the transparency is oil mounted – a very thin layer of a special oil ensures good, even contact with the drum surface. Fastening the transparencies in place is quite a delicate procedure, and demands skillful handling of the film originals. High-end drum scanners are often sited in an air-controlled room to minimize on dust. The image on the drum is rotated at high speed and a light source aligned with a photomultiplier probe travels the length of the film. This records the image color densities digitally at very fine detail. Drum scanners offer mechanical precision and advanced features such as the ability to make allowance for microscopic undulations in the shape of the drum and thereby guaranteeing perfectly even focussing. From the bright point light source, the photomultiplier is able to record shadow detail in the densest of transparencies (this is where inferior scanners are usually lacking). Drum scanners often have a separate photomultiplier (PMT) head to record tonal values in advance of the recording RGB heads and intelligently calculate the degree of sharpening required for any given area (of pixels).

Basically flatbed devices tend to use CCD chips and drum scanners use PMTs. CCD scanners tend not to emphasize dust and scratches the way a drum scanner (used in a normal dusty air environment) would. The reason for this is the light source is much softer in a CCD

CCD scanners

Flatbeds are generally OK for scanning large format film emulsions. But CCD (Charge Coupled Device) slide scanners are designed to scan film emulsions at much high resolutions. Microtek, Polaroid, Nikon, Canon and Kodak make good models for scanning from 35 mm and 120 formats. It is definitely worth investigating the Imacon Flextight range of CCD scanners. These CCD scanners offer high optical scanning resolution and a good dynamic range. To my mind the Flextight scanners such as the Flextight Photo (35 mm and 120 films only), Flextight 646 and Flextight 848 (which I use in my studio) are the best quality CCD scanners around for small and medium format professional scanning and offer excellent value compared to a desktop drum scanner.

Illusions of high resolution

Some manufacturers claim scanning resolutions of up to 9600 ppi when in fact the maximum optical resolution is only 600 ppi. This is a bit like claiming you possess a video of your car breaking the sound barrier and you prove it by playing the tape back at a faster speed.

scanner and it is a bit like comparing a diffuser with a condenser printing enlarger. The latter has a softer light source and therefore doesn't show up quite so many marks. To combat the problem of dusty originals, the Nikon LS 2000 was the first 35 mm CCD scanner to employ Digital ICE (Image Correction and Enhancement) image processing. This is a clever filtering treatment which automatically removes dust and scratches, with little softening of the image scan, involving the use of the infrared portion of the data to mask out surface imperfections.

Resolution

Specified as pixels per inch, this indicates how precisely the scanner can resolve an image. The Nikon LS-IV Coolscan has a scanning resolution of 2900 ppi and is an affordable 35 mm CCD scanner. This means that you can scan a full-frame 35 mm image and get a 32 MB 24-bit file. Higher optical resolutions (4800 ppi) are only possible with drum scanners and high-end CCD scanners. It is the optical resolution that counts and not the interpolated figures. The low-end flatbed machines begin with resolutions of 600 × 1200 ppi, rising to 3048 × 3048 ppi for the high-end models like the Heidelberg Linoscan 1800. Flatbed resolutions are expressed by the horizontal resolution – the number of linear scanner recording sensors – and vertical resolution – the mechanical accuracy of the scanner. My advice when using a flatbed is to set the scanning resolution no higher than the 'optical' resolution and interpolate up if necessary in Photoshop. There is also a good case to be made for scanning at the maximum optical resolution and reducing the file size in Photoshop, as this will help average out and reduce some of the scanner noise pixels which are typically generated by the cheaper flatbed scanners. Some CCD scanners have multi pass modes. Since a CCD will tend to generate random noise, especially in the shadow areas, scanning the original more than once, can help average out the CCD noise and produce a cleaner result, although the scanning process can

take four times longer. For the best optical quality, position the original around the center of the platen, known as the 'sweet spot'.

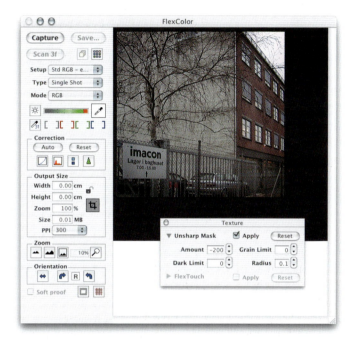

Figure 11.1 The Imacon FlexColor 3.6 interface. Like other camera and scanner software, FlexColor allows you to configure the scanner/capture settings. Most professionals prefer to keep the image processing options neutral, leaving all the tonal correction and sharpening to be done in Photoshop.

Dynamic range

A critical benchmark of scanner quality is the dynamic range – the ability to record detail across the widest tonal range from the shadows to the highlights. Not every manufacturer will want to tell you about the dynamic range of their scanner (especially if it is not very good). Without a wide dynamic range the scanner will be unable to record the subtle tonal variations in the photographic original. You may also find that the cheaper flatbed scanners are unable to record bright highlight detail. You may see highlight tones disappear entirely, where the RGB measured values in Photoshop are blown out to white (R:255, G:255, B:255). If you use a flatbed to scan in prints and have this problem, try making a print to match the recordable density range of your scanner. For example, select a softer grade of printing paper and print the highlights darker than normal

What to look for in a scanner

A flatbed is the cheapest option and if you get one with a transparency hood you will be able to scan prints, negatives and transparencies. But only the more expensive flatbeds are able to satisfactorily scan small format films. If that is your goal then you would be better off purchasing a basic 35 mm CCD scanner such as the Nikon LS4000 Super Coolscan. If you want to scan 120 films as well and get professional repro quality, the Nikon LS8000 and the Minolta DiMAGE Scan Multi Pro CCD scanners can scan larger film formats at near-repro quality. For the very best quality consider looking at any of the products in the aforementioned Imacon Flextight range. The manufacturer's technical specifications can guide you to a certain extent when whittling down your selection.

Scanner Bit depth

To understand how this works, it is best to begin with a grayscale image where there are no color values, just luminosity. A 1-bit or bitmapped image contains black or white colored pixels only. A 2-bit image contains 4 levels (2^2), 3-bit 8 levels (2^3) and so on, up to 8-bit (2^8) with 256 levels of gray. 8-bit Grayscale images are made up of 256 shades of gray. An RGB color image is made up of three color channels. Each channel contains 8-bit grayscale information defining the amount of each color component of the full color image. When the three color channels are overlaid a single pixel in an RGB color image contains 3×8-bits of information, which makes it a 24-bit color image that can define up to 16.7 million possible colors.

A scanner may be described as being able to scan an RGB image in 30-bit or 36-bit color. If you use a scanner to scan at a bit depth greater than 8 bits per channel it is possible to open a 'high-bit' image like this into Photoshop, where you will be able to edit it in 16-bit per channel mode (note that anything scanned at a bit depth greater than 8-bits per channel is automatically defined using 16-bit per channel mode, even though the image was actually scanned at a lower bit depth). Photoshop has extended support for 16 bits per channel editing. You can crop, clone, adjust the color and apply certain filters.

and make the shadows slightly lighter than usual. Print several versions from the negative and find which scans best with your equipment. A normal contrast photographic print has a reflectance range of about 2.2 which may be beyond the capabilities of an inferior scanner and when it comes to scanning transparencies the ludicrous density ranges of modern E-6 emulsions can be an even tougher scanning challenge (Ektachrome transparencies have a typical dynamic range of 2.85–3.6). Some photographers are deliberately overexposing a transparency film like Velvia and underprocessing it. This produces weaker shadows that are therefore easier to scan. A good quality repro drum scanner should be able to attain a dynamic range of 3.8, but note that the dynamic range specified by some manufacturers may be a little optimistic and the quoted values could actually be influenced by scanner shadow noise.

Bit depth

If you are scanning from negative originals, then the dynamic range won't be your main problem. But it will be important to capture enough detail within a narrow subject tonal range and expand this to produce a smooth continuous tone output after inverting to make a positive. A scanner that is capable of a higher bit depth means that more levels of tone will be captured in the scan. As was explained earlier in this chapter, a 24-bit RGB color image will be made up of three 8-bit image channels and each 8-bit channel can only contain up to 256 levels of tone. If you have a scanner that is only capable of capturing 256 levels per color channel and you want to expand the tonal range of a low contrast scan in Photoshop, when you apply a Levels adjustment you will end up stretching the limited number of levels of tone in each channel. Most of the scanners you come across will be able to scan at 12 bits per channel or higher. A 12-bit per channel scanner (quite common these days) will be able to record up to 4096 levels in each color channel. Therefore more tonal data information is captured and if you apply a levels correction

Bitmap image (1-bit)

Red channel (8-bit)

Figure 11.2 The bit depth of an image is a mathematical description of the maximum levels of tone that are possible, expressed as a power of 2. A bitmap image contains 2 to the power of 1 (2 levels of tone), in other words, either black or white tone only. A normal Photoshop 8-bit grayscale image or individual color channel in a composite color image can contain up to 256 levels of tonal information. When the three RGB 8-bit color channels are combined together to form a composite color image, the result is a 24-bit color image that contains up to 16.7 million shades of color.

Green channel (8-bit)

Blue channel (8-bit)

Combined RGB image (24-bit)

1 A black and white negative will contain a lot of subtle tonal information and it is important that the scanner you use is able to accurately record these small differences in tone. A histogram display of the inverted, but otherwise unadjusted negative confirms that you will need to expand the shadow and highlight points in order to produce a full tonal range image in print.

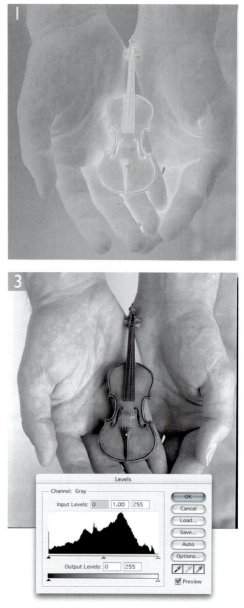

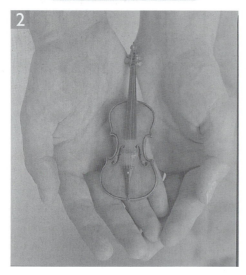

2 If we scan in the standard 24-bit RGB, 8 bits per channel mode and expand the shadow and highlight points, you will see how ragged the Levels histogram appears.

Photograph: Eric Richmond

3 If instead we always scan in high-bit (anything greater than 8 bits per channel scanning mode) the image will always open in 16 bits per channel in Photoshop. The histogram after adjusting the Levels will look smooth as shown here, meaning there is no tonal information lost.

to the shadows and the highlights (either in the scanner software or in Photoshop), you will still end up with enough data points to produce a nice smooth histogram when this is converted to a 24-bit RGB image. Any capture device that produces a file with a greater bit depth than 8 bits per channel will be translated into a 16-bit per channel file when opened in Photoshop (check the Image ⇨ Mode menu). I always scan and shoot everything in high bit data and perform all the initial image adjustments in this 16-bit per channel mode. This is especially important when you scan black and white negatives. You will probably have to greatly expand the shadow and highlight points of a negative and also want to apply a curves adjustment to increase the contrast. Editing in 16 bits per channel enables you to maintain ultimate integrity of your data providing the scanner was able to record all the necessary data in the first place.

Software

The scanner will be supplied with driver software that controls the scanner. The scanner driver may be in the form of a stand-alone application which will import the image and save as a TIFF file ready to open in Photoshop, or it may come in the form of a plug-in or TWAIN driver designed to be incorporated within Photoshop. The installer will automatically place the necessary bits in the Plug-ins folder. The scanner will then be accessed by choosing File ⇨ Import ⇨ *name of scanner device*.

A well-designed driver should be easy to use. A good, clear scan preview will help you make adjustments prior to capturing the full resolution scan. The ideal situation is one where the scanning device faithfully captures the original with minimal tweaking required in Photoshop to get an accurate representation in the master file. Modern scanner software should be using ICC-based color management to take care of interpreting the color from the scan stage to opening in Photoshop. Even the 'canned' scanner ICC profiles that might be supplied with your scanner should get you into the right ball park. For really accurate color

Scanning speed

If it takes a long time for the scanner to make a preview plus carry out the final scan, this could really stall your work flow. The manufacturer's quoted scan times may be a bit on the optimistic side, so check the latest magazine reviews or the Web for comparative performance times. Do also take into account the time it takes to set up and remove the original and the additional time it might take to scan at higher resolutions or work in a multi-pass scanning mode. I have used a drum scanner in the past and am very aware of the length of time it takes to mount each transparency, peel these off the drum and then have to clean everything afterwards.

Visual assessment

All scanners are RGB devices. CCD chips are striped with three or four colored sensors, usually with one red, two green and one blue sensor (the extra green is there to match the sensitivity of the CCD to that of the human eye). When evaluating the quality of a scan, check each individual channel but pay special attention to the blue channel because this is always the weakest. Look for excess noise and streaking. The noise will not always be noticeable with every subject scanned, but if you had lots of underwater pictures or skyscapes to process, this would soon become apparent.

management you will want to investigate having customized profiles created for you. If your scanner or capture device does not have an ICC color management facility, the instructions in Chapter 13 describe how to convert from the scanner color space to the Photoshop color work space.

Purchasing bureau scans

Low-end scanners are fine for basic image-grabbing work such as preparing scans for a web site. But professional photographers should really purchase a repro quality scanner and if you cannot afford to do that, get a bureau to do the scanning for you. The cost may seem prohibitive, but you should be getting the best that modern digital imaging technology can offer. It amazes me that people are prepared to spend good money on professional cameras and lenses, yet use the equivalent of a cheap enlarging lens to scan their finest pictures.

When buying bureau scans, you need to know what to ask for. First, all scanners scan in RGB color, period. The person you deal with at the bureau may say 'our scanners only scan in CMYK'. What they really mean is, the scanner software automatically converts the RGB scan data to CMYK color (for more information on RGB to CMYK, see Chapter 13 on color management). A bureau may normally supply scans to go direct to press, one that is converted to CMYK color and pre-sharpened. If you want to do any serious retouching before preparing the file to go to press you are better off with an RGB scan that can be converted to CMYK and sharpened later. You can edit and composite in CMYK, so long as you don't mind not being able to access many of the plug-in filters. The unsharp masking can be a real killer though – make sure you ask them to leave the image unsharpened and apply the unsharp masking (USM) yourself. Insist on the scans being done in 16-bits per channel of course and supplied with an embedded profile. If they don't understand these basic needs, you should probably shop around to find a bureau that is more used to the requirements of photographers.

Kodak Photo CD and Picture CD

Kodak launched Photo CD in 1992 as a platform-independent storage medium of digitized images for use with desktop computers and for display on TV monitors via a CD player. Photo CD was initially targeted at the amateur market, but some professional users were keen advocates. But interest has dwindled with the advent of Kodak Picture CD.

Labs/bureaux offering the Kodak Photo CD service can supply the processing of a roll of film, transparency or negative plus transfer of all the images to a Master CD disc as an inclusive package. Depending on where you go, it can work out at around a dollar per scan including the film processing, although in addition you will have to purchase the CD disc. A Master disc can store up to 100 standard resolution (18 MB) 35 mm scans, while the Pro disc can store 25 individual high resolution (72 MB max) scans from either 35 mm, 120 or 5 × 4 films.

Picture CD

Picture CD should not be confused with Photo CD, as Picture CD is simply a CD containing JPEG compressed files. All you have to do is check the appropriate box and a CD will be included when you go to collect your prints. Picture CD will supply a folder of JPEG scanned images on a disk.

Figure 11.3 The Photo CD interface. The Image Info on the left tells you which film emulsion type the photograph was shot on and the type of scanner used. This information will help you determine which source Profile setting to use. This latest, much simplified interface is a great improvement on those found in previous versions of Photoshop. It is now possible to set the pixel resolution you want the file to open at and you can now open a Photo CD file as a 16-bit per channel RGB image. It is claimed that the luminance channel in a YCC file contains 12 bits of information, so bringing a file in at 48-bit RGB will make the most of all the information captured in the original Photo CD scan.

Photo CD profiles

Pro Photo CD scans use the 4050 profiles and standard Photo CD scans use the 'Universal' profiles. The color negative profile is common to all Photo CD scanners. Selecting the correct Input profile will improve the quality of the imported image, particularly in the shadow detail of reversal films.

Photo CD website

www.kodak.com/US/en/digital/products/photoCD.shtml

Early digital camera systems

Five or six years ago the professional-level digital options were rather limited and hideously expensive. Some of the early digital cameras looked more like CCTV security cameras: a brick with a lens stuck on the front. The egg heads who designed these had perhaps spent too much time looking the wrong way down the lens as these cameras had no viewfinder and you were forced to preview directly off the screen (this was about as useful as replacing a car's steering wheel with a mouse). Manufacturers such as Leaf, Phase One and Dicomed began producing digital backs that could easily fit on the back of conventional professional camera systems.

Opening a Photo CD image

The easiest mistake Macintosh users can make is to go to the folder marked 'PHOTOS' and open the files directly in Photoshop. These PICT format images (for TV monitor display) are not suited for reprographic output as the highlight tones tend to be clipped. Insert the Photo CD disc into the CD-ROM drive. With Photoshop loaded, open the image required via the File ⇨ Open menu. Click to select desktop and open the PCD icon. Go to the 'Photo_CD' folder. Open the folder marked 'IMAGES'. Check the indexed print on your CD for the image number and click 'Open'. The dialog box which now appears offers several choices. Go to Pixel Size and choose the resolution size for output, i.e. 2048 × 3072 which will yield a file size of 18.4 MB. Where it says Profile, choose the one which closely matches the film type of the original and the scanner model used. You have a choice of opening the Photo CD image in either YCC (Photoshop Lab) mode or as an RGB. If you select RGB, the file will automatically convert and open to whatever is your current default RGB space. Note you can also choose to open a Photo CD image in 16 bits per channel color to produce a 48-bit RGB file.

Digital cameras

Silver film has been with us for over 150 years. We know it works well because the manufacturers are continuing to refine the film emulsions we use today. But digital capture technology has improved so much over recent years that it won't be long before digital cameras supercede film. In fact with the rise of PDA organizers and mobile phone cameras, it can be argued this is already the case. We have seen an incredible rise in the interest among the consumer end of the market. Digital capture has become popular because you get to see the results immediately, you can email pictures to friends and more importantly, it's fun!

Professional photographers are similarly adopting digital capture because of the immediacy and also because the approved image is the final file. All that waiting for labs to collect the film, process it and you sending the

edited results by courier to the client are a thing of the past. The client can leave the studio with the finished result burnt to a CD disk. The client not only saves time, they can save money on film, processing and scanning costs as well.

Comparing chips

If you are comparing consumer-level cameras in the first category, a lot of these are using CCD chips with a lowish number of megapixels. But you should be able to make decent inkjet prints from the files, and that is all that most users really want. The performance of some of the low-end consumer cameras is quite exceptional for the price you are paying. But you can't really compare the file output megapixel for megapixel with digital cameras listed in the other categories. The spectral response in consumer cameras can be uneven, especially when capturing certain shades of green. But nevertheless the results will compare well to mini lab prints. And once you have bought the camera there is no more film and processing to pay for and all you will need is a computer to download the images to and somewhere to store them.

There are essentially two types of camera chip: CCD, which stands for Charge Coupled Device. These have been around a long time and are used in a lot of digital cameras. The downside of CCDs is that they draw quite a lot of electric power. As a result the chip gets warm when it is in use and its charged nature attracts dust particles. This can lead to image artifacts and shadow noise, especially in the blue channel. The professional digital camera backs employ various strategies to keep the chip cool at all times. Probably the most effective of these is use of the Peltier Effect, which uses an electronic cooling as opposed to fans; the Peltier chip is attached directly to the sensor chip and dissipates the heat by transference and thereby significantly reduce the amount of noise generated. This is one of the reasons why they are so much bulkier compared to the 35 mm digital cameras. More recently, CMOS (complimentary metal oxide semiconductor) technology has begun to be used in still digital cameras. CMOS chips

Which digital camera is right for you?

As a service to readers, I have provided a PDF document on the CD-ROM and website that lists most of the professional and some of the better quality consumer digital cameras. The list is split up into four categories. The first lists a selection of cameras that are primarily targeted at the consumer market and have non-interchangeable lenses. Some of these, such as the Minolta DiMAGE 7Hi, Canon D300 and Olympus Camedia E20, are actually quite sophisticated and could be used professionally, as you can set the exposure manually or link them to an external flash unit. These models are really amateur cameras but with professional aspirations. What actually limits them is the awkward way they perform professional tasks and their limited battery life and card size. The next category features digital SLRs. These are all based on conventional 35 mm camera body designs and all accept interchangeable 35 mm lenses. They are mostly considered professional cameras, but at a more affordable price. The third section lists the medium format digital backs. These use approximately 24×35 mm or 35×35 mm sized chips, or larger and have the latest state of the art technology to reduce noise in the file and some use multiple captures to produce greatly increased file sizes. And lastly, I have listed the scanning back cameras, which although still around, are looking increasingly redundant in light of recent improvements in digital back technology.

Counting the megapixels

The most important component in any digital camera system is the pixel sensor and the first thing most people look for is a large megapixel size, which represents the number of pixels the chip can capture. For example, a 3000 × 2000 pixel chip can capture 6 million pixels (more commonly referred to as 6 megapixels). Be aware that very often not all of these pixels are actually used to capture an image and the megapixel size that is quoted should more precisely describe the effective number of pixels that the camera uses. Although the megapixel size can help you determine how big the image will be, it doesn't really tell the whole story, because not all sensor chips are the same.

are cheaper to make, and more significantly, they draw about a quarter the amount of power of a CCD chip and therefore don't suffer from the same type of noise problems. The Kodak DCS Pro 14n and Canon EOS 1Ds both use CMOS chips, and both these cameras have full-frame sized sensors that correspond to the area of a conventional 35 mm film frame.

There are some other subtle variants of camera chip. Fuji produce what they call a Super CCD, that has a honeycomb structure of large CCD elements. The Fuji S602 Zoom has a 3.1 megapixel chip and yet the (uninterpolated) pixel size is stated as being 6 megapixels. Some argue that this figure is a cheat, but the image results do actually compare well with the output from other 6 megapixel cameras. The Sigma SD9 features the unique Foveon® X3 CMOS chip, which unlike any of the other CCD or CMOS chips, reads full color information from every pixel sensor (or Photodetector, as Foveon prefer to call it). Figure 11.4 illustrates how a typical single shot CCD or CMOS sensor will generate pixel color values by averaging out the color pixel readings from one red, one blue and two green pixel sensors in a 2 × 2 mosaic structure. When you take a picture with a single-shot camera, the camera software has to 'guess' the color values for 75% of the red pixels, 75% of the blue pixels and 50% of the green pixels. This is why with some digital cameras moiré patterns and ugly color fringing artifacts can often appear when you shoot finely detailed subjects. Software programs such as Quantum Mechanic from www.camerabits.com are useful at helping to eliminate these problems. A 15–18 MB size RGB capture file has sufficient enough pixels to fill a magazine page. However, because of the way the sensor captures the one-shot image using a striped chip, there will be a limit as to how much you will be able to crop a picture and still enlarge it to fill the page. The Foveon® X3 features triple layers of red, green and blue sensors where red, green and blue color information is simultaneously recorded in each single sensor position. Although the Foveon® X3 contains a relatively small number of pixel

locations, each location actually contains three pixels, one on top of the other. The clean image quality attained using the Foveon® X3 sensor is comparable with that of the advanced multishot digital camera backs. But for all this, the maximum pixel size will limit its versatility.

The sensor size

As well as the number of the pixels, you will want to consider the physical size of the camera chip. Among the cameras in the 35 mm digital SLR category, these typically vary in size from 14 × 21mm on the Sigma SD9 to a 24 × 36 mm full-frame sensor on the Contax N1, Canon EOS 1Ds and Kodak DCS Pro 14n. The latter are all said to have a lens magnification factor of ×1, meaning that the relative focal length of any system lens will be the same as when shooting with an equivalent 35 mm film camera. If the sensor is smaller than 24 × 36 mm in size, then the magnification factor will increase. Therefore, a 28mm wide-angle lens on a 35 mm film camera will effectively behave more like a 35 mm wide-angle when used on a digital SLR that has a lens magnification factor of ×1.3. Most of the cheaper, non-interchangeable lens cameras typically have a maximum wide-angle that is equivalent to a 35 mm lens. But you can sometimes buy a specially designed wide angle lens adaptor to place over the camera lens. It is interesting to note that the sensors used in the digital camera backs for medium format cameras, are not that much larger than a full-frame 35 mm camera. They are nearly all 25 × 37 mm or 37 × 37 mm in size. Only Hasselblad, Pentax and Contax manufacture non-distorting lenses with a 35 mm focal length. There are no shorter length lenses that are designed for a medium format 6×4.5 cm system. So if wide-angle photography is your thing, your choice of camera will be restricted to one of the full-frame 35 mm digital SLRs The notable exceptions are the Phase One H25 and the Sinar 54, which both use a 37 × 49 mm sized sensor, with which a 35 mm lens would be roughly equivalent to shooting with a 28 mm lens on a 35 mm camera system.

Figure 11.4 The sensor chip in most one shot CCD and CMOS cameras consists of a mosaic of red green and blue sensors. The RGB sensor elements use what is known as the Bayer pattern. This is a 2 × 2 matrix with one red, one blue and two green sensors. The green sensors match closest the region of the visual spectrum that our eyes are most sensitive to.

Figure 11.5 Lets now analyze more closely the way a one shot camera captures and interprets color using the above arrangement of the CCD/CMOS sensor elements. The camera is simultaneously able to red, green and blue color. But there is only one red sensor element for every four pixel sensors. Likewise, there is only one blue sensor and there are two green sensors. The right hand picture gives some indication in close-up of how a CCD/CMOS chip captures the RGB data using this pattern of colored pixel sensors. The capture data must next be interpreted in order to produce a smoother looking result. Since only one in four pixel sensors is recording red or blue information, the values for the other three pixels (75%) has to be guessed. In the case of the green information, the other 50% has to be guessed. Once the image has been processed, the underlying pattern is not noticed. However, you should be aware that in the case of most one shot cameras, two thirds of the color information is guesswork. The weakness of these cameras can sometimes be seen in a capture of a subject containing lots of sharp detail. Sometimes you get to see Christmas tree type artifacts – this is a result of the pixel guess work having to fill in the gaps.

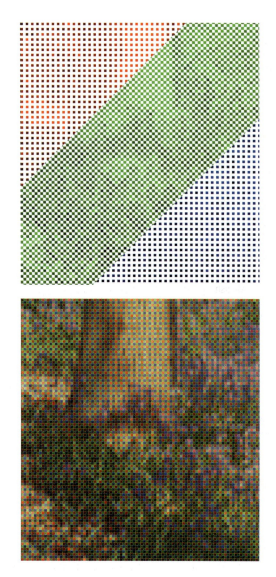

The quest for the ideal digital camera is somewhat hampered by the goal of trying to make digital sensors fit within conventional film camera system designs. The Sigma SD9 sticks the small Foveon® X3 chip inside a camera system body that is really designed to accommodate 35 mm film. This is done for practical reasons, because at the moment it is more economical to

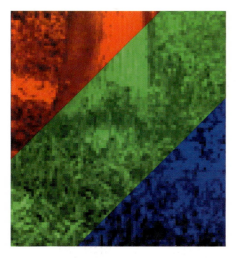

Figure 11.6 Multishot cameras capture sequential exposures of red, green and blue. Therefore, each resulting pixel is based on 100% color information, without any pixel guess work. The raw data is able to produce a much smoother and cleaner image. Multishot mode is only suitable for still-life photography. Many of the professional digital camera backs are able to shoot in one-shot and multishot modes.

Figure 11.7 The Foveon® X3 chip features a revolutionary new design whereby the RGB CMOS photodetectors overlap each other. Light can pass straight through the upper blue-sensitive layer of photodetectors to record information on the green and red-sensitive layers below. The result is a one shot CMOS chip less prone to moiré and edge artifacting that is able to capture image detail with a smoothness to rival the multishot mode camera backs. Although this is still a 'consumer' level product, it may hold the key to professional one shot digital camera design.

adapt conventional 35 mm camera bodies to digital than to reinvent an SLR system to suit the constraints of digital capture technology. Olympus have been working on an answer to this, called the four thirds system, based on the 4/3 inch Kodak CCD, which is smaller than a 35 mm frame area. Conventional film camera designs sometimes force the light to hit the surface of the CCD at acute angles and this can lead to light fall off towards the edges of the sensor. This is due to some CCD designs having a layer of

Megapixel limits

The first thing most people look for is a large megapixel size, which represents the number of pixels the chip can capture. For example, a 3000 × 2000 pixel chip can capture 6 million pixels (or 6 megapixels). Be aware that very often not all of these pixels are actually used to capture an image and the megapixel size that is quoted should more precisely describe the effective number of pixels that the camera uses. Although the megapixel size can help you determine how big the image will be, it doesn't really tell the whole story, because not all sensor chips are the same.

People have wondered if the megapixel sizes will keep getting bigger. This is unlikely in the case of digital SLRs, as the physical limit seems to have been reached. The Kodak DCS Pro 14n unfortunately suffered many delays in the release of a production model and the jury is still out as to whether the extra number of megapixels can produce a better looking image than its 11 megapixel rival, the Canon EOS 1Ds. What you have to take into account here is that as you squeeze more pixel sensors into a 35 mm frame area, they have to get smaller. Smaller pixel sensors would be less efficient at collecting light and the result of that would be noisier images. In my opinion the ideal professional digital camera body would have to be a 645 camera body featuring a large CCD or CMOS chip, or maybe a new hybrid digital format size that falls somewhere between 35 mm and 645.

micro lenses on the chip surface. By designing an interchangeable lens system SLR from the ground-up, Olympus have been able to avoid technical limitations such as these and establish a new digital format which has made its first appearance in the form of the Olympus E-1 camera. In the meantime, Nikon have released the DX Nikkor 12 – 24 mm f4/G zoom lens. This is a lens that has been custom-designed for the Nikon D100, D1X, D1H and D2 35 mm digital SLRs. The extreme wide-angle optics are optimized to match the coverage of the smaller chips in these cameras.

Making every pixel count

One of the reasons why we have been conditioned to work with large scans is due to the grain structure inherent in the film. When a film original is scanned, the scanner records the density of all the minute grain clusters that make up the photograph. The grain structure can cause the scanner to record sharp variations in pixel values from one pixel to the next. This is especially noticeable when you examine an area of pure color. Even on a low resolution scan, the pixel fluctuation caused by the grain can still be visible. At higher resolutions you actually see the grain clusters. If you increase the size of a file through image interpolation, the pixel fluctuations become even more magnified. There is no fluctuation in a professional digital camera capture file, so therefore it is possible to interpolate a file upwards in size without generating unpleasant image artifacts. The high-end digital cameras also cool the capture chip. This lessens digital noise from appearing in the shadows, especially in the blue channel. None of this comes cheap of course, but the purity of the pixel image obtained from a professional digital camera sets it apart from anything else you will have seen before, including the best drum scans made from film. The image details shown here compare the output from a LightPhase with a drum scan made from a transparency. The output files are not as large as those produced by the scanning back. The CCD chip in the Leaf DCB camera produces a 4 MB sized rectangular scanned

image. An RGB composite is therefore 12 MB. This does not sound very impressive, but with digital cameras you have to think differently about the meaning of megabyte sizes or more specifically pixel dimensions and the relationship with print output file size. Digitally captured images are pure digital input, while a high-end scanned image recorded from an intermediate film image is not. Good as drum scans may be, the latter are always going to contain some electronic or physical impurity, be it from the surface of the film, the drum or grain in the film image. The optimum relationship between pixels per inch and lines per inch for images prepared for print output is a ratio of either 1.5 or 2 to 1. In either case the film image must be scanned at the correct predetermined pixel resolution to print satisfactorily. If a small scanned image file is blown up, the scanning artifacts will be magnified. Because digital files are so pure and free of artifacts, it is possible to enlarge the digital data by 200% or more and match the quality of a similar sized drum scan.

It's hard to take on board at first, I know. It came as a shock to me too when I was first shown a digital picture: an A3 print blowup from a 4 MB grayscale file! Not only that, but digital images compress more efficiently compared to noisy film scans. The full-frame Leaf 12 MB image will compress losslessly to around a few megabytes (less with high quality JPEG) and transmit really quickly by Cable or fast modem. Catalog and product shot studios prefer to have the Leaf back attached to something like the Fuji GX68 III camera, because it provides a limited range of movements in the lens plane and can reasonably handle the same type of photography tasks as monorail plate cameras.

Chip performance

Apart from the physical size and the number of megapixels, it is equally important to give consideration to the bit depth and the dynamic range that a sensor is able to record. Both these topics were covered earlier in the scanner section. It is even more important when capturing

Comparing film with digital

The optimum ratio of an image's pixel resolution to the printer's line screen is close to ×1.5. If you were to make an RGB scan, to fill an A4 magazine page using a 133 lpi screen, you would need a raw RGB image that measured A4 and with a pixel resolution of 200 ppi. This would then be converted to produce a CMYK file of 15.5 MB. If you allow a little extra for the bleed, you need at least a 12 MB RGB file to produce an A4 output. All the professional cameras mentioned in this feature are able to capture at least 12 MB of RGB 8-bit per channel data. But these are by no means limited to producing A4 output. The file capture is so smooth that you can realistically interpolate the files up to reproduce at bigger sizes and without incurring any perceivable loss of image quality as you would if you were to interpolate up a scanned image.

Figure 11.8 Digital capture using a Phase One LightPhase back, 48 MB RGB 24-bit color file interpolated up by 66%. Image displayed at 100%.

Photograph by Paul Webster.

Figure 11.9 Photograph taken on a Hasselblad camera, using Fuji Velvia emulsion, scanned at 2600 ppi with a ScanMate 5000 scanner to produce a 100 MB RGB 24-bit color file. Image displayed at 100%.

a scene digitally that the camera you use is able to record data using more than 8-bits per channel information. If you refer to the camera manufacturer's specifications, a higher bit depth will mean that more detailed tonal information is recorded. Dynamic range is expressed in f-stops and this refers to the ability of the sensor to record image detail across a broad subject brightness range. So a camera with a large dynamic range will simultaneously be able to see and record detail in the darkest shadows and the brightest highlights.

Leaf, Sinar, Phase One, Kodak and Imacon all make single and multishot backs. Some of these cameras are built round the outstanding Philips 2K × 3K chip capturing 6 MB of raw pixel information in each color channel to produce finished files of 18 MB RGB or 24 MB CMYK. Kodak launched the DCS ProBack in 2001, which features their own Kodak designed 38 mm × 38 mm, 4000 × 4000 pixel Tin Indium Oxide CCD. Phase One have implemented the Kodak chip in their H20 back and Imacon have already used the Kodak chip in the Flexframe 4040. The new Imacon Ixpress 384 can capture a single or multishot 96 MB image in 48-bit color or a 384 MB 48-bit RGB image in the 16 exposure micro step mode.

At this level the photographer can expect quite superb image quality, exceeding that of film. It is sharper, has no grain structure to interfere when images are resized, and offers more precise control of color over a greater dynamic range – typically 10–11 f/stops, between shadows and highlights. To give you some idea of how impressive this is, transparency chrome film has a typical dynamic exposure range of around 4-5 f stops and negative film about 7-8 f stops. So if you take into account the benefits of shooting with a high-end digital system – the grain free smoothness, the absence of noise and the incredible amount of tonal information that can be captured digitally compared to film, you can see why many of the top pros are all being won over to shoot digital all the time now. In nearly all these cameras, special attention has been paid to reduce the electronic noise, which can be particularly

Multishot exposures

The very first multi-capture backs used grayscale CCDs to capture three sequential exposures through a rotating wheel of red, green and blue filters. As the new generation of mosaic CCD arrays were being designed it was realized that moving the CCD in one pixel increments gave similarly good results. The CCD chip is moved between three or four exposures by a piezo crystal that can be made to expand or contract in exact increments whenever a small voltage is applied. The piezo crystals shift the single grayscale chip, repositioning it by fractional amounts. In multishot mode such cameras are only suitable for shooting still-life subjects. Some multishot backs are also able to capture a single shot image keeping the chip still and capturing a single exposure.

Quality on a budget

One would not necessarily expect excellent performance from the general consumer cameras, although some of them do allow you to shoot in a raw data mode and these may possibly produce greater than 8-bit per channel, deep-bit files. When I tested the Minolta DiMAGE 7Hi, I was fairly impressed by that camera's performance. And all of the digital SLR cameras appear capable of capturing up to 12-bits per channel. There is of course, no such thing as the perfect digital camera. Even with a top of the range camera back system there are still a few limitations such as the lack of extreme wide-angle system lenses and the limited ISO sensitivity (some camera backs have a fixed setting of ISO 50). I would recommend that wherever possible you try to shoot using the lower ISO setting and only increase the speed setting when you really need to. The image quality can drop dramatically at the very highest ISO settings on some cameras.

evident in the red or blue channels. In some cases the chip is cooled to improve performance, or the electronics are put to sleep, awakening milliseconds before the exposure is made and then going back to sleep again.

Only a few years ago, medium format camera backs would cost a small fortune to purchase, requiring serious analysis in order to calculate the financial benefits of digital over film capture. And since a lot of professional photographers were then buying into digital imaging for the first time they would often have to factor in the cost of a computer imaging work station and perhaps a new camera body system as well. At the time of writing you can still purchase the C-Most camera back for just under $8,000 (check the current pricing with your nearest dealer).

Memory cards

Another essential consideration is the speed with which you can get your photographs from the camera to the computer. At the high-end, you can expect most if not all camera backs and cameras to have FireWire connectivity,

Figure 11.10 This picture was taken by Jon Gibson-Skinner using the Leaf digital camera back.

including the digital 35 mm SLRs. The only exceptions I can think of are the Canon D30, D60 and Nikon D100 that have USB 1.1 only, which is an incredibly slow method of transferring digital data via a cable. This need not be a problem though, as digital cameras can store the captured images on an internal memory card such as Compact Flash, so you can transfer the data directly off the camera via the PC (PCMCIA) card slot on your laptop, or via a separate card reader. The memory cards supplied with consumer cameras will usually be so small in storage capacity as to be useless, so it is worth buying something larger. If you set the camera to capture at the highest quality JPEG compression, you will be able to fit a lot of pictures on a single card and the image quality will certainly be fine for general use.

Selecting the right storage card for your particular camera is not a simple process. There are several types of card. The most common are the flash memory type I and type II cards. These contain nonvolatile memory that unlike RAM memory, is able to store and hold digital data in the memory cells when not connected to a power source. Flash memory cards will wear out with use, but nevertheless they are still very robust, although the higher capacity cards are quite expensive. Microdrives are popular, in particular the IBM 1GB Microdrive. These are miniature hard disks. They have a higher storage capacity, are fast and comparatively cheaper than buying memory cards. But they are also more fragile and prone to damage, especially if dropped. There is Memory Stick® – a memory storage medium for Sony devices. Secure Digital (SD), which can be used in Kodak, Konica, Kyocera and other cameras. Multimedia cards that can often be interchanged with the Secure Digital cards. And lastly, SmartMedia that can be used with Fuji and Olympus cameras, which is in the process of being superceded by the new xD card standard – also for Fuji and Olympus.

Choosing a memory card

It is worth doing a little research to find the right type of card for your camera. There are some recognized brands: Lexar compact flash and the aforementioned IBM Microdrive. Memory cards vary in read write speed specifications. This is usually specified on the card but I highly recommend that you visit Rob Galbraith's website and check out his ongoing data sheet reports into compact flash card performance with the latest cameras: <www.robgalbraith.com>. The speed test results of individual cards can be surprisingly varied from camera to camera.

Looking after the chip

As you might expect, the chip sensor is extremely delicate and is also the single most expensive component in a digital camera. If it becomes damaged in any way there may be no alternative but to have it replaced. Pay special attention to using the manufacturers' correct cleaning methods and take every precaution when removing dust from the sensor surface. Insurance policies against accidental damage are also available for the more expensive digital cameras – a wise step to take considering how fragile the sensor is.

Dust removal

Camera chips generate a static charge and this will attract dust like a magnet. The chips used in compact digital cameras are completely sealed, so they are not at risk. But if you use anything else, such as a digital SLR, the chip can be exposed to dust particles every time the mirror flips up. There is no getting around the fact that you have to keep a regular check on the camera chip and have to keep it clean. Do not use an aerosol spray, use a blower brush instead and if dust problems persist, seek out a company that specializes in cleaning chip sensors.

Camera response times

A major drawback with the lower end cameras is the time it takes for the camera to respond after you press the shutter. Compose your shot, press the shutter release, and by the time the shutter actually fires, your subject has disappeared out the frame. This annoying delay is not something you would experience with the high-end cameras, but even these can suffer from being able to only capture a limited number of shots within a given time. If you compare cameras carefully, you will notice that not many of the high-end digital backs can match the fast performance of the digital SLRs. News and sports photographers will probably prefer to use a camera such as the Canon 1D, purely because of the priority given to making this the fastest digital camera on the market, with the Nikon D1H coming a close second. However, the new Imacon Ixpress can shoot at an impressive rate of two frames every three seconds almost indefinitely to a high-capacity, portable, tethered drive. Rumor has it that the new Sinar backs use a fibre optic cable to transfer the data and this makes them very fast, but there is no further information available on their website to explain this more fully.

Comparing sharpness

As CCD and CMOS sensors have got to the point where they are now capturing a much greater number of pixels, there is less need for anti-aliasing filters. There was always a trade-off to be taken into account. You could remove the anti-aliasing filter and get sharper captures, or leave it in and have fewer problems with moiré . Note that the Camera Raw plug-in (see page 326) is able to resolve some moiré as you import the file and there is also a tutorial showing you how to remove moiré in Chapter 6. And if you want to compare the output sharpness of different cameras, you should be aware that many cameras carry out some on-board image processing that artificially sharpens the captured image to make it look better. Some cameras can even interpolate the captured data to enlarge the central area and call this a 'digital zoom', or 'digital marketing

con' as it's otherwise known. Don't use the digital zoom – crop the image and enlarge it in Photoshop – you'll get much better results.

A digital lightbox

Many people underestimate some of the potential pitfalls of switching to a digital work flow, especially those for the unwary or inexperienced digital photographer. All too often photographers and their clients have rushed into switching from an analog to a digital work flow without paying serious attention to important issues such as maintaining an image archive and color management. Worse still, mistakes made by ill-prepared newcomers risk jeopardizing the confidence of everyone else in the desktop publishing industry.

In the rush to 'go digital' many photographers (and clients) have overlooked some of the obvious work flow differences with a digital shoot. In a traditional, analog work flow, clients received transparencies or contact sheets and once the final picture had been selected and approved, the photographer's responsibility ended there. But now there are a lot more things for you to consider. How long does it currently take to review a contact sheet or roll of transparencies, compared to the time it takes to open and close an equal number of digital captures? On the other hand, what price the immediacy of having your photograph instantly displayed on the computer and ready to send off to print? For example, how are you going to preview and edit the pictures? If you are present while the photographs are being taken, then it will be easy to approve the results there and then and walk away with a finished CD or DVD. If you or the final client wish to approve the pictures remotely, then you need to work out a method of getting the pictures to them. Chapter 16 looks at the issue of image management in more detail, which is followed by automating Photoshop in Chapter 17. For example, the Web Photo Gallery in Photoshop is a very easy-to-use automated plug-in. A photographer can quickly build a web gallery of images, upload these to a server and share the

Hot mirror filters

The spectral sensitivity of many CCDs matches neither the human eye nor color film and extends awkwardly into the infrared wavelengths. This is partly inherent in their design and partly due to their original development for military uses. To overcome the extreme response to the red end of the spectrum, Kodak advise the use of hot mirror filters. Some Nikon cameras have this filter built in behind the lens. These high quality glass filters are made by Tiffen in the USA and are costly and inconvenient, since each lens used will require one. The Canon EOS and Nikon lens systems have about four common filter sizes (52, 62, 72 and 77 mm) so at over $150 each, these filters alone will cost much the same as a low-end digital camera. Kodak's newest chip technology delivers a dramatic improvement in color response and purity in the blue channel and a much more controlled response at the red end of the spectrum.

And as a further precaution Kodak fit a hot mirror filter immediately inside the throat of their CCD camera bodies. This filter, which is very thin and fragile, serves not only to reduce still further the infrared wavelengths reaching the CCD but also to reduce the color noise generated by high contrast fine detail in the image. This aliasing noise is generated by interference between fine detail and the mosaic of color filters applied to the chip. It is most visible in fabric textures or fine detail such as print.

Anti-aliasing filters

The Kodak anti-aliasing filter works by very slightly unsharpening the image, but a better method may be to use software such as Quantum Mechanic from Camera Bits Software. Other camera manufacturers overcome the infrared problem by fitting a hot mirror type filter to the face of the CCD itself, but within the engineering confines of the existing Canon and Nikon bodies; this option is not available to Kodak.

The need for a Camera Raw plug-in

Shortly after the release of Photoshop 7.0, Thomas Knoll set out to produce a plug-in that would enable Photoshop to interpret the raw file data from various cameras. Within a few months, Thomas had managed to 'reverse engineer' the code required to successfully open and convert the proprietary raw files of various camera systems. By the time it was released as a plug-in for Photoshop 7.0, Camera Raw was able to successfully interpret the raw files from many of the leading cameras. In testing I have done, the Camera Raw plug-in is able to convert and open raw camera files up to ten times faster than the camera manufacturer's own software.

results of a day's shoot with anyone who has Internet access. And if the client does not have a computer, you can always use the Contact Sheet II feature to produce printed contact sheets with identifying file names below each picture.

Camera Raw in Photoshop CS

The Camera Raw plug-in represents a milestone in digital imaging and is an important Photoshop development. In recent years we have seen huge advances take place in digital camera technology. But while the camera manufacturers have made many wonderful improvements to the hardware, the accompanying software development has pretty much stood still. So as the camera capture file sizes have got bigger, the software programs used to preview the camera files have if anything become slower. This is especially true with the software typically supplied with digital SLRs and advanced consumer cameras. Now if all you are concerned with is capturing and processing JPEG files, then your options are more open. The camera file browsers usually have no problem reading in the camera JPEG files and neither does Photoshop. But if you want to get the best quality images from your camera, then you should shoot raw files. And there is the problem. In the past, if you shot using the raw capture mode, then only the camera manufacturer-supplied software knew how to interpret that data, open it, and save in a universally-recognized image file format such as TIFF. And some camera software programs can take over a minute to open and convert a single raw capture! There are other software programs that can read the raw camera data, such as: Bibble www.bibblelabs.com, FotoStation www.fotostation.com, and iView MediaPro www.iview-multimedia.com. I particularly liked iView because it offered an easy-to-use digital lightbox interface. It can recognize many popular raw camera formats and is really fast at importing image files and generating large previews. The Capture One software from Phase One is also a popular choice among PC users, although at the time of

writing it has not been possible for me to install a stable version on Mac OS X 10.2, so am unable to comment. But the major advantage of Photoshop CS, is that so long as your camera is supported, you don't have to leave Photoshop to open your raw digital files.

For many years I have been used to editing my films on a lightbox and got accustomed to the ease with which one can quickly inspect lots of photographs. The slowness of the File Browser in Photoshop 7.0 and small image preview sizes were therefore still quite a handicap when trying to recreate a digital lightbox editing environment. A significant number of improvements have now been made to the Photoshop File Browser and these have also enabled the Camera Raw plug-in to integrate more smoothly with Photoshop. Photoshop CS users should find the new File Browser features and Camera Raw 2 Plug-in a much more satisfactory solution for previewing and making edited selections of images and this realistically provides you with the option to use Photoshop throughout for all your image processing needs.

Camera Raw in use

If you configure your digital camera to capture in raw mode, Photoshop CS will be able to read the raw file data and display a thumbnail and large preview of the image file in the File Browser. When you double-click the thumbnail, Photoshop will then display a dialog like the one shown in Figure 11.11. The Basic mode provides access to the image adjustment and detail tabs only. Clicking on the Advanced radio button will reveal the lens and calibration tabs.

General controls

The status bar area will summarize the camera EXIF metadata, always displaying in order: the make of camera used, the file name, ISO setting, lens aperture, shutter speed and lens focal length. In the top left corner you have three tools: zoom tool, hand tool and an eyedropper that functions as a white balancing tool. The main preview enables you to preview any adjustments that you make, and the zoom level

Camera Raw incompatibility

The Camera Raw plug-in won't 'officially' interpret the raw files from every digital camera (check the camera spec PDF on the CD-ROM). But Adobe are committed to providing intermittent, free Photoshop CS updates to include any new camera file interpreters as they become available. Now understand that while not all raw camera file formats are supported, this is in no way the fault of Adobe. Certain camera manufacturers continue to delude themselves that they know how to write image processing software and have stubbornly refused to play ball with the Photoshop engineers.

can be set in the pop-up menu just below the preview display. The Preview checkbox lets you toggle displaying any changes that you make using the image adjust controls on the right. And if the raw image needs rotating, click on either of the rotate buttons. Below that you have image import settings. The destination color space should ideally match your RGB work space setting configured in the Photoshop color settings, which in my case is Adobe RGB. I would suggest setting the bit depth to 16-bit. The camera you are using is probably only capturing in 12-bits per

Zoom tool (Z)

Hand tool (H)

White balance tool (I)

Camera file data information

Histogram display

Camera Raw settings

Fly-out menu

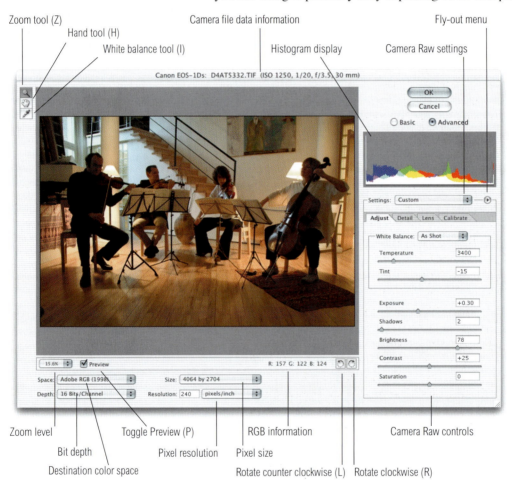

Zoom level

Bit depth

Destination color space

Toggle Preview (P)

Pixel resolution

Pixel size

RGB information

Rotate counter clockwise (L) Rotate clockwise (R)

Camera Raw controls

Figure 11.11 The Camera Raw dialog in Photoshop CS, showing the main controls and shortcuts.

channel. Selecting this option will ensure that the image bit depth integrity is maintained to the maximum when it is converted and opened up in Photoshop. Changing the resolution alone does not affect the pixel size of the image, however you can choose to open the image at sizes that are smaller or larger than the actual pixel dimensions as shot, and these are indicated by + or - signs against the dimensions offered. The pixel resolution field lets you set the file resolution in pixels per inch. Note that the value selected here will have no impact on the pixel dimensions.

White Balance controls

The preview shows you what the processed image will look like. The Camera Raw plug-in essentially contains a library of information with ICC profiles for all the supported cameras. Camera Raw therefore understands how each camera model will respond and record specific colors. However, the color response will also fluctuate under different lighting conditions. For example, you may already be aware that when shooting daylight balanced film, the colors will record much cooler if you use it to shoot using tungsten lighting conditions. The color temperature describes the warmth or the coolness of the lighting conditions. Tungsten lighting has a low, warm color temperature, while daylight has a higher, more blue color temperature. It does not matter how you set the white point settings at the time of shooting. That is the joy of shooting in raw mode, you can decide later which is the correct white balance setting to use.

You can adjust the color temperature setting in the Camera Raw dialog in several ways. To begin with, the camera you shot the image with should already have embedded white balance information in the raw file's metadata and this will provide you with a starting point setting in the Camera Raw dialog when it opens with the default 'As Shot' setting. If this is not correct, you can mouse down on the White Balance pop-up menu and select a preset setting that correctly describes the white balance used. Alternatively, you can select the white balance

Color temperature response

Note that the color response of the camera chip will always be relative to the standard color temperature setting used to create the ICC profile that is built in to the Camera Raw. Other light sources and daylight conditions will vary considerably. In the case of fluorescent strip lighting, the color temperature is harder to pinpoint, as the color is somewhere between daylight and tungsten, but this type of lighting can also have a strong magenta or green bias, hence the need for a Tint control slider in Camera Raw.

Image tonal adjustments

The exposure controls are below the White Balance section. These allow you to make further adjustments to the way the camera raw data will be interpreted and rendered as an image file in Photoshop and the live histogram provides a visual clue to the outcome of the adjustments you make. The Exposure slider is like the input highlight slider in the Levels dialog. Dragging it to the right will brighten the highlights. As with the Levels dialog in Photoshop, if you hold down the ⌥ alt key as you drag the Exposure slider, you get to see a threshold mode preview. This can make it easier to determine where to set the highlights. The Shadows slider is equivalent to the Shadow input slider in Levels and you can also use the Option/Alt key to obtain a threshold mode preview display. The Brightness control is like the gamma slider in Levels – you can use it to adjust the relative lightness of the image to be processed. And below that, the Contrast and Saturation sliders. Note that the default contrast setting in Camera Raw is now set to 25%, whereas this used to be 50% in the original Photoshop 7.0 plug-in.

(eyedropper) tool in the dialog box and click on an area of the picture that should be neutral. As you move the tool across the image, the RGB values will be displayed below. Using the image example in Figure 11.11, if I were to click on the white wall behind the musicians, the adjusted white balance value would vary depending on where I clicked. I would get a daylight reading on the left, just below the staircase and I would get a tungsten balance if I clicked anywhere towards the right of the picture. Or, you can simply drag the Temperature slider to any setting you feel appropriate and further tweak the white balance using the Tint slider.

Digital exposure

Shooting with a digital CCD chip instead of film requires a whole new approach to determining the optimum exposure setting. In some ways shooting digital is like shooting chrome, if you overexpose the image too much, you risk blowing out all the highlight detail. For this reason, seasoned photographers who used transparency film, would tend to err towards underexposing their photographs so as to preserve all the subtle highlight detail. And also because film emulsions are less good at recording tones in the highlights and shadows, and the optimum exposure response was always between these two extremes. CCDs respond to light differently. A typical CCD chip will have the potential to capture up to 4096 levels of tone per channel. But half these levels are used to describe the levels within the brightest portion of the histogram and as the exposure is halved the number of levels are halved. So every time you stop down below the optimum exposure you may ensure that the highlights are not being burnt out, but you are also dramatically reducing the number of levels available to describe the overall scene. And the other consequence of this is that as the exposure is reduced towards the shadow areas there are fewer levels and this is why digital photographs or scans can suffer from posterized shadow detail if the capture is underexposed or a CCD scanned transparency contains a lot of very dark areas.

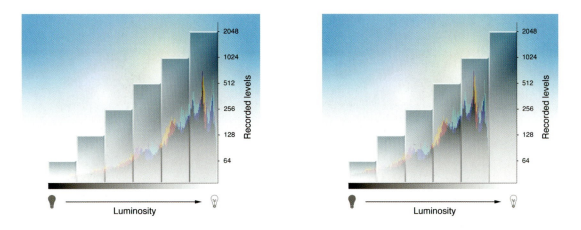

Figure 11.12 Most digital cameras such as the digital SLRs are capable of capturing 12-bits of data, which is equivalent to 4096 recordable levels per color channel. As you halve the amount of light that falls on the chip sensor, you potentially halve the number of levels that are available to record an exposure. In the above example let's say that the optimum exposure was f16. This exposure makes full use of the chip sensor's dynamic range and consequently, the potential is there to record up to 4096 levels of which there are 2048 shades of tone used to describe the highlight areas. Now if we were worried about overexposing the image, one could halve the exposure to f22. It would still be possible to make tonal corrections in Photoshop to expand the tonal range, but that one stop exposure difference has immediately lost us half the number of levels. The image is now effectively only using 11-bits of data instead of 12. This theory also illustrates that where possible, you have to be particularly careful to avoid heavy shadows. The darker the exposure in the shadows, the fewer discreet levels the CCD chip can capture.

Detail settings

The Detail tab is available in both Basic and advanced operating modes and is found next to the Adjust tab in the Camera Raw dialog. To make a proper judgement when using any of the detail slider controls, zoom in to 100% on the preview. The default settings will apply a 25% sharpening. This is a gentle amount of sharpening, but my personal preference is to turn this off completely and save the default setting as 0% sharpening and 0% smoothing. I would prefer to carry out any necessary pre-image processing sharpening once the image has been opened up in Photoshop. I believe that the PhotoKit sharpener product Bruce Fraser has created for Pixel Genius will offer improved capture sharpening over the Camera Raw sharpen slider control. It is possible to select a 'sharpen previews only' in the Camera Raw preferences (accessed

Figure 11.13 The Camera Raw Detail tab controls.

via the pop-up menu), but I have not found much need for this feature either. The Luminance smoothing amount can be increased when image files might benefit from this. If you shoot using a high ISO setting on the camera, then you will almost certainly encounter noisy images. The close-up preview in Figure 11.13 shows how a high Color Noise Reduction control helped remove nearly all the colored artifacts in this noisy image capture.

Lens settings

The Lens controls shown in Figure 11.14 help correct some of the optical problems that are associated with digital capture. Some of these camera capture issues were discussed earlier on in this chapter. If you inspect an image closely towards the edge of the frame area, you may notice some color fringing, which will mostly be apparent around

areas of high contrast. In Figure 11.14 there was a hint of a
color halo around the base of the music stand in the bottom
left corner of the picture. I was able to correct this by
adjusting mostly the red/cyan chromatic aberration slider.
Some camera/lens combinations can cause some fall-off to
occur towards the edges of the picture frame, which will
result in the corners being slightly darker in exposure
compared to the center. This is not a problem that is likely
to occur often, but you may notice the deficiency more if
the subject features a plain, evenly-lit background and you
are shooting with a wide angle lens. The vignetting amount
will apply a gentle lightening exposure from the center
outwards. The Vignetting midpoint slider will offset the fall
off exposure correction. As you increase the midpoint
value, the exposure compensation will be accentuated more
towards the outer edges.

Figure 11.14 The Camera Raw Lens tab controls.

Camera Raw calibration

The Camera Raw plug-in was created using knowledge gathered about the leading digital cameras and the raw file formats that they produce. This includes information about the spectral response of the chip from which a profile can be created. This base profile is used in combination with the white balance adjustment to produce a properly color balanced image. A lot of the work I shoot is in the studio, always using the same strobe lighting system. Early on I established that when shooting with the Canon EOS 1Ds camera, the optimum white balance setting for my flash equipment should be 4600 K. So I now use this custom white balance setting all the time. I simultaneously shoot chrome transparency film and later scan these using a profiled Imacon Flextight 848 scanner. I discovered that on nearly every shoot the final resulting files from the Canon camera and the Flextight scanner look almost identical. A

Figure 11.15 The Camera Raw Calibrate controls.

small amount of tweaking might be required, but not much. In fact, sometimes the only way to tell the two apart is to check the metadata! In most circumstances you should get accurate and predictable results using Camera Raw. But it is still possible that you may experience color variations. This could be due to variance in the manufacture of the chip in your camera, or it might be the result of a metameric color shift.

Batch processing

Once you have configured the Camera Raw settings you will be ready to click on the OK button and open the image. When you do this, the settings you have applied will by default be saved to the Camera Raw database Or, if you prefer, you can have this information saved as a sidecar '.xmp' file to the same folder location as the original raw file. To set this preference, go to the Fly-out menu in the Camera Raw dialog and choose Preferences... Change the Save image settings preference to sidecar '.xmp' files. Saving the applied settings to the Camera Raw database is a tidier solution, but only your machine will be able to access this database. If you open this raw image a second time, you are offered the previously applied settings. The saved settings are also used to generate a color corrected thumbnail in the file browser. It is not necessary to have to save the image in order for the camera raw settings to be saved. If you 🖱️ *alt* click the Save button an xmp settings file will be saved without processing the Camera Raw data. If you are opening several raw files at once, clicking Cancel will halt opening all the remaining images. *Shift* click the Save button to skip processing this image and progress to the next one.

Each time the Camera Raw dialog opens you have the option of applying a choice of settings to the selected file. The Camera Raw settings can be found just beneath the histogram display. The Selected Image setting will reference the Camera Raw database or sidecar file present and configure the settings to utilize the last used Camera Raw configuration. The Camera Default setting will use the

Metamerism and color shifts

Metameric color shifts occur because certain objects reflect wavelengths that are outside normal human vision, which the camera chip does pick up, resulting in an unnatural color appearance. In circumstances such as this you can use the calibrate controls that are available in the advanced mode, to make tweaks to the way camera raw interprets specific colors and renders the final image.

Figure 11.16 The Camera Raw Save Settings Subset dialog, which is accessed via the fly-out menu. Mouse down on the Subset pop-up menu to select a restricted group of settings to save as the defaults or select the custom option to create a custom group.

Sidecar .xmp files

If you select the save sidecar files option, sidecar '.xmp' files will then accumulate in the same folder as the raw camera files. The reason for having sidecar files is because the header in raw camera files cannot always be edited. Some camera manufacturers have been willing to share information about their file formats with Adobe. Others have not, and that is why keeping the metadata stored in a separate file has been necessary. Sidecar files normally remain hidden from view in the File Browser (unless you select show unreadable files in the File Browser View menu). If you move the folder location of a raw camera file, the sidecar file will (by its nature) move with it. The advantage of saving sidecar files is that they are very small in size and any previously applied settings will always be accessible should you want to burn the files to a CD or DVD or share with a user using another separate computer.

white balance settings recorded when the image was captured, while the Previous Conversion setting will utilize the settings applied to the last image that was opened using Camera Raw. You will also see a list of recently opened files and select from one of these recently-used settings instead. And lastly, you can create a custom Camera Raw configuration. Go to the Fly-out menu, choose Save Settings... and create a named setting that will in future be accessible whenever you use Camera Raw.

The Camera Raw dialog will pop up every time you open a raw camera file. This will prompt you to consider how each individual image should be treated – you are effectively encouraged to make tweaks to each and every camera captured image. In my opinion, the Camera Raw dialog offers every opportunity to make improvements to the raw capture data. I nearly always adjust the exposure, shadows and brightness sliders, but only to a limited extent and I prefer to keep the saturation as it is and turn off the sharpening and smoothing options. However, if you hold down the *Shift* key as you open single or multiple raw camera images via the File Browser, the images will open directly without displaying the Camera Raw dialog and in this situation they will default to use the pre-saved default Camera raw setting. Likewise, whenever you select a batch

operation that involves processing raw camera files, you will not be troubled with the Camera Raw dialog, and files will be opened using the default Camera Raw settings. On the other hand, if you record a Photoshop action, you can record specific configuration settings as part of that action and if you read on to the next paragraph, find out how to create a custom default setting that will for example, fix the detail settings to a preference of your own choosing, but let the white balance be adaptable to whatever the setting was when the image was captured.

Scanning backs

These record a scene similar to the way a flatbed scanner reads an image placed on the glass platen. A row of light sensitive elements travel in precise steps across the image plane, recording the digital image. The digital backs are designed to work with large format 5×4 cameras, although the scanning area is slightly smaller than the 5×4 format area. Because of their design, daylight or a continuous light source must be used. HMI lighting is recommended because this produces the necessary daylight balanced output and lighting power. Some flash equipment manufacturers, like the Swiss firm Broncolor, have made HMI lighting units which are identical in design to the standard flash heads and accept all the usual Broncolor lighting adaptors and accessories. Many photographers are actually able to use standard quartz tungsten lighting, providing the camera software is able to overcome the problem of light flicker. But the lower light levels may require a higher ISO capture setting and this can lead to increased blue shadow noise. Sometimes bright highlights and metallic surfaces will leave bright green streaks as the CCD head moves across the scan area. This is known as blooming and looks just like the effect you often saw in the early days of color television. It might have appeared cool in a TV recording of a seventies glam rock band, but it is really tricky to have to retouch out in a stills photograph. Some scanning back systems contain anti-blooming circuitry in the equipment hardware.

Modifying the default settings

The default settings can be overwritten by selecting the Set Camera Default option in the Camera Raw fly-out menu. This will replace the standard default with the current Camera Raw settings which will include everything you have configured currently. It is more likely that you will wish to save certain aspects only of your Camera Raw configuration as the new default. If you first choose the Save Settings subset option you will be presented with the dialog shown in Figure 11.16, you can check which groups or custom combination of Camera Raw settings are actually saved when you then go to choose the 'Set Camera Default' option in the fly-out menu.

Stephen Johnson

One of the first photographers to adopt digital capture was Stephen Johnson, who shoots fine-art landscape photographs, using a Betterlight scanning back attached to a 5 × 4 plate camera which he takes on location. When Stephen Johnson began testing a prototype Betterlight scanning system in January 1994, he simultaneously shot a sheet of 5 × 4 film and made a digital capture of a view overlooking San Francisco using the Betterlight. He made a high resolution scan of the film and compared it with the digital capture. He was blown away by what he saw. The detail captured by the scanning back was incredibly sharp when compared side by side with the film scan. This was the moment when Stephen Johnson declared 'Film died for me on that day in 1994.' Since then, everything he has photographed has been captured digitally (you can visit his gallery website at: <www.sjphoto.com>). It wasn't just the sharpness and resolution of the images that appealed. The Betterlight scanning back system is able to discern a much greater range of tonal information between light and shade than normal film ever can. The digital sensors are able to see deep into the darkest shadows and retain all the highlight detail. The color information can also be made to more accurately record the scene as it really appeared at that time of the day.

The exposure time depends on the size of final image output. It can take anything from under a minute for a preview scan to almost 10 minutes to record a 100 MB+ image. The latest Betterlight scanning back can now scan a high-resolution image in just a few minutes. Everything has to remain perfectly still during exposure. This limits the types of subject matter which can be photographed. You can use a scanning back on location, but sometimes you get unusual effects similar to the distortions achieved with high-speed focal plane shutters.

When digital photography was in its infancy, scanning backs were considered to be technologically superior to most of the CCD camera backs – mainly because they were the only devices that enabled you to capture such big file sizes. These days, you can capture a 384 MB 16-bit RGB file using the Ixpress 384 or a top of the range Sinar or Phase One camera back. To my mind, CCD technology now offers the better technical quality and at large file sizes.

Cataloging digital images

It is going to be very important that you maintain a cataloged archive of all your finished pictures – this is something the photographer should be able to do using an image database program. But your clients will need to get into a routine of building their own database record too. I know of an art director who told his photographer: 'we must go digital'. So the photographer on the strength of all the business he was getting from this client, invested heavily in lots of new digital camera kit. Six months later, the same art director wanted his photographer go back to shooting film, because he wasn't able to cope with the growing pile of CDs and he could never locate an image quickly enough! In Chapter 16 I will be going into more detail the ways photographers can manage their files and archive them securely.

Pros and cons of going digital

These are exciting early days, when high resolution digital image capture has become a reality. There are still a few obstacles to overcome before digital cameras can match the versatility of film cameras, but for many professional setups digital cameras are able to fulfil a useful role in the studio and on location. Digital cameras have arrived at a time when digital press technology is well and truly established. Film scanners have had to be designed to cope with the uneasy task of converting continuous tone film originals of different types to a standard digital output. Digital camera design has been invented from the ground up and digital camera development has therefore been very much designed to meet the specific needs of repro. A really important benefit of running a digital studio is increased productivity. When a client commissions a photographer to shoot digitally, they have an opportunity to see the finished results straight away. It is possible for the client to attend a shoot, approve the screen image after seeing corrections, then the picture can be transmitted by ISDN or FTP to the printer (or wherever) and the whole shoot be 'signed off' the same day. Because of the huge capital outlay involved

Storage

If you are inclined to get carried away shooting lots of photographs, how are you going to save all the images that you capture and archive them? Let's say each raw capture file is just less than 10 MB in size. That means you can store up to 65 exposures (just less than two rolls of 35 mm film) on a recordable CD disk. The Imacon Ixpress in single shot mode can shoot six raw 16-bit, 96 MB files in less than 10 seconds. But you would need to burn a whole CD to archive those six shots. Even with a ×48 speed CD recorder, it would take at least five minutes to load, write and verify each disk. I typically use DVD media to archive my capture files. DVD disks can store around 4.2 GB of data and it looks like the storage capacity of DVD is going to increase. Although the DVD recorder I use is not as fast as a CD recorder, it is possible to devise a work flow where everything that has been shot in a day can be copied across to a single DVD disk. Even if the process takes almost an hour on a standard DVD recorder, this is something that can be done in the background at a suitable time and does not necessitate hanging around the computer swapping a pile of CD disks in and out of the machine. I keep these raw files stored on the DVD as a backup and can then edit away at my original selection, safely discarding any of the shots that are no longer needed.

in the purchase and update of a digital studio camera system, it is not unreasonable for a photographer to charge some sort of digital premium, in the same way as the cost of studio hire is normally charged as an expense item. Digital capture is all too often being promoted as an easy solution and unfortunately there are end clients who view the advantages of digital photography purely on the basis of cost savings: increased productivity, fast turnaround and never mind the creativity. Some clients will look for the material savings to be passed on to them regardless, but there are other clients who are willing to accept this, as they will still be able to save themselves time and money on the film and processing plus further scanning costs. And as photographic studios are getting involved in the repro process at the point of origination, there is no reason why they should not consider selling and providing an extra menu of services associated with digital capture, like CMYK conversions, print proofing and image archiving.

Conclusion

Digital photography has become firmly established as the way of the future. But making the transformation from analog to digital can be a scary process. The photographer is rightly anxious to keep their customers happy and often compelled to invest in digital camera equipment because they will otherwise lose that client. Meanwhile clients want to see better, faster and cheaper results. But they also wish to avoid the disasters brought about through digital ignorance. For photographers this is like a replay of the DTP revolution that saw a massive shake-up in the way pages were published. For newcomers, there is a steep learning curve ahead, while for experienced digital pros there is absolutely no going back.

Chapter 12

Resolution

This chapter deals with the issues of digital file
resolution, and two of the first questions
everyone wants answered – how do you define
it and just how big a file do you really need?
When we talk about resolution in photographic terms, we
normally refer to the sharpness of the lens or fineness of
the emulsion grain. In the digital world, resolution relates
to the number of pixels contained in an image. Every
digital image contains a finite number of pixel blocks that
are used to describe the tonal information, and the more
pixels, the finer its resolving capacity. The pixel
dimensions of a digital image are an absolute value: a 2400
× 3000 pixel image could be output as 12" × 15" at 200
pixels per inch and the megabyte file size would be 20.6
MB RGB or 27.5 MB CMYK. A 2500 × 3500 pixel image

The Pixel resolution

The pixel dimensions are the surest way of defining what you mean when quoting digital file size. If we have a digital image where the dimension along one axis is 3000 pixels, these pixels can be output at 10 inches at a resolution of 300 pixels per inch or 12 inches at a resolution of 250 pixels per inch. This can be expressed clearly in the following formula: number of pixels = physical dimension × (ppi) resolution. In other words, there is a reciprocal relationship between pixel size, the physical dimensions and resolution. If you quote the resolution of an image as being so many pixels by so many pixels, there can be no ambiguity about what you mean.

could reproduce as an A3 or full bleed magazine page printed at the same resolution of 200 pixels per inch and megabyte file size would be about 25 MB RGB (33.4 MB CMYK).

Digital cameras are often classed according to the number of pixels they can capture. If the CCD chip contains 2000 × 3000 pixel elements, it can capture a total of 6 million pixels, or for shorthand, is described as a 6 megapixel camera. And if you multiply the 'megapixel' size by three you will get a rough idea of the megabyte size of the RGB image output. In other words, a 6 megapixel camera will yield an 18 MB RGB file. Quoting megabyte sizes is a less reliable method of describing things because document file sizes can also be affected by the number of layers and alpha channels present and whether the file has been compressed or not. Nevertheless, referring to image sizes in megabytes has become a convenient shorthand when describing a standard uncompressed, flattened TIFF file.

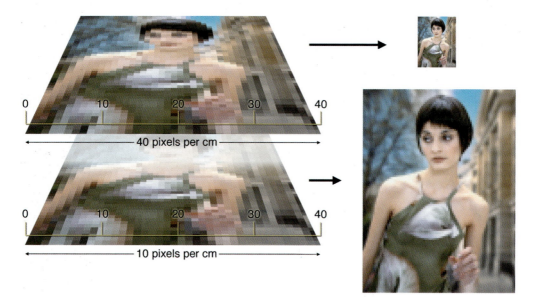

Figure 12.1 In this diagram you can see how a digital image that is comprised of a fixed number of pixels can have its output resolution interpreted in different ways. For illustration purposes let's assume that the image is 40 pixels wide. The file can be printed big (and more pixelated) at a resolution of 10 pixels per cm, or it can be printed a quarter of the size at a resolution of 40 pixels per cm.

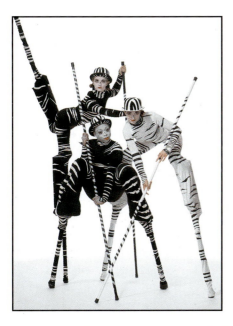

Figure 12.2 Digital images are constructed of a mosaic of pixels. Because of this a pixel-based digital image always has a fixed resolution and is said to be 'resolution-dependent'. If you enlarge such an image beyond the size at which it is meant to be printed, the pixel structure will soon become evident, as can be seen in the right-hand close-up below. But suppose the picture shown opposite was created not as a photograph, but as an illustration in a program like Adobe Illustrator™. If the picture is drawn using vector paths, the image will be resolution-independent. The mathematical numbers used to describe the path outlines shown in the bottom left example can be scaled to reproduce at any size: from a postage stamp to a billboard poster.

'Stalkers' by The Wrong Size.
Photograph: Eric Richmond.

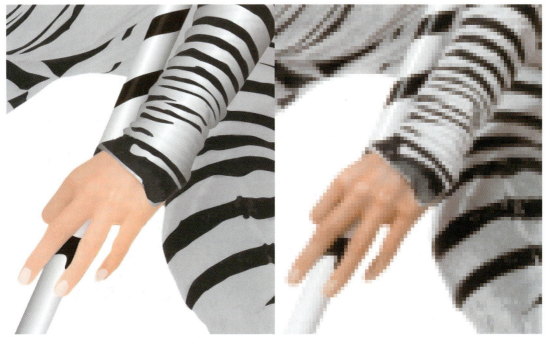

Photoshop as a vector program

Photoshop is mainly regarded as a pixel-based graphics program, but it does have the capability to be a combined vector and pixel-editing program because it also contains a number of vector-based features that can be used to generate images such as custom shapes and layer clipping paths. This raises some interesting possibilities – with Photoshop you can create various graphical elements like type, shape layers, layer clipping paths which are all resolution-independent. These 'vector' elements can be scaled up in size in Photoshop without any loss of detail, just as you can with an Illustrator graphic.

Pixels versus vectors

Digital photographs are constructed with pixels and as such are resolution-dependent. You can scale up a pixel image, but as you do so, the finite information can only be stretched so far before the underlying pixel structure becomes apparent (see Figure 12.1). Adobe Illustrator™ is an example of a vector-based program. Objects created in Illustrator are defined mathematically, so if you draw a rectangle, the proportions of the rectangle edges, the relative placement on the page and the color it is filled with can all be described using mathematical expressions. An object defined using vectors can be output at any resolution, from the display on the screen to a huge poster. It will always be rendered as a crisply defined shape (see Figure 12.2).

Terminology

Before proceeding further let me help clarify a few of the confusing terms used and their correct usage when describing resolution.

ppi: pixels per inch. Describes the digital, pixel resolution of an image. You will notice the term dpi is often inappropriately used to describe digital resolution. Scanning devices are sometimes advertised with their scanning resolution expressed in dots per inch. Strictly speaking, this is an incorrect use of the term 'dpi', because input devices like scanners produce pixels and only output printers produce dots. However, it's fallen into common parlance and unfortunately only added to the confusion. Photoshop always refers to the input resolution as being in pixels per inch or pixels per centimeter, and so should you. Monitor resolution is also specified in ppi: Macintosh monitors have a resolution of 72 ppi, whereas PC monitors are usually 96 ppi. One of the reasons for the Macintosh default resolution of 72 ppi (which dates back to the era of the first Apple Macs) is that it helps graphic designers get a better feel for the weight of their fonts when laying out a page.

1 The halftone screen shown here is angled at zero degrees. If the pixel resolution were calculated at ×2 the line screen resolution, the RIP would use four pixels to calculate each halftone dot.

2 To reproduce a CMYK print output, four plates are used, of which only the yellow plate is actually angled at zero degrees. The black plate is normally angled at 45 degrees and the cyan and magenta plates at less sharp angles. Overlay the same pixel resolution of ×2 the line screen and you will notice that there is no direct relationship between the pixel and line screen resolutions.

The pixel resolution (ppi) is the number of pixels per inch in the input digital image.

The line screen resolution (lpi) is the frequency of halftone dots or cells per inch.

3 There is no single empirical formula that can be used to determine the ideal 'half toning factor'. Should it be ×2 or ×1.5? The black plate is the widest at 45 degrees and usually the black plate information is more prominent than the three color plates. If a halftoning factor of ×1.41 (the square root of 2) were used, the pixel resolution will be more synchronized with this angled halftone screen. There is no right or wrong halftoning factor – the RIP will process pixel data at any resolution. If there are too few pixels, print quality will be poor. Having more than the optimum number does not necessarily equate to better output, it is just more pixels.

4 Each halftone dot is rendered by a PostScript RIP from the pixel data and output to a device called an imagesetter. The halftone dot illustrated here is plotted using a 16 × 16 dot matrix. This matrix can therefore reproduce a total of 256 shades of gray. The dpi resolution of the image setter, divided by 16, will equal the line screen resolution. 2400 dpi divided by 16 = 150 lpi screen resolution.

Confusing terminology

You can see from these descriptions where the term 'lines per inch' originated. In today's digital world of imagesetters, the definition is somewhat archaic, but is nonetheless commonly used. You may hear people refer to the halftone output as dpi instead of lpi, as in the number of 'halftone' dots per inch, and the imagesetter resolution be referred to as having so many spi, or spots per inch. Whatever the terminology I think we can all logically agree on the correct use of the term pixels per inch, but I am afraid there is no clear definitive answer to the mixed use of the terms dpi, lpi and spi. It is an example of how the two separate disciplines of traditional repro and those who developed the digital technology chose to apply different meanings to these terms.

lpi: lines per inch. The number of halftone lines or 'cells' in an inch, also described as the screen ruling. The origins of this term go back way before the days of digital desktop publishing. To produce a halftone plate, the film exposure was made through a finely etched criss-cross screen of evenly spaced lines on a glass plate. When a continuous tone photographic image was exposed this way, dark areas formed heavy halftone dots and the light areas, smaller dots, giving the impression of a continuous tone image when printed on the page and viewed from a normal distance.

dpi: dots per inch. Refers to the resolution of a printing device. An output device such as an imagesetter is able to produce tiny 100% black dots at a specified resolution. Let's say we have an imagesetter capable of printing at a resolution of 2400 dots per inch and the printer wished to use a screen ruling of 150 lines per inch. If you divide the dpi of 2450 by the lpi of 150, you get a figure of 16. Within a matrix of 16×16 printer dots, an imagesetter can generate a halftone dot varying in size from 0 to 255, which is 256 print dots (see Figure 2.3). It is this variation in halftone cell size (constructed from the combined smaller dots) which gives the impression of tonal shading when viewed from a distance. Desktop inkjet printers produce an output made up of small dots at resolutions of between 360 and 2880 dots per inch. Remember, an inkjet output is not the same as the reprographic process – the screening method is quite different.

Above all you need to understand that an image displayed on the screen at 100% does not represent the actual physical size of the image, unless of course your final picture is designed for screen use, such as for the Web or CD-ROM display.

Repro considerations

The structure of the final print output appearance bears no relationship to the pixel structure of a digital image. A pixel in a digital image does not equal a cell of halftone dots on the page. To explain this, if we analyze a CMYK cell or

rosette, each color plate prints the screen of dots at a slightly different angle, typically: Yellow at 0 or 90 degrees, Black: 45 degrees, Cyan: 105 degrees and Magenta: 75 degrees. If the Black screen is at a 45 degree angle (which is normally the case), the (narrowest) horizontal width of the black dot is 1.41 (square root of 2) times shorter than the width of the Yellow screen (widest). If we extend the width of the data creating the halftone cell, then multiplying the pixel sample by a factor of 1.41 would mean that there was at least a 1 pixel width of information with which to generate the black plate. The spacing of the pixels in relation to the spacing of the 45 degree rotated black plate is thereby more synchronized.

For this reason, you will find that the image output resolution asked for by printers is usually at least 1.41 times the halftone screen frequency used, i.e. multiples of ×1.41, ×1.5 or ×2. This multiplication is also known as the 'halftone factor', but which is best? Ask the printer what they prefer you to supply. Some will say that the 1.41:1 or 1.5:1 multiplication produces crisper detail than the higher ratio of 2:1. There are also other factors which they may have to take into account such as the screening method used. Stochastic or FM screening, which, it is claimed, permits a more flexible choice of ratios ranging from 1:1 to 2:1.

Ideally this information needs to be known before the image is scanned (or captured digitally). Because if you calculate that only 10 MB worth of RGB data will actually be required, there may be no point in capturing more image data than is absolutely necessary. If the printer's specification is not available to you, then the only alternative is to scan or shoot at the highest practical resolution and resample the image later. The downside of this is that large image files consume extra disk space and take longer to process on the computer. If a print job does not require the images to be larger than 10 MB, then you'll want to know this in advance rather than waste time and space working on unnecessarily large files. On the other hand, designers like to have the freedom to take a supplied image and scale it in the DTP layout to suit their

Determining output image size

Image size is determined by the final output requirements and at the beginning of a digital job, the most important information you need to know is:

- How large will the picture appear on the page, poster etc.?
- What is the screen frequency being used by the printer – how many lpi?
- What is the preferred halftone factor used to determine the output resolution?
- Will the designer need to allow for page bleed, or want to crop your image?

Ideal pixel resolution for printing

The optimum pixel resolution should ideally be the printer dpi divisible by a whole number. The following pixel resolutions could be used: 144, 160, 180, 240, 288, 320, 360. To make large inkjet prints for viewing at a greater distance, use a low pixel resolution. For smaller sized portfolio prints I normally use a 240 ppi pixel resolution. I doubt very much you will notice any improvement in print quality if you choose a resolution that is higher than this.

Inkjet output resolution

The pixel resolution of an image should be specified using the numbers of pixels per inch (ppi) so as to avoid confusion when using the number of dots per inch (dpi) to describe the imagesetter output resolution (although sometimes dpi is used to refer to the number of halftone cells per inch). Inkjet printers use the term 'dots per inch' to describe the output resolution of the printer. The dpi output of a typical inkjet will range from 360 to 2880 dpi. And although this is a correct usage of dpi, in this context the dpi means something else yet again. Most inkjet printers lay down a scattered pattern of tiny dots of ink that accumulate to give the impression of different shades of tone, depending on either the number of dots, the varied size of the dots, or both. The principle is roughly similar to the halftone process, but not quite the same. If you select a finer print resolutions such as 1440 or 2880 dpi, you should see smoother print outputs when viewed close-up.

New Document presets

New document settings can be saved as presets. Enter the desired dimensions, units, resolution and other settings and click the Save Preset... button. This will pop the New Document Preset dialog and you can check the various boxes to choose which components you want to save in the preset. Photoshop 7.0 had a New Doc Sizes.txt document in the Presets folder that you could edit, but this will no longer be recognized by Photoshop CS.

requirements. Use the ×2 halftone factor, and there will be enough data in the supplied file to allow for a 20% scaling without adversely compromising the print quality.

Creating a new document

If you want to create a new document in Photoshop with a blank canvas, go to the File menu and choose New... This will open the dialog shown in Figure 12.3, where you can select a preset setting from the Preset pop-up menu or manually enter the new document dimensions and resolution in the fields below. When you choose a preset setting, the resolution will adjust automatically depending on whether it is a preset used for print or computer screen type work. You can change the default resolution settings for print and screen in the Units & Rulers Photoshop preferences dialog. The Advanced section lets you do extra things like choose a specific profiled color space. The Pixel Aspect Ratio is there to aid multimedia designers who

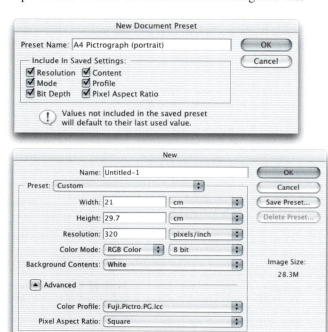

Figure 12.3 The New document and New Document Preset dialogs.

work in stretched screen formats. So, if a 'non-square' pixel setting is selected, Photoshop will create a scaled document which will preview how a normal 'square' pixel Photoshop document will actually display on a stretched wide screen. And the title bar will add [scaled] to the end of the file name to remind you are working in this special preview mode. When you create a non-square pixel document the scaled preview can be switched on or off by selecting the Pixel Aspect Correction item in the View menu.

Altering the image size

The image size dimensions and resolution can be adjusted using the Image Size dialog, shown in Figure 12.4. By default the dialog will open with the Resample image box checked. This means that you can enter new pixel dimension values to increase or decrease the image size. Or if you enter new physical dimensions, or change the image resolution, you can also increase or decrease the image size (and you will see the pixel dimensions adjust simultaneously). Remember the rule I mentioned earlier: the number of pixels = physical dimension × (ppi)

Figure 12.4 To change the image output resolution without altering the physical size, check the Resample Image box and enter a new resolution. To change image output dimensions without altering the resolution, leave the Resample box unchecked. Auto resolution will help you pick the ideal pixel resolution for repro work based on the line screen resolution.

When to interpolate?

I consider 'interpolating up' an image in Photoshop to be preferable to the interpolation methods found in basic scanner software. Digital files captured from a scanning back or multishot digital camera are extremely clean, and because there is no grain present, it is usually possible to magnify a digitally captured image much more than you would to a scanned image of equivalent size. There are other programs like Resolut and ColorShop which are used to good effect when interpolating digital capture files. There is a file format plug-in called Genuine Fractals from LizardTech™ software that is designed to provide improved interpolation when blowing up images. Interpolation works most effectively on a raw scan – one that has not already been pre-sharpened.

resolution. You can put that rule to the test here and use the Image Size dialog as a training tool to help understand better the relationship between the pixels, dimensions and resolution. The constrain proportions checkbox links the horizontal and vertical dimensions, so that any adjustment is automatically scaled to both axis. Only uncheck this box if you wish to squash or stretch the image when adjusting the image size. Any adjustment made to the image will not alter the total pixel size. If you adjust the dimensions the resolution value will adjust to compensate and vice versa.

When Resample Image is checked the image can be enlarged or reduced by making the number of pixels in the image greater or smaller. This resampling is also known as interpolation and Photoshop can use one of five methods when assigning approximated values for any new pixels that are generated. The interpolation options are located next to the Resample Image checkbox. Nearest Neighbor is the simplest interpolation method, yet I use this quite a lot, such as when I want to enlarge a screen grab of a dialog box for this book by 200% and I don't want the sharp edges of the dialog boxes to appear fuzzy. Bilinear interpolation will calculate new pixels by reading the horizontal and vertical, neighboring pixels. It is fast, and perhaps that was an important consideration in the early days of Photoshop, but I don't see there is much reason to use it now. Bicubic interpolation provides better image quality when resampling continuous tone images. Photoshop will read the values of neighboring pixels, vertically, horizontally and diagonally to calculate a weighted approximation of each new pixel value. Photoshop intelligently guesses the new pixel values, by referencing all the surrounding pixels. Photoshop CS bicubic interpolations are improved and more accurate than before, especially with regard to the downsampling of images.

Unsharp masking should always be applied last as the file is being prepared for print. This is because interpolating after sharpening will enhance the image artifacts introduced by the sharpening process. If you need to apply an extreme image resize either up or down in size,

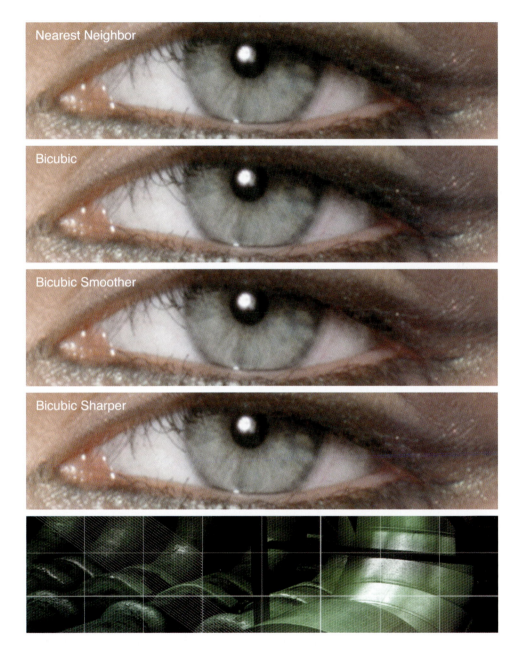

Nearest Neighbor

Bicubic

Bicubic Smoother

Bicubic Sharper

Figure 12.5 Here are a series of close-up showing what would happen if you interpolated an image by 400% in Photoshop using the different interpolation methods (I have excluded Bilinear since it is hardly ever used). As a comparison, I have also included an image that has been interpolated up using the Genuine Fractals plug-in for Photoshop from LizardTech™ software <www.lizardtech.com>.

Planning ahead

Once an image has been scanned at a particular resolution and manipulated there is no going back. A digital file prepared for advertising usages may never be used to produce anything bigger than a 35 MB CMYK separation, but you never know – that is why it is safer to err on the side of caution – better to sample down than have to interpolate up. It also depends on the manipulation work being done – some styles of retouching work are best done at a magnified size and then reduced. Suppose you wanted to blend a small element into a detailed scene. To do such work convincingly, you need to have enough pixels to work with to be able to see what you are doing. For this reason some professional retouchers will edit a master file that is around 100 MB RGB or bigger even. Another advantage of working with large file sizes is that you can always guarantee being able to meet clients' constantly changing demands. Although the actual resolution required to illustrate a glossy magazine double-page full-bleed spread is probably only around 40–60 MB RGB or 55–80 MB CMYK. Some advertising posters may even require smaller files than this, because the print screen on a billboard poster is that much coarser. When you are trying to calculate the optimum resolution you cannot rely on being fully provided with the right advice from every printer. Sometimes it will be necessary to anticipate the required resolution by referring to the table in Figure 12.8. This shows some sample file size guides for different types of print job.

I suggest that you use one of the new interpolation methods in Photoshop CS. Some people might be familiar with the step interpolation technique – this is where you gradually increase or decrease the image size in stages – it is not really necessary now. Bicubic smoother is the ideal choice if you wish to make an image bigger. And if you want to reduce the pixel resolution more accurately, use Bicubic sharper. Say for example, you have a high resolution digital capture of detailed machinery and you want to make a duplicate copy but at a much lower pixel resolution. A single image size reduction using the Bicubic sharper interpolation will produce a more accurate, sharper image when you reduce it down in size.

Practical conclusions

Amid all the conflicting opinions on how large a digital file should be, I find the guidelines given by some of the photographic picture libraries instructive. Photographers who submit digital work are asked to supply digital files of around 40–50 MB RGB. The thinking is that for the vast majority of picture purchases, these file sizes will be ample and in fact the majority of pictures purchased are probably printed using 20 MB of RGB data or less anyway. You can be sure that in any magazine publication you care to look

Figure 12.6 If Image Size is proving too confusing, the Resize Image assistant is on hand to help guide you. This wizard is located in the Help menu and can be used to resize images both for print and for the Web.

Pixel size	Megapixels	MB (RGB)	MB (CMYK)	Inches 200 ppi	Centimeters 80 ppc	Inches 300 ppi	Centimeters 120 ppc
1600x1200	2	6 MB	7.5 MB	8 x 6	20 x 15	5.5 x 4	13.5 x 10
2400x1800	4.3	12.5 MB	16.5 MB	12 x 9	30 x 22.5	8 x 6	20 x 15
3000x2000	6	17.5 MB	23.5 MB	15 x 10	37.5 x 25	10 x 6.5	25 x 17
3500 x 2500	8.75	25 MB	33.5 MB	17.5 x 12.5	44 x 31	11.5 x 8.5	29 x 21
4000 x 2850	11.4	32.5 MB	43.5 MB	20 x 14	50 x 36	13.5 x 9.5	33.5 x 24
4500 x 3200	14.4	41 MB	54.5 MB	22.5 x 16	56 x 40	15 x 10.5	37.5 x 27
5000 x 4000	20	57 MB	76 MB	25 x 20	62.5 x 50	16.5 x 13.5	42 x 33.5

Figure 12.7 The above table shows a comparison of pixel resolution, megapixels, megabyte file size and output dimensions at different resolutions, both in inches and in centimeters.

Separation settings	Ink colors	Separation method	Dot gain	Black generation	Black ink limit	Total ink limit	UCA
US printing							
Sheetfed (coated)	SWOP coated	GCR	10–15%	Light/Medium	95%	320–350%	0–10%
Sheetfed (uncoated)	SWOP uncoated	GCR	15–25%	Light/Medium	95%	260–300%	0–10%
Web press (coated)	SWOP coated	GCR	15–20%	Light/Medium	95%	300–320%	0–10%
Web press (uncoated)	SWOP uncoated	GCR	20 30%	Light/Medium	95%	260 300%	0–10%
Web press (newsprint)	SWOP newsprint	GCR	30–40%	Medium	85–95%	260–280%	0–10%
European printing							
Sheetfed (coated)	Euroscale coated	GCR	10–15%	Light/Medium	95%	320–350%	0–10%
Sheetfed (uncoated)	Euroscale uncoated	GCR	15–25%	Light/Medium	95%	260–300%	0–10%
Web press (coated)	Euroscale coated	GCR	15–20%	Light/Medium	95%	300–320%	0–10%
Web press (uncoated)	Euroscale uncoated	GCR	20–30%	Light/Medium	95%	260–300%	0–10%
Web press (newsprint)	Euroscale newsprint	GCR	30–40%	Medium	85–95%	260–280%	0–10%

Figure 12.8 Here is a rough guide to the sort of file sizes required to reproduce either a mono or CMYK file for printed use. The table contains file size information for output at multiples of ×1.5 the screen ruling and ×2 the screen ruling.

Resolution and viewing distance

In theory the larger a picture is printed, the further away it is meant to be viewed and the pixel resolution does not have to alter in order to achieve the same perception of sharpness. There are limits though below which the quality will never be sharp enough at normal viewing distance (except at the smallest of print sizes). It also depends on the image subject matter – a picture containing a lot of mechanical detail will need more pixels to do the subject justice and reproduce successfully. If you had a picture of a softly lit cloudy landscape, you could quite easily get away with enlarging a small image through interpolation, beyond the normal constraints.

at, it does not matter how large the original scans were, the same amount of digital information was eventually used to make the halftone separations on each page you are looking at. There are photographers and also clients who insist nothing less than a high resolution scan from a 5×4 or 10×8 sheet of film will provide good enough quality for advertising work. I do believe an over-obsession with 'pixel correctness' gets in the way of appreciating just how good the technical output quality can be from smaller format cameras or what can be created on a modern computer desktop setup in the hands of a talented artist.

An enormous industry was based around photographers supplying films to clients, who made positional scans for layout purposes. They in turn then sent the film for repro scanning at the bureau to make the final separations. Along comes a photographer armed with his or her computer loaded with Photoshop, offering to cut out a large chunk of the repro process, supplying repro quality digital files themselves. Tread on somebody's toes once and they won't like you very much. Stamp all over them and they begin to squeal (loudly), especially if they believe you don't have a clue what you are talking about. Obviously, the printers should know best when it comes to getting the best results from their machinery, but remember they have a vested interest too in keeping the likes of you out of the equation. This leads to occasional 'spoiling' tactics, designed to make you look foolish in front of the end client, but I reckon companies with attitudes like these are dying out now. The smart businesses recognize the digital revolution will continue apace with or without them and they have to continually adapt to the pace of modern technology and all its implications. Besides, printing companies have been getting into the supply of digital photography themselves and the boundaries between our industries are constantly blurring.

Color Management

Photoshop 5.0 was justifiably praised as a ground-breaking upgrade when it was released in the summer of 1998. The changes made to the color management setup were less well received in some quarters. This was because the revised system was perceived to be extremely complex and unnecessary. Some color professionals felt we already had reliable methods of matching color and you did not need ICC profiles and the whole kaboodle of Photoshop ICC color management to achieve this. The aim of this chapter is to start off by introducing the basic concepts of color management – the first part will help you to understand the principles of why color management is necessary. And as you will discover, there are some important historical reasons why certain Photoshop users feel they have no

Figure 13.1 The picture on the left shows how you would see the Photoshop image on your screen and the one on the right represents how that same image will print if sent directly to a proofing printer without applying any form of color management. This is an actual simulation of what happens when raw RGB data is sent without any form of compensation being applied to balance the output to what is seen on the screen.

You might think it is merely a matter of making the output color less blue in order to successfully match the original. Yes, that would get the colors closer, but when trying to match color between different digital devices, the story is actually a lot more complex than that. The color management system that was first introduced in Photoshop 5.0 will enable you to make use of ICC profiles and match these colors from the scanner to the screen and to the print proofer with extreme accuracy.

Client: Clipso. Model: Sheri at Nevs.

need to use ICC profiled color management. We will be looking at the reasons for this and then go on to consider the advantages of an ICC profiled workflow and lastly, how to optimize the Photoshop color engine settings. This latter section will take you step by step through the Photoshop Color Settings interface.

The need for color management

An advertising agency art buyer was once invited to address a meeting of photographers for a discussion about photography and the Internet. The chair, Mike Laye, suggested we could ask him anything we wanted, except 'Would you like to see my book?' And if he had already seen your book, we couldn't ask him why he hadn't called it back in again. And if he had called it in again we were not allowed to ask why we didn't get the job. And finally, if we did get the job we were absolutely forbidden to ask him why the color in the printed ad looked nothing like the original transparency!

That in a nutshell is a problem which has bugged us all our working lives. And it is one which will be familiar to anyone who has ever experienced the difficulty of matching colors on a computer system with the original or a printed output. Figure 13.1 has two versions of the same

Figure 13.2 All digital devices have individual output characteristics, even if they look identical on the outside. In a TV showroom you will typically notice each television displaying a different colored image.

Why not all RGB spaces are the same

What you have just witnessed illustrates why color management is so important. It is all very well getting everything balanced to look OK on your monitor and knowing how to tweak your printer settings to look right. But there is a better way, one that will allow you to mix and match any number of digital devices. Go into any TV showroom and you will probably see rows of televisions all tuned to the same broadcast source but each displaying the picture quite differently. This is a known problem that affects all digital imaging devices, be they digital cameras, scanners, monitors or printers. Each digital imaging device has its own unique characteristics. And unless you are able to quantify what those individual device characteristics are, you won't be able to communicate effectively with other device components and programs in your own computer setup, let alone anyone working outside your system color loop.

photograph. One shows how the Photoshop image is previewed on the monitor and the other is an example of how a printer might interpret and reproduce those same colors. Why can there be such a marked difference between what is seen on the screen and the actual printed result? The computer monitor will have manual controls that allow you to adjust the brightness and contrast (and in some cases the RGB color as well), so we have some element of basic control there. And the printer will also probably allow you to make color balance adjustments, but is this really enough though? And if you are able to get the monitor and your printer to match, will the colors you are seeing in the image appear the same on another person's monitor?

The way things were

What follows is a brief summary of working practices in the repro industry, but keen amateurs might also be interested to learn about some of the background history to color management. Ten years ago, most photographers only used their computers to do basic administration work and

CMYK color management

Printers naturally have an 'output-centric' view of color management. Their main concern is getting the CMYK color to look right on a CMYK press. Accordingly, you will hear an argument that suggests you don't need ICC profiles to get accurate CMYK color. In fact, if you know your numbers, you don't even need a color monitor. In this respect you can say they are right. These proven techniques have served the printing industry well for many years. But most Photoshop users and especially those who are photographers, face a far more complex color management problem, because we don't all have the luxury of managing the one scanner linked to a single press. We quite often have to handle digital files sourced from many different types of RGB devices such as: digital cameras, desktop scanners, or from picture libraries, other photographers etc.

there were absolutely no digital imaging devices to be found in a photographer's studio (unless you counted the photocopier). At the end of a job we would supply transparencies or prints to the client and that was the limit of our responsibilities. Our photographs then went to the printer to be digitized using a high-end drum scanner to produce a CMYK file. The scanner would be configured to produce a CMYK file ready to insert in a specific publication. If color corrections were required, the scanner operators carried this out themselves on the output file. These days a significant number of photographers, illustrators and artists are now originating their own files from digital cameras, desktop scanners or directly within Photoshop. This effectively removes the repro expert who previously did all the scanning and matching of the colors on the press. Imagine for a moment what would happen if our traffic laws permitted a sudden influx of inexperienced and unaccompanied teenage learner drivers on to our roads? This will give you some indication of the 'printer rage' that ensued when Photoshop users began delivering digital files instead of transparencies. There is no getting away from the fact that if you supply digital images to a printer, you will be deemed responsible should any problems occur in the printing. This may seem like a daunting task, but with Photoshop it is not hard to color manage your images with confidence. It need only take a few minutes to calibrate and profile your monitor as discussed earlier in Chapter 3.

RGB devices

If your production workflow is limited to working with the one high-end scanner and a known press output, then the number of variables in your workflow is limited and it would not be difficult to synchronize everything in-house. But this is not the experience for the average Photoshop user. Instead of handling color between a few known digital devices in a fixed loop, you are faced with files coming from any number of unknown digital devices. If we all worked with the same few pieces of digital capture

devices (like in the old days when there were only a handful of high-end scanner devices) the problem would be not so bad. But in the last decade or so the numbers of different types of capture devices has grown enormously. When you take into account all the different monitors that are in existence and other Photoshop users who supply you with files of unknown provenance, and well, you get the picture! Since the explosion of new desktop scanners and digital cameras arriving on the market, the publishing industry has been turned on its head. This is a relatively new phenomenon and the old way of doing things no longer holds all the answers when it comes to synchronizing color between so many unknown users and digital devices. On top of this our clients may expect us to output to digital proofing devices, Lambda printers, Pictrographs, Iris printers, web pages, and ultimately a four-color press. An appreciation of CMYK printing is important, but in addition to this, you will possibly have to control the input and output between many different RGB color devices before a file is ready to go to press.

ICC profiled color management

We are all familiar with magazine reviews of digital cameras. At some point the magazine may print a spread of photos where a comparison is made of all the different models and the results achieved from photographing the same subject. The object of this exercise being to emphasize the difference in the capture quality of each camera when each file is brought directly into Photoshop, without any compensation being made. If you could quantify or 'characterize' those differences then it should be possible to accurately describe the color captured by any camera or scanner.

The International Color Consortium (ICC) is an industry body representing the manufacturers of imaging hardware and software who devised a common method of interpreting color between one device and another. The ICC profiling system has been adopted in a number of guises, such as Apple's ColorSync™. All ICC systems are

Not all RGB color devices are the same

Consider for a moment the scale of the color management task. We wish to capture a full color original subject, digitize it with a scanner or digital camera, examine the resulting image via a computer screen and finally reproduce it in print. It is possible with today's technology to simulate the expected print output of a digitized image on the display with remarkable accuracy. Nevertheless, one should not underestimate the huge difference between the mechanics of all the various bits of equipment used in the above production process. Most digital devices work using RGB color and just like musical instruments, they all possess unique color tonal properties, such that no two devices are identical or will be able to reproduce color exactly the same way as another device can. Some equipment is capable of recording colors that are beyond the limits of human vision. Nor is it always possible to match in print all the colors which *are* visible to the human eye. Converting light into electrical signals via a device such as a CCD chip is not the same as projecting pixels onto a computer screen or the process of reproducing a photograph with colored ink on paper.

Figure 13.3 The tables shown here record the color readings in RGB and CMYK color spaces of a typical Caucasian flesh tone. As is explained in the text, while the CMYK readings are all fairly consistent, this is not the case when you try to compare the RGB values.

CMYK ink values	Cyan	Magenta	Yellow	Black
Euroscale Coated v2	09	28	33	0
3M Matchprint Euroscale	07	25	30	0
US Web uncoated (SWOP)	08	23	29	0
Generic Japan pos proofing	07	28	33	0

RGB pixel values	Red	Green	Blue
Adobe RGB	220	190	165
Pictrograph 3000	231	174	146
Lambda	230	184	158
Epson 9000 RGB	231	179	123

basically able to translate the color gamut of the source space via a reference space and accurately convert these colors to the gamut of the destination space. The color conversion processing is carried out by the Color Matching Module or CMM. In Photoshop you have a choice of three CMMs: Adobe Color Engine (ACE), Apple or Heidelberg. Figure 13.11 shows a graphical illustration of a CMM at work.

So let's imagine a scenario where everyone is working in a profile-free, digital workflow. Who would have the hardest job of managing the color? The printer can color correct a CMYK image 'by the numbers' if they wish. Take a look at the photograph of the young model in Figure 13.3. Her Caucasian flesh tones should at least contain equal amounts of magenta and yellow ink with maybe a slightly greater amount of yellow, while the cyan ink should be a quarter to a third of the magenta. This rule will hold true for most CMYK press conditions. The accompanying table compares the CMYK and RGB space measurements of a flesh tone color. Unlike CMYK, there are no set formulae to describe the RGB pixel values of a flesh tone. If you were to write down the flesh tone numbers for every RGB device color space, you could in theory build an RGB color space reference table. And from this you could feasibly construct a system that would assign meaning to these RGB numbers for any given RGB

Figure 13.4 This is an example of a Kodak color target which is used to construct a color ICC profile. Thomas Holm of Pixl in Denmark <th@pixl.dk> specializes in providing a custom ICC profiling service and PIXL are offering a special discount rate to readers of this book (see Appendix for more details). A profile service company will normally supply you with a test target and instructions on how to print it out. When they receive your prints, they can measure these and email the custom ICC profile back to you. For more information on printing a profile test target, refer to Chapter 14.

space. This is basically what an ICC profile does except an ICC profile will contain maybe several hundred color reference points. These can be read and interpreted automatically by the Photoshop software.

Figure 13.4 shows an example of a Kodak test target which is used to build an ICC profile. A target like this can either be scanned or photographed with a digital camera and the input color values compared using special software. I use targets like this to produce ICC profiles for my printers. The test target is opened and printed without using any color management. The printed targets are then measured using a spectrophotometer such as the Eye One from Gretag Macbeth (see Figure 13.5). The patch measurement results are then used to build a color profile for the printer. A profile will tell us so much more about the characteristics of a digital device like a camera or a scanner than could ever be achieved by just tweaking the monitor RGB gamma values to match the color balance of a specific output.

All RGB device spaces are different and without an accompanying profile, the RGB number values will lack specific meaning. Without profiles, the only way to compensate the color between different RGB devices was to adjust the monitor to reflect the color of the print output. This is like profiling, but is using only the midrange color balance to adjust the color. The 'mess up the monitor to look like the print' approach is seriously flawed and if you

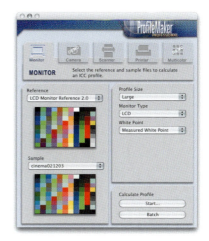

Figure 13.5 Once a print profile has been printed out, the color patches can be read using a Spectrophotometer and the measurements are used to build an ICC profile using software like ProfileMaker Pro.

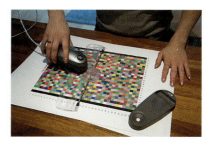

Figure 13.6 ProfileMaker Pro interface.

Figure 13.7 These photographs have been reproduced without any color management. This illustrates how the color reproduction will end up being different if you print from any of these color space files without applying color management. The colored shapes show a 3D representation of the gamut map of each space. This also gives you some indication of how much individual color spaces can differ from each other.

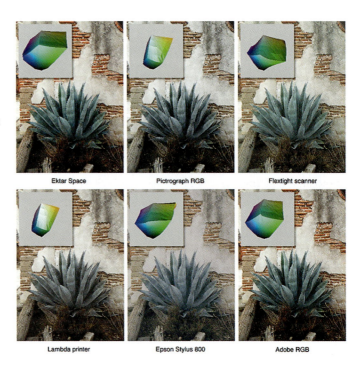

Ektar Space Pictrograph RGB Flextight scanner

Lambda printer Epson Stylus 800 Adobe RGB

take a look at the examples in Figure 13.7 you will see why. If you plot the color gamut of a device as a 3D shape, you will notice that the gamuts of these devices and edit spaces have their own distinctive signature shapes. It is not a simple matter of making the screen a little more red to match the reddish print. Color managing your images in this way can be about as successful as hammering a square peg into a round hole!

In Daniel Defoe's book, Robinson Crusoe faced something of a furniture management problem. He tried to make the legs of his table stay level by sawing bits off some of the legs. As soon as he had managed to even up two or more of the legs, he found that one of the others would now be too long. And the more he attempted to fix the problem with his saw, the shorter the table became. A similar thing happens when you try to color manage through adjusting the monitor settings. You may be able to obtain a good match for the skin tones, but if your subject is wearing a blue suit, the color might be way off and if

you then compensate successfully for the blue clothing, the skin tones will no longer be true or some other color will reproduce incorrectly. You will not be able to achieve consistently matching results using this method of color management.

Switching on Photoshop color management

A profile is therefore a useful piece of information that can be embedded in an image file. When a profile is read by Photoshop and color management is switched on, Photoshop is automatically able to find out everything it needs to know in order to manage the color correctly from there on. Note that this will also be dependent on you calibrating your monitor, but essentially all you have to do apart from that is to open the Photoshop Color Settings from the Edit menu and select a suitable preset such as the US Prepress Default setting. Do this and you are all set to start working in an ICC color managed workflow. Think of a profile as being like a ZIP code for images. For example, the address label shown in Figure 13.8 was rather optimistically sent to me at 'Flat 14, London', but thanks to the ZIP code it arrived safely! Some bureaux have been known to argue that profiles cause color management problems. This I am afraid is like a courier company explaining that the late delivery of your package was due to you including a ZIP code in the delivery address. A profile can be read or it can be ignored. What is harmful in these circumstances is an operator who refuses to use an ICC workflow. If you feel you are getting the run around treatment, it is time to change your bureau.

Profiling the display

The first step to making color management work in Photoshop is to calibrate the screen display. There are several ways of doing this which are all described in Chapter 3. As a minimum, use the Apple Display Calibration Assistant, or if using a PC, the Adobe Gamma control panel to calibrate the display and build a basic monitor profile. A better solution, if you can afford it, is to

Figure 13.8 Even if you have never been to London before, you know it's a fairly big place and 'Flat 14, London' was not going to help the postman much to locate my proper address. However, the all-important ZIP code or postcode was able to help identify exactly where the letter should have been delivered. An image profile is just like a ZIP code, it can tell Photoshop everything it needs to know about a file's provenance.

Figure 13.9 Good color management is very much dependent on having your display calibrated and profiled. This can be done using Adobe Gamma or the Apple Display calibration utility. Better still, use a hardware calibration device like the Eye-One from Gretag Macbeth.

Color vision trickery

They say that seeing is believing, but nothing could be further from the truth, since there are many interesting quirks and surprises in the way we human's perceive vision. There is an interesting book on this subject titled: *Why We See What We Do*, by Dale Purves and R. Beau Lotto (Sinauer Associates, Inc). And also a website at <www.purveslab.net>, where you can have a lot of fun playing with the interactive visual tests, to discover how easily our eyes can be deceived. What you learn from studies like this is that color can never be properly described in absolute mathematical terms. How we perceive a color can also be greatly influenced by the other colors that surround it. This is a factor that designers use when designing a product or a page layout. You do it too every time you evaluate a photograph, probably without even being aware of it.

purchase a hardware calibration device and software package. Some monitor displays like the Apple ColorSync and Barco feature built-in internal calibration. All these methods are doing the same thing – they optimize the monitor contrast and brightness, neutralize the color balance of the display to work with the monitor profile. The aim is to standardize the monitor display from the moment it is switched on to provide consistent color and have the ability to build an ICC monitor profile. As shall be explained later, the display profile will then be automatically used by Photoshop to accurately show profiled color files on the display.

People often ask 'How can I be sure that the color I see is the same as what someone else is seeing?' How reliable are an individual person's eyes when it comes to determining how to neutralize the display? There are several factors which can determine color perception, not least the health of a person's eyes. As you get older the color vision of your eyes will change, plus some people are color blind and may not even be aware of this. For the most part, younger people in their twenties and with healthy vision will perceive colors more consistently and with greater precision. Then there is also the question of how we interpret color – human vision is adaptable and we tend to accommodate our vision to changes in lighting and color temperature and can be influenced by the presence of other colors around us.

Figure 13.10 If you are using a third-party method of profiling the monitor on the Macintosh, other than a system utility, you may be required to manually load this profile next to where it says Display Profile in the Displays: Color System preference (Mac OS X 10.2). On a PC, you will probably need to carefully consult the instructions which came with the calibration device. These should guide you through the intricacies of how to configure the Windows system setups.

The value of a calibrated display

If you followed the steps described in Chapter 3, your display will already be calibrated. On the Macintosh, the profile should automatically be saved in the System/ColorSync Profiles folder. On a PC, save to the Windows/System/Color folder. The Apple Display Calibration Assistant and Adobe Gamma are extremely basic. They offer the simplest way of checking that your screen is neutral and is making full use of the display contrast to fully render the shadow and highlight tones correctly. This will get you on the right track with regards being able to open up an image in Photoshop and seeing it with the same brightness and color neutrality as seen on someone else's calibrated system. But only just.

There are other, better monitor profiling solutions you might consider using. A hardware calibration device combined with a dedicated software utility will be able to build a much more accurate monitor profile. The LaCie bluescreen prepress monitors can be sold with an optional Blue Eye calibrator device. Colorvision <www.colovisionl.com> make several calibration units, starting with the very affordable Monitor Spyder and PhotoCal software bundle. For really accurate monitor calibration consider the X-Rite DTP 92 with OptiCal

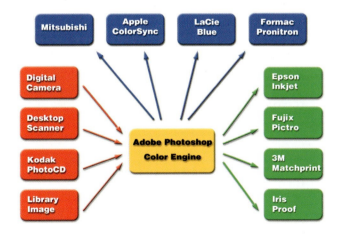

Figure 13.11 Photoshop's ICC color management system revolves around the use of profile information which will ideally accurately describe the characteristics of each digital device used in the chain from capture to print. In the diagram shown here, Photoshop can read or make use of the profile relating to any type of input source (the devices listed in the red boxes) and apply a conversion to the destination or output (the devices listed in the green boxes) and maintain consistent color throughout. Photoshop will reference the monitor display profile to ensure that what you see on the screen is an accurate as possible representation of the image data being processed in Photoshop.

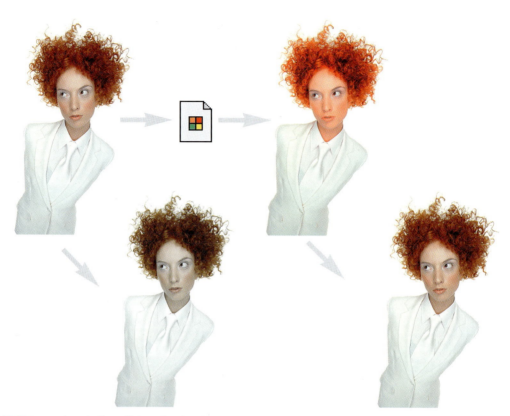

Figure 13.12 As was shown in Figure 13.1, sending the color data direct to the printer without applying any compensation will produce an incorrect color result. But applying a profile conversion with a custom profile for the proof printer will invisibly convert the colors to compensate for the specific characteristics of the printer and thereby produce a much more representative print of the original. The bright red 'profile converted' image will compensate for the color space deficiencies of the output device.

software or the very versatile Eye-One devices from Gretag Macbeth, which can be used to build profiles of almost everything in your studio. It is the system I prefer to use. Display profiling devices are attached to the screen via rubber suckers or hung over the edge of an LCD display using a counter weight which will gently rest the calibrator against the surface. Don't try to use a calibrating device with suckers as this will easily damage the delicate surface of the LCD. The calibration software will usually display a series of color patches on the screen and these are read by the calibrating device and the information is used to build a profile. If you have a third-party device or a built-in

monitor calibration system, always use this in preference to anything else. If you still have Adobe Gamma installed, disable it and do not try to use both systems. The performance of the display will fluctuate over time (especially a cathode ray tube display). It is therefore important to check and calibrate the monitor at regular intervals, like every two weeks. Remember, display calibration plays an essential part in establishing a first link in the color management chain.

The Photoshop color engine

Let's put all the pieces together – the diagram in Figure 13.11 illustrates the ICC color management route for handling ICC profiled files coming into Photoshop. It shows the different types of RGB input sources such as desktop scanner files or digital capture images being brought into Photoshop. If an ICC profile is embedded in the file, Photoshop will recognize this and know how to correctly interpret the color data. The same thing applies to profiled CMYK files as well. Photoshop uses the monitor display profile information to render a color correct preview on the monitor screen. It helps to understand here that in an ICC color managed workflow in Photoshop, what you see on the monitor is always a color corrected preview and you are not viewing the actual file data. This is what we call 'device-independent color'. When an image is in Adobe RGB and color management is switched on, what you see on the screen is an RGB preview that has been converted from Adobe RGB to your profiled monitor RGB. The same thing happens when Photoshop previews CMYK data on the screen. The Photoshop color management system calculates a conversion from the file CMYK space to the monitor space. Photoshop therefore carries out all its color calculations in virtual color spaces. For example, the RGB color space you edit within can be exactly the same as the work space set on another user's Photoshop system. If you are both viewing the same file, and your displays are correctly calibrated and profiled, a color image should look near enough exactly the same on both screens.

The profiled approach

To output a file from Photoshop in a color managed workflow, you will need to carry out a further profile conversion from the current work space or file space, to the printer's color space. We will be looking at color managed file outputs in deservedly more detail later on in Chapter 14. In the meantime, Figure 13.12 reexamines the problem encountered at the beginning of this chapter where the skin tones in the original image printed too blue. The profile created for this particular printer describes the variance. The (normally hidden) color shifting which occurs during the profile conversion process will compensate by making the skin tone colors more red, but apply less color compensation to other colors. The result is an output that more closely matches the original. That is a simple illustration of the ICC-based color management system at work. All color can be managed this way in Photoshop from capture source to the monitor display and the final proof.

Working in isolation

There are those who remain critical of the introduction of ICC-based color management in Photoshop. They look at the needs of their own setup and figure that what works well for them has got to be right for everyone else. I travel quite a lot and once I was driving off the normal tourist track and needed to find a decent road map, but couldn't find any local gas stations that sold one. When I enquired why, I was told 'Because we all know where everything is around here!' It seemed the locals had no need to accommodate lost strangers around those parts. You could say the same of some bureaux and printers because they work exclusively at the final stage of the print process.

The versatility of RGB

If your main area of business revolves around the preparation of CMYK separations for print, then I do recommend you invest in a training course or book that deals with CMYK repro issues. I can highly recommend *Real World Photoshop series* by Bruce Fraser and David Blatner. Photographers are mainly involved in the RGB capture end of the business. This is one of the reasons why I devote so much attention to the managing of RGB color, here and elsewhere in the book. But nevertheless, if any work you create is intended for print, the issue of RGB to CMYK conversion must be addressed at some point.

The proliferation of Photoshop use and the advent of high quality digital cameras is also another important factor to consider. If photographers are more likely to want to supply a digital file at the end of a job, how will this fit in with existing workflows? Printers once argued that they would prefer the digital files turned back into transparencies, so they could maintain the opportunity to scan it again themselves (and of course they maintain the scanning business). But at what cost to the client? Digital capture has clearly taken off in a big way, and any attempts made by printers to stall this progress have failed. One way or another the RGB to CMYK issue has to be resolved. Professional quality digital cameras are widely used these days, and photographers regularly supply digital files directly to the printer.

A major advantage of working in RGB is that you can access all the bells and whistles of Photoshop which would otherwise be hidden or grayed out in CMYK mode. And also these days there is no telling how many ways a final image may end up being reproduced. A photograph may get used in a variety of ways, with multiple CMYK separations made to suit several types of publications, each requiring a slightly different CMYK conversion because CMYK is not a 'one size fits all' color space. High-end retouching for advertising usage is usually done in RGB mode and a large format transparency output produced. That transparency can be used as an original to be scanned

again and converted to CMYK but the usual practice is to use the transparency output for client approval only. The CMYK conversions and film separations are produced working directly from the digital file to suit the various media usages. When you think about it, a transparency proof for all its glory is actually quite useless considering the end product is to be printed on paper. The ideal proof should be a CMYK output printed to match the expected output of the final publication. The RGB original should be preserved in RGB mode as a master archive image.

Choosing an RGB work space

Although I highly recommended that you switch on the color management settings in Photoshop, you cannot assume that everyone else will. There are many other Photoshop users and bureaux running outputs from files who will have Photoshop color management switched off and are not bothering to calibrate their display properly. If you are using Photoshop 6.0 or later it matters less individually which RGB color space you choose in the RGB setup, as long as you stick to using the same space for all your work. Photoshop can safely convert between RGB spaces with minimal loss of data, but the space you plump for does matter. Once chosen you should not really change it, except when preparing images to go on the Web. Whichever color work space you select in the RGB color settings, you will have to be conscious of how your profiled Photoshop RGB files may appear on a non-ICC savvy Photoshop system. What follows is a guide to the listed RGB choices.

Apple RGB

This is the old Apple 13" monitor standard. In the early days of Photoshop this was used as the default RGB editing space where the editing space was the same as the monitor space. If you have legacy images created in Photoshop on a Macintosh computer using a gamma of 1.8, you can assume Apple RGB to be the missing profile space.

Beyond CMYK

There are other types of output to consider, not just CMYK. Hexachrome is a six-color ink printing process that extends the range of color depth attainable beyond conventional limitations of CMYK. This advanced process is currently available only through specialist print shops and is suitable for high quality design print jobs. Millions have been invested in the presses currently used to print magazines and brochures, so expect four-color printing to still be around for a long time to come, but Hexachrome will open the way for improved color reproduction from RGB originals. Photoshop supports six-color channel output conversions from RGB, but you will need to buy a separate plug-in utility like HexWrench. Spot color channels can be added and previewed on screen – spot color files can be saved in DCS 2.0 or TIFF format. Multimedia publishing is able to take advantage of the full depth of the RGB color range. If you are working in a screen-based environment for CD, DVD and web publishing RGB is ideal, and with today's browsers color management can be turned on to take advantage of the enhanced color control they now offer.

Figure 13.13 The CD-ROM accompanying the *Adobe Photoshop CS for Photographers* book contains a short movie which helps to explain the RGB space issue by graphically comparing some of the main RGB spaces.

Figure 13.14 A CMYK color space is mostly smaller than the monitor RGB color space. Not all CMYK colors can be displayed accurately due to the physical display limitations of the average computer monitor. This screen shot shows a continuous spectrum going through shades of cyan, magenta and yellow. The image was then deliberately posterized in Photoshop. Notice how the posterized steps grow wider in the Yellow and Cyan portions of the spectrum. This sample gradient pinpoints the areas of the CMYK spectrum which fall outside the gamut of a typical RGB monitor.

sRGB IEC-61966-2.1

sRGB was conceived as a multipurpose color space standard that consumer digital devices could all standardize to. It is essentially a compromise color space that provides a uniform color space that all digital cameras and inkjet printers and monitors can match to. sRGB aims to match the color gamut of a typical 2.2 gamma PC monitor. Therefore if you are opening a file from a consumer digital camera or scanner and there is no profile embedded, you can assume that the missing profile should be sRGB. It is an ideal color space for web design but unsuitable for repro quality work. The sRGB space clips the CMYK gamut and you will never get more than 75%–85% cyan in your CMYK separations.

ColorMatch RGB

ColorMatch is an open standard monitor RGB space that was implemented by Radius. ColorMatch has a gamma of 1.8 and is favored by some Macintosh users as their RGB working space. Although not much larger than the gamut of a typical monitor space, it is a known standard and more compatible with legacy, 1.8 gamma Macintosh files.

ProPhoto RGB

This is a large gamut RGB space that is suited for image editing that is intended for output to photographic materials such as transparency emulsion or taking full advantage of the color gamut of photo quality inkjet printers. Any image editing in a wide gamut space should ideally only be done using 16 bits per channel mode.

Adobe RGB (1998)

Adobe RGB (1998) has become established as the recommended RGB editing space for RGB files that are destined to be converted to CMYK. For example, the Photoshop prepress color settings all use Adobe RGB as the RGB working space. Adobe RGB was initially labeled as SMPTE-240M which was a color gamut proposed for HDTV production. As it happens, the coordinates Adobe

used did not exactly match the actual SMPTE-240M specification. Nevertheless, it proved a popular space for prepress editing space for repro work and soon became known as Adobe RGB (1998). I have adopted Adobe RGB as my RGB working space, because it has a larger color gamut that is particularly suited for RGB to CMYK color conversions.

Photoshop color management interface

By now you should be acquainted with the basic principles of Photoshop ICC color management. Since Photoshop 6.0 it has become relatively easy to configure the Photoshop system. At the most basic level all you have to do is calibrate and profile your display and then go to the Photoshop Color Settings and select an appropriate prepress setting. This will switch on the Photoshop color management policies.

The Color Settings

The Color Settings command is located in the Photoshop or Edit menu (depending on which operating system is used). This Color Settings interface is more or less identical to that found in Illustrator 9.0 or later and Figure 13.15 shows

The ideal RGB working space

If you select an RGB work space which is the same size as the monitor space, you are not using Photoshop to its full potential and more importantly you are probably clipping parts of the CMYK gamut. Select too wide a space, like Wide Gamut RGB, and there will be large gaps in color tone between one data point and the next, as each color channel can only represent up to 256 data points. Although you can safely use a wide gamut space as long as you are editing in 16 bits per channel mode. But for 24-bit image editing I advise you don't use anything larger than Adobe RGB.

Figure 13.15 The Photoshop Color Settings. All the Photoshop color settings can be managed from within this single dialog. Photoshop conveniently ships with seven preset settings which are suited to various publishing workflows. As you move the cursor pointer around the Color Settings dialog, help messages are provided in the Description box area below – these provide useful information which will help you learn more about the Photoshop color management settings and the different color space options.

The new Photoshop CS presets

The only change to the color management settings in Photoshop CS, is the addition of some new 'general purpose' preset settings. Figure 13.16 shows the complete list of presets, plus some of the custom presets I use to make CMYK separations for this book. I usually advise people to select a prepress setting that matches the territory where the work will be printed, including settings for US Coated and US SWOP Coated press output. The General Purpose presets will preserve RGB profiles, but use sRGB as the RGB work space instead of Adobe RGB. And CMYK color management will be switched off. This is better than using the Web Graphics default for repro work and may help avoid confusion among novices. But you don't need them if you read this chapter!

```
Custom

Other

3M_Euro prepress
Color Management Off
ColorSync Workflow
default euro cinema display
Emulate Acrobat 4
Emulate Photoshop 4
Europe General Purpose Defaults
Europe Prepress Defaults
Japan Color Prepress
Japan General Purpose Defaults
Japan Prepress Defaults
North America General Purpose Defaults
Photoshop 5 Default Spaces
Trento_Max
Trento_med
✓ U.S. Prepress Defaults
US Coated
US SWOP coated
Web Graphics Defaults
```

Figure 13.16 The new Photoshop CS Color Settings presets.

the basic dialog controls and options. The first item you will come across is the Settings pop-up menu. Photoshop helpfully provides a range of preset configurations for the color management system. These can be edited (see Managing the Color Settings, page 375) if you wish them to meet your own specific requirements. The default setting will say 'Web Graphics Default'. If you want to edit your photographs with a view to outputting color separated CMYK files for prepress in Europe, you would select the Default Prepress – Europe setting from this list. A prepress color setting will also be an ideal starting point for any type of color managed workflow. That is all you need to concern yourself with initially, but if you wish to make customized adjustments, then you can select custom settings in the Working Spaces section below. Refer back to the section on RGB spaces for guidance on selecting the most appropriate RGB space here. The CMYK and Grayscale settings shall be covered later.

Color management policies

Now when a document is opened, Photoshop checks to see if an ICC profile is present. If so, the default policy is to preserve the embedded profile information. So whether the document has originated in sRGB, Adobe RGB or ColorMatch RGB, it will open in that RGB color space and after editing be saved as such (although with these default settings the opening profile mismatch dialog offers you a chance to convert to the current work space or discard the profile). You can have several files open at once and each can be in an entirely different color space. If you have only got accustomed to the Photoshop 5.0 and 5.5 way of doing things, this might take a little getting used to. A good tip is to set the Status box to show 'Document profile' (on the Mac this is at the bottom left of the image window; on the PC at the bottom of the system screen palette). This will give you a constant readout of each individual document's color space profile.

Figure 13.17 If Preserve Embedded Profiles is selected as the RGB color management policy, the above dialog will appear, asking if you want to use the embedded profile. This happens whenever a profile mismatch occurs and you have checked the Profile Mismatch: Ask When Opening box in Color Settings (see Figure 13.15). If the color management policy is Convert to Work space color, the second radio button will be highlighted in this dialog, asking if you wish to convert the colors to the current work space. In Photoshop CS the file name is now identified in this dialog.

The default policy of Preserve Embedded Profiles allows Photoshop users to use the ICC color management system straight away, without confronting a puzzling 'Convert Colors' dialog all the time. So long as there is a profile tag embedded in any file you open, Photoshop will give you the option to open the file in that same color space without converting it. So if someone asks you to open their Apple RGB file, the default choice offered to you upon opening is to open it in the Apple RGB color space and after saving it, the file will remain in and be tagged with this same Apple RGB color space. This is despite the fact that your default RGB work space might in fact be Adobe RGB. Photoshop will automatically adjust the monitor display to take into account the monitor ICC profile. There is no Display Using Monitor Compensation button to check or uncheck in this version and a good thing too! So many people innocently played around with the RGB settings in Photoshop 5.0 and ended up with bizarre configurations which only served to confuse matters (these are accessible, but are safely hidden away under the Advanced settings). You simply choose an appropriate RGB color work space and that's it. There is no Gamma or Primaries option to meddle with. You are given access to only the necessary range of options.

If you select the Convert to Working RGB policy, then Photoshop will behave more like Photoshop 5.0 and 5.5. If the incoming profile does not match the work space, then the default option will be to ask Photoshop to carry out a

Figure 13.18 If you attempt to paste image data from a document whose color space does not match the destination space, this dialog warning will appear, providing the Profile Mismatch: Ask When Pasting box in the Color Settings dialog is checked (see Figure 13.15).

profile conversion from the embedded profile space to your current work space. The same policy rules apply to CMYK and grayscale files. When Preserve Embedded Profiles is selected, Photoshop will read the CMYK or Grayscale profile, preserve the numeric data and not convert the colors. And the image will remain in the tagged color space – this is going to be the preferred option when editing incoming CMYK files. You normally do not want to change the CMYK colors, a CMYK file may already be targeted for a specific press output and you don't really want to alter those CMYK numeric color values. When the incoming profile matches the current RGB, CMYK or grayscale work space, there is of course no need to convert the colors.

The third option is Color Management: Off. With this configuration, Photoshop will not attempt to color manage incoming documents. If there is no profile embedded, then it will stay that way. If there is a profile mismatch between the source and work space, the profile will be removed (with a warning alert, pointing out that the embedded profile information is about to be deleted). If the source profile matches the work space, there is no need to remove the profile, so in this instance the profile tag will not be removed (even so, you can still remove the ICC profile at the saving stage).

The default settings make it easy for users to select an appropriate combination of color setting configurations with a single mouse-click. Also, the default color management policy will allow you to open up documents

which, if they do not match your current work space, you can still continue to edit in that source space and save them with the original profile accurately intact. A newcomer does not necessarily have to fully understand how Photoshop color management works in order to successfully start working in an ICC color managed workflow. They can open up legacy files tagged in sRGB (or any other space), edit and save them as such, even though the work space is Adobe RGB. And if they choose to convert the colors on opening, the file will be converted and saved with the new profile. This really makes the system far more foolproof – it is adaptable enough to suit the individual user's Photoshop skill level. Whichever option you select – convert or don't convert – the saved file will always be correctly tagged. The simplified Color Settings dialog gives you everything you need to get started and hides all the controls which could trap the unwary. The advanced settings can only be reached by clicking on the Advanced mode checkbox.

Managing the Color Settings

As your knowledge increases you will be able to customize and create your own color settings. You might want to start by loading one of the presets present in the Color Settings menu and modify this for a given job and customize the CMYK settings to match the conditions of your repro output. As was mentioned earlier, Adobe RGB is pre-chosen as the default work space. The CMYK setups are fairly similar to the previous CMYK setup defaults, except there are now two CMYK separation options available in the CMYK work space options for Euro and US printing: one for coated and another for uncoated print stock – these default setups in Photoshop are a pretty good starting point. The minimum you need to know is which of these listed color settings will be appropriate for the work you are doing. And to help in this decision, you should read the text descriptions which appear in the Description box at the bottom of the Color Settings dialog.

Adjusting from Photoshop 5.0

If you have previously only ever used Photoshop 5.0 or 5.5, you will probably have to spend a little time adjusting to what the color management policies mean as these now replace the Profile Setup settings in 5.0. As a Photoshop 5.0 user you will probably find yourself opening existing, tagged Photoshop 5.0 files with no problems or unexpected warnings other than a reminder to say 'would you like to carry on editing in that space or convert now?' to say that the file is in a color space other than your default work space.

The ability to save and load custom settings is a smart feature. You can clearly configure Photoshop to suit any workflow you require and save and name this setting for future projects which require you to use the same press settings. If you look again at the default color settings, you will notice how the list includes options such as 'Web Graphics Defaults' (the default setting on installation) and 'Emulate Photoshop 4'. The Color Settings interface is a logical progression from the first Photoshop 5.0 implementation of ICC color management and in my opinion, all users will find the system in Photoshop 6.0 and later to be a definite improvement.

Saving the settings

To save a new color setting, configure the settings to suit your intended workflow and click on the Save... button. Locate the Library/Application Support/Adobe/Color Settings (Mac OS X), Program Files/ Common Files/Adobe/Color/Settings folder (PC) and name the setting. The file will be appended with a .csf suffix. Enter any relevant comments or notes about the setting you are saving in the text box (see Figure 13.19). This information will appear in the Color Settings dialog text box. You might name the setting something like 'Internal annual report' and the note you write to accompany this might say 'Use this setting for editing and separating the digital photographs to go in the company's annual report'. The saved setting will now appear listed in the main menu the next time you visit the Color Settings dialog.

Profile conversions

One problem with having multiple color spaces open at once concerns the copying and pasting of color data from one file to another. The Profile Mismatch: Ask When Pasting box in the Color Settings (see Figure 13.15) should ideally be checked. When you attempt to paste color data from one document to another (or drag with the move tool) and a profile mismatch occurs, the dialog shown in Figure 13.17 will appear, asking you if you wish to convert the color data to match the color appearance when it is pasted into the new destination document. If you select Convert, the appearance of the colors will be maintained when pasting between the two documents.

If you decide to use the Preserve Embedded Profiles policy and with the Profile Mismatch warning set to Ask When Opening, you will always be given the option of choosing whether to convert to the current work color space or continue editing in the document's own color space. If you choose to continue editing in the document's color space, this is fine if you wish to maintain that document in its original profiled space. There are very good reasons for always keeping CMYK files in their original color space (because if the file has been targeted for a specific press output, you don't want to go changing this), but with RGB files, you will often find it more desirable to convert everything to your default RGB work space. The 'Convert to RGB' Color Settings policy will do this automatically. In the Image ⇨ Mode menu in Photoshop 5.0 there used to be an item called Profile to Profile. That has been replaced with the Convert to Profile command. Even when you choose to preserve the embedded profile on opening, you may still want to have the means to convert non-work space files to your current work space. I much prefer the Preserve Embedded Profile option, because it allows me the freedom to open up any document straight away, regardless of the space it is in, without converting. If I want to carry on editing but eventually save the file in the current work space, I can do so at the end, using the Convert to Profile command.

Figure 13.19 Custom color settings can be loaded or saved via the Color Settings dialog. The relevant folder will be located in the Library/ Application Support/Adobe/Color/Settings folder (Mac OS X), Program Files/Common Files/ Adobe/Color/Settings folder (PC). When you save a custom setting it must be saved to this location and will automatically be appended with the '.csf' suffix. When you save a color setting you have the opportunity to include a brief text description in the accompanying dialog. A Color Settings file can be shared between some Adobe applications and with other Photoshop users. The Mac OS X location can be 'user' specific, in which case the route would be: Users/*username*/ Library/Application Support/Adobe/Color/ Settings folder.

Let's suppose I was to open a photograph which had been captured digitally and it was tagged with the profile of the camera's color space. I can open this digital photograph immediately without a conversion, do all the RGB editing in this space and yet still be able to preview a color managed image on the screen. If I carry out a Convert to Profile command, I can instruct Photoshop to convert the image from the tagged camera RGB space to the current work space, or indeed, to any other color space. Convert to Profile is also useful when you wish to output to a printer for which you have a custom-built profile but the print driver does not recognize ICC profiles. You can have such a custom profile built for the printer by a color management service provider and choose this profile as the space you wish to convert to. The profile conversion will convert the color data to match the space of the output device, but at the same time Photoshop's color management system will convert the colors on-the-fly to produce a color managed screen preview. You will

Figure 13.20 Convert to Profile is similar to the old Profile to Profile command in Photoshop 5.0. Photoshop 6.0 and 7.0 color management is different in that you don't need to carry out a profile conversion in order to correctly preview a file in Photoshop. It is nevertheless an essential command for when you wish to convert color data from one profile color space to another profiled space, such as when you want to convert a file to the profiled color space of a specific output device.

When to use Assign Profile

If you find yourself in a situation where you know the profile of an opened file to be wrong, then you can use the Image ⇨ Mode ⇨ Assign Profile command to rectify the situation. Let's suppose you have opened an untagged RGB file and for some reason decided not to color manage the file when opening. The colors don't look right and you have reason to believe that the file had originated from the Apple RGB color space. Yet, it is being edited in your current Adobe RGB work space as if it were an Adobe RGB file. The Assign Profile command can assign correct meaning to what the colors in that file should really be. By attaching a profile, we can tell Photoshop that this is not an Adobe RGB file and that these colors should be considered as being in the Apple RGB color space. You can also use Assign Profile to remove a profile. Some digital cameras don't embed a profile, yet the EXIF metadata will misleadingly say the file is in sRGB color mode. Well, that issue is now resolved in Photoshop CS. The camera EXIF profile metadata will be ignored if it is wrong.

probably see only a slight change in the on-screen color appearance. Photoshop also attaches a warning asterisk (*) after the color mode in the title bar to *any* document that is not in the current work space. A Convert to Profile is just like any other image mode change in Photoshop, such as converting from RGB to Grayscale mode and it is much safer to use than the old Profile to Profile command in Photoshop 5.0. However, be careful if you use Convert to Profile to produce targeted RGB outputs and overwrite the original RGB master. Photoshop will have no problem reading the embedded profiles and displaying the file correctly and Photoshop 5.x will recognize any profile mismatch (and know how to convert back to the original work space), but as always, customized RGB files such as this may easily confuse other non-ICC savvy Photoshop users (see Figures 13.22 and 13.23 on page 381).

Converting to the work space

If you choose either the Preserve Embedded Profiles or the Convert to Work Space policies, you should have the Ask When Opening boxes checked, to provide a warning whenever there is a profile mismatch or a missing profile. When the Missing Profile dialog shown in Figure 13.21 appears on screen while you are opening a file, you can assign the correct profile and continue opening. Click on the pop-up menu and select the correct profile. Then check the box immediately below if you also want to convert the

Include a 'Read Me' file

When you save a profiled RGB file, enclose a Read Me file on the disk to remind the person who receives the image that they must not ignore the profile information – it is there for a reason! If you are designing images for screen display such as on the Web, then convert your images to the sRGB profile using Image > Mode Convert to Profile.

colors to your current work space. These settings will be remembered the next time a mismatch occurs and individual settings will be remembered for each color mode.

Reducing the opportunities for error

If you are sending an RGB file for someone else to view in Photoshop, then one of six things could happen.

• They open the file in Photoshop 6.0 or 7.0 with the RGB Color Settings set to Preserve Embedded Profiles. The file can be opened and color managed correctly even if their RGB work space is not the same as yours.

• They open the file in Photoshop 6.0 or 7.0 with the RGB Color Settings set to Convert to RGB. If a profile mismatch occurs, the colors can be correctly converted to their RGB work space.

• They open the file in Photoshop 5.0/5.5 with the RGB Color Mismatch Settings set to the default of Convert Colors on Opening. The file will be color managed correctly.

Handling legacy files

When you adopt an RGB space such as Adobe RGB as the preferred work space for all your image editing, you have to take into account that this might cause confusion when exchanging RGB files between your machine operating in a color managed workflow and that of someone who, for example, is using Photoshop 4.0, where the RGB they use is based on a monitor RGB space.

Figure 13.22 shows screen shot examples of how a profiled RGB file will be displayed on another monitor if this change in working procedure is not properly thought through.

• They open the file in Photoshop 5.0/5.5 with the RGB Color Mismatch Settings changed to Ask on Opening and they click Convert Colors.

• Before sending, you convert RGB image to Lab mode in Photoshop. This does not lose you any image data and is a common color mode to both programs. The end user will need to convert back to their RGB.

• You convert the RGB image in Photoshop from the RGB work space to match the RGB profile of the other user (if known) before saving. Go Image ⇨ Mode ⇨ Convert to Profile... and select the appropriate destination RGB space from the pop-up list. This could be something like Apple RGB. This is the profile which will be embedded when you save.

The last two examples take into account the limitations of Photoshop 4.0 (and earlier versions of Photoshop) not being able to understand and interpret a profiled Photoshop RGB file and displaying the RGB data directly on the monitor without compensation. There are potential pitfalls when opening a legacy file in Photoshop but this will only happen if you turn all the color management settings to 'Off', without appreciating how doing so will impact on the way the color data is going to be displayed within Photoshop. There are specific instances where you will find it necessary to switch color management off, but you must know what you are doing. The safe way to turn color management off is to select Emulate Photoshop 4 from the Color Settings menu. This will configure Photoshop to exactly match the earlier Photoshop color setup.

Figure 13.22 A Photoshop (5.0 or later) image (left) opened in Photoshop 4.0 (right). If the RGB work space selected in Photoshop is wider than the basic monitor RGB space in Photoshop 4.0, then the latter will interpret a Photoshop (5.0 or later) file as being like any other 4.0 legacy file. The RGB colors will appear compressed and desaturated in version 4.0. The only way round this is to convert the RGB image in Image > Mode > Convert to Profile to the monitor RGB color space used in Photoshop 4.0.

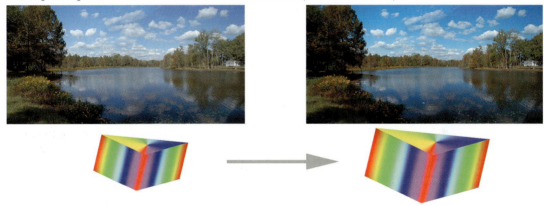

Figure 13.23 An untagged Photoshop 4.0 image opened in Photoshop with color management switched off. If the RGB work space selected in Photoshop is going to be wider than the monitor RGB work space used in Photoshop 4.0, then Photoshop will expand the RGB color space as shown here, *unless* you have the Color management switched on and the Policy settings set to Preserve Embedded Profiles or Convert to Working RGB and the Profile Mismatch Ask When Opening box is checked.

Working with Grayscale

Grayscale image files are also managed via the Color Settings dialog. It is important to note that the Grayscale work space settings are independent of the settings entered in the CMYK setup. The Photoshop prepress Grayscale work spaces should correspond with the dot gain characteristics of the press. If you examine the Grayscale

Grayscale for screen display

If you intend creating grayscale images to be seen on the Internet or in multimedia presentations, choose the Default Web Graphics color setting. The Grayscale work space will then be set to a 2.2 gamma space, which is the same gamma used by the majority of PC computer screens. The truth is, you can never be 100% sure how anybody who views your work will have their monitor calibrated, but you can at least assume that the majority of Internet users will have a PC monitor set to a 2.2 gamma. This is a darker setting than the default 1.8 gamma used on the Macintosh system.

work space options, you will see that it contains a list of dot gain percentages and monitor gamma values. For prepress work select the dot gain percentage that most closely matches the anticipated dot gain of the press. Figure 13.29 shows a range of dot gain values that can be used as a guide for different types of press settings. This is a rough guide as to which dot gain setting you should use on any given job. When the Advanced color settings option is checked you can enter a custom gamma value or dot gain curve setting (see 'Dot gain' later on in this chapter, page 392). The color management policy can be set to either Preserve Embedded Profiles or Convert to Grayscale work space and again, the Ask When Opening box should be checked. If the profile of the incoming grayscale file does not match the current grayscale work space, you will be asked whether you wish to use the tagged grayscale space profile, or convert to the current grayscale work space. If there is no profile embedded, you will be asked to either: 'Leave as is' (don't color manage), assign the current grayscale work space or choose a grayscale space to assign to the file and if you wish, convert from this to the grayscale work space.

Here is a test you can easily try yourself. Make a screen capture of something that is in grayscale, like a plain dialog box or a grayscale image. When Photoshop opens this screen grab, it will recognize it as a grayscale file with a missing profile. In the absence of a profile and the color management policy is set as described above, ask yourself which option should be used. Do you want to assign the current grayscale work space as the missing profile? No, because you would be assigning a prepress profile that takes into account dot gain. This is a raw screen grab and not a prepress file. You therefore want to assign a grayscale profile that matches the space it originated in – i.e. the monitor space. And if the monitor space has a gamma of 1.8, then choose that as the profile to assign to this

grayscale screen grab. After opening, compare the color managed grayscale with the original screen image to see if the two both look the same. If you want to know how any existing prepress grayscale image will look like on the Web as a grayscale image, select the View ⇨ Proof Setup and choose Windows RGB or Macintosh RGB and adjust the image levels accordingly.

Advanced color settings

The advanced settings will normally remain hidden. If you check the Advanced Mode box, you will be able to see the expanded Color Settings dialog shown in Figure 13.24. The advanced settings unleash full control over the Photoshop color management system. Do not attempt to adjust these expert settings until you have fully understood the intricacies of customizing the RGB, CMYK, Gray and Spot color spaces. Read through the remaining section of this chapter first before you consider customizing any of these settings.

Figure 13.24 The Photoshop Advanced Color Settings dialog. Switching to the advanced mode unleashes full control over all the Photoshop settings. The remaining sections of this chapter will show how you can customize the advanced color management settings.

Blend RGB colors using gamma

This item provides you with the potential to the override the default color blending behavior. There used to be an option in Photoshop 2.5 for applying blend color gamma compensation. This allowed you to blend colors with a gamma of 1.0, which some experts argued was a purer way of doing things, because at any higher gamma value than this you would see edge darkening occur between contrasting colors. Some users found the phenomenon of these edge artifacts to be a desirable trapping effect. But Photoshop users complained that they noticed light halos appearing around objects when blending colors at a gamma of 1.0. Consequently, gamma compensated blending was removed at the time of the version 2.5.1 update. But if you understand the implications of adjusting this particular gamma setting, you can switch it back on if you wish. Figure 13.25 illustrates the difference between blending colors at a gamma of 2.2 and 1.0.

Figure 13.25 In this test a pure RGB green soft-edged brush stroke is on a layer above a pure red background layer. The version on the right shows what happens if you check the Blend RGB Colors Using Gamma 1.0 checkbox – the darkening around the edges where the contrasting colors meet will disappear.

Customizing the RGB and work space gamma

Expert users may wish to use an alternative custom RGB work space instead of the listed RGB spaces. If you know what you are doing and wish to create a customized RGB color space, you can go to the Custom... option in the pop-up menu and enter the information for the White Point, gamma and color primaries coordinates. My advice is to leave these expert settings well alone. Do avoid falling into the trap of thinking that the RGB work space gamma should be the same as the monitor gamma setting. The RGB work space is not a monitor space.

Adobe RGB is a good choice as an RGB work space because its 2.2 gamma provides a more balanced, even distribution of tones between the shadows and highlights. These are the important considerations for an RGB editing space. Remember, you do not actually 'see' Adobe RGB. The Adobe RGB gamma has no impact on how the colors are displayed on the screen, so long as Photoshop ICC color management is switched on. In any case, these advanced custom color space settings are safely tucked away in Photoshop and you are less likely to be confused by this apparent discrepancy between monitor gamma and RGB work space gamma.

Desaturate monitor colors

The desaturate monitor colors option enables you to visualize and make comparisons between color gamut spaces where one or more gamut space is larger than the monitor RGB space. Color spaces such as Adobe RGB and Wide Gamut RGB both have a gamut that is larger than the monitor space is able to show. So turning down the monitor colors saturation will allow you to make a comparative evaluation between these two different color spaces.

Figure 13.26 The Custom RGB dialog. Use this option to create a custom RGB work space. The settings shown here have been named 'Bruce RGB', after Bruce Fraser who devised this color space as an ideal prepress space for Photoshop.

Establishing a CMYK work space

The CMYK separation setup settings must be established first before you carry out a conversion. Altering the CMYK setup settings will have no effect on an already-converted CMYK file. Note that in Photoshop 6.0 or later, altering the CMYK setup will not affect the on-screen appearance of an already-opened CMYK file or cause the wrong profile information to be embedded when you save it. However, the profile setting selected here will be the CMYK space that all future CMYK conversions will convert to and will also be the default space to soft proof files when you chose View ⇨ Proof Setup ⇨ Working CMYK.

RGB to CMYK

The RGB color space is very versatile. An RGB master can be repurposed for any number of uses. As we are mostly concerned with four-color print reproduction, it is always very important to keep in mind the limitations of CMYK reproduction when editing in RGB. Digital scans and captures all originate in RGB but they are nearly always reproduced in CMYK. Since the conversion from RGB to CMYK has to take place at some stage, the question is, at what stage should this take place and who should be responsible for the conversion? We shall now look at how you can customize the CMYK setup.

CMYK setup

If you examine the US Prepress default setting, the CMYK space says U.S. Web Coated (SWOP). This setting is by no means a precise setting for every US prepress SWOP coated print job, but is at least closer to the type of specification a printer in the US might require for printing on coated paper with a web press setup. If you mouse down on the CMYK setup pop-up list, you will see there are also US options for web uncoated, as well as sheetfed press setups. Under the European prepress default setting, there is a choice between coated and uncoated paper stocks. And finally, you can choose Custom CMYK... where you can create and save your custom CMYK profile settings to the System/ColorSync profiles folder (Mac OS 9), Library/ColorSync folder (Mac OS X), WinNT/System32/Color folder (NT/2000), Windows/System/Color folder (PC). See the Custom CMYK dialog in Figure 13.26.

Rendering intents

When you make a profile conversion such as one going from RGB to CMYK, not all of the colors in the original source space will have a direct equivalent in the destination space. RGB is mostly bigger than CMYK and therefore those RGB colors which are regarded as 'out-of-gamut',

will have to be translated to the nearest equivalent in the destination space. The way this translation is calculated is determined by the rendering intent used. Figure 13.29 illustrates how these different rendering methods work.

Perceptual

Perceptual (Images) rendering is an all-round rendering method that can also be used for photographic images. Perceptual rendering compresses the out-of-gamut colors into the gamut of the target space when colors are out of gamut, while preserving the visual relationship between those colors, so they do not become clipped. More compression occurs with the out-of-gamut colors, smoothly ramping to no compression for the in-gamut colors.

Saturation (Graphics)

The Saturation rendering intent preserves the saturation of out-of-gamut colors at the expense of hue and lightness. Saturation rendering will preserve the saturation of colors making them appear as vivid as possible after the conversion. This is a rendering intent best suited to the conversion of business graphic presentations where retaining bright, bold colors is of prime importance.

Relative Colorimetric

Relative Colorimetric has always been used as the default rendering intent in the manual built-in CMYK setup in Photoshop 4.0 and earlier versions, and is the default rendering intent utilized in the Photoshop color settings. Relative Colorimetric rendering maps the colors that are out of gamut in the source color space (relative to the target space) to the nearest 'in-gamut' equivalent in the target space. When doing an RGB to CMYK conversion, an out-of-gamut blue will be rendered the same CMYK value as a 'just-in-gamut' blue. Out-of-gamut RGB colors are therefore clipped. This can be a problem when attempting to convert the more extreme range of out-of-gamut RGB

Photoshop CMYK myths

There are some people who will tell you that in their expert opinion, Photoshop does a poor job of separating to CMYK. And I bet if you ask them how they know this to be the case, they will be stumped to provide you with a coherent answer. Don't let anyone try to convince you otherwise. Professional quality CMYK separations *can* be achieved in Photoshop, you *can* avoid gamut clipping and you *can* customize a separation to meet the demands of any type of press output. The fact is that Photoshop *will* make lousy CMYK separations if the Photoshop operator who is carrying out the conversion has a limited knowledge of how to configure the Photoshop CMYK settings. As was demonstrated in the earlier sections, a wider gamut RGB space such as Adobe RGB is better able to encompass the gamut of CMYK and yield CMYK separations that do not suffer from gamut clipping. This is one big strike in favor of the Photoshop 5.0+ color system. But CMYK is not a one-size-fits-all color space. CMYK needs to be tailor-made for each and every job.

Conversion options

You have a choice of four Color Management Modules (CMM): the Adobe Color Engine (ACE), Apple ColorSync, Apple CMM or Heidelberg CMM. The Adobe color engine is reckoned to be superior for all RGB to CMYK conversions. For example, the Adobe engine uses 20-bit per channel bit-depth calculations to calculate its color space conversions.

Which rendering intent is best?

Opinions on this have shifted over the years as to which rendering intent is the best one to use. If you are converting photographic images, use only Relative Colorimetric or Perceptual. Relative Colorimetric has always been the default Photoshop rendering intent and is still the best choice to use. I recommend that you use the Soft proofing method described in Chapter 14 to preview the outcome of any profile conversion and examine if a Relative Colorimetric rendering will produce an acceptable preview. If you are faced with a tricky image where some of the color detail appears to be getting clipped, use the View ⇨ Proof Setup ⇨ Custom dialog to see if a Perceptual rendering might produce a better conversion. The Absolute Colorimetric rendering method is useful for producing simulated proof prints, also described in the following chapter.

colors to CMYK color and it is advisable that you consider using the soft proofing view of the space you are converting to, in order to check for possible gamut clipping. While in RGB mode, an image can be manually color adjusted to improve the quality of the final RGB to CMYK conversion.

Absolute Colorimetric

Absolute Colorimetric maps in-gamut colors exactly from one space to another with no adjustment made to the white and black points. This rendering intent can be used when you convert specific 'signature colors' and need to keep the exact hue saturation and brightness, like the colors in a commercial logo design. This rendering intent is seemingly more relevant to the working needs of designers than photographers. However, you can use the Absolute Colorimetric rendering intent as a means of simulating a target CMYK output on a proofing device. Let's say you make a conversion from RGB to CMYK using either the Relative Colorimetric or Perceptual CMM and the target CMYK output is a newspaper color supplement printed on uncoated paper. If you use the Absolute Colorimetric rendering intent to convert these 'targeted' CMYK colors to the color space of the proofing device, the proofer will reproduce a simulation of what the printed output on that stock will look like. For more about targeted proofing, see the following chapter on file management and outputs.

Creating a custom CMYK setting

If you wish to make precision separations, you can generate your own custom CMYK profile in the Color Settings in either the standard or advanced mode. Choose Custom CMYK... from the CMYK Work Space menu. Figure 13.30 shows the Custom CMYK dialog. This is better known as the familiar 'Classic' Photoshop CMYK setup. You can enter here all the relevant CMYK separation information for your specific print job. Ideally you will want to save each purpose-built CMYK configuration as a separate color setting for future use and label it with a description of the print job it was built for.

Figure 13.27 This example illustrates an RGB image which was acquired and edited in RGB using the Adobe RGB space. A CMYK conversion was carried out using an ICC profile conversion from Adobe RGB and the Perceptual (Images) rendering intent.

Figure 13.28 The image was assembled with a gradient chosen to highlight the deficiencies of sRGB. The master RGB file was then converted to fit the sRGB color space. A CMYK conversion was made. sRGB is weaker at handling cyans and greens. There is also a slight boost in warmth to the skin tones.

CMYK Info (Adobe RGB)	A	B	C
Cyan	97	75	95
Magenta	10	6	9
Yellow	96	8	5
BlacK	0	0	0

CMYK Info (sRGB)	A	B	C
Cyan	84	72	75
Magenta	18	7	10
Yellow	80	8	6
BlacK	1	0	0

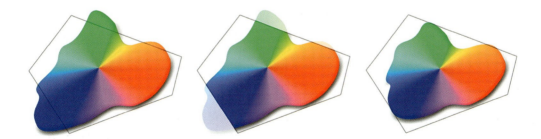

Figure 13.29 Each RGB image will have its own signature color space. In this example, imagine a scene with some blue sky and bright green colors going out of gamut. The middle example shows you the effect of a Relative Colorimetric conversion, which without some manual intervention may clip the out-of-gamut colors. A perceptual rendering will squeeze the out-of-gamut colors to fit the CMYK space, while preserving the relationship between the out-of-gamut colors. This rendering intent may produce a less vibrant separation.

Advanced CMYK settings

That's really all you can do with the standard CMYK settings – you can make a choice from a handful of generic CMYK profile settings or choose Custom CMYK... This is an improvement upon the preexisting single CMYK setup found in Photoshop 5.5 or earlier. If you check the Advanced options box, you will readily be able to select from a more comprehensive list of CMYK profile settings in the extended menu, depending on what profiles are already in your ColorSync folder.

Use Dither (8-bit per channel images)

Banding may occasionally occur when you separate to CMYK, particularly where there is gentle tonal gradation in bright saturated areas. Banding which appears on screen does not necessarily always show in print and much will depend on the coarseness of the screen used in the printing process. However, the dither option will help reduce the risks of banding when converting between color spaces.

Once the CMYK setup has been configured, the View ⇨ Proof Setup ⇨ Working CMYK and the View ⇨ Gamut Warning (for the CMYK space selected in the Proof setup) will enable you to pre-adjust an image to ensure the out-of-gamut colors are manually brought into gamut while still in RGB mode and before making a conversion. If this CMYK preview suggests that the CMYK conversion is not going to give you the best color rendering of some of the image colors, you have the opportunity to override this. For example, while the master image is in RGB mode, you can choose Working CMYK in the Proof setup (or any other CMYK color space in the list) and make an image color adjustment to bring these out-of-gamut RGB colors into CMYK gamut. See Chapter 9 for more detailed advice on how to do this. See also Chapter 14 for more information on the Photoshop soft proofing options.

Separation options

This section of the dialog controls what type of separation will be used and the total ink limits that are permitted.

Gray Component Replacement (GCR)

The default Photoshop setting is GCR, Black Generation: Medium, Black Ink Limit 100%, Total Ink Limit 300%, UCA Amount 0%. If you ask your printer what separation settings they use and you are quoted the above figures, you know they are just reading the default settings to you from an (unconfigured) Photoshop machine and they either don't know or don't want to give you an answer. If you are creating a custom CMYK setting it is more likely you will want to refer to the table in Figure 13.33 for guidance. Or if you prefer, stick to using the prepress Adobe CMYK setting that most closely matches the output (US Sheetfed/Web Coated/Uncoated). I prefer to use a GCR Light or Medium Black Limit for nearly all my CMYK separation work with a small amount of UCA (5–10%).

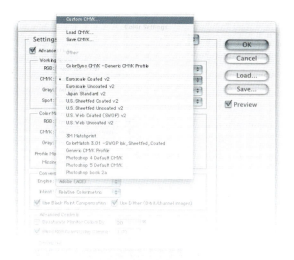

Figure 13.30 Select the Custom CMYK... option at the top of the pop-up menu list. This opens the dialog box shown opposite, where you can enter the specific CMYK setup information to build a custom targeted CMYK setting. When the advanced mode box is checked, you can choose from a wider range of pre-loaded CMYK profile settings. The various CMYK setup options are discussed in this chapter.

Black Point Compensation

This will map the darkest neutral color of the source RGB color space to the darkest neutrals of the destination color space. When converting RGB to CMYK, it is recommended you always leave this item checked. If you happen to be using Photoshop 5.x, it can pay to experiment with BPC on and BPC off when you test a new profile – some RGB to RGB profile conversions may be adversely affected and you can end up with weak, muddy blacks. These Black Point Compensation issues have been corrected since version 6.0.

Undercolor Removal (UCR)

UCR (Undercolor Removal) is said to be the preferred separation method in use today and a lot of commercial printers will use this separation method on their systems. UCR replaces the cyan, magenta and yellow ink in just the neutral areas with black ink. The UCR setting is also favored as a means of keeping the total ink percentage down on high-speed presses, although it is not necessarily suited for every job.

Dot gain

Dot gain refers to the spread of ink on the paper after it is applied and is very much dependent on the type of press and the paper stock being used. The dot gain value entered in the CMYK setup will affect the lightness of the color films generated from the CMYK file which will be used to make the final plates. The higher the dot gain, the lighter the film needs to be, this is because less ink needs to be laid down to produce the correct sized halftone dot. So therefore a high dot gain value, such as that used for newsprint, will cause the CMYK conversion to produce light-looking films. A lower dot gain value such as that used for a coated paper stock will mean that the films will look darker.

The dot gain value will not affect the way the image appears proofed on the screen. This is because Photoshop's color management system will always use the information entered in the CMYK setup to calculate the screen appearance and to provide you with an accurate soft proof of the expected output. But as was pointed out, if you were to compare the outputted films from the previous two examples, the films would actually have very different densities. Dot Gain Curves enable you to input more precise information about the dot gain (choose Curves from the pop-up menu next to Dot Gain). If you select the Dot Gain Curves option, you can enter custom settings for the composite or individual color plates. In the preparation of this book I was provided with precise dot gain information for the 40% and 80% ink values (see Figure 13.31).

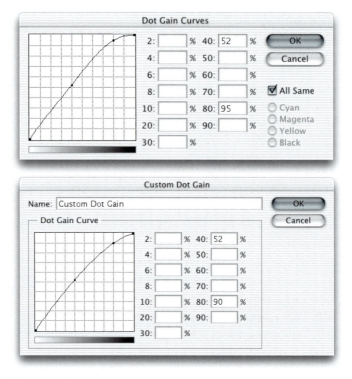

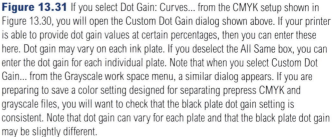

Figure 13.31 If you select Dot Gain: Curves... from the CMYK setup shown in Figure 13.30, you will open the Custom Dot Gain dialog shown above. If your printer is able to provide dot gain values at certain percentages, then you can enter these here. Dot gain may vary on each ink plate. If you deselect the All Same box, you can enter the dot gain for each individual plate. Note that when you select Custom Dot Gain... from the Grayscale work space menu, a similar dialog appears. If you are preparing to save a color setting designed for separating prepress CMYK and grayscale files, you will want to check that the black plate dot gain setting is consistent. Note that dot gain can vary for each plate and that the black plate dot gain may be slightly different.

Undercolor Addition (UCA)

Low key subjects and high quality print jobs are more suited to the use of GCR (Gray Component Replacement) with a small amount of UCA (Undercolor Addition). GCR separations remove more of the cyan, magenta and yellow ink where all three inks are used to produce a color, replacing the overlapping color with black ink. The use of UCA will add a small amount of color back into the shadows and is useful where the shadow detail would otherwise look too flat and lifeless. The percentage of black ink used is determined by the black generation setting (see page 394). When making conversions, you are better off sticking with the default GCR, a light to medium black generation with 0–10% UCA. This will produce a longer black curve and improved image contrast.

Opening CMYK and Lab files

CMYK files should not be converted back and forth to RGB. I always prefer to keep an RGB master and convert to CMYK using a custom conversion to suit each individual press requirement. Converting from one CMYK space to another is not normally recommended but in the absence of an RGB master, this will be the only option available. Photoshop makes the process of CMYK to CMYK conversion easier to accomplish. Just specify the CMYK profile to convert to in the Convert to Profile

Ink Colors

Where it says Ink Colors, you should choose the setting recommended by your press for the paper stock to be used. For example, European Photoshop users can choose from Eurostandard (coated), (uncoated), or (newsprint). These generic ink sets will do fine for most print jobs. If your printer can supply you with a custom ink color setting, then select Custom... from the Ink Colors menu, this will open the dialog shown in Figure 13.32.

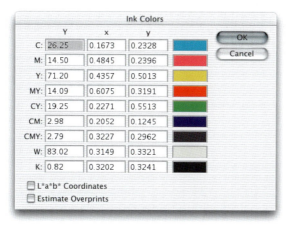

Figure 13.32 The Custom Ink Colors dialog. For special print jobs such as where nonstandard ink sets are used or the printing is being done on colored paper, you can enter the measured readings of the color patches (listed here) taken from a printed sample on the actual stock that is to be used.

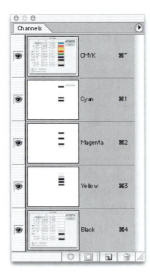

Black generation

This determines how much black ink will be used to produce the black and gray tonal information. A light or medium black generation setting is going to be best for most photographic images. I would advise leaving it set on Medium and only change the black generation if you know what you are doing. As a matter of interest, I always use a maximum black generation setting when I separate all the dialog boxes which appear printed in this book. When I separated the screen grab shown in Figure 13.32, a Maximum black generation separation was applied, so the black plate only was used to render the neutral gray colors. Consequently any color shift at the printing stage will have no impact whatsoever on the neutrality of the gray content. I cheekily suggest you inspect other Photoshop books and judge if their palette and dialog box screen shots have reproduced as well as the ones in this book!

dialog box. The Preserve Embedded Profiles policy means that incoming tagged CMYK files can always be opened without converting, thus preserving the numbers, while providing you with an accurate soft proofed screen preview. I do ensure that all my files have an ICC profile embedded, except when I am preparing images for the Web. In the case of the Lab color mode, if a Lab file is missing an ICC profile, it will open without interruption. Lab color mode is therefore assumed to be a universally understood color space, and it is argued by some that saving in Lab mode is one way of surmounting all the problems of mismatching RGB color spaces. But one of the problems with using Lab as a master space is that it is so large and there can be a lot of gaps between one color and the next when you save in Lab mode using 8 bits per channel.

Information palette

Given the deficiencies of the color display on a monitor, such as its limited dynamic range and inability to reproduce colors like pure yellow on the screen, color professionals will often rely on the numeric information to assess an image. Certainly when it comes to getting the correct output of neutral tones, it is possible to predict with greater accuracy the neutrality of a gray tone by measuring the color values with the eyedropper tool. If the RGB numbers are all even, it is unquestionably gray (in a standard/linearized RGB editing space such as Adobe RGB). Interpreting the CMYK ink values is not so straightforward. When printing a neutral gray, the color is not made up of an even amount of cyan, yellow and magenta. If you compare the color readout values between the RGB and CMYK Info palette readouts, there will always be more cyan ink used in the neutral tones, compared with the yellow and magenta inks. If the CMY values were even, you would see a color cast. This is due to the fact that the process cyan ink is less able to absorb its complementary color – red – compared to the way magenta

and yellow absorb their complementary colors. This also explains why a CMY black will look reddish/brown, without the help of the black plate to add depth and neutrality.

Separation settings	Ink colors	Separation method	Dot gain	Black generation	Black ink limit	Total ink limit	UCA
US printing							
Sheetfed (coated)	SWOP coated	GCR	10–15%	Light/Medium	95%	320–350%	0–10%
Sheetfed (uncoated)	SWOP uncoated	GCR	15–25%	Light/Medium	95%	260–300%	0–10%
Web press (coated)	SWOP coated	GCR	15–20%	Light/Medium	95%	300–320%	0–10%
Web press (uncoated)	SWOP uncoated	GCR	20–30%	Light/Medium	95%	260–300%	0–10%
Web press (newsprint)	SWOP newsprint	GCR	30–40%	Medium	85–95%	260–280%	0–10%
European printing							
Sheetfed (coated)	Euroscale coated	GCR	10–15%	Light/Medium	95%	320–350%	0–10%
Sheetfed (uncoated)	Euroscale uncoated	GCR	15–25%	Light/Medium	95%	260–300%	0–10%
Web press (coated)	Euroscale coated	GCR	15–20%	Light/Medium	95%	300–320%	0–10%
Web press (uncoated)	Euroscale uncoated	GCR	20–30%	Light/Medium	95%	260–300%	0–10%
Web press (newsprint)	Euroscale newsprint	GCR	30–40%	Medium	85–95%	260–280%	0–10%

Figure 13.33 These separation guidelines reflect a typical range of settings one might use for each type of press output. These are guidelines only and reflect the settings you will already find in Photoshop. For precise settings, always consult your printer.

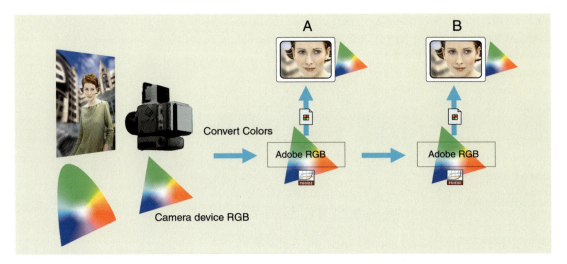

Figure 13.34 This and Figure 13.35 show a typical use of profiled, RGB workflow. The original subject is shot using daylight. The digital camera used to capture this scene has its own color characteristics and the gamut of the captured image is constrained by what colors the camera is able to capture in RGB. Photoshop is able to read the embedded ICC camera profile tag and converts the colors to the Adobe RGB work space. This RGB file can now be shared directly with other Photoshop 5.0+ users editing in Adobe RGB color.

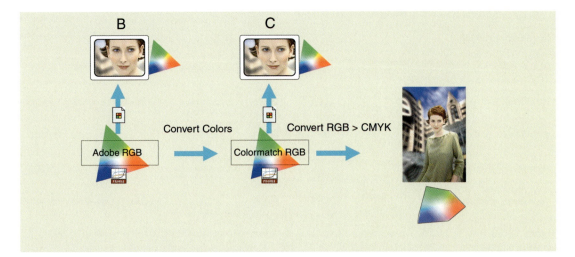

Figure 13.35 The Adobe RGB work space is a virtual space – you cannot actually see it. The monitor profile is generated when you calibrate your display and build an ICC profile for it. This profile converts the Adobe RGB data 'on-the-fly' to render the monitor screen image. The monitor RGB space is smaller than the Adobe RGB space. Using the monitor alone as your guide, you may not be able to see all the colors that end up in print. Nonetheless, they are preserved in the Adobe RGB edit space. Another Photoshop 5.0+ user may be using a different RGB space, like ColorMatch RGB. No matter, Photoshop converts with high precision from one space to another. When the RGB to CMYK conversion occurs, it is made from an RGB file which has been carefully color managed throughout. In this example, CMYK gamut clipping is avoided, because the limiting monitor RGB space has been taken out of the equation.

The ICC color managed workflow

Now that you have read through to the end of this chapter, see if the diagram of a typical workflow shown in Figure 13.34 makes sense. This represents one possible route an image file might take from the point of digital capture through to the CMYK conversion. If you assume everyone who handles such a file is using an ICC color managed workflow, the image data only has to be converted twice: once from the RGB camera space to the RGB work space and then from the RGB work space to the CMYK output space. In the Figure 13.35 example, an additional RGB to RGB conversion takes place because another Photoshop user receiving the Adobe RGB file is working in an alternative RGB work space. But as you can see, the Photoshop color management system makes it possible to accurately preview the colors on screen and minimize the number of color conversions that have to take place to get the most reliable and fullest gamut color reproduced in the final printed image.

Chapter 14
Output for Print

The preceding chapter considered the issues of color management and how to maintain color consistency between digital devices. This section though will deal with the end process of converting digital files into a print output. The standard of output available from digital continuous tone printers has improved enormously over recent years. Many people find they in fact prefer the print quality of a digital inkjet over conventional silver color prints. I see two reasons for this: the ability to finely control the color output yourself on the computer using Photoshop and the wider range of paper stock available. There are so many print methods and printer models to choose from, so it is therefore important to understand what the strengths and weaknesses are of each. To start with you need to consider your main print

output requirements. Are you looking for speed, volume printing or a high quality final art finish? And do you require your print output to form the basis of a repro contract print?

RGB output to transparency and print

Many photographers prefer to work in RGB throughout and supply an RGB output as the final art, the same way as one would normally supply a transparency or print. Writing to transparency film is a slow, not to mention quite expensive process, but is one means of presenting work to a client where money is no object. Such an output can either be scanned again or used as a reference for the printer to work from the digital file. In these situations, a CMYK proof is regarded as a better reference but nevertheless the transparency output is one that some photographers may feel more at home with.

Before sending a Photoshop file for printing, check with the bureau for any specific compatibility problems. Most bureaux like you to send them a flattened TIFF file with an ICC profile embedded.

Pictrography

The Fuji Pictrography printers are capable of producing a true photographic print finish. A single pass exposure (as opposed to the three or four passes involved with dye-sublimation) is made with a thermal laser diode onto silver halide donor paper, followed by a thermal development transfer to the receiving print. This, Fuji claim, has all the permanence of a conventional color photograph. Fashion photographers in particular like using Pictrograph outputs, maybe because of the current popularity of supplying C-type prints made from color negatives. I myself have owned a 3000 Pictrograph printer for many years and can vouch for the benefits of superb color and speed of print output at under two minutes. The machine prints at resolutions from 200 to 400 ppi in sizes ranging from A6 to A4 bleed (A3 on the Pictrography 4000). The results are very crisp and the smooth glossy surface will cause no

RGB photographic prints

Transparency writers use a scanning laser beam or LEDs to expose the light sensitive silver emulsion. The same technology is employed to make RGB photographic prints, particularly large blowups for exhibition display with print writers such as the Durst Lambda and CSI Light Jet 5000. As with the transparency writers, these machines are intended to be installed in labs and bureaux, where they can replace the enlarger darkroom.

After scanning in a negative or transparency, such printers are capable of outputting from all the common file formats to any size of photographic print (up to 48 inches wide with the Lambda service).

Substituting photographic prints

Pictrographs are beautiful as portfolio prints or substitutes for conventional color photographic prints. I consider the Pictrograph to be like having a mini lab in the studio. It particularly suits the way I work because I often have to contend with print orders from clients who want me to provide them with 10 x 8 glossy prints. The 120 seconds or so it takes to make each print makes the Pictrograph an ideal printer for these types of orders.

problem when scanned from again and the only chemical solution required is purified water! The more recent models have print drivers that are able to recognize ICC color space profiles US and European machines have different specifications, but if you can get a custom ICC profile built for your machine you will see a dramatic improvement in the quality of color output produced. Use the Image ⇨ Mode ⇨ Convert to Profile command and convert from your current RGB space to that of the Fuji Pictrograph profile prior to printing and switch off the color matching option in the driver dialog.

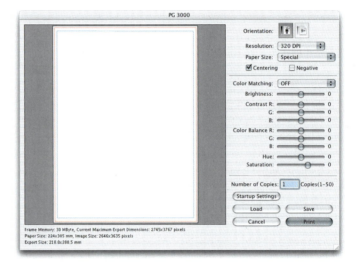

Figure 14.1 The Fuji Pictrograph driver interface. If you are using a custom-built profile, you should first convert your images to the Pictrograph profile color space and the ColorMatch option in this dialog must be set to 'Off'.

Inkjet printers

Inkjet printers now dominate the printing market, especially among photographers who use Photoshop. Inkjets come in all shapes and sizes from small desktop devices to huge banner poster printers that are the width of a studio.

Inkjet printers work by spraying very fine droplets of ink as the head travels back and forth across the receiving media/paper. With the IRIS/IXIA, the paper is mounted on

a drum which revolves at high speed and the print head passes across the surface in a linear fashion. The different tonal densities are created by varying the number of evenly-sized individual droplets and dithering their distribution. Hence the illusion of a lighter tone is represented using sparsely scattered ink dots. The more recent printers are also able to produce variable sized droplets. The Epson Stylus Photo models use six color inks and these are capable of producing an even smoother continuous tone output. The six color inkjets use additional light cyan and light magenta inks to render the paler color tones. The print output is still CMYK (or CcMmYK to be more accurate), but looks smoother because you have less noticeable dot dithering in the lighter areas. But the print times are also slower than the non-Stylus Photo models. Inkjet printers are used for all sorts of printing purposes. An entry-level inkjet can cost as little as $150 and is suitable for anything from office letter printing to outputting photographs from Photoshop. And you don't have to spend much more than a few hundred dollars to buy an A4 or A3 printer that is capable of producing photo-realistic prints. Later on in this chapter I will discuss how it is possible to use a printer like this to produce acceptable press proofs for CMYK press color matching.

Although inkjets are CMYK or CcMmYK color devices, they work best when they are fed RGB data. This is because a lot of printers use Quartz rendering (Mac) or GD (PC) drivers as opposed to PostScript. These print drivers can't understand CMYK. So if you send CMYK data to the driver it will convert the data from some form of generic CMYK to RGB before being able to process it. However, Mac OS X 10.3 will include 'Gimp Print', which may indeed allow you to print using PostScript. Then it will convert the data again to it's own proprietary CMYK or CcMmYK. If you perform the color management in Photoshop and disable the printer color management, it is possible to produce what is known as a cross-rendered CMYK proof from an RGB file, using the Proof Setup dialog to specify a CMYK space to print in.

Inkjet origins

The first inkjet devices were manufactured by IRIS and designed for commercial CMYK proof printing on a limited range of paper stocks. It was largely due to the dedication of country rock musician, Graham Nash that the IRIS also evolved to become an inkjet printing device suitable for producing fine art prints. This costly venture began in the early nineties and was to revolutionize the world of fine art printing thanks to the perseverance of the early pioneers who took a commercial proofing device and converted it into a fine art printer. The IRIS printer stopped production in 2000 and its successor is the IXIA from Improved Technologies. The IRIS/IXIA is still favored by many artists, but in the last decade companies like Epson, Hewlett-Packard (HP) and Roland have developed high quality wide-format inkjet printers that are suitable for large format printing, including fine art work applications.

The revolution in inkjet technology began at the high-end with expensive wide-format printers, but the technology soon diffused down to the desktop. Epson was one of the first companies to produce affordable, high-quality desktop printers. And Epson have retained their lead in printer and consumables technology, always coming out with new and better printers, inks and papers. Although companies like Canon and Hewlett-Packard, who have been making inkjets just as long, are now beginning to regain their slices of the printer market with printers to rival Epson's continuing dominance.

Branded Consumables

The inkjet manufacturers like to sell their printers cheaply and then make their profit through the sales of proprietary inks designed for their printers. If you care to read the small print, using anything but the manufacturer's own inks may void the manufacturer's guarantee. But this should not necessarily discourage you from experimenting with other ink and paper combinations and apparently this situation is being legally challenged in the USA . Although it has to be said that the number of ink and paper products you can buy these days is quite bewildering.

The ideal inkjet

Your first consideration will probably be how large do you want to make your prints? Desktop inkjet printers are able to print up to A3+ (13" × 19") and as the name suggests, are designed to be small enough to sit on a desk. The wide-format printers like the Epson 9600 and 10600 can print up to 44" wide and the HP printers, as wide as 96". These units are designed to be freestanding and require a lot of studio office space. Wide-format printers are suitable for all commercial purposes such as printing Photoshop files or vector-based artwork. To be able to print vector output you always need a PostScript RIP or driver, as without postscript the artwork will look coarse and dithered (I use the ImagePrint RIP to drive my Epson 7600).

Photographic print quality

Almost any inkjet printer can give you acceptable print quality, but some printers are definitely more photographer-friendly than others. The Epson Stylus Photo range of printers are marketed as a good choice for photographic print output because they use specially formulated inks and print with six or more ink colors which as I mentioned in the introduction, can yield superb results. Printers like these and others can also be adapted to take third-party inks that are specially formulated for black and white or archival printing. The latest Epson 2100/2200 Ultrachrome printers are suitable for archival printing and have an extra light black ink which also makes this an almost ideal printer for black and white work, although there are still some issues with an illuminant metameric gray balance shift. It is worth noting that the tolerance and color consistency of the Ultrachrome printers is far superior compared to older Epson printers.

Image permanence

The permanence of an inkjet print will be determined by a variety of factors. Mostly it is down to the environment in which a print is kept or displayed and whether it has been

specially treated to prevent fading, followed by the combination of inks and media that are used to produce the print. Light remains the biggest enemy though. If prints are intended for long-term exhibition, then you have to make sure that you use a suitable ink and paper combination, that the prints are displayed behind glass and that they are sited so as not be exposed to direct sunlight every day. Henry Wilhelm at www.wilhelmresearch.com has conducted a lot of research into the various factors that affect the permanence of inkjet prints.

Inks and media

To start with I recommend that you explore using the proprietary inks and papers that are 'officially' designated for use with your printer. Firstly, the manufacturing engineers have designed these ink and paper products expressly for their printers and secondly, the printer companies will usually supply canned profiles, which although not perfect, can be very useful at getting you an approximately matching print when you use their ink and paper. And if you stick to using proprietary inks and papers there are fewer variables for you to worry about when you are learning how to print from Photoshop.

There are two types of inks used in inkjet printers. Dye inks are the most popular because they are capable of producing the purest colors. But the dye molecules in such inks are also known to lack stability. This means that they are prone to deteriorate and fade when exposed to prolonged, intense light exposure, high humidity or reactive chemicals. Pigment-based inks have a more complex molecular structure and as a result are less prone to fading. But pigmented inks have traditionally been considered less vivid than dye inks and have a restricted color palette (the color gamut is smaller). Some modern inks are a hybrid combination of dyes and pigments. The latest Epson Ultrachrome ink printers (2100, 2200, 7600, 9600) are the only range so far to offer photo-quality printing using specially formulated pigment-based ink and paper combinations that will produce bright prints which

Third party delays

As new printers come to market it can take a while for third-party companies to devise their own ink sets. One reason for this is the way that recent inkjets have smart chips fitted to the ink cartridges. These are meant to alert the print driver when they are low on ink, but they are also harder to copy! Third-party manufacturers have to devise a way to reverse-engineer their cartridges so as to work with the newer printers.

Inkjet economies

Ink cartridges don't come cheap and once you get into serious print making, you will soon get through a lot of expensive cartridges. I don't recommend you economize by buying ink refill kits as these are very messy to use. A better solution is to invest in a continuous inkflow system (CIS). These can be bought as kits which you use to modify your printer. In place of the normal ink cartridges, you have a special cartridge that links to separate ink reservoirs which can feed a continuous flow of ink to the printer head. The advantages are that you don't have to keep replacing ink cartridges and such a system is more efficient and economical to run. Companies supplying continuous ink flow systems include: Lyson, NoMoreCarts CIS, MIS Cobra CFS, Camel Ink Systems CRS and MediaStreet Niagra II Continuous Ink Flow System.

also have exceptional image permanence. Using the correct paper and inks, the life expectancy is predicted to be over 100 years.

You can buy third-party inks. These are mostly designed for the Epson printers and even then you will find that not all printer models are supported. Lyson make a range of inks for both color and black and white printing. The Lyson Fotonic color inks are designed to provide increased image permanence and in some instances actually have a slightly larger gamut than many Epson inkjets. Whenever third-party inks are used, you will almost certainly want to have custom profiles made for each ink and paper combination. To work with third-party inks and papers a user must first optimize the printer settings. Neil Barstow is a UK-based color management consultant who offers a CD containing a manual and test files to help guide you do this. For more information on this and his UK-based color consultation services, go to: www.colourmanagement.net.

A lot of photographers like to use the special black ink sets such as the Lyson Quad Black and Small Gamut (SG) inks, MIS Quadtones, MIS Variable mix (VM) Quadtones, Lumijet Monochrome Plus and Ilford Archiva monochrome inks. Black inks can be used with four or six color printers in place of the usual color inks. The above ink sets print overlaying inks of varying gray lightness in place of the usual CMYK inks and have the potential to make rich-toned fine art prints with good image permanence on a variety of paper surfaces. When ordering ink supplies you need to make sure that the cartridges are compatible with the printer and if using a custom profile, are of the same type. But the paper can be equally critical. The Premium Glossy paper is a popular choice for photographers as this matches the quality of a normal glossy print surface and the print longevity when used with Epson six color dye inks, is estimated to be about 9 years. The equally popular Heavyweight Matte paper has a life expectancy of around 25 years when printed using the same inks. A lot of photographers and artists have enjoyed

experimenting with various fine art paper stocks. When combined with the right types of ink, it is possible to produce prints that can be expected to last even longer. Remember that the thicker papers require extra head clearance and there should be a lever on your printer where the head height can be adjusted.

Making an inkjet print

There are four Print menu items in Photoshop: The Page Setup, the 'System' Print dialog, Print with Preview and Print One Copy. In Photoshop CS, ⌘ P ctrl P will open the traditional System Print dialog and ⌘ ⌥ P ctrl alt P will open the Print with Preview dialog (which is the one I will be using throughout in this chapter). If you prefer this behavior to be reversed, you can easily switch these key settings in the keyboard shortcuts. Before making a print ensure that the correct printer is selected. On Mac OS X go to the Applications folder, open the Utilities and launch the Print Center application. On a PC, choose File ⇨ Print and click on the Setup button to select the printer driver.

I prefer using the Print with Preview dialog because it shows how the Photoshop document will print in relation to the page size and I can set the all-important color management options. When the Center Image box is

deselected, you can position the image anywhere you like, by dragging the preview with the cursor, although there are some issues over the accuracy of the preview placement when using Mac OS X. Or you can position and resize within the specified media chosen, using the boxes at the top. You cannot alter the actual number of pixels via this Print dialog. Any changes you make to the dimensions or scaling will always be constrained to the proportions of the image. In the Output options below that, click on the Background... button to print with a background color other than paper white. For example, when sending the output to a film writer, choose black as the background color. Click on the Border button to set the width for a black border. But be aware that setting the border width can be an unpredictable business. If you set too narrow a width, the border may print with an uneven width on one or more sides of the image. On the right, you can select whether or not to print the following: Calibration Bars, which will print an 11-step grayscale wedge on the left and a smooth gray ramp on the right. If you are printing CMYK separations, tint bars can be printed for each plate color. The registration marks will help a printer align the separate plates. The crop marks indicate where to trim the image and the Bleed button option which lets you set how much to indent these crop marks. Checking the Caption box will print any text that was entered in the File ➪ File Info box Description field. Check the Labels box to print the file name below the picture. Note that all of this is dependent on there being enough border space available surrounding the print area to print these extra items and whether you are using a PostScript print driver. The print dialogs reproduced here show the Epson 1290 inkjet printer settings and instructions for Mac and PC. The interface and main control will be fairly similar for other makes of inkjet printers, but not identical. The first example shows you how to go about making a print from an RGB image in Photoshop using one of the Epson 1290 printer profiles that were automatically loaded when I installed the printer driver on my computer.

1 The first thing you need to do is go to the Page Setup dialog and make sure the right printer is selected (you will have to do this each time in Mac OS X). Now choose a paper size that matches the paper you are about to print with and choose the right orientation: either portrait or landscape. There is no need to adjust the scaling percentage here as this can be accomplished more elegantly in the Print with Preview dialog coming up next. On a PC you need to click on the Printer... button to select the printer model.

2 If you choose File ⇨ Print, you will jump straight to the dialog shown in step 3. But I recommend that you always start by choosing File ⇨ Print with Preview because this will enable you to correctly configure the color management options. Most of the features have already been covered in Figure 14.2. Note that the Show More Options are checked here and the Color Management options are being displayed. The source space should be left as Document and in this example the source space of the profiled RGB file is Adobe RGB. Next select the Print Space. Mouse down on the Profile menu and a list of possible profile spaces will appear. Assuming you have been supplied some printer profiles during the installation process, you want to select a profile that includes both the name of your printer and the type of paper that you are printing to. You can do this if you are using an Epson printer and the Mac OS X operating system. But if you are using a PC, Epson will only offer one choice of profile (it's more of a setting really). If you are printing to an Epson with a PC, select 'Printer Color Management' from the Profile menu. Do this and follow all the remaining steps exactly, paying special attention to have ICM switched off. The actual profile selection on a PC will be determined when you select the paper type in the next step. In Mac OS X, the rendering intent can be set to Perceptual or Relative Colorimetric and with Use Black Point Compensation switched on. These rendering options will be disabled on a PC, but will be available if you are selecting a custom profile instead.

3 Click the Print... button in Print with Preview and you will be taken to one of the Print dialogs shown here. No preset settings have been saved yet. In Mac OS X, mouse down on the Copies and Pages pop-up menu and choose 'Print Settings'. On a PC, click on the Properties... button.

4 In this section you need to select a media type that matches the paper you are going to be using. In this example I am printing with Epson's Premium Photo Glossy paper. If you are printing in color, make sure the Color ink button is checked. In Mac OS X, click on the Advanced Settings button and choose a print resolution (1440 dpi will produce nice smooth results). A higher print resolution will produce marginally better looking prints, but will take much longer to print. On a PC, click on the Custom button in the Printer Properties dialog, select the media type, click on the Advanced... button and proceed to the next step.

5 In the Advanced section on a PC you can now set the print resolution quality. And in the Color Management section click on the No Color Adjustment button. This is because you do not need to make any further color adjustments – the print driver already knows the source space color and the destination space, plus it knows the print resolution and the driver has all the information required to produce an optimum color print on the paper you have selected. In Mac OS X, go to the Color Management print settings option and click on the No Color Adjustment button. All you have to do now is click on the Print button at the bottom and wait for your image to print.

i1 TC 9.18 RGB Testchart part 1

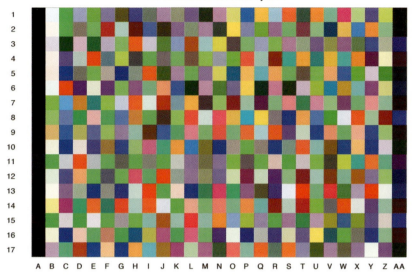

Building a custom printer profile

How pleased are you with the results that you are getting so far with your printer? If you followed the previous steps carefully, then you should be getting the colors to near enough match what you are seeing on the display. And if not, then I suggest you check the calibration of your display and rebuild the monitor profile. It is never possible to create a complete match between the display and the print, even under ideal light viewing conditions. But if you want to take your color management a step further, why not consider having a custom profile built for your favorite ink and paper combinations? If you don't have the necessary profiling kit and software, the most obvious thing to do is to contract the work out to a specialist service provider. I have recommended and used Pixl in Denmark myself in the past and Pixl are offering a special discount coupon to readers of this book that will entitle you to a discount on their remote printer profiling services. More details are in the back of this book and on the CD-ROM. The next series of screen shots lead you through the steps required to print out the target shown in Figure 14.3.

Figure 14.3 This is an example of a Gretag Macbeth color target which is used to construct a color ICC profile. Each file must be opened in Photoshop without any color conversion and the file is sent directly to the printer, again without any color modification and the print dimensions must remain exact. If it is necessary to resize the ppi resolution, make sure that the Nearest Neighbor interpolation mode is selected. The print outputs are then measured using a spectrophotometer and a profile can be built from these measurements. Thomas Holm of Pixl in Denmark (www.pixl.dk) provides a very good remote profiling service. Test targets like the one above can be downloaded from his website. All you have to do is make 'neutral path' prints (see pages 412-415), send these to Pixl and they will email a profile back to you.

1 Begin by opening the test chart file (or series of files) such as the one shown in Figure 14.3. These will be included as part of any print profiling package or supplied to you by the profile building service provider. This file will have no embedded profile and it is essential that it is opened without making any conversions and always printed at the exact same print size dimensions.

2 Choose File ⇨ Print with Preview. Configure the Page Setup as shown in the previous step-by-step example. The source space should be Document: Untagged RGB. The Print Space profile must be set to 'Same as Source'. Do not adjust the scale – this must remain at 100%. The idea here is that you want to create a print output of the unprofiled data without applying any printer color management. Now click Print...

3 In Mac OS X, choose the appropriate media type and the desired print resolution in the Print settings section. In this example, we are building a profile for the Epson Heavyweight Matte paper, at a print resolution of 1440 dpi. On a PC, click on the Custom button, choose the media type and click on the Advanced button.

4 In the Advanced section on a PC, select the printer resolution. In the color management section you can select 'No Color Adjustments' as before. But when preparing to profile an Epson six color dye inkjet like the 1290, you may want to try checking the Color Controls settings instead. Keep all the controls set to zero and select the Photo realistic mode and a Gamma of 1.8 (I have also had success building profiles at a gamma of 2.2). The main thing to remember here is that whichever route you follow, you should now save these print settings. These are to be used when you print using the custom profile. Go to the Presets menu, mouse-down and choose Save... This print setting was named: 'neutral path 1440 Matte HW'. We are now ready to print the test target.

5 Once the print has been allowed 24 hours or more to stabilize, it can be measured and a profile built. If you are using a remote profiling service, mail the prints off and wait for them to email you back your ICC profile. The profile will be applicable for use with your printer, using the same ink sets and with the same media/paper type and print resolution. To test the profile, choose the custom printer profile as the destination print space and choose the Perceptual or Relative Colorimetric rendering intent with Black Point Compensation checked. If you are using a PC the instructions are exactly the same as for a Mac.

6 After you click Print... make absolutely sure you select the same preset setting that you saved when creating the target print from your printer. And that's it. Mac OS X users will want to pay special attention to check that the correct printer and page setup settings are always selected correctly, but other than that you should expect to see a very accurate color print, providing that you have remembered to calibrate and profile your monitor display as described in Chapter 3.

Inkjet papers

The optical brighteners contained in many of today's inkjet papers can also bring about quite a noticeable shift in the way a print is perceived under different lighting conditions. If there is a high amount of UV light present the whites will look much brighter, but also bluer compared to a print that has been made using a paper stock such as the Tecco/Best Remote Proof 9180 or Tecco/Best Proof 9150 papers, which are ideally suited for CMYK proof printing and viewed using controlled lighting with a color temperature of 5000 K.

Perfect results from your printer profiles

There is no such thing as a perfect printer profile, but you should be suitably impressed by just how good the results can be and appreciate the pleasure of seeing your photographs print almost exactly the way you intended. But to achieve such excellence you have to use a calibrated light viewing box to view the printed colors correctly. All inkjet prints take a while to dry after they come off the printer. A print produced using the Epson 1290 inks will at first look particularly green in the shadows, but after a few hours you will notice how the ink colors stabilize and the green cast eventually disappears. This is why you are advised to wait at least 24 hours before measuring your printed target prints. Then there is the issue of what is commonly referred to as 'metamerism'. This refers to the phenomenon where when viewing under different lighting conditions, the ink dye/pigment colors will respond differently. This problem can be particularly noticeable when a monochrome image is printed using color inks. Although the color management can appear to be working fine when a print is viewed under studio lighting, if this environment is changed, and the print is viewed in daylight from a window, the print can appear to have a green cast. There was an example of this with the early Epson Ultrachrome 2000 printer where the pigment-based ink suffered from this green-shift in daylight problem. The later Ultrachrome printers have almost managed to resolve this.

Even despite your best efforts to produce a perfect profile, you may just find that a specific color on the display does not match exactly. I sometimes see this happening with the skin tones in a portrait. Although I usually obtain a perfect match with a specific ink and paper profile combination, sometimes the printed result is just a fraction out on an item of clothing or the skin tones, but every other color looks just fine. If you know what you are doing it is possible to tweak profiles using a program like Gretag Macbeth's ProfileMaker Pro. But I often just add a temporary hue/saturation adjustment layer using this to

make a minor correction by targeting say, the reds of the skin tones and shifting them to become 2–3% more yellow. But another more obvious reason why there may be a difference in the colors seen is that the color gamut of the printer is not the same as the gamut of the display on which you are viewing the image. This is where soft proofing can sometimes help you get more predictable results.

Soft proofing via the display

When you carry out a color mode conversion or a Convert to Profile command, the color data is converted to the destination/device color space. When the file is in this new space, Photoshop will continue to color manage the image. If you are converting an RGB master to the working CMYK space, Photoshop will simulate the CMYK print output appearance on the monitor after the file has been converted to CMYK. This is known as 'soft proofing'. A real proof is a hard copy print produced by a contract standard proof printer – soft proofing is therefore a term that is applied to using the monitor as a proofing device. The monitor will never be as accurate when it comes to showing how every CMYK color will reproduce, but it is usually close enough for carrying out all the preparation work, before reaching the stage where a final contract proof is demanded. Good quality displays such as the Apple Cinema display or Sony Artisan CRT monitor, are better at reproducing CMYK colors on the screen.

If you are editing an RGB master and go to the View ⇨ Proof Setup menu and select Working CMYK (which is the default setting), you can preview how the colors will look if you convert from RGB to the working CMYK color space using the default rendering intent. If you choose the Custom... option you can select any profile space you want from the pop-up list. Name and save the custom proof setting as a '.psf' file in the Users*username*\\Library\\Application Support\\Adobe\\Color\\Proofing folder (Mac OS X), or the Program Files\\Common Files\\Adobe\\Color\\Proofing folder (PC). This saved proof setting will then be appended to the bottom of the list in

Proof Setup

If you want to preview the outcome of a color mode conversion, you do not have to convert the color data. Instead, Photoshop is able to calculate a screen preview only, while keeping the color data in its original space. This can be done by choosing View ⇨ Proof Setup ⇨ Custom... or any of the other listed color spaces. The Photoshop color management system therefore enables you to simulate any CMYK or RGB print output (i.e. Pictrograph, film writer or inkjet printer) without having to carry out a mode conversion first.

The Proof Setup is not just limited to CMYK output. You can use the Proof Setup to preview RGB conversions to RGB output devices or do things like preview how a prepress grayscale file will appear on a Macintosh or Windows RGB monitor. And you can load a custom profile for your printer to gain a more accurate preview of how an image will print.

Each new window view can preview a different proofing setup. So for example, you can create several new window views of the same document and compare the results of outputting to various types of press output directly on the display.

Proof Setup. When a proof setting is selected in the Proof Setup you can preview the colors in this space by choosing View ⇨ Proof Colors. ⌘ Y *ctrl* Y is the default keyboard shortcut and this will toggle the preview on and off, making it very easy for you to switch from normal to proof viewing mode. The document window title bar will also display the name of the proofing space after the color mode: RGB/*Working CMYK*.

Simulate Paper White and Ink Black

Checking these options will modify the appearance of the preview that can be obtained via the Proof Setup dialog, so that the soft proof shows more accurately how a file might actually reproduce after it is converted to CMYK and been printed. To explain this a little better, when you select Proof Colors, Photoshop takes the current display view, and converts it on-the-fly to the destination color space selected in the Proof Setup. The data is then converted back to the RGB monitor space to form a preview using the relative colorimetric rendering intent and with black point compensation switched on. The Simulate: Black Ink option will simulate on screen the actual black density of the printing press. Simulate: Paper White will use an absolute colorimetric rendering to convert the proof color space data to the monitor space, simulating the paper white and black ink colors. However, the Paper White simulation only works if the CMYK profile used is made on the actual paper stock to be used for printing, and only if this paper doesn't have too much optical brightener in it. Otherwise the results will look bluish on screen. It is rather disappointing to see the display preview image deteriorate in front of your eyes this way, so I follow Bruce Fraser's advice and try looking away from the display just prior to checking these press simulation settings!

Color proofing for press output

If you are supplying digital files for repro, then you will want to obtain as much relevant information as you can

about the press, paper stock and print process that will be used to print a job. If the person running the printing press or repro bureau is cooperative and understands what you are asking for (these are big assumptions, I know), they will be able to supply you with a proofing standard ICC profile or printing inks and other specifications for the press. Enter these in the Edit ⇨ Color Settings ⇨ Working Space ⇨ CMYK ⇨ Custom CMYK dialog, as described in Chapter 13. Convert your RGB file to CMYK and save it as a TIFF or EPS file and supply this with a targeted CMYK print proof which shows the printer how the enclosed file should be expected to print within the gamut of the specific CMYK print process. You could also supply an RGB file tagged with an ICC profile, as well as the proof. But be warned, this will only work if it is clearly understood beforehand and accepted that the recipient will be carrying out the conversion to CMYK and using the CMYK proof as a guide. If you send RGB files to printers, be careful to label RGB folders as such and make every effort to avoid any potential confusion down the line.

Realistic proofs

When you supply a CMYK proof you are aiming to show the printer how you envisage the picture should look in print. A proof should be produced using the same color gamut constraints as the halftone CMYK process. That way the printer will have an indication of what colors they should realistically be able to achieve.

Figure 14.4 Use the Proof Setup menu to select the device you wish to soft proof with, whenever you select the Proof Colors command (⌘ Y / ctrl Y). Under the Custom... option you can select the profile of your printer – in this case, US Web Coated (SWOP) v2. Checking the Preserve Color Numbers box will preview how the image would print if the data was sent to the printer without any conversion.

Truer whites

If Relative Colorimetric is used as the rendering intent, the print output will print using the restricted gamut of the target CMYK space, and will map the whitest point of the CMYK proof space to the whitest point of the profiled paper setting. This produces a restricted gamut print with nice clean whites. If you select the Absolute Colorimetric rendering intent, the print output will print using the restricted gamut of the target CMYK space, but will reproduce the whites to match the true white of the target press. What this means is that the whites may appear duller than expected. This does not mean the proof is wrong, it is the presence of a brighter white border that leads to the viewer regarding the result as looking inferior. To get around this perception try adding some extra white canvas in Photoshop to the outside image you are about to print. When the print is done trim away the outer paper white border so that the eye does not get a chance to compare the dull whites of the print with the ultra white of the printing paper. In all cases the Black Point Compensation button must be deselected.

Inkjet technology is ideal for producing excellent quality 'targeted' CMYK prints that can be used as either an 'aim' print or contract proof by the printer. The term 'aim' print most justly describes the appropriateness of a standard Epson inkjet output, when used as a guide for the printer who is determining how to reproduce your image using CMYK inks on the actual press. The term contract proof is used to describe the same type of thing, except it refers to a more precise form of CMYK proof, one that has been reproduced by an approved proofing device. These include the Rainbow and Kodak dye-sub printers, the Epson 5000 inkjet (with RIP) and prepress bureau service proofs like the Dupont Cromalin™, 3M Matchprint™ and many others. Inkjet printers such as the IRIS iProof are essentially taking over the proofing industry, as many press houses move to Computer to Plate technology (CTP), thus eliminating the need for film at the proofing stage. The contract proofing devices benefit from having industry-wide recognition. It is safer to supply a digital file together with a proof which has such a seal of approval. The printer receiving it knows that the colors reproduced on the proof originated from a contract device and were printed from the attached file. Their job is to match the proof, knowing that the colors in the proof are achievable on the press.

Figure 14.5 shows the Print with Preview dialog for an Adobe RGB image that is currently being soft proofed with the Custom Proof Setup using an 'Offset print Euro catalog' color space profile. So the image to be printed is in RGB, but it is currently being soft proofed in the above CMYK color space. If Proof is selected as the source space, it is possible to use this CMYK preview as the designated source space and simulate the restricted CMYK gamut of the press on a desktop printer (using the default rendering intent in Color Settings). In the Print Space section the profile used is a custom print profile that was created by the method described earlier. It is a profile for the Epson Heavyweight Matte paper, to be printed on an Epson 1290 printer.

PostScript printing

When you print a document, graphic or photograph, the data has to be converted into a digital language that the printer can understand. Printing images directly from Photoshop is a fairly easy process. If you try to print anything directly from a page layout program, the printer will reproduce the screen image only. The text will be nice and crisp and TIFF images will print fine, but placed EPS images will print using the pixelated preview. This is why we need PostScript, which is a page description language developed by Adobe. When proofing a page layout via a PostScript printer, the image and text data in the layout are processed separately by a Raster Image Processor (RIP) which is either on the same machine or a remote computer. Once the data has been fully read and processed it is sent as an integrated pixel map (raster) file to print in one smooth operation. For example, you'll notice many proofing printers come supplied with PostScript (Level 3 or later). Normally a prepared CMYK image is embedded in the PostScript file of a page layout program and then converted in the RIP. The RIP takes the PostScript information and creates the series of dots for each separation to be output to

PostScript printers

There are many desktop PostScript printers to choose from for less than $10,000. Which one you should go for depends on the type of color work you do. Laser printers are useful to graphic designers where the low cost of consumables such as paper and toners is a major consideration. A setup including a laser printer and dedicated RIP server is ideal for low cost proofing and short run color laser printing. I am thinking here of a color laser printer such as a Canon copier or the recent QMS MagiColor 330GX. The ProofMaster Adesso RIP is a reasonable-priced software RIP for Mac OS X only. The ProofMaster Folio is a software RIP available on all platforms and works on around 90 types of inkjet printers (www.proofmaster.net).

Figure 14.5 This shows you how to customize the color management settings to simulate a CMYK proof and utilize a custom built profile for your printer. Under the Show More Options, select Color Management and select 'Document' to print direct from the current document color space. If you want to simulate a CMYK proof based on your current Proof Setup (see Figure 14.4), select 'Proof Setup' to use the current Proof Setup as the source color space. Select the profile of your inkjet printer as the Print Space Profile and set the Intent to Relative Colorimetric or Absolute Colorimetric (see the explanation in the body text). When you hit the Print... button repeat the same printing steps as were used to create the custom print profile.

film or plate. The Photoshop image data is likely to be in either TIFF or encapsulated PostScript (EPS) form in the file created by the page layout program and it is this which is passed along with the original vector images and fonts to be rasterized. Printing speed is dependent on the type of print driver software the printer uses and the amount of RAM memory installed in the server machine. Too little memory and either the document will take ages to process or won't print at all.

Printing via a RIP

In the studio office where I work, we have a number of printers. The Epson Stylus Photo1290 for example, is a reliable machine and I have successfully built profiles for a number of paper types with this printer. When I acquired the Epson 7600 Ultrachrome printer, I wanted to print using a dedicated RIP and decided to go for ImagePrint 5.6 from ColorByte software. The reason for this was that I wanted to mainly print to glossy roll paper when producing

Figure 14.6 The latest Epson Ultrachrome printers have proved popular with photographers who wish to produce enlarged prints or posters. The Epson 7600 shown here is reasonably priced but takes up a lot of space in the office.
 The paper can be fed into the printer either from rolls or as single sheets and is as simple to setup and manage as a normal desktop printer. This particular machine is connected to a print server Macintosh computer running the ImagePrint 5.6 by ColorByte Software. The ImagePrint interface is shown in Figure 14.7.

Figure 14.7 This is a screen shot of the ImagePrint 5.5 interface. ImagePrint is a visual RIP – you setup the page size and position the image to be printed on the page, When you select the paper type profile in the Color Management dialog, the document window will display a color managed preview of what the printed output will look like.

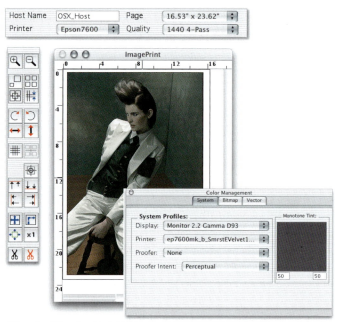

Client: Errol Douglas. Model: Vicky Kiernon @ Take Two.

posters for clients, but I also wanted to print on a variety of art paper types. ImagePrint is a visual RIP, which means it displays how the document will print the same as when in Photoshop, you use the Custom proof setup to create an adjusted preview on the screen. The Epson Ultrachrome printers are very consistent in output quality. So the paper profiles that are part of the software package, will work on any machine. The RIP software is being used as a replacement for the printer driver used by Photoshop. The software RIP is therefore directly communicating with the printer hardware, which means that the RIP software engineers are not constrained by what might be considered as limitations of the manufacturer's print driver defaults. For example, the ImagePrint program has its own way of controlling the inkjet printer heads to produce subtle tonal coloring in black and white prints.

Repro considerations

Color management plays an important role in ensuring that all the prepress activity comes together as smoothly as possible. For this reason, the profiling of RGB devices as described in the preceding chapter is very important. In today's rapidly changing industry, a digital file may take a very convoluted trip through the world of prepress. The aim of Photoshop ICC color management is to maintain consistency through this part of the process. In an 'all-digital' environment this is eminently doable. But once a digital file has been separated and converted to make the plates, it is down to the printer who is running the press to successfully complete the process.

Color management (even non-ICC profiled color management) is controllable and should be maintained within the digital domain, but once you leave that digital world and enter the press room, the operation takes a completely new direction. Fretting over how a proof print may have faded 0.3% in the last month is kind of out of balance to the bigger picture. The printer may be satisfied to keep the whole print job to within a 5% tolerance, although many manage to keep within even tighter

Quantity printing

If you are faced with a large print order there are some bureau solutions to consider. The Sienna printing process supplied by the photographic company Marrutt can produce low cost C-type prints in large quantities and at a reasonable cost. The aforementioned laser light writers such as the Lambda process are always going to be that bit more expensive. Beyond that, one should look at repro type solutions. The technologies to watch are computer to plate (CTP) or direct digital printing: Chromapress, Xericon and Indigo. These are geared to repro quality printing from page layout documents, containing images and text. They make short print runs an economic possibility.

tolerances. Imagine, for example, a large volume magazine print run. A printer may use up paper stocks from 17 different sources and make 'on-the-fly changes' to the press to accommodate for changing dot gain and other shifts which may occur during the run. The proof is like the printer's map and compass. Successful repro is as much dependent on the printer exerting their skills as it is reliant on the supplier of the digital file getting their side of the job right. Good communication can be achieved through the use of an accepted color proof standard. It is a mistake to think that one can accurately profile the final press output. The best we can hope to achieve is to maintain as accurate an RGB work flow as is possible and to this end, accurate profiling is very important. Once a file has been accurately proofed to a CMYK proofer that is the best we can do, because what happens next is generally out of our hands.

I have had a fair amount of experience producing this series of books on Photoshop. I will usually supply aim prints to the printer that have been printed using a desktop Epson printer and targeted using the custom profile based on the supplied press settings. We rarely have much trouble getting the colors right and the first proof sheets I get back from the printers are usually not that far out. After that I don't get to personally check every book of course, but I do get to see a fair sample of books and over a period of time. There are fluctuations in the color reproduction and that is to be expected. But they are well within an acceptable tolerance. If you want to learn more about printing from Photoshop, I can recommend some further reading: *Mastering Digital Printing* by Harald Johnson is a comprehensive title that does a good job of covering the subject of printing in extensive detail. *Real World Color Management* by Bruce Fraser, Chris Murphy and Fred Bunting and *Real World Photoshop CS* by Bruce Fraser and David Blatner are the industry bibles on the subject of color management.

File Formats

Photoshop supports nearly all image file formats. And some specialized file format plug-ins are supplied as extra on the Photoshop application CD. Choosing which format to output your images to should be determined by what you want to do with that file and the list can then be further narrowed down to a handful of recognized formats, appropriate to your needs. You may want to choose a format that is intended for prepress output, or screen-based publishing, or maybe you wish to use a format that is suitable for image archiving only. Screen-based publishing is a rapidly growing sector of the publishing industry and it is predicted that the percentage of designers operating in cross-media publishing, i.e. screen and print, will soon overtake those working in print design only. Adobe InDesign™ and Adobe GoLive™ enable you to share Photoshop files between these separate applications and see changes made to a Photoshop file be automatically updated in the other program. This modular approach means that many Adobe graphics programs are able to integrate with each other.

While an image is open in Photoshop, it can be manipulated without being limited by the range of features supported in the original source format. If you open an EPS format image in Photoshop and simply adjust the levels and save it, Photoshop will overwrite the original. But you can also edit the same EPS image in Photoshop, adding features such as layers or adjustment layers. When you come to save, you will be shown the Save dialog shown in Figure 14.8. This reminds you that the file contains features that are not supported by the EPS file format and alerts you to the fact that if you click Save now, not all the components in the image (i.e. layers) will be fully saved. This is because while you can save the file as an EPS, the EPS format does not support layers and the document will therefore be saved in a flattened state. If I were to select the native Photoshop file format and check the Layers box, then it will become possible for me to now save this version of the image in the native Photoshop format *and* preserve the layer features.

Maximum compatibility

Only the Photoshop, PDF and TIFF formats are capable of supporting all the Photoshop features such as vector masks and image adjustment layers. Saving in the native Photoshop format should result in a more compact file size, except when you save a layered Photoshop file with the Maximize Backward Compatibility checked in the preferences. Figure 14.12 at the end of this chapter contains a summary of file format compatibility with the various Photoshop features.

Figure 14.8 The Photoshop Save dialog box.

TIFF compression options

The TIFF format in Photoshop offers several compression options. LZW (which appears in the Save dialog box) is a lossless compression option. Data is compacted and the file size reduced without any image detail being lost. Saving and opening will take longer when LZW is utilized, so some bureaux will request that you do not use it. ZIP is another lossless compression encoding that like LZW is most effective where you have images that contain large areas of a single color. JPEG compression is a lossy compression method and is described more fully later.

TIFF (Tagged Image File Format)

This is the most universally recognized, industry-standard image format. Labs and output bureaux generally request that you save your output image as a TIFF, as this can be read by most other imaging computer systems. If you are distributing a file for output as a print or transparency, or for someone else to continue editing your master file, you will usually be safest supplying it as a TIFF. Photoshop 7.0 and CS saved TIFFs support alpha channels and paths, although bureaux receiving TIFF files for direct output will normally request that a TIFF file is flattened and saved with all alpha channels removed. Paths can cause problems too. This is because earlier versions of Quark Xpress had a nasty habit of interpreting any path that was present as a clipping path. An uncompressed TIFF is about the same size as shown in the Image Size dialog box. TIFF has the benefit of being able to support transparency and all of the Photoshop CS features (should you wish to). The byte order is chosen to match the computer system platform the file is being read on. However, most software programs

Figure 14.9 The TIFF save options allow you to apply LZW, ZIP or JPEG compression to a file. The Save Image Pyramid option will save a pyramid structure of scaled-down versions of the full-resolution image. TIFF pyramid-savvy DTP applications (there are none I know of yet) will then be able to display a good quality TIFF preview, but without having to load the whole file. If an open image contains alpha channels or layers, the Save dialog in Figure 14.8 will indicate this and you can keep these options checked to preserve these in a TIFF save. If the File Saving preferences have Ask Before Saving Layered TIFF Files switched on a further alert dialog will warn you after clicking OK to the TIFF options the first time you save a layered TIFF.

these days are aware of the difference, so the byte order is not relevant now. The main formats used for publishing work are TIFF and EPS (and also the native Photoshop file format in an Adobe InDesign™ or Illustrator™ work flow, where Maximize Backwards Compatibility must be switched on). Of these, TIFF is the more flexible format, but this does not necessarily imply that it is better. The PDF file format is also gaining popularity for DTP (desktop publishing) work. TIFF files can readily be placed in QuarkXpress™, PageMaker™, InDesign™ and any other DTP or word processing document. The TIFF format is more open though and unlike the EPS format, you can make adjustments within the DTP program as to the way a TIFF image will appear in print.

PSB format
Photoshop CS introduces a new file format that is targeted specifically for files that exceed the previous limit of 300,000 × 300,000 pixels. This implies that you can create huge-sized files, but the TIFF specification is limited to

Extended pixel limit

The extended pixel limit of PSB is useful in other ways though. If you have a large number of thumbnails in the File Browser, Photoshop CS is now able to display everything, whereas previously Photoshop 7.0 could display some thumbnails as black if there were more pixels than could be handled. PSB has to be enabled as an option in the General preferences and is the only format that will allow you to save an image with these greater dimensions. If you are in the business of creating extra large images, PSB will be the format to use, but the number of Photoshop users or other applications that can read the data will be limited (at least for the time-being).

EPS pros and cons

The downside of using EPS is that all the PostScript image data must be processed by the RIP every time you make an output, even if only a smaller amount of data is required to produce a proof and EPS files can take longer to process than a TIFF. However, you get an almost instantaneous rendering of the image preview when editing a DTP document on the screen.

4 GB and the native Photoshop PSD format, 2 GB. In addition, there are a lot of applications and printer RIPs that cannot handle images greater than 2 GB. There are exceptions, such as ColorByte's ImagePrint and Onyx's PosterShop. For this reason the $30,000 \times 30,000$ limit has been retained for all existing file formats in Photoshop CS.

EPS

EPS (Encapsulated PostScript) files are the preferred format for placing large color separated files within a page layout document. The EPS file format uses a low resolution preview to display the image on screen while the image data is written in the PostScript language used to build the output on a PostScript device. The image data is 'encapsulated' which means it cannot be altered within the desktop layout program (i.e. you need Photoshop to edit the image data). The saving options include:

Preview display: This is a low resolution preview for viewing in the page layout. The choice is between None, a 1-bit/8-bit TIFF preview which is supported on both platforms, or a 1-bit /8-bit/JPEG Macintosh preview. I recommend the 8-bit preview mode or JPEG Macintosh preview if working on the Mac.

Encoding: The choice is between ASCII or Binary encoding. ASCII encoding generates large files and is suited to PC platforms only. Binary encoded files are half the size of ASCII encoded files and can therefore be processed more quickly. Binary encoding is compatible with Mac and PC. JPEG coding produces the smallest sized, compressed files. Use JPEG only if you are sending the job to a Level 3 PostScript printer. Bear in mind that image quality will become significantly degraded whenever you select a lower quality JPEG compression setting.

Include Halftone Screen and **Include Transfer Functions:** For certain subjects, images will print better if you are able to override the default screen used on a print job. Transfer functions are similar to making Curves image adjustments. Check these boxes if you want information entered to

override the default printer settings. They do not alter the
screen appearance of the image and are adjusted to
accommodate dot gain output. The screen and transfer
functions are defined in Photoshop. If printing the same file
to two different printers, you may wish to save one file for
the final print job as it is and save another version for the
proof printer specifying the use of preset transfer functions
to compensate for the different printing characteristics. The
best advise is not to adjust anything here unless you are
absolutely sure you know what you are doing.

PostScript Color Management: This will enable PostScript
Level 2 devices or higher to read the Grayscale, RGB or
Lab profiles embedded in Photoshop and convert as
necessary. But I believe it is better to let Photoshop handle
the color management and conversions.

If any vector data is present in the document this can be
interpreted such that the vector information will be
rasterized in the EPS file. As usual, clipping paths can be
saved in an EPS file – a clipping path will act as an outline
mask when the EPS file is placed into a page layout
program. If you have a work path saved in the Paths palette
it can be specified to be used as the clipping path from
within Photoshop.

Figure 14.10 The Photoshop EPS Save dialog.

DCS

Quark Xpress also uses a version of the EPS format known as DCS (Desktop Color Separations). The DCS 1.0 format generates five separate files: one preview composite and four-color separation files. It can be difficult to manage all these individual color plate files, especially when there are a lot of images in a folder. The DCS 2.0 format is a self-contained file containing the preview and separations. Crucially, DCS 2.0 supports more than four color channels, i.e. spot colors and HiFi color.

PICT

PICT is primarily a Macintosh file format which while it can be read by PC versions of Photoshop, it is not a format for DTP work, although it has some uses in certain multimedia authoring applications. The PICT format utilizes lossless Run Length Encoding compression – areas of contiguous colors (i.e. subjects against plain color backgrounds) compress more efficiently without any image degradation, although files can be compressed using various levels of JPEG compression. I would add though that there is nothing about PICT which the native Photoshop file format cannot do better and there are also some pixel size limitations with the PICT format.

IVUE

The IVUE format was used by the Live Picture program for display and image processing in Live Picture. Although Live Picture is currently discontinued, there are a lot of die hard fans of the program who will want to continue to use it. Files can be converted from Photo CD or a TIFF file to the IVUE pyramid structure format using the Live Picture software before they can be opened in the Live Picture program. Photoshop and Live Picture complement each other and for that reason you can import IVUE files into Photoshop, for further modification. The IVUE Import plug-in (which came with Live Picture) must first be installed in the Photoshop plug-ins folder.

Figure 14.11 The DCS 2.0 Format options dialog box.

DCS 2.0 Format

Preview: Macintosh (JPEG)
DCS: Single File with Color Composite (72 pixel/inch)
Encoding: Binary

OK
Cancel

☐ Include Halftone Screen
☐ Include Transfer Function
☐ Include Vector Data
☐ Image Interpolation

File format	RGB	CMYK	Indexed Color	Grayscale	Layers	Alpha Channels	Paths	ICC	Annotations
Adobe Photoshop	•	•	•	•	•	•	•	•	•
Adobe Photoshop 2.0	•	•	•	•		•	•	•	
FlashPix	•			•			•		
CompuServe GIF			•						
JPEG	•	•					•		
Photoshop EPS	•	•	•	•					
Photoshop DCS 1.0		•					•		
Photoshop DCS 2.0	•	•		•		•	•		
Photoshop PDF	•	•	•	•	•	•	•	•	•
PICT	•		•	•			•	•	
PNG-8			•	•		•	•		
PNG-24	•			•		•	•		
Scitex CT	•	•		•			•		
TIFF	•	•	•	•	•	•	•	•	•

Figure 14.12 File format saving options showing which Photoshop features can be saved in the listed formats. Those indicated with a red dot are savable on the Mac OS only. This list includes file formats used to save for Web output (which are discussed in the following chapter).

Output for the Web

The Internet is something that most of us will use every day and having the means to transmit images can be just as important as being able to write. There is the well-known saying 'a picture is worth a thousand words. And it is so true, pictures allow us to communicate visually with clients, friends and family, in ways that words alone cannot. The most obvious advantage of sending or displaying images via the Web is it's immediacy. Pictures can be sent around the world almost instantly and it is quick and easy to prepare an image to be distributed. The downsides are that, unlike producing a finished print, you have little or no control over the way the image is viewed by the recipient and the people you want to have see your photographs must obviously have access to the Internet.

Let's look at the ways you would commonly want to distribute images over the Web. The simplest way of using the Internet is to transmit a file directly from yourself to one or more recipients. For a long time this has been done using a dedicated ISDN to transmit files directly. Setting up an ISDN connection is not cheap and there are line rental costs to consider as well. I would say that these days there is less demand for ISDN.

Email Attachments

With the increasing popularity of Broadband cable and ADSL connections, you can just as effectively use a fast connection to the Internet to transmit and receive large files. The easiest way to do this is to send the files as attachments in an email. Email programs may differ, but most should let you simple drag a file from a folder on your computer into the body text area of an email. Click Send and you're done – the attached document will be distributed along with the text message in the email. It's relatively easy to do, but by no means flawless, as there is no reliable way of knowing if the recipient's email program will be able to decode an attachment that has been sent from your email program. If you communicate using email this way, then you must remember to keep the attachments small. As a rule, I try to keep all attachments under 250 kilobytes. And that is assuming the recipient is also using a broadband type connection. If I wish to send anything bigger, then I like to check first to see if they mind receiving an attachment of so many kilobytes in size. Why? Because it is polite to check. The Internet suffers quite enough already with bandwidth being consumed by unwanted junk emails. Don't add to the problem by sending large, unsolicited attachments. But if it is OK to send a big file, ask the recipient if there is a limit in place for the size of files they can receive in a single email. If you exceed this, the email will only bounce back to you, so it is always worth checking.

Sending multiple images by email

Email programs can accept single or multiple attachments of any format, but not as a folder, unless compressed into an archive such as that provided by Aladdin Software, the ubiquitous Stuffit program. Although this originated for the Mac it is available to Windows and handles Zip compression as well as its own proprietary format. It is lossless, as well as avoiding the problem of Mac files appearing on Windows machines as two identically named files which contain the data and resource forks that constitute a Mac file. The archive created has a .sit extension, that requires expansion by Stuffit (which is incorporated into the MacOS), but this can be made self-extracting and then bears the .sea extension. Either WinZip or Stuffit can expand the Mac created archives. If the pictures in the source folder are JPEGs, then you probably won't notice a big difference in the final file size. Don't worry, this compression will not compromise the quality of the JPEG images.

FTP software

You will need File Transfer Protocol (FTP) software to upload documents to the server space. If using a Macintosh, I recommend using Fetch www.fetchsoftworks.com. If you are working on a PC, try using WS_FTP Pro www.ipswitch.com or Flash FXP www.flashfxp.com. All FTP software is more or less the same. To establish a connection you need to provide a link address to connect to the server. Next you need to enter your User ID and finally your password. If you are familiar with the steps required to configure your email account, you should already have the username and password information to hand. You may need to enter a sub-directory folder as well. If you have trouble configuring the connection, speak to your ISP. They are the best people to help you in these instances.

So to sum up, as long as you are aware of the parameters of how email programs work and the possible limitations of the recipient's server, email can be an effective way to transfer smallish documents. Lots of people use email this way to share photographs. And the advanced email programs are also capable of displaying image file attachments within the body text area. But remember, this is by no means a foolproof way to send large images.

Uploading to a server

With email you are sending a message that has the image embedded in it. If instead you upload an image file to a server, you can then send an email that contains a clickable link that launches the recipient's web browser and takes them directly to a page from where they can download the image. The advantage of this is that the email you send is small, as it contains text only. There will be less risk of the email being rejected and if the person you are sending the email to needs to share the image with someone else, they only have to forward the message. They don't have to forward the entire image attachment all over again. But first you need to know how to upload to a server. If you connect to the Internet using a subscription service your Internet Service Provider (ISP) will most likely have provided you with a limited amount of server space that you can use to host your own website and upload files for others to download from in the way I described. If you don't have a subscription service or your ISP doesn't provide enough adequate server space, then you can always rent space from a company that maintains a dedicated server and provides web hosting. I use Image Access at <www.image-access.net> to host my websites and they provide me with all the server space that I require.

Figure 15.1 shows the Fetch connection dialog box and how I would typically connect to a server. To save having to reenter the information each time you connect, it should be possible to save this information (along with the password if you wish) as a shortcut so that logging on to

the server becomes almost as easy as opening a folder on your hard disk. Another option available to Macintosh users is iDisk. This is a Macintosh utility that has been enhanced for Mac OS X 10.3. iDisk is an on-line server space that you can use for off site backup storage or as a space to place publicly-accessible files and folders.

I typically use my FTP software on a regular basis to upload image documents and Web photo galleries, created in Photoshop. To give you an example of how I do this, I will create a document and make a connection to the server. The connection window opens, and this is like any other hierarchically structured folder. The main connection window will display the website documents and sub-

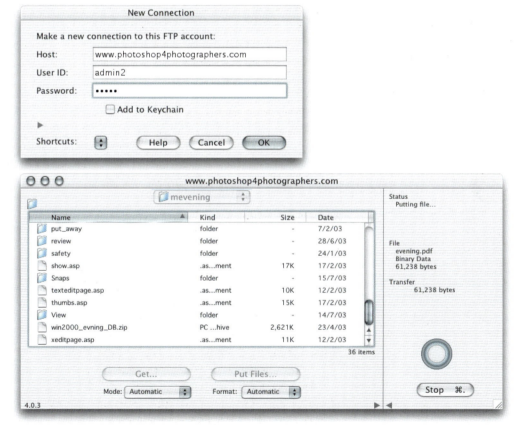

Figure 15.1 The Fetch 4.0 FTP software interface, showing a new server connection being made.

Recompressing JPEGs

Once an image has been compressed using the JPEG format, it is not a good idea to repeatedly resave it as a JPEG, because this will only compound the damage already done to the image structure. Unlike some programs, the JPEG compressor used in Photoshop converges, so that after repeated expansions and compressions using the same settings and without modifying the pixels, the data loss will be less and less with every save, to the point where there will be little or no further loss. The JPEG format should mainly be used to save a copy of an image whenever you want to reduce the file size so as to occupy a smaller amount of disk space. You normally want to compact a file in this way for inclusion on a web page, for faster electronic distribution, or saving a large file to a restricted amount of disk space. Some purists will argue that JPEG compression should never be used under any circumstances when saving a photographic image. It is true that if an EPS or TIFF file is saved with JPEG file compression this can cause problems when sending the file to some older PostScript devices. But otherwise, the image degradation is barely noticeable at the higher quality compression settings, even when the image is viewed on the screen in close-up at actual pixels viewing, never mind when it is seen as a printed output.

folders. In here, I have created new sub folders with names like 'Locations', 'travel' and 'review'. I use these specific folders to upload documents to, so that they do not get mixed up with the folder structure of the main website. I will then double-click on a folder such as 'Review' to reveal the sub folder contents and then drag the Internet-ready file or folder across into this window. And that's it – the time this takes to accomplish will depend on the size of your file and Internet connection speed. To access these files, you need to supply people with a weblink. To illustrate how this works, I have uploaded a photograph to my server which you can access by typing in the following URL address in your web browser: www.martinevening.com portraits/evening.pdf. This is an image document which was saved as a Photoshop PDF file. You will probably see a message asking if you want to save the file to the computer hard drive. Click save and the file will start to download. The reason I saved this image as a Photoshop PDF was to demonstrate the security features that are available when using this format. To open the PDF file you will need to enter the password *'evening'* when prompted (the Photoshop PDF file format is discussed on page 442).

File formats for the Web

Now that we have covered the fundamentals of how to access a server and administer your allocated server space, let's look at preparing images to be displayed on the Web and take a look at the different file formats you can use and which are the best ones to choose in any given situation.

JPEG

The JPEG (Joint Photographic Experts Group) format provides the most dramatic way to compress continuous tone image files. The JPEG format uses what is known as a 'lossy' compression method. The heavier the compression, the more the image becomes irreversibly degraded. For example, an 18 MB, 10" × 8" file at 300 ppi resolution can be reduced in size to around 1 MB with hardly any degradation to the image quality. If you open a moderately

Figure 15.2 Two JPEG images: both have the same pixel resolution and both have been saved using the same JPEG quality setting. Yet the Sahara desert image will compress to just 21 kilobytes, while the gas works picture is over three times bigger at 74 kilobytes. This is because of all the extra detail contained in the industrial picture. The more contrasting sharp lines there are, the larger the file size will be after compression. For this reason it is best not to apply too much unsharp masking to an image before you save it as a JPEG. If necessary, you can deliberately apply blur to a background in Photoshop to remove distracting detail and thereby reduce the JPEG size.

compressed JPEG file and examine the structure of the image at 200%, you will probably notice that the picture contains a discernible checkered pattern of 8 × 8 pixel squares. This mosaic pattern will easily be visible at actual pixels viewing when using the heaviest JPEG setting. Compression is more effective if the image contains soft tonal gradations as detailed images do not compress quite so efficiently and the JPEG artifacts will be more apparent.

The JPEG format is mostly used for web design work. A medium to heavy amount of JPEG compression can make most photographs small enough to download quickly over the Internet. Image quality is less of an issue here when the main object is to reduce the download times. Photoshop compresses images on a scale of 0–12. A setting of 12 will apply the least amount of compression and give the highest image quality. A setting of 0 will apply the greatest amount of compression and be the most lossy.

Choosing the right compression type

As you can see in Figure 15.4, JPEG compression is a most effective way to reduce file size, but this is achieved at the expense of throwing away some of the image data. JPEG is therefore known as a 'lossy' format. At the highest quality setting, the image is barely degraded and the JPEG file size is just 70 kilobytes, or 12% of its original size. If we use a medium quality setting the size is reduced further to just 18 kilobytes. This is probably about the right amount of compression to use for a photograph that features in a typical web page design. The lowest compression setting will squeeze the original 586 kilobytes down to under 7K, but at this level the picture will appear extremely 'mushy' and it is best avoided.

Figure 15.3 The JPEG Options save dialog box. Baseline Standard is the most universally understood JPEG format option and one that most web browsers will be able to recognize. Baseline Optimized will often yield a slightly more compressed sized file than the standard JPEG format and most (but not all) web browsers are able to read this correctly. The Progressive option creates a JPEG file that will download in an interlaced fashion, the same way you can encode a GIF file.

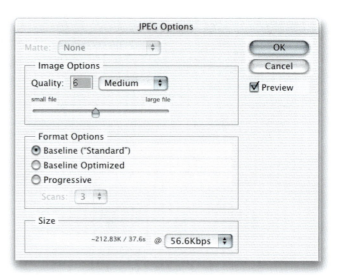

Client: Clipso. Model: Bianca at Nevs.

Figure 15.4 Here we have one image, but saved thirteen different ways and each method producing a different file size. The opened image measures 500 × 400 pixels and the true file size is exactly 586 kilobytes. The native Photoshop format is usually the most efficient format to save in. Large areas of contiguous color such as the white background are recorded using a method of compression that does not degrade the image quality. The PICT format utilizes the same 'run length encoding' compression method, while the uncompressed TIFF format doggedly records every pixel value and is therefore larger in size.

Figure 15.5 This close-up view of the JPEG saved at the 10% quality setting clearly reveals the underlying 8 × 8 pixel mosaic structure, which is how the JPEG compression method breaks down the continuous tone pixel image into large compressed blocks. At the higher quality settings you will have to look very hard to even notice any change to the image. Successively overwriting a JPEG will degrade the image even further. However, if no cropping or image size change takes place, the degradation will only be slight. As a general rule always re-JPEG an image from the uncompressed master file.

Zoom tool

Hand tool Description box

File size

Compression mode

Quality setting

Include metadata

Include transparency

JP2 compatibility

Optimization setting

Download speed

Preview button

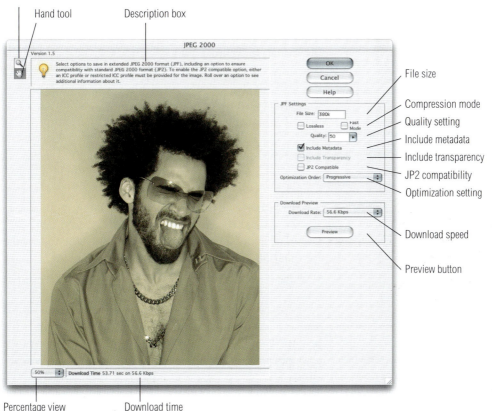

Percentage view Download time

Figure 15.6 The JPEG 2000 dialog.

Keeping it small

Only one thing matters when you publish images on the Web and that is to keep the total file size of your pages as small as possible. The JPEG format is the most effective way to achieve file compression for continuous tone images. But graphics that contain fewer, distinct blocks of color should be saved using the GIF format. Some web servers are case sensitive and will not recognize capitalized file names. Go to Edit menu and select Preferences > Saving Files and make sure the Use Lower Case Extensions box is checked.

JPEG extras

JPEG 2000 is different to the standard JPEG format because it has more extensive features. For example, you can save a 16-bit per channel image, which you can't do with ordinary JPEG and you can save alpha channels and paths, plus it is possible to choose to preserve the camera EXIF and all other metadata when you save an image using this format. But the main problem at present is that only another Photoshop CS user or someone who has bought the Camera Raw + JPEG 2000 plug-in for Photoshop 7.0 can read files that are encoded using the JPEG 2000 file format. There will be other programs in the future that will support it, including web browsers, but for the time being, use with caution.

When you choose to save as a JPEG, the document window preview will change to reflect how the compressed JPEG will look after it is reopened again as a JPEG. The JPEG Options dialog box will also indicate the compressed file size in kilobytes and provide an estimated modem download time. This feedback information can be really helpful. If you save a master file as a JPEG and then decide the file needs further compression, you can safely overwrite the last saved JPEG using a lower JPEG setting. It is possible to repeat saving in the JPEG format this way. For as long as the image is open in Photoshop, all data is held in Photoshop memory and only the version saved on the disk is degraded.

JPEG 2000

Photoshop CS was released in 2003, but the JPEG 2000 file format is still regarded as being fairly new and Adobe are so far the only serious player to have offered support for this format. To save a file using JPEG 2000, you need to check that the JPEG 2000 plug-in has been installed first. If not, it can be found in the Optional plug-ins folder inside the Goodies folder on the Photoshop application CD. Drag the plug-in to your Photoshop CS folder and place it in the File Format folder inside the Photoshop Plug-ins folder.

The JPEG 2000 save dialog is shown in Figure 15.6. The Zoom and Hand tools are self-explanatory. The Description box provides a commentary on the function of the other dialog items as you mouse over them. The main controls are over on the right, starting with the File Size box. This displays the current projected file size of the compressed JPEG file, but you can also type in the desired file size and Photoshop will calculate a custom file compression to meet this target figure. Below that is the Lossless compression mode button which if checked will render a larger file size, but non-lossy JPEG. The Quality setting can be set anywhere between 1–100%, with 100% being the highest quality image setting. JPEG 2000 does not support layers, but if the base layer is a non-background

layer and contains transparent pixels, checking the Include Transparency box will preserve the transparency. This will one day be useful for web designers when web browsers are able to recognize JPEG 2000 files. The Optimization settings are identical to those found in the Save for Web dialog which is discussed later on in this chapter on page 444.

GIF

The GIF (Graphics Interchange Format) is normally used for publishing graphic type images such as logos. Some people pronounce GIF with a soft G (as in George) and others use a hard G (as in garage). Neither is right or wrong as both forms of pronunciation are commonly used. To prepare an image as a GIF, the color mode must be set to Indexed Color. This is an 8-bit color display mode where specific colors are 'indexed' to each of the 256 (or fewer) numeric values. You can select a palette of indexed colors that are saved with the file and choose to save as a CompuServe GIF. The file is then ready to be placed in a web page and viewed by web browsers on all computer platforms. That is the basic concept of how GIFs are produced.

Working with GIF in Photoshop

Photoshop contains special features to help web designers improve the quality of their GIF outputs, such as the ability to preview Indexed mode colors whilst in the Index Color mode change dialog box and an option to keep matching colors non-dithered. This feature will help you improve the appearance of GIF images and reduce the risks of banding or posterization. Be aware that when the Preview is switched on and you are editing a large image, it may take a while for the document window preview to take effect, so make sure that you resize the image to the final pixel size first. You will find that when designing graphic images to be converted to a GIF, those with horizontal detail compress better than those with vertical detail – due to using Run Length Encoding (RLE) compression.

Figure 15.7 The GIF file format is mostly used for saving graphic logos and typography. The picture opposite is one that was used for the cover design of an earlier edition of this book. But this is also a good example to illustrate the type of image that would be suitable for saving in the GIF format for use on a web page design. Note that the image contains a large amount of solid red and few other colors. This photograph was reduced in size to around 350 x 300 pixels. I then converted the image to Index Color mode using a palette of 16 colors. When the image was saved as a GIF it measured a mere 19 kilobytes.

Figure 15.8 The PDF Options dialog. You can save all of the Photoshop CS features in the PDF format and include password security to restrict file access to unauthorized users.

PDF versatility

The PDF format in Photoshop is particularly useful for sending Photoshop images to people who don't have Photoshop, but do have Adobe Acrobat Reader on their computer. If they have a full version of Acrobat they will even be able to conduct a limited amount of editing, such as changing a text layer slightly. Photoshop is also able to import or append annotations from Adobe Acrobat. The Include Vector Data options allow you to embed text layer fonts and vector layer information. Use the Use Outlines for Text option only if you are dealing with an application that will have trouble interpreting the embedded font information.

Photoshop PDF

The PDF (Portable Document Format) is a cross-platform file format initially designed to provide an electronic publishing medium for distributing page layouts to people, without the need for the originating program. It has now gained far wider acceptance as a reliable and compact method of supplying pages to printers, due to its ability to embed fonts, compress images and be accurately color-managed. It is the native format for Acrobat, and is now almost native to both Illustrator and Photoshop, because it can preserve everything that a Photoshop (PSD) file can. Adobe Reader™ and its predecessor Acrobat Reader are free, and easily obtained from magazine covers and the Adobe Web site. Adobe Acrobat can reproduce pages designed in InDesign or Illustrator to be viewed as self-contained documents. Best of all, Acrobat documents are small in size and can be printed at high resolution. I can create a document in PageMaker™ and export as an Acrobat PDF using the Acrobat Distiller program (Distiller is part of the Acrobat program and also included as a separate, stand-alone application with PageMaker). Anyone who has installed the Adobe Reader program can open the PDF document I supply and see the layout just as I intended it to be seen, with the pictures in full color plus text displayed using the correct fonts. The Photoshop PDF format (see Figure 15.8) can save *all* Photoshop CS features, with either JPEG or lossless ZIP compression and is backwards compatible in as much as it will save a flattened composite for viewing within programs that are unable to fully interpret the Photoshop CS layer information.

PDF security

The PDF security options allow you to restrict file access to authorized users only. This means that a password will have to be entered before an image can be opened in either Acrobat or Photoshop. And you can also introduce a secondary password for permission to print or modify the PDF file in Acrobat. Note that this level of security only

Figure 15.9 The Photoshop PDF Security options.

Figure 15.10 If you try to open a generic Acrobat PDF from within Photoshop by choosing File ⇨ Open, you will see the Rasterize Generic PDF Format dialog, shown here. If you choose File ⇨ Import ⇨ PDF Image, you can extract the individual images (or Import All) from a self-contained PDF document.

Importing multi-page PDF files

The Photoshop Parser plug-ins enable Photoshop to import any Adobe Illustrator, EPS or generic single/multi-page PDF file. Using File ⇨ Automate ⇨ Multi-page PDF to PSD, you can select individual pages or ranges of pages from a generic PDF file, rasterizing them and saving to a destination folder. Use File ⇨ Import ⇨ PDF Image to extract all or individual image/vector graphic files contained within a PDF document as separate image files (see Figure 15.10).

applies to reading the file in Acrobat. You can only password protect the opening of a PDF file in Photoshop. Once opened in Photoshop, it will be fully editable. Even so, this is still a very useful feature. The PDF security allows you to prevent unauthorized first level access to your images. There are two security options: 40-bit RC4 for lower-level security and compatibility with versions 3 and 4 of Acrobat and 128-bit RC4, for higher security using Acrobat 5 and Acrobat 6.

PNG (Portable Network Graphics)

This file format can be used for the display and distribution of RGB color files on-line and also available as a file format option in Save for Web. PNG (pronounced 'ping') features improved image compression and enables alpha mask channels (for creating transparency) to be saved with the image. Other advantages over JPEG and GIF are higher color bit depths, supporting up to 32-bit images and limited built-in gamma correction recognition, so you can view an image at the gamma setting intended for your monitor. Newer versions of Netscape Navigator and Microsoft Internet Explorer web browsers will support the PNG format. Microsoft plan to phase out Internet Explorer for Mac OS X, but Apple's Safari web browser program will also support PNG.

Save for Web

The Save for Web option is found in the File menu. This comprehensive dialog interface gives you absolute control over how any image can be optimized for web use when choosing either JPEG, GIF, PNG-8 or PNG-24 formats. The preview display options include: Original, Optimized, 2-up and 4-up views. Figure 15.11 shows the dialog window in 2-up mode display. With Save for Web you can preview the original version of the image plus up to three variations using different web format settings. In the annotation area below each preview, you are able to make comparative judgements as to which format and

Save for Web tools

Preview display options

Optimize settings Optimize menu

Preview menu Output settings

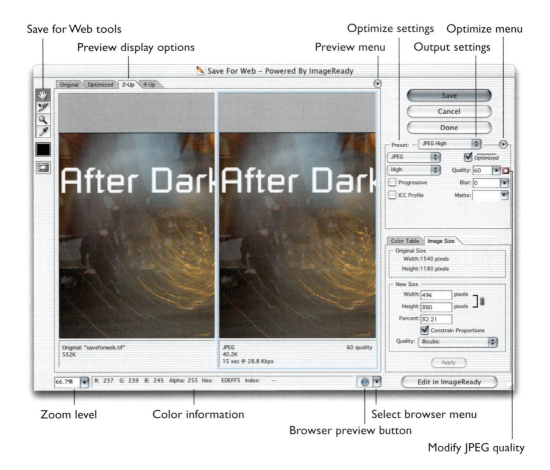

Zoom level Color information Select browser menu

Browser preview button

Modify JPEG quality

Figure 15.11 The Save for Web interface. Click on the button next to the Quality setting to open the Modify Quality Setting dialog. This will allow you to use an alpha channel to zone optimize the JPEG compression range or as shown above you can check the All Text Layers box to apply a higher quality compression setting to the text areas and a lower compression to the remaining image.

compression setting will give the best payoff between
image quality and file size, and also determine how long it
will take to download at a specific modem speed. Use the
Preview menu to select from a list of modem and Internet
connections on which these download times are based. You
can also use the Preview menu list to select a preview
setting and simulate how the web output will display on
either a Macintosh display, a PC Windows display or with
Photoshop compensation. The Select Browser menu allows
you to select which web browser to use when you want to
preview a document that has been optimized, in the
preferred system web browser program (see Figure 15.14).

Photoshop provides an option for Progressive JPEG
formatting. Most Netscape and Internet Explorer browsers
support this enhancement, whereby JPEGs can be made to
download progressively the way interlaced GIFs do. The
optimized format (see checkbox below the Optimize menu)
can apply more efficient compression, but again is not
generally compatible with really old web browser
programs. The quality setting can be set as Low, Medium,
High, Maximum or it can be set more precisely as a value
between 1 and 100%. Custom Save for Web output settings
can be saved via the Optimize menu. The Blur control will
allow you to soften an oversharpened original and obtain
further file compression when using the JPEG format.

Next to the Quality setting is a small selection mask
icon. Click on this icon to open the Modify Quality
Settings. In the JPEG mode Save for Web dialog you can
set zone optimized levels of compression based on the text
layer/vector layer content or an alpha channel stored in the
master document (see Figure 15.11) so that areas of
important detail can have less JPEG compression applied
to them. Adjust the sliders to establish the range of JPEG
compression from the total mask to no mask areas, and
vary the softness of this transition. In Figure 15.11, the All
text Layers option is checked and you can see a preview of
the mask based on the text layer in the Modify Quality
settings dialog. A higher quality of JPEG compression will
therefore be applied to the text in the final JPEG output. In

Figure 15.12 From the Optimize menu you can open the Optimize To File Size dialog and specify the optimum number of kilobytes you want the file to compress to.

the Save for Web GIF format mode (discussed next), an alpha channel can also be used to zone optimize the color reduction and modify the dither settings. The Save for Web Save dialog lets you save as: HTML and Images, only, or HTML only. The output settings allow you to determine the various characteristics of the Save for Web output files such as: the default naming structure of the image files and slices; the HTML coding layout; and whether you wish to save a background file to an HTML page output. Figure 15.14 shows an example of a temporary document window generated with the HTML code generated by Save for Web along with the HTML code in the format specified in the output settings.

Figure 15.13 The HTML section of the Optimize Settings found in the Save for Web dialog. Other menu options include Background, Saving, and Slices. Click on the Generate CSS button to create cascading style sheets based on the current image slicing.

Figure 15.14 When a browser window preview is selected (see Figure 15.11), the default web browser program is launched and a temporary page will be created, like the one illustrated opposite. This will allow you to preview the Save for Web processed image as it will appear on the final web page. This is especially useful for checking if the RGB editing space used will be recognized differently by the browser. If you are relying on embedded ICC profiles to regulate the color appearance on screen, you can check to see if the profile is indeed being recognized by the selected web browser program.

The Image Size options are fairly similar to those found in the Image ⇨ Image Size dialog box. Just simply enter a new percentage to scale the image to and check what impact this will have on the file size (this will change the file size in all the optimized windows). An alternative approach is to select Optimize To File Size from the Optimize menu (see Figure 15.12). Use this to target the optimized file to match a specific kilobyte file size output and if you wish, have Photoshop automatically determine whether it is better to save as a GIF or JPEG.

The GIF Save for Web options are also very extensive. You have the same control over the image size scale and can preview how the resulting GIF will appear on other operating systems and browsers – the remaining options all deal with the compression, transparency and color table settings that are specific to the GIF format. The choice of color reduction algorithms will allow you to select the most suitable 256 maximum color palette to save the GIF in. This includes the 8-bit palettes for the Macintosh and Windows systems. These are fine for platform specific work, but such GIF files may display differently on the other system's palette. The Web palette contains the 216

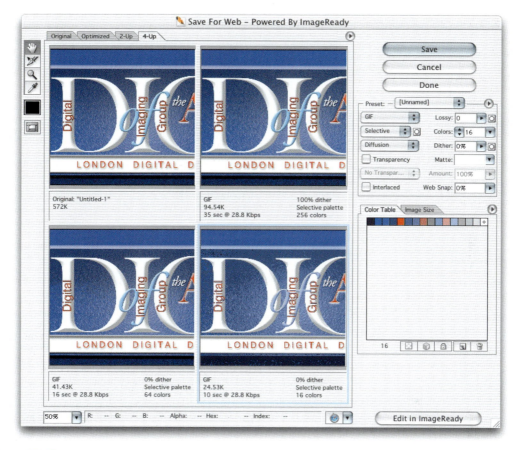

Figure 15.15 The Save for Web interface showing GIF settings. Design: Rod Wynne-Powell.

colors common to both platforms and is therefore a good choice for web publishing if viewers are limited to looking at the image on an 8-bit color monitor display. Now to be honest, restricting your colors to a Web palette should not really be that necessary these days, but the option is still there. The Perceptual setting produces a customized table with colors to which the eye is more sensitive. The default Selective setting is similar to the Perceptual table, but more orientated to the selection of web safe colors – this is perhaps the best compromise solution to opt for now as even the most basic PC setup sold these days is well able to display 24-bit color. The Adaptive table palette samples the

Figure 15.16 The color table with Color palette fly-out menu shown.

A: Maps the selected color to transparency.

B: Shifts/unshifts selected colors to the Web palette.

C: Adds eyedropper color to the palette.

D: Deletes selected colors.

Web snap colors

The Web Snap slider will let you modify the Color table by selecting those colors that are close to being 'browser safe' and making them snap to these precise color values. The slider determines the amount of tolerance and you can see the composition of the Color table being transformed as you make an adjustment. The Interlace option will add slightly to the file size, but is worth selecting – the image will appear to download progressively in slices.

colors which most commonly recur in the image. In an image with a limited color range, this type of palette can produce the smoothest representation using a limited number of colors.

The Lossy option allows you to reduce the GIF file size by introducing file compression. This can be helpful if you have an overlarge GIF file. But too much compression will noticeably degrade the image until it looks like a badly tuned TV screen. The diffusion dithering algorithm is effective at creating the impression of greater color depth and reducing any image banding. The Dither slider allows you to control the amount of diffusion dithering. The Pattern and Noise options have no dither control. If the image to be saved has a transparent background, the Transparency option can be kept checked in order to preserve the image transparency in the saved GIF. To introduce transparency in an image you can select the color to make transparent using the eyedropper tool and clicking inside the image preview area. The color chosen will appear selected in the color table. Select one or more colors and click on the Map Selected Colors to Transparent button in the Color table. You can apply a diffusion, pattern or noise dither to the transparent areas, which will help create a smoother transparent blend in your GIF.

1 The following steps are based on a tutorial I wrote a few years ago for *PEI magazine*, which showed you how to add a copyright symbol as a watermark. It is worth repeating the tutorial here because it illustrates an approach to watermarking images that makes use of the limited security features of the Adobe Acrobat PDF format.

2 To add a copyright symbol, choose Rulers from the View menu, double-click either ruler and set the ruler units to Percentage. Drag two guides out to intersect at 50%. Now select the Type tool, choose centered type alignment and click on the center point. Nearly all typefaces will produce a copyright symbol when you type [⌥][G] [alt][G]. The font size will probably be too small, so use Edit ⇨ Free Transform and use the [⌥][alt] key plus drag the corner handles to enlarge from the center. When happy with the transform click OK.

3 You could at this point choose Layer ⇨ Type ⇨ Convert to Shape. This will save the copyright symbol as a custom shape and saved to the Shapes presets folder, where it can easily be accessed again for future use. It does not really matter about the color of the type at this stage. Go to the Layers palette and set the Fill opacity to zero percent. The logo disappears. But if you add an effects layer such as Bevel and Emboss, the effect will become visible. The only adjustment I made in the Layer Style dialog was to reduce the Multiply opacity to 15%.

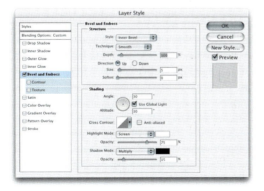

4 If you follow my advice about saving the copyright symbol as a custom shape, you can quite easily record a Photoshop action using the steps described. Just load the copyright symbol custom shape instead of entering in type. That way you can record an action that will always produce a correctly scaled symbol regardless of the image pixel dimensions. Lastly, I saved the image as a PDF using the PDF security options to make the image password protected. To open in Acrobat or Photoshop you will need to know the relevant passwords. Once a user has successfully entered a password they will see the layered image and can delete the watermark layer. Other copies made from this master file can serve as proof copies for use in page layouts or as a JPEG version on a website.

Client: Rainbow Room. Model: Greta at FM.

ZoomView Export

The ZoomView plug-in is made by Viewpoint <www.viewpoint.com>. There is a ZoomView Export option in the File menu with which you can create an output folder containing all the necessary components to produce a zoomable image web page. Visitors to these pages will need to have installed the Viewpoint Media Player (VMP) which is compatible with many (but not all) web browsers. The ZoomView format is ideal for portfolio presentations and commerce websites, where customers can easily view large images in close-up detail, downloading these views as tiled JPEGs.

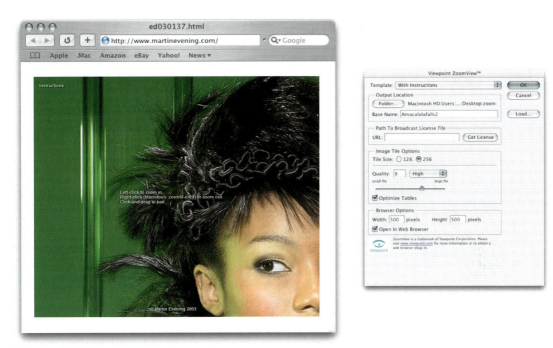

Figure 15.17 Here is the ZoomView export dialog box. The output will be a folder that contains all the necessary components to display a zoomable image. Once created, all you have to do is upload the folder to your website and add /*foldername*/*basename.html*/ to the usual URL weblink (note that the Base Name is based on the image's file name). Visitors to your website will be reminded that they must have a Viewpoint Media Player plug-in installed for their Web browser in order to see ZoomView images (unless it is already installed). Once the page has been accessed, visitors can left mouse-click on an area of interest to zoom in and _ctrl_ right mouse-click to zoom out. Licensing is free for noncommercial purposes. Commercial users must pay a licence fee to Viewpoint.

Web Photo Gallery

The Web Photo Gallery (WPG) can be used to process a folder of images and automatically generate all the HTML code needed to build a website complete with thumbnail images, individual gallery pages and navigable link buttons. This Photoshop feature can save you many hours of repetitive work. I use this automated plug-in all the time, and it is an essential tool in my daily production workflow. Imagine you have a set of Photoshop images that need to be forwarded to a client or colleague. When you build a self-contained web photo gallery in Photoshop, the processed images and HTML pages are output to a destination folder. You can then upload this processed

folder to your web server and simply pass the URL link on to the person who needs to see the photographs. For a quick reminder of how to do this, refer back to Figure 15.1. Drag the WPG processed folder across to the Server window and pass on the URL link via email. In the Figure 15.18 example, I decided to call the destination folder 'i3forum' and place it inside a folder called 'portraits' on my server. I therefore appended '/portraits/i3forum/' to my normal website address as the full URL for the recipient to follow. It is necessary to add a forward slash at the end of the URL link. This indicates that 'i3forum' is a folder containing a directory of files. But there is no need to add 'index.htm' after the forward slash because a web browser will by default always look for a file called 'index.htm' or 'index.html'.

The source can be any folder of images, regardless of whether they are in RGB or CMYK color mode. But if it is a really critical job, you might wish to make duplicates of all the source images and convert these to sRGB color first. Remember that the File Browser in Photoshop CS has its own Automate menu and you can now select the source images for a Web Photo Gallery directly from the File Browser thumbnails. This opens up a number of new workflow scenarios. For example, when applying flags to specific images in the File Browser, you can choose to display the flagged images only and proceed to create a gallery of these selected images and the Web Photo Gallery will ignore all the unflagged images. Furthermore, you can highlight specific images to make a selection and process only these pictures. The image order can be changed by simply dragging the thumbnails in the File Browser window. When the Include all Sub folders box is checked the subsets of folders can be processed too. It is not essential that you resize them to the exact viewing size, as the Web Photo Gallery options allow you to precisely scale the gallery images and thumbnails down in size while they are being processed.

There is a choice of ten brand new template styles to choose from in Photoshop CS (see Figure 15.20). Some of

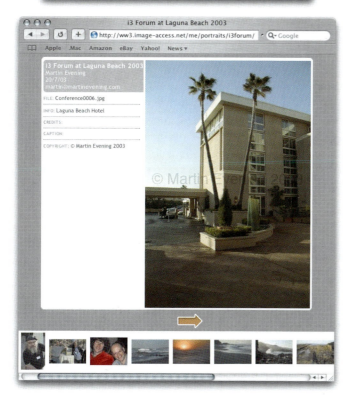

Figure 15.18 The Photoshop Web Photo Gallery will let you save extra information such as contact details and an active link to your email address. The security feature will enable you to apply a visible watermark to the gallery images that are created. This can be based on file data such as the file name, caption information, or alternatively, you can enter some customized text.

Figure 15.19 Once the Web gallery has been completed, it will automatically launch the completed pages in your default web browser, so you can preview the resulting pages off-line before uploading them to the server.

i3 Forum

The i3 Forum is a unique conference where leading figures from the world of digital imaging working in 2D, 3D design and movie making, including software engineers, authors and artists, gather together to share new ideas. To find out more, visit: <www.i3forum.com>.

these templates have a simple HTML table design, while others utilize frames and basic JavaScript. These gallery styles can be customized to some extent by adjusting the Options settings, as described on the following pages. Because these templates vary a lot in their design, not all of the options settings will be recognized when you come to build a gallery. If you process a folder of images and are not sure about the look of the layout chosen, then try adjusting the Options settings or selecting an alternate WPG style. It is worth pointing out that if you have to redo a Web Photo Gallery because the banner title was incorrect or you want to change the contact details, make sure the 'Add Width and Height Attributes for Images' option is checked in the General settings. Photoshop will not need to reprocess all the image data and will instead recode the HTML. After a web gallery has been processed the settings used will be remembered the next time you use the Web Photo Gallery.

You can also create your own layout templates. Go to the Photoshop CS/Presets/Web Photo Gallery folder and use the folders in there as a guide for designing your own customized HTML templates. One easy way of doing this is to make a copy of an existing WPG template, take a peek inside the template's images folder and open the various graphic elements in Photoshop. You can then create your own alternative graphic designs for things like the buttons and background patterns and save these, overwriting the previous image files, using the exact same file names. Give the modified template a new name and the next time you run the WPG, it will appear in the Styles pop-up menu. If you want to be really adventurous, search the Adobe Photoshop Help database for information listed under: Customizing Web Photo Gallery Styles and using tokens in Web Photo Gallery styles. This will provide tips and instructions on how to write the HTML code from scratch. Remember, when the output folder is complete, you can further enhance the appearance of your gallery pages by importing them into a separate website editing program such as Adobe GoLive™.

General

The Use UTF 8 Encoding option will apply to the URL only. If the Add Width and Height Attributes for Images is checked, Photoshop will be forced to reprocess every image every time you regenerate a Web Photo gallery, even if all you do is to change the Banner title. I prefer to uncheck this option. The Preserve all metadata option will ensure that the metadata is not stripped out of the image files you create, but at the expense of making the gallery images all bigger in size.

Banner

Enter the name of your site in the Site Name field. The text entered here will appear in both the title bar and as a bold heading on the gallery pages. Type your name below, or to be more specific type something like: 'Photography by:' followed by your name. Type in your contact details below, although only the Centered Frame, Horizontal Feedback and Horizontal Slideshow templates will use this data. Today's date will automatically appear in the Date Field and lastly you can customize the font type and font size used.

Large Images

This lets you control the size and appearance of the main gallery images. You can determine whether the images need to be resized or not, the pixel dimension limits and the JPEG quality setting to use, plus you can specify the number of pixels to add as a border. Many of the templates are capable of displaying image file metadata such as the Description (used to be Caption) and Copyright metadata. If the checkbox is enabled (and checked), this information is capable of appearing alongside or underneath each gallery image.

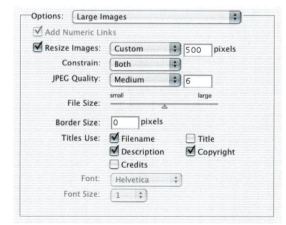

Thumbnails

The thumbnails are smaller versions of the main image files that are used as a visual aid to navigation. The thumbnail size and appearance can be adjusted to suit your requirements. Obviously, the smaller the thumbnail size, the faster the gallery pages will load. Although there is a range of title options, normally you can only have the file name appear beneath a thumbnail.

Custom Colors

The Web Photo Gallery templates mostly use neutral color schemes. If you want to go more colorful, you can choose any colors you like for the background, banner headers and text. The link colors can also be changed so that they override the default colors used in some of the templates.

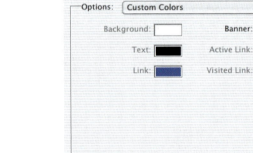

Security

These settings let you place watermarks on the gallery images. If you select the Copyright setting, any copyright notice contained in the IPTC file info will automatically be used to watermark the image. Or you can select another type of text source from the Content pop-up menu, or enter custom text. Choosing the right font size will depend on the pixel width dimensions of your gallery images. A little testing is usually required here. If you check out the sample gallery page I created, the copyright notice opacity was set to 15%.

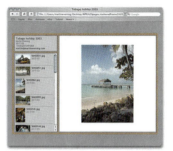

Centered Frame 1 Basic

Centered Frame 1 Feedback

Centered Frame 1 Info Only

Centered Frame 2 Feedback

Horizontal Feedback

Horizontal Neutral

Horizontal Patterned

Horizontal Slideshow

Table 1

Table 2

Figure 15.20 This shows examples of all the new Web Photo Gallery (WPG) templates in Photoshop CS. These screen shots will give you a better impression of what the individual templates will look like than the tiny thumbnail displayed in the WPG dialog. These pages were created using the default WPG color settings, so there is plenty of scope for you to produce your own customized WPG pages. The feedback templates allow visitors to mark favorite images, submit comments on individual photographs and send these back to you in the form of an email.

Client feedback

Clients can use the feedback gallery interfaces to make image selections, add comments even and forward these as an email. At present, only the file names are used in the email to reference the selected photos, but the system still works a lot better than having someone write the image file names or model details down by hand and call you up on the telephone with their comments!

Information and feedback

One of the big limitations of Web Photo Galleries up until now has been the inability for clients to interact with the websites you create in Photoshop and upload to the Web. Figure 15.21 describes how the new feedback feature works. Whenever I conduct a model casting, I shoot all the models digitally and input the model's name and agency in the Description field of the IPTC Metadata pane of the File Browser. This metadata information is then automatically stored in either the file header or an .xmp sidecar file. If I build a Web Photo Gallery and check the Description box under the options for Large Images, the model name and information will appear alongside each image in the final gallery.

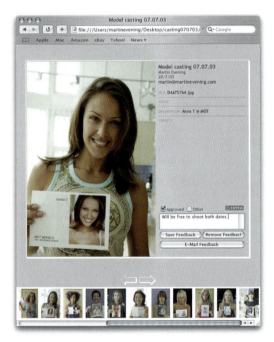

Figure 15.21 The Feedback templates provide those who visit your web photo galleries a means of communicating thoughts and ideas back to you, clearly and simply. I find these templates to be particularly useful when posting a collection of photographs taken from a model casting, or when I want to show a set of retouched photographs that require comment from a client. In this example, a client can visit my web gallery page, make a selection of the models she approves, add a few comments and click on the Save Feedback button. Sending these comments as an email couldn't be simpler. All the client has to do is click on the Email Feedback button and enter their name. After that, Photoshop will launch the default email program and complete the email. All the client has to then do is click 'Send'.

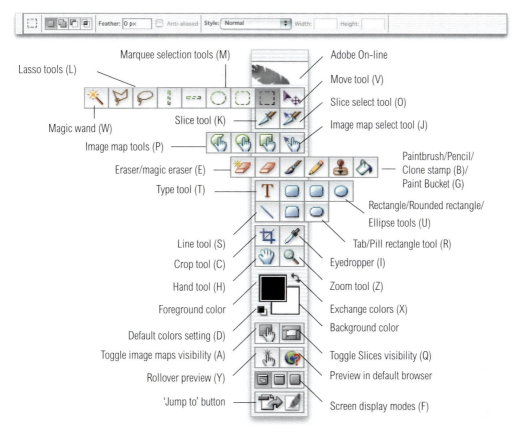

Figure 15.22 The ImageReady™ CS Tools palette, showing the keyboard shortcuts. The Tools palette fly-outs can be torn off and converted into stand-alone palettes.

Adobe ImageReady™ CS

Adobe ImageReady CS is bundled with Adobe Photoshop CS. This packaging primarily met the needs of web designers who use Photoshop. PSD documents created for the Web in Photoshop or ImageReady will integrate better with Adobe GoLive™ (you can output GoLive compatible HTML code or drop PSD files directly into GoLive). I have provided information in this book on all the graphic uses of Photoshop that are relevant to photographers. Web design is really a separate skill. Nevertheless, ImageReady deserves a brief mention here because it is an important component of the Photoshop program.

The ImageReady interface

Many of the ImageReady CS features and tools are identical to those found in Photoshop and Figure 15.22 provides you with an overview of the Tools palette layout and the keyboard shortcuts. Image Ready-specific options include: the ability to add image maps; toggle the visibility of image maps; a rollover preview; toggle slice visibility; and preview in a default web browser. And there are extra palettes in ImageReady designed to aid the management of a website and building things like rollovers and animations.

ImageReady layers

You can add layers in ImageReady just as you do in Photoshop. The layer features are shared between the two programs, so when you transfer a Photoshop image into ImageReady, all the layers, layer masks and layer effects will be preserved. You can add as many layers as you want and organize these using layer sets and the new Layer Comp palette feature. While adjustment layers can only be edited in Photoshop, the adjustment will be previewed in ImageReady. Gradient map and fill layers can be edited though. Using layers in ImageReady, you can construct a sophisticated web page with dynamic content such as rollover buttons and animations, which in turn can be linked, because the HTML code associated to the images can be generated upon saving.

Jump to

When you click on the Jump to button at the bottom of the Tools palette you are able to switch editing a document between two different editing programs. The Jump to command from Photoshop will enable you to switch to editing in ImageReady or (if specified) any another graphics-editing program. The Jump to command in ImageReady will also allow you to switch between other HTML editing programs, such as Adobe GoLive. To specify additional programs to jump to place an alias of the application (Mac) or shortcut (PC) in the Adobe Photoshop CS ⇨ Helpers ⇨ Jump To Graphics Editor folder. Place curly brackets ({ }) around an application to jump to from Photoshop and straight brackets ([]) around an application to jump to from ImageReady. In ImageReady CS you can choose either File ⇨ Jump to ⇨ Graphics Editor or File ⇨ Jump to ⇨ HTML Editor. The auto-updating of documents between the separate applications automatically happens in the background. This means that the jump tos between ImageReady and Photoshop are relatively smooth and fast. The image is displayed in each program in its own document window and the window preview will be dimmed in whichever application is inactive.

Image slicing

Slicing an image is a further example of how you can use Photoshop and ImageReady in tandem to create and design dynamic web pages which will download efficiently and also produce HTML output files which can be further edited in a program like Adobe GoLive 5.0 and 6.0 upwards. Slicing makes it easy to specify what type of content will appear in a slice and how the image content in a slice shall be optimized.

Select the slice tool and you will notice the first slice (01) is assigned to the entire image. There are several ways to slice an image. Choose Slice ⇨ Divide Slice(s) – this opens a dialog box allowing you to divide an existing slice vertically or horizontally. This is perhaps only useful where slice symmetry is vital. When you drag with the slice tool

Figure 15.23 This is an ImageReady document which has a button shape layer to which a rollover style has been added from the Styles palette. If you look at the Layers palette you can see the list of effects that have been added and in the Web Content palette you can see that these are the effects that will be used to generate the Standard rollover image state. If the Down state in the Web Content palette is selected, a different set of effects will be used to generate the down state version of this button.

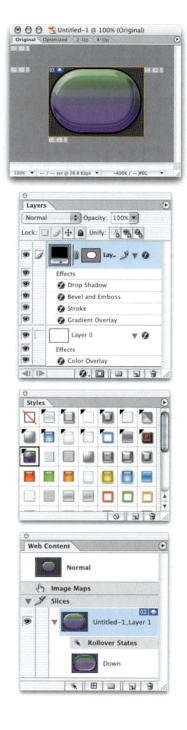

inside the document, you are creating what is known as a 'user-slice'. As you add a user-slice, 'auto-slices' are automatically generated every time you add or edit a user-slice. User-slices can be created by dragging with the slice tool, but they can also be based on a selection, layer bounds (Layer ⇨ Create Slice From Layer), or guides (Slices ⇨ Create Slices From Guides). Note that when you create a user-slice from a layer, the slice will automatically adjust to any changes made to the layer, such as when you add an outer glow layer effect.

You can modify a slice by selecting the slice select tool and clicking on the slice you wish to edit (all slices but the active slice will appear dimmed) and using *Shift* click to select multiple slices. Use the slice select tool to move a slice or resize it by dragging on one of the corner handles. A solid line border indicates that it is a user-slice and a dotted line that it is an auto-slice. It is possible to promote auto-slices to user-slices (Slices ⇨ Promote To User-Slice). Doing so will prevent it from being altered whenever a regeneration takes place. Slices can be merged together, choose Slices ⇨ Combine Slices.

Slice content

The default when slicing images is to create image content slices; however, you can create no-image slices that can have text or even solid color fills. The Background Color option will fill a no-image slice with a solid color or fill the transparent areas of an image content slice. No-image slices can also be created within the Save for Web dialog in Photoshop. HTML text can be added to a no-image type content slice via the Slice palette text box. A URL web link

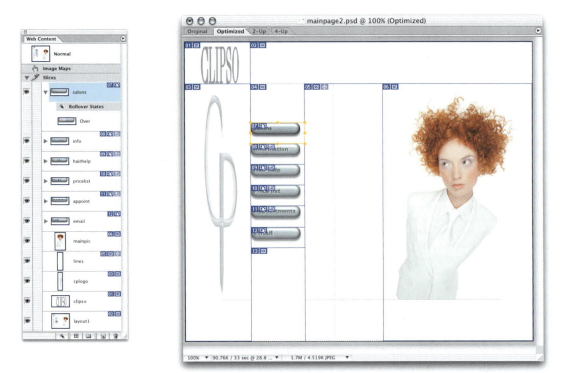

Figure 15.24 This layered image was created in Photoshop and contains shape button layers, type layers and image content layers. The image was sliced up using the Slice tool and brought into ImageReady. The Web Content palette provides a display of the Web content, such as the rollover down states associated with each slice. In this example, we can see the expanded view of the Salons button, showing the 'Over' button state.

can also be added in the Slice palette URL text box. These slice content modifications cannot be seen directly in the ImageReady document window, you will only be able to preview these in a browser or web page editing program.

Optimizing images and image slices

File optimization was discussed earlier in this chapter and the same Save for Web controls are all contained in ImageReady. The only real difference is in the interface layout. The Optimize controls can be accessed at any time via the Optimize palette and the normal image window layout can be changed to show the optimized version, 2-up or 4-up displays. When working with the optimized display, the optimized version will want to regenerate a

new preview after each editing action. To stop this happening you can deselect the Auto Regenerate option in the Optimize palette fly-out menu. If you do this, after the image is modified, a small warning triangle (⚠) will appear in the bottom right corner. To manually regenerate an optimized view, click on this warning symbol.

Animation

ImageReady can also be used to construct self-contained animated image files to go on a web page. If you create an animated GIF image you will therefore be limited to a 256 color palette. But you can also export ImageReady animations as Quicktime movies which can be incorporated into a web page or multimedia presentation. As with rollovers, animations are created by moving and modifying the layers in an image. The animation steps are controlled by the Animation palette. To add a frame, click on the New Frame button (you should always edit the animation frames using the original view, not optimized). You can modify various aspects of the image document such as color, layer opacity or the position of a layer for each frame. Now edit the frames by selecting them in the Animation palette and making adjustments. Shift-click to select contiguous frames, ⌘ *ctrl*-click to select discontiguous frames.

After you have produced a sequence of frames, you can then alter the time delay between each. The tweening feature will automatically add extra in-between frames and is a simple method with which to produce smoother looking animations. Tweening can be applied to individual frames or all frames. Tweening can also be applied to specific animation layers only and/or can be applied to specific layer attributes such as layer position, opacity and layer effects. Frames can easily be reordered by dragging within the palette. They can be copied and pasted using the Animation palette fly-out menu to copy and paste frames. Click the Animation palette Play button to preview the completed animation, or use the File ⇨ Preview In Command to preview them in a web browser program.

Figure 15.25 When the Document preview tool is selected in the tools palette, you can hover the mouse over the rollover buttons and mouse down, to preview how they will respond to mouse behavior in the final Web page design.

Compression options

Different compression or format options can be applied to individual slices such that areas where image detail matters most, less JPEG compression is used.

Linked slices

Linking slices allows you to share the optimization settings between linked slices, choose Link Slices from the Slices menu.

1 This is a logo that I designed for the Pixel Genius PhotoKit Sharpener plug-in for Photoshop. The master document was designed as a page layout graphic. I made a duplicate, smaller version that retained the original layers and could be modified to produce an animated GIF using ImageReady.

2 This was a complicated animation to produce, as it contained a total of 13 frames which showed the magnifying glass move from left to right across the 'Sharpener' logo lettering. In the final animation, as the glass moves over the blurred letters they are magnified by the lens and brought into focus. Here you can see the Layers palette with the prepared layers of the various magnified lettering stages organized into separate layer sets.

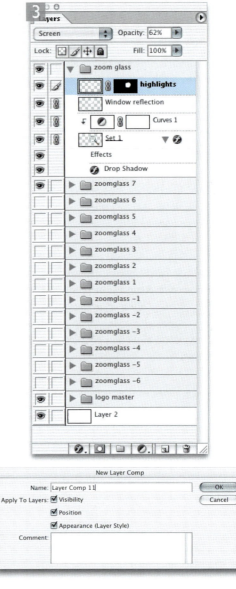

3 To create the individual animation frames, I needed to display one layer set at a time and simultaneously move the magnifying glass in register. The Layer Comps palette is ideally suited for this type of task since it allows you to effectively take snapshots of different layer arrangement layouts in a single document and recall these later.

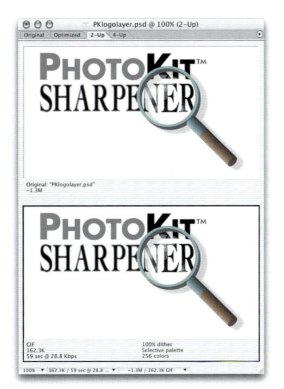

4 I clicked on the 'Jump To' icon in Photoshop to open the image document in ImageReady. By selecting the 2-up display mode, we can see the original and optimized documents next to each other and make decisions about the ideal GIF output settings in the Optimize palette. I then went to the View menu and brought the Animation palette into view. I clicked on the 'Layer comp 1' icon in the left-most palette column (click on the layer comp icon, not the layer comp name) to display the magnifying glass on the left. This established the start frame. I then clicked on the Add Animation frame button in the Animation palette to add a new frame and selected the Layer 2 comp. This created our second frame and so on, until all the layer comps had been used to create all thirteen animation frames. Once this exercise has been completed the animation can be tested by clicking on the Play button in the Animation palette. If a frame requires any editing, you can select it. The corresponding Layer Comp will also be selected and you can then modify the layer arrangement and possibly the selected layer content as well, so long as changing the layer content changes a layer that is only visible when this frame is active. When your work is complete, the animation can be saved as an animated GIF or choose Export to create a Macromedia® Flash movie.

Chapter 16

Image Management

One of the consequences of working with digital images in Photoshop is that you will soon find yourself struggling to cope with an ever-growing collection of image files, which if you are not careful, will consume all the remaining space on your computer's hard disk. Most people find it necessary to store their image files on separate CD or DVD disks. And the smart photographers will take care to catalog these disks and possibly create an image library database, so that pictures can be organized by categories and retrieved quickly.

I know of a photographer who was asked to 'go digital' by his main client. So he bought all the necessary kit, investing a small fortune in digital hardware. However, after a few months, the client said he wanted to go back to

the old days, when he had piles of transparencies to flip through. This was all because the client had a hard time tracking down specific images from the growing pile of CD-ROMs. This anecdote highlights a great potential weakness in professional digital capture workflow. If you don't manage your images efficiently, you will find it incredibly difficult to track them down later from your growing digital archives. Sifting through a disorganized pile of films is not an ideal solution either of course, but at the end of the day, images must be archived. But the argument can be made that once you do put in the effort to archive and manage your digital files properly, the rewards are that you can retrieve your pictures far more easily than with a conventional film-based archive.

If you are looking for a sophisticated archival retrieval system then consider purchasing an image database program. There are several popular programs that you can buy and I will be discussing these later, but the Photoshop CS File Browser now boasts a number of powerful new features that make it a powerful program in its own right with which to manage your image files.

The File Browser

The File Browser integrates smoothly with the updated Adobe Camera Raw plug-in, to enable you to work directly with your raw image files all within Photoshop (assuming the camera raw file format is one of those supported).

To display the File Browser you need to click on the File Browser button icon which is always to be found in the Options bar palette. Clicking this button will toggle showing and hiding the File Browser window (see Figure 16.1). But you can also open it on screen by choosing File ⇨ Browse... by using the ⌘ O ctrl O shortcut, or by selecting File Browser from the Window menu. If you have been used to working with Photoshop 7.0, then the first thing you notice is that it no longer behaves like a palette. The File Browser cannot be docked to the palette well, it remains open on screen until you click the File Browser button in the Options bar. To open an image, simply

Keeping track of your data

If you use a computer regularly you will already appreciate the importance of keeping track of all your office work files by saving things to their correct folders just as you would keep everything tidy inside the filing cabinet. The task is made slightly easier on the computer in as much as it is possible to contain all your word processing documents on the one drive (and a single backup drive). Digital files are by comparison too large to store on a single disk and need to be archived on many separate disks or tapes. One disk looks pretty much like another and without diligent marking, cataloging and storing, in a year or two it will take forever to trace a particular picture. I only have to look at my collection of video tapes to appreciate the wisdom of indexing – I know there are movie masterpieces in there somewhere, but am damned if I can find them when I want to.

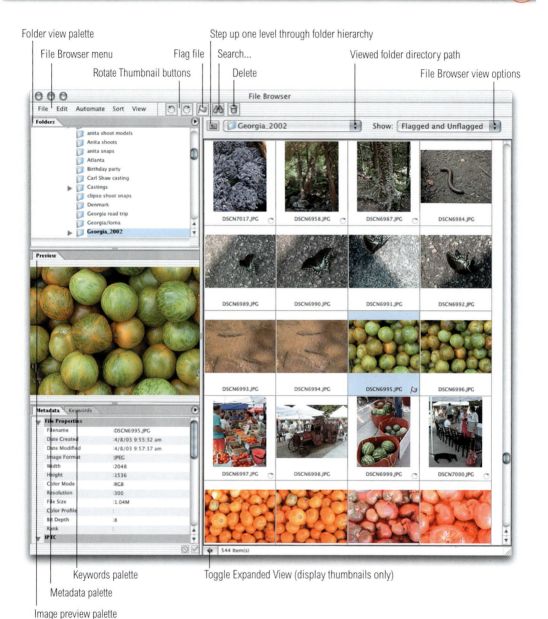

Folder view palette

File Browser menu

Rotate Thumbnail buttons

Step up one level through folder hierarchy

Flag file

Search...

Delete

Viewed folder directory path

File Browser view options

Keywords palette

Toggle Expanded View (display thumbnails only)

Metadata palette

Image preview palette

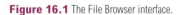

Figure 16.1 The File Browser interface.

double-click the thumbnail or image preview. And if you want the browser window to close at the same time, hold down the ⌥ *alt* key as you double-click.

Rotation and flagging

Lets look at the interface in more detail. At the top there is a menu display followed by a series of buttons. The two rotate buttons will rotate the thumbnails clockwise or anti-clockwise. Note that it is the thumbnail that gets rotated. The rotation is only applied when you actually open the image up afterwards, or if you choose 'Apply Rotation' from the File Browser Edit menu. Notice how the first three thumbnails in the File Browser dialog shown in Figure 16.1, display a small rotate icon next to the file name, which indicates that they have been marked to be rotated. There are also some keyboard shortcuts that can be used here. ⌘ *[* *ctrl* *[* will rotate a thumbnail anti-clockwise and ⌘ *]* *ctrl* *]* will rotate a thumbnail clockwise. The Flag button offers a convenient way to mark favorite images while you are editing a selection of images. In Figure 16.1, I have flagged an image of the fruit and you will notice a small flag icon appears next to the file name. Clicking the Flag button will toggle flagging and unflagging selected images, or you can use the keyboard shortcut ⌘ *ctrl* +' (apostrophe). After you have flagged a selection of images contained in a folder, you can then use the File Browser View options to display the flagged or unflagged images only.

Searching images

The Search function is a new feature which gives Photoshop the power to perform image searches based on selected criteria. Although Photoshop is not trying to be an image database program it is feasible to use it as such. For example, in my line of work we regularly hold model castings and each model is normally photographed using a digital camera and his or her name and model agency name details are entered into the Description metadata field in File Info (File Info is discussed later in this chapter). Over

File Browser history

The File Browser made its first appearance in Photoshop 7.0 (or if you want to be pedantic, you could say it was also in Photoshop 6.0 Elements before that). Photoshop CS has addressed a lot of its earlier shortcomings, is now more like the tool we always wanted and in my view it is probably the single most compelling reason why a photographer should upgrade to Photoshop CS. The File Browser is like an Open dialog on steroids. It is a central component of the Photoshop interface which allows you to quickly inspect and compare images at a full screen resolution, make picture selection edits, sort images using different criteria and conduct image searches based on things like the file name or metadata content (more of which later).

Saving Workspaces

Remember that after you have configured the File Browser to suit your ideal way of working, that you can save this arrangement as part of a workspace setting. Choose Window ⇨ Workspace ⇨ Save Workspace...

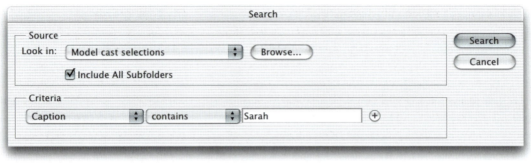

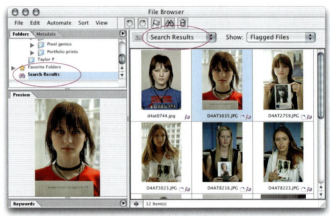

Figure 16.2 When you click on the Search button in the File Browser you will see the Search dialog shown above here. This allows you to conduct image searches based on single or combinations of search criteria. The search entered here matches the one described in the text and the results of the search (which included all the model casting sub-folders) are then displayed in the File Browser window under 'Search Results'.

the course of several months we build up many hundreds of model images. Let's say I need to carry out a search for a specific model called Sarah, but I can't remember any more than that. If I click on the Search button, I can select Caption under the Criteria section, type Sarah in the text field and click the Search button. Figure 16.2 shows the Search dialog and an example of the search results showing thumbnails of all the files that match this criteria, displayed in the File Browser window as a semi-temporary Search Results selection. This means that the Search Results will remain active up until when you either Quit Photoshop or make a fresh image search.

Arranging the File Browser contents

The File Browser window contents consist of a thumbnail view area that can be expanded to fill the whole window area, plus four palettes and the browser contents can be customized to suit your individual requirements. If for example, you want to use the File Browser to make a picture edit selection, you can drag the browser window dividers such that the Folders, Keywords and Metadata palettes are collapsed and the Preview palette is expanded to fill as much of the window area as possible. In Figure 16.3, the Preview palette area has been expanded. A customized arrangement like this will make it easier to check for small details when sorting through a large number of images in a folder, such as when you return from a location shoot and wish to create a short-list selection of pictures. You can also drag the thumbnails about within the Thumbnail area. This too makes the File Browser experience more analogous to editing slides on a lightbox.

My preferred way of working is to expand the preview palette as shown, to make it as big as possible. I then use the right and left keyboard arrow keys to progress forward or reverse through the image folder contents and if I see a picture I like, I use the ⌘ _ctrl_ +' (apostrophe) keyboard shortcut to flag it. I can then select Flagged Images from the File Browser View options menu, to display the flagged images only. If needed, I can drag the thumbnails around if it helps the edit selection process. You can rank the files displayed in the thumbnail pane to indicate their priority or importance. _ctrl_ right mouse-down on a thumbnail and select a ranking option from A to E from the contextual menu. File ranking can be displayed in the Large with Rank and Details thumbnail views and you can then use the file ranking to determine the order of how the thumbnails are arranged.

Deleting contents

The Delete button can be used to delete selected images. This action will remove the thumbnail from the File Browser window and send the original file to the Trash (Mac) or Recycle bin (PC). You need have no fear of deleting files in File Browser, as you cannot delete a file permanently from within Photoshop, this can only be effected by deleting the contents of the Trash (Mac)/Recycle bin (PC) at the Operating System level. Also, you can only delete a folder which is empty, when you use the Delete button (the Trash can) within File Browser.

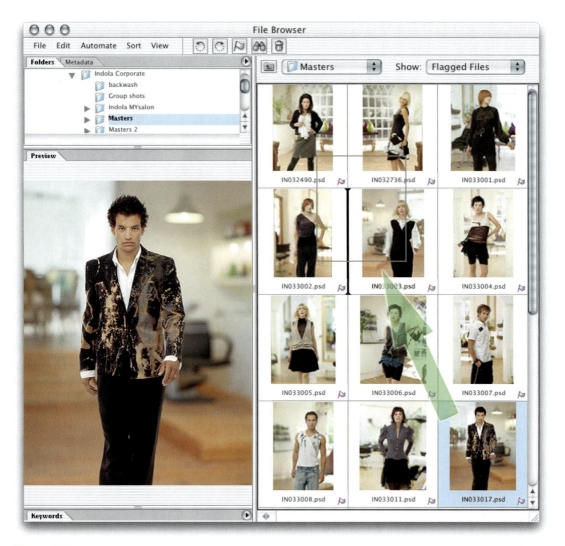

Figure 16.3 The palette arrangements within the File Browser can all be customized to suit your own way of working. If you click on the Expanded View button at the bottom (see Figure 16.1), this will expand the thumbnail view to fill the File Browser window, hiding the remaining palettes. Thumbnails can be moved around within the thumbnail area, as if you were editing photographs on a lightbox. If you double-click on a palette tab, such as I have done here with the Keywords palette, this will collapse the palette, hiding the palette contents. The palettes can be expanded by dragging on the vertical and horizontal dividers. In this example, the Preview palette has been expanded so that we see a large preview of the selected thumbnail. Note that whenever you save a workspace setting, you are also able to save a customized File Browser configuration.

File Browser Preferences

The File Browser preferences can be accessed via the File Browser Edit menu. The default settings limit building thumbnails to images of 100 MB or less, but you can increase this limit if need be. The Custom thumbnail size can also be increased, although 256 pixels does provide quite a decent sized thumbnail (see Figure 16.5). The Allow Background Processing option means that Photoshop will automatically get on with building all the thumbnails, reading in the file metadata and build large previews whenever you make a folder active. This is important if you have a large number of images to inspect as it may take several minutes or more to build a complete cache of the folder contents. This way you can leave Photoshop to process a folder of images in the background and when you come to edit through the shots, there is no waiting for previews to build each time you preview a new image. I have the High Quality Previews option checked too because I want to see the best quality previews possible in the File Browser window. This can matter a lot when you wish to make fine judgment calls concerning small areas of detail in the images you are editing. The Render Vector Files option is not important if you mainly work with pixel images.

Sidecar and non-image files

The Parse XMP Metadata from Non Image Files is something I'll come onto shortly, but basically you want to keep this checked as it will enable Photoshop to read in the metadata from non-image files such as camera metadata files, also referred to as 'sidecar' files. The reasons for creating these sidecar files were explained earlier in Chapter 11. But basically, sidecar files are a mechanism for storing essential, edited metadata information that for various reasons, cannot otherwise be embedded in the original file. Sidecar files are linked to specific images. It is a good thing to keep this option checked. It means that whenever you move a file about from one folder location to another, the associated sidecar file travels with it.

Figure 16.4 The File Browser preferences.

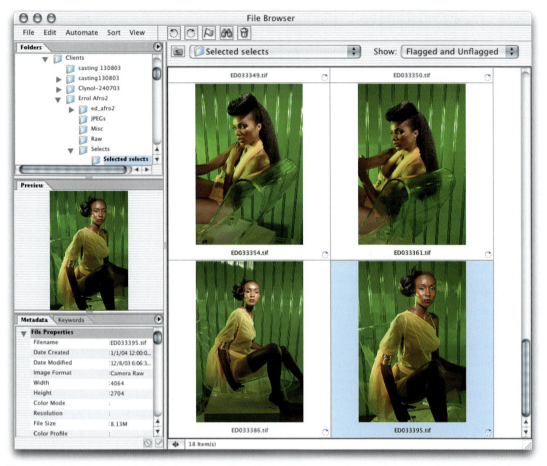

Figure 16.5 The Custom thumbnail file size can be configured in the File Browser preferences. Using larger thumbnails makes it easier to compare images inside the File Browser window.

Folders palette

The Folders palette displays a folder list view of the computer contents plus any other disks currently mounted. The Folders palette is used to navigate the folder hierarchy. Folders can be expanded or collapsed. Whenever you insert a CD or DVD disk, you may need to refresh the folders palette contents which can be done by _ctrl_ right mouse clicking and selecting 'Refresh', or by using the ∞ keyboard shortcut. When you highlight a folder in the folder palette, all the image files in that folder will be

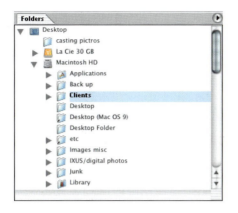

Figure 16.6 The Folders palette displays a
complete list view of all the folders in your main
hard drive and any mounted disks.

displayed as icons in the main thumbnail display on the
right. Note that Photoshop will only be able to create a
preview of image files it already understands or has a file
import plug-in for. As this is happening, Photoshop will
write a folder cache of all these image thumbnails and
previews to the hard disk, which will be stored within the
Application Support\Adobe\File Browser folder. The saved
cache will save time displaying the thumbnails whenever
you revisit that folder. Incidentally, it can be considered
advantageous to switch on the backward compatibility
option in the preferences as this will speed up the writing
of the thumbnail cache file. There are two cache-related
options in the File Browser fly-out menu. You can purge
the current folder cache or export it, so that a cache is also
saved in the same folder hierarchy. This is useful if you are
preparing a folder of images to burn to a CD/DVD disk,
because the exported cache can then be read by another
Photoshop CS user. If a disk contains a cache that was
exported from Photoshop 7.0, Photoshop CS will be able to
read it, which will save time, but Photoshop CS will still
have to spend time generating the previews.

Keywords palette

Keywording provides a way of grouping and organizing
images within Photoshop. Earlier on in this chapter I
demonstrated how the Search feature could be used to
locate all the models who were named Sarah from within a

Figure 16.7 The Keywords palette can be used to assign keywords to one or more images at a time. It can also provide feedback on the keywords already assigned. In the example shown here I have highlighted an image and I can see that it has been assigned three keywords telling me that it is a model casting photograph, shot in London and that the model agency is called Isis.

Delete button

Add new keyword set Add new keyword

large collection of model casting photographs. But supposing we wanted to conduct a search restricted to looking for models belonging to a specific model agency? Or perhaps we might want to categorize photographs in other ways as well, separating them according to the location where they were shot? We can achieve all this by applying specific keywords to groups of images. Figure 16.7 shows the Keywords palette. To add new keywords, click inside an existing Keyword set or create a new one and then click on the New Keyword button at the bottom of the palette. To assign keywords to one or more images, you need to make your image thumbnail selection from within the File Browser and then go to the Keyword palette and click on the empty square to the left of the desired keyword to assign one or more keywords from a Keyword set. This will allow you to apply keywords to multiple images at once. Keywording can help you search and retrieve images and the keywords will also be recognized by other image database programs such as Adobe Photoshop Album (PC only).

Image metadata

Several times now, I have referred to the term 'metadata' in this chapter. The best way to explain metadata is to describe it as being 'data about data'. These terms may sound off putting, but the concept of metadata is one you should be quite familiar with. Librarians use metadata to classify and catalog books in a library. In the old days they used index cards to enable you to do a search by author name or by a book's title. Everything is now computerized of course and you will find a computer terminal instead of card index system down your local library. And in a computerized system it is possible to record so much more information about a file and use this information to carry out sophisticated searches and cross-reference one file with another.

File Info metadata

The File Info dialog shown in Figure 16.8, has been around since the early days of Photoshop, yet few people have ever used it or known much about it. The File Info dialog was designed to enable you to edit the image metadata relating to picture content. Photoshop has always supported the information standard developed by International Press Telecommunications Council (IPTC) which was designed to help classify and label images and text files using metadata. In previous versions of Photoshop, you could access the File Info via the File menu and use it to title an image, add the name of the author, add keywords and inspect the camera capture metadata. File Info is still in the File menu, but can also now be accessed via the File menu in the File Browser, or by using the default keyboard shortcut: ⌘ ⌥ *I* ctrl alt *I*. The File Info dialog contains seven sections, some of which are editable, such as the Description section shown in Figure 16.4 and some which provide information only, such as the camera EXIF metadata. Using File Info, one can add the author name, mark the image as being copyrighted, add a copyright notice and a URL to your website. In the next chapter we will be looking at recording actions in Photoshop to help

Metadata everywhere

The most common place use of metadata these days is the Internet. Use a search engine and within a matter of seconds web links will appear on the screen, offering lots of suggestions for what you are looking for. Web designers add metadata tags to the headers of web sites to enable search engines to catalog them more effectively. Parents and schools use metadata to filter out the web content that children can access. MP3 players use metadata to categorize your music collections. Metadata is used in all sorts of ways and if anything, we seem to have too much metadata out there! Web search engines often offer you thousands of possible links, when you would rather have your choice narrowed down to a smaller selection. The trick is for distributors to provide metadata that is useful and for retrieval systems to intelligently sort through the metadata.

Metadata in use

Since version 6.0, Photoshop has been able to preserve any metadata that is written into a file. The use of metadata will play an extremely important role in the future of digital photography and the way images are managed. In a lot of cases this will happen automatically, thus saving end users' time and money, when cataloging their image databases. The Pixel Genius company I belong to have produced a freeware plug-in for Photoshop called MetaReader™, which you can download from the Pixel Genius website: www.pixelgenius.com. The plug-in will display and export to text files any industry standard metadata embedded in the file. This allows photographers and artists to use the exported metadata in a variety of common database programs.

Figure 16.8 The File Info palette

automate the use of the program. It is possible to start recording an Action, add basic information such as the above, close the File Info dialog and stop recording. This action can be used to apply your author details to images singly or in batches, without having to keep typing in the same data over and over again. As well as this you can create a File Info template. In Figure 16.8 I have opened the File Info for an image and added a description of the session which I can then apply to a whole folder of images. Mouse-down on the fly-out menu and choose Save Metadata Template... Save and name the template. Then when I select all files in a folder, I can go the File Browser Edit menu, mouse-down on the Append Metadata item and choose the recently saved metadata template from the list.

Interpreting the metadata

Metadata comes in many forms. In the early days of digital camera development, the manufacturers jointly came up with the EXIF metadata scheme for cataloging camera

information. You may find it interesting to read the EXIF metadata that is contained in your digital camera files. It will tell you things like what lens setting was used when a photo was taken and the serial number of the camera. This could be useful if you were trying to prove which camera was used to take a photograph when there were a lot of other photographers nearby trying to grab the same shot and also claiming authorship. The EXIF metadata can describe everything about the camera's settings, but the EXIF schema could not be adapted to describe the information that interests you. In 2001, Adobe announced XMP (eXtensible Metadata Platform), that to quote Adobe: 'will establish a common metadata framework to standardize the creation, processing and interchange of document metadata across publishing workflows'. Adobe has already integrated the XMP framework into Acrobat, InDesign Illustrator and Photoshop. XMP is based on XML (eXtensible Markup Language) that is the basic universal format for using metadata and structuring information on the Web. Adobe has also made XMP available as an open-source license, so it can be integrated into any other system or application. Adobe's enormous influence in this arena means that XMP will doubtlessly become a common standard in the publishing and imaging industry. One can anticipate that Adobe and also third party companies will want to exploit the potential of XMP to aid file management on a general level and for specific needs such as scientific and forensic work.

Metadata palette

Now let's take a look at the Metadata palette. The metadata information is divided into sections. The File Properties and IPTC sections duplicate the File Info dialog contents. Below that is the EXIF camera data, followed by Camera Raw data, GPS information and the Edit History log.

As with File Info, the IPTC metadata can be edited (which is indicated by the pencil icons that appear to the left of the metadata items). To edit the metadata, mouse-click the field next to the metadata heading. As I mentioned

Future uses of metadata

It is quite scary to consider the number of freely distributed digital images out there that contain no information about the contact details of the person who created it. Imagine a scenario in the future where metadata can be used to embed important information about usage rights. Imagine also that a third party developer could service a web site that allowed interested purchasers to instantly discover what specific exclusive usages were currently available for a particular image? You could even embed a self-generating invoice in the image file. If someone tried to strip out the metadata, you could even use an encrypted key embedded in the file to re-import the removed metadata, and/or update specific metadata information. I predict that the use of metadata will offer tremendously powerful advantage to individual image creators who wish to distribute their creative work more securely over the Internet and profit from legitimate image rights purchases.

Increasing the font size

If the pixel resolution of your screen renders these items too small, you can increase the font size in the Metadata palette via the palette fly-out menu. This will make it easier for typing into the metadata and for locating existing entries more accurately.

Figure 16.9 The File Browser File menu duplicates several of the controls already accessible in the File Browser. For example, to create a new folder, `ctrl` right mouse-click anywhere in the Thumbnail area to display the File Browser Contextual menu and choose New Folder. If a thumbnail image is selected in the File Browser, you can use the File menu to edit it directly in ImageReady or open the File Info dialog. The File menu is mostly useful for adding to and removing folders from the favorites list, and also for managing the File Browser image caches.

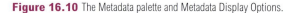

Figure 16.10 The Metadata palette and Metadata Display Options.

earlier, the amount of information displayed here is vast and more than you really need to know. If you open the Metadata display options (shown in Figure 16.9) you can exert control over how much metadata is displayed in the palette. Each metadata item has a checkbox against it. This allows you to show or hide individual items. If the Hide empty fields box is checked, the checked items will only be displayed in the Metadata palette if there is an accompanying data entry.

Edit history log

If the history log options are enabled in the General preferences, an edit history can be recorded in either the file metadata, as a separate text file log, or both. The Edit history has many potential uses. A log file will record how much time was spent working on a photograph and could be used as a means of calculating how much to bill. In the world of forensics, the history log could be used to verify how much (or how little) work was done to manipulate an image in Photoshop. And the same arguments can apply to validating images that are used to present scientific evidence

File Browser management

There will be many folders in your computer system, but most likely there are only a few you will wish to keep returning to with the File Browser. If you use the File menu to assign specific folders as Favorites, these folders can always be accessed swiftly using the Viewed folder directory path and selecting under 'Favorites' just next to the right of the File Browser menu items.

Every time you open a folder in the File Browser it will check to see if there is an image cache located in the Application Support\Adobe\File Browser\Photoshop CS folder. The image cache has two components: the image metadata and thumbnail cache. If a cache is present, the inspected folder will display the archived thumbnails, previews and metadata instantaneously. This works fine so long as the folder is being inspected on the computer that

Figure 16.11 The history log options are configured in the General preferences. The history log content can record: sessions only (such as the time a file was opened and closed); a Concise log listing of what was done in Photoshop; or as shown here, a detailed log, which will include a comprehensive list of the settings applied at every step. If you choose to embed the history log in the file metadata, the log can be viewed in the File Browser Metadata palette.

Figure 16.12 Sometimes flagging alone does not allow enough distinction to separate your images when making an edited selection. This is where applying a rank to an image can come in useful. The easiest way to do this is to choose Show Rank in the File Browser View menu (see Figure 16.19). This will display the Rank box below each thumbnail (see Figure 16.13). Click in the box next to where it says Rank and type a letter or number. To assign ranking to multiple images, make a thumbnail selection and choose Rank from the Edit menu. The Rank Files dialog will appear. Type in a letter or number and click OK.

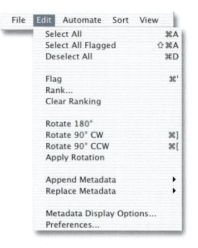

Flagging and Ranking

The easiest way to approve an image and mark it separately from the rest is to use the File Browser Flag button or the Command-' keyboard shortcut. I find that flagging preferred images works best for me and I rarely need a more detailed system to categorize my photographs. But if you want to apply a more structured form of marking then I suggest you use the image ranking feature. Select the Rank... item in the File Browser Edit menu or Control/Right mouse-click in the Thumbnail dialog and choose Rank... If Show Rank is selected in the File Browser View menu, all you need to do is click in the empty field next to the Field that says Rank. Any scheme can be used for ranking images. In Photoshop 7.0, the File Browser suggested using A, B, C, D... But you could just as easily rank your images using numbers instead.

created it and the folder name has not changed since the image cache was created. Every time you create a folder of images the best solution is to go to the File menu and choose Export Cache. This action will save a copy of the thumbnail and image cache to the same folder. The advantage of doing this is that it does not matter how you may rename the folder later, the folder image cache will still be recognized. It is particularly important to export a cache to the folder whenever you are about to burn a CD or DVD disk.

File Browser automation

The File Browser has become a hub for being productive in Photoshop. The Automate menu items will let you launch various Photoshop automated routines, such as Batch actions. Select a group of images in the File Browser, choose Batch... and configure the dialog to run a batch action processing routine on the selected photos. You can read more about this and all the other automation features in the following chapter on Shortcuts. But using the example of the Web Photo Gallery, which was covered in the previous chapter, you can flag a selection of images, choose show flagged images only, rearrange the thumbnail order as desired and then build a Web Photo Gallery of this flagged selection directly within the File Browser.

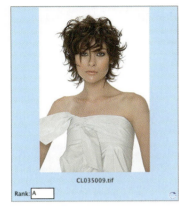

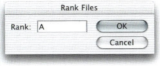

CL035009.tif

Rank: A

Figure 16.13 The File Browser Edit menu contains options for flagging and ranking and making selections of images within the File Browser. Ranking provides a more flexible approach beyond the basic flagging of selected images. The Append and Replace metadata sub menus enable you to apply or replace metadata in image files, using templates saved from the File Info dialog to selected images.

To rename an image in the File Browser, you just double-click the file name and enter a new one. But if you make a selection of thumbnail images in the File Browser, you can run Batch Rename from the Automate menu. This will enable you to rename the selected images any way you like (see Figure 16.15). You can rename the files in the same folder or rename and move them to a new (specified) folder. It would be useful to have had a Copy to new folder option, but if you do want to, copy the selected images before renaming them. Create a new folder, and drag the selected thumbnails across to the new location (will create a duplicate file). In Figure 16.15 notice how you can use the multiple fields to construct a batch renaming scheme. The first field contains two letters that are a shorthand for the client name. This is followed by '03' for the year 2003, followed by a four digit serial number and lastly the file format extension in lower case. If you want the serial number to begin at a number other than 0001, enter the number to start the sequence from in the box below. Incidentally, if you are reading this and using Photoshop 7.0, there is a work around: instead of selecting 4 Digit Serial Number, type in the start number between two hash signs. So to start the numbering from 0234, type in: #0234#. Lastly, I suggest if you are a Mac user, you check for Windows compatibility. The scheme I use here will help me catalog up to 10,000 images per year per client.

Editing the Batch renaming fields

When you edit the Batch renaming fields, the simplest way to do this is to mouse-down on a field entry and choose a preset item, such as today's date or a four digit number, from the list. The fields are edited in order from left to right and top to bottom. You can, as described in the text. Manually insert a field by typing something in. Consecutive fields cannot be left blank and the very last field must end with 'extension', or 'EXTENSION', if you want to use upper case. Above you will see an example of how the renaming structure will be applied. Don't be concerned by the fact that this has a GIF extension, it is only an example of how the naming will work!

Applying Camera Raw settings

Another useful thing in the Automate menu is the Apply Settings function. Lets say you have a folder of raw camera files, you open one of the images and make some camera raw adjustments to the picture. You either click OK to open the image using these settings or Hold down the key and the OK button will modify to say: 'Update'. Now once a camera raw setting has been produced for one image you can select all the other similar images, go to the Automate menu and choose Apply Camera Raw Settings... and be shown the dialog in Figure 16.16. If all that you want to do is apply the exact same settings, to the other camera files, choose 'Previous Conversion', click Update and you are done. However, if you want to apply some settings globally and not others, in Advanced mode, you can deselect the various individual camera raw settings in the left hand section of the dialog. This is actually a pretty cool feature. Imagine that you have just shot a series of photos and they all require the same type of settings adjustment in Camera Raw. All you have to do is work on one image and then apply these settings to all the rest of the images. When it comes to opening up and converting the images, you can adjust the settings again if you wish. But by being able to apply batch settings, you can use the Automate menu to build Web Photo Galleries, contact sheets etc., that are more representative of the finished results.

Figure 16.14 The File Browser Automate menu.

Figure 16.15 The Batch Rename dialog.

Figure 16.16 Apply Camera Raw Settings.

Figure 16.17 On-line Services.

Figure 16.18 The Sort menu options allow you to arrange the displayed thumbnail images by ascending or descending order using any of the criteria listed in the menu. Normally this is left at the default File name setting. But if you selected Rank for example, the images would be displayed according to the ranking priority, with all the Rank A images appearing before the Rank B images and so on.

On-line Services

Adobe have been keen to promote the file sharing and on-line services aspect of Photoshop CS. At the time of writing it is hard to predict how Photoshop customers will respond to the availability of this service. So far, there is an organization called Shutterfly who are collaborating with Adobe to provide an on-line printing service and I anticipate that others will follow. To use Shutterfly, launch On-line Services from the File Browser Automate menu and follow the dialog instructions to create yourself an account with Shutterfly. Selected images can then be uploaded from the Photoshop File Browser to your account folder with Shutterfly. From there on you can explore the various print options and finally place an order to have a print made and delivered. On-line print services have become very popular in recent years, mainly due to the speed and popularity of broadband Internet services making it easier to upload large image files. An on-line printing service can prove useful if you need to make enlargements bigger than your own printer can handle or if you wish to produce multiple print copies at a reasonable cost.

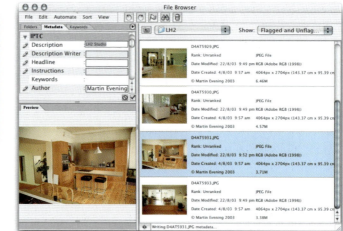

Figure 16.19 Using the View menu, thumbnail images can be displayed at different sizes, including the new Custom Thumbnail size (see Figure 16.5). The 'Details' view shown in Figure 16.20 will display the thumbnail along with some of the more useful file metadata information. If you are wanting to rank the images, then make sure the Show Rank option is checked in the menu list. I normally prefer the folders to be displayed in the File Browser as I don't have to rely solely on the Folders palette to navigate to access the folder's contents. Unreadable files refers to non-image files, such as Word documents. I prefer to leave this item unchecked, but it can otherwise allow you to inspect a complete list of documents in a particular folder.

Figure 16.20 The Details view provides some of the file metadata information alongside the image thumbnail, which makes it easy at a glance to see things like the color mode and profile space an image is in, plus the file size dimensions. In this illustration, you can see that I am adding a title into the metadata Description tag. To make it easier to enter the data, I have increased the font size of the metadata palette.

Managing your images

I began this chapter with an anecdote about a photographer who had been left stranded by a client who was unable to manage the digital image files. Whether you are a professional or amateur photographer, it should be clear that you have to plan to do something to manage your pictures or else you too will become just as frustrated. The File Browser tools are designed to make it easier for you to catalog and locate images and you may also want to consider using a separate stand-alone image library program to administer your image collections. Mac OS X users have iPhoto as standard on their computers, which is an Apple only application. Adobe produce a program called Photoshop Album (PC only), which integrates nicely with the File Browser in Photoshop, recognizing and using the Keyword and metadata structure used in Photoshop CS. Image management is something we all need to have. For example, if you want to manage your music files, a

program like iTunes will update your music database automatically. When A CD is inserted, iTunes will query an on-line database, downloading the album title, artist, track listings and genre of music. This is an example of metadata in action, which is used to help you manage your music collections as easily as possible. In this example where you are converting music files to an MP3 format, the cataloging is effortless because it happens in the background automatically. But when you want to catalog image files, these are usually original documents. And the only way to catalog them is to do it yourself. I have described in this chapter some of the ways that you can go about handling this process in Photoshop, but quite likely you may find that this finishing off process can be managed better using a dedicated image library software program. Having said that, it is interesting to conjecture how one day it might be possible to use the Global Positioning Satellite (GPS) metadata to automatically complete the location metadata fields. To explain what I mean by this, it is possible with some setups to record a GPS reading at the time of capture and embed this information in the image file. Take a look at the Metadata palette contents and you will see that there is already provision to display the GPS data. Now imagine that there was an on-line database (similar in principle to the one iTunes references) that could read in the GPS data and translate this into meaningful location information. So the images shown in Figure 16.20 of LH2 Studio, could automatically be cataloged as being located in 'Stoke Newington, London'.

The digital lightbox experience

Let's now look at the process as a whole of bringing digital images into Photoshop and how you can manage them successfully with a view to maintaining a digital image library archive. These are the steps I use in the studio and on location. That is a brief summary of how I typically use Photoshop to manage my photographs, automating the process as much as possible and at the same time maintain

1 The process begins with the digital captures which are always shot using Raw mode being copied from the media card to the computer. All media cards are vulnerable to damage, but so too are computer hard drives. I copy the files across to a laptop computer in the studio, initially, copying the files across to a LaCie FireWire pocket drive. This is the simplest way to get the files off the card without having to worry if they are in the right folder or not, which is important when you are in a hurry.

Name	Date Modified	Size	Kind
▼ 📁 Camera transfer files	Today, 12:26 am	--	Folder
D4AT0306.TIF	19/8/03, 5:41 pm	9.9 MB	TIFF Document
D4AT0307.TIF	19/8/03, 5:42 pm	9.6 MB	TIFF Document
D4AT0308.TIF	19/8/03, 5:42 pm	9.9 MB	TIFF Document
D4AT0309.TIF	19/8/03, 5:42 pm	10 MB	TIFF Document
D4AT0310.TIF	19/8/03, 5:42 pm	9.9 MB	TIFF Document
D4AT0311.TIF	19/8/03, 5:42 pm	9.8 MB	TIFF Document
D4AT0312.TIF	19/8/03, 5:43 pm	10.5 MB	TIFF Document
D4AT0313.TIF	19/8/03, 5:43 pm	10.7 MB	TIFF Document
D4AT0314.TIF	19/8/03, 5:43 pm	10.6 MB	TIFF Document

Storage 60GB — 30 items, 51.88 GB available

2 Next, I will make a backup of these files to a designated folder on the main computer hard disk. At this point it is now safe to delete all the files off the card So it can be used again.

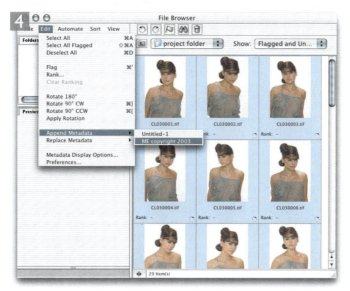

3 In Photoshop, I will open the File Browser and select the camera file folder on the main computer hard disk (not the one on the pocket drive) and once the thumbnails have been generated, select those that need to be rotated. I will choose Select All from the File Browser Edit menu or use the ⌘ A / ctrl A keyboard shortcut followed by Batch Rename from the Automate menu. You can use any identification/ numbering system you like. The method shown here is the one described on page 485.

4 The Canon camera has a neat feature whereby I can program it to automatically embed my name as the author whenever I shoot an image. But I can also make sure every photograph I process in Photoshop is copyright marked with my name again plus any other details, using the Append Metadata command as described on page 480.

5 At this stage the photographs will be ready for editing. One of the key demands made of the Photoshop engineers was that the File Browser should become the digital equivalent of a photographer's lightbox. I like having the ability to move the dividers around so that the preview image can fill the screen as much as possible. You may find it easier to create and save a custom Workspace setting for making edit selections where the Preview palette is maximized to fill as much of the screen area as possible.

6 I can now navigate from one image to the next using the keyboard arrow keys, and flag favorite pictures using the ⌘ ctrl+' keyboard shortcut. The favorite, flagged images can be viewed in isolation and at this point I may want to make the thumbnail size bigger and rearrange them in order to make a final image choice. If I want to show the final selection to friends or a client, I can choose to make a Web Photo Gallery of the edited photos and upload this to my server.

a backup of all the raw data on a separate hard drive. When adding new images to the collection throughout the day, I will follow all the above steps, except when using the Batch Rename function to renumber the photos, I have to start the numbering so as to follow on from the last image in the previous batch.

Storage Media

The biggest bottleneck in the digital management process right now is the time it takes to archive data to a storage medium. Over the years we have seen many types of storage media systems come and go. But the most popular media these days are recordable CDs. Just about every computer sold today will have a built-in CD drive that is capable of reading and writing disks. Some CD disks can theoretically hold up to 700 MB of data, although 650 MB is probably a more realistic upper limit to aim for. Not so long ago, 650 MB used to be considered an enormous amount of storage space, but these days it won't go very far. My layered master images often exceed 200 MB and if storing to CD, I would therefore have to separate my files into two or more folders before burning the disks, taking care that none exceeds the capacity of the CDR media. A colleague of mine, Seth Resnick, has adopted a very thorough approach to working with digital captures and I have learned a lot from attending his seminars on managing the digital workflow. Seth argues that it makes sense to process all the selected favorites as 16-bit TIFFs and archive these on an actual hard drive as well as a CD or DVD. A 250 GB external hard drive is not too expensive and if you accumulate around 25 GB worth of data for each job, then it only costs a tenth of the cost of a hard drive to store these. He also points out that in all the years he has been working with computers that hard drives are the one standard that has survived all the various types of recordable media. For example, does anyone now remember Syquest disks?

DVD as an alternative to CD

Recordable DVD drives have become increasingly popular and are often supplied as standard with some computer models. Recordable DVD disks are capable of storing 4.7 GB of data. But again, to be realistic, I would knock that figure down to something more like 4.2 GB as the actual amount of data you can store on a disk. Early DVD drives were x1 speed and painfully slow to work with. But you can now get x4 speed DVD drives, which from my point of view make an appreciable difference to the time it takes to archive my data. I typically shoot around 300-400 raw captures during a day's shoot and usually I am able to backup these raw files to a single DVD drive. The only problem with a CD or DVD disk is that if it gets damaged you lose everything and that might mean losing a hefty chunk of valuable data. So make an extra backup copy of important data and archive this separately. Recordable disks also have a finite life span. And who is to say if CD or DVD will not be superseded by some other form of recordable media? And furthermore, if you archive raw camera files, will you always have the software to interpret these? In this industry a lot can happen in a matter of just a few years.

Bureau checklist

Make sure you have everything fully checked before you send that disk. Some bureaux supply their customers with guidelines, others assume you know enough about digital imaging to understand the basic requirements. The preferred image file format is usually a TIFF, that is uncompressed and saved using either PC or Mac byte order. Bureaux also prefer you to remove any masking channels and paths from the final output file. Removing unwanted alpha channels from a TIFF will economize on the stored file size. Only leave paths when saving a clipping path with an EPS or TIFF file. The bureau might also be placing your file in a page layout program like Quark Xpress in order to use a RIP, and your paths may be misinterpreted. Likewise the alpha channels may also choke the RIP. Check that you are supplying your file at an appropriate resolution for the print process, the image dimensions are correct and always make allowance for the extra bleed dimensions (which is usually 3 mm along each edge) if the photograph is to fill the page. There are limits as to how much one can 'interpolate up' a digital image. Apply unsharp masking as necessary. A lot of sharpness gets lost in the repro process and therefore apply a little more unsharp masking than looks correct on the monitor screen (see Chapter 4). Make sure you supply your images in the correct color mode – either RGB or CMYK. Some service providers, like those outfits who produce the Iris art prints, may use their own color conversion hardware to work from your RGB files.

Image protection

Anyone who fully understands the implications of images being sold and transferred in digital form will appreciate the increased risks posed by piracy and copyright infringement. The music industry has for a long time battled against pirates duplicating original discs, stealing music and video sales. Digital music recordings on CD made this problem even more difficult to control when it became possible to replicate the original flawlessly. The issue of piracy is not new to photographers and image makers, but the current scale of exposure to this risk is. It includes not just us Photoshop geeks who are going to be affected, but includes anyone who has their work published or is interested in the picture library market.

To combat this problem, the first line of defence had been to limit the usefulness of images disseminated electronically by (a) making them too small in size to be of use other than viewing on a screen and (b) including a visible watermark which both identified the copyright owner and made it very difficult to steal and not worth the bother of retouching out. The combination of this two pronged attack is certainly effective but has not been widely adopted. The World Wide Web contains millions of screen sized images few of which are protected to this level. The argument goes that these pictures are so small and degraded due to heavy JPEG compression, what possible good are they for print publishing? One could get a better pirated copy by scanning an image from a magazine on a cheap flatbed scanner. Shopping is now replacing sex as the main focus of interest on the Internet, so screen sized web images therefore do now have an important commercial value in their own right. Furthermore, the future success of digital imaging and marketing will be linked to the ability to transmit image data. The technology already exists for us to send large image files across the world at speeds faster than ISDN. Once implemented, people will want to send ever larger files by telecommunications. The issue of security will then be of the utmost importance.

In recognition of this market need, software solutions have been developed to provide better data protection and security, giving suppliers of electronic data the means to warn, identify and trace the usage of their intellectual property. From a user's point of view, the requirements are to produce an invisible 'fingerprint' or encrypted code, which does not spoil the appearance of the image but can be read by the detection software. The code must be robust enough to work at all usage sizes – screen size to high resolution. They must withstand resizing, image adjustments and cropping. A warning message should be displayed whenever an image is opened up alerting the viewer to the fact that this picture is the property of the artist and a readable code embedded from which to trace the artist and negotiate a purchase.

Two companies have produced such encryption/ detection systems – SureSign by Signum Technology and Digimarc by the Digimarc Corporation. Both work as plug-ins for Photoshop. They will detect any encrypted images you open in Photoshop and display a copyright detection symbol in the status bar alongside the file name. The Digimarc plug-in has been included free since Photoshop 4.0. To use Digimarc to encrypt your own work, you have to pay an annual usage fee to Digimarc to register your individual ID (check to see if free trial period offers are in operation). Anyone wishing to trace you as the author, using the Photoshop Digimarc reader plug-in, will contact their website, input the code and from there read off your name and contact number. Here is the main difference between the two systems – the Digimarc code is unique to each author/subscriber while SureSign provide a unique author code plus transaction number. In my opinion, the latter is a more adaptable system. Anyone contacting me with regard to image usage can quote the transaction number which would relate to a specific image. As for pricing methods, with Digimarc the software is free but you have to pay an annual fee to register your code. At the time of writing, SureSign also sell the software with an annual fee.

Investing in protection

Both systems work effectively on digital originals (you can compare them for yourself, a Signum Technology demo is available on the CD-ROM). There is no guarantee that a fingerprint will remain intact when scanned from a halftone printed image, yet Signum report that one client was able to detect the SureSign code from a scanned newspaper page! These programs herald an important step forward for the secure distribution of copyright protected data.

The detection business is very important if fingerprint type encryption is to become trusted as a valuable method of copyright protection. Detection software will also help people searching for a particular image, whether encrypted or not. New Mexico Software and Signum Technologies recently joined forces with C E Heath and Beazley, a Lloyd's insurance syndicate, who are providing an insurance cover plan to enforce copyright protection and recover damages where ownership can be proved using the encryption detecting software.



Chapter 17

Automating Photoshop

etting to know the basics of Photoshop takes
a few months, learning how to become fluent
takes a little longer. There are a great many
keyboard shortcuts and not all of them are
listed in the Adobe Photoshop User Guide. In this chapter I
have grouped together a list of tips and keyboard shortcuts
to help expand your knowledge of Photoshop and automate
the image processing. Use it as a reference for productive
and efficient Photoshopping. Learn the keyboard shortcuts
a few at a time, and don't try to absorb everything at once.
Here are the single key shortcuts for accessing tools and
commands in the Tools palette, followed by the default
standard keyboard shortcuts for the main Photoshop
menus.

Toolbox

Ⓐ	Direct selection path/path component selection tools
Ⓑ	Brush/pencil tools
Ⓒ	Crop tool
Ⓓ	Reset to default black foreground/white background colors
Ⓔ	Eraser/background eraser/magic eraser
Ⓕ	Toggle the three screen display modes
Shift Ⓕ (after first Ⓕ)	Toggle menu bar on/off in two secondary display modes
Ⓖ	Gradient/paint bucket tools
Ⓗ	Hand tool
Spacebar	Access hand tool whilst any other tool is active
Ⓘ	Eyedropper/color sampler/measure tools
Ⓙ	Healing brush/patch tool/color replacement tool
Ⓚ	Slice/slice select tools
Ⓛ	Lasso/polygonal lasso/magnetic lasso tools
Ⓜ	Rectangular/elliptical marquee tools
Ⓝ	Notes/audio annotation tools
Ⓞ	Dodge/burn/sponge tools
Ⓟ	Pen/freeform pen path drawing tools
Ⓠ	Quick mask mode/selection mode
Ⓡ	Blur/sharpen/smudge tools
Ⓢ	Clone stamp/pattern stamp tools
Ⓣ	Type tools
Ⓤ	Shape drawing tools: rectangle/rounded rectangle/ellipse/polygon/line/custom

Toolbox continued

Mac	PC	
V		Move tool
⌘	ctrl	Access move tool whilst any tool is active, bar pen tool
Arrow keys		Nudge selection border only, by 1 pixel
Arrow keys		Whilst move tool selected: nudge selection by 1 pixel
Shift + Arrow keys		Nudge using 10 pixel increments
W		Magic wand tool
X		Exchange foreground/background colors
Y		History brush/art history brush
Z		Zoom tool
Hold down ⌥ key	Hold down alt key	Zoom out when the Zoom tool is selected
⌘ Spacebar-click	ctrl Spacebar-click	Zoom in
⌥ Spacebar-click	alt Spacebar-click	Zoom out

Modifier key tip

To cycle through the hidden tools, hold down the ⌥ alt key and click again on the tool icon in the Tools palette or hold down *Shift* and press the key shortcut again. For example, if the eraser tool is currently selected, ⌥ alt click the eraser tool icon or press *Shift* E to cycle through the other eraser tools. There is also an option in the first dialog of the General Preferences that allows you to cycle through the tools without using the Shift key modifier.

Keyboard shortcuts tip

The shortcut for Keyboard shortcuts is: ⌘ ⌥ *Shift* K ctrl alt *Shift* K

Custom Keyboard shortcuts

The default keyboard shortcuts in Photoshop utilize just about every key combination that is available on a standard English language computer keyboard. The toolbox uses every letter of the alphabet to perform a function, then you have the ⌘ ctrl keys plus a letter, number or keyboard symbol, followed by the ⌘ *Shift* ctrl *Shift* key combinations, the ⌘ ⌥ ctrl alt combinations, and finally, a few key combinations that combine three modifier keys, such as: ⌘ ⌥ *Shift* ctrl alt *Shift*. Non-English language computer keyboards will differ. For example, keyboards produced for the Scandinavian countries will assign different special language symbols in place of the ones found on a US or British keyboard. In the past, this presented problems for non-English language Photoshop users, as things like the tilde key (~) wouldn't exist on some keyboards. But the shortage of spare

Toolbox continued

Shift A	Toggle between direct select/path component selection tools
Shift B	Toggle between brush and pencil tools
Shift E	Cycle through eraser tools
Shift G	Toggle between gradient and paint bucket tools
Shift I	Cycle through eyedropper tools and measure tool
Shift J	Toggle between healing brush and patch tool
Shift K	Toggle between slice and slice select tools
Shift L	Cycle through lasso tools
Shift M	Toggle between rectangular and elliptical marquee tools
Shift N	Toggle between notes and audio annotation tools
Shift O	Cycle through toning tools
Shift P	Toggle between pen and freeform pen tools
Shift R	Cycle through focus and smudge tools
Shift S	Toggle between clone stamp and pattern stamp tools
Shift T	Cycle between the different type tools
Shift U	Cycle between the different shape tools
Shift Y	Toggle between history and art history tools

keyboard shortcuts also limited the number of Photoshop functions that could have a keyboard shortcut. When you use Photoshop CS, you can customize the keyboard shortcuts to suit your own way of working. Shortcuts you find redundant can be reassigned to execute functions that are more useful to you.

Modified shortcuts can be saved as new sets. To do this, go to the Edit menu and choose Keyboard Shortcuts and click on the Create New Set button (see Figure 17.1). This

Shortcuts subset Create new set

Keyboard shortcut set Save changes Delete

Menu/tool/palette command Keyboard shortcut

Generate a shortcuts summary in HTML

Figure 17.1 The Keyboard Shortcuts dialog.

Figure 17.2 The Keyboard Shortcuts Save set dialog. The default location for saving sets is the Keyboard Shortcuts folder in the Adobe Photoshop CS application folder.

will open the Save dialog box shown in Figure 17.2. Give the new set a name and save the new set to the Keyboard Shortcuts folder. You will have just created a duplicate of the currently selected keyboard shortcut set which can now be modified. To create a shortcut, click in the Shortcuts column (as shown in Figure 17.3). Hold down the keyboard key combination exactly as you would if you were using the keyboard shortcut. The key combination will then appear in the Shortcut column space.

When you are happy with the changes made to the new set, click on the button to the left, to save the changes. If you click on the Summarize button, this will generate a document in a web page format that summarizes all the

Palette Menu Command	Shortcut
Delete Hidden Layers	
New Layer Set...	
New Set From Linked...	
Lock All Layers In Set...	
Layer Properties...	
Blending Options...	
Merge Layers	⌘+E
Merge Visible	Shift+⌘+E
Flatten Image	Opt+Shift+⌘+E ⚠

⚠ Opt+Shift+⌘+E is already in use and will be removed from "Merge a copy of all visible layers into the target layer" if accepted. You cannot assign a different shortcut to "Merge a copy of all visible layers into the target layer".

(Accept) (Undo Changes)

Figure 17.3 As you edit the keyboard shortcuts, you will come up against the same problem that has long bugged the Photoshop engineers, and discover that many of the key combinations are already in use. When this happens, an alert message will appear at the bottom of the dialog telling you that the shortcut is already in use elsewhere. You can either undo the change or choose Accept. When you change the assigned shortcut the old shortcut will be removed from this set. If the Palette menu shortcut is also shared as a menu item, the changes will take place in both locations.

available shortcuts in this set. This summary can be printed out and used as a guide to all the available shortcuts, much like some of the tables shown in this chapter.

The Palette shortcuts are grouped into: Application menus, Palette menus and Tools. The Application and palette menu sets contain subsets of items with expandable views. You can also create more than one shortcut for each item. To do this, select an item in the list and click on the Add Shortcut button. Enter the secondary shortcut as usual.

Photoshop menu

Mac	PC	Function
⌘ Shift K	ctrl Shift K	Color Settings
⌘ K	ctrl K	General Preferences
⌘ ⌥ K	ctrl alt K	Open General Preferences (last used dialog box)
⌘ ctrl H	ctrl right mouse H	Hide Photoshop
⌘ ⌥ H	ctrl alt H	Hide other applications
⌘ Q	ctrl Q	Quit/Exit Photoshop

File menu

Mac	PC	Function
⌘ N	ctrl N	File ⇨ New File
⌘ ⌥ N	ctrl alt N	File ⇨ New File using previously selected settings
⌘ O	ctrl O	File ⇨ Open File
⌘ Shift O	ctrl Shift O	File ⇨ Open File Browser
⌘ W	ctrl W	File ⇨ Close Window/Close File
⌘ ⌥ W	ctrl alt W	File ⇨ Close All
⌘ S	ctrl S	File ⇨ Save
⌘ Shift S	ctrl Shift S	File ⇨ Save As...
⌘ Shift ⌥ S	ctrl Shift alt S	File ⇨ Save for Web...
⌘ ⌥ I	ctrl alt I	File ⇨ File Info...
⌘ P	ctrl P	File ⇨ Print File
⌘ Shift P	ctrl Shift P	File ⇨ Page Setup
⌘ ⌥ P	ctrl alt P	File ⇨ Print with Preview
⌘ Shift ⌥ P	ctrl Shift alt P	File ⇨ Print One Copy
⌘ Shift M	ctrl Shift M	Jumps to the default Jump to application
esc or D	esc	Activate Don' t Save after File ⇨ Close (System command)
esc or ⌘ .	esc or ctrl .	Cancel or Abort function (System command)

Edit menu

Mac	PC	Function
⌘ Z	ctrl Z	Edit ⇨ Undo last operation (see Preferences)
⌘ Shift Z	ctrl Shift Z	Edit ⇨ Step forward through history
⌘ ⌥ Z	ctrl alt Z	Edit ⇨ Step backward through history
⌘ Shift F	ctrl Shift F	Edit ⇨ Fade last operation (image adjustment, filter etc.)
⌘ X	ctrl X	Edit ⇨ Cut
⌘ C	ctrl C	Edit ⇨ Copy
⌘ Shift C	ctrl Shift C	Edit ⇨ Copy Merged
⌘ V	ctrl V	Edit ⇨ Paste
⌘ Shift V	ctrl Shift V	Edit ⇨ Paste Into
⌥ Delete	alt ⬅	Edit ⇨ Fill with foreground color
⌘ Delete	ctrl ⬅	Edit ⇨ Fill with background color
⌥ Shift Delete	alt Shift ⬅	Fill layer with foreground color while preserving transparency
⌘ Shift Delete	ctrl Shift ⬅	Fill layer with background color while preserving transparency
Shift Delete or Shift F5	Shift ⬅ or Shift F5	Open Edit ⇨ Fill... dialog box
⌘ ⌥ Delete	ctrl alt ⬅	Fill from history
⌘ T	ctrl T	Edit ⇨ Free Transform
⌘ Shift T	ctrl Shift T	Repeat the last applied Transform
⌘ ⌥ T	ctrl alt T	Free Transform with Duplication
⌘ ⌥ Shift Z	ctrl alt Shift Z	Transform again with Duplication
⌘ ⌥ Shift K	ctrl alt Shift K	Keyboard Shortcuts

Image menu

Mac	PC	Function
⌘ L	ctrl L	Image ⇨ Adjustments ⇨ Levels
⌘ Shift L	ctrl Shift L	Image ⇨ Adjustments ⇨ Auto Levels
⌘ Shift ⌥ L	ctrl Shift alt L	Image ⇨ Adjustments ⇨ Auto Contrast
⌘ Shift B	ctrl Shift B	Image ⇨ Adjustments ⇨ Auto Color
⌘ M	ctrl M	Image ⇨ Adjustments ⇨ Curves
⌘ B	ctrl B	Image ⇨ Adjustments ⇨ Color Balance
⌘ U	ctrl U	Image ⇨ Adjustments ⇨ Hue/Saturation
⌘ Shift U	ctrl Shift U	Image ⇨ Adjustments ⇨ Desaturate
⌘ I	ctrl I	Image ⇨ Adjustments ⇨ Invert Image Color
⌥ Image ⇨ Duplicate	alt Image ⇨ Duplicate	Holding down the ⌥ alt key whilst choosing Image ⇨ Duplicate bypasses the Duplicate dialog box

The ⌥ alt key can be used in combination with any of the above image adjustment commands (just as you can with filters) to open up the relevant dialog box with the last used settings in place. This is a generic Photoshop interface convention. The above fade command will fade filters, image adjustments and all types of brush strokes. It used to be located in the Filter menu, but is now an Edit menu item.

Select menu

Mac	PC	Function
⌘ A	ctrl A	Select ⇨ Select All
⌘ D	ctrl D	Select ⇨ Select Deselect
⌘ Shift D	ctrl Shift D	Select ⇨ Reselect
⌘ ⌥ D or Shift F6	ctrl alt D or Shift F6	Select ⇨ Feather
⌘ Shift I or Shift F7	ctrl Shift I or Shift F7	Select ⇨ Invert Selection

Layer menu

Mac	PC	Function
⌘ Shift N	ctrl Shift N	Layer ⇨ New Layer
⌘ ⌥ Shift N	ctrl alt Shift N	Layer ⇨ New Layer (without dialog box)
⌘ G	ctrl G	Layer ⇨ Group With Previous Layer
⌘ Shift G	ctrl Shift G	Layer ⇨ Ungroup
⌘ E	ctrl E	Layer ⇨ Merge Down
⌘ J	ctrl J	Layer ⇨ New ⇨ Layer Via Copy (float to new layer)
⌘ Shift J	ctrl Shift J	Layer ⇨ New ⇨ Layer Via Cut
⌘ Shift E	ctrl Shift E	Layer ⇨ Merge Visible
⌘ ⌥ Shift E	ctrl alt Shift E	Layer ⇨ Merge Visible and paste to selected layer
⌘]	ctrl]	Arrange ⇨ Bring a layer forward in the stack
⌘ Shift]	ctrl Shift]	Arrange ⇨ Bring a layer to the top of the stack
⌘ [ctrl [Arrange ⇨ Send a layer backward in the stack
⌘ Shift [ctrl Shift [Arrange ⇨ Send a layer to the bottom of the stack

Filter menu

Mac	PC	Function
⌘ F	ctrl F	Filter ⇨ Apply last filter used (with same settings)
⌘ Shift F	ctrl Shift F	Edit ⇨ Fade filter
⌘ ⌥ F	ctrl alt F	Open dialog with last used filter settings
⌘ ⌥ X	ctrl alt X	Filter ⇨ Extract
⌘ Shift X	ctrl Shift X	Filter ⇨ Liquify
⌘ ⌥ Shift F	ctrl alt Shift F	Filter ⇨ Pattern Maker

View menu

Mac	PC	Function
⌘ Y	ctrl Y	View ⇨ Proof Colors (see Preferences)
⌘ Shift Y	ctrl Shift Y	View ⇨ Gamut Warning
⌘ +	ctrl +	View ⇨ Zoom in with window resizing
⌘ ⌥ +	ctrl alt +	View ⇨ Zoom in without resizing window size
⌘ −	ctrl −	View ⇨ Zoom out with window resizing
⌘ ⌥ −	ctrl alt −	View ⇨ Zoom out without resizing window size
⌘ 0	ctrl 0	View ⇨ Fit To Screen (constrained by open palettes)
Double-click hand tool	Double-click hand tool	View ⇨ Fit To Screen (constrained by open palettes)
⌘ ⌥ 0	ctrl alt 0	View ⇨ Actual Pixels at 100%
Double-click zoom tool	Double-click zoom tool	View ⇨ Actual Pixels at 100%
⌘ H	ctrl H	View ⇨ Show Extras (selections/target path/grid/guides/slices/notes)
⌘ Shift H	ctrl Shift H	View ⇨ Show/Hide Path only
⌘ ;	ctrl ;	View ⇨ Show/Hide Guides only
⌘ '	ctrl '	View ⇨ Show/Hide Grid only
⌘ R	ctrl R	View ⇨ Show/Hide Rulers
⌘ Shift ;	ctrl Shift ;	View ⇨ Snap (guides/grid/slices/document bounds)
⌘ ⌥ ;	ctrl alt ;	View ⇨ Lock Guides
Double-click guide with move tool	Double-click guide with move tool	Edit Guides & Grid settings: color and increments
ctrl Tab	ctrl Tab	Cycle through open document windows (Mac only)

Window menu

Mac	PC	Function
`Tab`	`Tab`	Hide/show all palettes
`Shift` `Tab`	`Shift` `Tab`	Hide/show all palettes except Tools palette and Options bar
`⌘` `ctrl` `M`	`ctrl` right mouse `M`	Minimize window

Window display options

Choose Window ⇨ Documents ⇨ Cascade to display windows stacked one on top of the other going from top left to bottom right of the screen. Choose Window ⇨ Documents ⇨ Tile to display document windows edge to edge.

Navigation

Mac	PC	Function
Page up	Page up	Scroll up by one screen
Page down	Page down	Scroll down by one screen
`Shift` Page up	`Shift` Page up	Scroll up in smaller steps
`Shift` Page down	`Shift` Page down	Scroll down in smaller steps
`Shift` Page up/Page down	`Shift` Page up/Page down	Scroll up or down a single frame of a Filmstrip file
`⌘` Page up	`ctrl` Page up	Scroll left one screen
`⌘` Page down	`ctrl` Page down	Scroll right one screen
`⌘` `Shift` Page up	`ctrl` `Shift` Page up	Scroll left one screen in smaller steps
`⌘` `Shift` Page down	`ctrl` `Shift` Page down	Scroll right one screen in smaller steps
Home key	Home key	Display top left corner of image
End key	End key	Display bottom right corner of image

Contextual menus

A good many shortcuts are just a mouse-click away. Contextual menus are available throughout Photoshop. On a Macintosh you use *ctrl* click and on the PC use a right mouse-click to open a contextual menu in an image document window or a Photoshop palette such as the Layers, Channels or Paths palette. For example, you can *ctrl* right mouse-click in the document window to access a list of all the menu options associated with the current selected tool.

Moving and cloning selections

To move the border outline only, place the cursor inside the selection border and drag. To move the selection contents, use the move tool (⌘ *ctrl*) – just hold down the ⌘ *ctrl* key and drag inside the selection.

To clone a selection (without making it a layer), hold down the ⌘ ⌥ *ctrl* *alt* keys and drag.

To cut a selection, hold down the ⌘ *ctrl* key and drag.

Selections

Holding down the *Shift* key when drawing a marquee selection constrains the selection being drawn to a square or circle.

Holding down the ⌥ *alt* key when drawing a marquee selection centers the selection around the point from where you first dragged.

Holding down the *Shift* ⌥ *Shift* *alt* keys when drawing a marquee selection constrains the selection to a square or circle and centers the selection around the point where you first clicked.

If you hold down the Spacebar at any point, you can reposition the center of the selection. Release the Spacebar and continue to drag using any of the above combination of modifier keys to finish defining the selection.

After drawing a selection and releasing the mouse, hold down the *Shift* key to add to the selection with the lasso, marquee or magic wand tool.

Hold down the ⌥ *alt* key to subtract from the existing selection with the lasso, marquee or magic wand tool.

Hold down the *Shift* ⌥ *Shift* *alt* key to intersect with the existing selection using the lasso, marquee or magic wand tool.

Info and Navigator

Double-click the ruler margins to open the Units & Rulers preferences. *ctrl* right mouse-click on a ruler to change the Units settings. You can use the keyboard numbers to set the tool opacity while any paint or fill tool is selected (1 = 10%, 9 = 90%, 0 = 100%). For more precise settings, enter any double number values in quick succession (i.e. 04, 23, 75 etc.). Use the up arrow to increase values in the box by 1% and use the down arrow to decrease values in the box by 1% (hold down the *Shift* key to decrease or increase by 10%). The Navigator palette provides a swift way of scrolling across an image. The bottom left box in the Navigator palette indicates the current viewing percentage scale. As with the identical box in the document window

display, any value can be entered between 0.19% and 1600.00%. To zoom to a specified percentage and keep this box highlighted, hold down the *Shift* key whilst pressing *Enter*. Use the Navigator slider control to zoom in and out or mouse down on the left button to zoom out incrementally and the right button to zoom in. The dialog palette preview display indicates by a red rectangle which portion of the image is visible in relation to the whole – the rectangle border color can be altered by going to the palette options. To scroll quickly, drag the rectangle across the Navigator palette screen. Hold down the *⌘* *ctrl* key and marquee within the thumbnail area to specify an area to zoom to. The Navigator palette can also be resized to make the preview window larger.

Working with Actions

Photoshop is able to record many of Photoshop's operations in a sequence and save them as an Action. These Actions can then be replayed on other images and shared with other Photoshop users so that they can repeat this sequence of Photoshop steps on their computer. Actions can save you the bother of laboriously repeating the same steps over and over again on subsequent images.

Playing an Action

The Actions palette already contains a set of prerecorded Actions called *Default Actions.atn*. And if you go to the Actions palette fly-out menu you can load other sets from the menu list such as: *Frames* and *Image Effects*. To test these out, open an image, select an Action from the menu and press the Play button. Photoshop will then apply the recorded sequence of commands to the selected image. If the number of steps in a complex Action exceeds the number of available histories, there will be no way of completely undoing all the commands when the action has completed. So as a precaution, either take a snapshot in the History palette or save the document before executing an Action and if you are not happy with the result, fill from the saved snapshot in History or revert to the last saved

Sourcing ready made actions
You will find several Actions already available when you install Photoshop and discover many more which are freely available on the Internet. A useful starting point is the Adobe Studio Exchange site at: <http://share.studio.adobe.com>. This is a comprehensive of Actions, plug-ins and Scripts etc. Another is the Elated site <http://www.elated.com/actionkits/>. Both these sites have ready prepared actions or sets of actions with examples of the types of effects achieved with them for you to freely download for use in Photoshop.

Limitations when recording Actions

Most Photoshop operations can be recorded within an Action such as image adjustments, History palette steps, filters, and most tool operations in Photoshop. Tools such as the marquee and gradient fills are recorded based on the currently set ruler unit coordinates. Where relative positioning is required, choose the Percent units in Units & Rulers preferences before you begin recording. Avoid using commands which as yet cannot be recorded with an Action. This is less of a problem now, as the scriptability of Photoshop has been vastly improved, but certain operations like brush strokes (or any of the other painting tools) cannot be recorded as this goes beyond the scope of what can be scripted.

version. Photoshop Actions are normally appended with the .atn file extension and saved by default to the Photoshop Actions folder, inside the Photoshop Application Presets folder. But you can store them anywhere you like. And if you want to install an Action you have downloaded or someone has sent to you, all you have to do is double-click it.

Recording Actions

To record an Action open up a test image first. Click the New Action button at the bottom of the Actions palette. Give the Action a name and then press the Record button. At this stage you can also assign a custom key combination using a combination of Function keys (F1-F15) with the Shift and ⌘ ctrl keys. You can then simply use the key combination to initiate running the Action. Now carry out the Photoshop steps you wish to record and when finished, click the Stop button.

Watch out for recording commands that rely on the use of named layers or channels that may be present in your test file, as these will not be recognized when the Action is applied to a new image. Also try to make sure that your actions will not always be conditional on starting in one color mode only, or being of a certain size. If you intend recording a complex Action, the best approach is to carefully plan in advance the sequence of Photoshop steps you intend to record. The following example demonstrates how to record a basic Action. A break can be included in an Action. This will always open a message dialog at a certain point during playback. It can include a memo to yourself (or another user replaying the Action), reminding you of what needs to be done at a certain stage. Or if the Action is to be used as a training aid, the message could include a teaching tip or comment. Actions are always created within sets and if you want to save an Action, it has to be saved as a set. So if you want to separate an action to save on its own, click on the New Set button in the Actions palette to create a new set, drag the action to the new set, name the set and choose Save Actions... from the Actions palette fly-out menu (an Action Set must be highlighted, not an

1 The Actions palette shown here has been expanded to list all the steps that make up an Action I have named *Vignette frame 15%*. As a first step, I chose Show Rulers from the View menu. I double-clicked a ruler and set the units to 'Percent'. By doing this, all positions were recorded, measured as a percentage of the document's dimensions. The recorded action will be effective whatever the size or proportions of an image.

2 using the ruler, I added four guides at 15% in from the edge, used this to draw a rectangular marquee and then deleted the guides. To create the vignette effect, I chose Feather from the select menu and feathered the selection by 100 pixels, followed by an Inverse Selection.

3 I then clicked on the Add adjustment layer button in the Layers palette and chose Levels. This step added an adjustment layer, automatically adding a layer mask at the same time, so as I darkened the image using Levels, only the outer areas were effected.

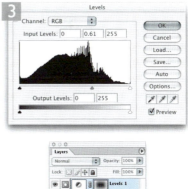

4 When the recording is complete, you need to remember to click on the Stop button in the Actions palette. The Action is now ready for testing. And when you have fine tuned the Actions as necessary, it is ready for use to apply as a single action or for batch processing.

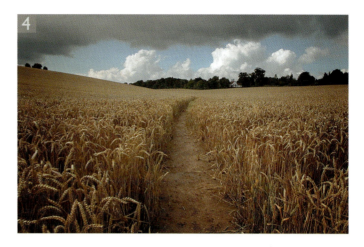

Actions only record changed settings

One of the problems you commonly face when preparing and recording an Action, is what to do if certain settings are already as you want them to be. Actions will only record a setting as part of an Action if it actually changes. So for example, you are recording an image size adjustment where you want the image resolution to end up at 300 pixels per inch, but the image is already defined in the Image Size dialog as 300 pixels per inch. In these situations, Photoshop does not record anything. To resolve these potential problems, you have to deliberately make the image size something else before you record the step, and then when you change the pixel resolution, this will get recorded.

action). If you hold down the ⌘ ⌥ ctrl alt keys as you choose Save Actions... this will save the text descriptions of the Action steps for every Photoshop Action currently in the Actions palette.

Troubleshooting Actions

Check that the image to be processed is in the correct color mode. Many Actions, such as those that use certain Photoshop filters, are written to operate in RGB color mode only. Color adjustment commands will not work properly if the starting image is in CMYK and not at all if in Grayscale. Some pre-written Actions require that the start image fits certain criteria. For example, the Photoshop supplied Text Effect Actions require that you begin with images that already contain layered text. If you have just recorded an Action and are having trouble getting it to replay, you can inspect it command by command. Open a test image and expand the Actions palette to display all the items. Hold down the ⌘ ctrl key and click on the Play button. This will play the first command only. If there is a problem, double-click the command item in the list to rerecord it. Hold down the ⌘ ctrl key again and click on the Play button to continue. To replace an item completely, press Record and perform a new step, then click Stop. This will delete the old step and replace it with the one you have just recorded.

Action recording tips

Action recordings should be as unambiguous as possible. For example, if you record a step in which a named layer is brought forward in the layer stack, on playback the action will look for a layer with that name. Therefore, when adding a layer include naming the layer as part of the Action. Do not use *Layer 1, Layer 2* etc. This can only cause confusion with Photoshop's default naming of layers. And use the main Layer menu or Layer key command shortcuts to reorder the layer positioning. Doing so will make your Action more universally recognized.

Inserting menu items

There are some things which can be included as part of a Photoshop Action, which can only be included by forcing the insertion of a menu item. For example, Photoshop will not record zoom tool or View menu zoom instructions. But if you select Insert Menu Item from the Actions palette fly-out menu, as you record, you will see the dialog in Figure 17.4. The Menu Item dialog will initially say *None Selected*. Choose a zoom command from the View menu and the instruction will now be recorded as part of the Action. Although frustratingly, the image won't actually zoom in or out until you actually replay the Action. I use the Insert Menu Item to record opening dialogs that I regularly access, like the Web Photo Gallery. This saves me always having to navigate the File menu.

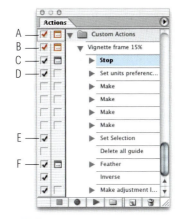

Figure 17.4 The Insert Menu Item dialog will initially say *None Selected*. Select a menu item such as Window > Tile and click OK. When the Action is replayed the instruction will be included.

Figure 17.5 Actions palette column icons.
A: The Set contains inactive operations.
B: The Action contains inactive operations.
C: Indicates the Action step is active and contains a Stop.
D: An active operation that has a dialog box.
E: An active operation with no dialog box.
F: An active operation with a pause, opening the dialog box.

Stop and pause

When editing an Action, you can insert what is known as a Stop, which will allow you to halt the action process to display an alert message. This could be a useful warning like the one shown in Figure 17.6, which is displayed at the beginning of the Action playback. If you want to display a dialog setting during playback, insert a Pause by clicking in the blank space to the left of the Action step (see Figure 17.5 – F).

Figure 17.6 The Record Stop dialog.

Complete Photoshop scripting

One of the most neglected aspects of Photoshop has been the ability to write scripts to automate the program and make it go even further than you can with Actions. It is possibly the most scary as well and I freely confess I am one of those who has looked at the 100 plus page scripting guide PDF and simply shuddered at the prospect of learning how to do computer programming. But steps have been taken to make this stuff more accessible to the general user. You will also be able to download pre-made scripts from the afore mentioned website: <http://share.studio.adobe.com>.

Go to the Scripts menu in the Photoshop File menu and you will see a few sample Scripts to experiment with. Among these are Scripts that will generate a Web Photo Gallery from the Layer Comps in a file. Figure 17.7 shows the interface for the Export Layers to Files Script.

Figure 17.7 An example of the Export Layers to Files Script dialog from the Scripts menu in Photoshop.

Batch processing Actions

One of the great advantages of Actions is having the ability to batch process files. The Batch dialog can be accessed via the File ⇨ Automate menu. And it can also be accessed via the File Browser Automate menu. You need to select an Action Set and Action from the Play section. Then you need to select a Source and Destination. The Source can be all currently open images, selected images in the File Browser window or a designated folder, in which case, you need to click on the Choose... button below and select a folder of images. If you check the Override Action Open commands check box, Photoshop will only open and process images if the Action includes an Open command. Check Include All Sub-folders if you want to process all folders within the selected folder. Checking the Suppress Color Profile Warnings option will prevent the missing profile and profile mismatch dialogs appearing when you batch process images. If there is a profile mismatch, Photoshop will check what you did previously. If you previously chose to keep the image in its own profile space, this is how the images will be batch processed. If there is no profile present, Photoshop will check to see if your previous preference was to: Ignore, Assign a profile, or Assign and convert to the working space. The Action may contain a Save or Save As command, which uses a specific file format and format settings. This step will also contain a Save destination. Now it might so happen that the Save destination is an important part of the Action. But if the destination folder no longer exists, the Action will fail to work. Besides, you can specify a destination folder using the Batch dialog. If the Action contains a Save instruction, I recommend you check this box.

The file naming options let you define the precise naming and numbering structure of the batch processed files. For example, the existing file document name can be made capitalized or use lower case type. Figure 17.9 shows the complete list of naming and numbering options (these are also used in the Batch Rename dialog). If a folder is selected as the destination, you have six editable fields at

Figure 17.8 An example of the Batch Action dialog set to apply a prerecorded Action. You can write your own fields. I have created a batch process where the image will be renamed 'Bookimage_' followed by a two digit serial number, followed by an underscore '_' the month and year, followed by a lower case extension. Note that the numbering has been set to start at '101'. So in this example the filename structure will be something like: *Bookimage_101_0830.gif.*

Figure 17.9 The Batch interface naming and numbering options.

your disposal. You can use any combination you like, but the file extension must always go at the end. As you edit the fields, you will see an example of how the naming will work on a nominal image called *MyFile.gif*. And you can also enter your own custom text (see Figure 17.8).

Creating a Droplet

A Photoshop Action can be converted into a self-contained application, known as a Droplet, that can be saved outside of Photoshop to somewhere useful, like the desktop and which will launch Photoshop and initiate a specific Action sequence, whenever you drag and drop a file on top of the Droplet icon.

To make a droplet, go to the File ⇨ Automate menu and choose Create Droplet... Figure 17.10 shows the Create Droplet interface. The Droplet options are identical to those found in the Batch Actions dialog. Choose a location to save the Droplet to and choose a destination folder for the droplet processed files. When you are finished, click OK.

Figure 17.10 The Create Droplet dialog. When you drag and drop an image file on top of a droplet, this will launch Photoshop and perform a single or batch processing operation within the program. Droplets can perform Save and Close operations or save the processed results to an accompanying folder. I have an easily accessed folder on my main hard drive containing dozens of Droplets and droplet folders which are laid out as shown below.

Cross Platform Droplets

You can name a droplet anything you like, but to be PC compatible you should add a .exe extension. If someone sends you a droplet that was created using a PC, it can be made Mac compatible by dragging it over once to the Photoshop application icon.

Droplets can play a useful role in any production work flow. They are effectively self-contained Photoshop batch processing routines. I have got into the habit of keeping a folder located on the desktop specifically designed to contain Photoshop droplets and their associated destination folders.

Picture Package

The Picture Package can automatically produce a picture package page layout based on one or more images. Figure 17.11 shows how you could have a combination of a single 5×7, with four smaller sized images all oriented to fit within a single 10×8 print area. Picture Package will normally generate a layout based on the frontmost image open in Photoshop. You can also select a specific file as the

Figure 17.11 The Picture Package dialog box.

Figure 17.12 The Picture Package layout editor.

Fit Image

Fit Image... is a very simple automated plug-in that bypasses the Image > Image Size menu item. It is well suited for the preparation of screen-based design work. Enter the pixel dimensions you want the image to fit to, by specifying the maximum pixel height or width.

Figure 17.13 The Fit Image dialog.

Multi page PDF to PSD

With the Multi-Page PDF to PSD... plug-in, you can open multiple pages of a PDF document as individual Photoshop image files. The opening dialog offers a choice of source file, which pages you want to select, what resolution to open to and the location of the folder to save to.

source or a folder, in which case a Picture Package will be created of every image in the folder, which might take a while to process. If you double-click in one of the Picture Package template spaces you can load an alternative file to replace one of the repeated images. The Label section is useful if you wish to add, say, the file name or have the caption appear within the image area. For example, you could enter custom text, choose a low opacity and have it appear in the center of each image as a watermark (such as a copyright message). This labeling feature is still very limited as you cannot place the label outside of the image area (like just below each image). But you can edit the layouts more easily. The Picture Package Edit Layout dialog is shown in Figure 17.12. Click on a template zone and an eight handle bounding box will appear, allowing you to edit the size and positioning of each zone, and have the ability to add or delete zones, and create new page sizes. With the Grid Snap To box checked, it is easy to make sure the zones are neatly aligned

Contact Sheet II

The Contact Sheet II is able to take a folder of images or a selection of pictures from the File Browser and make them into a contact sheet. If there are more images in the folder than will fit a single page layout, then extra contact sheets will be produced. The Contact Sheet II shown in Figure 17.14 has some nice refinements. In the Document section you can define the contact sheet page size, color mode and pixel resolution. Below that is the Thumbnails section where you can set the number of rows and columns to be used in the layout. When the Use Auto-Spacing box is checked, Photoshop will position the contact sheet images as closely together as possible. But bearing in mind that some images may be in landscape and others in portrait mode, there will still be some gaps between each image. If the Rotate For Best Fit box is checked, Photoshop will ignore the orientation of images and lay them out to achieve the best fit on the page. This means you will end up with something that looks more like a normal film contact sheet.

Figure 17.14 The Contact Sheet II interface in Photoshop CS features a few new refinements which enable you to automatically produce contact sheet prints that make the best use of the space on the paper as can be seen in the contact sheet example below.

Automation plug-ins

The Automation features described in this section are all examples of Automation plug-ins. What distinguishes these from normal plug-ins, is that they enable Photoshop to perform a complex set of procedures based on simple user input. Some automated plug-ins are like 'wizards'. An on-screen interface will guide you through various options and help you produce the desired result. Third-party developers have the means to build their own Automated plug-ins for Photoshop and so far I believe it is only Pixel Genius (of which I am a cofounder) who have made use of this feature in Photoshop to produce the PhotoKit™ and PhotoKit Sharpener™ automated plug-ins.

Figure 17.15 The Crop and Straighten Photos plug-in can be used to extract scanned photos that need to be rotated and cropped.

Check the Use Filename As caption checkbox if you want the file name to appear below each picture. You can choose to use any font and point size for the caption.

Crop and Straighten Photos

This is a new, Photoshop CS Automated plug-in that is very straightforward to use. If you have scanned images that need to be rotated and cropped. Gang up several images on your scanner, scan the pictures in as one image and choose Crop and Straighten Photos from the Automate sub menu (note, this option is not available in the File Browser Automate menu). Photoshop will create a rotated and cropped copy version of each picture (see Figure 17.15).

PDF Presentation

This is a new Photoshop CS feature which enables you to produce a multi-page document or a slideshow presentation in a PDF format. PDF files can be read by various programs, including Adobe's own Acrobat Reader. PDF Presentation is useful if you want to produce a portfolio slideshow, or a self-contained document containing a series of images that are to be sent to a client. A feature like this should have great potential for the professional market, but its usefulness in this implementation of Photoshop is rather limited at the moment. Hopefully the interface design will be improved in the future to enable fuller control over the creation of PDF presentations.

Photomerge

The Photomerge feature first appeared in Photoshop Elements, just after the release of Photoshop 6.0. And has now at last been included in Photoshop itself. The main difference being that this version of Photomerge is able to handle the processing of large compositions and you can save a Photomerge composition as a layered file.

Photomerge is mainly used to join photographs together to make a panoramic composition. If you are planning to create a panoramic scene, then here are a few words of advice. You need to make sure that all the images overlap

Figure 17.16 The PDF Presentation automation feature is capable of producing PDF documents from selected images. You can click on the Browse... button to select single or *Shift* select multiple images. Or check the Add Open Files box to select all files that are currently open in Photoshop. If you are using the File Browser, you can make an image selection there and choose PDF Presentation from the Automate menu. You can choose to generate either a multi-page PDF document or a PDF presentation slideshow. Both can be opened in any application that can read the PDF format, including Adobe Acrobat Reader.

PDF presentation can read files in RGB or CMYK color that are either layered or flattened. But there is no means to control the image output pixel size. If you select a folder of master documents to process, the image pixel dimensions will remain as they are. If all you want to produce is a compact slideshow to fill the screen, you must carefully resize each image beforehand. The transition effects can be very pretty, but only versions 6.0 or later of Adobe Acrobat or Acrobat Reader are capable of rendering these on the screen.

sufficiently, by at least 15% and as you take your series of pictures, rotate the camera in gradual steps aiming to pivot the rotation around the center of the lens. And try to prevent the camera lens axis shifting about too much. You will generally get good results if you start with a simple composition that stitches together only a few shots. Before you shoot the photographs, lock the camera settings so that the exposure is on manual and the exposures consistent. If shooting digitally, make sure that the white balance setting remains the same. The focal length must remain constant as well. Don't attempt to zoom in or out as you are taking

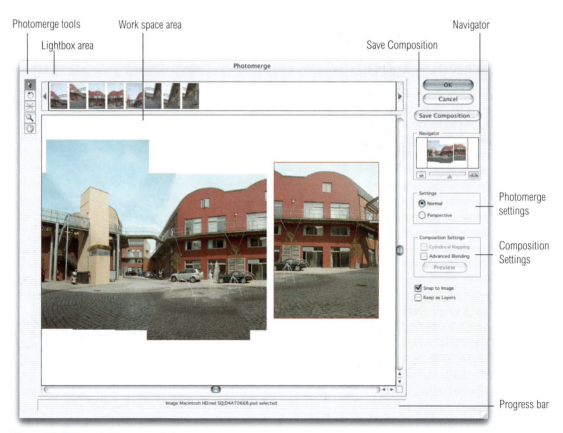

Figure 17.17 The Photomerge opening dialog.

photographs. Wide angle shots are more tricky to stitch together, so try to use a focal length that is equivalent to a 35 mm lens on a 35 mm camera, or longer.

Launch Photomerge from the File ⇨ Automate menu, and click on the Browse button in the introductory dialog to select a folder of images, all open files or add individual files that you wish to merge together. If you check the box at the bottom, Photomerge will always attempt to automatically join images together. This setting will apply when Photomerging images directly from the File Browser menu as well. If you have already pre-saved a Photomerge composition, you can click the Load Composition... button, which will load the saved composition data and locate the associated source files.

Photomerge tools Work space area Navigator

Lightbox area Save Composition

 Photomerge
 settings

 Composition
 Settings

 Progress bar

Figure 17.18 The main Photomerge dialog.

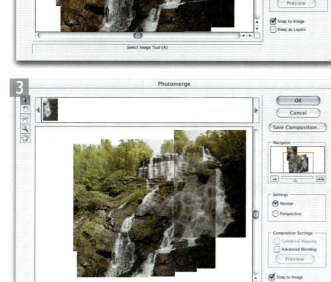

1 Gather together a selection of images that you wish to build a panoramic image with. I find that the best approach is to make an edited selection of photographs via the File Browser and choose Photomerge... from the File Browser Automate menu.

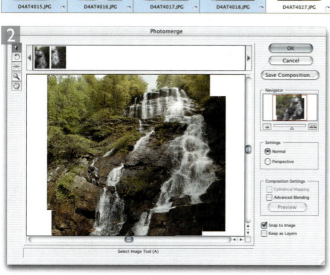

2 As Photomerge launches it will open all of the images in sequence and attempt to auto stitch the pictures together. As you can see here, Photomerge was able to work out how to assemble six of the eight shots in the work area all by itself. The two shots that wouldn't auto match are held in the Lightbox area above. You can use the Navigator controls to zoom in and out of the work space area and scroll around the composition.

3 If you want to merge the remaining images held in the lightbox area, make sure the Select Image tool is active and the Snap to Image box is checked. Click on one of the above images, drag it into the work area. The image will appear semitransparent where it overlaps the underlying composition. This will enable you to judge where to position it so that the image registers as closely as possible to the rest of the composition. If the image does not appear to match too well, select the Rotate image tool and rotate it slightly until it does.

523

4 Once all the image components are in place, you can try making further improvements. If you click on the Perspective button in the dialog settings, Photomerge will adjust the composition preview, transforming each image component in order to achieve an improved composition perspective, centered around the currently active image, which will be the one outlined in red. If the perspective needs adjusting, select the set Vanishing Point tool and click in the work area to set a new vanishing point.

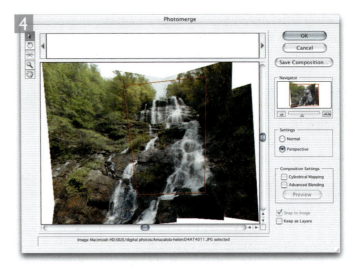

5 If the perspective correction produces a rather extreme looking composite image, check the Cylindrical Mapping button. This will implement the perspective correction to blend the images better, but the composite image will be rendered 'flatter'. If you check the Advanced Blending box, you can preview how the image will look using the improved blending mode. When Advanced Blending is selected, Photomerge will aim to produce the smoothest tonal transition possible between the composite images. I normally use this mode all the time. Click the Save Composition button if all you want to do for now is save the composition settings. To load a Photomerge setting, choose Photomerge from the File ⇒ Automate menu and click on the Load Composition button in the opening dialog. Photomerge settings can be saved anywhere, but they may fail to work if the source folder name is changed. Click OK to process the images and create a blended panorama. The Keep all layers option will produce a layered file with the elements in register, as they appear in the composition.

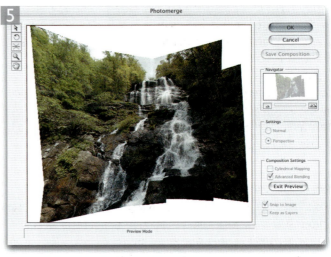

Using Photomerge to align images

Photomerge can also be used to align images in a photo composite. Figure 17.19 succinctly illustrates how this feature might be applied to a typical job. In this example, I had four images shot from an identical viewpoint that I wanted to combine together to make a single image composite. I selected the image files and opened them up in Photomerge with the Automatically Arrange Images option turned off. I then dragged the images one by one into the work space area. Photomerge will attempt to align points of similarity in the images if the Snap to Image option is checked. The composition might look a bit weird, since Photomerge will be attempting to blend the images as if you were intending to stitch them together. If you click the Keep as Layers check box and Click OK, Photomerge will align the images and convert them to a layered image, without any blending. In this example, I added layer masks to each of the layers in order to cut out each of the shots.

This technique may prove particularly useful if you need to combine two or more shots from a group photo series, replacing people in a shot and aligning them with other consistent elements in the picture. You could also use this feature to combine a scanned negative or chrome with a print or Polaroid™ of the same picture.

How To help files

This is yet another new feature in Photoshop CS. Although Photoshop users will find books like mine useful in helping to understand the program, there are times when they want quick answers to questions without having to go to far to search for an answer. The How To menus can be found in the Help menu. A selection of How Tos are included already with the program and these cover a variety of subjects. The How To format can be used by anyone who wishes to write and publish their own How To help files. These can be shared or published in the same way Actions and other Photoshop settings can be distributed between fellow users.

Figure 17.19 Aligning images with Photomerge.

Figure 17.20 The Resize Image Assistant can help you resize your images to the optimum resolution for multimedia or print output, based on the resolution of the print screen used. A warning may appear if the image is too small to be enlarged for print, which will suggest the image may need to be re-scanned.

Figure 17.21 The Export Transparent Image Assistant will require the image to be either: against a transparent background, or there needs to be a selection active of the area to be made transparent. The Export Transparency Assistant will then guide you to make a transparent GIF or PNG format image for the Web or a transparent image for print.

Export Transparent Image and Resize Image

These last two Automation plug-ins are located in the Help menu. They are very nicely designed and illustrate just what we might come to expect in the future. The Export Transparent Image interface starts by asking you whether the purpose of the final image is for print or on-line use. For example, if you want to make a transparent GIF and there is no selection currently active, it will tell you to cancel and make a selection first. From there on it will duplicate the current image and ask clearly put questions about the intended final output and guide you towards that desired goal. The Resize Image Automation plug-in also has a clearly designed interface and takes the user step by step through the process of sizing an image for reprographic or on-line use (see Figure 17.20).

Brushes — Palette shortcuts

Mac	PC	Function
[Reduce brush size
]		increase brush size
Shift [Reduce the brush hardness
Shift]		Increase the brush hardness
⌘ Shift F	ctrl Shift F	Edit ⇒ Fade last brush stroke
Caps Lock		Display precision crosshair cursor/brush size cursor
Double-click a brush preset in the Preset Manager		Rename the brush
⌥ click on a brush preset in the Preset Manager	alt click on a brush preset in the Preset Manager	Delete a brush preset
ctrl click	Right mouse click	When a painting tool is selected, this will open the brush presets dialog Hit Enter to dismiss the dialog
ctrl Shift click	Right mouse Shift click	When a painting tool is selected, this will access the brush blend mode options
Shift key		Having started using the brush, then pressing and holding the shift key will use this brush in a straight line to the next click

Swatches — Palette shortcuts

Mac	PC	Function
Click on swatch	Click on swatch	Choose swatch as foreground color
Shift click swatch color	Shift click swatch color	Replace a swatch with the foreground color
⌘ click on swatch	ctrl click on swatch	Choose swatch as background color
Click in an empty slot	Click in an empty slot	Add the foreground color as a swatch and name it
⌥ Shift click in a slot	alt Shift click in a slot	Add the foreground color as a swatch without naming it
⌥ click on swatch	alt click on swatch	Remove a swatch from the palette
Drag a swatch within the Preset Manager		Reposition a swatch in the Swatches palette

Color		Palette shortcuts
Mac	**PC**	**Function**
Shift click Color bar	*Shift* click Color bar	Cycle between all the color spectrum options
ctrl click Color bar	Right mouse click Color bar	Specify Color bar to use
Click gamut warning swatch		Select nearest in gamut color

History		Palette shortcuts
Mac	**PC**	**Function**
⌘ Z	*ctrl Z*	Toggle moving back and forward one step (undo/redo) (see Preferences)
⌘ ⌥ Z	*ctrl alt Z*	Move one step back through history
⌘ Shift Z	*ctrl Shift Z*	Move one step forward through history
Click New Snapshot button		Create a new Snapshot
Click New Document button		Create a new document from current image state
⌥ click on a history state	*alt* click on a history state	Duplicate any previous history state

Compact saves

If you want to save lots of channels, the native Photoshop file format will save the channels more compactly. A simple silhouette type mask will not add much to the total file size of a Photoshop document. However, this is not the case when you save using the TIFF file format, unless you use one of the TIFF compression options, when it becomes even more compact using say ZIP, a lossless format, or a JPEG lossy compression format.

Layers and channels

Extra layers will add to the overall file size and add to the RAM memory usage. Photoshop will also take longer to calculate the screen redraw every time you scroll the image or change the viewing magnification. If you anticipate editing very large image files (over 50 MB RGB) then you should raise the number of Image Cache levels in the General Preferences from four to five, or even higher. Doing this will speed up the screen redraws at lower viewing magnifications. Adjustment layers may only occupy a few kilobytes of file space, but when a document contains several adjustment layers, this too can slow down the time it takes to refresh the screen image. There are two things that can be done to remedy this – either temporarily switch off the eye icons on these layers or merge them with the layers below and apply the adjustment permanently.

Layers		Palette shortcuts
Mac	**PC**	**Function**
Click New Layer button		Create new empty layer
🖱 click New Layer button	*alt* click New Layer button	Create new empty layer, showing New Layer dialog box
Drag layer to New Layer button		Duplicate layer
Click palette Delete button		Delete selected layer (or drag layer to delete button)
🖱 click palette Delete button	*alt* click palette Delete button	Delete selected layer (bypassing alert warning)
🖱 [*alt* [Select next layer down
🖱]	*alt*]	Select next layer up
Shift 🖱 [*Shift* *alt* [Select bottom layer
Shift 🖱]	*Shift* *alt*]	Select top layer
Double-click layer name		Rename layer
Double-click layer (outside the layer name)		Open Layer Style dialog box
🖱 double-click layer name	*alt* double-click layer name	Open Layer Properties dialog box
Double-click adjustment layer icon		Edit adjustment layer settings
🖱 double-click adjustment layer	*alt* double-click adjustment layer	Edit Layer Style blending options
Double-click layer style icon		Edit Layer Style effect options
Keyboard numbers (1=10%, 9=90%, 0=100%)		Set layer opacity whilst a non-painting tool is selected (Enter any double number values in quick succession)
Up arrow		Increase value setting in box by 1%
Down arrow		Decrease value setting in box by 1%
Shift Up arrow		Increase value setting in box by 10%
Shift Down arrow		Decrease value setting in box by 10%
Return		Commits edit in pop-up slider in mouse up mode
esc or *⌘* .	*esc* or *ctrl* .	Exit slider edit in mouse up mode
Click Layer Eye icon		Show or hide layer (toggle)

Layers		Palette shortcuts continued
Mac	**PC**	**Function**
⌥ click Layer Eye icon	alt click Layer Eye icon	View layer on its own/view all visible layers (toggle)
⌘ click layer thumbnail	ctrl click layer thumbnail	Load layer transparency as a selection
⌘ Shift click layer thumbnail	ctrl Shift click layer thumbnail	Add layer transparency to selection
⌘ ⌥ click layer thumbnail	ctrl alt click layer thumbnail	Subtract layer transparency from selection
⌘ ⌥ Shift click layer thumbnail	ctrl alt Shift click layer thumbnail	Intersect layer transparency with selection
Click Add a Mask button		Create a layer mask with reveal all/reveal selection
⌥ click Add a Mask button	alt click Add a Mask button	Create a layer mask with hide all/hide selection
⌥ click layer mask thumbnail	alt click layer mask thumbnail	View layer mask as a mask on its own (toggle)
⌘ click layer mask icon	ctrl click layer mask icon	Load a layer mask as a selection
Click in Link icon area		Link/unlink a layer to currently selected layer
Click Link layer between the layer mask/clipping layer thumbnail		Link/unlink the layer and the layer mask/clipping layer
Shift click layer mask/clipping layer thumbnail		Disable/enable layer mask/clipping layer
Double-click layer mask thumbnail		Open Layer Mask Display Options
⌥ Shift click layer image mask thumbnail	alt Shift click layer image mask thumbnail	View layer mask as an alpha channel (rubylith)
⌥ click the divide line between two layers	alt click the divide line between two layers	Toggle between creating a layer clipping group and ungrouping
/	/	Switch on/switch off Lock transparent pixels
⌘ ⌥ Shift E	ctrl alt Shift E	Merge visible layers to selected layer
⌥ Merge Down	alt Merge Down	Merge down and leave a copy of the selected layer
⌥ Merge Linked	alt Merge Linked	Merge a copy of linked layers into layer below

Layer sets		Palette shortcuts
Mac	**PC**	**Function**
Click new layer set button		Create new layer set above target layer
⌘ click new layer set button	ctrl click new layer set button	Create new layer set below target layer
⌥ click new layer set button	alt click new layer set button	Create new layer set with layer set options dialog
Click trash button or drag layer set to Trash button		Delete selected layer set (with an alert)
⌥ click trash icon	alt click trash icon	Delete selected layer set (without an alert)
⌘ E	ctrl E	Merge selected layer set
⌘ Shift]	ctrl Shift]	Move set to top of the stack
⌘]	ctrl]	Move set up, move layer into set that is right above it or move top layer in a set out of the set
⌘ [ctrl [Move set down, move layer into set that is right below it or move bottom layer in a set out of the set
⌥ Shift]	alt Shift]	Select topmost layer or set
⌥]	alt]	Select next layer or set (cycle up)
⌥ [alt [Select next layer or set (cycle down)
⌥ Shift [alt Shift [Select bottom layer or set
⌥ click eye icon for the set	alt click eye icon for the set	Toggle show all layers/show just this set

Layer Sets

Layers are arranged using sets, you can quickly change the
visibility and blending options for all layers in a set at a
stroke. You can also consider saving the different layered
versions of the image as you progress, before merging and
moving on to the next stage. This way, you will always be able to
revert back to any previous layered version of the image.

Layer blending modes

Mac	PC	Function
Shift +		Set laycr to next blend mode in list
Shift −		Set layer to previous blend mode in list
⌥ Shift N	alt Shift N	Normal mode
⌥ Shift I	alt Shift I	Dissolve mode
⌥ Shift K	alt Shift K	Darken mode
⌥ Shift M	alt Shift M	Multiply mode
⌥ Shift B	alt Shift B	Color Burn mode
⌥ Shift A	alt Shift A	Linear Burn mode
⌥ Shift G	alt Shift G	Lighten mode
⌥ Shift S	alt Shift S	Screen mode
⌥ Shift D	alt Shift D	Color Dodge mode
⌥ Shift W	alt Shift W	Linear Dodge mode
⌥ Shift O	alt Shift O	Overlay mode
⌥ Shift F	alt Shift F	Soft Light mode
⌥ Shift H	alt Shift H	Hard Light mode
⌥ Shift J	alt Shift J	Linear Light mode
⌥ Shift V	alt Shift V	Vivid Light mode
⌥ Shift Z	alt Shift Z	Pin Light mode
⌥ Shift L	alt Shift L	Hard Mix mode
⌥ Shift E	alt Shift E	Difference mode
⌥ Shift X	alt Shift X	Exclusion mode
⌥ Shift U	alt Shift U	Hue mode
⌥ Shift T	alt Shift T	Saturation mode
⌥ Shift C	alt Shift C	Color mode
⌥ Shift Y	alt Shift Y	Luminosity mode

Channels		Palette shortcuts
Mac	**PC**	**Function**
⌘ click channel	ctrl click channel	Load channel as a selection
⌘ Shift click channel	ctrl Shift click channel	Add channel to current selection
⌘ ⌥ click channel	ctrl alt click channel	Subtract channel from current selection
⌘ ⌥ Shift click channel	ctrl alt Shift click channel	Intersect channel with current selection
Shift click channel	Shift click channel	Add to or remove from the channels active
⌘ 1	ctrl 1	Activate channel-1, e.g. red or cyan channel and so on
⌘ ~ (tilde)	ctrl ~ (tilde)	Activate composite channel, e.g. RGB, CMYK or Lab
⌘ ⌥ 1	ctrl alt 1	Load channel 1 as a selection and so on to channel 9
Click New channel button		Create a new channel
⌥ click New channel button	alt click New channel button	Create a new channel whilst opening the Options dialog box
⌘ click New channel button	ctrl click New channel button	Create a new Spot color channel
Click on Save Selection button		Create a new channel from current selection
⌥ click on Save Selection button	alt click on Save Selection button	Create a new channel from current selection with channel options dialog box
Click Load Selection button		Load active channel as a selection
Shift click Load Selection button		Add selected channel to current selection
⌥ click Load Selection button	alt click Load Selection button	Subtract selected channel from current selection
⌥ Shift click Load Selection button	alt Shift click Load Selection button	Intersect selected channel with current selection
Click Delete button		Delete selected channel
⌥ click Delete button	alt click Delete button	Delete selected channel (without alert warning)
Drag channel to wastebasket		Delete selected channel (without alert warning)

Layer Comp

Mac	PC	Function
Click New Layer Comp button		Create new layer comp, showing New Layer Comp dialog box
⌥ click New Layer Comp button	*alt* click New Layer Comp button	Create new layer comp, without New Layer Comp dialog box
Drag layer comp to Create New Layer Comp button		Duplicate layer comp
Click Update Layer Comp button		Update current layer comp
Click Apply Previous Selected Layer Comp button		Select next layer comp down
Click Apply Next Selected Layer Comp button		Select next layer comp up
Click Delete button		Delete selected Layer Comp (or drag Layer Comp to delete button)
Double-click layer comp name		Rename layer comp

Column headers for this table: **Layer Comp** / **Palette shortcuts** with sub-headers **Mac**, **PC**, **Function**.

Pen tool shortcuts (with pen tool selected)

Mac	PC	Function
⌘	*ctrl*	Direct selection tool (whilst key is held down)
⌥	*alt*	Convert direction tool (whilst key is held down)
Click on anchor point/path	Click on anchor point/path	Remove anchor point/add anchor point (toggle) (Auto Add Delete must be checked in the Options bar)
Shift	*Shift*	Constrains the path drawing horizontally, vertically and at 45 degrees
⌘ click Path	*ctrl* click Path	Activate all control points without selecting them
⌘ *Shift* click	*ctrl* *Shift* click	Add to selected path points
⌘ ⌥ click path in image	*ctrl* *alt* click path in image	Select entire path or uppermost sub-path
⌘ ⌥ *Shift* drag path	*ctrl* *alt* *Shift* drag path	Clone selected path (Shift key constrains movement to 45 degree increments, let go after first dragging)

Paths | Palette shortcuts

Mac	PC	Function
Click New path button	Click New path button	Create a new path
⌥ click New path button	alt click New path button	Create a new path showing the New Path dialog box
Drag path to New path button	Drag path to New path button	Duplicate path
Click Delete path button	Click Delete path button	Delete path
⌥ click Delete path button	alt click Delete path button	Delete path, bypassing the alert warning
Drag path to Delete button		Delete path, bypassing the alert warning
Double-click Path name	Double-click Path name	Edit the path name
Click Make work path button	Click Make work path button	Convert a selection to make a work path
⌥ click Make work path button	alt click Make work path button	Convert a selection to make a work path via Make Work Path dialog (choose pixel tolerance setting)
Double-click work path icon	Double-click work path icon	Save the work path as a new path
Drag a work path to the New path button	Drag a work path to the New path button	Convert a work path into a new path
⌘ click a Path in the palette	ctrl click a Path in the palette	Load the path as a selection
Click Load path as a selection button	Click Load path as a selection button	Convert active closed path to a selection
⌥ click Load path as a selection button	alt click Load path as a selection button	Convert active closed path to a selection via Make Selection dialog box
⌘ Enter (selection or path tool active)	ctrl Enter (selection or path tool active)	Convert active path to a selection
Click Stroke Path button	Click Stroke Path button	Stroke perimeter of path with Foreground color
⌥ click Stroke Path button	alt click Stroke Path button	Stroke perimeter of path via the Stroke Path dialog box
Click Fill path button	Click Fill path button	Fill path with Foreground color
⌥ click Fill path button	alt click Fill path button	Fill path via the Fill Path dialog box
Click empty Paths palette area	Click empty Paths palette area	Deactivate path

General		
Mac	**PC**	**Function**
esc or ⌘ .	esc or ctrl .	Cancel or abort an operation
esc	esc	Cancel operation (Crop/Transform/Save)
Delete	←	Remove selected area to reveal transparency (on layer) or background color (on background layer)
⌥	alt	When a painting tool is active, use the Option key to sample in window area to make foreground color
Tab	Tab	Toggle Show/Hide palettes (see Window menu)
Tab	Tab	Jump to next setting in any active dialog box
⌥ click Cancel button	alt click Cancel button	Change Cancel button in dialog boxes to Reset

Let Photoshop take the strain

If Photoshop can do something quickly and effectively, it makes sense to do it on the computer rather than waste time in the studio when you could be more productive and creative attending to other important things. The Automation tools and shortcut tips supplied in this chapter should go a long way to reducing the unnecessary time spent huddled over the computer, when you could be enjoying a nice cup of coffee instead! Furthermore, I hope the tips and techniques demonstrated throughout have helped you understand more about the power of Photoshop as a professional quality image editor. Don't forget that the CD-ROM features some of the tutorials as movies and that there is a website for the book: <www.photoshopforphotographers.com>. This contains an FAQ section and email support links to help people who are experiencing problems running the CD-ROM movies. I thank you for buying this book and if you liked it, then let us know or tell me what other things you would like to see covered in future editions. Working with Photoshop has proven to be for me a fascinating and rewarding experience. It literally changed my life and the way I work and opened up many new avenues to explore!

Appendix

Most of the photographs you see in this book were taken by myself. Some were from commissioned assignments, others are personal shots. I also asked friends and colleagues to include work too, all of whom are professional photographers. Here then is some biographical information on the other contributors whose work has been featured.

Davis Cairns

A partnership specializing in fashion accessory still-life photography with clients who include Red or Dead Ltd and Paul Smith. Davis Cairns are currently moving into more portrait and fashion-based work with an emphasis in portraying creative textiles. I have worked on all the Davis

Cairns computer retouching work and a number of these commissioned and personal images were used in this book.
Email: mail@daviscairns.demon.co.uk

Laurie Evans

Laurie Evans was born in Scotland in 1955. Having studied photography at Art School he spent two or three years as a rock and roll photographer before coming to London to seek his fortune. Transferring his interests to still life, and always a passionate cook, he quickly found that he could combine work with pleasure as he discovered the joys of food photography. He works extensively in the advertising and design industry and contributes to a broad range of magazines in the UK and abroad, and has also illustrated more than 40 cookbooks. He is married, has two sons and lives and works in London.

Tel: +44 (0)20 7284 2140
Email: Laurie@evansphoto.demon.co.uk

Thomas Fahey

Thomas Fahey, originally from Oklahoma, opened his Atlanta studio in 1990. His photography takes him from New York to Miami and occasionally overseas to London and Milan. He is a regular cover and feature photographer for *Atlanta* magazine, among others, and his pictures have appeared in numerous advertising campaigns. Formerly, Thomas trained and worked as an archival photographic printer and worked as a photojournalist. Today he enjoys a diversified client base and relies on his Mamiya RZ, Pentax 6×7, Norman light control, and an indispensable Macintosh G4 workstation.

Tel: 001 404 355 5948
Email: faheystudio@bellsouth.net Web: www.thomasfahey.com

Jon Gibson-Skinner

Jon Gibson-Skinner is a freelance photographer turned retoucher based in London – after discovering the virtues of Photoshop 2.5 at college Jon embraced digital photography, working with the first Leaf DCB 1s, and has

now turned solely to retouching. See his website at
www.jon.gs (thank you South Georgia!)
Tel: +44(0)20 7381 2727
Email: jon.gs@jon.gs

Peter Hince

Peter Hince is an advertising photographer specializing in
people/lifestyle. He works mainly on location throughout
the world and is very experienced with big productions and
'round the globe' projects. He also has a unique style of
underwater work and produces toned and textured black
and white shots for his 'Ocean Images' collection. His
work has won many advertising and photographic awards.
Tel: +44 (0)20 7386 0244
Email: peter.hince@btinternet.com

Thomas Holm

Thomas Holm from Pixl is an advertising photographer,
who also provides advanced tutoring in color management,
Photoshop and digital photography. Pixl has a remote
custom ICC profile service available online.
Email: th@pixl.dk Web: www.pixl.dk

Eric Richmond

Eric Richmond is an American born resident of London,
specialising in arts based photography. His clients include
the Royal Ballet, English National Ballet and Birmingham
Royal Ballet. Other commissions include posters for West
End theatre productions, CD covers, publicity photos for
various orchestras, actors, singers and musicians. He might
not have gone to all this trouble if he had been a better
guitar player.
Tel: +44 (0)20 8880 6909
Email: eric@ericrichmond.net Web: www.ericrichmond.net

Paul Webster

Paul Webster now does all his work digitally, much of it food photography for the likes of Sainsbury's. He also runs an extensive prop hire business for use by other photographers as well as his own studio in west London.

Tel: +44 (0)20 8749 0264
Email: paulsnap@dircon.co.uk

SOLUTIONS Photographic

Now in its eighteenth year, SOLUTIONS Photographic's work is rarely credited, but lies behind many advertising images, book jackets, report and accounts brochures, and packaging designs. Clients tend to have very individual understandings of these services, and so most of the work comes by personal recommendation; the consultancy offered varies from the ad hoc to the retained, and he is particularly pleased with the 'flying doctor' service over the telephone, as this gives clients access to Rod's advice and expertise in the midst of a crisis! His training sessions are careful to avoid' 'information overload' in these increasingly technical times, but if the student can take the pace, he will continue to provide answers! Rod is much sought after for his grasp of the digital technology pitfalls. In this vein, he can be found contributing to Internet lists, such as ProDIG. Also, increasingly photographers who are happier to keep shooting than retouching, find it handy to bring him into the studio to do any manipulating alongside the art director.

Rod Wynne-Powell

SOLUTIONS Photographic was originally a *double-entendre* to link photographic chemistry and problem-solving. The consultancy side of the business began when he was sales manager of a London color laboratory, where many calls he received began with the words: 'Rod, I've got a problem...' Prior to his time in the Lab, he had been a commercial/industrial photographer.

His attention to detail and dogged determination led some developers to accept his offers to beta test their graphics products. This gave him the opportunity to fashion these to meet the requirements of retouchers and manipulators, giving his clients an edge against their competitors. It allowed him to offer in-depth training very early in the product life cycle, and gain insights into the developers' future direction.

Speaking the same language as photographers has enabled him to guide others past the problems that might ensnare them when entering the digital world. He offers help from the basics of Mac housekeeping (Mac OS 9.x and Mac OS X), its interface, and fault diagnostics, through to the far more enjoyable aspects of teaching techniques for the productive and creative use of Photoshop as a montaging and retouching tool. His help has been valued and respected amongst digital photographers, several of whom have engaged him alongside them in their studios, thus allowing them greater creative control over the output of their work. An added bonus has been his ability to pass on his skills whilst their job proceeds.

Tel: +44 (0) 1582-725065 Mobile: 07836-248126
Email: rod@solphoto.co.uk

PIXL Profiling service for readers

Remote RGB Profile Discount Offer: only € 70

Since you have purchased one of the coolest digital imaging books on the market, we'd like to offer you a *very* cheap top quality printer profile, to get your color management kick-started.

Download the RGB profiling kit from www.pixl.dk. Print the targets according to the enclosed PDF manual and send them to us. We will measure these and Email a custom ICC profile for your printer right back to you. See www.pixl.dk for further details. Our ICC profiles are compatible with both PC and Mac. And the price for this is only € 70 (Exclusive VAT).

To purchase a printer profile log on to www.pixl.dk - **Pixl Store**, and select **Remote Profiles**. In the Special field write the code: **EveningCS8**, and the correct price will appear. If you have particular enquiries please drop us a mail at profiles@pixl.dk.

Pixel Genius PhotoKit plug-in discounts

www.pixelgenius.com

PhotoKit Sharpener
A complete Sharpening Workflow for Photoshop

Other products may provide useful sharpening tools, but only PhotoKit SHARPENER provides a complete image "Sharpening Workflow". From capture to output, PhotoKit SHARPENER intelligently produces the optimum sharpness on any image, from any source, reproduced on any output device. But PhotoKit SHARPENER also provides the creative controls to address the requirements of individual images and the individual tastes of users. PhotoKit Sharpener is priced at $99.95.

PhotoKit
Analog Effects for Photoshop

This Photoshop™ compatible Plug-in is designed to provide photographers accurate digital replications of common analog photographic effects. PhotoKit is quick and simple and allows for a greatly enhanced workflow. Priced at $49.95.

Pixel Genius is offering a 10% discount on any whole order, which must be placed from the Pixel Genius store at: www.pixelgenius.com. This is a one-time discount per email address for any order made from Pixel Genius. This coupon will not work on affiliate sites. Also it cannot be combined with other discounts or programs except for certain cross-sell items. Please note that this coupon will expire upon next revision of *Adobe Photoshop for Photographers*.

Coupon ID: PFPCPNME

World Wide Web Contacts

Adaptec ... www.adaptec.com
Adobe ... www.adobe.com
Adobe Photoshop www.adobe.com/prodindex/photoshop/main.html
Adobe Photoshop discussion list www.listmoms.net/lists/#photoshop
Agfa .. www.agfa.com
Alien Skin ... www.alienskin.com
Andromeda ... www.andromeda.com
Apple .. www.apple.com
Association of Photographers .. www.the-aop.org
Binuscan .. www.binuscan.com
British Journal of Photography ... www.bjphoto.co.uk
Calumet Photo .. www.calumetphoto.com
Canon cameras .. www.canon.com
ColorVision ... www.colorvision.com
Colorbyte Software .. www.colorbytesoftware.com
Connectix ... www.connectix.com
Contact Images .. www.contact-uk.com
Exabyte ... www.exabyte.com
Extensis ... www.extensis.com
Formac ... www.formac.com
Fractal .. www.fractal.com
Fuji .. www.fujifilm.com
Fujitsu .. www.fel.fujitsu.com
Gretag Macbeth .. www.gretagmacbeth.com
Hitachi .. www.hitachi.com
Hewlett-Packard ... www.hp.com
Imacon ... www.imacon.dk
Iomega ... www.iomega.com
Kensington ... www.kensington.com
Kingston ... www.kingston.com
Kodak .. www.kodak.com
Kodak Photo CD www.kodak.com/daiHome/products/photoCD.shtml
LaCie ... www.lacie.com
Martin Evening Photography ... www.martinevening.com
MetaTools ... www.metatools.com
Minolta ... http://konicaminolta.net/

Mitsubishi ... www.mitsubishi.com
Microsoft ... www.microsoft.com
Nikon .. www.nikon.com
Olympus ... www.olympusamerica.com/digital/
Panasonic .. www.panasonic.com
Pantone ... www.pantone.com
Philips ... www.philips.com
PhotoKit Sharpener ... www.pixelgenius.com/sharpener/
Pixl/Thomas Holm ... www.pixl.dk
Pixel Genius .. www.pixelgenius.com
Polaroid ... www.polaroid.com
ProDIG digital imaging discussion list www.prodig.org
ProRental discussion list ... www.prorental.com/pr_digf.htm
Quantum ... www.quantum.com
Quark Incorporated ... www.quark.com
Ricoh ... www.ricoh.com
Samsung .. www.samsung.com
Signum Technologies .. www.signumtech.com
Sony ... www.sony.co.jp
Sun Microsystems ... www.sun.com
SuperMac ... www.supermac.com/index.html
Symantec .. www.symantec.com
Taxan ... www.taxan.co.uk
TDK ... www.tdk-europe.com
Tektronix ... www.tek.com
Texas Instruments ... www.ti.com
Toshiba .. www.toshiba.com/home/work.shtml
Umax ... www.umax.com
Verbatim ... www.verbatimcorp.com
Vivitar ... www.vivitarcorp.com
Wacom ... www.wacom.com
Rod Wynne-Powell ... www.solphoto.dircon.co.uk
Xerox ... www.xerox.com
Xaos Tools ... www.xaostools.com
Yamaha ... www.yamaha.com

Index

Symbols

16-bit editing
 4, 125, 127, 306, 308, 309

A

Absolute Colorimetric 388, 420
Acrobat format (PDF) 442
 notes 65
Actions 30, 509–513
 creating droplets 515
 editing an Action 512
 inserting menu items 513
 recording 510
 sourcing actions 509
 stop and pause 513
 troubleshooting 512
Actual pixels viewing 67
Adaptive Web palette 449
Add noise to a layer 166
Adding a border 250
Adding a layer mask 203
Adjustment layers 32, 180, 528
 change layer content 206
Adobe Acrobat Reader 521
Adobe Acrobat™ 442
Adobe Color Engine 388
Adobe Gamma 79, 363–365
Adobe GoLive™ 461, 462
Adobe Illustrator™ 427
Adobe ImageReady™ CS 461–465
Adobe InDesign™ 427
Adobe PageMaker™ 427
Adobe Photoshop Album™ 478, 488
Adobe RGB 370
ADSL Internet 433
Advanced color settings 383
Advanced layer blending 209
Agfa 302
Aim prints (for proofing) 420
Aligned mode cloning 163
Aligning images 525
Aligning layers 44, 256, 272

Alpha channels 34, 192
AltiVec 85
Animated GIFs 466
Annotation tools 65
Anti-aliasing 192, 194–196
Anti-aliasing filter 326
Appending file names 87
Apple Cinema display 417
Apple Display Calibration 363
Apple RGB 369
Apply Camera Raw settings 486
Apply Image 225, 275
Arbitrary map mode (curves) 149
Arrow heads 64
Art history brush 55
Artifacts 350
ASCII encoding 428
Ask when opening 378
Assign Profile 378
Assigning shadows and highlights 115
Auto Color 144–146
Auto contrast 144–146
Auto Levels 144–146
Auto select layer 44
Auto Select mode (move tool) 208
Auto-update documents 86
Automatic Levels 115
Automatic masking 231
Automation plug-ins 514, 519

B

Background eraser 55
 find edges mode 57
Background printing color 406
Backward compatibility 3, 88
Banding
 use dither option 390
Banding (removal) 165
Barco Calibrator monitor 74, 364
Barstow, Neil xxii, 404
Batch Actions 514, 515
Batch Rename 485, 491
Bayer pattern 315

Beauty retouching 185
Betterlight 338
Bibble 326
Bicubic interpolation 7, 85, 350
Bicubic sharpen 352
Bicubic soften 352
Big data 45, 128
Bilinear interpolation 350
Binary encoding 428
Binuscan 302
Bit depth 306
Bitmapped images 306
Black and white from color 236
Black Generation 394
Black Point Compensation
 115, 391, 408, 420
Blatner, David 368, 424
Blend interior effects 209
Blend RGB colors using gamma 384
Blending mode adjustments 124
Blending modes 198, 257
 Color 185, 257
 Darken 188, 257, 258, 260
 Difference 201
 Exclusion 202
 Hard Mix 7
 Hue 257
 Lighten 188
 Linear Burn 199
 Linear Dodge 200
 Linear Light 201
 Luminosity 125, 140, 257
 Multiply 126, 250, 251
 Overlay 256
 Pin Light 201
 Saturation 257
 Screen 126, 249
 Vivid Light 200
Blending options 242
Blur filters 281–282
Blur tool 61, 184
Blurring along a path 184
Brightness/Contrast 113

Broadband cable 433
Broback, Steve xxii
Broncolor 337
Brown, Russell xxii, 166, 238
Browser preview 448
Browser safe colors 450
Brush attributes 27
Brush blending modes 184
Brush controls 187
Brush cursors 90
Brush dynamics 48, 187
Brush tool 27, 49
Brushes 26
 Shape dynamics 29
Brushes palette 27
Building a printer profile 411
Bunting, Fred 424
Bureau checklist 494
Bureau output
 checklist 494
Bureau scans 310
Burn tool 62, 189
Bus connection 85
Byte order 426, 494

C

C E Heath and Beazley 495
Cable Internet 433
Cache memory 86
Cairns, Davis 537
Calibrating hardware 77
Calibration 75–79
Calibration bars 406
Camel Ink Systems CRS 404
Camera chip performance 319
Camera Raw 324, 326, 469
 Batch processing 335
 Calibration 334
 Compatibility 327
 Custom configuration 336
 Detail settings 331
 exposure controls 330
 General controls 327
 Lens settings 332
 preferences 331
 Save Settings 336

vignetting 333
 White Balance 329
Camera raw 2–3
Camera response times 324
Canned profiles 403
Canon
 1D 324
 D30 323
 D300 313
 D60 323
 EOS 1Ds
 301, 314, 315, 318, 334
 injet printers 401
Canvas 5
Canvas color change 69
Canvas Size 128, 131
Caplin, Steve xxii
Caption box (printing) 406
Capture One 326
Cascading Style Sheets 447
Cataloging images 339
CCD 303
CCD cameras 313–315
CD recorders 339
CD-ROM 84
Channel Mixer 236, 240, 249
Channel sharpening 137
Channels 33, 191, 528
Channels palette
 make new channel 191
 make selection 192
Character palette 26, 63, 278
Chip acceleration 86
Chip speed 85
Chromapress 423
Cintiq input device 84
Classic Photoshop CMYK setup 388
Cleaning camera chips 324
Cleanup tool 231
Cleanup tool (Extract command) 233
Clear guides 18
Clipboard 85
Clipping groups 228
Clipping paths 111, 234, 429, 494
Clone stamp 49, 163–166, 178–180
Cloning 49, 163

Cloning alternatives
 dodge tool 163
Cloning selections 178
Clouds filter 296
CMOS cameras 313
CMYK
 conversions 386
 gamut 22
 proof 419
 selective color 161
 separation setup 386
CMYK color management 358
CMYK myths 387
CMYK proofing 421
CMYK settings 388
 advanced 390
CMYK setup 386, 391
CMYK skin tones 159
Coated CMYK settings 375
Color Balance 146
Color blending modes 257
Color Burn mode 199
Color Dodge mode 199
Color Management Modules 388
Color management off 374, 380
Color management presets 372
Color Matching Module 360
Color mode 202
Color monochrome filters 236
Color overlays 255
Color palette 30
Color picker 59, 68, 85, 191
Color policies 372
Color proofing 418
Color Replacement tool 11, 48, 156
Color sampler tool 65, 148
Color settings 83, 371, 375
 ask when pasting 374
 convert to work space 373
 profile mismatch 373
Color settings files 377
Color temperature 150, 329
Color toning 239
Color vision trickery 364
Color wheel 143
ColorByte 422

ImagePrint 422
Colorize
 hue/saturation 154
ColorMatch RGB 370
ColorShop 350
ColorSync 359
ColorVisions 365
Compact Flash 323
Compression
 LZW 426
Computer
 mail order 73
 multiprocessor 85
 system maintenance 102
Contact Sheet II 10, 518, 519
Contax
 N1 315
Contextual menus 37, 508
Contiguous selections 38, 55
Continuous inkflow system 404
Contour editor 271
Contours 270
Contract proofing 420
Convert to Profile 376–
 378, 379, 393, 400, 417
Convert to Shape 451
Convert to workspace 373, 378
Cox, Chris xxii
Create Droplet 516
Create Layers 268
Create New brush 27
Crop and Straighten 9
Crop and Straighten Photos 9, 520
Crop tool 45
Cropping 128
Cross-processing 251
CSI Lightjet 399
CTP 420, 423
Cursor display options 90
Curves 117, 146
Custom brushes 27
Custom CMYK 386, 388, 419
Custom colors 277
Custom gradients 59
Custom ink colors 393
Custom shapes 279

Customizing RGB color 385
Cutouts against white 111

D

Dark Matter 39
Darken mode 198
Deficiencies of grayscale 245
Define brush 27
Define custom shape 279
Delete preferences 94
Density range 301
Desaturate monitor colors 385
Desaturate with sponge tool 63
Determining output size 347
Device-independent color 367
Difference mode 201
Diffusion dither 90
Digimarc 495
Digital camera exposure 330
Digital cameras 312–322, 339–340
 Dust removal 324
 image quality 318–319
 Multishot exposures 321
Digitizing pad 84
Direct selection tool 216
Disk Doctor 102
Disk performance 96
Displacement filters 287
Display 73
Display calibration 75
Dissolve mode 198
Distortion filters 287
Distribute layers 44
Distribute linked layers 272
Document profile 15, 372
Document size 15
Dodge tool 62, 189
Dot gain 117, 381, 392
Dot gain curves 392
Dots per inch 346
Droplets 515
Dual displays 74
Duotone options 247
Duotones 245
Duplicate an image state 51
Dupont Cromalin™ 420

Durst Lambda 399
DVD 84, 493
DVD recorders 339
Dynamic Color Sliders 86
Dynamic fill layers 123–124
Dynamic range 321

E

Easter eggs 39
Edge highlighter tool 232
Edge sharpening 138
Edge touchup tool 231
Edit history 87
Edit History log 481–483
Edit history log 2
Edit menu
 fade command 249, 260, 504
 Keyboard Shortcuts 499
Efficiency 15
Eismann, Katrin xxii
Electronic publishing 442–444
eMac computer 71
Email attachments 433
Emulate Photoshop 4 375, 380
Epson
 10600 402
 2100/2200 402
 5000 420
 7600 403, 422
 9600 402
 Photo Stylus 1290 406
 Stylus Photo 401, 402
 Stylus Photo1290 422
 Ultrachrome printers 422
Epson inkjet printers 401
Epson print dialog 406
Erase to history 55
Eraser tool 55
Evaluating sharpening 133
Evans, Laurie xxii, 538
Exchange foreground/background 68
Exclusion mode 202
EXIF metadata 327, 440, 479, 480
Export Clipboard 85
Export image cache 477
Export Transparent Image 526

Extract command 8, 57, 231, 232–233
 smart highlighting 57
Eye-One 77, 361, 363
Eye-One calibrator 366
Eyedropper 65
Eyedropper tool 115

F

Fade command 140
Fade filter 260
Fahey, Thomas xxii, 538
Fetch software 434
Fibers filter 7, 296
File Browser 2, 3, 20, 327, 469–483
 Allow Background Processing 475
 Apply Settings 486
 Automate menu 484
 Batch Rename 485
 Custom thumbnails 476
 Custom views 474
 Delete contents 473
 Details view 488
 Edit History log 481–483
 Edit menu 485
 Export Cache 484
 Export cache 477
 File Info 479
 File menu 482
 Flagging 484
 Folder cache 477
 Folders palette 476, 477
 Image cache 483
 Increase font sizes 482
 Keywords palette 477, 478
 Metadata Templates 480
 Preferences 98
 Preview palette 473, 474
 Purge cache 477
 Ranking 473, 484
 Rotation 471
 Search function 472
 Search images 471
 Sidecar files 475
 Sort menu 487

Thumbnail view 473
View options 473
File compression 528
File extensions 87
File formats 425–429
 CompuServe GIF 441
 DCS 430
 EPS 35, 428
 for the Web 436
 GIF 87
 importing PDF files 444
 JPEG 87, 436
 baseline optimized 438
 baseline standard 438
 optimized JPEG 446
 JPEG 2000 440
 JPEG compression 426
 Lossy GIF format 450
 PDF 277, 278, 436
 password security 442
 PICT 430
 PNG 444
 PSB 427, 428
 Raw Binary 87
 Save options 431
 TIFF 88, 98
 compression 426
 saving paths/channels 194
File Info 479
File menu
 automate 514
 place 269, 287
 preferences 85
 plug-ins 92
 scratch disk 92
File optimizing 464
File Transfer Protocol 434
Fill layers 29, 257
Filter Gallery 7, 290
Filter menu
 Blur
 Gaussian Blur 260, 281
 Gaussian blur 183, 224, 260, 287
 Lens Blur 283
 Motion blur 282

 Radial Blur 273
 Radial blur 281
 Smart blur 283
 Distort
 Displacement filter 287
 Pinch 291
 Extract command 231
 Fade filter 281
 Lens Blur 7
 Liquify 291
 freeze/thaw 294
 reconstruction modes 293
 tool options 293
 Liquify tools 292
 Noise
 Add Noise 165, 184
 Dust & Scratches 167
 Median 283
 Remove dust & scratches filter 166
 Other
 High pass 289
 Maximum 227, 289
 Minimum 221, 289
 Pattern Maker 175, 288
 Photo Filter 150
 Photomerge 9
 Render
 Clouds 296
 Difference clouds 296
 Fibers 7, 296
 Lens flare 296
 Lighting Effects 296–297, 298, 299
Fine art inkjets 405
Finger painting 61, 184, 495
FireWire™ 84, 96
Fit image 518
Fit to screen view 16, 67
Flagging images 484
Flash FXP 434
Flash memory 323
Flat panel LCD displays 74
Flextight CCD scanner 303
FM screening 347
Foreground/background 68

FotoStation 326
Foveon
 X3 CMOS chip 314, 316, 317
Fractional widths 278
Fraser, Bruce
 xxii, 140, 331, 368, 418, 424
Free Transform 179, 211, 214, 226
Freehand lasso tool 40
fsck repair instructions 102
FTP software 434, 435
Fuji
 GX68 III camera 319
 Pictrography 399
 S602 314
 Super CCD 314
Fuzziness control 158

G

G5 Macintosh 71
Galbraith, Rob 323
Gamut 91
Gamut warning 159, 160
Gaussian Blur 281
Gauthier, Karen xxii
GCR separations 390
General Purpose presets 372
Genuine Fractals 350
Gibson-Skinner, Jon xxii, 538
GIF 441
GIF transparency 450
Gimp Print 401
Gloss contour 264
Goodies folder 246
Gorman, Greg xxii
GPS metadata 489
Gradient Fill 58, 255, 257–259, 258
Gradient Map 259
Gradient tool 58, 229
 transparency stops 59
Gradients 59
 noise gradients 259
Graphic tablet 48
Grayscale conversions 236
Grayscale management 381
Grayscale mode 306
Grayscale proofing on screen 247

Gretag Macbeth 77, 366
 Color target 411
 Eye-One 361, 363
 ProfileMaker Pro 361, 416
Grid 17–18, 92, 130
Guides 92

H

Halftone factor 345
Hamburg, Mark xxii
Hand tool 67
Hard Light mode 200
Hard Mix mode 201
Hasselblad 315
Healing brush 48, 166–
 174, 169, 170
Heidelberg 303
Hewlett Packard printers 401
Hexachrome 369
Hexadecimal web colors 30
HexWrench 369
Hide crop 128
Hiding the palettes 69
HiFi color 430
High Pass filter 289
Highlight point 117
Hince, Peter xxii, 539
Histogram 104–107
Histogram palette 4, 23
History 15
 memory usage 52
 non-linear history 222
History brush 50, 166
History options 94
History palette 32
Holm, Thomas xxii, 361, 411, 539
Horwich, Ed xxii
Hot mirror filters 325
How To files 525
How To menu 11
HSB color model 154
HTML 461
Hue mode 202
Hue/Saturation 154
Human color vision 364
Hyphenation 276

I

i3 Forum 455
IBM Microdrive 323
ICC 359
ICC color management 359–363
Ideal RGB space 371
iDisk 435
Ilford inks
 Archiva 404
Illegal colours 22
Imacon xxii
 FlexColor 3.6 305
 Flexframe 4040 321
 Flextight 646 303
 Flextight 848 303
 Flextight 848 scanner 334
 Flextight scanners 305
 Ixpress 321, 324, 338, 384
Image Access (ISP) 434
Image adjustments
 Arbitary map curves 243
 Auto Color 144
 Auto Contrast 144
 Auto Levels 144
 Auto levels 107
 Brightness/Contrast 111, 113
 Channel Mixer
 236, 237, 240, 254
 Color Balance 146, 239, 242
 Curves 117–122, 146, 147
 Desaturate 241
 Gradient Map 259
 Hue/Saturation 154–157, 238
 Levels 107, 108, 115, 144
 Match Color 5, 152
 Photo Filter 6
 Replace Color 158
 Selective Color 159–160
 Shadow/Highlight 5, 120–122
 Amount 123
 Color Correction 123
 Midtone Contrast 123
 Radius 122
 Tonal Width 123
 Variations 143
Image cache 97, 477, 528

Image interpolation 350
Image menu
 Apply Image 225
 Canvas Size 128, 129
image rotation 132
Image security 494–495
Image Size 349
Image size 349
Image window 14
ImagePrint 422, 428
ImagePrint 5.6 422
ImageReady 461
 animation 465
 Animation palette 467
 auto regenerate 465
 Document preview tool 465
 image slicing 462
 layers 462
 linking slices 465
 rollovers 463, 464
 Slice content 463
 Slice tool 464
 Styles 463
ImageReady™ CS 461–465
Import from Illustrator 287
Indigo 423
Info palette 22, 144, 394, 508
infrared simulation 249
Infrared technique 248
Ink Colors 393
Inkjet media 403
Inkjet papers 416
Inkjet printers 400–402
 Print resolution 347
Installing Mac OS X 100
Interlaced GIFs 450
International Color Consortium 359
Internet Service Providers 434
Interpolation 7, 318, 350, 494
iPhoto 488
IPTC Metadata 460
IPTC metadata 479
IRIS iProof 420
IRIS/IXIA printer 400, 401
ISDN 433
iTunes 489

iView MediaPro 326

J

JavaScript 11, 456
Jitter 28
Johnson, Harald 424
Johnson, Stephen 338
JPEG 436
JPEG 2000 439, 440
JPEG compression 436
Jump To application
 69, 86, 462, 467
Justification (type) 276

K

Keyboard shortcuts 2, 15, 498
Keystone correction 128
Keywording 478
Knack, John xxii
Knockout blending 209
Knockout layers
 shallow knockout 210
Knoll brothers 280
Knoll, Thomas xxii, 326
Kodak
 DCS Pro 14n 314, 315, 318
 DCS ProBack 321
 Photo CD 311–312
 sharpening 132
 Picture CD 311
Kodak dye-sub 420
Kodak test target 361

L

Lab color mode 393
LaCie Blue screen monitor 365
LaCie pocket drive 490
Lambda printer 399, 423
Lasso tool 36, 40, 243
Laye, Mike xxii, 356
Layer
 group linked 228
Layer arrange menu 272
Layer blending modes 198
Layer blending options 241
Layer comps 9, 33, 466

Layer effect contours 270
Layer effects 29, 64, 262
 Bevel and Emboss 264, 270
 Color Overlay 266
 Drop Shadow 262, 270
 Gradient Overlay 265
 Inner Glow 263
 Inner Shadow 263
 Outer Glow 263
 Pattern Overlay 266
 Satin 265
 Stroke 267
Layer linking 207
Layer locking 209
Layer masks 203, 221, 257, 269
Layer menu
 matting
 remove matte color 230
Layer set blending
 Pass Through mode 210
Layer Sets 531
Layer sets 207, 208
 lock all layers 209
 moving layers in a set 208
Layer Styles 267
Layer styles 268
Layers 32, 196, 272, 528
 clipping paths 234
 fill opacity 268
 group with previous layer 222
 layer mask
 removing 203
 linking layers 207
 masking a layer 203
 new layer/copy layer 196
Leaf
 C-Most 322
Leaf DCB 318
Legacy color files 380
Legacy files 381
Legacy Serial Number 94
Lens Blur filter 7, 283
Lens Flare filter 296
Levels 108, 144
Levels adjustments
 threshold mode 108

Lexar 323
LH2 Studio 489
Lighten mode 199
Lighting and rendering 296
Lighting Effects filter 296
Linear Burn mode 199
Linear Dodge mode 200
Linear Light mode 201
Lines per inch 346
Linguistic libraries 12, 276
Linoscan 303
Linotype 302
Linotype-Hell 302
Liquify 8, 291, 294, 295
 Bloat tool 292
 Freeze tool 292
 Pucker tool 292
 Reconstruct tool 292
 Reflection tool 292
 Shift Pixels tool 292, 294
 Thaw tool 292
 Turbulence tool 292, 295
 Twirl Clockwise tool 292
 Twirl Counter Clockwise tool 292
 Warp tool 292
Live Picture
 IVUE 430
Lloyd's insurance 495
Lock guides 18
Lock image 211
Lock image pixels 211
Lock transparency 209
Lossy compression 436, 437
Lotto, R. Beau 364
Lumijet inks
 Monochrome Plus 404
Luminance sharpening 138
Luminosity mode 202
Lyson
 Fotonic inks 404
 Quad Black 404
 Small Gamut 404
LZW compression 426

M

Mac OS X 99–101
 print center 405
Macbeth, Gretag xxii
Macromedia® Flash 467
Magic eraser 55, 56
Magic wand 37, 38, 195
Magnetic lasso 37, 40, 43
Magnetic pen tool 40, 63
Managing your images 488
Map GIF Colors to transparent 450
Marquee tool 36, 191
Marrutt 423
Mask channels 191
Masking hair 223
Mastering Digital Printing 424
Match Color 5, 152
Match Location 67
Match Zoom 67
Maximize backward compatibility 425
Maximum filter 289
Measure tool 66, 132
Median Noise filter 283
MediaStreet Niagra II 404
Megapixel limits 318
Megapixels 342
Memory
 clearing the memory 98
Memory cards 322
Memory management 95
Memory Sticks 323
Merged layer cloning 163
Metadata 2, 479–481
Metadata palette 481
Metallic layer effects 270
Metamerism 335, 416
MetaReader™ 480
Minimum filter 289
Minolta
 DiMAGE 7Hi 313, 322
 DiMAGE Scan Multi Pro 305
MIS Cobra CFS 404
MIS inks
 Quadtones 404
 Variable mix 404
MMX 85

Modifier keys 37, 39–43, 498
 defining selections 194
Moiré patterns/removal 182
Monitor calibration 75
Monitor display 73
Monitor gamma (PC) 382
Monitor Spyder 77, 365
Motion blur 273, 282
Move tool 44
Multichannel mode 245
MultiPage PDF to PSD 518
Multiple layers 207
Multiple undos 50
Multiply mode 198
Murphy, Chris 424

N

Nash, Graham 401
National Air and Space Museum 218
Navigator palette 22, 67, 508–509
Nearest Neighbor interpolation 350
Nested layer sets 207
Neutral gray tones 144, 394
Neutral RGB color 144
New Document 348
New guide 18
New Mexico software 495
New spot channel 277
Nikon 303
 D100 323
 D1H 324
 LS4000 305
 LS8000 305
Nikon digital cameras 318
Noise gradients 60
NoMoreCarts CIS 404
Nonaligned cloning 164
Nonlinear history 53
Norton Utilities 102
Numeric transform 44, 213

O

Olympus
 Camedia E20 313
 E-1 318
 Four thirds system 317

On-line Services 10, 487
Onyx
 PosterShop 428
OpenType fonts 276
OptiCal 365
Optimize save for web settings 447
Optimize to file size 447, 448
Options bar 24, 35
Output
 guidelines 494
Overlay mode 200

P

Page bleed 494
Page Setup 405, 407
Paint bucket 60, 69
 pattern fill mode 61
Palette docking 19
Palette well docking 24
Palettes 18
Pantone™ color 277
Paragraph palette 26, 63, 276
Parse XMP Metadata 475
Pass through blending 209
Patch tool 48, 171
Paths 63
 convert path to a selection 216
Paths palette 34
 make path 194
 stroke path/sub path 184
Pattern Maker 175, 288
Pattern presets 289
Pattern stamp tool 49
Pawliger, Marc xxii
Paynter, Herb xxii
PC monitor caibration 79
PCI card 96
PCMCIA cards 323
PDF
 PDF Presentation 9
PDF (Acrobat) 442
PDF Image Import 443
PDF Presentation 520, 521
PDF Security 443
PDF security 442, 452
PEI magazine 451

Peltier Effect 313
Pen paths 214
 drawing 215
 stroking 184
 subtract mode 205
Pen tool 63, 184, 214, 219, 223
 create shape layer mode 194
 curved segment 216
 pointer 216
 Rubber Band option 217
Pencil 49
Pentax 315
Perceptual rendering 387
Perspective cropping 128, 130
Phase One
 Capture One 326
 H20 321
 H25 315
Photo CD 311–312
Photo CD interface 311
Photo Filter 5, 150
PhotoCal 365
Photographic borders 250
PhotoKit Sharpener 140, 331, 466
Photomerge 9, 520–525
Photomultiplier 303
Photoshop
 improving performance 102
 Photoshop 4.0 limitations 380
 preferences 85
Photoshop 7.0 100
Pictrograph
 SCSI cards for 101
Pictrography 399
Picture CD 311
Picture Package 10
Picture package 516
Piezo crystals 321
Pigment inks 403
Pillow emboss 264
Pin Light mode 201
Pixel Aspect Ratio 11
Pixel doubling display option 90
Pixel Genius 140, 331, 466, 480
Pixel size limits 428
Pixels 302, 341

Pixels per inch 344
Pixl xxii, 361, 411
Plug-ins
 third party 280
Plug-ins folder preferences 93
PNG format 444
Polaroid™ 303
Polygon lasso tool 37, 40, 179
Polygon shape tool 64
PostScript 278, 428
PostScript color management
 EPS options 429
PostScript printing 421–422
PostScript RIP 345
Precise flare center 297
Preference file 85
Preserve Embedded Profiles
 372, 373, 376, 394
Preserving image luminosity 248
Preset Manager 30, 31
Presets 267
 Patterns 176
Preview box 14
Primary scratch disk 94, 102
Print Center (Mac OS X) 405
Print dialog 409
 Color Management 410
Print Keys 85
Print registration marks 406
Print Selected Area 405
Print size viewing 67
Print Space 408
Print stabilization 416
Print with Preview 405, 408, 420
Printer Color Management 408
Printer profiles 411
Printer Properties 409
Printers
 Chromapress 423
 custom profiles 411
 Fuji Pictrography 399
 Indigo 423
 inkjet 401
 Lambda 423
 laser 421
 PostScript 421

Sienna/Marrutt 423
Wide-format inkjet 402
Xericon 423
Printing duotones 245
Printing via a RIP 422
Process colors 246
Profile conversions 376
Profile Mismatch
ask when pasting 376
ProfileMaker Pro 361, 416
Progressive JPEG 438
progressive JPEG 446
Progressive sharpening 138
Proof Setup 247, 390, 417, 417–
418, 419
Proof Setup - grayscale 383
ProofMaster
Adesso RIP 421
Folio RIP 421
ProPhoto RGB 370
Purge history 53
Purge memory 98
Purves, Dale 364

Q

QMS MagiColor 421
Quadtones 245
Quantum Mechanic 314, 326
Quark Xpress 426, 430
Quartz rendering 401
Quick mask 68, 192
Quickmasks 191

R

Radial blur 281
RAID hard drives 96
Rainbow proofer 420
RAM memory 94, 96
RAM memory settings 97
Ranking (File Browser) 473
Raster Image Processing 421
Rasterized type 276
Raw camera files 326
Read Me files 379
Real World Color Management 424
Real World Photoshop 368

Real World Photoshop CS 424
Recent files menu 89
Recompressing JPEGs 436
Redo keys 85
Refresh list tree view 476
Relative canvas size 128
Relative Colorimetric 387, 420
Reloading selections 192
Removing a matte color 230
Removing wrinkles 189
Render Vector Files 475
Rendering intents 386
Replace color 159
Repro printing 423–424
Reset palette locations 20
Reset tool settings 87
Resize image 526
Resize windows to fit 67
Resnick, Seth xxii, 493
Resolut 350
Resolution
film 341–342
output resolution 346–348
pixels 341
reciprocal formula 342
terminology 344–346
Restoring faded images 180
Reveal All 45, 128
RGB printers 399
RGB workspace 385
RGB workspaces 369
Richmond, Eric xxii, 539
Ring flash effect 274
Rodney, Andrew xxii
Roland printers 401
Rosettes (halftone) 347
Rotate canvas
arbitrary 132
Rotate image 128
Rubber Band option 217
Rubylith mode 203
Ruler units 91
Rulers 17, 508
Run Length Encoding 441
Run Length Encoding compression
430

S

Saturate with sponge tool 63
Saturation mode 202
Saturation rendering 387
Save
Image Pyramid 427
Save dialog 426
Save for Web
GIF format 448, 449
JPEG format 444
Save for Web interface 445
Save palette locations 86
Save Workspace 471
Saving 425
Compact saves 528
previews 87
Saving HTML code 447
Scaled layer effects 268
Scanner Bit depth 306
Scanning
bit depth 306
drum scanners 302
dynamic range 305
flatbed 302–304
noise 310
resolution 304–305, 347–348
scans from films 301
Scanning backs 337
Scanning speed 309
Schewe, Jeff xxii
Scratch disks 93, 94
memory 95
size 15
usage 52
Screen angles 347
Screen capture advice 382
Screen mode 199
Scripting 514
Scrubby sliders 7
SCSI compatibility 101
SCSI devices 84
Searching images 472
Secure Digital cards 323
Select menu
color range 37, 159, 160, 191

deselect 192
feather 195
grow selection 38, 195, 196
modify
 border 194
 expand/contract 194
 smooth selection 195
reselect 214
select similar 196
Selections 191, 508
 modifying 194
 smoothing a selection 194
Selective sharpening 135
Separation options 390
Shadow/Highlight adjustment 5
Shape layer 270
Shape tool modes 64
Shapes 279
Sharpen tool 61
Sharpening 131
Shift Pixels tool 294
Shortcuts 15, 500
Show Asian Text 86
Show Grid 17
Show Rulers 18
Show Tool Tips 85
Shutterfly 487
Sidecar .xmp files 336
Sidecar files 335, 475
sidecar files 99
Sienna printing 423
Sigma
 SD9 camera 314, 316
Signum Technologies 495
Simulate ink black 418
Simulate paper white 418
Simulated CMYK proofs 421
Sinar
 54 315
Skurski, Mike xxii
Slice tools 47, 462
Smart highlighting (Extract command)
 231
SmartMedia cards 323
Smooth selection options 37
SMPTE-240M 370

Smudge tool 61
 finger painting 184
smudge tool 184
Snap To 45
Snap To behavior 18
Snapshot 51–52, 509
Soft focus effect 260
Soft Light mode 200
Soft proofing 386, 417
Softening focus 260
Software RIPs 423
Solarization 242
Sony
 Memory Stick 323
Sony Artisan monitor 417
Sound annotations 65
Spectrophotometer 361
Specular highlights 110
Spell checking 278
Spirit of St Louis 218
Split toning 241
Sponge tool 62, 159
Spot color channels 34, 276, 369
sRGB IEC-61966-2.1 370
Stochastic screening 347
Storage Media 493
Stuffit 433
Styles 29, 64, 262, 279
Stylus pressure options 48
Super CCD 314
SureSign 495
Swatches palette 30
SWOP print settings 386
Syquest 493
SystemWorks 102

T

Target brightness
 assigning in Levels 116
Targeted CMYK prints 420
Tecco
 Best Proof papers 416
Temp files (PC) 102
Text on a path 276
THM extension 99
Thumbnail image cache 477

Tiffen filters 325
Timing 15
Title bar proxy icons 16
Tolerance settings 195
Tool options 24
Tool presets 25, 278
Tool selection info 15
Tool switching behavior 36
Tool tips info 36
Tools palette 35
Transfer function
 (duotones) 245
Transfer functions 428
Transform 211
 with the move tool 44
Transform again 214
Transforming selections and paths 214
Transforms 272
Transparency 91
Transparency output 399
Transparent GIFs 450
Transparent gradients 58
Trim 46
Tritones 245
TWAIN 309
Type 276, 276–278
 anti-aliasing 278
 hide highlighting 64
 warping 64
Type selections 276
Type tool 63
type tool
 type on a path 12

U

UCA 393
UCR separations 391
Ultrachrome inks 403, 423
Umax scanners 302
Uncoated CMYK settings 375
Units 508
Units & Rulers 91
Unsharp masking
 131, 132, 136, 350
 amount 133
 incremental 134

radius 133–135
selective channels 136, 140
threshold 135, 136
Uploading to a server 434
USB 84
Use all layers 163
Use cache for histograms 97
Use Dither 390
Use lower case extensions 440
Use Outlines for Text 442
UTF 8 Encoding 457

V

Vander Houwen, Greg 268
Variations 143
Vector effects 64
Vector masks 203, 205
based on work path 220
Vector output 278
Vector-based programs 344
Velocity engine 85
Vertical palette docking 19
Video cards 75
View menu
fit to window 128
gamut warning 91, 159, 161
hide edges 159
new view 16
proof setup 417
show rulers 17
Viewing distance 354
Viewpoint
ZoomView plug-in 452
Virtual memory 94
Vivid Light mode 200

W

Wacom™ 28, 84
Warping text 64, 278
Web Graphics color 382
Web Graphics defaults 375
Web Photo Gallery 11, 453, 484
Banner settings 457
Custom Colors settings 458
feedback 460
feedback forms 460
General settings 457
Large Images settings 457
Security settings 458
Template styles 454
templates 459
Thumbnails settings 458
Web safe colors 68, 449
Web snap slider 450
WebDAV 89
Webster, Paul 539
Wet edge painting 49
White Balance 329
White point 82
Wilhelm, Henry 403
Wilhelm Research 403
Williams, Russell xxii
Window menu 507
cascade windows 16, 507
reset palette locations 20
tile windows 16, 507
Windows XP 101
Windows XP System reverts 101
WinZip 433
Wizards in Photoshop 519

Woolfitt, Adam xxii
Work paths 192
Workgroups 89
Workspace Settings 19
Workspaces 20
WS_FTP Pro 434
Wynne-Powell, Rod xxii, 540

X

X-Rite DTP 92 365
xD SmartMedia cards 323
Xericon 423
XML 481
XMP 475, 481
XMP files 335

Z

ZIP compression 426
Zone optimization 445
Zoom blur 281
Zoom percentage info 14
Zoom shortcuts 15
Zoom tool 67
ZoomView export 452, 453